PROFESSIONAL DIGITAL
PHOTOGRAPHY

TECHNIQUES FOR LIGHTING, SHOOTING AND IMAGE EDITING

DAVE MONTIZAMBERT

Amherst Media
PUBLISHER OF PHOTOGRAPHY BOOKS

AUTHOR ACKNOWLEDGMENTS

- Dean Collins of Cinema Software & Collins Knowledge Network
- Foveon
- Julieanne Kost of Adobe Systems Incorporated
- Alexander Kruczynski of Kruze.com
- John Lau of Calli
- Dan Margulis
- Glenn Morrison of Digital Mechanics.ca
- Sylvianne St. Onge (The Saint) of Montizambert Photography Inc.

Published by:
Amherst Media, Inc.
P.O. Box 586
Buffalo, N.Y. 14226
Fax: 716-874-4508
www.AmherstMedia.com

Publisher: Craig Alesse
Senior Editor/Production Manager: Michelle Perkins
Assistant Editor: Barbara A. Lynch-Johnt

ISBN: 1-58428-081-6
Library of Congress Control Number: 2001133137

Printed in Korea.
10 9 8 7 6 5 4 3 2 1

This book is dedicated to the memory of my lifelong business partner and brother Mark Montizambert (1961–2001), who shared in my photographic life adventure. Also, to my mother Bev Montizambert (1931–2002), who gave me the life tools to survive the last half of the 20th century and to prosper in the 21st—and hopefully the 22nd century.

TABLE OF CONTENTS

INTRODUCTION

The shift from silver halide imaging to digital imaging is a much greater event in the development and history of photography than was the change from black & white into color photography. Just as in the transition into color, not all photographers will survive the change. This is most unfortunate because, as in any transition period, there is tremendous opportunity.

BECOMING AN EXPERT

The imaging industry is crying out for digital imaging experts. Despite this fact, many photographers are not taking the plunge—either because it is beyond their comfort zone, or they are waiting to see what will happen. While these individuals are waiting, others who have embraced the technology are establishing themselves as the experts and creating a secure place for themselves in the future.

There is also a feeling among photographers that computers will eventually replace them—so what's the use? This is simply not true. Yes, digital technology is changing the way we work, but in a positive way. These new digital capabilities do not replace what we know. They simply give us better ways to express ourselves. Digital technologies not only allow us to

THE IMAGING INDUSTRY

IS CRYING OUT FOR

DIGITAL IMAGING

EXPERTS.

create the impossible, they also give us more powerful ways to do what we have always done. Creating meaningful photographic imagery is a very involved process that requires many advanced skills. There is no one better suited for the task than a photographer who has spent years honing his or her imaging abilities and sensibilities. There is no better time than now to adapt those abilities to digital. Now is the time to establish yourself as the expert.

ABOUT THIS BOOK

I have written the following pages based on what we at Montizambert Photography (my partner/brother Mark and I) have learned as professional digital imagers and beta testers. Since digital imaging is such a vast field, this book (like any other book on digital) is not a complete resource. It is a practical theory and a how-to book containing many intermediate-to-advanced techniques.

This book will focus primarily on digital capture and image editing. For image editing I will use Adobe® Photoshop®, since it is the most widely used application. The principles and techniques referred to and demonstrated are, for the most part, possible with most other serious image editing programs. I will refer to image editing programs in general simply as Photoshop. As for the difference between Apple and PC keystrokes, when the modifier key called the Command key is written, substitute the Control key if you work on a PC. PC users should also substitute the Alt key for the Option key.

Little space will be spent on scanning (which is so well covered in other books) because scanning relies on film. In the digital world, film is redundant—we can put "the scanner" in our cameras and capture reality directly. Since the experience level of the readership of this type of publication tends to be widespread, I have also included essential basics to get everyone on the same plane.

THERE IS

NO BETTER TIME

THAN NOW

TO ADAPT

THOSE ABILITIES

TO DIGITAL.

1

DIGITAL IMAGING CONCERNS

By now you have probably gathered that I am a digital imaging advocate. However, in all honesty, I must say that going digital is not all a bed of roses. There are some issues one has to address. The following chapter will spell out how Mark and I have dealt with them. The issues you must deal with when going digital are: image quality, file size, hardware obsolescence, the dreaded learning curve, price, and how it will pay for itself.

IMAGE QUALITY

Image quality is no longer an issue for high-end digital capture—the quality professionals demand has arrived. The main problems of the past (noise, bad color, and highlight burnout) have pretty much been eliminated.

FILE SIZE

File size is, however, still a relevant issue. When considering file size, look at how the majority of your work (say 80%) will be reproduced and to what size. A high-end, 4–6 megapixel (2K to 3K) digital camera can produce image files that will make stunning 30" to 40" photographic prints that are superior to traditional prints made from medium format nega-

IMAGE QUALITY

IS NO LONGER

AN ISSUE

FOR HIGH-END

DIGITAL CAPTURE . . .

tives. These same images can be printed at up to 6' sizes on large-format inkjet printers with photo-like quality. How is this possible? Clean, high quality raw capture files and printer interpolation software. The software that the printers use to increase the image files to the size required for large format output is very sophisticated. This software can enlarge digital image files more than 600% with great results. The newer 16.8 megapixel chip technology can more than double the above output dimensions.

HARDWARE OBSOLESCENCE

Despite the furious pace of digital development, obsolescence is becoming less of an issue. Increasingly, digital capture manufacturers are using, wherever possible, software-upgradable firmware to take the place of the hardware they install in their digital cameras. A digital camera bought today may not be as good as what will be available in the next five years, but it will still be more than useable. Keep in mind that when you do upgrade this equipment, the older equipment isn't thrown out, it is still used, but for less rigorous tasks. For example, a new computer will probably serve you for the next four to five years before you replace it. But, in reality, you don't really *replace* your "obsolete" technology, you use it to help you multi-task by relegating it to simpler tasks. An older computer is still well suited for CD- or DVD-burning, archiving, printing and word processing.

LEARNING CURVE

Learning to shoot with a digital camera takes no time at all. With most cameras, after two hours you have the hang of it, and after a couple of days, you are an expert. The real learning curve is in post-production—the image editing programs where you retouch, manipulate, color correct, and color manage your digitally-captured image files. Color is the biggest part of the post-production learning curve. When you become a digital imager, you automatically take the responsibility for color correction and management out of the hands of the film companies. Not every photographer is going to want this responsibility. I think that many photographers are not interested in going beyond creating a scene, lighting it, then capturing it digitally. For this reason, I see more partnerships forming between photographers and post-

production people from pre-press houses and digital photo labs—people who are already experts in image editing. If you are planning to go all the way, as I have done, you will need to master color (more on this later). And, due to the frantic pace at which software is advancing, you will need to allot 10% of your time to studying and experimenting to stay on top. Certainly, these duties can be shared with an employee or partner. If you *do* want to do the whole thing—because you are a passionate, obsessive perfectionist, who is also a control freak—there is a lot to learn about color, so I suggest that you start learning as soon as possible.

If you are serious about getting on to the learning curve right away, but do not have the necessary funding, consider this inexpensive solution. Buy a "prosumer" camera (a top-quality consumer camera), a program like Adobe Photoshop, and a second-hand computer. The prosumer camera's smaller file size requires very little computing power, making a cheaper, less powerful computer all you need to get started learning. And, really, a prosumer grade digital camera does not have to be just a learning tool; the quality of the images it produces is adequate for capturing the smaller image files that are usually used for the Web, for flyers and low-end catalogues—so you can make money while you learn.

PRICE

Most photographers are artists rather than businesspeople. For this reason, we have trouble wrapping our minds around the price of the high-end digital systems that we need if our businesses are to survive. Good digital systems cost more than what the average photographer has ever spent on a single system before (on average $10,000–$30,000).

For some reason, photographers do not consider leasing it. This is funny, because we photographers think nothing of financing automobiles and our homes, yet it never occurs to us to do the same thing with tools that will increase our income and help secure our business' future. The easiest way to justify the change to digital is to look at how much film and Polaroid you shoot per month. Compare this figure to a monthly lease payment on the digital system you need. Most serious studios are doing enough volume that the film and Polaroid they use each month easily offsets the cost of a lease on a high end digital capture system. At our studio, our

ALLOT 10%

OF YOUR TIME

TO STUDYING

AND EXPERIMENTING

TO STAY

ON TOP.

monthly cost of Polaroid and film was actually *more* than the lease on a high end digital capture system (with a computer, monitor, Photoshop, etc., all included).

When you think about paying for a digital system with the money you already spend on film and Polaroid, it starts to make sense. As a friend of mine says "You don't buy film, you lease it." You can't buy a roll once and reuse for many years— you have to keep buying more.

WILL IT PAY FOR ITSELF?

Digital also provides new revenue possibilities. A photographer can sell new services to clients—such as image manipulation, color correction, retouching, and CMYK conversion (a pre-press service). At the end of a shoot, a client can walk out the door with a completed image file on a disk. This means no waiting for film processing, and no waiting for scans. This fact alone attracts a lot of new business.

Quick turnaround is just one small benefit. I see digital capture systems as much more than a time- and materials-saving device. We compromise less with digital. Without digital capture, Photoshop is exclusively a post-production tool. Using a digital camera, however, we can experiment on the fly and create stronger images with less compromise. This is because we shoot with our workstation placed next to the camera. This allows us to composite with programs like Adobe Photoshop *while we are still shooting.* This provides incredible flexibility. If the captured image is not right for, let us say, a composite we are creating, then we go back to the camera, tweak it and/or the set, capture another exposure, and try again. With film, you do not have this luxury. You must wait for processing, then you must choose which frame you think might be best to scan for the composite. Chances are, you will experiment less and go the safe route because you have to pay for each scan. If the image does not work out with your composite, chances are you will compromise. You will compromise because the set is already struck. You will compromise because you will have to pay for more scans. You will compromise because you cannot afford the time.

Digital capture, in conjunction with Photoshop, provides incredible creative possibilities that are not practical with film-based photography. For example, providing the camera is not bumped between exposures, it is possible to shoot the same

I SEE DIGITAL

CAPTURE SYSTEMS

AS MUCH MORE

THAN A

TIME- AND MATERIALS-

SAVING DEVICE.

scene or set multiple times with varying lighting, exposure, etc. Each frame will be in perfect registration with the last. Talk about control—this is very powerful stuff! In Adobe Photoshop and other similar applications, using layer masks, you can paint desired areas of one image into another. This allows you to composite opposing light qualities that are impossible to combine in real life. This is totally impractical and nearly impossible (not to mention expensive) using digital files from film. Since digital capture files have no film grain they can be sharpened to very high levels using Photoshop's Unsharp Mask. Digital capture images also have a greater dynamic range than film, and they can be interpolated (sized up) further than film scans.

TALK ABOUT CONTROL—

THIS IS VERY

POWERFUL STUFF!

DIGITAL CAMERAS

There are four types of digital cameras: the scan-back one- to three-pass system; the single-chip three-exposure system; the single-chip single-capture interpolated color system; and the full-color single-exposure/single-capture system.

MULTI-EXPOSURE SYSTEMS

In the beginning of digital imaging, professional-quality images were only available from three-exposure digital capture systems, the scan-back three-pass camera, and the single-chip three-exposure camera. With these systems (which are still manufactured and in use today), a subject has to be exposed three (and, in some cameras, four) times in exactly the same position—neither the subject nor the camera can move. The first exposure is shot through a red filter, the second through green, third blue and, if a camera uses a fourth exposure for extra quality, a second green exposure. The three (or four) images form a composite that creates the illusion of full color. As you can imagine, lighting is critical since, if it shifts in color balance or intensity from one exposure to the next, the composite image will suffer. Anything that moves, like a person or steam from coffee, cannot be shot because the three exposures of the subject must be identical.

AS YOU

CAN IMAGINE,

LIGHTING

IS CRITICAL . . .

The subject must be in exactly the same position for each exposure, otherwise there will be color ghosting. This color ghosting looks just like a badly printed magazine or newspaper where the printing press has printed color images out of alignment. In Vancouver, we have one notorious newspaper that is the brunt of many jokes about image quality—when you buy four-color advertising in this paper you know you are getting your money's worth, because you can count all four colors (cyan, magenta, yellow, and black) fringing around your subject.

SCANNING BACKS

The highest resolution images are generated from scanning backs. These are backs that are designed to fit onto existing film cameras. (Keep in mind that, if you buy one, you may have to add in the cost of a traditional camera to affix it to.) These digital capture systems, which are the most difficult systems to use, are fitted into the back of a view camera, just like a film holder or a Polaroid cassette.

To make an exposure, the subject must be lit by a constant light source (as opposed to flash)—either tungsten, HMI, fluorescent, or sunlight. A constant source is required because the imaging head, which is a line of sensors called an array, actually moves down the image area scanning and recording the image as it goes. Some scan backs only need to do one pass because they capture all three colors simultaneously. Scan back technology is really identical to a scanner or a photocopier.

Creating an exposure with a scan back easily exceeds the quality of 4"x5" film, but it is the most difficult and the slowest (several minutes per scan) image capture system to use. Lighting for a scan back is the most critical of all four capture systems. Lighting has to be constant in color and in brightness during the whole time of the rather lengthy scan, otherwise the exposure and color balance at the beginning and end of the image will differ.

SINGLE EXPOSURE SYSTEMS

The most exciting advancement in digital capture is the single-exposure system, because it allows photographers to shoot animate objects (like people, wind blown foliage, fire, and smoke) in color with an instant view of the captured

○ **TIPS**
Three-exposure single-chip capture systems, unlike the three-pass scan back, capture the whole image area in a single instant. However, they still need three exposures to capture full color. Three-exposure single-chip capture can use strobe (flash) lighting or constant lighting. It is faster to use, but does not yield the large file sizes that the scan-back system can produce. However, some manufacturers have added a feature that allows the imaging chip to be moved around to increase the imaging area by four times.

A red, green, and blue mosaic filter is painted onto the imaging sensor.

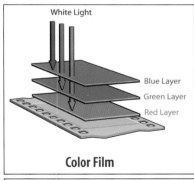

Color Film

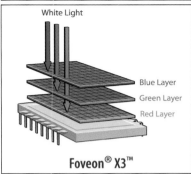

Foveon® X3™

A new type of CMOS called the Foveon X3 that captures color in very much the same way as photographic color film.

image. The majority of these systems do this with only one imaging chip. A red, green, and blue mosaic filter is painted onto the imaging sensor (see graphic, left). The problem with mosaic single-chip/single-capture systems is that each light-collecting cell on the chip can only capture one color. To create the missing color information, software is employed to interpolate color (it guesses what the missing color should be). The software that does this is very effective. However, the color is not as good as full-color capture. Also, funny swirling rainbows (called moiré patterns) sometimes appear in areas where patterns on the subject (like those typically seen on fabrics) interfere with the pattern of the imaging sensor. Moiré is less of a problem with the 16+ megapixel imaging sensors than it is with the 3–6 megapixel systems.

To address this phenomena and capture truer color, one digital camera manufacturer explored and perfected another solution: split the incoming light into red, green and blue using a color-separation prism system. The prism directs each of the split beams of light onto a separate imaging chip. This delivers the quality of three-exposure cameras with the flexibility of single capture. Since the captured data comes from three sensors, there is less opportunity for pattern interference—so almost no moiré.

The drawback to the three-sensor system that the light must pass through more glass. This results in softer images that require higher levels of post-production sharpening. Because there are three sensors instead of one, a very high quality prism, and complex alignment issues, this solution is also more costly.

To address these issues, the manufacturer created a new type of CMOS called the Foveon X3 that captures color in very much the same way as photographic color film (see graphics, left). With film, different colors of light penetrate to different layers of photosensitive material, with each layer detecting a specific color. Similarly, the X3 sensor captures all three colors (red, green and blue light) at each pixel in the sensor. The result is very sharp images with good color—and no moiré patterns. It does all of this using three layers of photodetectors embedded in silicon. The layers are positioned to take advantage of the fact that silicon absorbs different colors of light at different depths, so one layer records red, another layer records green and the other layer records blue. This

means that, for every pixel on the image sensor, there's a stack of three photodetectors, resulting in a full-color single exposure chip. Since this technology uses only one imaging sensor and requires no complex software to interpolate color and repair color errors from interpolation, cameras using the X3-type imaging chips are simpler and cheaper to manufacture.

COLOR ALIGNMENT

Color alignment is critical with all four types of digital systems. When you are in the market for a system, you should test out its alignment. Make an exposure, open it in Photoshop, then look at the individual color channels that make up the image. In Adobe Photoshop, you can toggle from one channel to the next by using the following keyboard strokes: Command+1 (or Control instead of Command on a PC) for the red channel, Command+2 for the green, Command+3 for the blue and Command+tilde (~) for the the color composite. If the image jumps a little as you toggle from one channel to the next, you will know that the channels are out of alignment. The result will be softer images that, in worse case scenarios, will display color fringing. You can, to some degree, manually align these image channels in Photoshop; however, this is time-consuming—imagine if you shot a catalogue of 1000 images and each image had to be manually aligned! Really, it should be the manufacturer's job to provide proper alignment in the first place. While we are on the topic of looking at individual channels, you should also look to see if any of the channels are softer looking or contain more noise (stray pixels that look like film grain) than the other two channels. There will probably be some difference, but there should not be a lot.

SENSOR CHIP TECHNOLOGIES

There are two imaging-sensor silicon-chip technologies in use today for digital cameras, they are: CCD (charge coupled device) and CMOS (complementary metal oxide semiconductor). Originally, high-end digital cameras and digital backs used only CCD image sensors. They had a greater dynamic range (light to dark tonal range), were more light sensitive (higher ISOs), and had less noise than CMOS. CMOS overcame these shortcomings, however, and is now also used in high-end systems.

The size of the imaging chips in digital cameras is smaller than film. This means that short lenses become long lenses, and long lenses become really long. This is a real benefit for telephoto photography, however, you will need a really wide-angle lens to achieve regular wide-angle coverage. Now that so many photographers are going digital, it has become worthwhile for lens manufacturers to consider creating the shorter lenses needed for wide-angle digital.

CMOS. Indeed, CMOS has some distinct advantages over CCD. First of all, CMOS uses the same silicon chip manufacturing techniques as most other semiconductors, whereas CCDs require a very specialized process unique to CCD manufacturing. This makes CCDs much more costly to manufacture, which makes the cameras more expensive. A three-chip CMOS camera typically sells for the price of a single chip CCD camera. Secondly, CMOS chips consume as little as $\frac{1}{100}$ of the power that a CCD chip requires. This means longer battery life and smaller batteries in portable units. Finally, when one of the pixels in a CCD chip is over-exposed, the excess light tends to spill over into the adjacent pixels, causing what is called "pixel blooming" glare. To avoid this image degradation, lighting control is very critical in the highlight end of the image. CMOS does not have this blooming problem; you can work with your lighting the same way you would for film.

One digital camera manufacturer, Foveon (they build single-chip and three-chip single-exposure cameras), designs and builds their own 2K and 4K CMOS chips through their manufacturing partner, National Semi Conductor. These partners design each of their chips to have a tonal response curve similar to Kodachrome 25—a steep toe (lots and lots of shadow detail) with a flat shoulder (detail is maintained in the highlights longer before burnout). This design creates images that look like film rather than digital. Kodak found another way around the highlight problem when they created their 16-megapixel sensor: an incredible dynamic range from 12–13 f-stops. This is amazing, especially when you consider that transparency film (also called positive or slide film) has a range of only 7 f-stops, and that the printing press can really only handle a 4–4.5 stop range from the darkest area with detail to the lightest area with detail.

3

GETTING STARTED

A key aspect to working efficiently in digital (or any other process) is to make things right at every stage of the process instead of correcting it at the next stage. For example, for years many portrait and wedding photographers have relied on labs to "fix" their color and exposure during printing. This makes for less than optimum prints, and it gives all of the control over how your image will look to a darkroom technician. With digital, you are responsible for your color and exposure. If you don't get it right, you will have to fix it yourself in Photoshop. Obviously, from a production, financial and commonsense point of view, it makes much more sense to get it right up front.

LIGHT COLOR BALANCE

The starting point is getting the color balance of your lights right. Once you have set up the subject and completed the lighting, it is time to check the color temperature of your lights. All reputable strobe (flash) light manufacturers daylight balance their lights to read somewhere around 5000°K (Kelvin). If you turn the power down on a light (using the fade control), the light will put out less light and it's color temperature will "warm up" (drop to a lower Kelvin num-

ber). Also, as that light's strobe tube ages, the color temperature will change. Because of these discrepancies, a multiple light setup will often have a different color temperature for each light. What is an acceptable difference? When viewing a print, our eyes can detect as little as a 200°K difference. Color discrepancies are much more noticeable on larger, single-tone areas, such as a flat-lit background.

How accurate you need to be depends on your clients and your subject matter. For example, if you shoot catalogue work, the same background often gets used for many shots. More often than not the same background will get used again at a later date to shoot more products that will appear next to the earlier set of images in the final printed piece. For this kind of work, you need to be very accurate. When shooting portraits, you can be much more relaxed about the color variation between strobes.

To balance all your strobes to 5000°K, you will need a strobe color temperature meter. After you have set up your lights, take a color temperature reading of each light. If a particular light reads warmer, lets say it reads 4700°K, add a thin strip of blue color conversion gel (3200°–5000°K) over the light. Keep adding more blue strips until you get a color meter reading within 100° of 5000°K. If the light reads too cool, let's say 5300°K, add thin strips of an orange color conversion gel (5000°–3200°K).

IN THE INTEREST OF

COLOR AND EXPOSURE

CONSISTENCY,

ALLOW THE STROBE

EXTRA TIME TO

RECYCLE ITS POWER.

When a strobe unit is ready to shoot, a light appears or the ready tone sounds—this means it is recharged, but not fully. In the interest of color and exposure consistency, allow the strobe extra time to recycle its power. For example, some strobe units can take up to an additional 14 seconds after the green light appears to reach full charge. This recharging is critical if you are using a three-exposure camera, and less critical if you are using a single-capture camera. Obviously, on something like an action fashion shoot, you cannot wait because you need to shoot a number of frames in rapid succession to capture the right look. In cases like this, it makes sense to deal with a minor color discrepancy after the fact, using Photoshop or the camera's processing software.

CAMERA COLOR BALANCE

Once the lights have been balanced to one another, it is time to balance the camera. Different manufacturers have different

methods, all with the same goal: to neutralize the camera's color balance. When shooting film, there are really only two choices in terms of color balance: daylight balanced (5000°K) film or tungsten-balanced (3200°K) film. When you shoot with available light on location, if the color temperature does not come out to 5000° or 3200°K, you need to figure out what filters to use to compensate.

What if, instead of fussing with filters you simply dialed in the color temperature on the camera? This is exactly the way digital cameras work. They give you everything from 5000°K to 3200°K—and a bit beyond. You can simply neutralize the camera to the lights, then start shooting. However, if one or more of the lights are over 100°K different from the other lights, you will get an average balance for everything. Color shifts will occur on areas that are not illuminated with all the lights to the same degree as the area that you balanced for.

To balance the camera, the most common practice is to place a gray card or a gray scale in the scene. Most high-end cameras come with capture software that includes a densitometer to read tone and color values. One or more readings are taken off the gray test swatch. The camera then automatically sets these known tones to equal amounts of red, green and blue (you can also do this manually with software controls such as Curves [more on Curves later]). Once this is done, a neutral gray tone will record as neutral gray, making all other colors and tones fall into place accordingly. Some digital cameras employ a more sophisticated system that involves shooting a card with color as well as gray swatches that are measured and adjusted by the camera software.

MOST

HIGH-END CAMERAS

COME WITH

CAPTURE SOFTWARE

THAT INCLUDES

A DENSITOMETER . . .

EXPOSURE

To get a good exposure there are a number of methods. The first is to simply meter, just like you do with film. The second is to take a first exposure that acts as a test shot (much like a film scanner's prescan), then use a histogram and read various points of the subject with the capture software's densitometer to see how the exposure is. With some digital camera capture software, you can affect how the camera will record the exposure by using Curves. This can save you time in lighting sets that have really dark- and really light-toned subjects together. However, it is always best to tweak the exposure and range of tonal contrast with the actual lights. If you have

A histogram gives an indication of what the exposure looks like by providing a graph that represents how much exposure each of the image pixels have received. Many photographers say a well-exposed image should have a "full" histogram such as the one shown inset in the JVC product shot image (left).

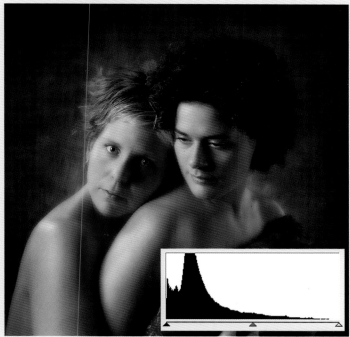

This is not *always* the case, however. When viewing a histogram, keep in mind what tones the image is made up of. An image made up of predominately dark tones, such as "Sorrento Fresco" (below), has little in the bright end (our

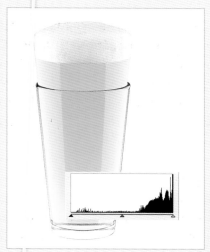

When judging exposure, the information provided by the histogram should be used in conjunction with common sense as well as a visual check of the image on a calibrated monitor. For the most accurate assessment, exposure should be judged by digital densitometer readings directly off the image file. The densitometer, which is part of most high-end digital cameras' capture software, is the digital equivalent of a dead-accurate spot meter (light meter). To read densities and color values of an image, refer to the Info palette (found under the Window menu) in Adobe Photoshop. Place your cursor on any part of the image file, and the values of the pixels underneath it will be displayed in the Info palette. You do not have to have the Eyedropper tool or the Color Sampler tool selected to use the densitometer. The Info palette will show the values under the cursor, no matter what tool is selected.

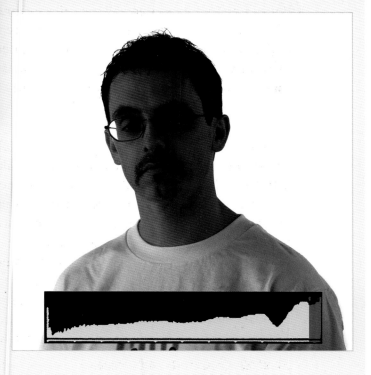

right side) of the histogram, whereas an image such as the one at the top of the next column is made up of mostly three-quarter to highlight tones and has little happening in the shadow end of the histogram. Yet, both of these images are exposed correctly. Conversely, look at the image at the bottom on the next column. The subject is obviously underexposed, yet the histogram looks pretty full, even at its highlight end, because the background happens to be slightly overexposed white seamless paper.

a calibrated monitor, it does not hurt to do a visual check of the exposure, too.

MONITOR CALIBRATION

Many digital photographers have heard complaints about the brightness and/or color of their digital images from clients who view the file on their own computers. Assuming the photographer has done his job right, the problem usually lies with the client's monitor. To fully understand what is happening, take notice next time you walk by an electronics store with a bank of televisions displaying the same channel. You will notice that the units all display the same image quite differently. There is no official standard for color, contrast and brightness. The same is true with computer monitors. However, if two or more monitors are calibrated with a colorimeter, these monitors will be pretty close.

A colorimeter, which looks a bit like a mouse with a suction cup on its underside, is an optical measurement device that reads color. It is positioned on top of a color target displayed on your computer screen. The color target is created by the colorimeter's software, which resides in the computer to which the monitor and the colorimeter are connected. A series of colors that make up the target are displayed in turn (100% red, 100% green, 100% blue), then a series of gray patches are displayed. The data measured from each patch by the colorimeter is analyzed by the software. The software adjusts the monitor's gamma, white and black point, and color balance. Since all phosphor-based monitors change over time, the above calibration process needs to be done on a regular basis—as often as every two weeks for older monitors. Liquid crystal display (LCD) monitors do not drift.

A less expensive, but also less accurate approach to monitor calibration is included with your computer's operating system: the visual monitor calibrator. Since this calibrator does not measure anything (it relies on your vision to balance the color), it is not as good as the colorimeter approach. It is, however, better than nothing.

OUR VISUAL SYSTEM

In addition to calibrating the monitor, you must take into consideration that our eyes are influenced by the color and brightness around the monitor. To reduce this effect, select a

OUR EYES

ARE INFLUENCED

BY THE COLOR

AND BRIGHTNESS

AROUND THE MONITOR.

neutral gray for your computer's desktop pattern, avoid placing colored walls and objects next to your monitor, and position your monitor to avoid glare on its screen. After calibration, do not change the brightness and contrast settings and, if possible, wear dark, neutral clothing to avoid casting color reflections on your monitor. In addition, you should keep the lighting level in your room consistent day in and day out.

Whether you are judging color or judging exposure, do not fully rely on your calibrated monitor. The real problem is in the way that our visual system constantly balances color and brightness for us. Due to a phenomenon called chromatic adaptation, our eyes and brain adjust to lighting conditions. When you step outdoors into the sunshine, your eyes neutralize to the daylight color balance and your pupils close down to balance the range of brightness. If you go indoors, into an artificially lit room, you neutralize the color and your pupils open up to balance the range of brightness. Your visual system is trying to maintain a constant value, so that you have the best possible visual information to survive by. Unfortunately, this works against us during monitor viewing.

When looking at a printed copy of our images, we can easily detect a color cast, because our vision has already neutralized itself to the ambient light. Since the print is lit by the same ambient light, any color cast is very obvious. Unfortunately, this is not the case when viewing an image on a monitor. On a monitor the light is coming *from the image itself*, so our visual system is constantly calibrating to that. The longer you stare at the image on the monitor the more neutralized the image becomes, making you think it is okay. When judging exposure—and especially when judging highlight detail—the monitor makes our pupils close down, leading us to think that we see more highlight detail than is really there. Therefore, you should not use your monitor to judge highlights, shadows, or neutrals. Instead, use your software's built-in densitometer to read the color/brightness values.

Metamerism and Simultaneous Contrast. There are two other visual phenomena you need to be aware of: metamerism and simultaneous contrast. Metamerism is when two colors appear to be the same under one lighting condition and different under another. I wear black clothing a lot. When I am buying clothes, I often try to match up the blacks.

Some blacks, however, are blue-based. Others are red-based (I did mention earlier that I am obsessive compulsive!). After matching up the blacks under the lighting in the store, I have often found that they appear noticeably different outdoors in the daylight. On a critical color job, you can check for metamerism by viewing a proof or print under two different conditions (for example, in your office and then outdoors); if they appear the same, then they are fine.

Now, look at the two dot-within-a-dot graphics to the right. The inner blue dots read exactly the same color values as do the gray dots. So why does the top inner dot appear different than the lower inner dot? Simultaneous contrast is the answer. Simultaneous contrast refers to the visual phenomenon of colors and tones appearing differently based on what is surrounding them. The human visual system has evolved, for survival's sake, to exaggerate the differences between similar colors and tones. I often run against this phenomena when retouching an image with Photoshop's Clone tool. I sample what I *think* is a similar color and/or tone to the area surrounding the imperfection that I am trying to cover up, only to find that the sampled area looks different against its new surroundings. It does not match.

DIGITAL DENSITOMETERS

By now, it is probably very clear that you need to know how to use the densitometer in your camera's software and in Photoshop. The densitometer will help you to establish whether the image you see on your monitor is neutral, and if the shadows and highlights (the darkest and the lightest significant area in an image that you want to maintain detail in) are set to the appropriate values for final output to color prints, a poster, a magazine, etc. For the best-looking image, it is common practice to set the shadow to the darkest possible value that will still hold detail in the final reproduction and highlight to the brightest possible value that will still hold detail in the final reproduction. This way, you are utilizing the full range of tones available.

When you view a single solid color in a photograph, whether it is film or digital, it is almost never made up of identical pixels. For this reason, you should check out the sample size setting for the densitometer. In Adobe Photoshop, select the eyedropper tool then look at its

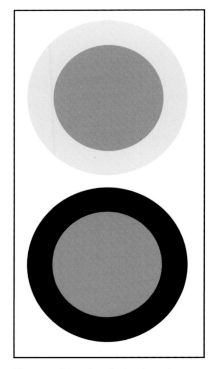

The inner blue dots (below) read exactly the same color values—as do the gray dots (above). So why does the top inner dot appear different than the lower inner dot? Simultaneous contrast is the answer.

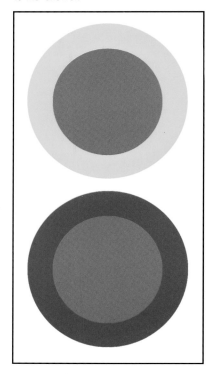

options. It is usually best to set it to Sample Size: 3x3 or 5x5 (for higher resolution images) average. When you read the numbers in the Info palette, you will be reading an average of several pixels instead of a single pixel.

Number Systems. Different color spaces use different number systems to express density or brightness values. The RGB (red, green and blue) color space, the color space that all digital cameras capture in, uses a scale of 256 levels of brightness (minimum brightness is 0 and maximum brightness is 255). Why 256 levels? Originally, programs like Adobe Photoshop worked only in 8-bit per channel color depth (8 bits for red, 8 bits for green and 8 bits for blue). Each image pixel is made up of 8 bits. Those individual bits can be either off or on. The total possible combinations of "offs and ons" in this binary system equals 256. Therefore, an 8-bit color space can display 256 levels of gray (8^8). In color, it can display 16.8 million colors (8^8 levels of red x 8^8 levels of green x 8^8 levels of blue).

DIFFERENT

COLOR SPACES

USE DIFFERENT

NUMBER SYSTEMS

TO EXPRESS DENSITY

OR BRIGHTNESS

VALUES.

When the densitometer's cursor is placed over an area of the subject that looks like it is a neutral tone, a reading of red, green and blue brightness levels appear in Photoshop's Info palette. If the three numbers read roughly the same, then the area under the cursor is a neutral color (a shade of gray). If the numbers are not equal, then it is not neutral. It has a color cast. Color casts occur in neutral tones when:

- The camera has not been properly gray balanced.
- The lights have not been color balanced to a single standard.
- The image sensor and/or camera software are less than optimal.

When the image sensor and/or camera software are to blame, the color cast may not be global (that is to say, there is not an even color cast over the whole image). Instead, it may be localized. For example, it might appear in the highlight but not in the midtone or shadow. Or, the image may have different casts in different areas—a red cast in the highlights, and a blue cast in the shadows, for example. For this reason, you need to take readings off neutral points in the highlight, the midtone, and the shadow areas. If there are no neutral tones to read from, then try to find known colors where you

know the approximate color "recipe" for that object. For instance, the first yellow pepper in the image of Sylvianne and Tim (seen to the right) is a good example of a known color. We all know what a yellow pepper is supposed to look like. However, a densitometer reading of the RGB values of this known color showed that the red component was way too high in relation to the green (253 red and 178 green). By pulling some red out and increasing the green, the color was brought into balance. (This image of Sylvianne and Tim is discussed in greater detail on page 45.) When analyzing an image, consider highlights, shadows, neutrals, known colors and fleshtones. Once these tones are balanced, and assuming that your monitor is reasonably well balanced, all other colors can be judged by eye. It is, how-ever, safer to know the color makeup of your subjects (which, unfortunately, only comes from experience) and judge the colors with the aid of the densitometer.

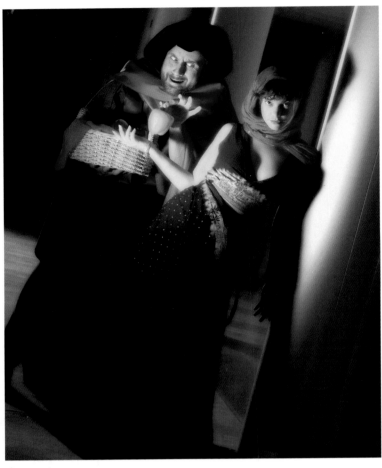

If there are no neutral tones to read from, then try to find known colors where you know the approximate color "recipe" for that object—here, the yellow pepper.

To recap, neutrality and brightness cannot be judged on the monitor, because our eyes constantly adjust to brightness and they constantly try to neutralize neutral colors. If you stare at an image with a yellow cast on your monitor, in a very short time your eyes will neutralize the yellow shift. However, that yellow color cast will become very evident when the image is printed.

IMAGE ANALYSIS AND CORRECTION

When you begin evaluating a digital image, you should determine the location(s) of the following:

1. Darkest significant shadow
2. Brightest significant highlight
3. Neutral tones
4. Flesh tones
5. Known colors (green grass, blue sky, red fire engine, yellow banana, etc.)

To find the darkest significant shadow and the lightest significant highlight in an RGB/grayscale image, open the Levels dialogue box (Image>Adjust>Levels). Press the Option/Alt key, and move one of the end sliders of the Input Levels (in pre-6.0 versions, turn off Preview by clicking its check box before sliding the sliders with the Option key depressed). The left slider will make the image grow darker as you slide it to the right. Keep moving the slider until almost everything has gone dark. This will show you where the lightest points of the image are. Choose the point that is the lightest significant area of the image you want to maintain detail in. Do the same for the shadow by sliding the right-end slider to the left. In

most color spaces (RGB, CMYK, LAB, grayscale), you can also determine significant end-points using the Threshold dialogue box (Image>Adjust> Threshold). Moving the Threshold slider to the left will reveal the darkest areas, and to the right, the lightest areas. The only disadvantage to this method is that it requires more than a simple keystroke.

RGB VALUES

RGB values (0–255 levels) express brightness. The higher the number, the greater the brightness: 255 is pure white, 0 is pure black. The following are target figures for neutral tones in RGB levels (0–255):

Black without detail	= 0—10
Shadow (black with lots of detail)	= 30—50
Quarter tone	= 60—100
Midtone	= 110—130
Three-quarter tone	= 160—170
Highlight (white with detail)	= 235—245
Pure white	= 255

Between these ranges are the transition areas. For example, a densitometer reading of 105 indicates that this area is neither quarter tone nor midtone, it is in the transition area between. The above ranges are, of course, rough figures and will vary depending on the output situation.

Shadow and Highlight Detail. Most output situations (such as a digital printer that exposes an image onto photographic paper with a laser), can easily hold detail in the highlight at a value of 245. However, if you captured a digital image that was destined to be printed on uncoated paper on a web printing press, you would probably want to set the highlight in RGB (assuming that you are correcting in RGB instead of CMYK) no higher than 240 to maintain detail. You would probably want to set the shadow no lower than 30 to maintain detail. The three-quarter tone and quarter-tone range are the most subjective brightness ranges of an image, since they are generally set relative to the type of image. For instance, an image made up of mostly dark tones may look best and reproduce better with lighter quarter tones.

Setting the lightest and darkest significant neutral areas of an image that need to hold detail is very critical. More often

MOST

OUTPUT SITUATIONS

CAN EASILY

HOLD DETAIL

IN THE HIGHLIGHT

AT A VALUE

OF 245.

than not, the brightness range of a digital capture does not fit within the available range of the final output (be it an inkjet print, brochure, or Web page). As noted earlier, the highlight and shadow zones are so important because we can only achieve the look of a full tonal range if these two areas are set to the brightest possible value and the darkest possible value that the final output can display while still holding detail.

PRACTICAL EXAMPLE: "GLEN ORD"

Using an uncorrected image (below), let's look at how to set these end-points and how this procedure also helps to correct global color casts.

IMAGE DATA:

Exposure:	f-16 at $^1/_{125}$ second
Camera:	Foveon Single Capture
Lens:	Canon L-Series 28–70mm/f-2.8 zoom set at 55mm
Lights:	one Paul C. Buff X2400 White Lightning mono-block strobe with a 7" reflector
Light modifiers:	a Chimera 36"x48" medium pro softbox
Processing software:	Foveon Lab
Image editing software:	Adobe Photoshop

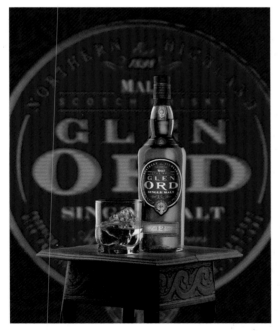

Uncorrected image.

This image, "Glen Ord," is made up of 21 different lighting situations. Each change to lighting was recorded as another image file, then all of the files were melded together in Photoshop (this technique is covered later in this book on pages 87–88, with the image called "Stamp Book"). What this image needs right now is to be optimized for output and to have an orange color cast neutralized. In other words, its lightest and darkest significant neutral areas need to be set to the brightest and darkest values that will still hold detail in the final output. By setting the end-points to maximize the available range that the final output has to offer, there is a wonderful side effect: most (or all) of the color cast will automatically be removed.

Image Analysis. The lightest significant neutral point of this image is the brightest part of the large letter "R" in the word "Ord" on the main label of the bottle. The black outer border (top left of the label) has the darkest significant point. Using the Info palette in Photoshop to read

the red, green, and blue values under the cursor, I came up with the following readings:

In the highlight : Red = 238
Green = 238
Blue = 232

In the shadow: Red = 38
Green = 29
Blue = 15

To hold highlight detail for final reproduction of the image in this book, a value of 245 in RGB color space is a safe brightness. This value, once converted to CMYK, should come out to around a 3% to 2% printing dot. The press printing this book should have no problem holding detail in the highlight at 2%, but if it were a 1% dot, chances are this highlight would have no detail.

As it is, the R=238/G=238/B=232 reading places the highlight too low in the red and green channels and even lower in the blue channel. To neutralize this area (remove the slight yellow cast) the blue curve needs to be raised up so that 232 reads 238. However, it makes more sense to place this point at 245, then drag the curves for the red and green channels up to 245 from 238. Setting all three channels to 245 will expand the range of the image and it will help to remove the orange color cast at the same time. This operation is best accomplished by using the Curves tool.

Curves. Instead of selecting Curves from the Image menu (Image>Adjust>Curves), I usually access the Curves dialogue box with an adjustment layer (see appendix, page 103). Using a Curves adjustment layer allows further editing of the curve at any time by double clicking on the Curves adjustment layer in the Layers palette. Once you click on the OK button in a Curves dialogue box brought up from the Image>Adjust menu, you cannot edit that curve any further.

Set the Highlight. To begin the color and contrast adjustment, select the red channel from the Channel pull-down menu. Really, it makes no difference which channel you start with and it does not matter whether you start with the highlight end or the shadow end of that channel. However, it is important that color adjustments are done to the *individ-*

USING A CURVES

ADJUSTMENT LAYER

ALLOWS FURTHER

EDITING

OF THE CURVE

AT ANY TIME . . .

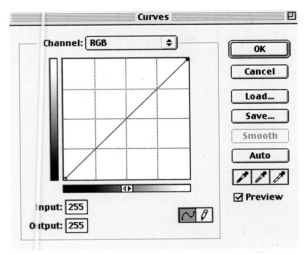

Composite curve.

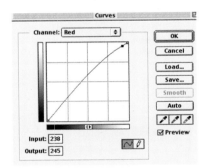

Highlight curve on the red channel.

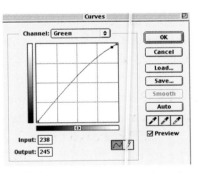

Highlight curve on the green channel.

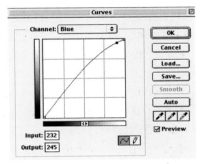

Highlight curve on the blue channel.

ual channels rather than the composite (RGB) channel, since each channel will need a different correction.

Next, place your mouse cursor over the lightest significant point. With Adobe Photoshop, pressing the mouse button will temporarily highlight the curve with a circle on the point of the curve that represents the value under the cursor. If you Command/Control click on this point of the image, that value will show up as a point on the curve. If the Shift key is held down at the same time, a point will appear on the curve for each individual channel in the image. With the Glen Ord image, these highlight points appear at value 238 on the red channel curve, 238 on the green channel curve, and 232 on the blue channel curve. With these points in place, it is a simple matter to drag the points on each of the curves (R, G and B) to their target values: R=245/G=245/B=245. See the Curves screen shots above.

To set the shadow (the darkest significant point) in the three channels, hold the cursor over the shadow area. In this

case, the numbers in the Info palette show that altering the curve for the highlight has changed the rest of the curve values, too. Before the highlight correction was applied, the shadow read: R=38, G=29, and

B=15. The corrections to the highlight pulled the curves up, making all of the values increase. As a result, R=38 became R=46, G=29 became G=35, and B=15 became B=19. Wanting this shadow area to be black with a touch of detail, I decided that a value of 15 in all three channels should do the job. You can see the shadow corrections in screen shots of the Curves dialogue box shown below.

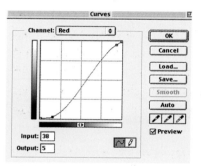

Shadow curve on the red channel.

Shadow curve on the green channel.

Shadow curve on the blue channel.

Overall Color Trends. When you drag your cursor over a highlight or shadow, not all of the values will read the same. For instance, reading the the darkest significant point of Glen Ord, the area I chose read: R=38, G=29, and B=15. Another reading on this dark border of the label, which looked to the naked eye to be about the same brightness and color, read: R=41, G=33, and B=16. Yet another nearby sampling read: R=39, G=31, and B=17. Once again, these readings all suggest that the supposedly-neutral area has an orange color cast. Since the numbers jump around from spot to spot, you should always draw your conclusions from the *overall color trend* rather than basing your corrections on a single point. In practice, I correct the shadow or highlight from the chosen point, then run the eyedropper tool over the area to see if the overall area has improved. The point is, you will not get perfect numbers throughout.

If the shadow corrections to the curve are strong enough, they may throw off the highlight correction—so always

double-check and readjust the highlight, if necessary. (Obviously, if you start with the shadow then you need to recheck *it* instead of the highlight to ensure that the shadow correction has not been affected by the later highlight correction.) You should also recheck the highlight and shadow points after applying sharpening to the image. Sharpening does increase image contrast and can push the range over the reproducible limits.

Midtones. Setting the end-points (the shadow and highlight) does not always correct the image color, so you should also evaluate the neutral midtones. In this image, I based my midtone corrections on the middle section of the letter "N" in the word "Glen" on the bottle label. It read: R=142, G=128, and B=107. The curves were adjusted in the red, green, and blue channel to read: R=128, G=128, and B=128. After this adjustment, I checked to make sure that these corrections did not affect the already-corrected highlight and shadow settings. You can see the midtone corrections in screen shots of the Curves dialogue box shown below. Then, Compare the before and after versions of the Glen Ord image on page 34.

Midtone curve on the red channel.

Midtone curve on the green channel.

Midtone curve on the blue channel.

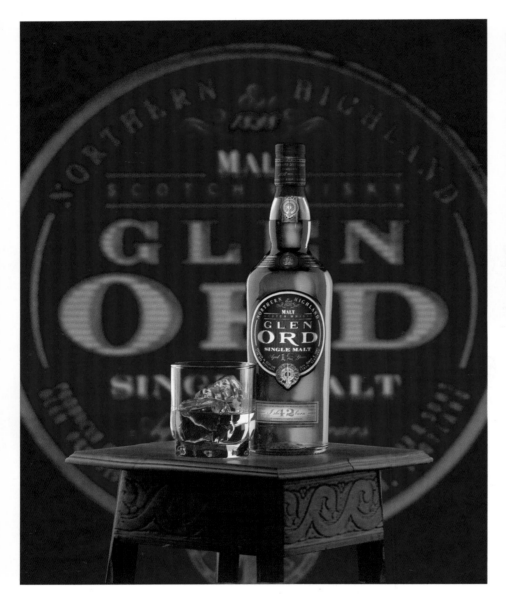

Compare the corrected photograph (left) with the uncorrected photograph (above).

Now, let us look at a faster way of doing corrections for color and contrast that works on images that are not too bad, in terms of color and contrast range. The image below, entitled "Bocuse d'Or," was created by Mark for an entrant in a European culinary exposition competition in France. This image makes a great testimonial for the speed with which an image can be perfected when using digital capture—it was completed in a little over an hour.

Lighting. Mark back-lit the subjects with a single undiffused strobe head. This light creates strong forward-falling shadows that are filled in with a light modifier panel fitted with white reflective fabric. The panel was placed 3' above the set, where it catches and reflects stray light from the strobe. To highlight select areas of the subject fronts, Mark positioned five silver-foil cards in front and to the sides of the set. These silver cards reflected stray light passing over the subject area from the strobe head back onto the subjects. Since the surface of a foil card is slightly reticulated, it reflects a soft edged puddle of light that is perfect for spotlighting areas of small tabletop sets. This silver foil card material, called foil board, is available at graphic arts supply stores. For next to no money, a 20"x30" sheet of this foil board can be purchased and cut to specific sizes and shapes for photographic lighting.

Uncorrected image.

IMAGE DATA:

Exposure:	f-11 at ¹⁄₆₀ second
Camera:	Foveon Single Capture
Lens:	Canon L-Series 28—70mm/f-2.8 zoom set at 47mm
Lights:	Paul C. Buff X3200 White Lightning mono-block strobe with a 7" reflector
Light modifiers:	five 3"x 4"silver foil cards, Chimera 42"x42" white reflective panel
Processing software:	Foveon Lab
Filtration:	in Foveon Lab, Color Adjust was set to 7 magenta and 15 yellow
Image editing software:	Adobe Photoshop

This image needs to have its lightest and darkest significant points set to the brightest and darkest values that will still

hold detail when converted to CMYK and printed in this book.

Warm Color Cast. "Bocuse d'Or" has an intentionally warm color cast; Mark neutralized the camera off a middle gray card for a perfectly neutral image, then during the processing of the raw image file in Foveon Lab, changed the color balance to develop the image with a color shift that would add 7 magenta and 15 yellow (see the labeled image below).

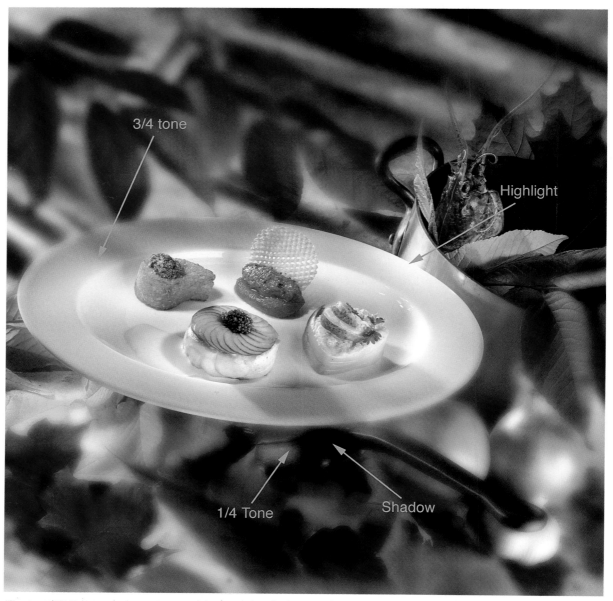

"Bocuse d'Or" image with important tonal zones identified.

The same color shift can be created in Adobe Photoshop, if the digital camera processing software does not give you the necessary controls. To do this, create a Curves adjustment layer with the Mode set to Color. In the Curves dialogue box, drag the midpoint (value 128) curve up in the red channel, and drag the same point down in the blue channel (or, instead of affecting the blue channel, drag the same point up in the green channel).

The traditional method for warming up an image also works just fine for digital capture—simply place an amber gel (such as a Roscolux Bastard Amber #02 or Amber #04) over the strobe head, or a Kodak Wratten 81 series filter (from 81A up to 81EF, with EF being the warmest balance) over the lens after balancing the camera to a neutral tone. This procedure, however, leaves you fewer options later on.

For the sake of this lesson, however, let's look at this color shift as though it were unwanted and had to be neutralized.

Highlight and Shadow. The lightest point of the bright puddle of light on the camera-right side of the white dinner plate contains the lightest significant point of the image. The dark area at the base of the pot handle contains the darkest significant point. Using the Info palette to read the red, green, and blue values under the cursor, I found the following readings:

In the highlight:	Red = 253
	Green = 241
	Blue = 221
In the shadow:	Red = 31
	Green = 22
	Blue = 18

To hold highlight detail, a value of 245 in RGB color space is a safe brightness. The current brightness of R=253/G=241/B=221 creates a warm amber color that places the highlight too high in the red channel and too low in the blue and green channels. Since the white dinner plate is a neutral tone, all three numbers in the highlight should read roughly the same. Since the pot handle base is also neutral, all three numbers in the shadow should read roughly the same if the image is to appear neutral.

To remove this color cast, either a Curves or Levels adjustment layer could be used. I generally use the Curves because of the extra control they provide; however, Levels has a great shortcut for setting and neutralizing Highlight and Shadow points, which I will demonstrate on this "Bocuse d'Or" image. To begin, I created a Levels adjustment layer and activated the Levels dialogue box (see appendix, page 103). In the Levels dialogue box, the Highlight Eyedropper was double-clicked to bring up the Color Picker (see below).

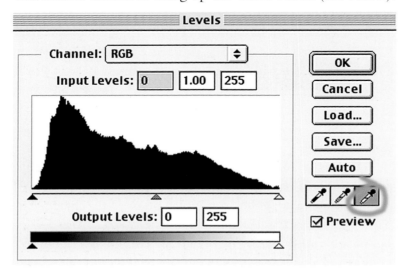

In the Levels dialogue box, the Highlight Eyedropper was double-clicked to bring up the Color Picker.

In the Color Picker dialogue box, the red, green, and blue values were changed to 245 (see below).

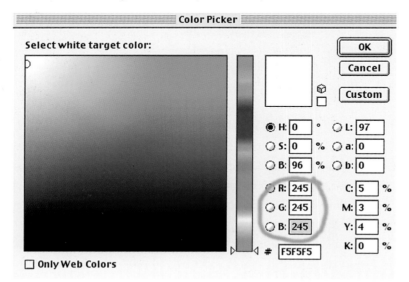

In the Color Picker dialogue box, the red, green, and blue values were changed to 245.

After hitting OK, I clicked on the lightest point of the bright puddle of light on the camera-right side of the white dinner

plate—the brightest significant highlight. Magically, this highlight jumped from R=253/G=241/B=221 to R=246/G=245/B=245. The same is done for the shadow, only the Shadow Eyedropper was set to 30 (see below).

In the Levels dialogue box, the Shadow Eyedropper was double-clicked to bring up the Color Picker.

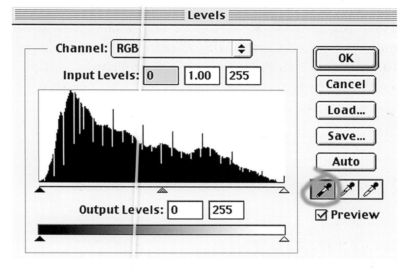

In the Color Picker dialogue box, the red, green and blue values were changed to 30.

The shadow was transformed from R=31/G=22/B=18 to R=29/G=30/B=30. Compare the before and after versions of the "Bocuse d'Or" image on page 40.

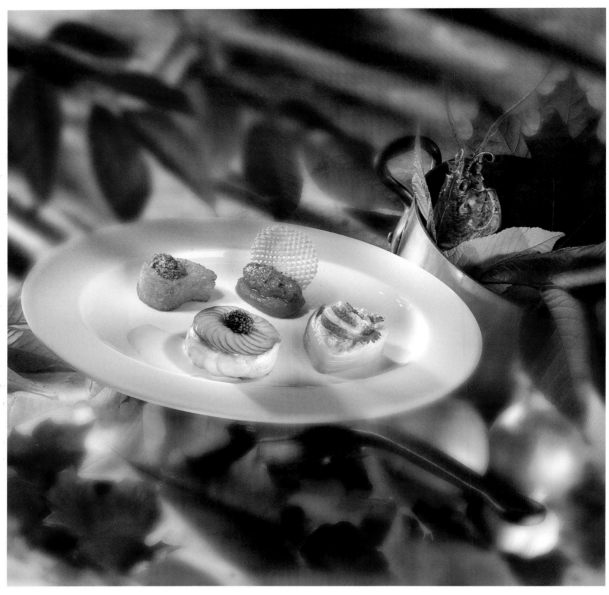

Compare the corrected photograph (above) with the uncorrect-
ed photograph (right).

After setting the highlight and shadow, it is important to evaluate how the tones and color are reacting to the changes in the in-between ranges. The three-quarter tone is around the outer rim on the top of the dish on the camera left side. Before the correction it read R=172/G=157/B=145. After the Levels correction it read: R=167/G=164/B=165. The quarter tone found on the cast-iron handle assembly originally read: R=104/G=96/B=86. After the Levels correction it read: R=101/G=102/B=102. The midtone sits in the shaded area of the inner edge of the plate at about six o'clock. It read: R=126/G=119/B=107 and became R=123/G=125/B=124.

Tolerance. Notice that the numbers are not equal. For instance, after correction, the three-quarter tone read: R=123/G=125/B=124—all three channels were slightly different. In 8-bit RGB, we have 256 levels of brightness, so the numbers can easily be off by a few points and be fine. Our eyes are more sensitive to the highlight end than they are to the shadow end of the brightness scale. For this reason, the numbers can be off by up to 10 points in the shadow without drawing much—if any—attention. In the highlight, however, even 2–3 points becomes noticeable.

5

COLOR AND COLOR PRINTING

Color as we know it exists only in our minds. The light energy entering our eyes is just electromagnetic radiation—waves. It is in our minds that these wavelengths become what we perceive to be color. Our brains must somehow mass-process the deluge of these wavelengths, and it does so by simplifying the information.

PRIMARY COLORS

Additive Primary Colors. The brain first breaks down the visible spectrum of light into its most dominant regions of red, green, and blue. These three primary colors, called additive primaries, can be combined in different ways to simulate most of the colors in nature. If an object reflects pure red light, pure green light and pure blue light, the eye perceives it to be white. A mix of blue and green makes cyan, red and blue makes magenta, red and green makes yellow. If no light is reflected (or present), then the eye perceives black.

The three-value color system is the very same system that digital cameras, scanners, printers, and monitors use. These devices mimic the eye's response to the additive primaries to create believable color. A color CRT monitor has a screen that is coated with microscopic pixels. These pixels contain

COLOR

AS WE KNOW IT

EXISTS ONLY

IN OUR MINDS.

red, green, and blue phosphors, that when charged with electrons at different voltages, produce a range of wavelengths that our eyes perceive as different colors.

Subtractive Primary Colors. Combining any two additive primaries creates a subtractive primary. For example, a mix of blue and green makes cyan, red and blue make magenta, while red and green make yellow. These subtractive primaries (C [cyan], M [magenta] and Y [yellow]) are the opposite of the additive primaries (RGB). It is the subtractive primaries in the form of colored inks that are needed to create color with ink on a piece of paper.

COLOR PRINTING

Cyan, magenta and yellow ink on paper act as color filters—just like colored photographic filters. When white light strikes cyan ink on a piece of paper, the red portion of the wave length is absorbed by the ink as the light passes through it. Having passed through the ink "filter," the light particles bounce off the paper, pass back through the cyan ink and enter our eyes—but without the red portion of the light waves. Our brain processes this as the color we call cyan. The same is true for magenta ink, which absorbs green, and for yellow ink, which absorbs blue.

Therefore, to create a particular color using subtractive primaries you have to think of what color you need to *absorb* in order to create the color you want. To create red on the printing press, tiny magenta and yellow dots of ink are placed close to one another. When white light hits these ink dots, the magenta dots hold back the green part of the spectrum and the yellow holds back the blue part of the spectrum. What is left of the spectrum is perceived as red by our brains. Likewise, cyan and yellow make green by holding back red and blue, while magenta and cyan make blue by holding back green and red. All other color variations are created by CMY-colored ink dots of varying sizes.

Four-Color Process. Actually, color printing presses rarely use just three inks, mostly they use four. The reason for this is that, in theory, if you place maximum-sized dots of cyan, magenta, and yellow ink side by side, they should absorb all of the red, green, and blue wavelengths and create blackness. Unfortunately, this is true in theory only. The inks are not as pure as we might wish, and the combination of all

CYAN, MAGENTA

AND YELLOW INK ON PAPER

ACT AS COLOR FILTERS—

JUST LIKE COLORED

PHOTOGRAPHIC FILTERS.

three results in muddy dark gray, rather than a pure black. So, the printing industry uses black ink as the fourth ink making CMY, CMYK. The K in CMYK stands for black. K stands for black? Well, to the printing industry it does. At one time, printer lingo used the words red, green, and blue in place of cyan, magenta, and yellow as a sort of shorthand. As you can imagine this was confusing because the abbreviation for each color was (and is) the first letter of the color name. If black was abbreviated as B, this could be confused with blue. In the printing industry, mistakes tend to be very expensive, so we have K for black.

You are probably thinking that printers are pretty silly—but no more silly than photographers. We have all kinds of confusing lingo. I remember, in my photographic infancy, standing at the lab counter picking up prints. The guy behind the counter said to a commercial photographer who had just entered, "Did you get it done in time?" To which the photographer replied, "Yeah, but I think I blew the trannie." Having experience with only *negative* film, I thought the poor guy had wrecked his car's transmission. If transparency actually means a positive image on a transparent acetate film, then why is a negative (which also is transparent), simply called a negative? In prepress shops and scanning houses, photographs are referred to as either reflective art or transparent art. Reflective art is an image (like a print) that is seen by light reflecting off its surface. Transparent art is a positive or negative image on a transparent piece of film that is viewed by light transmitted through the film base, hence the term transparent.

Why Not RGB? Since our eyes use the additive primaries, why not use RGB inks for printing images? The reason is simple: red, green, and blue ink each absorb *two* colors. Red ink absorbs blue and green light, green absorbs red and blue, blue absorbs red and green. With this in mind, which of these inks would you use or combine to create a color like yellow? None. Yellow is reproduced with an ink that absorbs only the blue wavelengths of light—an ink that absorbs only *one* color. That means that RGB ink can reproduce red, green, and blue, but it *cannot* reproduce cyan, magenta or yellow. It cannot create the variations of these colors, either—colors like teal, orange, and purple. CMY inks, on the other hand, can be used singularly to create cyan, magenta, and yellow, and in

To print a photograph on paper with a printing press, the image must first be broken down into dots called half tone dots. This transformation from continuous tone to a dot pattern is called applying a line screen. For example, a 150 line screen will break the image down into 150 rows of printing dots per inch. When supplying digital images for printing on a printing press, you need to set the resolution (the pixels per inch or ppi) of your files at 1.5 to 2 times the line screen ruling. Therefore, a 150 line screen requires an image resolution of 225–300ppi (1.5 or 2x150) at the final dimensions of the image. (In Adobe Photoshop, the controls for this are in the Image menu under Image Size.

combinations to create red, green, and blue. These combinations are:

$$
\begin{aligned}
\text{yellow} + \text{magenta} &= \text{red} \\
\text{cyan} + \text{yellow} &= \text{green} \\
\text{cyan} + \text{magenta} &= \text{blue}
\end{aligned}
$$

Dots. CMYK percentage values (0–100%) express ink density by the size of the ink dots. The higher the number, the greater the density (100% equals pure black, 0% equals pure white). That said, an image printed on a printing press is an illusion. It is really just an array of dots of varying sizes that creates the illusion of color and density.

The most common dot patterns used on a printing press place dots of varying sizes at equidistant intervals. The dots can range in size from 0% to 100% of their allotted space. At 100% the dot would fill in all of its allotted space. A 1% dot would only utilize 1% of its allotted space. Larger dots create more density. For instance, a dark gray area would be made up of the same *number* of dots as a light gray area. However, each dot in the dark gray area would be *larger* than each dot in the light gray area.

A high percentage value in CMYK means more density or darkness. The yellow pepper in the image of Sylvianne and Tim (below), once converted from RGB to CMYK, consists of nearly all yellow ink—2% cyan, 98% yellow, 11% magenta, and 0% black. Even though the density in the yellow channel is really high, the pepper appears light. The other colors

CMYK photograph.

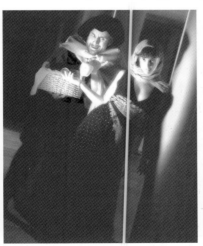

Cyan channel.

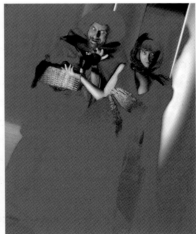

Yellow channel.

would have to have a lot more density for the pepper to appear dark. If you look at the density of the yellow pepper in its individual color channels, it looks really dark black in the yellow channel and nearly white in the cyan channel (see the two channel images on page 45).

Stocastic Printing. Not all printing presses, however, create color and density with equidistant dots of varying size. Some use a screening process that breaks the image into dots of the same size. It creates variances in tone and color by changing the *frequency* of the dots. A dark tone would have many dots close together, and a light tone would be made up of fewer dots further apart. For example, the yellow pepper in the Sylvianne and Tim image, discussed above, would be made up of mostly yellow dots close together and fewer cyan and magenta dots further apart.

This type of screening is called stocastic printing. This printing method is also used by inkjet printers, such as Iris, desktop and large format printers. It is wonderfully forgiving with interpolated files—especially in hiding stair stepping or "jaggies" (another silly printing term), those pixelated edges that, when blown up, look like a staircase. As mentioned earlier, I have seen 12MB files from my current digital camera printed up to 6'x6' with no visible stair-stepping or color anomalies (unwanted stray colored pixels from interpolation error) and with photographic quality.

RGB TO CMYK

When you capture an image with a digital camera, it is in the RGB color space. To make it CMYK, you must convert it using Photoshop or, in some cases, with the camera's image-processing software. Unfortunately, reproducing images in CMYK color is a bit of a struggle.

Part of the challenge is that CMYK is a smaller color space than RGB. Many saturated RGB colors are not reproducible in CMYK, because they exceed the CMYK color gamut. This means that some of the really beautiful, saturated colors that you can capture with your digital camera just won't print in CMYK. These out-of-gamut colors are reinterpreted by the conversion engine in Photoshop and remapped to the nearest CMYK equivalent, which is usually pretty wimpy in comparison to the RGB color. CMYK does, however, shine with the color yellow. It is far better at creating yellows than RGB.

Color Reproduction. Recreating additive primaries (RGB) in CMYK can yield reasonable reds and adequate greens, but it *really* has a problem with blue. If you want to make a pure-looking red (like the red of a fire truck), you would use 100% magenta and 100% yellow. With that in mind it stands to reason that to make a pure-looking blue you would use 100% cyan and 100% magenta. Unfortunately, this is not the case—a combination of 100% cyan and 100% magenta makes purple. The problem is in the cyan ink. Cyan ink is the worst of the four inks of CMYK at doing its job (absorbing the red wavelengths of light). As a result 100%, cyan does not absorb as much red as it should, so we have a red cast added to the blue color we are trying to create. The result is we end up with purple.

To make up for this shortcoming, some of the magenta ink must be removed. This results in a lighter blue. To bring the tone back to the density of blue needed, some of the magenta ink is replaced with black ink. Now the density is good but the saturation suffers—we see a grayed dark blue. And that is as good as it gets—unless you print a fifth color, like a blue or a second cyan (two cyans will absorb more red light).

We have looked at aim points for RGB color correction, now let's look at the same for CMYK.

NEUTRALS

Since cyan ink is somewhat deficient at absorbing red light, it should have higher percentage point readings than the magenta and yellow inks when creating neutrals. We should see readings in the following ranges:

Light tones — 3–4% more cyan than magenta or yellow
Midtones — 7–8% more cyan than magenta or yellow
Shadow tones — 10–12% more cyan than magenta or yellow

CONTRAST

There is so little contrast available in CMYK that we must spread the tones and color of an image over as much of the available range as the final reproduction will allow.

Shadows. A shadow is the darkest significant point of an image that has no color associated with it. By that definition almost every image has a shadow. When found, it needs to be

set to the darkest neutral color that you think the output conditions will handle. If you don't know the precise figure, then use a conservative one; for CMYK printing this would be 80% cyan, 70% magenta, 70% yellow, 70% black (for a neutral shadow). SWOP (Specifications for Web Offset Publications) standards, which are universally accepted in the publication of magazines and also widely used in commercial printing, say that the sum of all four colors, called the total ink, cannot exceed 300. Most magazines play it safe and specify 280. They will accept up to 300 (and sometimes up to 305), however, provided that, in the final reproduction, these areas are no larger than a dime. If the image is to be printed on a sheet-fed press, total ink is usually around 320 to 340. If it is to run on a web press or a sheet-fed press using SWOP standards, then the total ink should be 280 to 300. If it is to be printed on newsprint use 240. Keep in mind that these numbers are general figures. It is important to talk to the printer who will be outputting the images to get the most accurate figures (if they will tell you).

Highlights. A highlight is the lightest significant part an image that is not a specular highlight (mirror image of the source illumination—glare, shine, and sheen). For a correct printing highlight, it should read as a neutral color and it should read at the lowest ink density in cyan, magenta and yellow that will still hold detail in the final reproduction. It should not be "off white," like a cream-colored shirt. If it does read as "off white" but you know that it should be neutral, then the image has a color shift. In this case, you can correct it by resetting its values (covered below).

Specular Highlights. A specular highlight is a mirror image or reflection of a source illumination. It is also called glare, hotspot, catch-light, shine, and sheen. Specular highlights are not good areas in which to take densitometer readings for use in setting and neutralizing the highlight value. A specular highlight is always brighter than the true tonality of the surface it is sitting on (otherwise it would not be visible). If it appears somewhat translucent in the image (because it is not too bright—for example, prior to capture it reads no more than two stops brighter than middle gray with a photographic reflective light meter), then some of the colored surface underneath it will show through. This will shift its color and cause it to yield an inaccurate densitometer reading for

A SPECULAR HIGHLIGHT

IS ALWAYS BRIGHTER

THAN THE TRUE TONALITY

OF THE SURFACE

IT IS SITTING ON . . .

neutrality in Photoshop. If the specular highlight appears opaque, because it is so bright that it is pure white (for example, prior to capture it reads more than two stops brighter than middle gray with a photographic reflective light meter), none of the underlying surface will show through, and there will be no color shift. Even in this event, it is still not a good neutral area to read for color balance, because the rest of the image can still have poor color, even though this burned-out reflection reads as pure white. Specular highlights should *not* be set to the lightest value that will still hold detail. If an area is burned out to the point that it is pure white, then it contains *no detail.* It should, therefore, read at a value that is higher than the lightest significant point in the image.

COLOR BALANCE

A well-balanced highlight should contain more cyan than magenta and yellow, and it should contain no black. There is much debate about what a highlight should read. A safe "all-around" setting is C=5/M=2/Y=2/K=0 (5% cyan, 2% magenta, 2% yellow and 0% black). Many experts will use: C=3/M=1/Y=1/K=0; C=6/M=2/Y=2/K=0; or C=5/M=3/Y=3/K=0. The point is, there is some leeway. However, if the ink densities are off by 3–4 percentage points in any of the three colors, you will see a color cast (i.e., a white shirt at C=6/M=2/Y=6/K=0 will be perceived to have a greenish-yellow cast).

In the shadow, most people cannot see the difference between C=80/M=70/Y=70/K=70 and C=80/M=60/Y=60/K=60. Our eyes are more sensitive to color in brighter tones than in darker tones. Even though most of us see it as neutral, a shadow of C=80/M=60/Y=70/K=70 is technically green. It is important to neutralize this shadow because these out-of-balance numbers suggest that the rest of the image is too green also. An imbalance in the shadow or in the highlight could be either a global color shift or a localized color shift—usually it is global. This green shadow can be ignored if you carefully check out the rest of the image to make sure it is not too green.

DYNAMIC RANGE

On press, a 1–2% dot gain (increase in the size of the dots as the ink bleeds into the paper) will not create a visible differ-

ence, except for in the highlight. A 5% dot gain *will*. On average, the dynamic range of a press allows for only 160 of the 256 available levels in Photoshop—approximately 40 to 60 shades of each ink color on press. Most people work on images in Photoshop that contain 8 bits of data per channel, but the press can only reproduce 6–6.5 bits per channel (per ink color). With this in mind, you can see why it is so important to manipulate an image's range by carefully setting highlight and shadow to maximize what little range the press offers us.

IMAGE EVALUATION

In selecting a shadow or highlight point to read from, choices about what is important in the image need to be made. For example, in choosing a good shadow point to read from in an image of a person holding a cup of black coffee, you might decide not to choose the coffee as the shadow point, even though it is the darkest point of the image. You may ignore the coffee because you feel that it is not an area of significance and that it does not matter if it reproduces as black with no detail. This decision will let you spread the image's tonal values over a greater range, creating an image with more punch.

Sometimes there isn't a neutral point in the image to read from. You may have to settle for the next best thing, like a semi-neutral point—an area that you know must be in the neighborhood of neutral. You might portray it as a neutral gray, or you might portray it as leaning in a certain direction colorwise. Consider an image where the only point resembling a highlight is a yellowish-white shirt. This point will at least give you two-thirds of a highlight. The yellow channel will have to be left alone, but the cyan and the magenta channels can be set to the proper highlight values. This does not apply only to the CMYK color space, it's true in RGB, too.

○ **TIPS**

For the most accurate view of an image on your monitor, zoom in or zoom out to 100%. At 100% one image pixel will equal one monitor pixel. Any zoom setting above or below 100% will force the computer to interpolate or sub-sample the view of your image, rendering a less accurate view. For instance, a one-pixel line at a 25% zoom will sometimes disappear—the line is hidden in the monitor's pixel interpolation. With Adobe Photoshop, use these quick key strokes to save time when zooming the image to 100%:

Mac
CMD+OPTION+0 (zero)

PC
CTRL+ALT+0 (zero)

COLOR AND CONTRAST MODIFICATION

COLOR CORRECTION

SHOULD BE DONE

ON ONE CHANNEL

AT A TIME.

Color correction should be done on one channel at a time. (The exception is if, with the Levels tool, you are using the Highlight and Shadow Eyedroppers with the minimum and maximum values preset, as described on pages 37–39.) For example, to set the maximum highlight and shadow values in an RGB image, I might first select the red channel, set the highlight and shadow values, then do the same to the green channel and then the blue. You can work on the individual channels in any order, and it does not matter whether you attend to the highlight or the shadow first. This is true with any color or contrast manipulation in any color mode.

Obviously, you cannot correct color using the master or composite channel (RGB channels combined or CMYK channels combined). The composite channel can be used for manipulating contrast, but I do not recommend it because, working on the composite channel affects all channels in the same way. Unfortunately, the black channel never behaves the same as the CMY channels, so working from the composite channel tends to cause problems in the black channel.

Modifying the color and contrast of images is generally performed with one of two tools, either Levels or Curves.

LEVELS

Adobe Photoshop features a slider-based tool called Levels. Levels uses three linear sliders: one for the shadow, one for the highlight, and one for the midtone. If any of these sliders are adjusted to the left or right, the color and contrast of the image will change. These three sliders are placed below a histogram that provides a graphic representation of the image's tonal distribution (see below). However, because there are only three sliders, you can only modify the tonal range of the image at three points. For this reason, if you are not already using Curves, and if you are serious about imaging, learn Curves and forget Levels. Well, don't *totally* forget Levels; the Levels dialogue box has that handy histogram and it is also a great tool when assessing where the light and dark point of an image are. For more on how to find the darkest significant shadow and the lightest significant highlight, see pages 27–28.

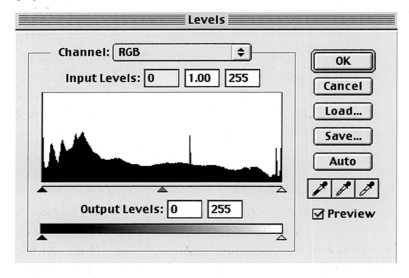

The Levels dialogue box in Adobe Photoshop.

CURVES

The Curves tool features a square grid with an adjustable line running through from the bottom-left corner to the top-right corner. If you click and drag any point along the length of this line, the line will curve (bend). As it curves, the color and contrast of the image is altered.

In the CMYK color mode, when using the default settings (grid set to light at bottom, dark at top), bending the line upward increases density (the image gets darker).

Bending the line downward decreases density (the image gets lighter). In RGB, it is the opposite—up is brighter, down is darker. Why not make both the same? You can—simply click on the light-to-dark bar at the bottom of the Curves grid. However, there *is* logic behind why the defaults are set this way. In any color mode, pulling the curve up causes something to increase, and pulling it down causes something to decrease. In CMYK that "something" is ink density, and an increase in density results in a darker image. In RGB that "something" is brightness, and an increase in brightness results in a lighter image.

The Curves dialogue box in Adobe Photoshop.

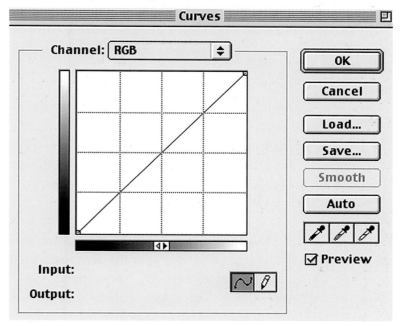

Curves is a more powerful tool than Levels because it allows the operator to affect the color and contrast of the image from more than three points. This extra control makes the tool more complex to use than Levels, so it takes a little longer to learn.

The horizontal axis of the grid represents the values that are in the original image. The vertical axis represents the values that will be. When a Curves dialogue box is first opened, it will be at its default setting. This is a straight, 45° line running through a square graph or grid. When this line is set to its default, all the values that "are" (the input) equal all the values that "will be"(the output). For instance, if you run your cursor along the line to the middle of the grid, you will notice that the resulting value reads the same whether you

read it from the horizontal or the vertical axis. If the line is clicked and dragged from the center point (or any point, for that matter), it becomes a curve. In the CMYK color space, pulling the midpoint up from 50% (midtone) to 70% will place the 50% midpoint at 70% (the 50% density becomes a 70% density). A point on a curve does not live in isolation. If you alter one point of the curve, all the other points on the curve will be affected too. In the example above, if the 50% point is pulled up to 70%, then the 25% point will increase to 39%, and the 75% point will become 89%.

As mentioned earlier, the Curves tool (unlike Levels) allows you to modify the color and contrast of an image from more than three points. You can adjust the shadow, highlight, midtone, quarter tone, and three-quarter tone—as well as any point in between. This level of control makes it possible to correct local as well as global color casts. If there is a color cast only in the highlights, you can bend the curve at just the highlight end to correct the color cast there without affecting the shadow or midtones. In RGB, you can increase overall contrast by dragging the quarter tone up and the three-quarter tone down.

LAB COLOR

Sometimes, one of the frustrating aspects of color correction in RGB or CMYK is that color and contrast are closely tied together. Often, after a furious session of bending curves in RGB or CMYK to massage the color of a less than perfect image, you will find that the contrast has suffered. Wherever the line of the curve flattens out or starts to flatten out, the corresponding areas in the image will flatten in contrast. Where the curve grows steeper, the corresponding image areas will increase in contrast.

There is, however, a way of controlling color and contrast separately in RGB and in CMYK. Adobe Photoshop uses Lab color space (pronounced L-A-B, not "lab") as its internal color space. Versions 4.0 and later of Photoshop allow you to access some of Lab's strengths when color correcting in the RGB or CMYK color space.

Start by creating a new adjustment layer. When the adjustment layer's dialogue box appears, choose Luminosity or Color from the Mode pull-down menu. If you select Luminosity, the changes you make to the curve will affect

only the brightness and contrast information in the image. This is the one situation in which it is perfectly fine to adjust contrast in the image's composite channel; in the Luminosity mode, the color will not be even slightly affected. If you select Color from the Mode pull-down menu, any modifications you make will affect only the color of the image. As you make your adjustments, keep in mind: a flat curve equals low contrast, a steep curve equals high contrast.

How Lab Works. The LAB color space has a wider gamut than RGB, and a much wider gamut than CMYK. In fact, the LAB gamut is similar to that of the human eye. This incredible range makes it an ideal color space to correct really difficult color problems—curves can be bent much further than in RGB or CMYK before the colors start to break apart.

Like RGB color space, the Lab color space is comprised of three channels. The first of the three channels is L (for Luminance). This channel contains all of the luminance (or contrast and brightness) information of the image. It contains no color information. The L channel works just like a CMYK channel, in that dragging the curve up increases density (darkens), dragging down decreases density (lightens). The A and B channels contain all of the color information and none of the luminance information. These two channels contain opponent colors. The A channel is the difference between red and green, while the B channel is the difference between blue and yellow. This means that if you drag the curve up in the A channel, the image will shift towards green. If the curve is dragged down, the image will shift toward red. The principle applies to the B channel—only up is blue and down is yellow. Image color can be saturated (with no effect on contrast) by dragging the top end-point of the curve to the left across the top of the Curves grid box, and the bottom end-point to the right. The same technique can be applied in the opposite direction to desaturate an image—drag the top end-point down the right side of the grid box and drag the bottom end-point up the left side.

In the Lab color space, a little movement of the curve makes a big difference—making Lab perfect for those images that are otherwise too far off in color to be fixed in CMYK or RGB. However, this same feature makes Lab less desirable for fine color changes. On a really troubled image, you might convert to Lab to do the big color corrections, then convert

back to RGB or CMYK to do the fine-tuning of the color. It is possible to convert an image to and from Lab from RGB several times with little to no image degradation—certainly with no visible destruction. In CMYK, converting back and forth will degrade the image—but not visibly, if you do it only once or twice.

○ **TIPS**

You can see where the various areas of your image fall on the curve in the Curves dialogue box in Adobe Photoshop. With the Curves dialogue box open, click and drag over the image area you want to evaluate. A circle will then appear on the line of the curve identifying that this is the area of the curve where those tones reside. You can use this to do things like increase contrast of just one area by identifying where it is on the curve, then increasing the steepness of the curve in just that range—a great way to make a subject pop out from a background. In RGB, this feature works on the composite channel as well as the individual channels. In CMYK, however, it only works on the individual channels.

SHARPENING

Viewers usually think that blurry images are the fault of the photographer or the resolving power of the camera. Now that we are in the digital age, there is a third direction in which to point accusing fingers: the digital process itself. All digitized images, including captures from high-end digital cameras and scanners, require artificial sharpening because of the inherent softness of the digital process.

EDGES

Our eyes are extremely good at discerning edges between one color and another. The softness that we see in our digital images is caused by the inability of digital cameras and scanners to resolve the narrow transitional edges found in real-life objects. As a result, these lines of transition record as blurry, out-of-focus edges. On top of this, there is a further reduction in edge sharpness during output. Printing presses and inkjet printers are the worst—but even continuous-tone output devices, such as film recorders and dye sublimation printers, contribute to overall blurry images.

As responsible digital imagers who do not like having fingers pointed at them, we must somehow make up for this loss of sharpness during capture and output of our images. The

solution that we require exists in most scanner, image editing and digital capture software. The solution is a sharpening filter called Unsharp Mask (or USM).

Unless you are already in the know, you are probably wondering why a filter that sharpens is called "unsharp." *Unsharp* refers not to the result, but to the method that the filter uses to sharpen an image. When the filter is applied, two versions of the image are generated: one in-focus image and one out-of-focus image. The out-of-focus version is applied selectively to the in-focus one. This creates the illusion of a sharper image by enhancing the contrast between discrete subject areas.

In the days before scanners and digital cameras, unsharp masking was performed by sandwiching a photographic negative with a slightly out-of-focus duplicate negative, called the unsharp mask, in an enlarger. When printed, this sandwich formed contrasting halos around object edges that were lighter in tone than the light object edges and darker in tone than the dark object edges. High-end drum scanners from just a few years ago mimicked this traditional process by making an in-focus scan and a out-of-focus scan.

Today's imaging software internally creates a blurred copy of the image. This out-of-focus version, which you never get to see, is compared pixel by pixel to the in-focus one. The differences that it detects between the two versions are exaggerated. These differences are not necessarily image edges, however. The USM filter does not look for *edges*, it looks for a certain amount of *contrast* between any two adjacent pixels, then adds the contrasting halo. This method is very effective for emphasizing edges. Unfortunately, it does not discriminate, and unwanted pixels—such as noise—are affected as well.

CONTROLS

The controls for the USM filter fall into three categories: Amount (the halo intensity), Radius (the halo size) and Threshold (how much difference there must be between two pixels before a halo is added). These controls are accessed in the USM filter dialog box (go to Filter>Sharpen>Unsharp Mask to activate this). To demonstrate how this sharpening filter works, let's apply the above three controls to a very simple graphic of a light-gray box overlapping a dark-gray box as

UNSHARP REFERS NOT TO THE RESULT, BUT TO THE METHOD THAT THE FILTER USES TO SHARPEN AN IMAGE.

Dark-gray box overlapping a light-gray box.

The Unsharp Mask filter increase the edge contrast, enhancing the apparent sharpness.

seen on above (top, left). Remember, you should always view the image at a 100% zoom level so that you are seeing the most accurate rendition of your image.

Amount. With the Amount slider, you can adjust the intensity of the halos. As the Amount is pushed higher (top, right graphic), notice that the difference between the contrasting halos increases, creating what looks like an increase in sharpness. An Amount setting of 100% doubles the intensity difference between the blurred version of the image and the in-focus version. Pushing the Amount slider to its maximum (500%) causes a *huge* change—a higher number equals higher intensity (below). Look closely at the transition from the dark gray square to the light gray square. Notice that the dark

Higher numbers in the Amount setting increase the intensity of the effect (and the visibility of the halos).

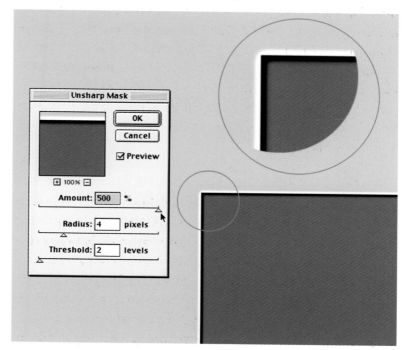

gray square progresses from dark gray to an even darker gray at its edge. Also, notice how the light gray square progresses from light gray to an even lighter gray at its edge. This very light gray halo against the very dark gray halo emphasizes the contrasting edge between the two squares, creating the illusion of a sharper image.

- **Increasing the Amount** increases the brightness difference between the sharpening halo. This makes the lighter halos lighter, and the darker halos darker.
- **Decreasing the Amount** reduces the brightness difference between the halos.

Radius. Adjusting the Radius controls the size of the halos. Radius is controlled by tenths of a pixel (from 0.1 to 250 pixels). As the Radius setting is increased, the amount of blur applied to the internal version of the image is increased, throwing it more out of focus. This results in larger sharpening halos in the image. Compare gray box graphic shown below.

- **Increasing the Radius** increases the size of the halos.
- **Decreasing the Radius** reduces the size of the halos.

As the Radius setting is increased from 4 pixels (left) to 10 pixels (right), the sharpening halos become larger.

Threshold. The third control is Threshold. Threshold gives us the option to ignore minor transitions by subtracting the chosen threshold value from the overall sharpening. It determines how much difference there needs to be between any two adjacent pixels before Photoshop adds a sharpening halo. It is measured in levels (0–255 levels). For example, if the Threshold is set to 14 levels, then contrasting pixels that are 14 or less levels different in brightness will receive no sharpening (Amount or Radius). Threshold is an important setting to use if you want to avoid sharpening noise in a noisy

image. Adjusting it allows us to be more selective about what gets sharpened and what does not, by allowing USM to concentrate on sharpening grosser detail (higher-contrast detail) while ignoring finer details (lower-contrast detail)—like noise in the dark areas of the image.

To see the difference that the Threshold setting can make, compare the two images shown below. These two images have been oversharpened and sized up for demonstra-

The Threshold setting determines how much difference there needs to be between any two adjacent pixels before Photoshop adds a sharpening halo.

tion purposes and to exaggerate my point. Notice that a Threshold setting of 1 allows USM to sharpen almost all of the noise in the shadow on Mark's nose. With a Threshold setting of 14, much less of this noise is sharpened. A higher Threshold setting may reduce how much noise is emphasized, but it also affects how much the rest of the image is sharpened. In the bottom image, Mark looks less sharp than in the top image. Threshold is an invaluable tool for controlling noise, but it is not an *intelligent* tool, it does not know the difference between noise and fine detail—so use it sparingly. I very rarely use a Threshold setting over 3 levels.

- **Increasing the Threshold** increases how much brightness difference there must be between pixels before a sharpening halo is applied.
- **Decreasing the Threshold** reduces how much brightness difference there must be between pixels before a sharpening halo is applied.

COLOR ANOMALIES

Unfortunately, the USM filter also emphasizes color artifacts. With higher settings, it creates bright artificial colors in the sharpening halos. It is possible to avoid emphasizing these color anomalies if you sharpen just the Luminosity information in the image and not the color information. To do this in Adobe Photoshop, the image must first be converted to Lab color space (Image>Mode>Lab color). Then, select the L channel in the Channels palette. This automatically leaves the A and B channels unselected (these can, however, still be seen if you turn on their visibility by clicking on their channel layer "eyeballs"). With the L channel activated, the USM filter will be applied only to the luminance information of the image, and—*viola!*—no color aberrations.

FADE UNSHARP MASK

In either the RGB or CMYK color space, it is possible to achieve results that are almost identical to the above procedure in the Lab color space. Immediately after applying the Unsharp Mask filter select Edit>Fade Unsharp Mask (in older Adobe Photoshop versions, you will find the selection under the Filter menu). In the Fade Unsharp Mask dialogue box, change the Mode from Normal to Luminosity. The result is

UNFORTUNATELY, THE USM FILTER ALSO EMPHASIZES COLOR ARTIFACTS.

L-channel sharpening in RGB and CMYK! Compare the pairs of images below, showing the change that results from setting the image mode to luminosity.

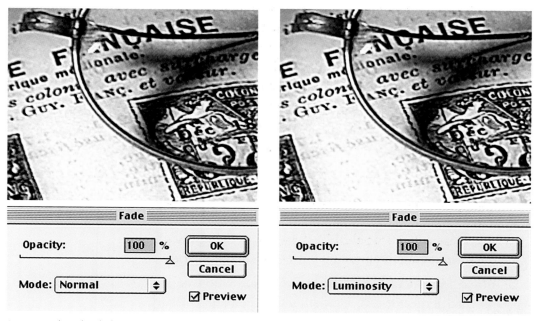

Image and Fade dialogue box with Mode set to Normal.

Image and Fade dialogue box with Mode set to Luminosity.

DARK SHARPENING, LIGHT SHARPENING

In some sharpening software, you have the option to control the dark sharpening halos separately from the light sharpening halos. This is an advantage because, more often than not, you can get away with much higher settings for the dark halos than you can with the light halos—creating superior overall sharpening. The USM dialogue box in Adobe Photoshop does not allow you to do this. However, you can accomplish this task using the Fade Unsharp Mask dialogue box. This technique will require you to apply the USM filter twice— once for the dark sharpening halos, and once for the light sharpening halos. Here is how to do it:

1. Apply the appropriate amount of USM for the dark halos (ignoring what the light halos look like).

2. Go to the Fade Unsharp Mask dialogue box and switch the mode from Normal to Darken.

3. Apply the appropriate amount of USM for the light halos (ignoring what the dark halos look like).

4. Go to the Fade Unsharp Mask dialogue box and switch the mode from Normal to Lighten.

Alternately, you can skip steps 3 and 4, and instead do the following. In the USM filter dialogue box, enter the same settings that were used for the dark halos. In the Fade Unsharp Mask dialogue box, you can then set the mode to Lighten. At this point, the light sharpening halos will look *really* overdone. To bring them down to an acceptable level, slide the Fade Opacity slider (in the Fade Unsharp Mask dialogue box) to the left, while viewing the results in the image window. More often than not, this slider will end up somewhere around 60%. As this procedure reveals, if sharpening is applied once without the benefit of Darken and Lighten mode, we can only take advantage of two-thirds of the sharpening that the dark halos can handle.

OPTIMUM SHARPENING

Combined Methods. I am the type of person who wants to have his cake and eat it too. Unfortunately the Fade Unsharp Mask dialogue box in Adobe Photoshop does not allow us to combine Lighten and Darken sharpening with Luminosity sharpening. In some sharpening software such as Heidelberg's Linocolor Elite, you *can* have your cake and eat it—well, almost. In Linocolor, all USM is applied in Luminosity mode, plus there are separate controls for the light sharpening halos, called Light Contour, and the dark sharpening halos, called Dark Contour. Unfortunately, you do not get to eat all of your cake—you cannot view your settings until *after* applying them, and the Radius (called Size) only has three settings instead of a multiple-setting slider.

Persistent in my desire to have *all* of the cake, I have come up with a work-around in Adobe Photoshop. Be forewarned—it is a lengthy procedure, so it would make sense to automate it with Actions. Also, this procedure adds two extra layers to your image. The procedure is as follows:

1. In the Layers palette, duplicate the background layer.

2. For the dark sharpening halos, apply the USM filter to the duplicate layer.

3. In the Fade Unsharp Mask dialogue box, set the Mode to Luminosity.

I AM THE

TYPE OF PERSON

WHO WANTS TO

HAVE HIS CAKE

AND EAT IT TOO.

4. With the duplicate layer active, change the layer mode from Normal to Darken.

5. Duplicate the Background layer again.

6. For the light sharpening halos, apply the USM filter to the second duplicate layer.

7. In the Fade Unsharp Mask dialogue box, set the Mode to Luminosity.

8. With the second duplicate layer active, change the layer mode from Normal to Lighten.

9. In the Layers palette, adjust the layer opacity of the two duplicate layers to fine-tune the amounts of dark and light sharpening.

(You can cut corners in the above procedure by copying the Darken layer instead of the Background layer in step 5. If you do so, omit steps 6 and 7.)

When you finish, you will have the light halos sharpened to the best possible level—without compromising the amount that the dark halos can be sharpened. Best of all, this will be done in the Luminosity mode, so that color anomalies are not emphasized.

USM in Channels. Higher levels of sharpening can be applied to images in RGB and CMYK by using the USM filter on the individual channels. In CMYK, apply sharpening to all the channels (CMYK), then squeeze extra sharpness out of the image by sharpening just the black or K channel. Since the black channel usually contains only skeletal image detail, high amounts of USM are possible without the image looking oversharpened.

You can also consider sharpening the weakest color channel more than the others. For instance, in an image of a caucasian face, you can apply more USM to the cyan channel than the other channels. If you have a noisy image, look at the individual channels to see which channels contain noise. Normally, one channel—in RGB it's usually the blue channel—will contain most of the noise in an image. Avoid sharpening this noisy channel, or sharpen it very little and concentrate on the less noisy channels. Prior to applying the USM filter, you may also want to try to reduce the noise in the

YOU CAN ALSO

CONSIDER SHARPENING

THE WEAKEST

COLOR CHANNEL

MORE THAN

THE OTHERS.

problem channel by adding a little blurring with the Gaussian Blur filter (Filter>Blur>Gaussian Blur) or the Despeckle filter (Filter>Noise>Despeckle).

HOW MUCH USM?

How much USM should you apply? As much as you can. Push the amount of USM to the point that the image starts to look artificially sharpened, then back off a little. It would be nice to have a formula for how much USM to apply, but there is not.

Subject Matter. Also, the subject matter will affect how much USM you can apply. An image with lots of fine detail will require a higher Amount and a lower Radius setting. A headshot will require a lower Amount and higher Radius setting, because it needs to emphasize gross detail, not fine detail (like wrinkles and acne). Higher Radius settings emphasize gross detail and obliterate fine detail. If you increase either one, you will have to decrease the other.

File Size. File size is also a determining factor in how much USM can be applied. My present digital camera can output images at different files sizes. For the 2048x2048 pixel output, I typically start out with Adobe Photoshop's USM filter set to: Amount=200, Radius=1.0 and Threshold=2. For the 4096x4096 pixel output, I typically start out with Adobe Photoshop's USM filter set to Amount=350, Radius=1.3, and Threshold=3.

When you work with images from the same source that are the same size, you will gradually develop a standard setting as a starting point. If you are inexperienced, here is a good place to begin: Start with Amount set quite high—200 to 350 (depending on size of files), Radius set to 1.0, and Threshold to 2. Then, adjust the Threshold until you have excluded as many unwanted pixels as possible (without killing the overall sharpening). This will usually range from 2 to 6 levels. Next, fine-tune the Amount and Radius settings, working back and forth between the two. My Radius settings rarely go over 1.6 pixels—on small files (6MB and below), I often go as low as 0.6. Keep in mind, from one camera (or scanner) to the next, the same size image file will need different amounts of USM.

For Printing. An image with the optimum amount of USM applied for output on a printing press will always appear

YOU WILL

GRADUALLY DEVELOP

A STANDARD SETTING

AS A STARTING POINT.

oversharpened on your monitor. As a rough rule of thumb, if the image is going to press, add the amount of USM that looks good on the monitor, then add at least 50% more to the Amount (make 150% become 200%, for example). Also, consider this: the lower the line screen ruling (printing-press resolution), the higher the Radius should be. When sharpening halos are smaller than the printing dots, they start to disappear and the image begins to look soft. An image destined for newsprint (low-resolution printing), therefore, needs a higher Radius setting than an image destined for an annual report (high-resolution printing).

SUPPLYING FILES TO CLIENTS

As we have learned, in addition to color correction, a digital imaging expert is responsible for image sharpness—applying the best amount of USM. In a typical, traditional workflow, a commercial advertising photographer sends film to the art director or designer. This person crops and calculates the percentage of enlargement or reduction then sends the film out to a service bureau to be scanned. The service bureau sends back a pre-sized scan of the image that has already been sharpened with USM.

Since a digital camera essentially "scans" reality, there is no preliminary step (such as film), so the art director or designer receives a digital file from us that has not been sized. It has not been sized because the art director or designer rarely knows the final cropping and sizing until they have the final image. If an image is to be resized more than 10%, it is best to do this sizing on a version of the file that has not yet been sharpened. Since most art directors and designers are also used to receiving a sized image that has been sharpened, many of them do not know how to correctly apply sharpening with the USM filter.

As a result, some of our early digital images went to press without sharpening. Yikes! The reproduction of these images looked soft. The art directors and designers involved wrongly concluded that digital capture was not as crisp as film. To solve this problem, my partner/brother Mark and I labeled the CDs we sent out as "Needs Unsharp Mask." Inside the CD jewel case we included thorough, step-by-step instructions on how to apply the USM filter to a digital image. At the time of the shoot *and* on the phone during a follow-up

SOME OF OUR

EARLY DIGITAL IMAGES

WENT TO PRESS

WITHOUT SHARPENING.

YIKES!

call, we would remind them that the files required sharpening. Unfortunately, soft images were still going to press, and the instructions were not always getting carried out. Now Mark and I avoid this dilemma by providing the designer or art director with low-resolution versions of the images on CD at the end of the shoot. Once they drop these files into their layouts and figure out the sizing, they contact us with the required percentage of enlargement or reduction. Mark or I then resize the file, add USM, and have the final images delivered to the client via courier, or send them over the wire.

UNFORTUNATELY,

SOFT IMAGES

WERE STILL

GOING TO PRESS . . .

THE ARTFUL IMAGE

THE IMPRESSIONIST PERIOD

IN PAINTING WAS

ACTUALLY SPAWNED

BY EARLY

PHOTOGRAPHY.

Photography has had an impact on art history. The Impressionist period in painting was actually spawned by early photography. Before photography, the only way to have a portrait made of oneself was to have an artist draw or paint your likeness. Creating portraits for people was the bread and butter of many artists. When photography hit the scene, many painters feared for their livelihoods, as clients were starting to go to photographers to have their "lifelike" portraits made. There was no way that the painters could outdo the realism of a photograph.

In response to this, artists very wisely went in the opposite direction. They started to create paintings that were less rigid and less realistic. Instead of trying to record reality, they created an artful interpretation—an impression of reality. These artists were the "Impressionists," and this was the start of the Impressionist period. Even to this day, Impressionism has left many photographers feeling inadequate as artists. We do not want to be just recorders of reality, we wanted to be artists, too!

As a result, we have been trying to create images that are more artful—more Impressionistic—by manipulating reality with photographic techniques and procedures, such as

Polaroid transfers and emulsion manipulation, filters, bad optics, long exposures with camera or subject movement, film grain, cross processing and many other darkroom techniques. It was not until the dawn of the digital age, however, that photographers were given a technology that provided us with powerful tools for transforming reality into artful impressions. In my opinion, we are now entering the "Photoshopist" period—or at least we are in this next section, where the "arty" side of image manipulation is explored.

PRACTICAL EXAMPLE: "PARASOL GOSSIP"

IMAGE DATA:

Exposure:	f-4 at $\frac{1}{60}$ second
Camera:	Hasselblad ELM
Lens:	Hasselblad/Zeiss 150mm f-4
Lights:	Overcast sky
Light modifiers:	None
Scanner:	Umax Astra 610S
Filtration:	None
Image editing software:	Adobe Photoshop
Image capture medium:	B&W Polaroid 100 rated at 100 ISO

Grainy, Sepia Toned. As you will see in this next image, creating artful digital images can be done without a big investment in capture equipment. For this image, Mark and I wanted to create the feel of an old, grainy, sepia-toned photo. In the not-so-distant past, photographers were looking for old, low-quality lenses from the 1950s that were manufactured in the Soviet Block countries. The resolving power of these lenses is so poor that the resulting images lack detail and have an overall softness. Mark and I developed (quite by accident) a great way of mimicking this look.

Discovery. During an outdoor workshop, we shot several medium format 100 ISO black & white Polaroids on a Hasselblad ELM camera fitted with a 150mm Zeiss lens before going to film. After dropping off the film at the lab, we continued the workshop back at our studio. Not wanting to wait for film and scans we proceeded to demonstrate some Photoshop techniques. The Polaroids were scanned on a $150 U-Max desktop scanner that was free with our office computer (can't get much cheaper than that!). Since Polaroids are anything *but* high resolution, and since the scanner was not high-end, the resulting digital files were a little soft and they lacked detail. Once we saw these attributes

CREATING ARTFUL DIGITAL IMAGES CAN BE DONE WITHOUT A BIG INVESTMENT IN CAPTURE EQUIPMENT.

Mark and I got quite excited—they had that cheap lens look! All that the images required to finish off the look was some digital enhancement with some selective softening and an artificial film-grain effect in Adobe Photoshop.

Overall Softening. The finished version of one of the images from this shoot, called "Parasol Gossip" (below), was shot at our local beach on an overcast day. An incident meter reading of the light striking the subjects from the open sky

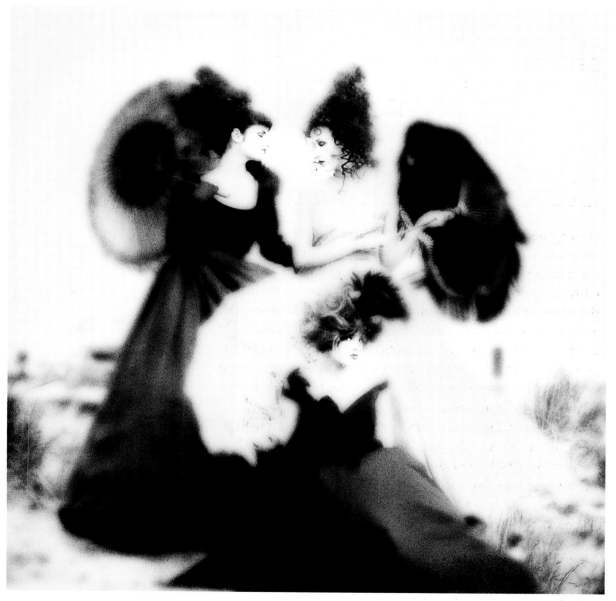

The finished version of "Parasol Gossip" after digital retouching.

read f-8 at $\frac{1}{60}$ second. The camera was set to f-4 at $\frac{1}{60}$ second to overexpose the image by two stops. After scanning the image, it was opened in Adobe Photoshop. Prior to retouching (below), the image lacked detail, due to the overexposure and the Polaroid material's low resolving power. However, the image was still too sharp for the look we were after.

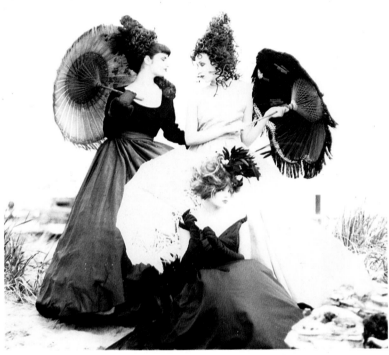

Despite its lack of detail and over-exposure, the raw Polaroid image was too sharp for the look we wanted.

A softening filter could have been used over the lens at the time of exposure to create an *overall* softening effect on the image. But we wanted a *selective* softening effect that would allow some areas to appear softer than others, and some key areas (such as the faces) to remain relatively sharp. With digital, anytime that I create an image that needs some filter effect(s), I prefer to create the effect(s) after capture in Photoshop. This allows much more control. With a filter over the lens, you are stuck with what you get at the time of capture. Doing the filtration in Photoshop makes it possible to increase or decrease the effect at any time—or get rid of it all together.

In Adobe Photoshop, to create an overall softening effect that is similar to a softening filter over the camera lens, duplicate the background layer in the Layers palette. This automatically copies the background layer and places this copied

layer exactly (pixel to pixel) on top of the original background layer. Softening can then be applied to the top layer by selecting the Gaussian Blur filter from the Filter menu (Filter>Blur>Gaussian Blur). For this 12MB image, the radius was set to 6 pixels (below, left). Applying the Gaussian Blur filter makes the image appear out of focus, rather than softened, however (bottom).

Using the Gaussian Blur filter (left), softening was applied to the top layer. The effect is seen below.

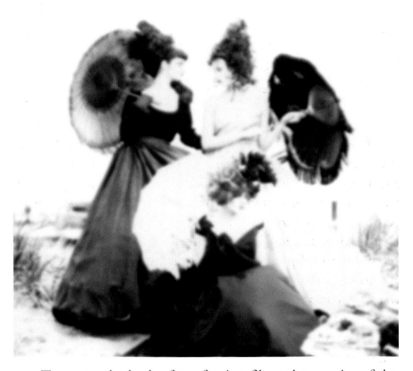

To create the look of a softening filter, the opacity of the top layer was partially reduced so that the sharp bottom layer would partially show through. On this image the Opacity of the top layer was set to 42% (see page 74, top). To see the

To reduce the visibility of the softening, the layer opacity was reduced (left). The result is shown in the image below.

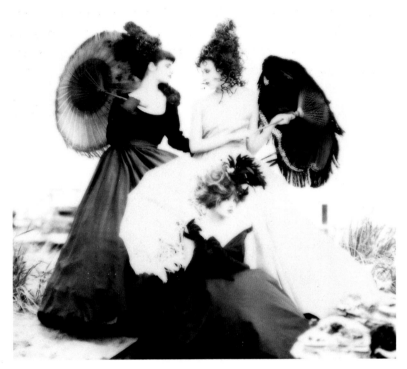

effect on the photograph, see the image directly above. This digital softening method is so much more powerful then using camera softening techniques because it allows you to change your mind at anytime and it provides a hundred different amounts of softening—rather than a mere handful.

Selective Softening. Looking back at the final image, shown on page 71. Notice that the image does not have an *overall* softening effect. Selective softness (or sharpness, depending on how you look at it), is yet another tool that can be used to draw the viewer's eye to key points in the image— as well as to add depth. To create this selective softening effect, I usually do not lower the blurred top layer opacity setting below 100%. To reveal select parts of the sharp bottom

layer through the top blurred layer, a layer mask is used to hide (make transparent) areas of the blurred layer.

With this in mind, the previously-created blurred layer (see above) was thrown out; it had too little Gaussian Blur for the effect I was after. It was replaced with a new duplicate of the background, and blurred with a Radius of 12 pixels (see below left and right). To reveal select parts of the sharp bottom layer, it would make sense to erase portions of the top blurred layer with the Eraser tool. This will do the job, but it will limit your options later on. A more powerful solution is to *hide* these parts by gradually painting black onto a white Reveal All layer mask. This method allows you to paint back what has been painted away at any time—even after the image has been saved and reopened.

Using the Gaussian Blur filter (above), softening was applied to the top layer. The effect is seen to the right.

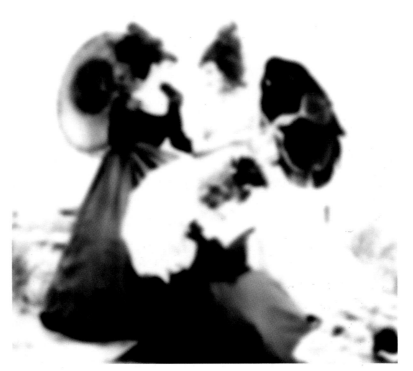

To try this technique, start by clicking on the blurred layer to activate it. From the Layer Menu, select Layer Mask and then Reveal All (Layer>New Layer Mask>Reveal All). Next, select the Airbrush tool and set its pressure to 10% or less, then make black the Foreground Color in the vertical tool bar. Use the Airbrush to paint over the areas of the image that you wish to appear sharper. Wherever you paint with the Airbrush tool, you will begin to hide the top layer—allowing

the sharp bottom layer to show through. If you change the Foreground Color from black to white and repaint over these same areas, the previously hidden areas will again be revealed (i.e., blurred). To see the completed layer mask painting effect, see the pair of photos below. On the left is the unpainted version, on the right is the painted one with sharp areas revealed through the blur.

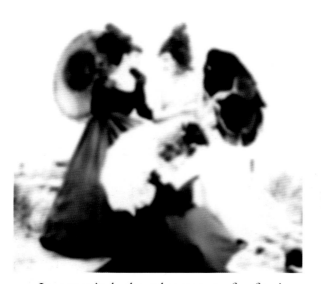 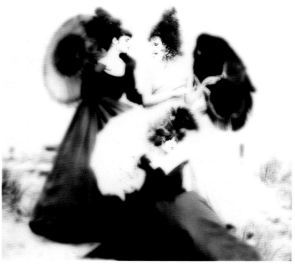

On the left, the photo with the Gaussian Blur has an all-over reduction in sharpness. On the right, sharpness has been selectively restored by painting with black on the layer mask.

In my mind, the advantages of softening an image digitally (either globally or selectively) makes traditional methods obsolete. I also think that using a layer mask to selectively hide areas of the top soft layer so that parts of the bottom sharp layer show through is superior to selectively erasing the top layer with the Eraser tool. This is because a layer mask allows you to change your mind about where the layer mask hides the top layer and by how much. It also allows you to edit the effect at any time thereafter. The use of layer masks is covered more extensively in the upcoming section on painting with pixels.

Sepia Tone. "Parasol Gossip" was captured on black & white Polaroid film, so it is a black & white image. However, the scanner scanned the image in the RGB color space, making it a monochrome color image. Since the image was already in RGB color space, it was a very simple matter to colorize it so that it looked like a sepia tone. The brown-toned, sepia effect we see in the version of "Parasol Gossip" shown on page 77 was created using a Hue/Saturation adjustment layer in Adobe Photoshop (see appendix, page 103). When

you see the Hue/Saturation dialogue box, activate the Colorize box (on the bottom right side of the dialogue box).

A brown tone is added to the photo (top) using the Hue/Saturation tool (settings shown below).

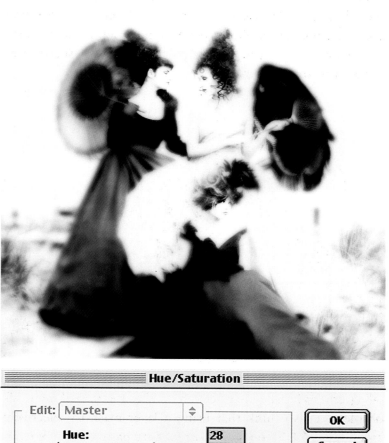

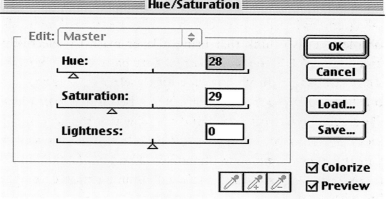

Make sure the Preview box is also activated. Next, drag the Hue slider to the left until the image is Colorized with a brown tone. If the effect is too saturated, move the Saturation slider to the left. Refer to the screen shot above to see my settings. If sepia is not your cup of tea, try other Hue/Saturation settings. Blue toning, for example, can be easily mimicked using the Hue/Saturation controls.

Film Grain. The finishing touch added to "Parasol Gossip," as seen on page 71, is film grain. As discussed earli-

er, captures from digital cameras have no film grain—and this is an advantage for most image creation. If you *want* a grainy-looking image, however, you can mimic film grain with the Noise filter. To add noise to an image in Adobe Photoshop, first activate the layer to which you want to add the effect. Then select Filter>Noise>Add Noise. In the dialogue box, zoom in on the preview to 100%. Then, drag the Amount slider until the desired amount of grain effect is achieved. This slider controls the intensity of the individual noise pixels, that is to say, how bright or dark the contrasting noise pixels are. Depending on your tastes, select either Uniform or Gaussian for Distribution. You should also select Monochrome, or the noise pixels will be colored red, green, or blue—and, to my eye, this looks fake.

As you do this, you'll need to the keep the intended use of the image in mind. As noted on page 45, to print a photograph on paper with a printing press, the image must first be broken down into dots—a process called applying the line screen. Applying a line screen, however, tends to hide noise and film grain in an image. A low line screen ruling hides noise and film grain more than a high one. Usually, this is a bonus—in most cases, noise and film grain are unwanted. In

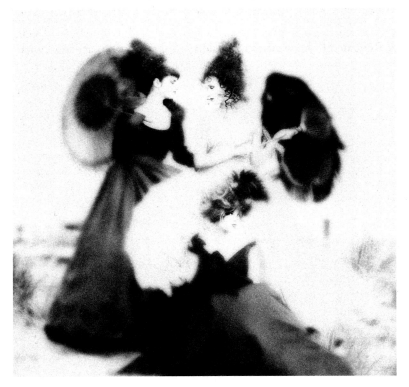

A grainy look is added to the image using the Noise filter.

the case of "Parasol Gossip," though, we *wanted* the noise in the image to make it look grainy. If the digital file is output as a photographic print, the grain effect would show up quite nicely. However, for the effect to be visible in this book, which is printed on a printing press with a line screen of 175 applied to the images, I needed to use a higher Amount setting, or apply Unsharp Mask to the image after the noise was applied. In other words, since the noise would be somewhat hidden after printing, I needed to overemphasize it. The screen shot on page 78 shows my settings, and the photo to the left of it shows the results.

The only problem with adding noise to the whole image evenly, as I did in the version of the image shown on page 78, is that too much noise shows up in brighter tones for the effect to truly look like film grain. To maintain heavier noise in the dark areas with less in the light areas of the image, I have another approach.

First, the noise that was applied to the image was undone (Command/Control+Z). A new Curves adjustment layer was then created. In the Curves dialogue box, the composite RGB curve was dragged down, darkening the image. This curve is illustrated in the screen shot below (left). Next, notice the white square thumbnail in the Curves layer in the Layers palette, shown in the screen shot below (right). This is a Reveal All layer mask (which appears automatically with every Curves adjustment layer). The next step is to fill this layer mask with black, converting it to a Hide All. To do this,

The composite RGB curve was dragged down, darkening the image.

Creating a Curves adjustment layer also creates a Reveal All layer mask.

select black as the foreground color, then go to Edit>Fill> Foreground Color (or use the keystroke shortcut: Option/Alt + Delete). Notice that the Curves layer mask thumbnail in the Layers palette is now black in the screen shot to the right. With this in place, the effect of the darkening curves layer is hidden.

Next, use the Noise filter to add noise to the Hide All layer mask (Filter>Noise>Add Noise). In the Noise dialogue box, set the Amount to 400%, then select Uniform and Monochrome (see screen shot below, right). The Noise added to the black mask will be made up of contrasting white pixels. Wherever a white pixel shows up on the black mask, that small portion of the image will be darkened by the darkening curve. Visually, this results in dark bits of grain (noise) on the image (which will also darken the image). If these dark grains make the image too dark, use another Curves adjustment layer to correct the brightness.

Applying the Noise filter to a Curves layer mask, rather than to an image layer, provides separate control over how visible the noise is in different tonal areas. In "Parasol Gossip," the RGB composite curve was dragged downward, increasing the noise's visibility throughout the image. Since the curve was pulled down at the quarter-tone point (the darker end of the curve), the noise in the dark areas of the image was emphasized more than the noise in the lighter areas. You can see the effect of this curve on the image at the top of page 81 (left). As mentioned earlier, simulated film grain looks more realistic if the noise is heavier in the dark tones and less intense in the light tones. With this in mind I also dragged the three-quarter-tone point (the brighter end of the curve) up a little, reduc-

With the layer mask filled with black, the effect of the darkening curves layer is hidden.

In the Noise dialogue box, set the Amount to 400%, then select Uniform and Monochrome.

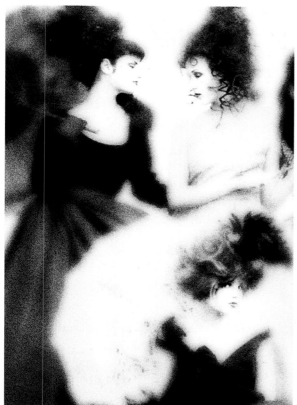

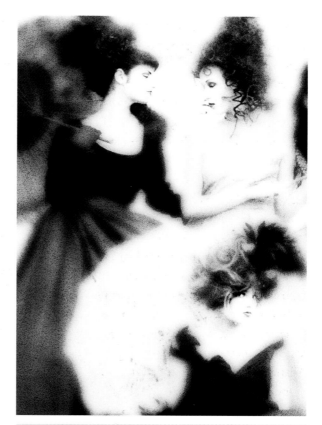

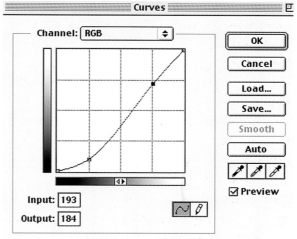

The RGB composite curve was dragged downward, increasing the noise's visibility throughout the image.

Simulated film grain looks more realistic if the noise is heavier in the dark tones and less intense in the light tones. Therefore, I dragged the three-quarter-tone point (the brighter end of the curve) up a little, reducing the noise in the light-toned faces.

ing the noise in the light-toned faces. You can see this curve in the screen shot at the bottom of page 81 (right). Its effect on the image is shown at the top of page 81 (right).

For a side-by-side, close-up comparison of the three different applications of noise to the image, see the facing page. The image on the left has noise applied to the image layer. The center image has noise applied to a Hide All layer mask in the Curves adjustment layer, which uses the curve seen on page 81 (bottom, left). The image on the right is similar to the center image, except that the three-quarter-tone portion of the curve was pulled up to reduce the grain effect in the highlight end of the image (as seen in the curve on page 81 [bottom, right]).

○ **TIPS**

For the most part, digital cameras tend to have more depth of field than their film counterparts. This is because digital imaging sensors tend to be smaller in size than a frame of film. The difference between the subject's actual size relative to its imaged size is, therefore, greater on most digital cameras than it is on film cameras. Depth of field is controlled by aperture and image size, so the greater the reduction, the greater the depth of field. For example, a full-length image of a person will have a sharper background than a head-and-shoulders image of the same person (when shot on the same camera at the same aperture). This extra depth of field is a nice bonus for many images; however, it works against us in more artsy images that call for shallow depth of field. The selective softening technique demonstrated on the "Parasol Gossip" image can be used to mimic shallow depth of field, as well as the thin plane of sharpness created when using a view camera with the lens aperture wide open. While the camera movements on a view camera allow select areas of the image to be sharp, this sharpness can only be distributed over a two-dimensional plane. Erasing or hiding part of a blurred top layer so that the sharp bottom layer can selectively show through can be used not only to mimic this effect, but to take the effect much further. Since you are not limited by camera movements or a two-dimensional plane, it is possible to make any part of the image sharp or soft—you are not tied down to sharpness over all areas that are lying on the same plane.

FOR THE MOST PART,

DIGITAL CAMERAS

TEND TO HAVE

MORE DEPTH OF FIELD . . .

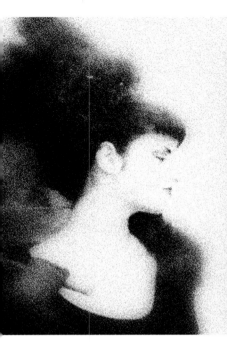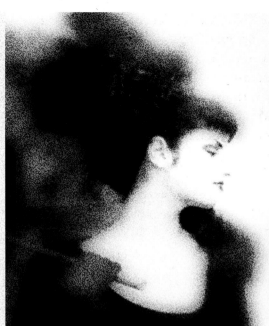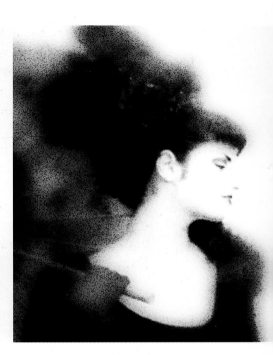

The results of noise applied in three different ways.

Digital imaging not only gives us many new tools and abilities for creating fine art images it also provides us with easier solutions that offer much more control than traditional photographic techniques. And as we saw with "Parasol Gossip" (and will see in the following chapter, "Painting with Pixels"), with a little thought, it is possible to mimic any traditional photographic technique digitally.

9

PAINTING WITH PIXELS

Of all the photographic techniques used to create artful images, painting with light—the surreal, painterly style that American photographer Aaron Jones made popular in the late 1980s and early 1990s—is probably one of the most powerful. Unfortunately, for digital capture, painting with light relies on the buildup of multiple timed exposures on a single frame of film. Digital cameras/backs cannot capture multiple exposures in one image—every exposure you make is a new image. Frustrated with the fact that we could not use light painting techniques with a digital camera, my brother Mark and I—in the first few hours after receiving our first digital camera—developed a new lighting technique. Well, it's really an old technique with a digital twist. This technique, called "painting with pixels," is the digital equivalent of painting with light (see "Stamp Book" on page 86).

PAINTING WITH LIGHT
RELIES ON THE BUILDUP OF
MULTIPLE TIMED EXPOSURES
ON A SINGLE FRAME
OF FILM.

PAINTING WITH LIGHT: A REFRESHER

In a nutshell, painting with light works like this: in relative darkness, with the camera shutter open, an intense beam of light from a small handheld lamp is directed away from the camera onto the surface of the subject. With the lamp placed only inches from the subject, a timed exposure (typically

4–16 seconds at f-16–f-32) is made. The light is in motion throughout the exposure, painting its energy onto the subject. Many such exposures are made over the surfaces of the set and are recorded onto a single frame of film.

This sounds much easier than it actually is. Aaron Jones had an advantage over most of us; he was an airbrush artist as well as a photographer. Consequently, he applied many of his airbrush techniques to the movement of the light-painting tool over the subject. Developing your technique for painting with light takes some practice. Since most of us are not experienced airbrush artists, we have to develop the coordination and manual dexterity required. In addition to time, the learning curve consumes a considerable amount of film. Once the technique is perfected, it is still somewhat hit and miss, because you cannot view the results of your efforts until you get the film back. You can shoot Polaroid prints to see an approximation of what you're doing, but you cannot paint light over the same area, in the same way, every time. As a result, each attempt will be different. This fact makes painting with light seem unreliable (and often unacceptable) to many art directors and clients.

DEVELOPING YOUR TECHNIQUE FOR PAINTING WITH LIGHT TAKES SOME PRACTICE.

PAINTING WITH PIXELS: OVERVIEW

Painting with pixels is a digital process where two (or more) nearly identical images—differing only in lighting—are painted together in Photoshop using layer masks. Painting with pixels is the digital equivalent of painting with light—and it has major advantages over the traditional technique. First, it is not a blind, one-way process. The painting effect is visible as you create it, so you can modify it at any time. Additionally, it does not require any special handheld lighting devices. Finally, you do not have to work in darkness.

There is, however, one catch: image alignment. This technique relies on perfect registration between the image variations. Image files from scanned film are always out of alignment. It can easily take one to two hours to align two layers in Photoshop, making this an unrealistic solution—especially on multi-image/layer shots. Digital capture, however, is the perfect solution. As long as you do not bump the camera or the subject, you will have perfect alignment—pixel to pixel—from one frame to the next. Digital capture has another distinct advantage over film: you see the results immediately and

don't have to wait to have your film scanned to put the image into Photoshop.

PRACTICAL EXAMPLE: "STAMP BOOK"

IMAGE DATA:

Exposure:	f-8 at $\frac{1}{60}$ second
Camera:	Foveon Single Capture
Lens:	Canon L-Series 28–70mm/f-2.8 zoom set at 29mm
Lights:	one Paul C. Buff X1600 White Lightning mono-block strobe
Light modifiers:	48" x 48" white translucent nylon Chimera panel
Processing software:	Foveon Lab
Image editing software:	Adobe Photoshop

Creating the Images. To create base illumination for the image, the book and domino set was flat-lit by a light panel placed 2½' directly overhead. A single strobe head, placed 1½' above the panel, provided the light energy. The power output slider on the back of the strobe was adjusted to create an image that was underexposed by 2–3 f-stops at f-8 at $\frac{1}{60}$ second (see below). (The highlights for this image are to be created afterwards in Adobe Photoshop.)

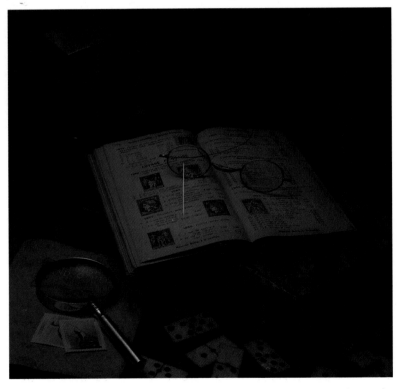

The power output slider on the back of the strobe was adjusted to create an image that was underexposed by 2–3 f-stops. This created the base exposure for the image.

In preparation for a second capture of the same subjects, the light panel was moved out of the way. The strobe head was lowered to about 12" above table height. It was placed in front of the subjects, to the left of the camera. The power of the strobe was adjusted to create a correct exposure at f-8 and $\frac{1}{60}$ second. Select parts of this overexposed image (seen below) were then used to paint over the dark image, creating highlighting.

The power of the strobe was adjusted to create an overexposure at f-8 and $\frac{1}{60}$ second, overexposing the subjects by about one f-stop. Select parts of this overexposed image were then used to paint over the dark image.

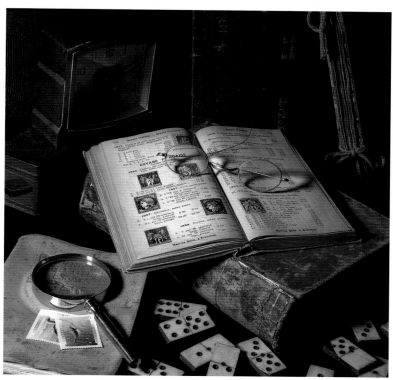

One Image From Two. Next, the two versions of the image (above and facing page) needed to be brought together into one image file, with the underexposed version as the bottom layer, and the overexposed version as the top layer. To do this, open both images, then go to the image window of the overexposed image. Then, hold down the Shift key as you drag the background layer from the Layers palette of the overexposed image (above) into the open window of the underexposed image (facing page). For this technique to work, make sure that the overexposed image is dragged into the approximate center of the host image. It is critical to hold down the Shift key, otherwise the layer you drag over will not sit in perfect registration with the layer below. Holding down the Shift key instructs Photoshop to place the dragged image

exactly in the center of the image window. Since this image has exactly the same pixel dimensions of the host image, the two images will be perfectly registered. (To double-check the registration, try clicking the top layer "eyeball" on and off in the Layers palette—if the image appears to jump, the registration is not correct.)

Painting Technique. Next, a Hide All layer mask and the Airbrush tool were used to make select parts of the darker bottom layer visible through the overexposed layer. Essentially, the bottom layer provided the basic form, while the top layer provided the highlighting. To hide the top layer, go to the Layer menu and select Hide All from the Add Layer Mask menu (Layer>Add Layer Mask>Hide All). Even though the top image layer "eyeball" is still turned on, notice that the image is no longer visible. If you look at the top layer, you'll see a black square thumbnail (see screen shot, right). This black square thumbnail represents a Hide All layer mask, making the image invisible. The opposite (a white square thumbnail) represents a Reveal All layer mask. If a Reveal All layer mask had been chosen, the whole top layer would still be visible.

Now for the fun part! Set the foreground color to white. As you paint over the image, you will apply white onto the black layer mask, selectively revealing the over-exposed top layer. If you reveal too much, switch the paint color to black and paint over the area to gradually "re-conceal" it.

To mimic the soft edge-transfer shadow effect of the traditional technique, I prefer to paint using the Airbrush tool with a very soft-edged brush. The pressure of the Airbrush tool is best set at a low value (10% or less), so that you have to paint many strokes over the area to reach the brightness required. This slow buildup helps you to get just the right amount of brightness, and it creates a softer edge. (By the

The black square thumbnail represents a Hide All layer mask, making the image invisible.

○ **TIPS**

You do not have to place an overexposed image on top of a dark one. You can do it the other way around: hold down the Shift key and drag the dark image background layer into the image window, then select a Reveal All layer mask instead of a Hide All layer mask. Paint with black selected as the foreground color instead of white.

The effect of the first brush stroke.

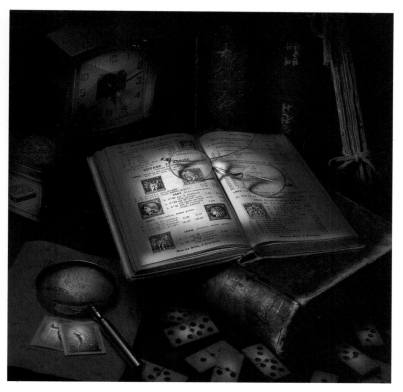

The image with the pixel painting complete.

way, dragging over an area with the Airbrush tool pressure set to 10% reveals 10% of the top layer. Dragging over the same area again reveals 20% [10% has been added to the original 10%]). Each time you drag over the same area, 10% more is revealed—until 100% is reached. This is assuming you are painting with white and not a darker tone such as middle gray. Middle gray would max out at 50% visibility.)

If you look above (left), you'll see the effect of the first brush stroke. This is the most amazing thing—you are actually "painting light" onto the image in the computer! (It is probably the closest you will ever come to being God!) The image with the pixel painting complete is also shown above (right). It took me all of ten minutes to create.

Highlights. However, after my ten minutes of living as a "divine being," I decided that I wanted a couple of big, bright, specular highlights to appear on the magnifying glass. Painting from the bright top layer in these areas would not simulate a specular highlight (alas, I am only a mortal, after all), because the highlights did not physically exist on the subject in that capture. Therefore, another exposure of the set

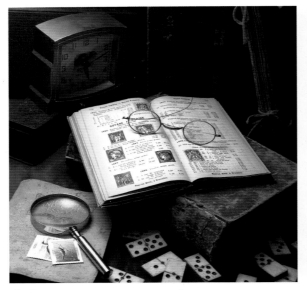

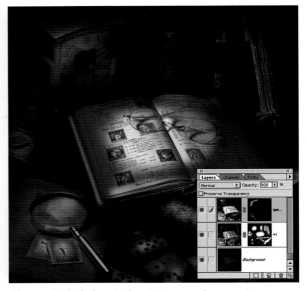

Third image, one stop overexposed.　　　　　　The image with the pixel painting complete.

was taken with these specular highlights in place (above, left). For this exposure, the White Lightning strobe and the Chimera panel were repositioned above the set. The power setting on the strobe was adjusted in order to create an overexposure of one stop at the f-8 aperture setting. Only a small portion of this third image was used: the reflection of the overhead panel light source on the magnifying glass handle and lens, as well as a little more brightness on the top of the clock and on the small book under the magnifying glass (above, right).

○ **TIPS**

To save time, try these shortcuts:

• To change the pressure of the Airbrush tool, hit the 0 key for 100% pressure, the 5 key for 50% pressure, and the 1 key for 10% pressure. For a setting under 10, type the number 0 in front of the desired value. For instance, to set a pressure of 5%, type 05 in rapid succession.

• To change the size of the brush, hit the left square bracket key ([) for a smaller brush, or hit the right square bracket (]) key for a larger brush.

• Hit the letter D key to switch to the default colors. This makes the foreground color white and the background color black.

• Hit the X key to toggle between the foreground color and the background color.

○ TIPS

- At some point when using layer masks you will run into a slight complication. Instead of the brush stroke revealing/hiding the image layer, white or black paint will appear on the image from the brush stroke. This means you are editing the *image layer* not the *layer mask*. Look at the layer you are working on in the Layers palette. You should see one of two things between the thumbnail of the image and the layer visibility "eyeball" icon. If you click on the Layer Mask icon (the white or black square), a square with a dotted circle will appear. This signifies that the layer mask is activated and that your brush strokes are affecting only the layer's visibility. If you click on the layer's image thumbnail, then a paintbrush icon will appear. This signifies that you are affecting the actual image (in this case, brushing white or black paint onto it). For painting with pixels, you want the square with the dotted circle icon visible.

- You cannot create a layer mask on the background layer. To create a layer mask for the background, double-click on this layer in the Layers palette. When the New Layer dialogue box appears, you can rename the layer, if you like (or Photoshop will name it Layer 0). You can then create a layer mask.

- If you want to view the actual layer mask instead of the image in the image window, hold down the Option/Alt key and click on the layer mask thumbnail. Repeat the process to return to the image.

- To turn off the layer mask, hit Shift and click on its thumbnail. To turn the layer mask back on, repeat the process.

- You can also transfer your layer mask from one file to another in order to save time (and frustration) when working on really large image files. Start by creating a smaller copy of the file (Image>Image Size>enter the desired width and height—50% of your original image size [even 25%, if necessary]). Once you have completed your pixel painting, turn the paint strokes on the layer mask into a selection by holding the Command/Control key and clicking on the layer mask thumbnail. Click on the "Save Channel as a Selection" icon (the dotted circle inside a square thumbnail at the bottom of the Channels palette). The selection will now be saved as a channel. Then, resize the image back up to the exact size of the really large image file (Image>Image Size>enter the original width and height). Hold down the Shift key, and drag the channel in question from the Channels palette into the open image window of the original large-size file. Hold down the Command/Control key and click on the copied channel in the Channels palette to activate the selection. In the Layers palette, select the layer that corresponds with the layer you pixel-painted in the smaller file version. Then, create a layer mask (Layer>Add Layer Mask>Reveal Selection/Hide Selection). The layer mask will conform to the selection, showing just your pixel painting.

This ability to go back to the set and alter the shot is a powerful new tool available to digital photographers. Photoshop has always been a valuable post-production tool, but with digital capture it is now an important photographic tool. No more compromises!

Selective Softening. Part of the Aaron Jones look is selective softening. In light painting, the subject is selectively exposed in many different areas, on top of a base fill exposure. Placing a softening filter over the camera lens for some of these exposures selectively softens the image. With digital capture, we cannot do multiple exposures onto one frame, so we soften in Photoshop after the image is captured. As you have probably just realized, the Adobe Photoshop method Mark and I used to selectively soften "Parasol Gossip" is based on the same layer-mask painting method as our painting with pixels technique. This digital selective softening

Images with digital selective softening technique applied.

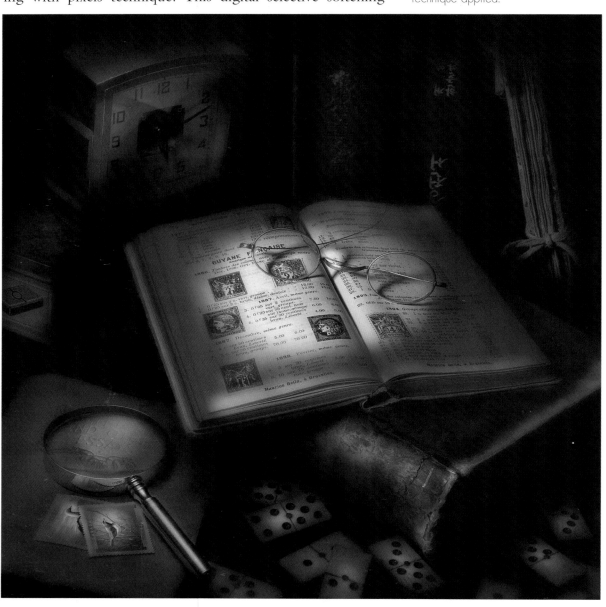

○ **TIPS**

- A Reveal All layer mask can also be created by clicking on the Add Layer Mask icon (dotted circle in a square) at the bottom of the Layers palette. Pressing the Opt/Alt key when clicking the Add Layer Mask icon creates a Hide All layer mask.

- Photoshop (for the most part) works in 8-bit per channel color depth. When you create gradations, as was done with the blur filter, banding will occur—especially if the image is converted to CMYK color space. 8-bit color does not generate enough information to create a smooth tonal gradation. Instead of an unbroken, smooth gradation, subtle breaks occur. The easiest remedy for this shortcoming is to apply the Add Noise filter. (Before adding noise, however, save a copy of the image as a PSD file so that you can go back, if necessary, and do further image editing to the individual layers at a later date.) The image needs to flattened before adding noise, otherwise it will only be applied to the layer that is selected. Once flattened, apply any needed sharpening using the Unsharp Mask filter. If you sharpen after adding noise, it may emphasize the noise too much. From the Filter menu select Noise>Add Noise>Amount (2–4 pixels, Distribution: Gaussian, Monochromatic). In most cases, with a Noise Amount of 2–4, the banding will be broken up enough that we will not notice it in the gradient, yet the noise itself is invisible to the untrained eye.

technique was applied to "Stamp Book," seen at the bottom of page 92.

In order to start the selective softening, the image file's three layers need to be flattened (Layer>Flatten Image). As a precaution, before flattening the image, a PSD copy of the file (preserving all of the individual layers) was saved in case I decide to go back and change something later on. Once flattened, a Gaussian Blur with a Radius of 12 pixels was applied to a copy of the background layer.

As you will recall, to create selectively soft areas in the image (instead of the whole image), a layer mask is needed. But which type? Hide All or Reveal All? In the pixel-painting portion of this exercise, the top layer was hidden with a black, Hide All layer mask, then parts of the top layer were selectively revealed by airbrushing over it with white paint. The selective softening could be done this way too. However, since the majority of the image will remain soft, I decided to use a Reveal All (white) layer mask, then selectively airbrush black paint (at 5–10% pressure) over key areas to hide the softness and reveal sharpness.

IMAGE DATA:

Exposure:	f-11 at 1/60 second
Camera:	Foveon Single Capture
Lens:	Canon L-Series 28—70mm/f-2.8 zoom set at 44mm
Lights:	one Paul C. Buff X2400 White Lightning monoblock strobe
Light modifiers:	Medium (3'x4') Chimera soft box with silver lining
Processing software:	Foveon Lab
Image editing software:	Adobe Photoshop

The traditional light-painting techniques work well on subjects that are stationery, but fall short on subjects that move—subjects such as people. It is difficult because, in most cases, the subject cannot hold still long enough for the required series of time exposures. Of course, difficult doesn't mean entirely impossible—if you lean your subject against a wall, lay him/her on the ground, or sit him/her in a chair with his head supported. Usually, the results are pretty static looking.

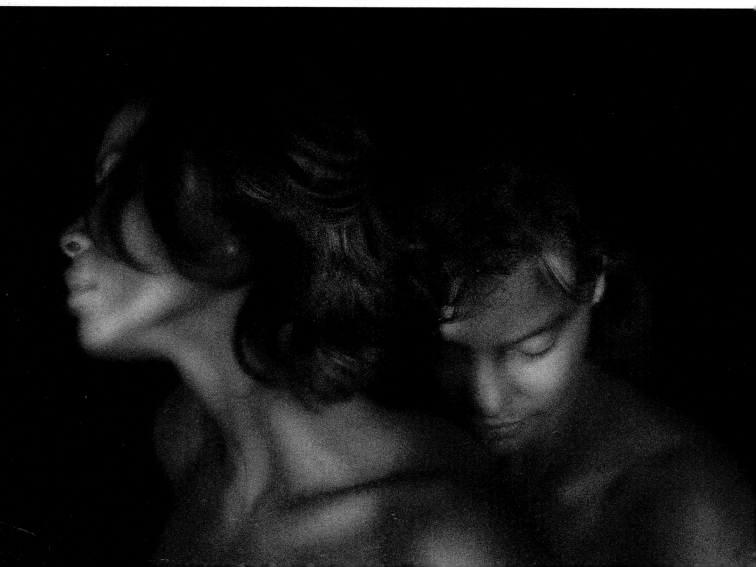

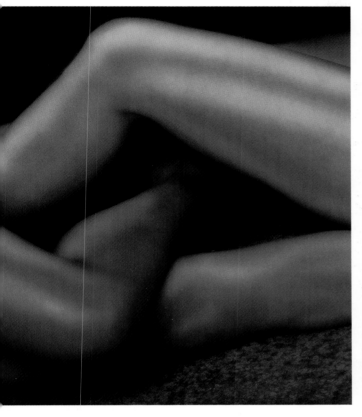
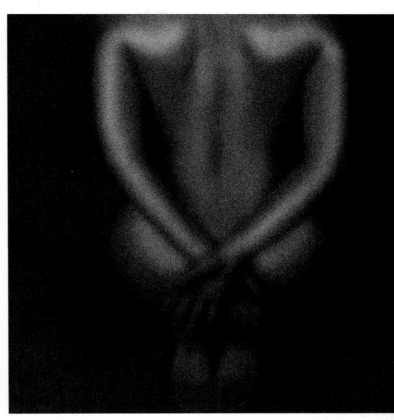

The images seen above and on the facing page are a pixel-painted series inspired by the poems of the ancient Greek poetess, Sappho, who wrote about love.

It is very difficult to capture meaningful expressions in such a constrained situation. However, when everything does come together, painting with light on a person can have a lot of impact.

Painting with pixels provides an easier and more effective way to create the arty/painterly look of painting with light on people. It is easier, and more effective, because a single exposure in a single instant of the subject is all that is needed. This frees the subject to be animated (it can even be an action shot), allowing you, the photographer, to capture meaningful expressions more easily. And, just like painting with pixels on objects, painting with pixels on people is not a blind, one-way process—the painting effect is visible as you create it, you can modify it at any time, and you do not have to work in darkness. The images seen above and on the facing page are a pixel-painted series inspired by the poems of the ancient Greek poetess, Sappho, who wrote about love.

People. Using my ever-trustworthy, always-available subject (Montizambert Photography Inc.'s marketing enchantress, who also doubles as my wife after work)

Sylvianne St.Onge (a.k.a, The Saint), let's take a look at how the painting with pixels technique can be applied to images of people.

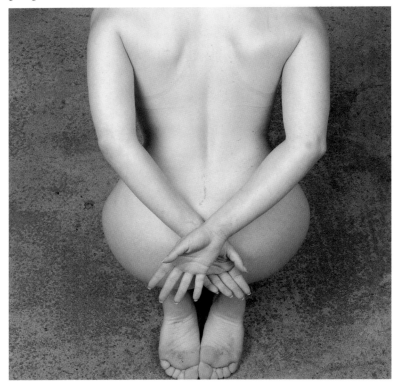

Sylvianne was correctly exposed and flat-lit by a softbox fitted to a monoblock strobe.

Lighting. The lighting for this image is very simple. In the image shown above, Sylvianne was correctly exposed and flat-lit by a softbox fitted to a monoblock strobe. This assembly was positioned 7' behind her, above the camera. The frontal position of the softbox is important since frontal lighting creates the flattest lighting possible (the highlights and shadows will be created in Adobe Photoshop later). The size and distance of the softbox is also important. A large light source placed close to the subject creates softer-edged shadows. More importantly, when pixel painting a person, the specularity (sheen) on the flesh will not burn out, creating ugly-looking hotspots that limit where you might want to airbrush highlights onto the image.

To capture the best pose, several exposures were digitally recorded. Only one of these raw-capture image files was processed in the digital camera's processing software. It was processed as a normal exposure. Since a conscious human being cannot stay perfectly still while several exposures of different lighting setups are recorded, only one flat-lit image was

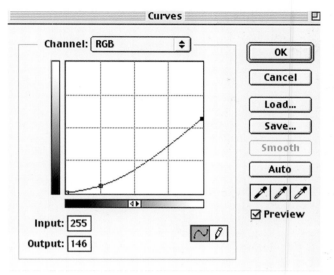

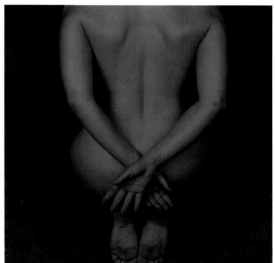

To darken and flatten the contrast of the image, two points of the composite curve were altered.

The result of this curve on the photograph.

used. This did not allow the same control and flexibility over image contrast as was used in the "Stamp Book" shot—but it still worked pretty well.

Technique. Since we did not have the luxury of a second, darker exposure of Sylvianne to paint together with the normally exposed image, a slightly different procedure from that used with the "Stamp Book" example had to be employed. A Curves adjustment layer was generated (see appendix, page 103). To darken and flatten the contrast of the image, two points of the composite curve were altered. First, the highlight value (255), which is at the extreme top end of the curve, was dragged down to 146. Value 64 (the 25% point near the bottom of the curve [called the quarter tone]) was pulled down to 14. See this curve in the screen shot above (left), and see the accompanying image (above, right) to view the curve's effect on the photograph.

As noted previously, a Curves adjustment layer automatically comes equipped with a Reveal All layer mask (left). Since the layer mask is white, the effect of the curve is fully visible. Choosing black as the foreground color, then painting selectively over the image with the Airbrush tool set at a low pressure causes a gradual buildup of black on select areas of the white layer mask. These black areas hide the effect of the curve, allowing the normal exposure to show through.

Highlights. It is much harder to do a good job of painting highlights onto an image of an amorphic shape, such as a

A Curves adjustment layer automatically comes equipped with a Reveal All layer mask.

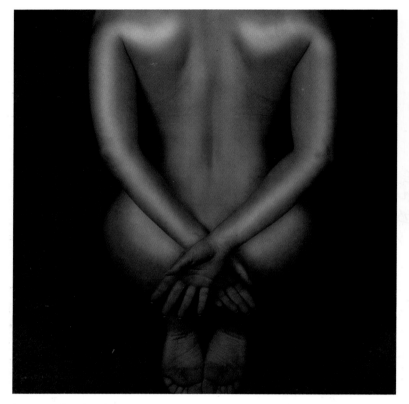

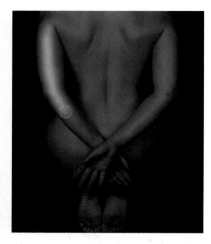

Above, you see the first stroke of the Airbrush painting tool. To the left is the image with the painting complete.

human body, than onto a shape like a book—we are so tuned-in to what the human body should look like, that a few out-of-place brush strokes are visually interpreted as deformities (making this is a great technique for making a loved one into a monster!). For this reason, I used 5% (or less) pressure to achieve a gradual buildup of the effect. This allowed me to fine-tune my paint strokes *before* they got out of hand. This painting-with-pixels technique on a Curves adjustment layer has the same visual effect as seen in "Stamp Book"—it looks like you are painting light right onto the subject! See the first strokes of the airbrush tool in the image above (right), and the painting complete in the second image above (left).

Special Effects. Notice how the pixel painting gives the image a surreal look? To remove this image even further from reality, let's add some special effects. The final image, as seen on page 95, has three effects added to it: blur, noise and a blue color shift—the digital equivalents of a soft-focus lens, grainy film, and a blue color shift created with color printing correction filters on a darkroom color enlarger. The following is a step-by-step breakdown of these three effects.

First, the softening effect was created by going to Filter>Blur>Gaussian Blur and setting the Radius to 15 pixels. To view the effect, see the image below (left). To add the grain effect, noise was added by going to Filter>Noise>Add Noise. The Amount was set to 32, the Distribution to Gaussian, and Monochromatic was selected. To view the effect see the image below (right).

The effect of the first brush stroke.

The image with the pixel painting complete.

Finally, to create the blue color shift effect, a new adjustment layer was created and set to Curves. In the Curves dialogue box, I selected the blue channel. The midpoint of the curve (value 128) was dragged up the grid, giving the image a strong blue cast. This curve is shown below.

Finally, to create the blue color shift effect, a new adjustment layer was created and set to Curves. In the Curves dialogue box, the blue channel was adjusted.

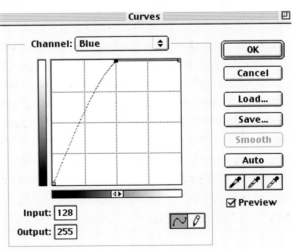

○ **TIPS**

• The Radius setting in the Gaussian Blur filter is expressed in pixels. The effect of this setting is relative to the size of the image. A larger image file requires a higher Radius setting than a smaller one. For instance, the image "Sappho Blue" (shown on page 93) is 2896x2896 pixels in size (a 24MB file in RGB). It has had Gaussian Blur filter applied to it with a Radius of 15 pixels. A 15-pixel Radius creates a lot of blurring on an image of this size. However, this same setting applied to a larger file—let's say 6000x6000 pixels (just over a 100MB file in RGB), would render considerably less blurring effect.

• In any channel of a curve in the RGB color space, when you drag up on a point, the image will become brighter. Dragging the curve up in the blue channel of "Sappho Blue" brightened the image. In Adobe Photoshop, if you want to affect only the color and not the brightness of the image, make sure to adjust the curves via a Curves adjustment layer. After selecting this layer in the Layers palette, change the layer mixing mode from Normal to Color. (Or do this earlier in the process by changing Mode: Normal to Mode: Color in the dialogue box that appears when you first create the adjustment layer. In versions of Adobe Photoshop after version 5.5, this dialogue box is only available if you hold down the Opt/Alt key when clicking on the Make New Adjustment Layer icon [the half-black, half-white circle at the bottom of the Layers palette].)

CONCLUSION

Digital not only gives us many new tools and abilities for creating fine art images, it also provides us with easier solutions that offer much more control than traditional photographic techniques. As we saw with "Parasol Gossip," "Stamp Book," and "Sappho Blue" with a little thought, it is possible to use digital means to mimic any traditional photographic technique.

Painting people with pixels is a perfect example of digitally improving on a traditional technique. Unlike the traditional technique, digital imaging provides complete freedom to capture moving, breathing subjects with all their moods and expressions—and still create the artistic painting-with-light-effect. It is hard to imagine actually painting with light, now that I can create a superior product with a lot less blood and sweat—and turn it out *faster*. Also, by capturing images digitally, we have immediate previewing capability. This means we can get immediate feedback on what the client likes and does not like.

PERFORMANCE ART

Since turning our studio over to digital capture, Mark and I have found a side benefit: performance art. Digital capture

provides a final image file within a couple of minutes of releasing the shutter, allowing us to digitally retouch our shots right in front of the client while they wait. The client, with our guidance, makes the decisions about how much is enough, what needs to stay, and what needs to go. Clients absolutely *love* the experience because, for the first time in photographic history, they can be included in the creative process—and they receive an image that is tailored exactly to their tastes. These new "friends" leave our studio thinking of us as artists, not mere picture-takers. This, too, has a wonderful side benefit—you can charge what you are worth, rather than a price set by the "undercutters"!

THE FUTURE

In the future, I see all professional photographers working digitally—often with remote clients. These remote clients will be "plugged-in" to the studio over a high-speed, electronic connection with digital video so they can watch the shoot in real time. Photographers will shoot, then send low-resolution versions of the images over this electronic connection to the client to approve. Once approved, a final, enhanced and color-corrected, full-resolution file will be sent over a high-speed line (or by a high-speed wireless satellite connection) to the client. Actually—forget about the *future*, all of this technology exists now!

Digital technology gives imagers the ultimate control. As a result, it gives photographers all the power—the power to be in charge of digitizing their own creations, create their own CMYK separations, to retouch, and to composite their images. No longer do we need to be at the mercy of a technician who does not share our passion for our images. Besides, digital capture is instant gratification! Isn't that why we photographers picked up a camera and not a paintbrush in the first place?

DIGITAL TECHNOLOGY

GIVES IMAGERS

THE ULTIMATE

CONTROL.

BASIC PHOTOSHOP OPERATIONS

CREATE AN ADJUSTMENT LAYER

Method 1: New Adjustment Layer
(Photoshop 6.0 or later)

1. Go to the Layers palette.
2. Click on the half-black/half-white circle icon at the bottom.
3. From the list that pops up, select the desired type of new adjustment layer (Curves, Levels, Hue/Saturation, etc.).
4. The new adjustment layer's dialogue box will open, and you can begin adjusting the image with it. (Any desired changes to the name, opacity or mode of the new adjustment layer may be made from the Layers palette, or by holding down the Option key when initially clicking on the half-black/half-white circle icon—this brings up the New Layer window first, instead of taking you straight to the New Adjustment Layer's dialogue box.)

Method 2: New Adjustment Layer
(Photoshop 6.0 or later)

1. Go to the Layer menu.
2. Select New Adjustment Layer.

3. Select the desired New Adjustment Layer (Curves, Levels, Hue/Saturation, etc.).

4. In the New Layer dialogue box, make any desired changes to Name, Opacity, Group-With-Previous-Layer checkbox, Color (for the color of the layer in the Layers palette), or Mode (for how this layer mixes with the layers below it). Then hit OK.

5. The new adjustment layer's dialogue box will now open, and you can begin adjusting the image with it. (Any further changes to the Name, Opacity, Group-With-Previous-Layer checkbox, Color, or Mode of the new adjustment layer may be made from the Layers palette.)

Method 3: New Adjustment Layer (Photoshop 4.0, 5.0, 5.5)

1. Select the Layer pull-down menu from the Layers palette.

2. Select New Adjustment Layer.

3. Select the desired type of New Adjustment Layer (Curves, Levels, Hue/Saturation, etc.) make any desired changes to Name, Opacity, Group-With-Previous-Layer checkbox, or Mode (for how this layer mixes with the layers below it). Then hit OK.

4. The new adjustment layer's dialogue box will now open and you can begin adjusting the image with it. (Any further changes to the Name, Opacity, Group-With-Previous-Layer checkbox, or Mode of the new adjustment layer may be made from the Layers palette.)

5. (You can skip steps 1 and 2 by using the New Adjustment Layer quick stroke: Command/Control + click on the Create New Layer icon [the turning page icon] at the bottom of the Layers palette.)

Note:

• A new adjustment layer automatically comes equipped with a Reveal All (white) Layer Mask. With the adjustment layer selected in the Layers palette, simply paint on the image with black to selectively hide parts of the Adjustment Layer's affect on the image. In Adobe Photoshop 4.0, 5.0, and 5.5, there is no Layer Mask thumbnail shown with the New Adjustment Layer in the Layers palette, but the layer mask is there. In Adobe Photoshop 6.0 this visual feature was added.

Method 1: Create a Reveal All or Hide All Layer Mask from the Layer menu

1. In the Layers palette, activate a layer. Go to the Layers menu.
2. Select Add Layer Mask.
3. Select Hide All or Reveal All. (Hide All makes the layer transparent or invisible, Reveal All makes the layer opaque or visible).

Method 2: Create a Reveal All Layer Mask from the Layers palette

1. In the Layers palette, select a layer.
2. Click the Add Layer Mask icon at the bottom of the Layers palette (the dotted circle in the gray rectangle).
3. This creates a Reveal All Layer Mask.

Method 3: Create a Hide All Layer Mask from the Layers palette

1. In the Layers palette, select a layer.
2. Hold down the Option key as you click the Add Layer Mask icon at the bottom of the Layers palette (the dotted circle in the gray rectangle).
3. This creates a Hide All Layer Mask.

Notes:

- You cannot create a Layer Mask on the background (at the bottom of the layer stack in the Layers palette) without first turning it into a layer. To turn the background into a layer double-click on it in the Layers palette. When the New Layer dialogue box appears, type in a new name or keep the default name (eg. Layer 0). When you press OK, the background will be transformed into a layer.

- When editing an image with a Layer Mask, make sure you are in Layer Mask mode. This means that the Layer Mask is selected and not the layer. To be sure look to the box to the immediate right of the "eyeball" layer-visibility icon, the Layer Mask icon (a dotted circle in a rectangle) should be showing. If a paintbrush icon is showing you will be editing the image rather than the Layer Mask.

- When you apply paint onto an image when in Layer Mask mode, you are actually applying the paint to Layer Mask and not the image. To see the actual Layer Mask, hold down the Option/Alt key as you click the white or black Layer Mask thumbnail in the Layers palette. Press Option and click again to go back to viewing the image.

- To modify a Reveal All Layer Mask (white), make sure you are in Layer Mask mode, then brush over the image with black or create a selection and fill it with black. Where you apply black hides this image area of this layer or you could say makes that part of the image transparent so that the underlying layer(s) show through. (To restore the mask, either paint with white or fill a selection with white.)

- To modify a Hide All Layer Mask (black), make sure you are in Layer Mask mode, then brush over the image with white or create a selection and fill it with white. Applying white to all or part of a Layer Mask makes all or parts of the image on that layer visible again, and since these white areas on a layer mask make the image opaque, the underlying layers will be partially or totally hidden. (To restore the mask, paint with black or fill a selection with black.)

- You can use gray instead of white or black to partially reveal or hide an area of the image with a Layer Mask. You can also paint with any of the brush tools set at a pressure less than 100% to gradually hide or reveal an area.

- To turn off the Layer Mask, hold down the Shift key and click on its thumbnail. To turn the Layer Mask back on, repeat the process.

IMAGE VIEW

For the most accurate view of an image on your monitor, zoom in or zoom out to 100%. At 100% one image pixel will equal one monitor pixel. Any zoom setting above or below 100% will force the computer to interpolate or sub-sample the view of your image, rendering a less accurate view. With Adobe Photoshop, use these quick keystrokes to save time when zooming the image to 100%:

> Mac: CMD+OPTION+0 (zero)
> PC: CTRL+ALT+0 (zero)

DETERMINING WHERE A TONE FALLS ON A CURVE

1. Open the Curves dialogue box.
2. Click and drag over the image area you want to evaluate.
3. A circle will then appear on the line of the curve identifying that this is the area of the curve where those tones reside.

Note:

In RGB, this feature works on the composite channel as well as the individual channels. In CMYK, however, it only works on the individual channels.

SHARPENING

Method 1:

In some sharpening software, you have the option to control the dark sharpening halos separately from the light sharpening halos. This is an advantage because, more often than not, you can get away with much higher settings for the dark halos than you can with the light halos—creating superior overall sharpening. The USM dialogue box in Adobe Photoshop does not allow you to do this. However, you can accomplish this task using the Fade Unsharp Mask dialogue box. Here is how to do it:

1. Apply the appropriate amount of USM for the dark halos (ignoring what the light halos look like).
2. Go to the Fade Unsharp Mask dialogue box and switch the mode from Normal to Darken.
3. Apply the appropriate amount of USM for the light halos (ignoring what the dark halos look like).
4. Go to the Fade Unsharp Mask dialogue box and switch the mode from Normal to Lighten.

Notes:
• You can skip steps 3 and 4, and instead do the following: type Command/Control F to apply the last filter settings, in this case the Unsharp Mask settings from step 1. In the Fade Unsharp Mask dialogue box, you can then set the mode to Lighten. At this point, the light sharpening halos will look really overdone. To bring them down to an acceptable level, slide the Fade Opacity slider (in the Fade

Unsharp Mask dialogue box) to the left, while viewing the results in the image window. More often than not, this slider will end up somewhere around 60%.

- You cannot access Fade Unsharp Mask if you are sharpening a layer with a Layer Mask unless you apply the Layer Mask first by selecting Remove Layer Mask from the Layer menu then select Apply. Or click and drag the square Layer Mask thumbnail from the layer to the trash can at the bottom of the Layers palette, then select Apply from the resulting dialogue box.

Method 2:
When you finish the procedure, you will have the light halos sharpened to the best possible level—without compromising the amount that the dark halos can be sharpened. Best of all, this will be done in the Luminosity mode, so that color anomalies will not be emphasized.

1. In the Layers palette, duplicate the background layer.
2. For the dark sharpening halos, apply the USM filter to the duplicate layer.
3. In the Fade Unsharp Mask dialogue box, set the Mode to Luminosity.
4. With the duplicate layer active, change the layer Mode from Normal to Darken.
5. Duplicate the background layer again.
6. For the light sharpening halos, apply the USM filter to the second duplicate layer.
7. In the Fade Unsharp Mask dialogue box, set the Mode to Luminosity.
8. With the second duplicate layer active, change the layer mode from Normal to Lighten.
9. In the Layers palette, adjust the layer Opacity of the two duplicate layers to fine-tune the amounts of dark and light sharpening.

Note:
You can cut corners in the above procedure by copying the Darken layer instead of the Background layer in step 5. If you do so, omit steps 6 and 7.

GLOSSARY

Action—In Photoshop, a way of automating repetitive tasks by recording a sequence of image editing operations that can be played back at any time to another image file.

Additive Primary Colors—The colors red, green and blue. These colors are the primary colors of the visible spectrum of light. When our eyes receive equal amounts of red, green and blue light we see white. When all three are absent we see the absence of light—black. Colors that we perceive to be something other than black or white are varying percentages of red, green and blue light mixed together.

Adjustment Layer—In Photoshop, a layer that contains image adjustment information (such as the Curves or Levels settings). When image adjustment tools are applied via an Adjustment Layer, their settings can be accessed repeatedly.

Array—A line of sensors that moves down the image area scanning and recording the image as it goes. Also called an imaging head.

Banding—An effect where subtle breaks occur in gradient areas when there is not enough information to create a smooth tonal gradation.

Bit (8-Bit Color)—In 8-bit color, an image pixel is made up of 8 bits (1 byte). Our present-day computers work on a binary system, a system of two—either off (0) or on (1). In 8-bit color, an image pixel is made up of either 8 zeros or 8 ones or 8 of any combination of zeros and ones. The total number of pixel values or shades of gray from these combinations of zeros and ones is 256. In RGB color you have not one but three channels, so 8 bits for red, 8 bits for green and 8 bits for blue equals 24-bit color. From 24-bit color, approximately 16.8 million colors can be generated. That is 256 for red x 256 for green x 256 for blue.

Black Point—The darkest significant neutral point in an image that you want to hold detail in.

Brightness—The lightness of a color or tone, independent of hue and saturation.

CCD (Charge Coupled Device)—Light-sensor chip used in high-end digital cameras. Manufacturing requires a specialized process, making these chips more expensive than CMOS chips. *See* CMOS.

Channel—One of the semi-transparent, colored-light overlays that are the building blocks of every digital image. Images in the RGB color space have three channels: R (red), G (green) and B (blue). Images in other color spaces have other numbers and types of channels.

Chromatic Adaptation—Mechanism by which our eyes and brain adjust to lighting conditions, attempting to maintain a constant color neutrality and brightness value.

Clone Tool—In Photoshop, a tool used to paint data from one area of an image onto another area. Commonly used in retouching.

CMOS (Complementary Metal Oxide Semiconductor)—Light-sensor chip used in high-end digital cameras. Original models offered less dynamic range and had more noise than the CCD chips, but these problems have been resolved. Cheaper to manufacture than CCD chips, CMOS chips also require less power (improving battery life).

CMYK Color Space—The color space normally used to create images for print output. Consists of four channels: C (cyan), M (magenta), Y (yellow) and K (black). Its gamut is very limited compared to an RGB color space.

Color Alignment—Correct pixel-to-pixel alignment of the channels in an image.

Color Artifacts—Stray color pixel anomalies often caused by computer errors from the interpolation of missing color information from a single-chip/single-shot digital camera. Can also be caused by a noisy camera or scanner or from enlarging a digital image file.

Color Balance (Image)—To eliminate color casts in an image in order to produce color that accurately reflects the colors in the original subject.

Color Balance (Monitor)—To calibrate a monitor so that the colors seen on screen are displayed as accurately as possible.

Color Cast—An overall (global) or localized shift toward one color, resulting in color that does not accurately reproduce the colors in the original subject.

Color Conversion Gel—A transparent material placed over a light source to adjust its color temperature by filtering the light.

Color Correction—To eliminate color casts in an image in order to produce color that accurately reflects the colors in the original subject.

Color Depth—The number of bits per channel. More bits means more color—because there are more ons (1s) and offs (0s) per pixel. 8-bit color has less color depth than 12-bit color. 8-bit can produce 256 different brightnesses whereas 12-bit can produce 4096 different brightnesses.

Color Fringing—Unwanted color halos around groups of pixels, often caused by applying Unsharp Mask to an image. Color fringing from Unsharp Mask can be avoided or reduced by sharpening only the luminance information and not the color information of an image.

Colorimeter—A device used to measure light output from a light source such as a monitor. For monitor calibration, this information is used by the software to be used in the color-balancing process.

Color Picker—In Photoshop, a palette in which custom foreground and background colors can be selected.

Color Sampler Tool—Is used to target points of an image that you wish to read as you affect the tonal and/or color values and brightnesses in an image. It can be set to read 1 pixel, or average a 3 x 3 pixel area, or average

a 5 x 5 pixel area. These sampled points are listed in the Info palette with a before and after reading of their values.

Color Space—Describes method by which the tones and colors in an image are created. Common color spaces include: RGB, CMYK and Lab.

Color Temperature—Measured in degrees Kelvin (°K), describes how warm or cool the illumination from a light source is. Important for correct color balancing.

Composite—A digital image that is made up of more than one capture or scan.

Composite/Master Channel—A channel that represents the combination of all the individual channels that make up the image. Changes in this channel are applied identically to each individual channel.

Constant Light Source—A light source (like the sun or a lightbulb) that emits an uninterrupted stream of light energy over a relatively long period of time. (As opposed to a strobe or flash light source that emits a stream of light energy over a relatively short period of time.)

CRT Monitor—Monitor made up of a big vacuum-sealed tube that houses three electron guns in its rear. These three guns—one for red, one for green and one for blue—fire beams of electrons to the screen at the front of the tube. The tube front is covered with a coating of millions of RGB-colored phosphor cells that glow briefly when energized by the electrons beamed at them. These energized cells or dots result in glowing colored pixels that make up an image on the monitor's screen. CRT stands for cathode-ray tube.

Curves Tool—In Photoshop, the most versatile tool for correcting the color balance of an image.

Densitometer—A sensitive, photoelectric instrument or a tool in image editing software that measures the density of images or colors.

Depth of Field—The distance range over which there is sharpness in an image. Because digital imaging sensors tend to be smaller in size than a frame of film, they tend to yield greater depth of field.

Dot Gain—In printing, an increase in the size of the dots as the ink bleeds into the paper.

Dynamic Range—The range from the lightest to the darkest tone a device can capture/produce.

Film Recorders—Continuous-tone device used to output negative/positive transparencies from a digital file.

Firmware—Circuits in an electronic device that can be upgraded with software rather than physical upgrading. Digital cameras with upgradable firmware become obsolete at a much slower rate than those without.

Gamma—A measure of contrast in the midtones of an image or a monitor screen.

Gaussian Blur—In Photoshop, a filter used to soften (decrease sharpness in) an image.

Ghosting—In multi-pass digital cameras, the effect that occurs when the subject (or camera) moves during an exposure. This results in the subject not being rendered identically in each of the image channels and therefore looking blurred and with multiple-colored edges. Ghosting can also occur with digital captures with less than optimum software that does not align the three color channels accurately.

Grain—*See* Noise.

Gray Card—A neutral card with 18% reflectance used as a standard by which to color balance a digital camera.

Highlight—The lightest area of an image that you wish to hold detail in. Not to be confused with a specular highlight.

Highlight Burnout—Loss of detail in light areas of an image. Historically a common problem with digital images, this is no longer a major issue.

Histogram—A type of graphic representation of the tones in an image. *See also* Levels Tool.

HMI Light—HMI stands for Hg (mercury) Medium arc Iodide. HMI lights create a constant flow of light energy that is daylight-balanced and is flicker-free due to its high-frequency current. Flicker causes a band of reduced exposure across an image that is captured with a scan-back digital camera. As the light flickers, the row of pixels being created gets less illumination during the millisecond(s) that the light is dimmer. HMI light is created by electricity arcing through mercury vapor, this method of light production is extremely efficient compared to other light production (such as tungsten light). It produces less heat and

approximately four times more light energy than tungsten lighting.

Image View—The degree of enlargement at which an image is displayed on-screen. Use a 100% view (1:1 pixel relationship between the image and the monitor) for the most accurate view.

Imaging Head—*See* Array.

Info Palette—In Photoshop, displays the percentage output for each channel in the area under the cursor (when the cursor is over an area of a digital image).

Ink Density—In printing, the maximum amount of ink that can fall on any one area of paper.

Input Levels—When working with the Levels dialogue box in Adobe Photoshop, there are three little windows next to the words "Input Levels." Each of these windows has an input value in it and corresponds to the sliders immediately below the histogram. The far left window is the input value for the shadow slider (far left slider), the center window for the gamma slider (center slider) and the far right window for the highlight slider (far right slider). As you slide any of these sliders the values in the boxes change accordingly. You can also type in values in these windows and the sliders will move accordingly. Moving the end sliders inward increases contrast in the image. The shadow slider, when moved to the right makes, all the tones get darker—from the dark tones up to the light tones. The highlight slider, when moved to the left, makes all the tones get brighter—from the light tones down to the dark tones. Moving the gamma slider affects the brightness of the image from the midtones outward.

Interpolation—Process by which the computer must add or subtract data as it displays an image on the monitor, or to a resized image file.

Iris Printer—Uses an inkjet-type technology to put ink on paper. Iris printers are one of the ways that CMYK digital files can be proofed before making film and plates for the printing press. It can emulate printing press dots and it is designed to proof on the paper you are going to go to press with. It is also used for short-run printing, like posters for point-of-purchase advertising. The fact that Iris printers can print on a wide variety of papers and that the prints are considered archival quality makes it a very attrac-

tive medium for artists who make fine-art prints. The Iris printer is now seeing stiff competition from large-format inkjet printers.

Jaggies—In printing, pixelated edges that—when blown up—look like a staircase.

LAB—A color space often used in color correction. Features three channels: L (luminosity), A (difference between red and green) and B (difference between blue and yellow). Its gamut is very wide—similar to that of the human eye.

Layer Masks—Pixel-based masks that allow you to hide portions of an image layer without permanently erasing or deleting the contents of the layer. The Layer Mask can be re-edited, allowing you to reveal or hide parts of the layer image at any time in the future.

LCD Monitor—Unlike a CRT monitor, an LCD monitor has a thin panel display. It creates images with tiny backlights that project light through glass sheets, polarizing filters, and tiny electronic switches, plus a transparent liquid-crystal layer. One of the layers, called a thin-film transistor (TFT) layer, alters the liquid crystals causing them to block varying degrees of light passing through the various layers. The TFT addresses the light in minuscule cells. The cells are grouped together in threes, and with the aid of an RGB filter, each set of three cells makes up one color pixel.

Levels Tool—In Photoshop, a tool used for color correction. The image histogram is displayed in its dialogue box and can be a helpful reference.

Light Painting—Applying light (via a handheld source) to a subject over the course of a timed exposure (or multiple exposures).

Line Screen—In printing, the transformation from a continuous tone to a dot pattern.

Megapixel—Refers to one million pixels and is used as a form of measurement for digital file dimensions. For instance, a 16 megapixel digital camera creates images that are approximately 4000 pixels wide by 4000 pixels high. 4000 x 4000 = 16,000,000 or 16 megapixels. A 4-megapixel digital camera creates images that are approximately 2000 pixels wide by 2000 pixels high.

Metamerism—A visual effect that occurs when two colors appear to be the same under one lighting condition and different under another.

Midtone—A tone that is in the middle portion of the grayscale. Using 8-bit values that provide a scale of brightness levels from 0 to 255, the midtone region would approximately span from levels 110 to 130. In CMYK, midtones reside around 50%. CMYK uses a scale where 0% represents pure white and 100% represents pure black. Percentages refer to the percentage of total printing dot size.

Mode (Layer Mixing)—In Photoshop, controls how the data on an overlying layer interacts (if at all) with the data on an underlying layer.

Moiré Patterns—Swirling rainbows that often appear in areas where patterns on the subject (like those typically seen on fabrics) interfere with the pattern of the digital imaging sensor.

Noise—Stray pixels that look like film grain.

Opponent Colors—Opposite colors. Cyan is the opposite color to red, magenta is the opposite color to green, and yellow is the opposite color to blue. Therefore, cyan cancels red, magenta cancels green and yellow cancels blue.

Out-of-Gamut Colors—Colors that cannot be reproduced/displayed by a particular device (such as a printing press or monitor) or in a particular color space (such as CMYK).

Output Levels—When working with the Levels dialogue box in Adobe Photoshop there are two little windows next to the words Output Levels. These windows display an output value that corresponds with the two sliders below. Dragging these sliders inward decreases image contrast. The left slider when dragged to the right increases the brightness from the dark tones up to the light tones, and the right slider when dragged to the left decreases the brightness from the light tones down to the dark tones. For example, if 20 were entered in the left window or if the left slider were dragged to the left until 20 appears in the left output window, 0 will read 20, 20 will become 38, 128 will become 138 and so on. This feature is useful for compressing the brightness range of a file so that it can fit an output device like an inkjet printer, which may not be able to print the darkest and lightest tones in an image.

Phosphor-Based Monitor—*See* CRT Monitor.

Pixel—The smallest discrete part of a digital image.

Pixel Blooming—Effect that occurs when one of the pixels in a CCD chip is overexposed. As a result, the excess light tends to spill over into the adjacent pixels and cause glare.

Prism—Called a color-separation prism in photography, this is a specially-shaped piece of glass (or similar clear material) that splits the spectrum of light apart into its primary colors. It is used in three-chip video and still digital cameras to separate and channel each of the primary colors of the broken-apart spectrum onto the appropriate imaging chip so that the camera can capture red, green and blue image information simultaneously.

Prosumer Camera—A very high-end consumer digital camera, ideal for professionals who want to experiment with digital capture without a large investment. Can also be used professionally to create images where smaller file sizes are needed (such as small catalog images or images for the Web).

Quarter Tone—A group of brightnesses ranging from approximately levels 60 to 100 in the 8-bit-per-channel RGB color scale (where 0 = pure black, and 255 = pure white). In the RGB scale, the quarter tone resides between the image shadow and midtone. Conversely, in CMYK, a quarter tone resides between the highlight and the midtone. Why the difference? In RGB, higher numbers mean more brightness, in CMYK higher numbers mean more ink density—which equates to darker tone. CMYK values are expressed as percentages of the maximum possible printing dot size (0% is pure white and 100% is pure black). A quarter tone in CMYK sits at around 25%.

Raw Capture Files—Similar to the negative in tradition photography, this is an image data file that contains raw pixel information and is usually only editable with the proprietary software from the digital camera that took the capture in the first place. These raw image data files are designed to have more information than can be used, so that there is room in the processing of the file for control over color, density and contrast. This is similar to a negative, which also contains more information than can be printed on photographic printing paper.

Registration—The correct alignment of the channels in a digital image (or the inks in a printed image).

Resolution—The number of pixels per inch in a digital image.

Retouching—Altering an image to correct flaws or create new effects.

RGB—The color space in which digital captures and scans are created. Consists of three channels: R (red), G (green) and B (blue). Its gamut is wider than CMYK, but narrower than Lab.

Sepia Tone—A brownish tone added to an image. Traditionally accomplished by soaking a print in a chemical solution, but easily mimicked with digital technology.

Shadow—In photographic lighting, a shadow is an area on a subject that receives absolutely no light from the main light source. It may, however, receive light from a secondary light source, such as a reflector or a fill light. In the printing industry, the meaning of shadow is more broad—it means a dark area in an image, whether it be a fully-lit, dark-toned object or a light-toned, underlit object.

Sharpening—To digitally increase the contrast of edges in an image, reducing or eliminating apparent softness in the image.

Sheet-Fed Press—Sheet-fed printing uses a press that is fed individual sheets of paper. It sacrifices speed for quality and is more expensive per page than web printing. It is usually used for shorter runs of printing.

Shoulder—The lighter, top portion of a film's tonal response curve. Typically, the curve flattens out somewhat (hence the term "shoulder") so that a visually pleasing gradual transition from a light-toned area into burned-out area occurs.

Simultaneous Contrast—Visual phenomenon by which colors and tones appear different based on what is surrounding them. The human visual system has evolved to exaggerate the differences between similar colors and tones.

Softening—To digitally reduce the sharpness in select areas of an image or in the entire image.

Specular Highlight—In the printing world, this term refers to a bright, burned-out reflection that contains no detail. In lighting for photography, it is a reflection of a light source whose apparent brightness is affected by the size and distance of that light source. For this reason, specular highlights may or may not be reproduced with detail.

Stocastic Printing—A line-screening process that breaks the image into dots of the same size. It creates variances in tone and color by changing the frequency of the dots.

Subtractive Primary Colors—The colors cyan, magenta and yellow. Cyan ink absorbs (subtracts) the red portion of the visible spectrum of light, magenta absorbs green, and yellow absorbs blue. When magenta and yellow are printed together we see red. When cyan and yellow are printed together we see green. When magenta and cyan are printed together we see blue. These are the colors of the printing world, where the color and density of an image is created by inks on paper absorbing varying amounts of the visible spectrum of light. Light that is not absorbed is reflected off the paper back to our eyes. In theory, if the maximum density of cyan, magenta and yellow are printed on top of each other we should see black—that is, all of the light striking the page should be absorbed by the ink so that none can be reflected to our eyes. Unfortunately, true black cannot be attained with just cyan, yellow and magenta ink on a printing press or a printer. Instead, this combination ends up as a dark, muddy, brownish-gray due to the poor ability of cyan ink to absorb the red portion of the visible spectrum of light. When all three color inks are absent, the full spectrum of visible light is reflected off the page, resulting in white.

SWOP Specifications (Specifications for Web Offset Publications)—Standards that are universally accepted in the publication of magazines (and also widely used in commercial printing). These say that the sum percentages of all four colors, called the total ink, cannot exceed 300.

Three-Quarter Tone—Brightnesses ranging approximately from levels 160 to 170 in the 8-bit-per-channel RGB color scale (where 0 = pure black, and 255 = pure white). In the RGB scale, the three-quarter tone resides between the image highlight and midtone. Conversely, in CMYK, a three-quarter tone resides between the shadow and the midtone. Why the difference? In RGB higher numbers mean more brightness, in CMYK higher numbers mean more ink density, which equates to darker tone. CMYK values are expressed as percentages of maximum possible printing dot size (0% is pure white and 100% is pure black). A three-quarter tone in CMYK sits at around 75%.

Toe—The dark portion of a digital capture or film tonal response curve. Typically, the curve is steep in this area, to create high contrast that will emphasize any detail.

Tonal Response Curve—A line on a graph that represents the reaction of a given film or imaging sensor to light.

Total Ink—The sum percentages of all four colors of ink (cyan, magenta, yellow and black) applied to an area. In most commercial printing, this cannot exceed 300.

True Tonality—The natural brightness of the subject.

Unsharp Mask—In Photoshop, a filter used to increase edge contrast and reduce softness.

Web Printing Press—A web press is used for high-speed, high-volume printing runs—such as magazines, flyers and newspapers. The paper it uses comes in gigantic rolls that run through the press as a continuous band of paper that gets cut at the end. It sacrifices quality for speed. *See also* Sheet-Fed Press.

White Point—The lightest significant neutral point in an image that you want to hold detail in.

Zoom—In Photoshop, a tool used to modify the percentage of enlargement at which an image is viewed on screen.

INDEX

Other Books from
Amherst Media

Outdoor and Location Portrait Photography
2nd Edition
Jeff Smith

Learn how to work with natural light, select locations, and make clients look their best. Step-by-step discussions and helpful illustrations teach you the techniques you need to shoot outdoor portraits like a pro! $29.95 list, 8½x11, 128p, 60+ full-color photos, index, order no. 1632.

Wedding Photography:
CREATIVE TECHNIQUES FOR LIGHTING AND POSING, 2nd Edition
Rick Ferro

Creative techniques for lighting and posing wedding portraits that will set your work apart from the competition. Covers every phase of wedding photography. $29.95 list, 8½x11, 128p, full-color photos, index, order no. 1649.

Lighting Techniques for Photographers
Norman Kerr

This book teaches you to predict the effects of light in the final image. It covers the interplay of light qualities, as well as color compensation and manipulation of light and shadow. $29.95 list, 8½x11, 120p, 150+ color and b&w photos, index, order no. 1564.

Infrared Photography Handbook
Laurie White

Covers black and white infrared photography: focus, lenses, film loading, film speed rating, batch testing, paper stocks, and filters. Black & white photos illustrate how IR film reacts. $29.95 list, 8½x11, 104p, 50 b&w photos, charts & diagrams, order no. 1419.

Computer Photography Handbook
Rob Sheppard

Learn to make the most of your photographs using computer technology! From creating images with digital cameras, to scanning prints and negatives, to manipulating images, you'll learn all the basics of digital imaging. $29.95 list, 8½x11, 128p, 150+ photos, index, order no. 1560.

Creating World-Class Photography
Ernst Wildi

Learn how any photographer can create technically flawless photos. Features techniques for eliminating technical flaws in all types of photos—from portraits to landscapes. Includes the Zone System, digital imaging, and much more. $29.95 list, 8½x11, 128p, 120 color photos, index, order no. 1718.

Professional Secrets for Photographing Children
2nd Edition
Douglas Allen Box

Covers every aspect of photographing children on location and in the studio. Prepare children and parents for the shoot, select the right clothes capture a child's personality, and shoot storybook themes. $29.95 list, 8½x11, 128p, 80 full-color photos, index, order no. 1635.

McBroom's Camera Bluebook, 6th Edition
Mike McBroom

Comprehensive and fully illustrated, with price information on: 35mm, digital, APS, underwater, medium & large format cameras, exposure meters, strobes and accessories. Pricing info based on equipment condition. A must for any camera buyer, dealer, or collector! $29.95 list, 8½x11, 336p, 275+ photos, order no. 1553.

Macro and Close-Up Photography Handbook

Stan Sholik & Ron Eggers

Learn to get close and capture breathtaking images of small subjects—flowers, stamps, jewelry, insects, etc. Designed with the 35mm shooter in mind, this is a comprehensive manual full of step-by-step techniques. $29.95 list, 8½x11, 120p, 80 photos, order no. 1686.

Infrared Wedding Photography

Patrick Rice, Barbara Rice & Travis HIll

Step-by-step techniques for adding the dreamy look of black & white infrared to your wedding portraiture. Capture the fantasy of the wedding with unique ethereal portraits your clients will love! $29.95 list, 8½x11, 128p, 60 images, order no. 1681.

Dramatic Black & White Photography
SHOOTING AND DARKROOM TECHNIQUES

J.D. Hayward

Create dramatic fine-art images and portraits with the master b&w techniques in this book. From outstanding lighting techniques to top-notch, creative darkroom work, this book takes b&w to the next level! $29.95 list, 8½x11, 128p, order no. 1687.

Posing and Lighting Techniques for Studio Photographers

J.J. Allen

Master the skills you need to create beautiful lighting for portraits of any subject. Posing techniques for flattering, classic images help turn every portrait into a work of art. $29.95 list, 8½x11, 120p, 125 full-color photos, order no. 1697.

Studio Portrait Photography in Black & White

David Derex

From concept to presentation, you'll learn how to select clothes, create beautiful lighting, prop and pose top-quality black & white portraits in the studio. $29.95 list, 8½x11, 128p, 70 photos, order no. 1689.

Watercolor Portrait Photography
THE ART OF POLAROID SX-70 MANIPULATION

Helen T. Boursier

Create one-of-a-kind images with this surprisingly easy artistic technique. $29.95 list, 8½x11, 128p, 200+ color photos, order no. 1698.

Techniques for Black & White Photography
CREATIVITY AND DESIGN

Roger Fremier

Harness your creativity and improve your photographic design with these techniques and exercises. From shooting to editing your results, it's a complete course for photographers who want to be more creative. $19.95 list, 8½x11, 112p, 30 photos, order no. 1699.

Corrective Lighting and Posing Techniques for Portrait Photographers

Jeff Smith

Learn to make every client look his or her best by using lighting and posing to conceal real or imagined flaws—from baldness, to acne, to figure flaws. $29.95 list, 8½x11, 120p, full color, 150 photos, order no. 1711.

Basic Digital Photography

Ron Eggers

Step-by-step text and clear explanations teach you how to select and use all types of digital cameras. Learn all the basics with no-nonsense, easy to follow text designed to bring even true novices up to speed quickly and easily. $17.95 list, 8½x11, 80p, 40 b&w photos, order no. 1701.

Portrait Photographer's Handbook

Bill Hurter

Bill Hurter has compiled a step-by-step guide to portraiture that easily leads the reader through all phases of portrait photography. This book will be an asset to experienced photographers and beginners alike. $29.95 list, 8½x11, 128p, full color, 60 photos, order no. 1708.

Basic Scanning Guide For Photographers and Creative Types

Rob Sheppard

This how-to manual is an easy-to-read, hands on workbook that offers practical knowledge of scanning. It also includes excellent sections on the mechanics of scanning and scanner selection. $17.95 list, 8½x11, 96p, 80 photos, order no. 1708.

Professional Marketing & Selling Techniques for Wedding Photographers

Jeff Hawkins and Kathleen Hawkins

Learn the business of successful wedding photography. Includes consultations, direct mail, print advertising, internet marketing and much more. $29.95 list, 8½x11, 128p, 80 photos, order no. 1712.

Photographers and Their Studios

CREATING AN EFFICIENT AND PROFITABLE WORKSPACE

Helen T. Boursier

Tour the studios of working professionals, and learn their creative solutions for common problems, as well as how they optimized their studios for maximum sales. $29.95 list, 8½x11, 128p, 100 photos, order no. 1713.

Photographing Creative Landscapes

Michael Orton

Boost your creativity and bring a new level of enthusiasm to your images of the landscape. This step-by-step guide is the key to escaping from your creative rut and beginning to create more expressive images. $29.95 list, 8½x11, 128p, 70 photos, order no. 1714.

Advanced Infrared Photography Handbook

Laurie White Hayball

Building on the techniques covered in her *Infrared Photography Handbook*, Laurie White Hayball presents advanced techniques for harnessing the beauty of infrared light on film. $29.95 list, 8½x11, 128p, 100 photos, order no. 1715.

Zone System

STEP-BY-STEP GUIDE FOR PHOTOGRAPHERS

Brian Lav

Learn to create perfectly exposed black & white negatives and top-quality prints. With this step-by-step guide anyone can learn the Zone System! $29.95 list, 8½x11, 128p, 70 photos, order no. 1720.

Selecting and Using Classic Cameras

Michael Levy

Discover the charms and challenges of using classic cameras. Folders, TLRs, SLRs, Polaroids, rangefinders, spy cameras and more are included in this gem for classic camera lovers. $17.95 list, 6x9, 196p, 90 photos, order no. 1719.

Traditional Photographic Effects with Adobe Photoshop

Michelle Perkins and Paul Grant

Use Photoshop to enhance your photos with handcoloring, vignettes, soft focus and much more. Every technique contains step-by-step instructions for easy learning. $29.95 list, 8½x11, 128p, 150 photos, order no. 1721.

Master Posing Guide for Portrait Photographers

J. D. Wacker

Learn the techniques you need to pose single portrait subjects, couples and groups for studio or location portraits. Includes techniques for photographing weddings, teams, children, special events and much more. $29.95 list, 8½x11, 128p, 80 photos, order no. 1722.

Photographic Lenses

PHOTOGRAPHER'S GUIDE TO CHARACTERISTICS, QUALITY, USE AND DESIGN

Ernst Wildi

Gain a complete understanding of the lenses through which all photographs are made—both on film and in digital photography. $29.95 list, 8½x11, 128p, 70 photos, order no. 1723.

The Art of Color Infrared Photography

Steven H. Begleiter

Color infrared photography will open the doors to an entirely new and exciting photographic world. This exhaustive book shows readers how to previsualize the scene and get the results they want. $29.95 list, 8½x11, 128p, 80 full-color photos, order no. 1728.

The Art of Photographing Water

RIVERS, LAKES, WATERFALLS STREAMS & SEASHORES

Cub Kahn

Learn to capture the dynamic interplay of light and water with this beautiful, compelling and comprehensive book. $29.95 list, 8½x11, 128p, 70 full-color photos, order no. 1724.

High Impact Portrait Photography

Lori Brystan

Learn how to create the high-end, fashion-inspired portraits your clients will love. Features posing, alternative processing and much more. $29.95 list, 8½x11, 128p, 60 full-color photos, order no. 1725.

Digital Imaging for the Underwater Photographer

COMPUTER APPLICATIONS FOR PHOTO ENHANCEMENT AND PRESENTATION

Jack and Sue Drafahl

This book will teach readers how to improve their underwater images with digital imaging techniques. This book covers all the bases—from color balancing your monitor, to scanning, to output and storage. $39.95 list, 6x9, 224p, 80 color photos, order no. 1726.

The Art of Bridal Portrait Photography

TECHNIQUES FOR LIGHTING AND POSING

Marty Seefer

Learn to give every client your best and create timeless images that are sure to become family heirlooms. Seefer takes readers through every step of the bridal shoot, ensuring flawless results. $29.95 list, 8½x11, 128p, 70 full-color photos, order no. 1730.

Photographer's Filter Handbook

Stan Sholik and Ron Eggers

Take control of your photography with the tips offered in this book! This comprehensive volume teaches readers how to color-balance images, correct contrast problems, create special effects and more. $29.95 list, 8½x11, 128p, 100 full-color photos, order no. 1731.

Beginner's Guide to Adobe® Photoshop®

Michelle Perkins

Learn the skills you need to effectively make your images look their best, create original artwork or add unique effects to almost image. All topics are presented in short, easy-to-digest sections that will boost confidence and ensure outstanding images. $29.95 list, 8½x11, 128p, 150 full-color photos, order no. 1732.

An interview with the creators of *Pokémon Omega Ruby* and *Pokémon Alpha Sapphire*

Pokémon Omega Ruby and *Pokémon Alpha Sapphire* are different types of games that have their original predecessors, and also add many brand-new elements. We had the creators share the behind-the-scenes of development with us.

From a deep understanding of the richness of the Hoenn region come two games where different values can exist together.

Pokémon Omega Ruby and *Pokémon Alpha Sapphire*
Producer
増田順一 JUNICHI MASUDA

Director
GAME FREAK inc.

Pokémon Omega Ruby and *Pokémon Alpha Sapphire*
Director
大森 滋 SHIGERU OHMORI

Game Director
GAME FREAK inc.

CAUTION

Many details of the game are discussed in these interviews and the design documents that follow. If you want to experience your game unspoiled, skip ahead to page 1 for now and come back to read this exclusive content after you've completed your adventure!

Exciting new adventures created with the energy of the young staff that brought it together

So we hear that *Pokémon Omega Ruby* and *Pokémon Alpha Sapphire* were developed with Mr. Masuda serving as producer and Mr. Ohmori serving as director, is that correct?

Masuda Yes, Ohmori is acting as director for the first time with these two games. I decided back on November 21, 2012 that we would appoint him as director while I would be the producer. That day was the 10th anniversary of the original *Pokémon Ruby* and *Pokémon Sapphire* being released in Japan. We chose that very special day to tell Ohmori, "We want you to be the director of these games."

Ohmori It was back when I was very busy working as the planning director for *Pokémon X* and *Pokémon Y*. I got called into a meeting room and asked if I wouldn't consider serving as director. I was so happy that I accepted at once, but when I thought things through, I remembered that I still wasn't finished with the development of *Pokémon X* and *Pokémon Y*. So while I had *Pokémon Omega Ruby* and *Pokémon Alpha Sapphire* lurking in the back of my head, I had to focus on first completing *Pokémon X* and *Pokémon Y*.

Masuda My job as the producer started with communicating my plans for the games and suggestions about team formation to Ohmori. The game plans included how to tie *Pokémon Omega Ruby* and *Pokémon Alpha Sapphire* to *Pokémon X* and *Pokémon Y*, and what these new games were like overall. Everything else, including the game's quality, we left in Ohmori's hands.

Ohmori As the director, I added my own ideas to Masuda's plans, and I was in charge of the direction for all of the features of these games, from the start of development until we reached master up. (Editor's note: "Master up" is what it is called in game development when the game is finalized and ready for production.)

Masuda Ohmori and I are just exactly 12 years apart in age, and the first products that he worked on when he joined GAME FREAK were the original *Pokémon Ruby* and *Pokémon Sapphire*.

Ohmori I was totally new to the work at that time, but I was entrusted with designing the Hoenn region map almost entirely on my own. So the layout of the Hoenn region was already ingrained in my mind. I was also in charge of the TV specs and the gameplay records specs that dealt with communication features. I was entrusted with so many different parts of the game that I completely lost myself in my work back then. I never even dreamed that I would be able to work as director on a project based on the games that held so many memories for me.

Mr. Masuda, can you explain why you chose Mr. Ohmori as the director?

Masuda One of the main reasons was my wish to have someone from a younger generation working as the director this time. I thought that the staff members like Ohmori, who had developed

Pokémon Ruby and *Pokémon Sapphire* and played it in depth, must have held a great many different feelings in those days—perhaps thinking that, "Actually if we changed this to be like that, the game would be even more fun!" That's why I wanted to build our project team from our younger staff, from the *Pokémon Ruby* and *Pokémon Sapphire* generation, and have them confront all those feelings and ideas. But I did also imagine that Ohmori would probably face some struggles, acting as director for the first time, so I did try to support him as much as I could. For example, I gave him everything I'd developed for the original *Pokémon Ruby* and *Pokémon Sapphire*, the worldview and settings and specs, back at the earliest stages of the development. And I told him about my feelings for Kyushu, the island which had been the basis for the Hoenn region.

Ohmori Even though I thought that I knew *Pokémon Ruby* and *Pokémon Sapphire* inside and out, when I read those 12-year-old specs that Masuda gave me, there were plenty of times when I realized for the first time the meaning behind different aspects. And I was really moved, thinking of how much I had grown and learned as well in the 12 years since I joined GAME FREAK. I could finally understand on a deeper level what Masuda had truly wanted to achieve as the director in the original *Pokémon Ruby* and *Pokémon Sapphire*. And so I began the development of *Pokémon Omega Ruby* and *Pokémon Alpha Sapphire* by taking the ideas that Masuda had wanted to make into reality back then, and adding to them my feelings of what I would've wanted to change back then.

Coexistence: a keyword that runs all through the game, and a world where different values can coexist

What did you want to express with *Pokémon Omega Ruby* and *Pokémon Alpha Sapphire*, Mr. Ohmori?

Ohmori *Pokémon Ruby* and *Pokémon Sapphire* were the first Pokémon games we made for the Nintendo Game Boy Advance system. The games until then had been released for the Game Boy, which generally had a monochromatic screen, and so I thought long and hard about what Masuda was trying to express back then on the Game Boy Advance, which was hugely different in the number of colors that could be used. One of the main themes of *Pokémon Ruby* and *Pokémon Sapphire* had been "abundance" or "richness." While delving further into what this "richness" was on my own, I was wondering about what concepts we think of nowadays when we think of abundance or

richness, and the idea of "coexistence" popped into my head. There is a kind of richness inherent in the idea that different values can coexist at the same time, and in people who hold different values accepting one another. I had this conviction that creating a world like that would bring us closer to a modern sense of this "richness," and so I made "coexistence" one of the principal ideas in these games.

Pokémon Ruby and *Pokémon Sapphire* included a lot of ways to play, including contests and the Secret Bases. That abundance of ways to play also matches quite well with the idea of different things existing together.

Ohmori Yes, that theme of coexistence is not just limited to the storyline. It's also reflected in the many different forms of gameplay. The Pokémon Contest Spectaculars and Super-Secret Bases are examples of that, as are other new features that capture that spirit of different things existing side-by-side, like the PokéNav Plus. We wanted to create a sense of "coexistence" through the synergy of how all these ways to play connect: how you can adventure around while checking out which wild Pokémon are nearby on the DexNav or learning about how other players' games are going on your BuzzNav.

Mr. Masuda, what kind of checks did you perform on the games that Mr. Ohmori was creating, and how often did you feel the need to do so?

Masuda Of course I did thoroughly check them out in the latter part of the development, but I really didn't check much during the rest of the development stages. Because if I did look at it, I'd start meddling all over the place. (Laughs) To be specific, I played through the whole build once, at about six months into development, and wrote up all the things I'd noticed in an email. I wrote, "These are the things I noticed, but it's up to you if you want to fix them or not," and I left the decisions to Ohmori.

Ohmori When I read that email from Masuda, I felt like I'd seen a whole other point of view and noticed a lot of things for the first time. Whether or not to fix them all ended up requiring discussion with the other staff members and consultation of the schedule. But in the end, we did implement all the suggestions that we thought would improve the game.

The difficulties of making a game based on another, and how these two overcome them

What did you feel, Mr. Masuda, when you got to play through the completed *Pokémon Omega Ruby* and *Pokémon Alpha Sapphire*?

Masuda I thought they were incredibly well done. I think you always worry a bit about a game that has a predecessor. After all,

the players all hold strong feelings about the originals. When an RPG that I played long ago is re-released, I also find myself hoping that the developers will be able to leave as much of what was so good about it originally still in it. Even something like rearranging the music slightly can seem jarring and incorrect. So what do you keep and what do you change? It's incredibly hard to make those considerations, but these games passed the test with flying colors. The whole team's attitude toward their creation was wonderful, and while I'm sure it must've been tough with just a year for creation time, I think they did a great job. I'm very pleased with it.

Mr. Ohmori, how do you feel hearing Mr. Masuda's words?

Ohmori Very happy. I don't normally get to hear that kind of praise directly. (Laughs)

Mr. Masuda spoke about the difficulty of making games based on previous games. We here creating the strategy guide also felt like this was a really multilayered game that could also be considered a new game.

Ohmori The most important thing to us when developing *Pokémon Omega Ruby* and *Pokémon Alpha Sapphire* was to reproduce the feelings that the originals inspired back in the old days. I was incredibly moved by seeing Pokémon move from being monochromatic to being expressed in full color. So how can I express to modern players the same kind of shock that I felt back then? I wanted to put that feeling of awe into *Pokémon Omega Ruby* and *Pokémon Alpha Sapphire*. How could I recreate the emotion that I felt when I first saw that colorful world filled with different Pokémon when we moved from working on the Game Boy to the Game Boy Advance? I kept thinking through how I could create these games without losing what was so good about the originals. One of my answers to this question was how you could come in contact with wild Pokémon. Encountering wild Pokémon that are right there in the field is an important feature for helping re-create in others the awe that I felt encountering wild Pokémon back then.

I asked Ohmori to be the director back on November 21, 2012. It was the 10th anniversary of the release of *Pokémon Ruby* and *Pokémon Sapphire*. —Junichi Masuda

When you're walking along routes or through caves, you'll be able to see pixel-art sprites of Pokémon if you set your lower screen to the DexNav, right? Your love for *Pokémon Ruby* and *Pokémon Sapphire* was really obvious there, too, Mr. Ohmori.

Ohmori Yes, we intentionally used the pixel art there. It creates a way for our players to visually compare the originals and these games. So if you're walking along a route, looking for a wild Pokémon, and you set your lower screen to the DexNav, you'll be able to see pixel art sprites of the Pokémon and the route. With a single glance, players will be able to see that, "Hey, it may have looked like this in the original Game Boy Advance games, but now it can be shown in these rich graphics on the Nintendo 3DS." I'd be happy if our players can really feel the evolution in terms of how well we can illustrate everything while they enjoy their adventures.

A DexNav that lets you encounter wild Pokémon while frolicking through nature

I'd like to ask for more details about the new features in *Pokémon Omega Ruby* and *Pokémon Alpha Sapphire*. For example, the DexNav makes it more fun to encounter wild Pokémon and helps support you in completing your Pokédex, right?

Ohmori The DexNav was developed from the idea that you could hear Pokémon's cries when walking around the field in *Pokémon Ruby* and *Pokémon Sapphire*. So when I would enter a forest, I would actually hear this cry coming from somewhere and feel the presence of other living things. I wanted to express that kind of atmosphere in the games. And to make it even more Pokémon-like, I wanted players to be able to instantly check what kind of Pokémon it is or other information about it in the Pokédex when they hear a Pokémon crying out. I hope that the players will get a taste for how it really feels to be out strolling about in natural areas.

From the new hidden Pokémon encounters in the field, you really get a better sense of the lives of these wild Pokémon that inhabit such natural environments.

Ohmori Such encounters really came about from *Pokémon Omega Ruby* and *Pokémon Alpha Sapphire*'s keywords of "richness" and "coexistence." That excitement you feel when catching wild Pokémon is even stronger when you use the searching functions on the DexNav.

And as you try to carefully sneak closer to a hiding Pokémon, you sometimes get so nervous that your fingers jerk too fast on that Circle Pad, huh? (Laughs)

Ohmori Yes, sometimes. (Laughs) We wanted to retain that heart-pounding thrill you get when you're about to encounter a

wild Pokémon, so we redesigned these hidden encounters countless times until we were satisfied with them. It was tough for us to figure out just how much information we should show, when we're expressing it in our games.

Masuda Yes, it's really hard to decide how to illustrate something like the encounters with the hidden Pokémon. If done poorly, the Pokémon would fail to look like they are real living and breathing creatures in the world, and that would be a complete 180 from our worldview that highly values Pokémon.

Ohmori We had to work with the nuances quite a bit so that we wouldn't give people that impression.

And encounters with wild Pokémon are a key part of the series, of course.

Masuda Stepping into the tall grass and meeting with wild Pokémon is the very basis of Pokémon. The idea of showing off just a glimpse of a wild Pokémon and having the player sneak up on them to get closer got great feedback as being "very fun" as a new way to meet wild Pokémon.

Ohmori You were able to meet a lot of different Pokémon in the Kalos region, which was the setting of *Pokémon X* and *Pokémon Y*. Now that our players have experienced that once, we needed to add some new idea to *Pokémon Omega Ruby* and *Pokémon Alpha Sapphire*. These games are set in the Hoenn region, and the different varieties of wild Pokémon that live there are limited when compared to the Kalos region. These new encounters were what we needed to help turn this weakness into a strength. Since the information that you can learn about wild Pokémon gradually increases each time that you encounter a Pokémon of the same species, the encounters themselves become more fun. You'll meet plenty of Pokémon like Zigzagoon and Poochyena, but thanks to that, those Pokémon might be hiding some amazing skills. We've designed these encounters with Pokémon in the field in the hope that our players will want to meet the various different Pokémon and learn more about them.

I think that you've made a lot of Pokémon fans' dreams come true by being able to climb atop Mega Latios or Mega Latias and Soar through the skies.

Ohmori That was Masuda's idea. He was certain that players would be happy about being able to Soar through the sky on the back of a Pokémon, and so he requested that we put it in the games without fail. Back in *Pokémon Ruby* and *Pokémon Sapphire*, there was a feature where you could explore deep under the sea. In *Pokémon Omega Ruby* and *Pokémon Alpha Sapphire*, the world is expressed in even more dimensions: with the land and the sea, and now the sky above as well. Since the Hoenn region already existed, it was very easy to imagine

climbing astride a Pokémon and soaring over it, and very easy to design as well. When you Soar, you discover that there are places you can't reach just by walking or traveling across the water. We wanted to show that the Hoenn region has even more to it than what everyone already knows.

Were there any particular locations that you really wanted people to see from the sky?

Ohmori What we wanted to show was the view that you could never see except from the sky. I hope that players will fully enjoy all the pleasures that soaring through the sky has to offer them: gazing down at familiar towns and routes from above, for example, or chasing after the wild Pokémon that fly through the skies. We definitely want them to find the Mirage spots where Pokémon from the National Pokédex appear and legendary locations where Legendary Pokémon can be caught, and to search out the secret places that can't be found in any way but by soaring through the sky. We hope that players will discover Mirage spots and tell their friends about them, sharing them through StreetPass. In that sense, the Mirage spots are also another communication tool that you can use to enjoy your game together with other players.

I was surprised when I saw the Cosplay Pikachu, thinking, "Are they really going to change the image off such a hugely popular character?!"

Masuda We had the idea of a Cosplay Pikachu as far back as during *Pokémon X* and *Pokémon Y*'s development, but it seemed perfect for the Pokémon Contest Spectaculars in these games, so we decided to include it in *Pokémon Omega Ruby* and *Pokémon Alpha Sapphire*. Many people told me that they were surprised, but my thinking was actually the opposite. Pikachu is a character known by people all around the world, and they would still recognize it as Pikachu even if it changed its appearance in different ways. I felt more secure about any chances that it might be misunderstood in some way than I would have if it were some new kind of Pokémon. I think that's a strong point that only Pikachu could bring to this character.

Ohmori In truth, we thought of a lot of different ideas for the cosplaying, and we tried out other kinds of Pokémon as well, but we decided that the idea would be more effective if we just focused it on Pikachu and so it ended up as you see it now. However, we did create five different outfits, since the goal was

not to simply add new variations of Pikachu, but to sync up with the Pokémon Contest Spectaculars in this world. We recommend that you put Cosplay Pikachu in your party and enjoy taking it on your adventure, though, and not just limit your fun with it to the Contest Spectaculars. Since its moves change based on which outfit it is wearing, your adventure will have extra excitement.

The Pokémon Contest Spectaculars in these games are based on the contests in *Pokémon Ruby* and *Pokémon Sapphire*, but the way you play them and the strategies have changed a lot, haven't they?

Ohmori We've overhauled the Contest Spectaculars to make them easier for kids nowadays to play. We made it easier to make Pokéblocks, and lowered the importance of using move combos. In the original contests, if you knew a combo, you could win—and if you didn't know any, you couldn't win. But we've changed it so that contests can be played through a bit more simply. So we hope that even more people will enjoy Pokémon Contest Spectaculars.

Super-Secret Bases where you can connect to other players around the world

And there are new characters as well, like Lisia and Aarune.

Ohmori *Pokémon Omega Ruby* and *Pokémon Alpha Sapphire* have a lot of different ways to play crammed into them, more than just adventuring around and completing your Pokédex. To make it easier to understand the appeals of these different features, we included characters to serve as guides. For Super-Secret Bases, that character is Aarune, and for Pokémon Contest Spectaculars, we have Lisia. Lisia is an especially important figure. She gives you a clear goal to work toward: "It would be pretty sweet if I could become more popular than Lisia in Contest Spectaculars."

We want to recreate the kinds of feelings that *Pokémon Ruby* and *Pokémon Sapphire* inspired. So we tried to express the same sense of wonder today as the games held back then.
—Shigeru Ohmori

In *Pokémon Omega Ruby* and *Pokémon Alpha Sapphire*, the Super-Secret Bases should really get people excited as a way to communicate with others, shouldn't they?

Ohmori Yes, back in the time of *Pokémon Ruby* and *Pokémon Sapphire*, you could connect with friends by connecting your Game Boy Advances with a special link cable made just for that purpose. But these games can exchange data over the Internet and now the Super-Secret Bases of other players from around the world may appear in your game, and the information from other players from around the world may be broadcast on your BuzzNav.

The way that you can make your own secret team in your base brings back the kind of games we would play as children.

Ohmori You can have the characters that you meet in other player's Super-Secret Bases join you to form your own team. And now your team members can use special skills, which will make you want to visit your own Super-Secret Base over and over again. These special skills have some handy effects, and each member of your team can use them. It's the kind of setup that might end up with you running into your friend at school later and saying, "Boy, you really helped me out [in my game] yesterday!" And you can create a QR Code for your Super-Secret Base and share it with others, so we hope players will enjoy interacting with others even from far away.

The deep connections between *Pokémon X* and *Pokémon Y*, and *Pokémon Omega Ruby* and *Pokémon Alpha Sapphire*

I also felt like it was quite significant that the two pairs of games, *Pokémon X* and *Pokémon Y* and *Pokémon Omega Ruby* and *Pokémon Alpha Sapphire*, allow you to collect all the Pokémon needed to complete the National Pokédex. It's really strong motivation to complete the National Pokédex.

Masuda Well, we needed to put particular work into the settings for the locations that Legendary Pokémon would appear in and how they would appear, and so that was something we were always concerned about. A lot of Legendary Pokémon were to appear in these games, so I thought that there must be this great power in the Hoenn region that would make all these mysterious phenomena and the appearance of so many Legendary Pokémon make sense. The idea that the Legendary Pokémon are on these lands that you can only arrive on by soaring through the sky on the backs of Mega Latios or Mega Latias has some weight for convincing players, and I think it was made in a way that really keeps the dreams alive. *Pokémon Omega Ruby* and *Pokémon Alpha Sapphire* may be based on the original games, but they were designed so that even someone playing Pokémon for the first time would be able to enjoy them fully. There is an equality between *Pokémon X* and *Pokémon Y* and *Pokémon Omega Ruby* and *Pokémon Alpha Sapphire*, so there is no problem with someone first playing *Pokémon Omega Ruby* and *Pokémon Alpha Sapphire,* and then going back and playing *Pokémon X* or *Pokémon Y* to complete their Pokédex. In short, *Pokémon X* and *Pokémon Y* and *Pokémon Omega Ruby* and *Pokémon Alpha Sapphire* can exist in parallel: a kind of coexistence. We hope that people can get a game from both pairs and enjoy them in a variety of ways.

GAME FREAK has been developing Pokémon games at a pretty high pace these past few years, pretty much releasing a new entry each year. What allows you to create Pokémon games at this high pace?

Masuda Luckily we are blessed with an excellent staff at GAME FREAK. I may work as the director on a completely new game, like *Pokémon X* and *Pokémon Y*, but I can feel safe leaving sequels in the hands of other directors. With *Pokémon Black 2* and *Pokémon White 2*, that was Takao Unno, and with these games, we had Ohmori here as the director. To leave everything up to another director is really to believe that it is best for them to make the game they want to make. The responsibility may go to the director, but you also create an environment where they can develop the game freely. And you hope that the team members rally around these directors, pour their utmost energy into the project, and make a fine game. Developing games at a high pace becomes a battle [of pace versus] quality. The more time you spend, the higher the quality becomes, but you begin to feel doubts: like, if we were to spend three years on the next games, would that really fit with the speed of the modern world? We're always thinking that we want to release new games with the right timing: when players want to play them. To frame it another way, though, if we decide that we have just one year to

I think many people will be surprised by Cosplay Pikachu, but it is actually easier to try out something new because it's a character everyone knows. —Junichi Masuda

develop a new game, it's easier to say, "We'll change this, and leave this as it is" and decide on improvements. And then we do our best on what we can do in that one year.

I suppose it must have been necessary to have *Pokémon X* and *Pokémon Y* and *Pokémon Omega Ruby* and *Pokémon Alpha Sapphire* releases just about a year apart, since they are meant to coexist.

Masuda Yes, that's right. We have the strong hope that everyone will complete their National Pokédexes using these two entries in the series. And of course *Pokémon X* and *Pokémon Y* are set in the Kalos region, inspired by France, while *Pokémon Omega Ruby* and *Pokémon Alpha Sapphire* are set in the Hoenn region, based on Japan's Kyushu. Just as is true of Japan and her relationships with other countries, within Pokémon as well, we want players to feel that these various worldviews coexist together in parallel.

How would you like to see the players enjoying *Pokémon Omega Ruby* and *Pokémon Alpha Sapphire*?

Masuda These are interesting games—a fusion of so many things, including nostalgia and newness. We've made them into deep games that can also answer to the needs of those who want to experience rich gameplay, and not just games to be picked up when you want to pass a bit of time.

Ohmori There is a big difference in the storyline between *Pokémon Omega Ruby* and *Pokémon Alpha Sapphire*. I'd love it if people end up talking with their friends about these differences and enjoying debating them as they play. There are also many mysteries in the games that can only be understood after a careful reading. If people are able to enjoy playing the games for a long time, that would be my joy as a developer.

Pokémon X and *Pokémon Y* and *Pokémon Omega Ruby* and *Pokémon Alpha Sapphire* all share a sense of coexistence, so players can start playing from any of them.

—Junichi Masuda

Main Character (male)

‹Summary› This is the male main character. He wears his Mega Bracelet, fitted with a Key Stone, on his left arm. And while he may clutch a Poké Ball in his left hand, he throws it with his right. Check out the gallant-looking side view and how super functional his Bag design looks.

Main Character (female)

1 Mega Bracelet (a gift from Steven)

‹Summary› This is the female main character. She wears her Mega Bracelet on her left arm, just as the male main character does. She uses a favorite fanny pack, slung about her hips, as her Bag. You can see all the details of her hairstyle, thanks to the front, back, and side-angle views.

Main character (male) in Pokémon Contest Spectacular costume

1 Mega Bangle

2 Has a clasp on the back side

Summary This is the main character in the suit that he wears for Pokémon Contest Spectaculars. From its collar to its sleeves, belt, boots, and accessories, the design is full of sharp angles and gives off a wild masculine air.

Main character (female) in Pokémon Contest Spectacular costume

1 Dangles

2 These are culottes.

Summary This is the main character in the dress that she wears for Pokémon Contest Spectaculars. Her dress, of course, and her ribbons, ruffles, and flaring skirt are all bursting with girlish glamour and cuteness.

Lisia

1 Left hand held up in front of the tiara

2 This will be the set pose for the idol character, which we'll make later (also the same as the one used in battle art)

3 Heels of shoes are wedges

4 "Oh, Contests are really…!"

5 When set in her hair, the curved bits are hidden

6 Mega Stone (sic) can be taken out

7 Earrings are made of the same material

8 Stone can be easily swapped into whichever of her tiaras she likes

Summary The Contest Star Lisia was designed with plenty of different lively expressions, as you'd expect of a star. Her very elaborate outfit and the design of her tiara are also worth checking out. The tiara is even fitted with a Key Stone.

Aarune

1 "Forward! To wherever the secret path leads!"

2 Indent

3 Ragged sleeve

Summary Aarune is a wandering vagabond chasing his dreams. He was once a top Pokémon Ranger in the Unova region. After living a migrant lifestyle for so long, his clothes have grown frayed around their hems. Check out the amazing sketch of his discovering a Secret Base together with his Flygon.

Roxanne

1 There is a line in the middle of her necktie, but it is not actually split

⟨Summary⟩ Roxanne, the Gym Leader of Rustboro City, is drawn very neatly in the style of a well-brought-up young lady. You can see the care and detail put into her blouse, skirt, necktie, and ribbons here, even if they aren't visible in the game.

Brawly

1 Underside of shoes

⟨Summary⟩ Check out how Brawly, the Gym Leader of Dewford Town, was designed with a ripped physique to fit with his Gym settings and the cave he frequents. His well-developed muscles are obvious even through his sporty clothes.

Wattson

Summary The Mauville City Gym Leader Wattson is easily recognized by his large, round belly wrapped in a bright yellow jumpsuit. His short-sleeved shirt is also designed to include an Electric-themed pattern.

Flannery

Summary Flannery, the Gym Leader of Lavaridge Town, easily catches the eye with her wild hairstyle and bright red locks. The "belt" she uses to hold her pants up is also a hand towel, and can be used to wipe away sweat. It's just the sort of trick you would expect from a Fire-type Gym Leader.

1 Back of tracksuit jacket

Summary The Gym Leader of Petalburg City, Norman, is the main character's father. He is often drawn with his arms crossed in front of him. The posture captures how baffling and yet inspiring he finds it to be challenged to a Pokémon battle by his own child. He is the only Gym Leader who wears traditional geta sandals.

Summary Winona is the Gym Leader of Fortree City, and you can see both the front and rear designs of her pilot costume in these sketches. Her hat, back, sleeves, pant legs, and even her shoes all have a wing-themed treatment, a symbol of her Flying-type affiliation.

Liza and Tate

1 Tate's design is the mirror image

◀ Summary ▶ Liza and Tate together serve as Gym Leaders of Mossdeep City, and their costumes match, just as you would expect from a pair of twin Gym Leaders. The color of the stars adorning their suits and the location of the designs on their pants are all symmetrical.

Wallace

1 Wears bracelets on this arm as well

2 "Cape" is attached right above the shoulders

◀ Summary ▶ You may find your eyes captured by the audacious costume of the Gym Leader of Sootopolis City, Wallace. The design brings to mind flowing water, and you'll notice how it shows off his well-trained torso. The three sets of white bracelets he wears on each arm are also quite distinctive.

Maxie

1 Opposite side of glasses just has an indentation

2 Mega Glasses

⟨ Summary ⟩ Maxie, the leader of Team Magma, has a very calm and collected personality, so his face shows little expression. The Mega Glasses that he wears were designed in great detail, and you can see all their particulars revealed here at last. His Key Stone is fitted into the left arm of his glasses, but it can be swapped into the right arm as well.

Archie

1 Height: 5'7"

2 His mega-rage state is enough to put even the Admins in a state of utter fear (not the kind of anger that makes you yell, "You scum!", but rather just a delighted shout)

3 Not a scar, but shadows that never lift

4 Rigging (shroud)

5 Sailcloth

6 Mega Anchor

⟨ Summary ⟩ The black lines you see on the face of Archie, Team Aqua's leader, are not scars but rather dark shadows. He gets worked up about things quite easily, and you can even see a sketch of his face when it is positively red with rage. His Key Stone is set in the Mega Anchor he wears around his neck.

Wally

1 Wally sketches

2 He's about this tall.

3 Wally's Mega Necklace (sic)

4 He made it himself.

5 Wood

6 About half of the stone is set inside.

7 Shaped like Gallade

◀ Summary ▶ The key thing to notice about Wally is the difference between his regular expression and his expression during your final battle against him. He normally looks quite innocent, but when you face him for the last time, he shows an intense expression worthy of a Pokémon Trainer. He has a Key Stone set in the pendant he wears.

Steven

1 "Megaaa!"

2 Wears a vest under his jacket

3 No lines here to break the different colored parts.

4 Width is uniform.

5 Line ends right here

6 Had one line

7 Line ends right here

8 Lines are visible from the pleats in the center of both the front and back of the legs. (The end is just about at the hem of his jacket.)

9 Idea is that these meet up to and are attached to the cuffs of his suit.

10 Illustration of inner wear

11 Vest has a line that extends down from the armpit

12 The back view, left and right. Has no pockets.

◀ Summary ▶ The Champion, Steven, likes to wear metal accessories that don't just show off stones but also metals—and namely steel. The sleeves of his suit and the rings he wears on his hands are all illustrated in great detail. He wears a Key Stone in the Mega Stickpin that adorns his jacket's lapel.

 For more Game Freak Concept Art, see the *Pokémon Omega Ruby* and *Pokémon Alpha Sapphire: The Official National Pokédex,* available March 2015.

THE OFFICIAL HOENN
REGION STRATEGY GUIDE

TABLE OF CONTENTS

Article Index

TRAINER HANDBOOK

ADVANCED HANDBOOK

ADVENTURE DATA

How to Register Pokémon in the Hoenn Pokédex

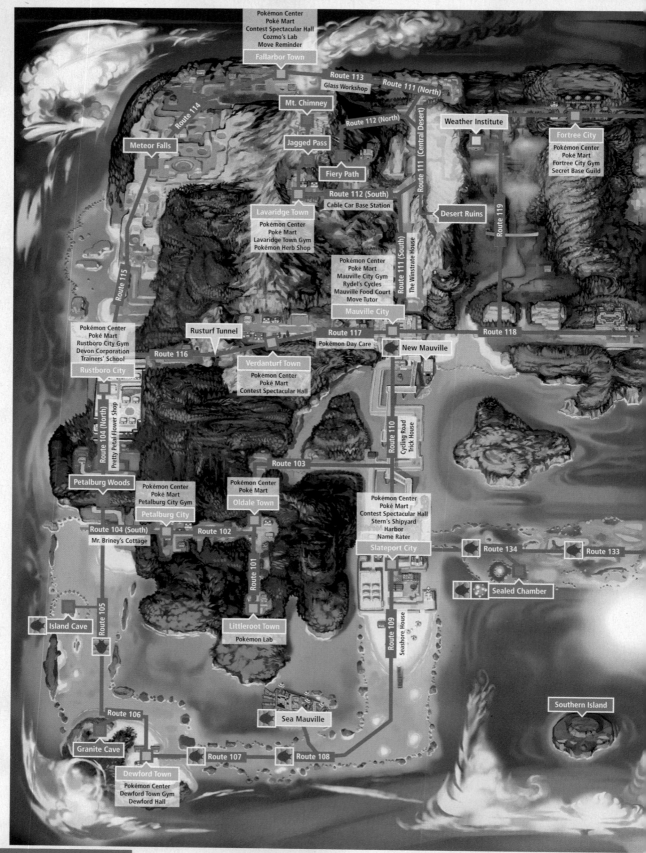

Pokémon OMEGA RUBY / Pokémon ALPHA SAPPHIRE

Hoenn Region Map

Fallarbor Town
Pokémon Center
Poké Mart
Contest Spectacular Hall
Cozmo's Lab
Move Reminder

Route 113
Glass Workshop

Route 111 (North)

Route 114

Mt. Chimney

Weather Institute

Route 112 (North)

Fortree City
Pokémon Center
Poké Mart
Fortree City Gym
Secret Base Guild

Meteor Falls

Jagged Pass

Route 111 (Central Desert)

Fiery Path

Route 112 (South)

Desert Ruins

Route 119

Cable Car Base Station

Route 115

Lavaridge Town
Pokémon Center
Poké Mart
Lavaridge Town Gym
Pokémon Herb Shop

Route 111 (South)

The Winstrate House

Pokémon Center
Poké Mart
Mauville City Gym
Rydel's Cycles
Mauville Food Court
Move Tutor

Mauville City

Rusturf Tunnel

Route 117

Route 118

Pokémon Center
Poké Mart
Rustboro City Gym
Devon Corporation
Trainers' School

Pokémon Day Care

New Mauville

Route 116

Verdanturf Town
Pokémon Center
Poké Mart
Contest Spectacular Hall

Rustboro City

Route 104 (North)

Pretty Petal Flower Shop

Route 110
Cycling Road
Trick House

Route 103

Petalburg Woods

Pokémon Center
Poké Mart

Pokémon Center
Poké Mart
Petalburg City Gym

Oldale Town

Pokémon Center
Poké Mart
Contest Spectacular Hall
Stern's Shipyard
Harbor
Name Rater

Petalburg City

Route 104 (South)
Mr. Briney's Cottage

Route 102

Slateport City

Route 134

Route 133

Route 101

Sealed Chamber

Route 105

Route 109
Seashore House

Island Cave

Littleroot Town
Pokémon Lab

Route 106

Southern Island

Sea Mauville

Granite Cave

Route 107

Route 108

Dewford Town
Pokémon Center
Dewford Town Gym
Dewford Hall

This is the map of the Hoenn region, where your adventure awaits. All of the cities, towns, routes, caves, and other important places are shown. Routes are labeled in red, towns and cities in orange, caves or naturally occurring locations in purple, and man-made facilities and buildings in yellow.

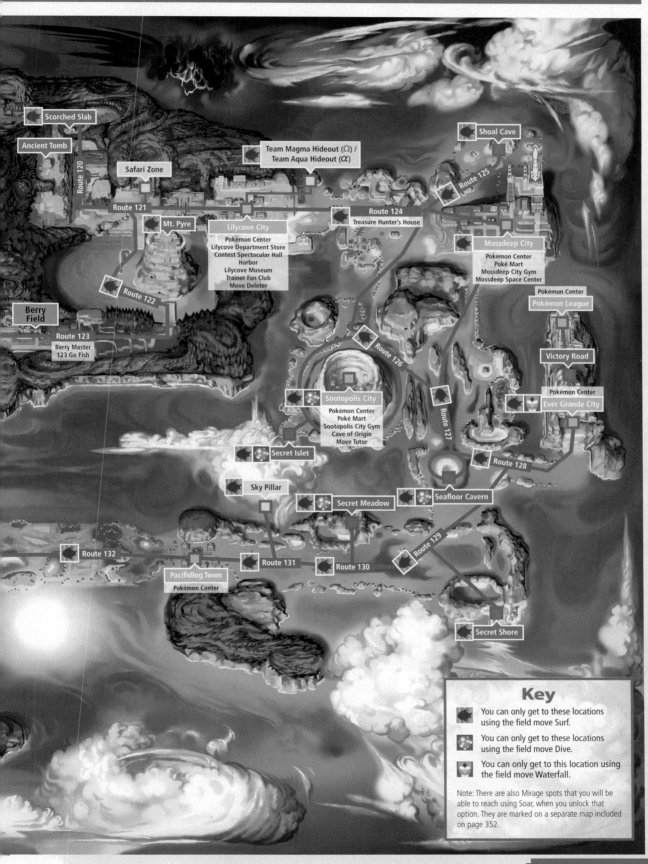

Scorched Slab

Ancient Tomb

Route 120

Safari Zone

Route 121

Team Magma Hideout (Ω) /
Team Aqua Hideout (α)

Shoal Cave

Route 125

Route 124

Treasure Hunter's House

Mt. Pyre

Lilycove City
Pokémon Center
Lilycove Department Store
Contest Spectacular Hall
Harbor
Lilycove Museum
Trainer Fan Club
Move Deleter

Mossdeep City
Pokémon Center
Poké Mart
Mossdeep City Gym
Mossdeep Space Center

Pokémon Center
Pokémon League

Route 122

Berry
Field

Route 123
Berry Master
123 Go Fish

Route 126

Victory Road

Pokémon Center
Ever Grande City

Route 127

Sootopolis City
Pokémon Center
Poké Mart
Sootopolis City Gym
Cave of Origin
Move Tutor

Secret Islet

Route 128

Sky Pillar

Secret Meadow

Seafloor Cavern

Route 129

Route 132

Route 131

Route 130

Pacifidlog Town
Pokémon Center

Secret Shore

Key

You can only get to these locations using the field move Surf.

You can only get to these locations using the field move Dive.

You can only get to this location using the field move Waterfall.

Note: There are also Mirage spots that you will be able to reach using Soar, when you unlock that option. They are marked on a separate map included on page 352.

WELCOME TO THE WORLD OF POKÉMON!

The Pokémon world is a world much like our own, filled with people young and old who are going about their daily lives. But the lives of these lucky people are made much more thrilling by the fantastic creatures that share their world: Pokémon! Pokémon come in all shapes and sizes, and in the wild they fill the forests, caves, seas, and skies of this world.

There are many distinct regions in the Pokémon world, each with its own unique Pokémon native to it. *Pokémon Omega Ruby* and *Pokémon Alpha Sapphire* are set in the Hoenn region, a subtropical island region filled with sunshine and sparkling seas. You've just moved to the Hoenn region from nearby Johto because your father—a renowned Pokémon Trainer—got a new gig as one of the Hoenn region's Gym Leaders. He's making quite a name for himself!

So what is a Pokémon Trainer? Anyone can become a Trainer—they just need to have a Pokémon of their very own to care for. You might be given your first Pokémon, but you will also be able to try to catch any of the Pokémon you meet in the wild and add them to your team!

Become a great Trainer!

Despite your dad's passion for Pokémon training, you never really got into it before you moved to the Hoenn region. But a few special encounters soon have you following in your father's footsteps. After using a Pokémon in battle, you suddenly realize how exciting it can be to have a partner of your own. Setting off on your very own journey—like all new Pokémon Trainers do—you'll help your chosen partners grow into fantastic Pokémon as you experience the world together!

Complete your Pokédex!

Lucky Trainers are sometimes chosen to help contribute to the Pokédex. The Pokédex is a device that collects data on all of the wild Pokémon found in a region and adds it to an ever-growing database. Each time you spot a new Pokémon species, its name and appearance are automatically added to your Pokédex. When you successfully catch a new Pokémon species, your Pokédex helps you learn everything there is to know about it! Try to catch them all and help Professor Birch on his quest to record the Pokémon distribution in the Hoenn region.

Take on the Pokémon League!

Being a Pokémon Trainer isn't just about traipsing through the wilds to find and catch new Pokémon. Trainers also battle one another to help their bonds with their Pokémon grow stronger by learning how to understand one another. Trainers thrive on the thrill of friendly competition, and they can also learn a lot about each other by the strategies they use in Pokémon battles. Most Trainers aim to measure themselves against the Pokémon League and see how far they can take their bid for the region's Championship!

The Pokémon League

The Pokémon League organizes all official Pokémon battle competitions, allowing Trainers to prove themselves by battling to become the top of their regional League—a real Pokémon League Champion! But before you can earn the right to battle for the Champion's seat, you must first prove yourself through several levels of competitive battling.

The Gyms' Leaders

Most major cities and even some towns in a region contain a Pokémon Gym. These facilities provide a place for aspiring Trainers to learn and grow. A strong Trainer will be appointed Gym Leader—much like how your dad was named the Leader of the Petalburg City Gym! Other strong Trainers fill the Gym, hoping to learn from the Leader or to one day replace him or her. Defeat the Leader of a Gym, and he or she will award you with a Gym Badge as proof of your skill as a Trainer!

The Elite Four

Once you've gained eight Gym Badges by beating Gym Leaders all over Hoenn, you'll have earned the right to challenge the Elite Four, a group of four masterful Trainers that stand above even the toughest Gym Leaders. They are some of the strongest Trainers in the region, and they await you at the end of the brutal gauntlet known as Victory Road. You receive no Badges for defeating the Elite Four one after another—instead, you earn the right to challenge the Pokémon League Champion!

The Pokémon League Champion

At the top of the Pokémon League stands the Champion: the one Trainer designated as the region's most capable. If you can manage to defeat him or her in battle, your name and your team of Pokémon will be recorded forever in the Hall of Fame, and you'll also be recognized as a Champion of the region. It may seem like your adventure is over when you become Champion, but the adventure never really ends in the world of Pokémon. Even greater Trainers still wait to battle you, both within your game and in the real world!

TIP

The above may sum up your goals in the game, but the world of Pokémon extends far beyond your screen. One of the best parts of playing Pokémon is connecting with other players. You'll be able to trade Pokémon with other players (p. 41), battle with friends or even random opponents (p. 41), challenge friends to Pokémon Contest Spectaculars, visit each other's Secret Base (p. 112), and even take part in international competitions (p. 415). Explore these numerous communication features to experience all your game has to offer!

GAME DIFFERENCES

Two games, two teams

Although they each cover a similar adventure in the Hoenn region, *Pokémon Omega Ruby* and *Pokémon Alpha Sapphire* are two separate games that feature different foes and different Pokémon, some of which can only be caught in one game or the other.

Pokémon Omega Ruby Ω

In *Pokémon Omega Ruby*, Maxie, Team Magma's Leader, wishes to increase the world's landmass over the ocean and give mankind more space to develop and grow.

Pokémon Alpha Sapphire α

In *Pokémon Alpha Sapphire*, Archie, Team Aqua's Leader, seeks to raise the world's oceans over the landmass to wash away man's influence and create a world where Pokémon can flourish.

Different Pokémon

In your game, you will encounter one of two super-ancient Pokémon. Which one you encounter will depend on the game you are playing. These are not the only two Pokémon that are exclusive to the different versions, though. To get every last Pokémon, trade with friends who have the opposite game from you, or find trade partners around the world (p. 41)!

***Pokémon Omega Ruby*–exclusive Pokémon (Ω):** Seedot, Nuzleaf, Shiftry, Mawile, Minun, Zangoose, Solrock, Latios, Groudon, Kabuto, Ho-Oh, Shieldon, Palkia, Throh, Archen, Tornadus, Reshiram, Skrelp

***Pokémon Alpha Sapphire*–exclusive Pokémon (α):** Lotad, Lombre, Ludicolo, Sableye, Plusle, Seviper, Lunatone, Latias, Kyogre, Omanyte, Lugia, Cranidos, Dialga, Sawk, Tirtouga, Thundurus, Zekrom, Clauncher

Complete the National Pokédex!

When combined with *Pokémon X* and *Pokémon Y*, *Pokémon Omega Ruby* and *Pokémon Alpha Sapphire* now make it possible to catch every Pokémon necessary to complete the National Pokédex! Every last common Pokémon and Legendary Pokémon from the first six generations can be obtained with these four games, so catch as many as you can, and trade with other players to get the ones that aren't available in your games.

TIP

There are exceedingly rare Pokémon known as Mythical Pokémon, which can only be obtained through special events. It's not necessary to catch Mythical Pokémon to complete your National Pokédex, but you'll definitely want to grab them for yourself if the chance comes up. Stay tuned for new Holo Clips on your PSS's Holo Caster (p. 401), which will tell you about upcoming distributions and events. You can also check the official Pokémon website, www.pokemon.com!

MENUS AND SETTINGS

The following pages will help explain some of the screens and menus that you'll see in the game. First up is the main menu, though not all of the options illustrated below may be available at the beginning of your game. Don't worry, they will be unlocked as you progress through the beginning of the game. Press ⊗ at any time during your journey to call up the main menu on the Touch Screen. You'll get a lot of use out of this menu!

Main menu functions

TIP

See the small icons beside each menu option? They also appear at the bottom of the touch screen whenever you have the PokéNav displayed. You can tap the small icons there to go directly to any of these sub-menus without needing to open the main menu.

1 Pokémon

View the Pokémon that are currently traveling with you in your party. You can also access detailed info about each of them.

2 Pokédex

Access your Pokédex: a device that automatically records Pokémon data, including how many you've seen and caught, and where Pokémon can be found.

3 Bag

All of the items you've collected are kept in your Bag. Open it to view and use the items inside.

4 Trainer Card

Check how far you've come as a Trainer. You can see which Gym Badges you've obtained and lots of other useful data about your character. It displays your character name.

5 Save

Tap here to save your game. Make sure to save often, because there is no auto-save feature!

6 Options

Adjust the gameplay options to your liking, including text speed, battle effects, and more.

Pokémon menu functions

Press Ⓧ to open the main menu, and then select "Pokémon" to access the Pokémon menu. Select a particular Pokémon to call up the following options:

Summary: Shows where you caught the Pokémon, its moves, its stats, and more.

Use a move: Lets your Pokémon use a field move if it has learned one, such as Surf or Rock Smash.

Restore: Lets you restore your Pokémon's HP or heal its status conditions with items kept in your Bag.

Item: Lets you give a Pokémon an item to hold, or take away its held item, as well as using items or TMs on your Pokémon.

Switch: Move a Pokémon around in your lineup. The top-left Pokémon is the first Pokémon and the top-right Pokémon is the second Pokémon to join the battle.

TRAINER HANDBOOK

Pokémon Data under "Summary"

From the Pokémon menu, choose Summary to view a Pokémon's info. There are three separate pages of info.

1. Stats and Learned Moves

The top screen shows the Pokémon's stats, types, Ability, and more. The lower screen shows the moves it knows, and pressing Ⓐ will display a description of its moves on the top screen.

2. Contest Info

The top screen displays how Cool, Beautiful, Cute, Clever, and Tough your Pokémon are. The lower screen displays which of these conditions your Pokémon's moves will show.

3. Trainer Memo and Ribbons

The top screen shows the Pokémon's Nature, Characteristic, and more. The lower screen shows any Ribbons it has earned or been given.

ADVANCED HANDBOOK

ADVENTURE DATA

Bag menu functions

Press Ⓧ and select "Bag" to access the Bag menu. All of the items you collect during your journey are stored in your Bag. Your Bag has five Pockets (Items, Medicine, TMs & HMs, Berries, and Key Items), and anything you collect is automatically placed in the correct Pocket.

Items: Stores items for Pokémon to hold, Evolution stones, and more.

Medicine: Stores items that restore HP/PP or cure status conditions.

TMs & HMs: Stores Technical Machines & Hidden Machines, special items that can be used to teach your Pokémon moves.

Berries: Stores Berries you obtain on your journey.

Key Items: Stores important items acquired on your journey, like Bikes and the Dowsing Machine.

TIP

You can sort the items in each Pocket of your Bag by tapping the third icon from the right on the bottom of the Touch Screen, which resembles two arrows chasing each other.

Saving menu functions

Press Ⓧ and select Save to access the Save menu. The Save menu lets you save your data when you want to take a break from playing *Pokémon Omega Ruby* or *Pokémon Alpha Sapphire*. The Save menu appears when you choose to save your data and shows some of the main details about your game, including the Pokémon that are currently traveling in your party, the number of Gym Badges you've collected, and more.

TIP

Saving is important, but rest assured that you can never truly "lose" when playing Pokémon. Even if all your Pokémon are defeated in battle, you'll rush off to the nearest Pokémon Center or healing spot, restore your Pokémon, and be ready for more adventuring!

Good Times to Save

Before battling a Gym Leader

It doesn't hurt to save before battling a Gym Leader. If you forget to save before the battle and then you end up losing, you'll have to navigate the Gym again.

Before battling the Elite Four

It's an equally good idea to save the game before battling the Elite Four in the Pokémon League. Save your data before entering any of the private chambers of the Elite Four.

Before trying to catch a valuable Pokémon

When you know you're about to face a rare Pokémon, it's a good idea to save the game before trying to catch it. That way, if you unluckily make the Pokémon faint, you can easily try again.

Deleting saved data

If you want to delete your saved data and start the game over, press and hold Ⓑ + Ⓧ while simultaneously pressing and holding Up on the +Control Pad while on the title screen. You can't restore your data after you delete it, so be very sure it's what you want to do before deleting it.

Options menu functions

Press ⊗ and select Options to access the Options menu. This lets you adjust game settings to suit your preferences, making it easier to play. For instance, if the game text scrolls too slowly, you can increase the speed. If there's a game feature you want to change, open the Options menu and adjust it to your preference. You have access to the options below.

Text Speed: Choose from slow, normal, or fast text speeds to affect how quickly messages appear on the screen.

Battle Effects: Choose whether you want to see animations when Pokémon use their moves and when they are affected by status conditions.

Battle Style: When you defeat one Pokémon on a team, you'll be asked whether you want to switch your own Pokémon when your opponent sends out his or her next team member. If you want to automatically stay with your current Pokémon, select Set to stop being asked this question.

Button Mode: You can disable Ⓛ and Ⓡ, or set Ⓛ to function as Ⓐ for easier one-handed gameplay. This also disables Ⓡ.

Forced Save: Choose whether or not you must save before PSS battles and other communication features.

PokéNav Plus

PokéNav Plus is a new feature in *Pokémon Omega Ruby* and *Pokémon Alpha Sapphire*. This multipurpose menu appears on the Touch Screen as you play. As your adventure continues, you'll unlock more and more fun features that you'll be able to use just by tapping the Touch Screen at any time. Each new feature will be explained in the walkthrough when it becomes available.

Using StreetPass

A number of game functions in *Pokémon Omega Ruby* and *Pokémon Alpha Sapphire* take advantage of your system's StreetPass feature, using it to swap data with other players that you pass by. The first time you open the BuzzNav app (p. 61), you're asked if you want to activate StreetPass—go ahead and choose to enable it at that time. If you choose not to enable StreetPass right away, but decide to enable it later, tap the icon on the BuzzNav screen that looks like a blue folder. You'll then be prompted to activate StreetPass again.

TIP

For Parents: The StreetPass function exchanges data between systems, such as the location and layout of a player's Secret Base (p. 112) in the game, data about their progress in the game through the BuzzNav app's shows (p. 61), and brief messages that players can input on the PSS (p. 401). If you wish to disable StreetPass or any other communication features, please refer to your Nintendo 3DS or Nintendo 2DS Operations Manual.

UNDERSTANDING THE BATTLE SCREEN

Once you've sent a Pokémon into battle, the top screen displays your Pokémon and the opposing Pokémon, while the Touch Screen displays all of the options available to you during the battle.

TRAINER HANDBOOK

ADVANCED HANDBOOK

ADVENTURE DATA

Top screen

All of the relevant information regarding the Pokémon that you're currently battling is shown in the top screen's top-right corner. Its name, level, and HP are clearly visible, as is its gender if it has one. If you're battling a Trainer, a number of Poké Balls equal to the number of Pokémon in the Trainer's party is also displayed. Meanwhile, this same information on your party is displayed in the lower-left portion of the top screen.

TIP

The Poké Balls representing your Pokémon may sometimes appear in different colors. A yellow Poké Ball indicates a Pokémon that is currently under the effects of a status condition, while a grayed-out Poké Ball represents a Pokémon that has fainted. This is a handy way to quickly see how many of your team members are fully ready to participate in battle!

Touch Screen

The Touch Screen is where you control the action during a battle. Four options are displayed here: Fight, Bag, Run, and Pokémon.

A Fight

Unleash one of the four moves that your current Pokémon knows. Choose the type of move carefully to maximize your damage output. Keep an eye on the PP of each move, too. This number represents how many times your Pokémon can use a move without resting. If a move's PP falls to zero, you won't be able to use it again until you let your Pokémon rest someplace like a Pokémon Center or use an item to restore PP. You can hold down ⃞ while selecting a move to see a description of it before using it.

B Bag

Tap the "Bag" button to access items you may need during a battle. These items are separated into four categories:

HP/PP Restore: Use Potions, Ethers, and other items that can restore health to your Pokémon or PP to moves.

Status Restore: Use Berries, Antidotes, and other items that can heal your Pokémon of troublesome status conditions and other conditions.

Poké Balls: Throw a Poké Ball and see if you can catch a wild Pokémon. Don't throw Poké Balls in battles against Trainers—you can't steal their Pokémon!

Battle Items: Use X Attack, X Defense, and other items to help give your Pokémon a boost during battle.

C Run

This is the simplest option available to you. Tap the "Run" button, and you and your party will attempt to run away. You may or may not get away safely, though, so be careful!

D Pokémon

Tap "Pokémon" to swap in a different Pokémon; restore a Pokémon's HP or PP; view a summary of your Pokémon's stats, levels, and Abilities; or check the moves that your party Pokémon currently know.

TRAINING YOUR POKÉMON

Your Pokémon grow with you

The Pokémon on your team will grow together with you on your journey. By continuing to battle other Pokémon, either in wild encounters or in battles against other Trainers' teams, they will gain Experience Points (Exp. Points). When they gain enough Exp. Points, your Pokémon will level up. The maximum level any Pokémon can reach is Level 100.

TRAINER HANDBOOK

Level up to power up

Leveling up has two great effects on your Pokémon. Every time your Pokémon levels up, its stats increase and it may learn new moves. There's also a chance that it may evolve into another Pokémon! See page 20 for more on Pokémon Evolution.

Treecko grew to Lv. 13!

HP	+ 2
ATTACK	+ 1
DEFENSE	+ 1
SP. ATK	+ 2
SP. DEF	+ 1
SPEED	+ 2

Each time your Pokémon levels up, you will be able to see how its stats (p. 16) have improved. Some stats may show bigger gains than others. This is because stats are calculated using three main factors: your Pokémon's species strengths (p. 321), its individual strengths (p. 324), and an underlying factor called base stats (p. 325).

TIP

There's more depth than you may imagine when it comes to finding the perfect Pokémon and raising it to have the best possible stats. If you feel ready for more, turn to page 19 to start learning all about how to catch and train the perfect Pokémon. Otherwise, you'll naturally learn more as you proceed in your adventure.

FORGET

KEEP OLD MOVES!

Every few levels, your Pokémon might also be able to learn a new move. Pokémon can learn up to four moves, so if your Pokémon already knows four, you'll have to decide whether to replace one of its old moves or give up on learning the new one. Read each move's description and weigh their merits when making your decision.

TIP

You'll eventually find people on your adventure who can help remind your Pokémon of moves that they have forgotten, so don't feel too bad if you regret making your Pokémon forget a move. It's not lost forever!

Maximize your experience

Pokémon gain Exp. Points when they take part in battles. That means that you should switch any Pokémon that you want to grow stronger into battles often. They don't have to take any action in battle to gain Exp. Points, so a common strategy is to make a weak Pokémon your party's leader so that it appears at the start of every battle, and switch it out for a stronger ally on your first turn. Just make sure that you revive it if it faints in battle—a fainted Pokémon won't gain any Exp. Points, no matter how much it participated!

All Pokémon that take part in a battle get the same amount of Exp. Points, so there's no penalty for using lots of Pokémon during battle. For example, if a wild Pokémon will net you 100 Exp. Points, then every Pokémon that appears in the battle will get 100 Exp. Points. These points are never split, so you can actually get six times the benefit from every battle by switching in all of your Pokémon!

TIP

Special battles called Horde Encounters will pit you against up to five wild Pokémon at a time, and you'll earn Exp. Points for every one of them. If you use moves that can hit multiple targets at once, they can be a great way to gain five times the Exp. Points for each of your Pokémon in a single battle! Learn more about Horde Encounters on page 320.

ADVANCED HANDBOOK

ADVENTURE DATA

Gain bonus experience

There are a number of ways to earn even more Exp. Points for your team. Some are available to you right away.

You are challenged by Youngster Calvin!

Battle Trainers: You get more Exp. Points for battling other Trainers you meet along routes, as well as Gym Leaders and the Pokémon League members, than when you battle untrained Pokémon in the wild. You can also visit the Mauville Food Court (p. 92) in Mauville City and other special battle facilities for back-to-back battles each day.

Prevent Pokémon from evolving: You can stop your Pokémon from evolving by pressing ® when your Pokémon is trying to evolve. Pokémon that have been prevented from evolving will gain extra Exp. Points for as long as you don't let them evolve.

More Bonuses Become Available Once You Have PlayNav

Trade Pokémon with others

Once you obtain the PlayNav (p. 41), you'll be able to use the PSS and trade Pokémon with other players. Pokémon that you receive in a trade from another player will receive 50 percent more Exp. Points from battles than Pokémon that you catch on your own, helping them level up much faster.

Use O-Powers

Exp. Point Power Lv. 1
Increases the Exp. Points from battles a little.
The effect lasts three minutes.
Required Energy
When Used on Self ⊙ × 4
When Given to Another ⊙ × 2
Use | Give | Cancel

O-Powers are also available through the PSS. Eventually, you'll obtain a special O-Power called Exp. Point Power, which can boost the amount of Exp. Points your Pokémon earn for a brief time. See page 91 to learn about O-Powers, or just wait until your O-Powers are unlocked to learn more.

Show some affection

Pokémon-Amie (p. 412) is another feature that becomes available in PlayNav. Playing with your Pokémon in Pokémon-Amie makes them more affectionate toward you, and affectionate Pokémon gain more Exp. Points in battle.

TIP

Pokémon that you receive from players in other countries will gain an even greater bonus!

Even More Ways to Help Pokémon Level Up

Use the Exp. Share

Orlando obtained an Exp. Share!

The Exp. Share is a wondrous item that you receive early in the adventure. It allows all of the Pokémon in your party to earn some Exp. Points from a battle, even if they don't appear in the battle. They won't earn as much as they would by actually appearing in battle, but switching all of your Pokémon in can sure make each battle drag. Turn it on to easily and automatically net all of your party Pokémon some Exp. Points!

Use Rare Candies

MEDICINE
Rare Candy
× 4
A candy that is packed with energy. When consumed, it will instantly raise the level of a single Pokémon by one.

Rare Candies are handy items that you may occasionally find. If you feed one to a Pokémon, it will instantly gain a level.

Carry a Lucky Egg

ITEMS
Lucky Egg
× 1
An item to be held by a Pokémon. It's an egg filled with happiness that earns extra Exp. Points in battle.

Wild Pelipper sometimes hold an item called a Lucky Egg. Catch a Pelipper holding one, and give it to one of your Pokémon to hold, and it will earn extra Exp. Points in battle.

TIP

Try to combine these tricks, such as having a foreign Pokémon with high affection that has been prevented from evolving take part in battle. Give that Pokémon a Lucky Egg to hold, and pretty soon it'll be inundated with Exp. Points!

TRAINER HANDBOOK

Pokémon Day Care

Pokémon Day Care
Let us raise your Pokémon.

Along your adventure, you'll discover a place called the Pokémon Day Care (p. 103). Among other things, the Pokémon Day Care makes it possible for you to drop off two Pokémon to be cared for by the Day-Care workers. When you come back to pick them up, they'll have most likely leveled up. How many levels they gain depends on how long you leave them at the Pokémon Day Care—but the longer you leave them, the more you'll owe the Day-Care staff for their work when you pick them up!

BATTLING WITH POKÉMON

Basic battle flow

Battles against other Trainers or against wild Pokémon follow a basic pattern:

1. You choose a move to use

2. The Pokémon with higher Speed uses its move

3. The Pokémon with lower Speed uses its move

4. Repeat!

This orderly pattern of fair play continues until one side has no Pokémon left with which to battle. That side has lost the battle and must rush to a Pokémon Center or similar facility to have its team restored to full health.

ADVANCED HANDBOOK

ADVENTURE DATA

Understanding stats

All Pokémon have six main stats, which affect how well they perform in Pokémon battles. These stats improve as a Pokémon levels up and can be increased in other ways, such as through the use of items or Super Training (p. 409). You can check your Pokémon's stats at any time by viewing its Summary page (see p. 9).

HP: Hit Points (HP) show how healthy a Pokémon is, which decides how many hits it can take before it gets too tired to battle and faints. HP increases as a Pokémon levels up.

Speed: The Speed stat decides which Pokémon acts first in battle. If your Pokémon's Speed stat is higher than its opponent's, it gets to perform its move first!

Attack: Attack decides how powerful your Pokémon's physical moves will be. Many Pokémon naturally prefer physical moves, while others lean more toward special moves.

Defense: Defense decides how well your Pokémon can defend against physical moves. A low Defense stat means your Pokémon will take more damage from physical moves.

Special Attack (Sp. Atk): Special Attack decides how powerful your Pokémon's special moves will be. Many Pokémon naturally prefer special moves, while others lean more toward physical moves.

Special Defense (Sp. Def): Special Defense decides how well your Pokémon can defend against special moves. A low Special Defense stat means your Pokémon will take more damage from special moves.

Using the right moves based on stats

Pokémon can only learn up to four moves at maximum. This is why move choice is very important in Pokémon battles. All moves fall into one of three categories: physical moves, special moves, and status moves. Physical and special moves both deal damage, while status moves may affect the Pokémon in a battle in more subtle ways, like making them faster or making them sleep.

Check your Pokémon's stats on its Summary page to see whether it has a higher Sp. Atk or Attack stat. If its Sp. Atk stat is higher, it will be more effective if you teach it special moves. If its Attack stat is higher, it will deal more damage in battle by being taught physical moves.

Move Icons

 Physical move icon ◎ Special move icon ◉ Status move icon

How do you know if a move is a physical, special, or status move? Look for these icons when reviewing a Pokémon's moves on its Summary page (p. 9), or when selecting a TM or HM in your Bag (p. 12).

Understanding types

All moves and all Pokémon have a type. Some Pokémon have two types, but moves can only normally have one. Check a Pokémon's Summary page to discover its type, and view its moves to discover their types.

Types interact like a big game of rock-paper-scissors. For instance, the Water type is strong against the Fire type, but weak against the Grass type. It may seem complicated, but the complete Type Matchup Chart on page 463 makes it easy to check these matchups at any time.

If your opponent uses a type of move that your Pokémon is weak against, it will be super effective against your Pokémon and do much more damage than normal. If your opponent uses a move that your Pokémon is strong against, it won't be very effective and will do far less damage than usual. The same is true when your Pokémon attacks an opponent—a great reason to have different types of Pokémon on your team!

It's super effective!

Using the right moves based on types

To select the most effective moves in battle, consider the strengths and weaknesses of each type. When attacking, look at the opposing Pokémon's type. Use moves of types that the opposing Pokémon is weak against based on its type, and you'll do supereffective damage.

From a defensive point of view, assume that your opponent's Pokémon may well use moves that match its type. Try to send out a Pokémon whose type is strong against the opposing Pokémon's type in anticipation of the moves it's likely to use.

TIP

It's easy to see your Pokémon's move types in battle, but the opposing Pokémon's type isn't revealed to you. Still, it's possible to glean the opposing Pokémon's type from its appearance and its reactions to your moves. Or you can just turn to the Pokémon Native to the Hoenn Region list on page 338 to discover each Pokémon's type without the guesswork! Combine this list with the Type Matchup Chart on page 463 to easily discover which types of moves the opposing Pokémon is weak against.

Type Matchups Matter!

Good type matchups mean increased damage!

Mudkip attacks Torchic with a Water-type move: Deals increased damage because Water-type moves are super effective against Fire types.

Bad type matchups mean decreased damage!

Mudkip attacks Treecko with a Water-type move: Deals reduced damage because the Grass type is strong against Water-type moves.

Water Fire Water Grass

Battle messages that describe the damage range

Message	Matchup	Damage
It's super effective!	Good	2–4 times damage
It's not very effective...	Not good	Half damage or less
(No message)	Normal	Regular damage
It doesn't affect...	Bad	No damage
A critical hit!	—	1.5 times damage

Match Pokémon and move types for increased damage

If your Pokémon uses a move that has the same type as itself, it will do 50 percent more damage. For example, Mudkip can learn the moves Tackle (Power: 50) and Water Gun (Power: 40). Normally, Tackle would seem to be the more powerful move of the two. But Water Gun is a Water-type move, and Mudkip is a Water-type Pokémon, so it gets a 50 percent boost and its power is cranked to 60 in battle! Tackle is a Normal-type move, and Mudkip is not a Normal-type Pokémon, so it gets no such boost. Therefore, Water Gun actually ends up being the more powerful of the two moves for Mudkip. In addition, if you use Water Gun against a Pokémon that is weak to water, like Torchic, it will do twice as much damage, effectively reaching a power rating of 120! But if Mudkip uses Water Gun against Treecko or another Pokémon that is strong against Water-type moves, it would do only half the regular damage—essentially dropping its power down to 30. In that case, using a move of a different type would be best—Tackle becomes the preferable move in this example.

Using items

Some items, such as healing items, can be chosen from your Bag and used during battle. Using items from your Bag in battle takes up your turn, so your Pokémon won't be able to attack on the same turn in which you use an item. Other items can be held by your Pokémon and may have effects that are triggered during the course of battle. Unlike using items from your Bag, the use of a Pokémon's held item does not take up a turn. You'll learn more about held items on page 316.

Understanding Abilities

Mightyena's Intimidate!

The wild Wurmple's Attack fell!

Each Pokémon has an Ability—a special power that is automatically triggered when the necessary conditions are met. Some Abilities might affect the Pokémon itself, protecting it from a certain kind of move or increasing one of its stats, for example. Other Abilities can affect opposing Pokémon, by lowering their stats, for example. There are many Abilities with extraordinary and varied effects. See pages 436–440 for the list or read pages 315–316 for more about what Abilities can do for you, and try to catch Pokémon with Abilities that you think will come in handy!

Status conditions and other effects in battle

Treecko Lv. 11
POISONED 22/30

In addition to giving and receiving damage with physical and special moves, Pokémon can also be afflicted with a variety of debilitating status conditions and similar conditions caused by status moves or certain Abilities. Some conditions go away on their own, while others must be healed with items or a visit to a Pokémon Center. Familiarize yourself with every status condition or other effects that a Pokémon might suffer.

TIP

Yearning for more battle-based info? See the Advanced Handbook on pages 313–418 and learn more about becoming a Pokémon battle master!

- **Asleep:** Unable to use most moves. May recover spontaneously during battle.
- **Frozen:** Unable to use most moves. May recover spontaneously during battle.
- **Paralysis:** Lowers Speed and causes moves to fail 25 percent of the time. Does not go away on its own during battle.
- **Poisoned:** Reduces HP at the end of every turn. Does not go away on its own during battle.
- **Burned:** Lowers the power of physical moves and reduces HP at the end of every turn. Does not go away on its own during battle.

- **Confusion:** The Pokémon may hurt itself in its confusion instead of attacking the opponent. Recovers spontaneously after the battle ends and may recover spontaneously during battle.
- **Infatuation:** Moves will fail 50 percent of the time. Recovers spontaneously after the battle ends. Once the Pokémon that inflicted the Infatuation status is defeated or replaced, the condition wears off.
- **Flinching:** The Pokémon will flinch, and its move will fail on the current turn. The effect only lasts for the turn in which the Pokémon flinches.

CATCHING POKÉMON

You've learned how to battle with your Pokémon, but what about how to catch them? Finding Pokémon friends is a big part of life for a new Pokémon Trainer. You'll quickly want to get more Pokémon on your team so you're ready for any situation. Read on to learn how to catch Pokémon and get them on your side!

TRAINER HANDBOOK

Catching wild Pokémon

A wild Wurmple appeared!

Wild Pokémon love nature, and their many different habitats include tall grass, caves, deserts, lakes, rivers—even deep in the sea or high in the sky. Often you'll find that wild Pokémon leap out to attack you when you stumble across them in these kinds of areas, so always be ready for battle. But you may also find that some of them attempt to hide from you (although not very successfully), and you can try to sneak up on these hiding Pokémon in their natural habitat, as you'll learn on page 35.

Main Places and Ways to Find Pokémon

Tall Grass

Very Tall Grass

Caves

Deserts

Water Surface

Seaweed

Fishing

Hidden Pokémon

Cracked Rocks

Soaring

Throw Poké Balls to catch Pokémon

Encountering a Pokémon in the wild startles it, and a battle soon begins. In that battle, you can try to throw a Poké Ball to catch the wild Pokémon. Poké Balls are a real technological wonder that can somehow comfortably keep any size Pokémon in their nice, portable confines. But a wild Pokémon won't just meekly hop into the Poké Ball you've thrown. Pokémon that are still full of energy are likely to escape from the Poké Ball, and the Poké Ball is lost when this happens. Use the following techniques to conserve your Poké Balls and catch Pokémon successfully.

Tips for Catching Pokémon

Lower its HP

Everything's easier to catch when it's tired, and a Pokémon's HP is a measure of how tired it is. Use physical or special moves to attack a Pokémon and lower its HP. Every little bit that you lower a Pokémon's HP makes it that much easier to catch. When its HP bar is red, it means that the Pokémon is very weak. That's the best time to throw a Poké Ball!

Inflict status conditions

Some Pokémon moves and Abilities inflict status conditions on their targets. A Pokémon with a status condition, such as Poison or Paralysis, is easier to catch. Lower the target's HP and use status conditions to maximize your chances of success.

Use the right Poké Ball

Many different kinds of Poké Balls exist, although some can only be bought in certain towns or cities. Each kind of Poké Ball performs differently because they're each specialized for a certain use (like being used in caves or to catch water-dwelling Pokémon). You can always use a regular old Poké Ball, but also try to choose a Poké Ball that's effective for the location or kind of Pokémon you want to catch. It's a basic Pokémon-catching principle! You'll learn more about the different kinds of Poké Balls in the walkthrough as they become available.

ADVANCED HANDBOOK

ADVENTURE DATA

POKÉMON EVOLUTION

Some Pokémon have the potential to evolve into a different species of Pokémon. For example, Torchic evolves into Combusken and then into Blaziken. Many things change when a Pokémon evolves, including its appearance and its name. A Pokémon's type or Ability might even change when it evolves. Evolved Pokémon are usually more powerful than their Evolutionary predecessors, and they can often learn more-powerful moves.

<div style="writing-mode: vertical">TRAINER HANDBOOK</div>

What?
Wurmple is evolving!

Some Pokémon can never be caught in the wild and can only be obtained through Evolution. This is especially true of the final Evolutions in an Evolutionary line. This means that Evolution is key to two of your main goals:

- For battles, you'll probably want to learn about Evolution to get the most powerful Pokémon on your team.
- For your Pokédex, you'll need to master the art of evolving Pokémon to obtain every species.

Conditions for Pokémon Evolution depend on Pokémon species. Learn the main ways to evolve your Pokémon here.

Evolve Pokémon by leveling them up

Many Pokémon evolve by leveling up. The basic way to level up Pokémon is to gain Exp. Points through battling. Flip back to page 13 for tips on how to gain Exp. Points more quickly.

Congratulations! Your Wurmple evolved into Silcoon!

Most Pokémon will automatically try to evolve when they reach a certain level, but some Pokémon need a little more help to evolve. For these Pokémon, certain conditions must be met for them to evolve when they level up. Refer to the Pokémon Native to the Hoenn Region list on page 338 to learn how each Pokémon evolves, including any special conditions that must be met for Evolution to occur.

Examples of Pokémon that evolve with special conditions

With special stones

Some Pokémon, like Vulpix, evolve through the use of a special stone, like a Fire Stone.

Vulpix Fire Stone Ninetales

> **TIP**
>
> You can find some special stones out in the field, and you can receive some stones from the Treasure Hunter on Route 124 in exchange for Shards. You can also get special stones from a Secret Pal with the Stone Searcher skill (p. 390).

Through friendship

Some Pokémon, such as Golbat, can evolve when they are friendly toward the player (p. 76).

In a certain place

Some Pokémon, like Nosepass, can evolve when they are in a certain place.

At a certain time

Some Pokémon, like Budew, can evolve at a certain time of day.

> **TIP**
>
> Some Pokémon must meet multiple conditions in order to evolve. For example, Budew evolves into Roselia when it levels up between 4 A.M. and 7:59 P.M. with high friendship.

These two Pokémon have unique Evolution conditions

Feebas evolves into Milotic when its Beauty condition is high enough.

Nincada evolves into Ninjask naturally at Level 20. If you have an extra Poké Ball in your Bag and an open space in your party when Nincada evolves, you'll find a Shedinja joins your team as well!

Evolve Pokémon by Link Trade

Some Pokémon evolve by Link Trade. For example, if you receive Kadabra by Link Trade, it will evolve into Alakazam when you receive it. However, some Pokémon must also be holding a certain item when traded in order to evolve, as noted in the following table.

Pokémon before trade	Pokémon after trade	Held item required
Dusclops	Dusknoir	Reaper Cloth
Rhydon	Rhyperior	Protector
Clamperl	Huntail	Deep Sea Tooth
Clamperl	Gorebyss	Deep Sea Scale
Seadra	Kingdra	Dragon Scale

<div style="writing-mode: vertical">ADVANCED HANDBOOK</div>

<div style="writing-mode: vertical">ADVENTURE DATA</div>

WALKTHROUGH

UNDERSTANDING THE WALKTHROUGH

This walkthrough is mostly illustrated with the male main character from *Pokémon Omega Ruby*, but the information applies equally to *Pokémon Alpha Sapphire* or to either version of the game with the female main character.

1 Location Name

2 Location Guide

Here's your guide to the special features of various locations!

3 Field Moves Needed

Check these icons to see what moves you need to access every area on the map and collect all the items.

Cut Dive Flash Rock Smash Soar Strength Surf Waterfall

4 Items and Poké Marts

This is your checklist of the items you can find by searching the area or talking to other people in the area. At times, you must meet certain conditions to get an item, and those conditions are included. For cities and towns, you'll find the items sold by the clerks in the Poké Marts and other shops.

5 Trainers Waiting to Challenge You

Find out where you can encounter Pokémon Trainers to battle against. The Poké Balls beneath each Trainer's name indicate how many Pokémon are in that Trainer's party. Trainers who challenge you to special battles are also marked, as are those who can be challenged to a rematch. You will learn how to challenge other Trainers for rematches when that feature becomes available in the game.

⭐ = Double Battle

⭐ = Horde Battle

🔄 = Rematch possible

▶ This icon indicates a Secret Spot. Later in your adventure, you will be able to use these Secret Spots to make your own Secret Base (p. 112).

6 Restore Your Pokémon's Health

You'll sometimes find people in homes or places along routes that can restore your Pokémon's health. These locations are marked on each map.

7 Pokémon Encounters

See the Pokémon that appear in the area. This information helps you complete your Pokédex. To encounter all of the Pokémon, you may sometimes need special items (like fishing rods) or have to fulfill other requirements. These will be labeled.

8 Completion Guide

What do you need to move forward? Get step-by-step descriptions of key events in each city, route, or cave. If you follow these steps in order, you'll be able to complete the main story!

9 Extra Information

You want hints? Get 'em right here! Learn effective ways to use the items you receive and behind-the-scenes stories.

10 Gym Battle Preparation

A little preparation before attempting to challenge a Gym Leader will make it much easier to take home a win. The information in this section will help you get ready.

11 Gym Battle Guide

Get some hints on the tricks of each Gym and the best ways to attack the weak points of each Gym Leader's Pokémon.

12 Gym Leader's Pokémon

Find out about the Pokémon that each Gym Leader will use in battle, including their weaknesses. This gives you the info you need to choose the appropriate Pokémon and moves so you can target your opponent's weaknesses relentlessly!

13 Gym Badges

Take a look at the Gym Badge you get for defeating a Gym Leader, plus the effects of the Gym Badge.

14 Rewards Received from Gym Leaders

Get an outline of the TMs you get for defeating Gym Leaders.

15 Backtrack Box

These teal-colored backtrack boxes remind you to go back to places you've visited before to get new rewards or complete some event.

16 Optional Box

These yellow optional boxes let you know when you can choose to explore an optional area. They may be a single box or they may extend over several pages.

RECOMMENDED ROUTE

Below is the recommended route for your grand adventure through the Hoenn region. Check this guide when you want to know how much progress you've made so far, or when you're not sure where to go next.

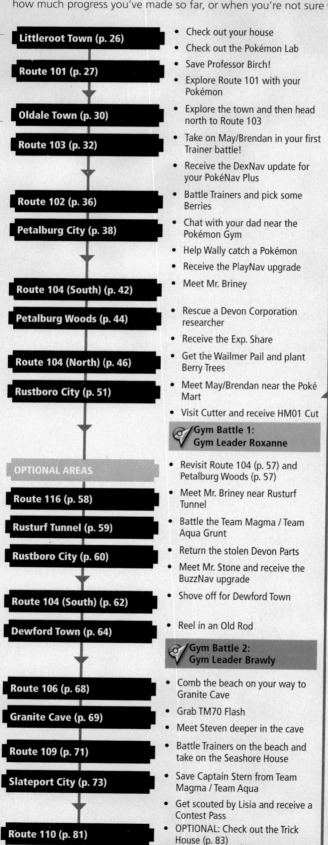

Littleroot Town (p. 26)

Route 101 (p. 27)

Oldale Town (p. 30)

Route 103 (p. 32)

Route 102 (p. 36)

Petalburg City (p. 38)

Route 104 (South) (p. 42)

Petalburg Woods (p. 44)

Route 104 (North) (p. 46)

Rustboro City (p. 51)

- Check out your house
- Check out the Pokémon Lab
- Save Professor Birch!
- Explore Route 101 with your Pokémon
- Explore the town and then head north to Route 103
- Take on May/Brendan in your first Trainer battle!
- Receive the DexNav update for your PokéNav Plus
- Battle Trainers and pick some Berries
- Chat with your dad near the Pokémon Gym
- Help Wally catch a Pokémon
- Receive the PlayNav upgrade
- Meet Mr. Briney
- Rescue a Devon Corporation researcher
- Receive the Exp. Share
- Get the Wailmer Pail and plant Berry Trees
- Meet May/Brendan near the Poké Mart
- Visit Cutter and receive HM01 Cut

☑ Gym Battle 1: Gym Leader Roxanne

OPTIONAL AREAS

Route 116 (p. 58)

Rusturf Tunnel (p. 59)

Rustboro City (p. 60)

Route 104 (South) (p. 62)

Dewford Town (p. 64)

- Revisit Route 104 (p. 57) and Petalburg Woods (p. 57)
- Meet Mr. Briney near Rusturf Tunnel
- Battle the Team Magma / Team Aqua Grunt
- Return the stolen Devon Parts
- Meet Mr. Stone and receive the BuzzNav upgrade
- Shove off for Dewford Town
- Reel in an Old Rod

☑ Gym Battle 2: Gym Leader Brawly

Route 106 (p. 68)

Granite Cave (p. 69)

Route 109 (p. 71)

Slateport City (p. 73)

Route 110 (p. 81)

- Comb the beach on your way to Granite Cave
- Grab TM70 Flash
- Meet Steven deeper in the cave
- Battle Trainers on the beach and take on the Seashore House
- Save Captain Stern from Team Magma / Team Aqua
- Get scouted by Lisia and receive a Contest Pass
- OPTIONAL: Check out the Trick House (p. 83)

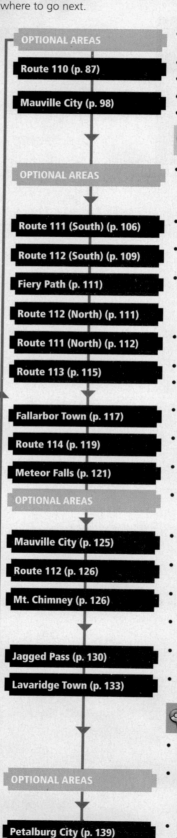

OPTIONAL AREAS

Route 110 (p. 87)

Mauville City (p. 98)

- Explore Route 103's east half (p. 83)
- Have a battle with May/Brendan
- Receive the Dowsing Machine
- Accept Wally's battle challenge
- Receive HM06 Rock Smash

☑ Gym Battle 3: Gym Leader Wattson

OPTIONAL AREAS

Route 111 (South) (p. 106)

Route 112 (South) (p. 109)

Fiery Path (p. 111)

Route 112 (North) (p. 111)

Route 111 (North) (p. 112)

Route 113 (p. 115)

Fallarbor Town (p. 117)

Route 114 (p. 119)

Meteor Falls (p. 121)

OPTIONAL AREAS

Mauville City (p. 125)

Route 112 (p. 126)

Mt. Chimney (p. 126)

Jagged Pass (p. 130)

Lavaridge Town (p. 133)

- Visit Route 117 (p. 102), the Pokémon Day Care (p. 103), Verdanturf Town (p. 104), and Rusturf Tunnel (p. 105)
- Battle the Winstrate Family
- Receive HM04 Strength from May/Brendan
- Make a dash through the Fiery Path
- Meet Aarune and learn about Super-Secret Bases
- Meet up with May/Brendan
- Receive a Soot Sack at the Glass Workshop
- Catch up with May/Brendan
- Follow May/Brendan into Meteor Falls
- Help May/Brendan battle Team Magma / Team Aqua
- Take the long route through Meteor Falls (p. 121) and Route 115 (p. 124) and around the southern area
- Swap your Bike at Rydel's Cycles
- Take the Cable Car up to Mt. Chimney
- Battle Team Magma Admin Tabitha / Team Aqua Admin Shelly
- Battle Team Magma Leader Maxie / Team Aqua Leader Archie
- Use the Acro Bike to reach items around the pass
- Receive a Pokémon Egg from the old lady near the hot springs

☑ Gym Battle 4: Gym Leader Flannery

OPTIONAL AREAS

Petalburg City (p. 139)

- Receive the Go-Goggles from May/Brendan
- Take the long route and revisit Mt. Chimney (p. 134), Fiery Path (p. 137), Mauville City (p. 137), and Route 111 (p. 138)
- Return to Petalburg City and challenge your dad

TRAINER HANDBOOK

ADVANCED HANDBOOK

ADVENTURE DATA

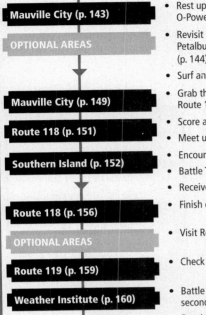

Petalburg City (p. 140)

Mauville City (p. 143)

OPTIONAL AREAS

Mauville City (p. 149)

Route 118 (p. 151)

Southern Island (p. 152)

Route 118 (p. 156)

OPTIONAL AREAS

Route 119 (p. 159)

Weather Institute (p. 160)

Route 119 (p. 163)

Fortree City (p. 163)

Route 120 (p. 169)

OPTIONAL AREAS

Fortree City (p. 170)

Route 120 (p. 174)

Route 121 (p. 175)

OPTIONAL AREAS

Lilycove City (p. 180)

Route 122 (p. 185)

OPTIONAL AREAS

Mt. Pyre (p. 188)

Slateport City (p. 193)

Lilycove City (p. 193)

Team Magma Hideout Ω (p. 194)

Team Aqua Hideout α (p. 199)

Route 124 (p. 204)

Gym Battle 5: Gym Leader Norman

- Receive HM03 Surf from Wally's dad
- Rest up and receive a new O-Power
- Revisit Littleroot Town (p. 144), Petalburg City (p. 144), Route 104 (p. 144) and Route 115 (p. 145)
- Surf and explore Route 105
- Grab the Acro Bike on your way to Route 118
- Score a Good Rod
- Meet up with Steven
- Encounter another Pokémon
- Battle Team Magma / Team Aqua
- Receive the Mega Bracelet
- Finish exploring Route 118

- Visit Route 123 (p. 186)

- Check out the Weather Institute

- Battle Tabitha/Shelly on the second floor
- Receive Castform
- Battle May/Brendan en route to Fortree City
- Get blocked by an invisible object

- Meet Steven on the bridge
- Receive the Devon Scope and a Mega Stone
- Explore the Scorched Slab (p. 273)

Gym Battle 6: Gym Leader Winona

- Explore the rest of Route 120

- Catch sight of Team Magma / Team Aqua
- Swing by the Safari Zone (p. 176)

- Scope the Lilycove Department Store with May/Brendan
- Pursue Team Magma / Team Aqua up Mt. Pyre
- Explore the rest of Route 123 (p. 186)
- Confront Maxie/Archie on the summit
- Battle Team Magma Admin Courtney / Team Aqua Admin Matt
- Obtain the Blue Orb / Red Orb
- Confront Maxie/Archie near the submarine
- Prepare your party and then head for the hideout
- Search the hideout to find the sub
- Search the hideout to find the sub
- Surf to Mossdeep City

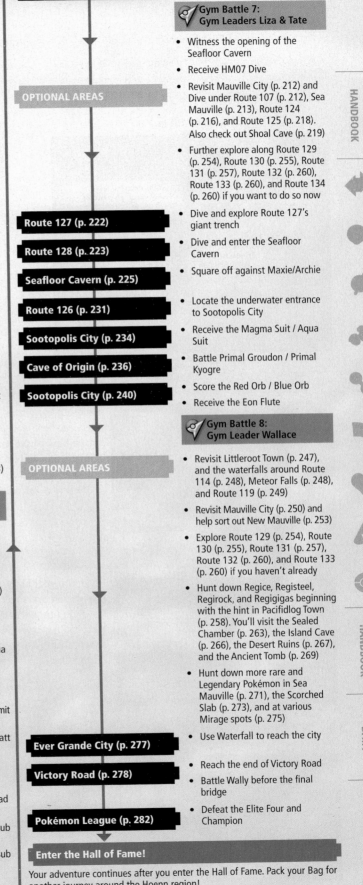

Mossdeep City (p. 205)

Route 127 (p. 222)

Route 128 (p. 223)

Seafloor Cavern (p. 225)

Route 126 (p. 231)

Sootopolis City (p. 234)

Cave of Origin (p. 236)

Sootopolis City (p. 240)

Ever Grande City (p. 277)

Victory Road (p. 278)

Pokémon League (p. 282)

OPTIONAL AREAS

OPTIONAL AREAS

- Explore the city and visit the Space Center

Gym Battle 7: Gym Leaders Liza & Tate

- Witness the opening of the Seafloor Cavern
- Receive HM07 Dive
- Revisit Mauville City (p. 212) and Dive under Route 107 (p. 212), Sea Mauville (p. 213), Route 124 (p. 216), and Route 125 (p. 218). Also check out Shoal Cave (p. 219)
- Further explore along Route 129 (p. 254), Route 130 (p. 255), Route 131 (p. 257), Route 132 (p. 260), Route 133 (p. 260), and Route 134 (p. 260) if you want to do so now

- Dive and explore Route 127's giant trench
- Dive and enter the Seafloor Cavern
- Square off against Maxie/Archie

- Locate the underwater entrance to Sootopolis City
- Receive the Magma Suit / Aqua Suit
- Battle Primal Groudon / Primal Kyogre
- Score the Red Orb / Blue Orb
- Receive the Eon Flute

Gym Battle 8: Gym Leader Wallace

- Revisit Littleroot Town (p. 247), and the waterfalls around Route 114 (p. 248), Meteor Falls (p. 248), and Route 119 (p. 249)
- Revisit Mauville City (p. 250) and help sort out New Mauville (p. 253)
- Explore Route 129 (p. 254), Route 130 (p. 255), Route 131 (p. 257), Route 132 (p. 260), and Route 133 (p. 260) if you haven't already
- Hunt down Regice, Registeel, Regirock, and Regigigas beginning with the hint in Pacifidlog Town (p. 258). You'll visit the Sealed Chamber (p. 263), the Island Cave (p. 266), the Desert Ruins (p. 267), and the Ancient Tomb (p. 269)
- Hunt down more rare and Legendary Pokémon in Sea Mauville (p. 271), the Scorched Slab (p. 273), and at various Mirage spots (p. 275)
- Use Waterfall to reach the city

- Reach the end of Victory Road
- Battle Wally before the final bridge

- Defeat the Elite Four and Champion

Enter the Hall of Fame!

Your adventure continues after you enter the Hall of Fame. Pack your Bag for another journey around the Hoenn region!

LITTLEROOT TOWN

Basking amid vibrant nature, this simple town is not shaded with any one hue.

A quaint little hamlet that's nestled along the lush southern edge of Hoenn's mainland, Littleroot Town is the place where your adventure begins. It's also the place where Hoenn's renowned Pokémon researcher, Professor Birch, conducts research about Pokémon distribution—normally by escaping from his high-tech Pokémon Lab.

To Route 101 (p. 27)

Your House (Boy) /
Professor Birch's House

Your House (Girl) /
Professor Birch's House

Professor Birch's
Pokémon Lab

Items

After obtaining the Pokédex

☐ Poké Balls ×10

TIP

Which house is your family's new home will depend on the gender you chose for your character. If you are playing as a boy, your house will be the one on the left. If you are playing as a girl, your house will be on the right.

1 Get outta that truck!

What do you think?
This is going to be our new home!

Littleroot Town sure is a relaxing place, but your ride here was anything but. Climb out of the back of the moving van in which you arrived and find your mom waiting for you outside. She's excited about your new home and asks you to follow her inside.

2 Check out your house

You've got to set the time!

Head into your home to find some burly Pokémon movers hard at work. After they leave, go upstairs and check out your room. Your dad has given you a thoughtful gift: a wall clock! Face the clock and press Ⓐ to set the time.

TIP

Pokémon Omega Ruby and *Pokémon Alpha Sapphire* are tuned to your Nintendo 3DS system's internal clock. You'll notice changes in the game depending on the time of day, so be sure that your Nintendo 3DS system's clock is set properly!

3 Meet your mom downstairs

Looks like your dad was on, but we missed his part.

Feel free to check out other items of interest in your room. You can examine the open notebook on your desk, the big doll, the TV, and more. When you're ready, head downstairs to find your mom watching TV. Oops, you've just missed the broadcast of your dad's latest Gym battle. That's right, your dad is Petalburg City's Gym Leader!

TIP

Don't forget to save! You can save your game by tapping the little icon on the bottom of the screen that looks like a notepad, or by opening the menu with Ⓧ. This game does not automatically save your progress, so remember to do it yourself from time to time, especially before entering a new area where there might be tough Pokémon waiting!

TRAINER HANDBOOK

ADVANCED HANDBOOK

ADVENTURE DATA

4 | Say hi to your neighbors

You've just moved to a new town, so why not visit your new neighbors? Visit the house next door, which is the home of Professor Birch, Hoenn's foremost Pokémon researcher. Go inside to meet his wife, and then head upstairs to meet his daughter, May, or his son, Brendan.

TIP

The gender of Professor Birch's child is determined by the gender you chose for your character when you began the game. If you chose a male character, then your neighbor is May. If you chose a female character, your neighbor is Brendan.

5 | Check out the Pokémon Lab

Huh? You're looking for Professor Birch?

After chatting with May/Brendan, go south to find Professor Birch's Pokémon Lab. Talk to everyone you meet along the way, and check out the big sign in the center of town to learn Littleroot Town's motto and catch a cool view of the place. Inside the Pokémon Lab, speak to the researcher to learn that Professor Birch is out and about, conducting important field research.

TIP

In a hurry? Hold Ⓑ while walking to run! It doesn't work in all environments, but it will generally help you get around routes and towns a lot faster.

6 | Head to Route 101

I think I hear someone screaming up ahead!

Route 101 lies just north of Littleroot Town. Perhaps Professor Birch is somewhere up there? Take the north trail out of town to reach Route 101. Unexpectedly, a cry for help greets you as you enter the route!

ROUTE 101

This grassy path running between Littleroot Town and Oldale Town is perfect for doing fieldwork.

Route 101 features several patches of tall grass, a favorite hiding place of wild Pokémon. You must cross some of the route's tall grass to reach Oldale Town.

To Oldale Town (p. 30)

To Littleroot Town (p. 26)

Tall Grass	
❏ Poochyena	○
❏ Wurmple	◎
❏ Zigzagoon	◎

Horde Encounters	
❏ Poochyena	▲
❏ Zigzagoon	◎

◎ frequent ○ average △ rare ▲ almost never

Zigzagoon `Normal`
Abilities: Pickup, Gluttony

Poochyena `Dark`
Abilities: Run Away, Quick Feet

TRAINER HANDBOOK

ADVANCED HANDBOOK

ADVENTURE DATA

1 Save Professor Birch!

Hallo! You over there!
Please! Help me out!

Oh no, Professor Birch is in danger! A wild Pokémon has cornered him, and the professor's Bag has fallen out of his reach. You've got to do something! Choose one of the three Pokémon from the Poké Balls in the professor's Bag, and then use it to battle the wild Poochyena that's giving him grief. This might not be just a one-time encounter, so see below for a guide to these three Pokémon of Birch's to pick the one you like best.

TIP

During battle, hold ⒧ and select a move to view vital information on any of your Pokémon's moves. This helps you pick the right move for the situation at hand.

Professor Birch's Pokémon

Each Pokémon has its own strengths and weaknesses, but their weaknesses can be covered by other Pokémon you catch later. So just choose your favorite!

Treecko — Grass
Ability: Overgrow

Strong Against:	Water	Ground	Rock		
Weak Against:	Fire	Ice	Poison	Flying	Bug

Treecko has the best speed of the three Pokémon. It can easily beat the first Gym Leader, Roxanne, because it's strong against Rock types. It learns some great moves as it levels up and from TMs and Move Tutors, including moves that can drain HP from opponents, like Absorb and Mega Drain. Treecko evolves into Grovyle at Level 16, which evolves into Sceptile at Level 36.

Torchic — Fire
Ability: Blaze

Strong Against:	Grass	Ice	Bug	Steel	
Weak Against:	Water	Ground	Rock		

Torchic has well-balanced stats. Since the Fire type is weak against the Rock type, it may struggle at the first Gym unless it's evolved into Combusken. Torchic evolves into Combusken at Level 16, and then into Blaziken at Level 36, both of which are Fire- and Fighting-type Pokémon.

Mudkip — Water
Ability: Torrent

Strong Against:	Fire	Ground	Rock		
Weak Against:	Grass	Electric			

Mudkip has the highest Attack stat among the three Pokémon. Overall, it's a great Pokémon for Gym battles. Mudkip evolves into Marshtomp at Level 16, and then into Swampert at Level 36, both of which are Water and Ground types. The Ground type cancels out Water type's weakness against the Electric type, which leaves only Grass as its weakness.

TIP

Each move has a certain number of Power Points (PP), which sets how many times the move can be used. When a Pokémon runs out of PP for a move, you will need to let it rest up at a Pokémon Center or elsewhere to restore its PP along with its HP. Your mom will take care of that for you, too!

TIP

The little ledges that you see along Route 101 can't be climbed. Instead, you can only jump down from these special ledges. Keep this in mind! You'll encounter many other environmental objects and obstacles as you explore Hoenn's sprawling wilds, including cracked rocks, big boulders, bodies of water, quicksand, trees you can Cut, ladders, slippery slopes, and more. Consult this walkthrough whenever you're unsure of how to advance!

◀◀ BACKTRACK LITTLEROOT TOWN p. 26

Oh, yes! To say thanks for rescuing me out there, how about I give you that Pokémon you used earlier?

Return to the Pokémon Lab

Professor Birch's Pokémon are more than a match for that wild Poochyena. After the battle, the good professor thanks you for saving him and invites you back to his Pokémon Lab in Littleroot Town. He happily lets you keep the Pokémon that you used to save him. He then encourages you to scout Route 103 to find his daughter/son, who can teach you more about what being a Pokémon Trainer is all about. With your very own Pokémon for the first time, it seems like it's time to learn more about the world of Pokémon training that you've gotten yourself into.

2 Explore Route 101 with your Pokémon

If your Pokémon get tired, take them to a Pokémon Center.

Now that you have a Pokémon of your own, why not do a little exploring? Head north to Route 101 and give the area a thorough search. You can't catch any new Pokémon without Poké Balls, but you can battle wild Pokémon in the tall grass to increase your Pokémon's Exp. and level it up, making it stronger. Speak to everyone you meet as you maneuver through the route on your way to Oldale Town.

Using the AreaNav

Tap the big map that's displayed on the Touch Screen to open the AreaNav. The AreaNav will continue to grow as you progress through your game, so remember to keep an eye on it. Soon it will be bursting with handy information. You'll then see five buttons at the bottom of the Touch Screen: Places, Pokémon, Trainers, Bases, and Berries. Press ⓨ to zoom the map in and out.

Towns and Routes

Pokémon Distribution

Trainer's Eye

Berry Trees

Secret Bases

Through the use of the AreaNav, you can fly directly to many of Hoenn's locations—not only to Pokémon Centers, but to Hoenn's many routes, and other areas of interest as well! This makes getting around the region a breeze, but before you can fly around with the AreaNav, you must have a Pokémon that's learned the Fly field move. (Fly becomes available for you to use later in the adventure.) The places that you can visit with Fly will vary depending on which AreaNav feature is selected.

Feature 1: Places

This AreaNav feature displays the Hoenn map with all of its cities, towns, routes, and other locations. These locations are darkened on the map until you've visited them. Information on each location is shown when you select one, including a description and any known points of interest.

- Touch the pink dots for information on cities and towns.
- Touch routes for information pertaining to each route.
- Touch the green dots for information on other locations (caves and the like).

Feature 2: Pokémon

This AreaNav feature shows the kinds of Pokémon you've caught at different places. Any Pokémon you haven't caught won't be visible. You will be notified once you have caught all Pokémon in an area, which makes it a great tool to help you complete your Pokédex!

How to unlock: This feature becomes available once you start exploring the wilds and catching Pokémon for yourself.

Feature 3: Trainers

This tab opens the Trainer's Eye application. Some of Hoenn's aspiring Trainers will challenge you more than once. These special Trainers are shown when this feature is selected. Information regarding these Trainers is provided, including their strategy, favorite Pokémon, special message, and even their team of Pokémon. The "Battle Ready!" message appears when a Trainer is ready for a rematch. You can even view information about Gym Leaders, the Elite Four, and the Champion once you've faced each in battle!

How to unlock: This feature becomes available when you start battling Trainers who are interested in rematches.

Feature 4: Secret Bases

This AreaNav feature shows the location of your Secret Base, as well as the bases of others. Touch a route to see its list of Secret Bases (if any). Your Secret Base will have a special icon that looks like a house. Any new bases will have a question mark icon next to them. Gotta check 'em all!

How to unlock: This feature becomes available when you learn about Secret Bases from a special character later in the game.

Feature 5: Berries

This AreaNav feature shows the locations of Berries you've planted, as well as how long it's been since you planted them. It doesn't take long for those Berries to grow! Touch a route to see the list of Berry Trees growing there.

How to unlock: This feature becomes available when you start harvesting and growing Berries for yourself.

TIP

Notice how the dotted lines on your AreaNav are sometimes different colors? Routes may be lined with dots when you've chosen views like Berries, Bases, or Trainers. A dotted line often means that there is something to check out there, like ripe Berries or Trainers who are ready to battle again. On the Pokémon view, a white dotted line means that you've caught every possible Pokémon in that area!

OLDALE TOWN

A town where the contrast between colorful flowers and deep, verdant forests is most beautiful.

Featuring a Pokémon Center and a convenient Poké Mart, Oldale Town is an ideal place for Trainers to rest their weary Pokémon and stock up on useful items. Sadly, the Poké Mart has recently run out of Poké Balls, so until they restock, you can only buy Potions there.

To Route 103 (p. 32)

Poké Mart

Pokémon Center

To Route 102 (p. 36)

To Route 101 (p. 27)

Poké Mart	
Potion	300
After obtaining the Pokédex	
Antidote	100
Poké Ball	200

Items
☐ Potions ×10

1 Score 10 Potions from a friendly Poké Mart clerk

I'd like you to have these as part of a special promotion!

The moment you set foot in Oldale Town, an excited Poké Mart clerk races toward you. The clerk tells you all about Poké Marts, then gives you 10 free Potions as part of a promotion his shop is running. What luck!

2 Check out the local Pokémon Center

Hello, and welcome to the Pokémon Center. Would you like to rest your Pokémon?

Before you continue on your merry way, the friendly shop clerk escorts you to Oldale Town's red-roofed Pokémon Center. Head inside and speak with the nice lady at the counter, and she'll ask you if you'd like to rest your Pokémon. Go ahead, and your Pokémon will be restored to full health free of charge!

TIP

Looking for some helpful advice? Whenever you visit a Pokémon Center, check out the books on the shelves near the counter. Pokémon Centers always stock the latest issue of the *Aha! Pokémon Journal*, which features tips for aspiring Trainers.

TIP

Having your Pokémon cared for at Pokémon Centers doesn't just restore their HP. It also cures any status conditions that they might have picked up while battling and, even more important, it restores all of their moves' PP. If you teach your Pokémon all powerful moves with lower PP, you'll need to rest often!

3 Pop by the Poké Mart

Buy
Sell
No thanks!

Welcome to the Poké Mart! May I help you?

After you've chatted with everyone in the Pokémon Center, head north to find the blue-roofed Poké Mart. Speak with the clerk at the counter to find that only Potions are currently in stock. You've just received a bunch of free Potions, so save your money for future purchases.

TRAINER HANDBOOK

ADVANCED HANDBOOK

ADVENTURE DATA

Shop till You Drop!

Now that you've seen your first Poké Mart, it's time for a shopping spree, right? Well, unfortunately there's not much available yet—and you don't have much money yet, either. Continue reading to learn how to solve both problems.

Earn Badges to buy more

As you defeat Gym Leaders and earn your first few Badges, more and more items will become unlocked in Poké Marts around Hoenn. After you earn a Badge, the new goods associated with that Badge will be available at every Poké Mart you visit, anywhere in the region (even Poké Marts back in previous towns). See page 462 for the full list of what each Badge unlocks.

TIP

Whenever you buy 10 of any kind of Poké Ball, you will get a bonus Premier Ball for free!

Visit different Poké Marts for a specialized selection

Sometimes you'll find a second clerk in the Poké Mart, who can sell you goods unique to that city or town. In Slateport City, for example, they sell items that give you a boost in battle, while Mauville City offers you some new TMs. You can always check the list of every Poké Mart's special inventory on page 462.

Save money for other shopping spots

Poké Marts aren't the only places for you to spend your savings. Specialty shops around the region sell incense, herbal remedies, and more. There's even a huge department store in one of the cities—you'll want to save up for that! Plus, you'll be able to buy special Decorations once you're able to make your own Super-Secret Base (p. 112).

Battle Trainers to earn money

Orlando received ₽600 for winning!

The main way to earn money is by battling other Trainers, so dive in and take on every Trainer you encounter on routes around Hoenn. Be sure to use the AreaNav's Trainer's Eye feature (p. 328) to locate Trainers that can be challenged to rematches as well.

Use items and O-Powers to increase your wealth

You can increase the amount of prize money you get from Trainer battles by having your Pokémon hold Luck Incense (which can be bought in Slateport City's market) or the Amulet Coin (which becomes available after getting your fifth Badge). The right O-Power can also provide a special earnings boost (p. 407).

Sell items to earn money

You'll also sometimes find items whose descriptions hint that they can be "sold at a high price to shops." These items generally don't do much for you, so sell them off and reap the rewards. A prime example is the Big Nugget, which can be earned in the Mauville Food Court (p. 92).

TIP

Some moves, like Pay Day and Happy Hour, can earn you more prize money from battles, but unfortunately they are not very easy to get. Meowth and Persian both learn Pay Day, but neither is native to the Hoenn region. Happy Hour is only found on special Pokémon gifted to players as part of a special event.

Aaaaah! Wait!
Please don't wander around here!

Try as you might, there's no getting through the west trail that leads to Route 102. A man believes that he has discovered some extremely rare Pokémon tracks along the trail, and he won't let you tread across them until he's finished sketching them for the sake of research. Leave the man to his important work and head north to Route 103 instead. After all, didn't Professor Birch say that May/Brendan was headed there?

ROUTE 103

Field Moves Needed Surf

On weekends and holidays, fishing enthusiasts flock to every section of the coastline on this seaside route.

There's plenty of room to roam around Route 103, but only a portion of this scenic route can be explored during your first visit. The Surf field move is needed to cross the water and see the rest of Route 103, but it'll be a while before you learn Surf.

Fisherman Andrew ⊙⊙⊙⊙⊙⊙

Twins Amy & Liv ◉
★ Double Battle
⊙⊙⊙⊙⊙⊙

Berry Trees

To Route 110 (p. 81)

To Oldale Town (p. 30)

Poké Fan Miguel ◉
⊙⊙⊙⊙⊙⊙

Aroma Lady Daisy
⊙⊙⊙⊙⊙⊙

Items

After learning Surf	
☐ Guard Spec	

Tall Grass

☐ Poochyena	◎
☐ Wingull	○
☐ Zigzagoon	◎

◎ frequent ○ average
△ rare ▲ almost never

Horde Encounters

☐ Poochyena	○
☐ Wingull	▲
☐ Zigzagoon	◎

On the Water

☐ Pelipper	▲
☐ Tentacool	◎
☐ Wingull	○

Fishing

Old Rod	
☐ Magikarp	◎
☐ Tentacool	○
Good Rod	
☐ Magikarp	◎
☐ Tentacool	○
☐ Wailmer	▲
Super Rod	
☐ Wailmer	◎

TIP

Wondering about those fishing rods? Unfortunately you haven't gotten your hands on one yet. But if you keep your eye out on your journey, you'll be able to collect all three, and then you can revisit places like this route to snag more Pokémon for your Pokédex. Pokémon that are encountered "on the water" also require your party to be a bit more skilled, namely in the form of the move Surf. For now, focus on collecting Pokémon found in the tall grass. You can also run into Horde Encounters in the tall grass, though they don't happen that often. You'll learn more about them on page 320.

I'll give you a taste of what being a Trainer is really like!

Head north through Route 103, admiring the briny blue sea to the east as you work your way around the winding trail. Your friend from Littleroot Town, May/Brendan, awaits you at the route's north end. Speak to her/him, and you'll be challenged to your very first Trainer battle!

May/Brendan's Pokémon

○○○○○○

The Pokémon that May/Brendan uses will be of the type that counters your own. This means that its moves may be very effective against your Pokémon, while your Pokémon's moves might not be very effective against it. Avoid using moves of a type that May/Brendan's Pokémon is strong against, and try using Normal-type moves (or moves of another type) instead. Your Pokémon should be a few levels higher than hers/his by now, which helps even the odds. Remember to use Potions if the battle isn't going your way!

If you chose Treecko	If you chose Torchic	If you chose Mudkip
Torchic ♀/♂ Lv. 5 — Fire	**Mudkip** ♀/♂ Lv. 5 — Water	**Treecko** ♀/♂ Lv. 5 — Grass
Weak to: Water, Ground, Rock	Weak to: Grass, Electric	Weak to: Fire, Ice, Poison, Flying, Bug

◀◀ **BACKTRACK** | **LITTLEROOT TOWN** p. 26

That Pokédex is a high-tech tool that automatically makes a record of any Pokémon you meet or catch.

Return to the Pokémon Lab in Littleroot Town

No matter how the battle plays out, May/Brendan is kind enough to heal your Pokémon. She/he thanks you for the battle and heads back to the Pokémon Lab in Littleroot. You can't explore any farther along Route 103, so why not follow your friend back to the lab?

When you arrive, Professor Birch gives you a handy gadget: the Pokédex! Data on every Pokémon you see and catch is automatically stored in this vital device.

Orlando obtained Poké Balls!

Score 10 Poké Balls

May/Brendan hates to be shown up by the professor, and so she/he also gives you 10 Poké Balls. At last you can catch wild Pokémon and start raising a whole party! It's a lot easier to travel around with a full party, without the fear of your one-and-only Pokémon fainting in battle. See page 19 if you skipped over the basics of catching Pokémon.

> **TIP**
>
> Now that you've received some Poké Balls, you'll find them for sale at Poké Marts all around Hoenn. Handy!

If anything happens, you can always come home, honey.

Meet up with mom

Take your leave of the lab after obtaining the Pokédex, and feel free to tinker with your newfound gadget if you like. When you're ready, head north toward Route 101. Your mom stops you along the way. She's proud that you've found your own Pokémon, but urges you not to push too hard. She reminds you that you can always come home to rest. That's what a home is for!

TRAINER HANDBOOK

ADVANCED HANDBOOK

ADVENTURE DATA

Receive the DexNav update for your PokéNav Plus

May/Brendan catches up with you as you reenter Route 101. She/he has a new update for your PokéNav Plus: the DexNav! This handy app gives information about the Pokémon that live in each area and will help you in your quest to catch lots of different Pokémon.

TIP

Now that you can catch Pokémon on Route 101, keep an eye out for Zigzagoon with the Pickup Ability. This handy Ability allows Zigzagoon to find items for you as long as it's in your party. What a way to free goodies! The only trick is that it can't be holding anything if you want it to find new items. So every time it picks up something new, take that item and put it in your Bag at once!

Check Out Your New DexNav App

DexNav is a handy app that helps you tell whether or not you've caught all of the Pokémon in an area. Early in the adventure, DexNav only features Pokémon that you can encounter on land. Once you obtain a fishing rod, DexNav shows Pokémon that you can catch by fishing. And once you're able to use Surf, DexNav shows Pokémon that you can catch on the water.

TIP

Even more Pokémon might become available as you play!

Catching and seeing Pokémon

Pokémon that you've encountered but haven't caught will appear as shadows on DexNav and will be listed as "Seen" in your Pokédex. Pokémon that you've caught will appear in full, living color on DexNav. Tap a full-color Pokémon to activate Detector Mode and search for more specimens!

As you catch Pokémon, special marks will appear in the upper-right-hand corner of the screen. A bronze trophy means you've caught all of the available Pokémon through one of the following methods: encountering them in the tall grass, surfing, fishing, or sneaking up on hidden Pokémon. The more methods you complete, the better the trophy becomes! A platinum trophy means you've caught all of the Pokémon possible for that area!

TIP

In caves, each floor can feature different Pokémon. Keep an eye on your DexNav and try to get the platinum trophy on every floor!

Checking your progress

Tap the DexNav display to call up a message that gives you a better idea of your progress.

"There are no wild Pokémon in this area."	No Pokémon can be caught.
"There are still Pokémon in this area that you have not caught!"	More than one Pokémon remains to be caught.
"Nearly complete!"	Only one more Pokémon remains to be caught.
"Good job! You've caught them all!"	Every available Pokémon has been caught through regular encounters.
"Amazing! Fantastic! You caught every possible Pokémon in this area!"	Every available Pokémon has been caught, including all hidden Pokémon that appear in the field.

Sneak up on unsuspecting hidden Pokémon

Now that you have some Poké Balls and the DexNav upgrade, you're all set to catch wild Pokémon. You can encounter wild Pokémon just by running through tall grass, but every so often, a hidden Pokémon will appear that you can see and sneak up on! Advance along Route 101 until May/Brendan points out a hidden Pokémon to you, then follow her/his instructions to catch it. Refer to the next page for complete details.

TRAINER HANDBOOK

ADVANCED HANDBOOK

ADVENTURE DATA

Sneaking Up on Hidden Pokémon

On Route 101, you'll see a hidden Pokémon trying to hide in tall grass. When you see one of these hidden Pokémon in the field, or when one is detected in Detector Mode on your DexNav, sneak up on it by pushing lightly on the Circle Pad!

When you approach a hidden Pokémon, a symbol of a magnifying glass will appear on the Touch Screen. Tap it to open up Detector Mode. Detector Mode can be triggered by hidden Pokémon that you can battle, or by Pokémon that are just passing by, like a flock of Wingull or schools of Luvdisc.

Detector Mode

Detector Mode lets you see information about hidden Pokémon and also hints at how close you are to them.

 You are still quite far.

 You're getting warmer.

 You're definitely hot!

 You can likely see them on the screen!

If you keep using Detector Mode over and over to find a particular kind of Pokémon, you're more likely to encounter a hidden Pokémon with exceptional traits. These hidden Pokémon might have great potential (or individual strengths, see page 324 for details), or they might know moves that they could usually only learn through breeding. They might even possess special Hidden Abilities (p. 338), or have significantly higher levels than other Pokémon in the area, or they might hold special items. You'll know that a hidden Pokémon is exceptional when you see an exclamation point beside any part of its summary on the Detector Mode screen.

What do the stars under "Potential" mean?

☆ = This Pokémon has the maximum possible individual strength for one stat.

☆☆ = This Pokémon has the maximum possible individual strength for two stats.

☆☆☆ = This Pokémon has the maximum possible individual strength for three stats.

Repeatedly finding the same species of hidden Pokémon also raises the search level in Detector Mode, which is shown in the upper-right corner of the Touch Screen while Detector Mode is open. The search level is set for each Pokémon species and is increased by battling that kind of Pokémon in the wild. More and more information on hidden Pokémon is displayed in Detector Mode as the search level increases.

Why did my search fail?

Three main actions can make your searches fail:

1. Walking at regular speed instead of sneaking up on a hidden Pokémon.
2. Taking too long to find a hidden Pokémon.
3. Trying another search immediately after the last search. Try to take at least 20 steps between searches.

ROUTE 102

Many Trainers gather on this route in the hope of encountering Pokémon in the wild.

Compared to other places you've visited, Route 102 is chockfull of wild Pokémon. Spend some time shuffling through this route's tall grass and you will certainly add several new entries to your Pokédex!

Lass Tiana ⬤⭘⭘⭘⭘⭘

Youngster Calvin ◉ ⬤⭘⭘⭘⭘⭘

Berry Trees

To Petalburg City (p. 38)

To Oldale Town (p. 30)

Youngster Allen ⬤⭘⭘⭘⭘⭘⭘

Bug Catcher Rick ⬤⭘⭘⭘⭘⭘

Horde Encounters

☐ Lotad	⭘	α
☐ Ralts	▲	
☐ Seedot	⭘	Ω
☐ Zigzagoon	◎	

◎ frequent ⭘ average △ rare
▲ almost never

On the Water

☐ Azumarill	⭘
☐ Marill	◎
☐ Masquerain	▲
☐ Surskit	△

Items

☐ Potion

Tall Grass

☐ Lotad	△	α
☐ Poochyena	⭘	
☐ Ralts	▲	
☐ Seedot	△	Ω
☐ Surskit	▲	
☐ Wurmple	⭘	
☐ Zigzagoon	⭘	

Fishing

Old Rod	
☐ Goldeen	⭘
☐ Magikarp	◎
Good Rod	
☐ Corphish	▲
☐ Goldeen	⭘
☐ Magikarp	◎
Super Rod	
☐ Corphish	◎

◀◀ BACKTRACK | OLDALE TOWN — p. 30

I thought I was sketching some rare Pokémon prints... It turned out they were my own footprints!

No more roadblock

Back in Oldale Town, the man who was sketching the rare Pokémon tracks has finished his work. It turns out that the tracks were, in fact, his own. What a goof! At any rate, the path to Route 102 is now open, so you're free to head on through. Consider stopping by the Pokémon Center to rest your party, and check out the Poké Mart to find new items for sale—Poké Balls and Antidotes.

TIP

Antidotes cure Poison, a nasty status condition that doesn't go away even after a battle ends. You'll soon be encountering wild Pokémon that can poison your party, so it's a good idea to carry a few Antidotes with you.

1 Check out those Wingull!

Your DexNav goes berserk as you enter Route 102. An overhead flock of Wingull has activated your DexNav! You've no chance at catching those high-flying Pokémon, but it's an impressive lesson in how sensitive your DexNav is. Tap the magnifying glass to open Detector Mode and see what data it could pick up about these passersby.

2 Take on a Pokémon Trainer!

If you have Pokémon with you, then you're an official Pokémon Trainer!

A bit farther ahead, your eyes lock with a young lad who happens to be an aspiring Pokémon Trainer. When two Trainers' eyes meet like this, a battle is sure to follow! Take on the youth in a Trainer battle and see if you can beat him. You can't catch another Trainer's Pokémon (that would be rude), but you'll earn some prize money if you win!

3 Battle more Trainers and pick some Berries

Harvested 2 Berries from the Oran Berry tree!

More Trainers await you along this popular route. Take on each one as you make your way west, and of course, keep an eye out for hidden Pokémon as you go. Your DexNav will alert you. It also won't be long before you spot a couple of Berry Trees. Harvest their fruit, which your Pokémon might find useful.

4 Find a free Potion

Orlando found a Potion!

After harvesting the Berries, continue along and battle a Lass. After that, hop the south ledge to find a Poké Ball lying on the ground. Inspect the Poké Ball to find a Potion inside! You don't get to keep the Poké Ball, only the Potion. Still, it's a nice find!

5 Eye some Beautifly with May/Brendan

Look! Up there! Check 'em out, Orlando!

May/Brendan catches up with you as you near the route's west end. The two of you watch in awe as a flock of Beautifly flutter past. She/he is headed for Petalburg City, which is just ahead. Your friend points out that your dad is the Gym Leader of Petalburg City, and then hurries on to take in the sights.

TIP

You know now that each move has PP, which decides how many times it can be used. So what happens if you run completely out of PP for all of your moves? Then you are just left with Struggle. Struggle is a unique move that a Pokémon can use when it cannot use any of its regular moves, but while it damages the target, it also deals 50% of that damage to the user.

TIP

Berries grow naturally around the Hoenn region, so keep your eyes peeled for them. You can feed them to your Pokémon by selecting them from your Bag. Berries are also unique because you can give them to your Pokémon to hold, and they'll munch on them if the need arises in battle. For example, Oran Berries restore some HP. If you give one to a Pokémon to hold and it's taking a pounding in battle, it will eat the Berry to restore its own HP. Eating a Berry doesn't even use up its turn!

TIP

Always keep an eye out for Poké Balls in the field. Red Poké Balls contain useful items like Potions or Antidotes. Yellow Poké Balls are more rare and contain precious TMs (Technical Machines). These special finds are used to teach new moves to your Pokémon, so do whatever it takes to claim them. Note that some items in the field can't be reached without taking roundabout routes or using special moves that open up new paths.

Here on Route 102, you have the chance to encounter a Psychic- and Fairy-type Pokémon, Ralts. Ralts can learn Teleport at Level 9, which instantly transports you back to a place where you can heal your Pokémon, such as a Pokémon Center, your home in Littleroot Town, and so on. This is just one of the many handy moves that you can use outside of battle as well as in battle. Below is a list of some of the moves you can get your hands on during your adventure.

Moves that can be used in the field

 Cut
Can be used to cut down thin, prickly trees in the field after you get the Stone Badge.

How to obtain: Visit Cutter's House in Rustboro City

 Rock Smash
Can be used to pulverize small boulders in the field after you get the Dynamo Badge. Boulders may contain items or Pokémon.

How to obtain: Receive it in Mauville City

 Dig
Can be used in caves to instantly transport you back to the entrance you used.

How to obtain: Receive from the Fossil Maniac's little brother on Route 114

 Strength
Can be used to move large boulders in the field after you get the Heat Badge.

How to obtain: Receive it on Route 112

 Surf
Can be used to surf across bodies of water on the back of your Pokémon after you get the Balance Badge.

How to obtain: Receive it after you get the Balance Badge in Petalburg City

 Fly
Can be used to fly back to towns, cities, and routes you've already visited after you get the Feather Badge.

How to obtain: Receive it on Route 119

 Dive
Can be used to dive underwater and explore deep underwater trenches after you get the Mind Badge.

How to obtain: Receive it after you get the Mind Badge in Mossdeep City

 Waterfall
Can climb up and down waterfalls on the back of your Pokémon after you get the Rain Badge.

How to obtain: Receive it after you get the Rain Badge in Sootopolis City

 Sweet Scent
Attracts hordes of Pokémon when used.

How to obtain: Normal level-up move of Pokémon like Surskit and Roselia

Teleport
Transports you back to the last place where your Pokémon had their health restored.

How to obtain: Normal level-up move of Pokémon like Ralts and Abra

 Flash
Lights up dark caves, letting you navigate them with greater ease.

How to obtain: Receive from the Hiker in Granite Cave near Dewford Town

 Secret Power
Helps you find the entrances to Secret Spots.

How to obtain: Receive it on Route 111

TIP

You'll learn more about using HMs and TMs to teach your Pokémon new moves on page 48!

PETALBURG CITY

Field Moves Needed Surf

A whiff of salt is always in the air in this city, which is skirted by the ocean shore.

Compared to the humble hamlets you've visited thus far, Petalburg City is a bustling place filled with people and activity. It is here that your dad, Petalburg City's Gym Leader, proudly takes on all comers at the Petalburg City Pokémon Gym!

Poké Mart	
Antidote	100
Poké Ball	200
Potion	300

Items
After learning Surf
☐ Ether
☐ Max Revive

Hidden Items
After learning Surf
☐ Rare Candy

 Azumarill Water Fairy
Abilities: Thick Fat, Huge Power

 Masquerain Bug Flying
Ability: Intimidate

On the Water	
❑ Azumarill	○
❑ Marill	◎
❑ Masquerain	▲
❑ Surskit	△

Wally's House

Petalburg City Gym (p. 140)

Poké Mart

To Route 104 (South) (p. 42)

Pokémon Center

To Route 102 (p. 36)

Fishing		
Old Rod		
❑ Goldeen	○	
❑ Magikarp	◎	
Good Rod		
❑ Corphish	▲	
❑ Goldeen	○	
❑ Magikarp	◎	
Super Rod		
❑ Corphish	◎	

◎ frequent ○ average △ rare
▲ almost never

1 Rest your Pokémon and visit the Poké Mart

You faced many battles on your way to Petalburg City, so head straight for the Pokémon Center and restore your Pokémon back to full health. Speak to everyone in the Pokémon Center for advice and information, and flip through the latest *Aha! Pokémon Journal* on the bookshelf. When you're done, go northeast and visit the Poké Mart to stock up on vital items—namely, Poké Balls!

TIP

You've likely caught several Pokémon by now, but you can only travel with six Pokémon at a time. Log on to the PC on the Pokémon Center's counter to view all of the Pokémon you've caught, even the ones that aren't with you. Use the PC to move Pokémon to and from your team, picking out the perfect party. You can learn more on page 63.

2 Chat with your dad near the Pokémon Gym

Why, if it isn't Orlando!

Go west from the Poké Mart to find Petalburg City's Gym. Out front is an aspiring Trainer talking to a rather serious-looking man. Hey, it's your dad! He's Petalburg City's Gym Leader, and he's pretty surprised to see that you've made it all the way to his city on your own. You then follow him into the Gym.

TIP

The girl in the Pokémon Center tells you the strengths and weaknesses of the first Pokémon partner you picked. Some folks really know their stuff! This is why it's important to speak with everyone you meet along your journey.

3 Help Wally catch a Pokémon

You go with Wally, and make sure that he safely catches a Pokémon.

Inside the Gym, your chat with your dad is cut short by the arrival of a sickly boy named Wally. Wally is about to be sent to his uncle's place in Verdanturf Town, where the air is cleaner. Wally would really like to catch a Pokémon before he goes, but he needs your help! Follow Wally back to Route 102 and keep an eye on him as he uses one of your dad's Pokémon to battle and catch a wild Pokémon of his own.

Pokémon-catching Tips

Here's how to improve your chances of encountering and catching wild Pokémon.

Reduce HP

Pokémon are much easier to catch when their health is low and they are close to fainting. For now, you may want to focus on not using your most powerful moves when battling a new Pokémon you want to catch, or use moves that are not very effective. Some special moves that you'll find during your adventure will be highly useful at reducing HP without defeating the Pokémon. Here are some to look out for in the future.

Moves useful to reduce HP:

- False Swipe (always leaves 1 HP)
- Super Fang (halves current HP)

> **TIP**
>
> These moves are not effective against Ghost-type Pokémon.

Inflict status conditions

Pokémon that have been affected by status conditions are easier to catch, especially status conditions that immobilize them, like Sleep, Paralysis, and Frozen. Moves that inflict the Frozen status condition won't be available until later in the adventure, but moves that inflict Sleep and Paralysis are available early on. Catch the following Pokémon to obtain these useful moves.

- Shroomish can be caught in the Petalburg Woods (p. 44). It can learn Stun Spore, which causes Paralysis. Check Shroomish's Ability, too. The Effect Spore Ability can sometimes inflict Paralysis or Poison, or cause the opposing Pokémon to fall asleep. All of these status conditions increase your chances of catching wild Pokémon.
- Gulpin can be caught on Route 110 (p. 81). It can learn Yawn very early, which causes Sleep.
- Oddish can also be caught on Route 110 (p. 81). It can learn Stun Spore, which causes Paralysis.

- Roselia can be caught on Route 117 (p. 102). It can learn Stun Spore, which causes Paralysis.

> **TIP**
>
> See page 420 for a list of Pokémon moves and the status conditions they inflict.

Attract more wild Pokémon

If one of your Pokémon knows the Sweet Scent move, you can use this move in the field to attract wild Pokémon. Oddish, encountered on Route 110, can learn Sweet Scent early on. Some items, like Honey, will also attract Pokémon to you—though often in hordes!

Use O-Powers

Once you receive the PlayNav upgrade for your PokéNav Plus, you can activate the O-Power Capture Power to temporarily increase your chances of catching Pokémon with Poké Balls. See page 91 for more on using O-Powers.

The wild Golbat can no longer escape!

Block their escape

Some Pokémon may try to escape from battle before you can catch them. As you reach the more advanced stages of the game, you can learn moves to help prevent that (like Mean Look or Spider Web). Some Pokémon even have Abilities that help prevent escape (like Shadow Tag and Arena Trap). Learn more about these moves and Abilities in the Adventure Data section at the back of the book.

Pokémon-catching Tips (cont.)

Use special Poké Balls. As you progress in the adventure and collect Badges from Gym Leaders, a variety of special Poké Balls will become available for purchase at Poké Marts. Some examples:

 Ultra Ball: A far more effective version of the standard Poké Ball that can be bought at Poké Marts all around Hoenn after you've obtained three Gym Badges.

 Quick Ball: Effective at the beginning of a battle for a chance to catch a Pokémon without having to weaken it first.

 Dusk Ball: Most effective when used to catch Pokémon encountered at night or in caves.

 Dive Ball: Most effective when used to catch Pokémon encountered while you're surfing across the water, diving underwater, or fishing for Pokémon.

Pokémon-catching notes

- You get Exp. Points whether you catch or defeat wild Pokémon, so don't feel obliged to defeat them.
- Critical captures can sometimes occur. You'll know you've scored a critical capture when the Poké Ball doesn't bounce or wiggle. The Pokémon is caught immediately! The more Pokémon you've caught, the better your chances of scoring a critical capture.

TIP

See page 455 for the complete list of Poké Balls, where to find them, and their unique benefits.

4 Receive the PlayNav upgrade

Wally updated Orlando's PokéNav Plus!

Back at Petalburg City's Pokémon Gym, Wally can't thank you enough for helping him catch his very own Pokémon. His spirits lifted, Wally happily upgrades your PokéNav Plus with the PlayNav upgrade. Now you can play games with your Pokémon, train them up, and even connect with other *Pokémon* players around the world!

PlayNav Features

Your PlayNav has three different features: PSS (Player Search System), Pokémon-Amie, and Super Training.

Battle: Take on other players via infrared connection, local wireless, or the Internet. Simply tap the icon of any player who appears in the PSS, or use the Battle Spot feature to find players to battle.

Trade: Swap Pokémon with other players via infrared connection, local wireless, or the Internet. Just tap the icon of any player who appears in the PSS, or use the GTS (Global Trade Station) or Wonder Trade. In Wonder Trade, you don't know what kind of Pokémon you'll receive. It's a thrilling way to trade!

O-Power: Activate O-Powers for a variety of benefits, or give O-Powers to other players (p. 405).

Communication: View other players' profiles, send them messages, and more.

Holo Caster: Get the latest announcements via SpotPass.

Game Sync: Sync up your progress in the game with the Pokémon Global Link (PGL) (p. 415).

PSS (Player Search System) (p. 401)

The PSS helps you interact with other players, whether they are nearby or in another part of the world (p. 401). Here's what you can do with the PSS.

PlayNav Features (cont.)

Pokémon-Amie (p. 412)

This PlayNav feature lets you play with your Pokémon, pet them, and even feed them treats to make them more affectionate toward you. Affectionate Pokémon sometimes cure themselves from status conditions, avoid attacks, or land more critical hits.

Here's what you can do in Pokémon-Amie:

Play with your Pokémon: Play mini games, pet them, make funny faces at them, and more.

Feed your Pokémon: Feed them delicious treats called Poké Puffs.

Decorate: Customize your Pokémon-Amie wallpaper.

Super Training (p. 409)

This PlayNav feature lets you raise your Pokémon's base stats through various training regimens. A Pokémon's base stats affect its stats, like Attack and Defense, and increasing them is key to making it through tough battles.

Here's how you can train them in Super Training:

Core Training: Punch training bags and get a good workout.

Super-Training Regimens: Shoot balls into goals while dodging inbound balls fired from Balloon Bots.

5 Visit Wally's parents, and then go to Route 104

> Thank you for helping our Wally out back there.

You've come a long way, but you're not yet strong enough to challenge your dad to a Pokémon battle. Instead, Norman advises you to head for Rustboro City, which features another Pokémon Gym. Finish exploring Petalburg City and speak to everyone in town, including Wally's grateful parents. They'll tell you that Wally has already struck out for Verdanturf, so you'd best continue your own journey as well!

ROUTE 104 (SOUTH)

Field Moves Needed
Cut

This path, rich with water and colorful plant life, runs north and south of Petalburg Woods.

Route 104 is home to even more wild Pokémon. In the middle of the route lies Petalburg Woods, a forest with multiple paths that connect to different areas of Route 104. You'll be exploring both places at once, moving into and out of Petalburg Woods to visit all of Route 104. This section covers Route 104's southern half.

Fishing

Old Rod
☐ Magikarp	◎

Good Rod
☐ Magikarp	◎

Super Rod
☐ Magikarp	◎

◎ frequent ○ average
△ rare ▲ almost never

Tall Grass
☐ Taillow	▲
☐ Wingull	△
☐ Wurmple	◎
☐ Zigzagoon	◎

Horde Encounters
☐ Wingull	▲
☐ Zigzagoon	◎

On the Water
☐ Pelipper	▲
☐ Wingull	◎

Items
☐ Poké Ball

Hidden Items
☐ Antidote
☐ Heart Scale
☐ Potion

Wingull `Water` `Flying`
Ability: Keen Eye

To Petalburg
Woods (p. 44)

To Petalburg
Woods (p. 44)

Berry Trees

Rich Boy Winston ◉
◉◉◉◉◉◉

Mr. Briney's
Cottage

To Petalburg
City (p. 38)

Youngster Billy
◉◉◉◉◉◉

To Route 105
(p. 145)

1 Check out the beach

Route 104's southern half features a sandy shoreline that you can sprint along. You can't catch the Wingull you see sunning on the beach, but you can run through them to send them flying away! Enjoy this refreshing change of scenery as you battle Trainers and explore.

TIP

Did you notice the item on the ledge near the boy? It's a Poké Ball, but you can't reach it from here. You'll need to enter Petalburg Woods and loop around to claim it.

2 Meet Mr. Briney

Hoh hoh hoh hoh!
My pretty Peeko's as full of energy as usual!

The cottage at the beach's northern end is home to a friendly old-timer named Mr. Briney. Speak with him and say hi to his pet Wingull, Peeko. If you like, stroll through the nearby tall grass in search of a wild Wingull to catch for your own! It's a very fast Pokémon, with relatively few weaknesses.

TRAINER
HANDBOOK

ADVANCED
HANDBOOK

ADVENTURE
DATA

3 Help a Trainer in Need

Will you give him one of your Potions?
▶ Yes
No

To the east of Mr. Briney's cottage, a little boy is in need of help. Speak with the lad to learn that his Pokémon has grown very weary. The boy asks if you could spare a Potion to help his Pokémon recover. The child has nothing to offer in return except his gratitude, but that's no reason not to help him out!

TIP

Route 104 and Petalburg Woods are filled with Trainers and wild Pokémon. Don't hesitate to return to the Pokémon Center in Petalburg City and rest your Pokémon. You can also use the Pokémon Center's PC to move Pokémon out of your party, swapping them for any new ones that you've caught.

4 Harvest some Berries, and then head into the woods

Harvested 2 Berries from the Oran Berry tree!

Two Berry Trees stand just north of the boy. Harvest two Oran Berries and two Pecha Berries from these trees, and then continue toward Petalburg Woods. Battle a Rich Boy just before you enter the woods for a significant sum of winnings.

TIP

Some Trainer types tend to yield more prize money than others. Gym Leaders and their ilk pay out quite a lot, but the Rich Boys and Ladies that you'll encounter also have deep pockets! As you'd expect, younger Trainers like Bug Catchers and Lasses don't have a lot of extra cash around—nor do Swimmers. Where would they keep it?

PETALBURG WOODS

Field Moves Needed Cut

This dense forest, with its abundance of trees, is well known to be a favorite habitat of Shroomish.

Many secrets lie hidden in the thick tangles of Petalburg Woods. This forest stands smack in the middle of Route 104, splitting the route into two halves.

Bug Catcher James
◉◉◉◉◉◉

To Route 104
(North)
(p. 46)

Bug Catcher Lyle
◉◉◉◉◉◉

To Route 104
(South)
(p. 42)

To Route 104
(South)
(p. 42)

Items

- ☐ Ether
- ☐ Exp. Share
- ☐ Paralyze Heal

After learning Cut
- ☐ Great Ball
- ☐ Miracle Seed
- ☐ X Attack

Hidden Items

- ☐ Balm Mushroom
- ☐ Potion

After learning Cut
- ☐ Tiny Mushroom ×2

Tall Grass

Pokémon	Rarity	
☐ Cascoon	△	
☐ Shroomish	△	
☐ Silcoon	△	
☐ Slakoth	▲	
☐ Taillow	▲	
☐ Wurmple	○	
☐ Zigzagoon	○	

Horde Encounters

Pokémon	Rarity	
☐ Shroomish	▲	
☐ Wurmple	◎	
☐ Zigzagoon	○	

◎ frequent ○ average △ rare
▲ almost never

Zigzagoon `Normal`
Abilities: Pickup, Gluttony

Taillow `Normal` `Flying`
Ability: Guts

TRAINER HANDBOOK

ADVANCED HANDBOOK

ADVENTURE DATA

Orlando found a Pokè Ball!

Just visiting

Your first foray into Petalburg Woods is brief. Go east and take the southern trail back to Route 104, and you'll be right next to the item you recently saw there. Collect the item to pocket a Poké Ball, and then return to Petalburg Woods.

1 Explore the woods

Go, go, go!
My Bug Pokémon team!

Reenter Petalburg Woods, and this time, go west to battle a Trainer who has caught multiple Bug-type Pokémon. There's another item nearby as well. It's a Paralyze Heal! This valuable item removes the Paralysis status condition.

2 Rescue a Devon Corporation researcher

No one who crosses Team Magma gets any mercy, not even a kid!

No one who crosses Team Aqua gets any mercy, not even a kid!

Continue advancing along the forest's winding path, searching the tall grass for wild Pokémon as you go. You'll soon encounter a friendly employee of the Devon Corporation who's searching the woods for Shroomish. Before you can help the researcher, you're suddenly ambushed by a member of Team Magma / Team Aqua! Battle the aggressive Grunt to drive him off.

Team Magma Grunt's Pokémon ⊖⚪⚪⚪⚪⚪

The type of adversary you face at this point hinges on the version of the game you're playing. You face a Team Magma Grunt if you're playing *Pokémon Omega Ruby.*

⦿ **Poochyena** **Dark**
♂ Lv. 9
Weak to: Fighting Bug Fairy

Team Aqua Grunt's Pokémon ⊖⚪⚪⚪⚪⚪

The type of adversary you face at this point hinges on the version of the game you're playing. You face a Team Aqua Grunt if you're playing *Pokémon Alpha Sapphire.*

⦿ **Poochyena** **Dark**
♂ Lv. 9
Weak to: Fighting Bug Fairy

3 Receive the Exp. Share

Orlando obtained the
Exp. Share!

Beaten, the Team Magma / Team Aqua Grunt flees the scene, but not before hinting that his cohorts are up to mischief in Rustboro City. Relieved that the Grunt wasn't able to steal his research papers, the grateful Devon employee gives you a handy item: the Exp. Share. Now every Pokémon in your party will receive Exp. Points from battles, even those that don't participate!

TIP

The Exp. Share is automatically turned on, but you can turn it off by visiting the Key Items section of your Bag. It's best left on, however, for all of your party Pokémon will now gain Exp. Points and grow steadily stronger. They will also share any base-stat gains received from battling. See page 325 for more about base-stat training. If you want to reduce the base-stat gains your other party members have received from the Exp. Share, there are ways to do that, and they'll be explained in that section.

4 Tricky times ahead

...Phew!

...Phew!

Proceed north through Petalburg Woods, collecting an Ether as you make for Route 104's northern half. As you exit the woods, the scene shifts to show another Team Magma / Team Aqua Grunt reporting to her superior about their failure. What energy could she be talking about?

Whatever the case may be, it seems clear that a conflict is brewing in Hoenn. Team Magma / Team Aqua appear to be at odds with the Devon Corporation, and they sure aren't playing by the rules. You'd best be on your guard!

TIP

An unusual tree with prickly thorns lies at Petalburg Woods' north end. The trail continues beyond this tree, but you don't have the means of exploring it yet. You need a Pokémon that can use Cut to explore further! Remember this location, though, for you'll soon be returning for a Great Ball and an X Attack.

ROUTE 104 (NORTH)

Field Moves Needed — Cut, Surf

This path, rich with water and colorful plant life, runs north and south of Petalburg Woods.

Route 104 stretches on beyond the Petalburg Woods. The northern half of this route features the Pretty Petal flower shop, which is run by three green-thumbed sisters. The walls of Rustboro City stand just north of the route's central lake.

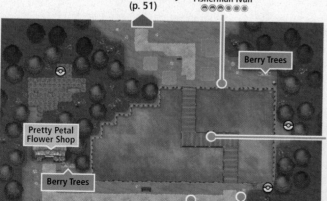

To Rustboro City
(p. 51)

Fisherman Ivan
●●●●●●●

Berry Trees

Pretty Petal
Flower Shop

Twins Gina & Mia
★ Double Battle
●●●●●●

Berry Trees

To Petalburg Woods
(p. 44)

Lady Cindy
●●●●●●●

Lass Haley
●●●●●●●

Horde Encounters

☐ Taillow	▲
☐ Zigzagoon	◎

Fishing

Old Rod	
☐ Magikarp	◎
Good Rod	
☐ Magikarp	◎
Super Rod	
☐ Magikarp	◎

Tall Grass

☐ Taillow	△
☐ Wingull	▲
☐ Wurmple	◎
☐ Zigzagoon	◎

On the Water

☐ Pelipper	▲
☐ Wingull	◎

◎ frequent ○ average
△ rare ▲ almost never

Pretty Petal Flower Shop

After Earning 5 Badges

❑ Big Plant	3,000
❑ Colorful Plant	3,000
❑ Elegant Bonsai	3,000
❑ Flowering Plant	2,000
❑ Red Flower	2,000
❑ Tropical Plant	2,000

Items

❑ TM49 Echoed Voice
❑ Wailmer Pail
❑ X Attack

After learning Cut

❑ Revive

After learning Surf

❑ PP Up
❑ White Herb

Hidden Items

❑ Poké Ball
❑ Super Potion

1 Receive TM49 Echoed Voice

Orlando obtained
TM49 Echoed Voice!

As you enter Route 104's northern half, go west and speak with a boy in a ball cap. The kid has a noisy habit of shouting his lungs out, but after hollering at you, he hands you TM49 Echoed Voice. Now you can teach your Pokémon to use a powerful move that grows stronger and stronger when used repeatedly in battle!

Teaching Your Pokémon Moves

Zigzagoon learned Echoed Voice!

Your Pokémon will naturally learn new moves as they level up, but you can also help them learn many more moves than the ones natural to their Evolution line. Now that you've gotten your first TM (Technical Machine), you can start experimenting with raising your Pokémon to be exactly as you want them to be.

Here are some things to keep in mind when teaching your Pokémon new moves:

Pokémon can only learn four moves. If your Pokémon already knows four moves, you'll have to tell it to forget one in order to teach it a new move. Sometimes you'll realize later that you should have kept a move that you chose to forget. If that happens, you can visit the Pokémon Move Maniac in Fallarbor Town (p. 118). In exchange for a Heart Scale, he can help your Pokémon learn (or relearn) any level-up move up to its level.

An HM is forever. Or nearly so. You cannot forget an HM to learn another move. The only way to forget an HM is to visit the Move Deleter in Lilycove City (p. 181), so think carefully before filling your Pokémon's move slots with lots of HMs. The Move Deleter can help you delete any moves, not just HMs.

Same-type attack bonuses are brutal. When your Pokémon has the same type as a move that it uses, that move will get a 50% boost. This means that you may want to teach your Grass-type Pokémon some great Grass-type moves, for example, because it can do more damage with them than a Pokémon of another type, such as Normal type, would do.

Balance is also vital. You'll want some variety of moves, especially if you plan to battle other Trainers. If you teach your Grass-type Pokémon all Grass-type moves, it won't be much help against Bug-, Dragon-, Fire-, Flying-, Poison-, Steel-, or other Grass-type Pokémon. Your opponent might send out some of these types, guessing that your Grass-type Pokémon will know mostly Grass-type moves. So mix things up and add some unexpected moves!

Play to your strengths. Each move has a category, either physical, special, or status.

☀ Physical moves are more powerful with a high Attack stat, and the best protection against them is a high Defense stat.

◎ Special moves are more powerful with a high Sp. Atk stat, and the best protection against them is a high Sp. Def stat.

◔ Status moves inflict no damage, but instead inflict status conditions or have other effects. They could increase your Pokémon's stats and defenses, or decrease the stats of an opposing Pokémon, or inflict a status condition that affects the opposing Pokémon, such as Poison or Paralysis.

Teaching Your Pokémon Moves (cont.)

Evolution has effects. Sometimes Pokémon in the same evolutionary line can learn different moves. For example, Treecko can naturally learn Giga Drain at Level 21, but its Evolution Sceptile cannot. Check out move tables, like those in official Pokédexes, carefully to help you decide if you might want to hold off on evolving a Pokémon to help it learn a great move—or maybe evolve it as soon as possible to get access to a great move.

TIP

Most Pokémon tend to be higher in one stat than the other, so play to their strengths by teaching Pokémon with high Attack stats more physical moves, and Pokémon with high Sp. Atk stats more special moves. For more on stats, turn to page 74.

Use TMs to teach moves

Technical Machines contain moves that can be taught to many Pokémon. Not every Pokémon can learn every TM move, but they do open up the world of customizing your team to seemingly infinite possibilities. Open your Bag and go to the TMs & HMs section to see the TMs you have. As you browse, you will see that the Pokémon on your team will either be able or unable to learn the move it contains.

Use HMs to teach moves

HMs (Hidden Machines) are used just like TMs and can be accessed from your Bag in the same way. They can be used in battle, but some also have special effects in the field. To use them in the field, you may need to have a certain number of Badges. See page 433 for more about these field effects.

Learn moves from Move Tutors

Some people around the region can teach moves to Pokémon. You'll find that most of them flock to the fancy new facilities in Mauville City (p. 89), though there is also one in Sootopolis City (p. 234).

2 | Pop by the Pretty Petal flower shop

Enter the building to the north of the boy to visit the Pretty Petal flower shop. Speak with the sisters who run the shop to learn about Berries. The youngest one will give you a random Berry, while another will give you the Wailmer Pail. With this item, you'll be able to grow healthy Berry Trees of your own!

TIP

Visit the Pretty Petal flower shop each day to receive a random Berry from the youngest sister. She'll give you either a Cheri, Chesto, Pecha, Rawst, Aspear, Leppa, Oran, or Persim Berry.

3 | Plant some Berry Trees

Exit the Pretty Petal flower shop and harvest some Berries from the Berry Trees out front. After harvesting the Berries, you can plant more to harvest later. And don't forget that you can plant Berries in the patches of soil where you previously harvested Berries on Routes 102 and 104 (South).

All about Berries

Berries are wonderful items with a variety of benefits. You can use them outside of battle to restore a Pokémon's HP, heal its status conditions, and provide other effects.

You can also give your Pokémon Berries to hold. If a Pokémon is holding a Berry, it will automatically use the Berry during battle as needed, without spending a turn. For example, if your Pokémon is holding a Cheri Berry and becomes afflicted with the Paralysis status condition, that Pokémon will automatically eat the Cheri Berry and heal its Paralysis. Pokémon can't do this with items you can buy in shops, like Antidotes, because they don't know what to do with man-made objects. This makes Berries very useful during battle!

Berries are also an ingredient of Pokéblocks (p. 358). Pokéblocks are great snacks that you can use to raise a Pokémon's conditions for Contest Spectaculars (p. 359). You can make Pokéblocks by mixing up Berries with a Pokéblock Kit (p. 358).

How to get Berries

Harvested 2 Berries from the Oran Berry tree!

Some people give you Berries, and you can also harvest Berries from trees in certain places (p. 458). You can even grow your own Berries in soft soil after harvesting Berries from trees!

It's soft soil.

Berries grow on trees that thrive in soft soil, such as the patch in front of the Pretty Petal flower shop. It's a good habit to plant a Berry after harvesting Berries

from a tree. The soil will be dry after you plant a Berry, so remember to water it with the Wailmer Pail that one of the sisters in the shop gave you. Water them whenever the soil is dry, and you'll reap a bigger Berry harvest when the tree grows!

The soil is dry... Would you like to water it?

Growing Berries takes time. Berry Trees have different growing rates. Some grow fast, while others take longer to bear their fruit. The number of Berries that grow from a tree depends on the type of Berry Tree as well as the number of times you water the soil. If you don't pick the Berries, they'll drop off onto the ground. Don't worry, they'll sprout again!

Tracking Berries

Want to check where you've planted Berries? It's easy! Just open your AreaNav and tap "Berries" at the bottom of the Touch Screen. The areas where you've planted Berries will be indicated by the dotted lines. Press Ⓐ to view details in the Berry list, and you can see which stage of growth your Berries are in. When your Berries have ripened for picking, Berry symbols will be shown on the Berry list. If your Pokémon knows the move Fly (p. 173), press Ⓐ while viewing the Berry list, and you can fly directly to that location to water your trees or harvest your crop!

When you've finished planting Berries near the Pretty Petal flower shop, explore behind the shop to discover an X Attack among the tall grass. Backtrack around the shop afterward, and then go east and north across a wooden bridge that spans some water. (Hey, it's another one of those prickly trees! Remember its location!) Twin Pokémon Trainers will challenge you to a daring Double Battle as you cross.

Tips and Strategies for Multi-opponent Battles

In some battle formats, you will be facing multiple opponents at once, and your regular strategies may not serve you well when your Pokémon is taking multiple attacks in a row. Use the following tips to modify your tactics for these challenging battles.

Useful offensive moves in Double Battles, Triple Battles, and Horde Encounters

During battles against multiple Pokémon, it's important to weaken or affect as many of the opposing Pokémon as possible each turn. Moves that target multiple Pokémon, or moves that cause opposing Pokémon to flinch and lose their turn, are extremely useful. Here are some examples of these types of offensive moves.

Fake Out. This move can cause an opposing Pokémon to flinch, preventing it from using its move this turn. Makuhita, which can be received in trade in Rustboro City (nicknamed Makit) or caught in Granite Cave, can learn this move, as can Skitty, found just east of Rustboro City on Route 116.

Moves that affect "the opposing Pokémon," such as Tail Whip, String Shot, Bulldoze, and Air Cutter. Look closely at a move's description. If it says that it targets "opposing Pokémon" instead of "the target," then it will affect multiple opposing Pokémon, potentially the entire opposing team! Zigzagoon, found on Route 101, can learn Tail Whip. Wurmple, found in Petalburg Woods, can learn String Shot. Many Flying-type Pokémon can learn Air Cutter, like Wingull, which is found on Route 104. TM78 Bulldoze can be bought in Mauville City and taught to many Pokémon that can use Ground-type moves.

Useful defensive moves in Double Battles, Triple Battles, and Horde Encounters

Defending your party against the opposing team's moves is also important during battles against multiple Pokémon. Use moves that raise the defenses and resistances of your whole party, and you'll quickly turn the tide of battle. Here are some examples of moves that shelter your party from the opposing team's offenses.

Mist. Wingull, found on Route 104, can learn this move, which protects the entire party from stat-reducing moves for five turns.

Protect and Detect. These moves can protect your Pokémon from most opposing moves.

TIP
See page 420 for a list of Pokémon moves.

Combos involving your first partner Pokémon's final Evolution

When the very first Pokémon you picked from Professor Birch's Bag is fully evolved, it can learn devastating moves. These moves won't come into play until much later in the adventure, and although they're quite strong, they can be made even stronger by pairing them with other moves, such as the following.

- Ally Pokémon's Sunny Day (move) + Sceptile's Solar Beam (move)
- Ally Pokémon's Fake Out (move) + Blaziken's Focus Energy (move)
- Ally Pokémon's Discharge (move) + Swampert*

*Swampert is also Ground type, so it is not affected by the Electric-type move Discharge.

Score more Berries and find a hidden item

After the Double Battle, finish crossing the bridge and speak to a kindly old lady. She'll give you a Chesto Berry. Harvest some Berries from the nearby trees as well, and then plant more Berries in the soft soil. Rustboro City is just ahead, but before you pass through the main gate, search around the eastern side of the city's walls to find an X Defense. Press Ⓐ at the end of the path to collect it, even though it's tough to see. You'll technically be inside Rustboro City when you find this item.

RUSTBORO CITY

This city is the main hub of industry in the Hoenn region, with the Devon Corporation as its beating heart.

Rustboro City is a bustling metropolis that's filled with Pokémon fanatics. In addition to the familiar Pokémon Center and Poké Mart, you'll also find a Pokémon Gym and Trainers' School among the city's sturdy stone buildings. Gym Leader Roxanne awaits your challenge!

To Route 115 (p. 129)

Devon Corporation

To Route 116 (p. 58)

Rustboro City Gym (p. 55)

Pokémon Trainers' School

Cutter's House

Pokémon Center

Poké Mart

To Route 104 (North) (p. 42)

Poké Mart

Antidote	100
Poké Ball	200
Potion	300
After obtaining the Stone Badge	
Awakening	250
Burn Heal	250
Great Ball	600
Ice Heal	250
Paralyze Heal	200
Repel	350
Super Potion	700
After obtaining a Repeat Ball	
Net Ball	1,000
Repeat Ball	1,000
Timer Ball	1,000

Items

- ❑ Float Stone
- ❑ HM01 Cut
- ❑ Quick Claw
- ❑ Premier Ball
- ❑ TM54 False Swipe
- ❑ X Defense

TRAINER HANDBOOK

ADVANCED HANDBOOK

ADVENTURE DATA

1 Meet May/Brendan near the Poké Mart

It's really big here, isn't it? Littleroot can't even compare.

The Poké Mart is the first building you'll see in Rustboro City, and who steps out of it but your friend May/Brendan. Appreciate the size of the city together, and then watch as she/he dashes off to face Roxanne, the local Gym Leader. You probably want to do the same, but this will be your first Gym challenge, so take time to prepare, and check out everything the city has to offer first.

2 Revive TM54 False Swipe

Orlando obtained TM54 False Swipe!

Enter the Poké Mart after May/Brendan departs and speak with the swanky-looking man near the counter. He'll give you TM54 False Swipe as part of a free promotion. Teach this invaluable move to one of your Pokémon, and you'll have a much easier time weakening wild Pokémon for the catching. Remember that it is one of the moves that always leaves its target with 1 HP. If you need some new team members to help you take on the Rustboro City Gym Leader, you'll definitely want to use this move.

TIP

Just open your Bag to the TMs & HMs Pocket and select False Swipe from your growing collection of TMs. Then choose Use and teach it to one of your Pokémon that is able to learn it. That's how easy TMs are!

3 Visit Cutter and receive HM01 Cut

Orlando obtained HM01 Cut!

The Pokémon Center can be found north of the Poké Mart. After resting your party, enter the home to the west of the Pokémon Center, which features two prickly trees out front. This is Cutter's House. Speak with Cutter to receive HM01 Cut. Teach this move to one of your Pokémon, and you'll finally be able to cut down those prickly trees you've seen—after you've won the Stone Badge, that is.

TIP

Talk to the man inside the Pokémon Center, and he'll tell you what kind of Trainer Type you resemble. If you agree with his assessment, your PSS profile icon will be changed accordingly. Or you can disagree and choose a Trainer type for yourself. You can also view and change your PSS profile icon anytime by opening the PlayNav, choosing the PSS, and editing your profile.

4 Get schooled and snag a Quick Claw

Orlando obtained a Quick Claw!

After receiving HM01 Cut from Cutter, enter the building to the east of the Pokémon Center to visit the Pokémon Trainers' School. Talk to everyone inside for tips and advice, including descriptions of each Badge. The teacher at the podium forks over a handy Quick Claw. Give this item to one of your Pokémon to hold, and that Pokémon will have a good chance to act first during battle! Check the blackboard to learn about status conditions before you leave.

Held Items and Their Uses

Some items, like the Quick Claw, can be held by Pokémon. Some of these held items are useful during battles or outside of battles.

To easily identify items that will have an effect once held by Pokémon, open your Bag, select the ITEMS Pocket, and then tap the icon at the bottom of the Touch Screen that looks like two arrows chasing each other. This calls up a side menu with options that let you sort the items in the Pocket however you like. Choose to sort your items "By Type," and items that have an effect once held by Pokémon will be grouped at the top of the list. Whenever you obtain a new item, check your Bag and see how it can be used.

Useful held items for battles

Many held items grant your Pokémon special benefits during battles. Here are some examples of useful held items for battles:

 Amulet Coin. Doubles the prize money you win from Trainer battles if the holding Pokémon joins the battle.

 Lucky Egg. The holding Pokémon earns more Exp. Points, helping it level up faster.

 Leftovers. The holding Pokémon slowly recovers HP during battle.

 Smoke Ball. The holding Pokémon will be successful if you attempt to flee from any wild Pokémon encounter.

 Various Plates, such as Splash Plate and Zap Plate. These items boost the power of certain types of moves when held, as indicated by the Plate's description.

Useful held items outside of battle

Some held items grant benefits while you're exploring the field outside of battle. Here are just a few examples:

 Cleanse Tag. Helps keep wild Pokémon away, reducing the chances of encountering wild Pokémon.

 Everstone. Prevents the holding Pokémon from evolving. It's also useful passing down certain traits of Pokémon left at the Pokémon Day Care.

 Soothe Bell. Increases the rate at which the holding Pokémon will become friendly toward you.

TIP
See page 444 for the complete list of items and their uses.

See page 444 for the complete list of items and their uses.

5 | Delve into the Devon Corporation

Rustboro City's impressive northwest building houses the Devon Corporation's offices. You aren't allowed to explore much of this building, but if you visit the tall building to the south, you can check out the Devon employees' living quarters. You'll meet all sorts of characters inside, and you'll get your hands on a Float Stone and a Premier Ball. You might even get a little surprise when you come back downstairs from the top floor. Apparently the Float Stone really works, for the man who gave it to you has put on a little weight!

6 | Trade your Slakoth for a Makuhita

Darrell sent over Makit.

Rustboro City's Gym beckons, but before you enter the Gym, visit the home to the east. Inside, a boy is eager to trade his Makuhita for your Slakoth, provided you caught a Slakoth back in Petalburg Woods. Go ahead and make the trade if you're able, for Makuhita is a powerful Fighting-type Pokémon that will be of great value in the Gym!

TIP

Pokémon that you receive in trades like this, or by trading with other Pokémon players over PSS, will gain more Exp. Points from battles and level up faster than normal. This boy's Makuhita is also holding an X Attack to sweeten the deal.

7 | Prepare for the Gym by exploring Routes 115 and 116

Orlando found a Zinc!

If you'd like every advantage going into the Rustboro City Gym, feel free to pop out to one corner of Route 115 to the north (p. 129) and explore Route 116 to the east (p. 58). It's not necessary to visit these routes right now, but you'll find useful items, more Trainers to battle, and more wild Pokémon to catch.

TIP

If you opt to explore Routes 115 and 116, be sure to bring Pokémon with you for the coming Gym battle. Roxanne is a Rock-type Pokémon user, so bring along Water-, Grass-, and Fighting-type Pokémon, which are strong against Rock types. This way, you'll level up these vital Pokémon as you participate in battles while exploring these optional routes. Ground- and Steel-type Pokémon are also strong against Rock types, but you haven't had a chance to catch any of those Pokémon yet.

8 | Challenge Roxanne and win the Stone Badge!

Rustboro City Pokémon Gym
Leader: Roxanne

When you're ready to earn your first Badge, rest your Pokémon at the Pokémon Center, save your game, and then head for the Rustboro City Gym, with its distinctive yellow roof. The time has come to challenge Roxanne, Rustboro City's Gym Leader!

TRAINER HANDBOOK

ADVANCED HANDBOOK

ADVENTURE DATA

RUSTBORO CITY GYM BATTLE

Gym Battle Tips

- Make sure to bring lots of Potions to keep your team in fighting condition.
- Trading for Makuhita with the boy in the house near the Gym will give you an advantage, because Fighting-type moves are super effective against Rock types, and Makuhita is resistant to Rock-type moves thanks to its Fighting type. Steel types would have a similar advantage, but you haven't yet had the chance to find any in the wild.

Gym Leader Roxanne ⊙⊙⊙⊙⊙⊙

Schoolkid Georgia ⊙⊙⊙⊙⊙⊙

Youngster Tommy ⊙⊙⊙⊙⊙⊙

Youngster Josh ⊙⊙⊙⊙⊙⊙

Entrance

1 Meet Roxanne inside the Gym

> I am Roxanne, the Rustboro City Pokémon Gym Leader.

Gym Leader Roxanne greets you inside Rustboro City's Gym. She's eager to see what you're made of and takes her place at the back of the Gym. The stage is set for a showdown!

2 Battle or avoid Trainers as you navigate the Gym

Rustboro City's Gym doubles as an impressive Fossil museum. An array of exhibits are displayed here, and you can examine them all. In short, it's a Rock-type Pokémon lover's dream Gym! So it makes sense that several Trainers who use Rock-type Pokémon stand between you and Roxanne. You can avoid these Trainers if you're careful not to make eye contact with them, but defeating them will earn you money and Exp. Points, and it will give you a taste of what Roxanne has in store for you.

TIP

If your Pokémon faint or become weary on your way to Roxanne, leave the Gym and rest them at the Pokémon Center. When you return, you won't have to rebattle any of the Trainers that you beat before. Battling every Trainer in the Gym is a good way to get some extra experience.

Roxanne Rock-type Pokémon User

♐ Rustboro City Gym Leader

Use Water-, Grass-, Ground-, and Fighting-type moves to smash her fast!

Like the other Trainers you may have faced in this Gym, Roxanne begins the battle with Geodude. This tough customer possesses the Sturdy Ability, giving it a chance to survive even after you've dealt a blow that should have caused Geodude to faint in one hit. Couple this Ability with Roxanne's HP-restoring Potions, and you may find yourself battling Geodude for what feels like a long time. Keep in mind that because Geodude is Ground type, Electric-type moves will not affect it.

After Geodude falls, Roxanne brings out her other Pokémon, Nosepass. This Rock-type Pokémon's level is even higher than her Geodude's, making Nosepass a bigger threat. Keep hammering away with Water-, Grass-, Ground-, and Fighting-type moves to wallop Nosepass and earn your very first Gym Badge, along with TM39 Rock Tomb!

Roxanne's Pokémon

Geodude ♀ Lv. 12		Rock	Ground	
Weak to:	4× Water	4× Grass	Ice	Fighting
	Ground	Steel		

Nosepass ♀ Lv. 14			Rock	
Weak to:	Water	Grass	Fighting	Ground
	Steel			

Stone Badge

Pokémon up to Lv. 20, including those received in trades, will obey you. You can now use the HM move Cut outside of battle, enabling you to cut down the thorny trees that have been blocking your path.

TM39 Rock Tomb

Boulders are hurled at the target. This also lowers the target's Speed stat by preventing its movement.

Getting your first Badge marks you as a serious Trainer, and you'll find that the clerks at Poké Marts now offer you more items! Revisit any Poké Mart in Hoenn, and you'll find Great Balls and Super Potions added to the inventory. They are both more-effective versions of the Poké Balls and Potions that you're used to. You'll also find more status condition-healing items (Paralyze Heal, Awakening, Burn Heal, and Ice Heal) and the wonderful item Repel, which will keep low-level Pokémon away from you for a time. It's always handy to have a Repel in your Bag when you're down to just one Pokémon and not sure you'll make it to the next Pokémon Center!

3 Stop, thief!

Out of the way! Move it!

Out of the way! Move it!

As you exit Rustboro City's Gym with your shiny Stone Badge, a Team Magma / Team Aqua Grunt comes rushing through the streets. He's being chased by a Devon researcher—the same one you rescued back in Petalburg Woods. The Grunt has managed to steal some valuable parts called Devon Parts from the researcher and has fled to Route 116. You'd better help get them back!

◀◀ **BACKTRACK** | **ROUTE 104 (NORTH)** | p. 46

Would you like to use Cut?

Yes
No

Cut some trees, if you please!

Armed with the Stone Badge, you're now able to use HM01 Cut in the field. Don't have HM01 Cut? Visit Cutter's House in Rustboro City (just west of the Pokémon Center) and get it so you can teach it to one of the Pokémon in your party! Backtrack through Route 104, crossing the bridge and using Cut to remove the prickly tree at the bridge's south end. Beyond that tree lies a Revive, which can bring one of your Pokémon back after it has fainted.

◀◀ **BACKTRACK** | **PETALBURG WOODS** | p. 44

Orlando obtained a Miracle Seed!

Orlando found a Great Ball!

Score a special item

But wait, there's more! Continue backtracking into Petalburg Woods, then Cut the prickly tree near the woods' north end. Explore the path beyond the tree and speak to a kid to receive a Miracle Seed. When held by a Pokémon, this valuable item boosts the power of its Grass-type moves!

Finish your explorations of Petalburg Woods

Continue exploring the path beyond the prickly tree to find a Great Ball and an X Attack. That's a wrap! Head back to Rustboro City, rest your Pokémon, and then journey east to Route 116 in pursuit of the Team Magma / Team Aqua Grunt.

TIP

You will generally find more items available for sale at the Poké Marts every time that you earn a new Gym Badge. You'll probably want to visit the Pokémon Center after each Gym battle anyway, to restore your team to fighting condition, but make it a habit to also pop in the Poké Mart and check out what's new. Get ready to spend some of that hard-earned prize money you got from the Gym Trainers!

ROUTE 116

Field Moves Needed
Cut

A path that many workers take on their daily commute between Rustboro City and the Rusturf Tunnel.

This well-traveled route is used by the workers digging the Rusturf Tunnel. The tunnel was planned to connect Rustboro to Verdanturf Town, but progress on it has all but halted.

Lass Janice

Youngster Joey

Schoolkid Jerry ☻

To Rusturf Tunnel (p. 59)

Berry Trees

Tunnelers' Rest House

To Rustboro City (p. 51)

Schoolkid Karen ☻

Hiker Clark

Bug Catcher Jose

To Rusturf Tunnel (p. 59)

Tall Grass

Nincada	◎
Skitty	▲
Taillow	△
Whismur	○
Zigzagoon	○

Horde Encounters

Nincada (×5)	○
Skitty (×5)	▲
Zigzagoon (×5)	◎

◎ frequent ○ average △ rare ▲ almost never

Items

Potion
Repel
X Sp. Atk
After learning Cut
Ether
After learning Rock Smash
HP Up
After delivering the Devon Parts to Captain Stern
Repeat Ball

Hidden Items

Super Potion

Skitty [Normal]
Abilities: Cute Charm, Normalize

Nincada [Bug] [Ground]
Ability: Compound Eyes

Whismur [Normal]
Ability: Soundproof

1 Use Cut to find an Ether and some Berries

Would you like to use Cut?
Yes
No

If this is your first visit to Route 116, collect a Potion and a Repel, and battle a few Trainers as you explore. Up north, use Cut to fell a few thorny trees, and then snag an Ether and harvest some Berries from the nearby Berry Trees.

TIP

Chesto Berries can cure the Sleep status condition when held, but they're also a useful ingredient for making Pokéblocks. See page 358 for details!

2 Meet Mr. Briney near Rusturf Tunnel

> We were just out on our walk, Peeko and I, when we were attacked by an odd thug...

Just past the Tunneler's Rest House, you find old Mr. Briney standing near the entrance to Rusturf Tunnel. It seems that the Team Magma / Team Aqua Grunt who stole the Devon Parts has also made off with Mr. Briney's beloved Wingull, Peeko! Grab the X Sp. Atk on the ledge beyond Mr. Briney, and then hurry into Rusturf Tunnel in pursuit of the suspect Grunt.

TIP

Did you notice those fishy-looking holes around the ledge? You can't do anything with them now, but you'll find a use for them before long!

RUSTURF TUNNEL

Field Moves Needed — Rock Smash

This stone tunnel links together Rustboro and Verdanturf. Its name was chosen as a mixture of the two.

Tunnelers are working hard to complete Rusturf Tunnel, which will soon connect Rustboro City and Verdanturf Town. The tunnel's native Whismur are very sensitive to loud noises, however, so the project is taking longer than expected.

To Route 116
(p. 58)

To Route 116
(p. 58)

To Verdanturf Town
(p. 104)

Hiker Mike
◎◎◎◎◎◎

Whismur — Normal
Ability: Soundproof

Cave
- ☐ Whismur ◎

Horde Encounters
- ☐ Whismur (×5) ◎

Rock Smash
- ☐ Geodude ◎

◎ frequent ○ average △ rare
▲ almost never

Items
- ☐ Poké Ball

After learning Rock Smash
- ☐ Aggronite
- ☐ Max Ether

Hidden Items

After learning Surf
- ☐ Dire Hit

1 Battle the Team Magma / Team Aqua Grunt

> And you!
> Now you're here to battle me. Really?

> And you!
> Now you're here to battle me. Really?

Inside Rusturf Tunnel, go north and nab a Poké Ball. Then go east until you catch up to the Team Magma / Team Aqua Grunt. Sure enough, the scoundrel who stole the parts also grabbed Peeko as a hostage, but he can't get past the rocks that still block the incomplete tunnel. The Grunt is trapped, and there's no escape. Battle him to save Peeko and reclaim the stolen Devon Parts!

TRAINER HANDBOOK

ADVANCED HANDBOOK

ADVENTURE DATA

Team Magma Grunt's Pokémon

⊖○○○○○

Poochyena [Dark]
♂ Lv. 13
Weak to: [Fighting] [Bug] [Fairy]

Team Aqua Grunt's Pokémon

⊖○○○○○

Poochyena [Dark]
♂ Lv. 13
Weak to: [Fighting] [Bug] [Fairy]

2 Reunite Peeko and Mr. Briney

> If there's ever a thing I can do to help you in turn, don't you hesitate to tell me.

The Grunt flees after you beat him, leaving you to look after Peeko. Mr. Briney soon arrives, and he couldn't be happier to find his beloved Pokémon safe and sound. The grateful old sailor says he'll always be there for you, if there's ever anything he can do to repay your kindness. Considering how much of Hoenn is on the water, having a friend with a boat will surely help. Well done!

◀◀ BACKTRACK — RUSTBORO CITY — p. 51

> Oh, yes! Young man! Please come with me!

Return the stolen Devon Parts

Now that you've reclaimed the Devon Parts, you'd best return them to the researcher. Hightail it back to Rustboro City and head for the Devon Corporation's office building in the city's northwest corner. You'll run into the grateful Devon researcher, who hands you a Great Ball and escorts you inside to meet his boss, Mr. Stone.

Meet Mr. Stone and receive the BuzzNav feature

Many rare stones are displayed within Mr. Stone's office. Devon's president certainly lives up to his name! Mr. Stone thanks you for reclaiming the stolen parts and then asks you for another favor. To prove that he wouldn't ask you to do something for nothing, he rewards

> I'm Mr. Stone, the president of the Devon Corporation.

you first by upgrading your PokéNav Plus. Now you can watch all sorts of entertaining and informative broadcasts with the BuzzNav feature!

🏅 TIP

There's an Aggronite in the tunnel, but you can't get it just yet. Once you can use the field move Rock Smash, see page 105 for info on getting this sought-after Mega Stone.

TIP

BuzzNav works with your system's StreetPass functions. (To find out about StreetPass, check your Nintendo 3DS or Nintendo 2DS Operations Manual.) When you first open BuzzNav, you'll be asked whether you would like to use StreetPass. If you opt to use StreetPass, you'll find your BuzzNav app full of news stories from other players around you! You'll be able to learn where they encounter hidden Pokémon, where their Secret Bases are, what items they've found with their Dowsing Machines, and more. It's a great way to get the inside scoop on what's going on around Hoenn!

What Is BuzzNav?

When you want to catch up on the latest news, turn your attention to BuzzNav! This special feature of the PokéNav Plus presents fun and informative news programs that keep you current on what's happening around Hoenn. By gathering information from StreetPass, BuzzNav can also broadcast programs about other players' activities!

BuzzNav shows

Hoenn News Network (HNN)

HNN broadcasts news updates based on your progress through the main story. Whenever newsworthy events happen, you can expect to see a news report about it on HNN right away.

Today's Smart Shopper

This show is all about shopping in Hoenn. See what items other players are purchasing around the Hoenn region—and who's getting things at sale prices!

The Name Rater Show

Like a fortune-teller, the Name Rater can judge how well a Pokémon's nickname suits it, and what that Pokémon is destined for. He's got quite a talent!

Trend Shoot!

The hosts of this show keep you looped in to what's cool around Hoenn. If you'd like to know more about the latest trends (and possibly even influence them), speak with the hip, happening folks who live in Dewford Town (p. 64).

Search2Catch

Search2Catch is a show about Trainers and their attempts, successful or not, to catch hidden Pokémon that they see in the world around them.

TM Treasures

This show's host is here to remind you to use those valuable TMs in your Bag!

Trainer × Trainer

Some Trainers just can't get enough of battling each other. This show is dedicated to those Trainers who keep coming back for more.

Super-Secret Base Crashers!

Discover who has Secret Bases (p. 112), and where they're located, on Secret Base Crashers!

The Great Flag Hunter

Once you know about Secret Bases (p. 112), it's time to get in there and take someone's flag! The Great Flag Hunter updates you on Trainers who have made it to someone's Secret Base and claimed their flag.

Shall We Dowse?

This program tells you about Trainers who have used their Dowsing Machines (p. 88) to find the coolest items, and how their lives have been changed by this marvelous device.

Poké Fans!

The members of the Pokémon Fan Club, AKA Poké Fans, conduct surveys about their favorite topic: Pokémon! Responses to their surveys are then presented on this program. Head to Slateport City (p. 73) and maybe you, too, could make it onto the show!

Talk of the Town

There's a lot going on around Hoenn, and Talk of the Town keeps you current on what Trainers are talking about. Once again, Slateport City (p. 73) is the place to be if you'd like the rest of Hoenn to hear what you have to say.

Special ☆ Spectaculars

Contest Spectaculars (p. 79) are big in Hoenn, and this show keeps you up on the latest stars. Join in the drama once you reach your first Contest Spectacular Hall, and maybe you'll be featured next!

Seeking Trainers

The intrepid news team of Gabby and Ty (p. 75) are out interviewing Trainers all across Hoenn. This reporter/cameraman duo is also crazy for Pokémon! Battle them for a chance to see yourself and your team on their show.

Happy, Happy Birthday!

There are lots of Trainers all over Hoenn, and an equal number of birthdays to celebrate! Happy, Happy Birthday lets you know which Trainers in your area have celebrated their birthday recently. Join in their joy by giving them an O-Power via the PSS!

Mirage Detection Unit

So you've visited all of Hoenn's cities and towns, but might there still be more to explore? MDU is on the case, reporting on Mirage spots (p. 351) for you, the inquiring viewer.

Wonder Trade

Ever tried a Wonder Trade (p. 404)? If you have, then you might see yourself and your Pokémon on this special program!

Pokémon News

Pokémon News is here to keep you informed about worthy events. Tune in for the latest updates on places that you might want to visit today.

I want to ask you to deliver this Letter to a man named Steven.

Deliver a letter for Mr. Stone

Devon's president, Mr. Stone, views you as a trustworthy Trainer and asks you to undertake an important mission. He hands you a letter that must be delivered to a man named Steven in Dewford Town. You'll need to cross the sea to reach Dewford, so Mr. Stone advises you to book passage with Mr. Briney, the friendly old sailor who lives on Route 104.

I am researching Pokémon Fossils here.

Find the Fossil restoration desk

Feel free to explore the Devon Corporation's impressive offices after your meeting with Mr. Stone. Down on the second floor, speak with the researcher who stands behind the counter at the lower left. This researcher is a pro at identifying and restoring Fossils, and he asks you to bring him any Fossils you might discover along your travels. Keep this guy in mind!

◄◄ **BACKTRACK** | **ROUTE 104 (SOUTH)** | p. 42

Mr. Briney's Cottage

Make tracks back to Route 104

When you've finished checking out Devon's office building and make your exit, May/Brendan will talk to you about meeting Mr. Briney on his way to his cottage on Route 104. Rest your Pokémon if you need to, and then head south to Route 104. Continue south through Petalburg Woods, hopping a series of ledges as you streak down to Route 104's southern half, where Mr. Briney's cottage is located.

Shove off for Dewford Town

Head to Dewford
Never mind

Inside the cottage, you find Mr. Briney chasing after Peeko. Catch his attention as he runs around, and tell him of your important mission for Mr. Stone. Still grateful for your help back in Rusturf Tunnel, Mr. Briney gladly offers to ferry you across the sea to Dewford Town. Anchors aweigh!

You've come to the right man! Shall we hoist sail for Dewford at once?

TIP

One of the Scientists in the Devon Corporation will tell you about his plans to develop a way of making Pokémon's dreams visible! If you've ever played *Pokémon Black Version*, *Pokémon White Version*, *Pokémon Black Version 2*, or *Pokémon White Version 2*, you may have an inkling of what he's talking about…

TIP

If you head north out of Rustboro City, you can explore a small portion of Route 115 (p. 124). No new Pokémon can be caught in the small bit you can explore from the south, and you can't reach any of its tough Trainers yet from this end, but you can claim a Zinc if you want to give one of your Pokémon's base Sp. Def stat a boost.

TIP

While you're out on the route again, keep your eyes peeled for unusual Pokémon. There's a tiny chance that you may find a Pokémon of a different color than normal for its species. These are known as Shiny Pokémon, and if you catch one, it will pop out of its Poké Ball in a burst of sparkling light. They are incredibly rare, so if you happen to run into one in the wild, do everything in your power to catch it!

TRAINER HANDBOOK

ADVANCED HANDBOOK

ADVENTURE DATA

All about PCs

PCs are useful machines that let you store and organize your growing Pokémon collection using the storage system. You'll find PCs near the reception desk in every Pokémon Center, as well as in other convenient locations.

Someone's PC

This option lets you view and organize your own Pokémon. Here's what you can do when you select the "Someone's PC" option.

Deposit Pokémon: Move Pokémon out of your party and put them into one of your PC Boxes.

Withdraw Pokémon: Move Pokémon out of your PC Boxes and add them to your party.

Organize Boxes: This option lets you do several things. You can move Pokémon into or out of your party, or release Pokémon back into the wild. You can also view summaries of your Pokémon, give or take items from them, and change their position. You can change the wallpapers (backgrounds) of your PC Boxes and edit the names of the PC Boxes. This option also provides you with different ways of selecting your Pokémon—press START or tap one of the icons above the Box name to cycle through three modes of selecting Pokémon (red, blue, and green).

Red arrow mode

This mode lets you select a single Pokémon and choose what to do with it.

Highlight a Pokémon and press Ⓐ to call up a side menu full of useful options.

Blue arrow mode

This mode lets you move a Pokémon to another place or swap the positions of two Pokémon.

Press Ⓐ on a Pokémon, and then move the Pokémon to another place (or onto another Pokémon) and press Ⓐ again to place it.

Green arrow mode

This mode lets you move multiple Pokémon at once.

Press Ⓐ on a Pokémon, then use the +Control Pad to highlight multiple Pokémon. Press Ⓐ again to select all of the highlighted Pokémon, then use the +Control Pad to move them all as a group. Press Ⓐ again to place them.

Organize Items: Use this to move an item from one Pokémon to another, give an item to a Pokémon, or return the item to your Bag. Pokémon with items appear brighter than Pokémon without items, which will appear shaded, so it's easy to spot which of your Pokémon currently hold items.

Professor's PC

Select this option when you want to have Professor Birch evaluate your progress in completing your Pokédex. Gotta catch 'em all!

DEWFORD TOWN

New trends are always the rage among the inhabitants of this small island town.

Surrounded by the briny blue sea, this small seaside town is home to friendly Fishermen and other sun-loving souls. Gym Leader Brawly keeps in shape by flexing his muscles at the local Pokémon Gym.

To Route 106
(p. 68)

Dewford
Hall

To Route 104
South (p. 42)
To Route 109
(p. 71)

Pokémon
Center

Dewford
Pokémon Gym
(p. 66)

To Route 107
(p. 146)

On the Water

☐ Pelipper	▲
☐ Tentacool	◎
☐ Wingull	○

Fishing

Old Rod	
☐ Magikarp	◎
☐ Tentacool	○
Good Rod	
☐ Magikarp	◎
☐ Tentacool	○
☐ Wailmer	▲
Super Rod	
☐ Wailmer	◎

◎ frequent ○ average
△ rare ▲ almost never

Vending Machine

Gym	
Fresh Water	200

Items

☐ Old Rod
☐ Silk Scarf

Pelipper	Water	Flying
Ability: Keen Eye		

Tentacool	Water	Poison
Abilities: Clear Body, Liquid Ooze		

Magikarp	Water
Ability: Swift Swim	

Wailmer	Water
Abilities: Water Veil, Oblivious	

1 Score a Silk Scarf

Ah, Dewford Town. Breathe in the fresh sea breeze as you step off Mr. Briney's boat, then enter the first house up north. Speak to the man inside to score a Silk Scarf, which powers up Normal-type moves.

A Silk Scarf raises the power of
Normal-type moves. It's a marvelous scarf

2 Set the latest trend

Go west to find Dewford Hall, where all the locals gather to buzz about the latest hip, happening trends. Speak with the kid outside, and he'll ask you about the biggest things that are happening where you're from. Depending on your response, you might just set Dewford ablaze with a hot new trend!

Potion festivals are the biggest
thing happening where you're from, too, right?

Yes
No

TIP

The trends that you start in Dewford can spread far from this sleepy town. In fact, if you have StreetPass enabled, everyone that you pass by could hear about them on their BuzzNav! You will also get to see the trends that other people are trying to spread when you pass them by. How about an Awakening Party? Or maybe you're an Iron Master? See what you can come up with!

3 | Reel in an Old Rod

Orlando obtained the
Old Rod!

Go south from Dewford Hall to find the Pokémon Center. Rest your party if you like, and you'll find the local Gym to the east. Ignore the Gym for the moment and speak with the nearby Fisherman. He'll give you an Old Rod that he's no longer using. Now you can fish for wild Pokémon all around Hoenn!

Go Fish!

There are three levels of fishing rods, each able to catch more powerful kinds of Pokémon than the last. As you obtain each rod, you may wish to revisit locations that you've explored and try your hand at reeling in some new Pokémon!

Old Rod

 An old, beat-up fishing rod. Use it at any body of water to fish for wild aquatic Pokémon.

How to obtain: Talk to a Fisherman in Dewford Town

Good Rod

 A new, good-quality fishing rod. Use it at any body of water to fish for wild aquatic Pokémon.

How to obtain: Talk to a Fisherman on Route 118

Super Rod

 An awesome high-tech fishing rod. Use it at any body of water to fish for wild aquatic Pokémon.

How to obtain: Talk to a Fisherman inside a house in Mossdeep City

How to fish

You can fish at the edge of a body of water, like a pond, or at the shore of the sea. You can also fish from the back of a Pokémon while using the field move Surf (once Surf becomes available to you). Cast your line by selecting a fishing rod from within your Bag or from among your registered items. Wait and watch carefully. If there is a tug on your line, exclamation points will appear above your character's head. That's your cue! Quickly press Ⓐ to reel in your line and battle the wild Pokémon you've hooked. If you're too slow at pressing Ⓐ, the Pokémon will escape.

Registering Key Items for quick use

Want easy access to Key Items like your Old Rod? Register them to Ⓨ! You can register up to four Key Items to Ⓨ.

Start by opening your Bag and selecting the desired Key Item. Options like Use, Register, and Cancel will appear. Select Register and the Key Item will be assigned to Ⓨ for quick use. (Note that some Key Items can't be registered.)

SELECT/START Switch Buttons

If you've only registered one Key Item, pressing Ⓨ will simply summon that item. If you've registered multiple Key Items, you'll need to press Ⓨ and then use the +Control Pad to select the desired item. Press Ⓨ again to put the item away.

DEWFORD TOWN GYM BATTLE

Gym Battle Tips

- Buy some refreshing Fresh Water from the Gym's Vending Machine
- If you've evolved a Wurmple to Silcoon and then to Beautifly, you'll have a strong advantage

Gym Leader Brawly

Battle Girl Tessa

Black Belt Hideki

Battle Girl Laura

Entrance

1 Assemble your party, then enter the Gym

Dewford Town Pokémon Gym
Leader: Brawly

When you've finished exploring the island, rest your Pokémon and then head for the Gym. Be sure to use the Pokémon Center's PC to pick the right party for the coming battles. The Gym is filled with Trainers who favor Fighting-type Pokémon, so bring Flying-, Psychic-, and Fairy-type Pokémon to counter them.

TIP

Want every advantage going into the Gym? Explore the coastal edges of Routes 106 (p. 68) and 107 (p. 146) before entering. They are both water-based routes that lie on either side of Dewford Town. You'll battle a few Trainers and claim a few items. You can also visit Granite Cave (p. 69) along Route 106 as well to catch new species of wild Pokémon and score TM70 Flash.

2 Battle Trainers as you navigate the Gym

Dewford Town's Gym is a fitness center that's filled with weight-lifting equipment and exercise machines. The buff Trainers who battle you here favor Fighting-type Pokémon and hone their instincts by training in total darkness. Step on the main hall's floor-switches to temporarily light up the Gym's dark rooms, and then plot your path through those rooms before stepping off the switch and moving into the pitch-black darkness.

TIP

Remember to leave the Gym and rest at the Pokémon Center if your party becomes weary on your way to Brawly. You won't have to rebattle any Trainers you've beaten when you return.

📍 **Dewford Town Gym Leader**

Brawly Fighting-type Pokémon User

Use Flying-type moves to blow him away!

Buff and burly Brawly begins the battle by sending out Machop, a formidable Fighting-type Pokémon. After Machop comes Makuhita, another Fighting type whose level is even higher. Both of these Pokémon are vulnerable to Flying-type moves, so use Flying-type Pokémon you may have caught by this point, such as Wingull (found along Route 104) or Zubat (found in Granite Cave).

Your best possible Pokémon for this battle is Beautifly, which evolves from Silcoon after evolving from Wurmple. (Both Silcoon and Wurmple can be caught in Petalburg Woods.) Not only can Beautifly batter Brawly's Pokémon with its Flying-type moves, but the fact that it's a Flying- and Bug-type Pokémon means that Fighting-type moves will hardly have any effect on it! Just don't use any Bug-type moves, because Fighting-type Pokémon are strong against them.

Blow away both of Brawly's Pokémon with Flying-type moves, and he'll have no choice but to admit defeat. Way to go! You've just won your second Gym Badge, along with TM08 Bulk Up!

Brawly's Pokémon

	🔘 **Machop**	**Fighting**
	♂ Lv. 14	
	Weak to: **Flying** **Psychic** **Fairy**	

	🔘 **Makuhita**	**Fighting**
	♂ Lv. 16	
	Weak to: **Flying** **Psychic** **Fairy**	

🔘

🔘

🔘

🔘

TIP

Brawly has a Super Potion that he can use during the battle to restore up to 50 HP to one of his Pokémon, so be ready for that by bringing some Potions of your own.

Knuckle Badge

Pokémon up to Lv. 30, including those received in trades, will obey you.

TM08 Bulk Up

The user tenses its muscles to bulk up its body, raising both its Attack and Defense stats.

3 Get one more TM before moving on

Orlando obtained TM36 Sludge Bomb!

Go back to the Dewford Hall, where all those trendy people like to hang out. If you talk to the Collector inside again, he will give you the TM for Sludge Bomb, a pretty powerful move that also has a chance of poisoning the target for continual damage. Then it's time to pursue Brawly's tip and check out Granite Cave!!

TRAINER HANDBOOK

ADVANCED HANDBOOK

ADVENTURE DATA

ROUTE 106

Field Moves Needed

This is the site of serious battles between the fishermen of the seaside area and the wild Pokémon of the seas.

Get your kicks on Route 106! This sandy shore lies northwest of Dewford Town and is a favorite fishing spot for Trainers. Granite Cave, found here, is a must-see tourist attraction.

Triathlete Caleb

Swimmer ♂ Douglas

To Route 105
(p. 145)

Swimmer ♀ Nicole

Fisherman Elliot

Backpacker Graeme

To Granite Cave
(p. 69)

To Dewford Town
(p. 64)

On the Water	
Pelipper	▲
Tentacool	◎
Wingull	○

Fishing	
Old Rod	
Magikarp	◎
Tentacool	○
Good Rod	
Magikarp	◎
Tentacool	○
Wailmer	▲
Super Rod	
Wailmer	◎

◎ frequent ○ average △ rare ▲ almost never

Items
Protein

Hidden Items
Heart Scale
Poké Ball
Stardust

Wailmer — Water
Abilities: Water Veil, Oblivious

1 Comb the beach on your way to Granite Cave

Orlando found a Protein!

If you've yet to explore the coastal parts of Route 106, take a moment to give it a thorough search. Battle every Trainer here, and search the beach's northwest corner to find a Protein that can be used to permanently boost the base Attack stat of one of your Pokémon. Once you're done exploring, loop back and enter Granite Cave.

TIP

Now that you have two Gym Badges, new items will be available to you at Poké Marts, including Escape Ropes, Hyper Potions, Revives, and Super Repels. Dewford Town doesn't have a Poké Mart, though, so you'll need to revisit previous towns or venture onward to new ones to purchase these new items.

GRANITE CAVE

Field Moves Needed
Flash · Rock Smash

This cavern is famous for its cave art, which depicts events from thousands of years ago.

No visit to Dewford Town is complete without a trip to Granite Cave, the island's big tourist attraction. You can't explore much of Granite Cave until you've beaten Gym Leader Brawly. Also, once you've got a Mach Bike, you can return to Granite Cave and explore its deep, dark depths!

1F

To Route 106
(p. 68)

B1F

B2F

Ruin Maniac Omari ◉◉◉◉◉◉◉

Hiker Davian ◉◉◉◉◉◉◉

1F Back

Makuhita `Fighting`
Abilities: Thick Fat, Guts

Aron `Steel` `Rock`
Abilities: Sturdy, Rock Head

Items

1F	
❏ TM51 Steel Wing	
❏ TM70 Flash	

B1F	
After obtaining a Mach Bike	
❏ Escape Rope	
❏ Poké Ball	

B2F	
After obtaining a Mach Bike	
❏ Escape Rope	
❏ Rare Candy	
❏ Repel	
❏ Steelixite	
❏ TM65 Shadow Claw	

Hidden Items

B1F	
After obtaining a Mach Bike	
❏ Paralyze Heal	
❏ X Defense	

B2F	
After obtaining a Mach Bike	
❏ Everstone	
❏ Super Potion	

Cave

1F	
❏ Abra	△
❏ Geodude	▲
❏ Makuhita	◎
❏ Zubat	◎

B1F	
❏ Abra	○
❏ Aron	○
❏ Makuhita	○
❏ Zubat	○

B2F		
❏ Abra	○	
❏ Aron	○	
❏ Mawile	○	Ω
❏ Sableye	○	α
❏ Zubat	○	

Horde Encounters

1F		
❏ Makuhita (×4) Geodude (×1)	○	
❏ Makuhita (×5)	▲	
❏ Zubat (×5)	◎	

B1F		
❏ Aron (×5)	○	
❏ Zubat (×5)	◎	

B2F		
❏ Aron (×5)	○	
❏ Mawile (×5)	▲	Ω
❏ Sableye (×5)	▲	α
❏ Zubat (×5)	◎	

Rock Smash

B2F	
❏ Geodude	◎
❏ Nosepass	△

◎ frequent ○ average △ rare ▲ almost never

1 Grab TM70 Flash

Orlando obtained
TM70 Flash!

Inside the cave, the helpful Hiker at the top of the steps hands you TM70 Flash, which can be used outside of battle to brighten up dark areas. (The Knuckle Badge is required to use Flash in the field.)

2 Meet Steven deeper in the cave

Oh?
A letter for me?

After you've beaten Gym Leader Brawly, you can head down into a deeper chamber of the cave, where you'll find Steven admiring Granite Cave's ancient wall drawing. Give Steven the letter from Mr. Stone to complete your mission, and Steven will give you TM51 Steel Wing in return. Admire the impressive mural before heading back to Dewford Town.

Magnificent Mural

A fantastic and very ancient mural has been discovered in Granite Cave, which attracts visitors from far and wide!

In *Pokémon Omega Ruby*, the mural depicts the figure of a huge Pokémon in a terrible rage, with what appear to be omegas (Ω) marked on its arms. Volcanoes are erupting all around it, while humans and Pokémon alike are overwhelmed by its power. There also appears to be a comet or asteroid falling from the sky, shaped like a triangle, while the other half of the sky is dominated by a broiling, monstrous sun.

In *Pokémon Alpha Sapphire,* a different Pokémon is wreaking havoc—this one marked with what appear to be alphas (α). The sea swells around it in huge waves, and a great storm seems to rage overhead, with heavy rain and lightning bolts. Again, a falling star appears over the figures of defeated people and Pokémon, a dark herald of their suffering.

There is also a faint figure in the space that would separate these two monstrous Pokémon. When the two images are overlapped, the figure appears to be a person! How could one human being stand between these two terrible titans?

And what about the symbols that appear on each of the Pokémon? What mysteries lie buried in Hoenn's forgotten past?

◀◀ **BACKTRACK** ▌**DEWFORD TOWN** p. 64

Route 104 (near Petalburg)
Route 109 (near Slateport)
Never mind

This old seadog will see you there safely!
Weigh anchors! We're for Slateport!

Set sail for Slateport City

Talk to Mr. Briney on Dewford's jetty and inform him of your success. He'll tell you that Mr. Stone has already assigned you a new task, one that involves delivering the Devon Parts that you recovered to a person named Stern in Slateport City. New adventures await, so set sail without delay!

ROUTE 109

Field Moves Needed · Surf

People and Pokémon alike enjoy ocean swims in this water route.

This spacious beach is packed with eager Trainers who aren't just here to work on their tans. Slateport City lies to the north, but this sizzling route is well worth searching before you go there.

Sailor Edmond

To Slateport City (p. 73)

To Slateport City (p. 73)

Seashore House

Tuber Lola

Tuber Ricky

Sailor Huey

Ace Trainer Portia

To Dewford Town (p. 64)
To Route 104 (South) (p. 42)

Swimmer ♂ David

Tuber Carmen

Tuber Gwen

Young Couple Mel & Paul
★ Double Battle

Swimmer ♀ Alice

Fisherman Carter

To Route 108 (p. 147)

On the Water

☐ Pelipper	▲
☐ Tentacool	◎
☐ Wingull	○

Fishing

Old Rod		
☐ Magikarp	◎	
☐ Tentacool	○	
Good Rod		
☐ Magikarp	◎	
☐ Tentacool	○	
☐ Wailmer	▲	
Super Rod		
☐ Wailmer	◎	

◎ frequent ○ average
△ rare ▲ almost never

Seashore House

After beating five Trainers	
☐ Soda Pop	300

Items

☐ PP Up	
☐ Soft Sand	
After learning Surf	
☐ Big Pearl	

Hidden Items

☐ Ether	
☐ Great Ball	
☐ Heart Scale ×2	
☐ Revive	
After learning Surf	
☐ Heart Scale	

Tentacool `Water` `Poison`
Abilities: Clear Body, Liquid Ooze

1 · Talk to two Tubers to receive a Soft Sand

Land, ho! After Mr. Briney drops you off at Route 109, head north along the beach and locate a pair of young Tubers. Speak to the girl Tuber (the one with the pink tube), and she'll give you a Soft Sand. Give this item to a Pokémon to hold, and the power of its Ground-type moves will be boosted!

Orlando obtained
Soft Sand!

2 Battle Trainers on the beach and find a PP Up

Orlando found a PP Up!

Plenty of Trainers can be found around the beach, and there's a PP Up on the northwest shore. Speak to everyone and participate in battles to maximize your prize money. You can also fish for wild Pokémon with your Old Rod here if you like.

TIP

You remember how each move has a limited amount of PP? Well, some very valuable items exist that raise the PP for a move. The PP Up is one of these, as is the PP Max. They're hard to get, but can help you boost the PP of powerful moves so that you can use them more times, which is especially handy for long battles or back-to-back battles.

3 Take on more Trainers in the Seashore House

Orlando obtained Soda Pops!

Enter the hut on the beach's west side to visit the Seashore House, where refreshments are sold to thirsty beachgoers. This place is just packed with Trainers! Defeat them all and then speak to the proprietor at the counter. He'll reward your sizzling display with six free Soda Pops!

Reward: Soda Pop ×6

TIP

After you've cleared out the Seashore House and received your free Soda Pops, you can buy more Soda Pops from the proprietor at just 300 a pop. A Soda Pop restores 60 HP to a Pokémon, making them more effective than a Super Potion and for half the price!

Street Thug Blair

Delinquent Destinee

Beauty Johanna

Sailor Dwayne

Tuber Simon

4 Take the northeast path into Slateport City

Sprint along the beach's north edge to find two paths leading into Slateport City. Either one works, but the northeast path lets you in right before Slateport's towering lighthouse. If you'd like to see it, head into the entrance near a hidden item. When you're ready to leave, you can head west to the main entrance or take the other entrance from the beach that leads to the heart of the city.

SLATEPORT CITY

People from many different regions gather and mingle in this bustling port city.

Now this is a city! Slateport is by far the biggest place you've been to, and it's just stuffed with sights to see. From the Contest Spectacular Hall to the Oceanic Museum, there's plenty to marvel at in this seaside metropolis.

Map Labels

To Route 110 (p. 81)

Contest Spectacular Hall

Slateport Harbor

Name Rater's House

Pokémon Center

Poké Mart

Oceanic Museum

To Route 134 (p. 260)

Pokémon Fan Club

Stern's Shipyard

TM Salesman

Energy Guru

Incense Seller

Lighthouse

Doll Shop

Decorations Supplier

To Route 109 (p. 71)

To Route 109 (p. 71)

Energy Guru

Calcium	9,800
Carbos	9,800
HP Up	9,800
Iron	9,800
Protein	9,800
Zinc	9,800

Incense Seller

Full Incense	9,600
Lax Incense	9,600
Luck Incense	9,600
Odd Incense	9,600
Pure Incense	9,600
Rock Incense	9,600
Rose Incense	9,600
Sea Incense	9,600
Wave Incense	9,600

Decorations Supplier

After obtaining Secret Power

A Note Mat	500
B Note Mat	500
Blue Balloon	500
Blue Brick	500
D Note Mat	500
E Note Mat	500
F Note Mat	500
G Note Mat	500
High C Note Mat	500
Low C Note Mat	500
Red Balloon	500
Red Brick	500
Yellow Balloon	500
Yellow Brick	500

On the Water

❏ Pelipper	▲
❏ Tentacool	◎
❏ Wingull	○

Fishing

Old Rod

❏ Magikarp	◎
❏ Tentacool	○

Good Rod

❏ Magikarp	◎
❏ Tentacool	○
❏ Wailmer	▲

Super Rod

❏ Wailmer	◎

◎ frequent ○ average △ rare ▲ almost never

Items

❏ Alakazite
❏ TM41 Torment
❏ TM46 Thief

Poké Mart

Normal Wares

Antidote	100
Awakening	250
Burn Heal	250
Escape Rope	550
Great Ball	600
Ice Heal	250
Hyper Potion	1,200
Paralyze Heal	200
Poké Ball	200
Potion	300
Repel	350
Revive	1,500
Super Potion	700
Super Repel	500

Special Wares

Dire Hit	650
Guard Spec.	700
X Accuracy	950
X Attack	500
X Defense	550
X Sp. Atk	350
X Sp. Def	350
X Speed	350

TM Salesman

TM01 Hone Claws	5,000
TM73 Thunder Wave	5,000
TM76 Struggle Bug	5,000
TM100 Confide	5,000

Doll Shop

After obtaining Secret Power

Marill Doll	3,000
Azurill Doll	3,000
Skitty Doll	3,000

Vending Machine

Stern's Shipyard

Fresh Water	200
Lemonade	350
Soda Pop	300

Harbor

Soda Pop	300

Wingull — Water / Flying
Ability: Keen Eye

Slateport City's open-air market is a must-see. It's straight west from where you entered the city, at the very edge of the town. Numerous vendors peddle rare goods from their stalls here, and the man near the market's southern entrance hints that you'll find even more bargains if you obtain the TM Secret Power. Even without this TM, you can purchase stat-boosting items for your Pokémon from the Energy Guru, or pick up precious incense or TMs from other vendors. When you're finished marveling at the market, continue your thorough exploration of the city.

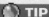 **TIP**

Did you spy the sparkling spot on the ground near the old lady who's setting up her doll stand? Look for it at the market's southwest corner, then press Ⓐ to inspect it and you'll discover a precious Alakazite! But what is this special Mega Stone? If you've visited the Kalos region, then you may know what Mega Stones are for. Regardless, be sure you don't lose it! You'll find it immensely useful later on.

Base Stats and the Energy Guru

What are base stats?

Every Pokémon has six base stats: Attack, Defense, Sp. Atk, Sp. Def, Speed, and HP. These stats have an impact on how your Pokémon performs in battle. And these stats, in turn, are impacted by a Pokémon's base stats.

For example, have you ever hoped that your Pokémon would be a little faster and could attack before the opposing Pokémon? If so, then you want to raise its base Speed stat! Base stats are not the only thing that decides your Pokémon's final stats, but it is the one thing that you can most easily affect, so definitely take advantage of training them to make your ultimate team.

You can use the PlayNav's Super Training to check the current base stats of your Pokémon. Your Pokémon's final stats can be seen on their Summary page, viewable by selecting Pokémon from the menu or tapping the small Poké Ball icon on the lower screen. If you like, you can also use the PlayNav's Super Training feature to raise their base stats. See page 325 for more about base stats, and see page 409 to learn about Super Training.

The Energy Guru can help raise your Pokémon's base stats!

The Energy Guru sells the following items at Slateport Market. Each of these items raises base stats, and they cost 9,800 apiece. The Energy Guru holds special sales on Mondays, however, and they are always advertised on your BuzzNav!

 Protein: Raises the base Attack stat

Zinc: Raises the base Sp. Def stat

Iron: Raises the base Defense stat

Carbos: Raises the base Speed stat

Calcium: Raises the base Sp. Atk stat

HP Up: Raises the base HP

2 | Get an Effort Ribbon

Orlando received the Effort Ribbon.

The red-clad clerk who stands next to the Energy Guru will give you an Effort Ribbon if your party's lead Pokémon has been well trained and has excellent base stats. Ribbons are special collectibles that Pokémon wear with pride. View a Pokémon's Ribbon collection by checking its Summary page, and quickly get your Pokémon into shape by whipping out your Super Training app (p. 409)!

Reward: Effort Ribbon

3 | Stop by Stern's Shipyard

Sorry, but could I ask you to find the captain and give the parts to him?

Stern's Shipyard is located to the east of the market. It stands behind two houses. Inside, you'll find Captain Stern's assistant, Dock, mulling over the plans to the new ferry that they're building. Stern is nowhere in sight, but Dock hints that the captain likes to frequent the city's Oceanic Museum. You'll have to track him down to hand off the Devon Parts, but you might as well check out the shipyard while you're here. The ferry *S.S. Tidal* can be seen in the dry dock, and the Vending Machine upstairs offers a selection of refreshing, HP-restoring beverages.

4 | Pop by the Pokémon Fan Club

Do you know what? I'm a TV reporter.

Go north from Stern's Shipyard to find the Poké Mart and Pokémon Center. Visit them both, then go west to find the Pokémon Fan Club. This is where Pokémon fanatics gather to talk about their favorite Pokémon! Speak to Gabby, the reporter, and tell her a bit about the first Pokémon on your team. You can receive a Soothe Bell from the woman in the back if your lead Pokémon is friendly toward you (p. 76). There's also a Breeder inside who offers to trim a Pokémon called Furfrou, but this furry Pokémon isn't native to the Hoenn region, so you'll have to trade for it from another game.

Reward: Soothe Bell

> **TIP**
>
> Slateport's Poké Mart features a second clerk who sells a selection of special, stat-boosting items for use during battle. These items are much more affordable than the ones sold by the Energy Guru in the market, but their stat-boosting effects are only temporary and will last just for the duration of a single battle.

Gabby and Ty

An intrepid TV reporter, Gabby loves interviewing Pokémon Trainers. Her partner, Ty, is always right there with her, recording her interviews on his camera for the entire region to enjoy.

Your first chance to encounter Gabby and Ty is in the Pokémon Fan Club in Slateport City. Give them a great interview, and you might just see yourself on the news over at BuzzNav. And not only that, if you have StreetPass enabled (p. 11), your interviews can be broadcast to others passing by, just like you'll see the results of their interviews in your game!

You'll also encounter Gabby and Ty while exploring certain routes. Your first chance to meet them out in the field is on Route 111 (p. 106). When you talk to them, they'll challenge you to a Double Battle! After the battle, you'll be interviewed. Describe your feelings about the battle you just had with them, and when you check out BuzzNav later, you'll see a new story about yourself!

After the first battle and interview, Gabby and Ty will appear on Route 111 (p. 106), Route 118 (p. 150), and Route 120 (p. 166). Battle them for more exciting interviews!

> **TIP**
>
> Use Mega-Evolved Pokémon (p. 317) in battles against Gabby and Ty, and they'll talk about that, too!

5 | Score a Scarf from the Fan Club chairman

Er-hem! I am the chairman of the Pokémon Fan Club!

The chairman of the Pokémon Fan Club lounges on the club's plush sofa. Speak with him to have him examine your Pokémon's condition for contests held at the city's Contest Spectacular Hall. He'll give you an honest opinion, along with a special Scarf to use in future contests if he likes what he sees!

Rewards: Blue Scarf, Green Scarf, Pink Scarf, Red Scarf, Yellow Scarf

> **TIP**
>
> You can get up to five different Scarves from the Pokémon Fan Club chairman by showing him Pokémon that excel in different Contest Spectacular conditions. Each of these Scarves boosts a different contest condition, helping to improve your performances. You'll be finding out all about these exciting contests soon! You can also turn ahead to page 79 for more info on Contest Spectaculars.

Friendship is the bond of trust that can grow between a Pokémon and its Trainer. Keep a Pokémon happy and it will grow to like you, but a Pokémon treated badly will dislike you. Two things Pokémon definitely don't like are fainting in battle and swallowing bitter herbal medicines. Certain characters you meet will check how friendly you and your Pokémon are.

How to improve your friendship with your Pokémon

Let me see how friendly your Pokémon is toward you.

- **Level it up.** Level up your Pokémon and it will become more friendly toward you.
- **Travel together.** Put a Pokémon in your party and go on an adventure together.
- **Use stat-boosting items on it!** Use items such as Protein or Zinc to boost its base stats. The Energy Guru here in Slateport City sells these valuable items.
- **Use battle items on it.** Use items such as X Attack and X Defend to give it a temporary boost during battles. The Poké Mart's upper clerk in Slateport City sells these helpful items.

- **Use it in major battles.** Use it when you battle with Gym Leaders, the Elite Four, and the Champion.
- **Have it hold a Soothe Bell.** Have it hold a Soothe Bell, which you can receive from a lady in the Pokémon Fan Club in Slateport City.
- **Get it a massage.** Have it get a massage (p. 94) at Pokémon Reflexology Services in Mauville City or in your Secret Base (p. 112).
- **Give it Pokéblocks.** Make Pokéblocks with the Pokéblock Kit you'll soon receive, and give them to your Pokémon (p. 358).
- **Use your O-Powers.** Use the Befriending Powers you'll eventually obtain from a man in the Pokémon Center in Mauville City (p. 89).
- **Use a Soothing Bag.** The Soothing Bag is a bag used in Super Training that will make your Pokémon more friendly toward you (p. 409).

Benefits of friendship

- **Pokémon evolve.** A number of species of Pokémon evolve when leveled up while they're on friendly terms with you. There are often other conditions that affect these Evolutions, however, like the time of day.
- **They can learn more moves.** If you are friendly with some of your Pokémon, you can teach them some special moves, including battle-combo moves, the strongest Dragon-type move, and the Ultimate Moves for Evolutions of the Pokémon partners you receive from professors.
- **You can receive special items.** A man in Pacifidlog Town will give you TMs depending on how friendly (or unfriendly) your lead Pokémon is toward you (p. 259). And, as previously mentioned, a woman here in Slateport City will give you a Soothe Bell—which will help a Pokémon grow friendlier more quickly if it holds onto it.

Sceptile learned Frenzy Plant!

Differences between friendship and affection

Affectionate Pokémon have numerous benefits in battle. For example, they might cure themselves of status conditions or avoid attacks. Friendly Pokémon do not perform differently during battle, but as you've just read, there are many other benefits to increasing your friendship bond.

Orlando obtained TM27 Return!

The ways to raise friendship and affection are also different. You've just read how to make your Pokémon more friendly. To make them more affectionate, play with them in Pokémon-Amie (p. 412) once you get the PlayNav app for your PokéNav Plus, or let them participate in Contest Spectaculars (p. 79).

6 | Meet the Name Rater

Hello, hello!
I am the official Name Rater!

Go directly north from the Pokémon Fan Club to find the Name Rater's House. Head inside to speak with the Name Rater, who has the special power to evaluate and change your Pokémon's nicknames. Feel free to change your Pokémon's nicknames to anything you like! You can change them as often as you want.

TIP

The Name Rater cannot change the nickname of any Pokémon you've received in trades. The same goes for Pokémon that you trade away as well. Once a Pokémon has been traded, the new Trainer can't change its nickname!

7 | Swing by the Contest Spectacular Hall

Orlando obtained
TM41 Torment!

Enter the impressive building to the north of the Name Rater's House to visit the Contest Spectacular Hall. You can't do much here without a Contest Pass, but you can go upstairs to meet a steamed-up sailor who'll give you TM41 Torment after recounting his long-winded tale of woe.

8 | Hang at the Harbor

I'd love to go deep underwater like that some day.

Go east from the Contest Spectacular building to find the Harbor. You can't do much of anything at the Harbor right now besides buy Soda Pops from the Vending Machine. Best be moving on to the Oceanic Museum!

9 | Enter the Oceanic Museum

₽ 6,940

Yes
No

The entrance fee is ₽50.
Would you like to enter?

Head south from the harbor to find the Oceanic Museum. You've explored the whole city now and you haven't spotted him, so Captain Stern must be around here somewhere! Pay the nominal entrance fee to the receptionists to gain entry.

TIP

You'll be allowed to enter the Oceanic Museum even if you don't have enough funds to cover the entrance fee.

10 | Scare up TM46 Thief

Orlando obtained
TM46 Thief!

Orlando obtained
TM46 Thief!

The Oceanic Museum is filled with fascinating exhibits—and members of Team Magma / Team Aqua! Don't worry, these Grunts aren't here to fight you—not yet, at least. Speak to all the Grunts in an effort to gauge their purpose. Talk to the Grunt in the lower-right corner to give him a start. It's the Grunt you thumped back in Rusturf Tunnel! This guy knows better than to mess with you and begs forgiveness by giving you TM46 Thief before fleeing the scene.

11 Save Captain Stern from Team Magma / Team Aqua!

Just a moment! We'll be taking those parts!

Hold up a moment! We'll be taking those!

Go upstairs to find Captain Stern on the second floor. He's down in the lower-right corner. Before you can hand him the Devon Parts for his new ferry, you're suddenly attacked by two Team Magma / Team Aqua Grunts! Defeat both Grunts in two consecutive battles to save Captain Stern and complete your delivery mission for Mr. Stone.

12 Meet the leader of Team Magma / Team Aqua

I suggest you take care that you never again stand against Team Magma.

Get in my way again, and you won't walk away unscathed next time.

Shocked at their failure, the Grunts begin to ponder their next move. Suddenly, a stranger appears. It's the leader of Team Magma / Team Aqua, Maxie/Archie! Battle seems imminent, but does not occur. Instead, Maxie/Archie seems impressed by the fire in your eyes. He explains the goal of his organization and then departs, but not before issuing you a stern warning not to interfere with his group's future plans.

Two Opposing Teams

Team Magma and Team Aqua are the two opposing groups in the Hoenn region. They represent the crossroads at which the region finds itself. Human society and technology are developing faster and faster, while the natural world that every living thing inhabits captures less and less of people's attention.

At the top of Team Magma stands Maxie. He is a hard and analytical man with a noble goal in mind: he wants human society to continue to grow and develop. Humanity has grown and developed on land, and it continues to increase in numbers. With his scientific frame of mind, Maxie has decided that humanity needs more land to expand on and develop to reach its highest possible level. Team Magma therefore works in an effort to expand the landmass on the planet so that society will have more space to grow.

At the helm of Team Aqua is Archie. This gruff and boisterous sailor lives with a passion that drives him to extremes. He looks at the development of humanity and sees only destruction. The world is becoming one without space for Pokémon to flourish, and the precious space that's left is quickly becoming polluted and unsuitable for life. Archie yearns to return the world to a pristine state—to the nurturing waters that foster life and wash away the stain of human development. Team Aqua works for that purpose: to find a way to raise the sea level around the world and create larger oceans.

13 Get caught up in something spectacular

Lisia's...Miraculous...Contest Scouting!

Well, that was unsettling! At least you've delivered the Devon Parts to Captain Stern. As you take your leave of the museum, you may pause to give an interview to the reporter who's now downstairs. You're all done here in Slateport, so rest at the Pokémon Center before heading to the city's north exit. Try to go through the exit, and you're suddenly drawn to the excitement of a video shoot that's happening at the nearby Contest Spectacular Hall.

14 | Get scouted by Lisia and receive a Contest Pass

Orlando's story begins today!

In front of the Contest Spectacular Hall, a spunky girl named Lisia is being filmed alongside her Pokémon pal, Ali. The crowd is in a frenzy to see which lucky Trainer Lisia will pick to make a debut in the Contest Spectaculars. And the lucky Trainer is... you! Lisia hands you a Contest Pass and a Pokéblock Kit—everything you need to begin your quest to conquer the Contest Spectacular!

TIP

The Pokéblock Kit lets you create tasty Pokéblocks out of Berries. Pokéblocks are yummy treats that help your Pokémon perform better in contests! See page 358 for details.

15 | Enter the Contest Spectacular and score a costume

"My Big Beginning! A Heart-Pounding Contest Debut!"

Now that you've got a Contest Pass, why not use it? Follow Lisia into the Contest Spectacular Hall and chat with her inside. After that, head to the back counter, and Lisia will talk to you again. She'll be thrilled at your eagerness to try a contest and will lead you into the dressing room, where she gives you a snazzy Contest Costume to wear for the upcoming show. How thoughtful! When you're done with contesting for now, carry on up north to Route 110

TIP

After taking part in your first contest, an inspired Breeder gives you a very special Pikachu, which can really wow the crowd in future contests. This Cosplay Pikachu just loves dressing up in special costumes for contests, and delights everyone when it appears onstage! Not only that, but it even has great stats for battling, and looks stylish doing it! See page 362 for further details.

Welcome to the World of Pokémon Contest Spectaculars!

Pokémon Contest Spectaculars offer a whole different way to show off your Pokémon's strengths. To participate in a contest, just visit one of the Contest Spectacular Halls located in Slateport City, Verdanturf Town, Fallarbor Town, or Lilycove City.

Contest conditions

In Contest Spectaculars, you don't battle other Pokémon—at least, not in the traditional sense. Instead, your Pokémon is judged alongside other Pokémon in one of five contest conditions: Coolness, Beauty, Cuteness, Cleverness, or Toughness. There are individual contests for each of these five conditions, along with four ranks of difficulty: Normal Rank, Super Rank, Hyper Rank, and Master Rank.

Contest ranks

You begin each contest at Normal Rank. Win, and you'll unlock the next, more prestigious rank. Your opponents will become more difficult to win against as you move up the ranks, so you'll need to perfect your strategy to win them all!

Contest prizes

Work your way up to a Master Rank contest, and your win earns a special Ribbon that your Pokémon can wear with pride. Collect all five contest Ribbons with a single Pokémon, and you'll receive a rare Ribbon that features a special effect in battle!

Ribbons

Coolness Master Ribbon	Win a Master Rank Coolness Contest
Beauty Master Ribbon	Win a Master Rank Beauty Contest
Cuteness Master Ribbon	Win a Master Rank Cuteness Contest
Cleverness Master Ribbon	Win a Master Rank Cleverness Contest
Toughness Master Ribbon	Win a Master Rank Toughness Contest
Contest Star Ribbon	Win all five contest types at the Master Rank

TRAINER HANDBOOK

ADVANCED HANDBOOK

ADVENTURE DATA

Contest rounds

Each contest features two rounds: the Introduction Round and the Talent Round. Do your best to outperform the other contestants in both rounds to secure your victory! The following sections provide a general summary of each round, but once you have the basics down, turn to page 358 for a more in-depth guide.

The Introduction Round

Use Pokéblocks to raise your Pokémon's conditions!

In the Introduction Round, your Pokémon are judged by how developed they are in the relevant contest condition (Coolness, Beauty, Cuteness, Cleverness, or Toughness). To raise these conditions, make and feed your Pokémon Pokéblocks—special snacks that are made from Berries.

TIP
The color of the Pokéblock determines the contest condition that it boosts (pink for Cuteness, red for Coolness, green for Cleverness, blue for Beauty, and orange for Toughness).

TIP
The color of the Berries you use to make Pokéblocks generally determines the Pokéblock's color.

TIP
Yearning to know the finer points of making Pokéblocks and raising contest conditions? Turn to page 358!

The Talent Round

Jamming and appealing your way to the top

In the Talent Round, you have five turns in which to use Pokémon moves that show off your Pokémon's best side—and steal the spotlight from your competitors!

Every Pokémon move has two main values that will be relevant for contests: appeal and jamming. You can view how Pokémon moves will perform in contests by opening the Pokémon Summary page, tapping the small contest ribbon icon on the Touch Screen, and then tapping a move. The more hearts you see next to Appeal, the more appealing that move will seem to the audience.

The more hearts you see next to Jamming, the better that move will be at getting in the way of other Pokémon's attempts to show off, thereby reducing their appeal.

TIP
If you want to speed up your contests, turn off battle animations in the settings (p. 8).

Contest screen elements

1. **Hearts**: Represent current appeal earned that round. Gray hearts mean you are in the negative (not good!).

2. **Stars**: Represent how pumped up a Pokémon is. Each star reduces the chance of becoming nervous by 10 percent, and will also award you extra appeal after each move.

3. **Downward spiral**: Shows that the Pokémon has been startled. Its appeal goes down.

4. **Drop**: Shows that the Pokémon is nervous, making it unable to use a move that turn.

5. **Claw**: Shows that the Pokémon is prepared for jamming attempts, and will not be startled so easily.

6. **Blue moves**: Blue text indicates that you used the move last turn. Don't repeat moves or you'll bore the audience!

7. **Order**: The Pokémon on the left goes first.

8. **Opponents**: Tap on an opposing Pokémon to view its moves.

After using an appealing move, you should see that your Pokémon has earned some hearts under its icon on the Touch Screen. If you are jammed by another Pokémon, it will be startled and the number of hearts will decrease.

Welcome to the World of Pokémon Contest Spectaculars! (cont.)

Tips for winning contests

- Raise your Pokémon's contest conditions with Pokéblocks (p. 358)
- Use highly appealing moves to delight the audience
- Use jamming moves to lower your opponents' appeal
- Use the secondary effects of moves wisely (pp. 360–361)
- Get pumped up to earn extra bonuses each round (p. 361)
- Excite the audience with the right moves and timing (p. 360)
- Trigger Spectacular Talents to get huge bonuses (p. 360)
- Create combos to rack up a lot of appeal (p. 361)

TIP

The outcome of the Introduction Round determines the order in which the Pokémon get to move on the first turn. The number of hearts (or the amount of appeal) a Pokémon has generally determines the order in which the Pokémon get to move on the next turn, although some moves can affect the order.

TIP

If your Pokémon is in first position, you may want to use a move that prevents any jamming, or a move that gets a bonus for going first. If your Pokémon is in last position, you might try a move that will jam all of the opposing Pokémon that went before you, or one that gets a bonus for going last.

TRAINER HANDBOOK

ADVANCED HANDBOOK

ADVENTURE DATA

ROUTE 110

A timeworn path where nature remains untouched. Above it on this route stretches the huge Cycling Road.

This long route connects two of Hoenn's largest cities, Slateport and Mauville, and it also links to Route 103. Those without Bikes must travel the pedestrian path, which features the mysterious Trick House. Once you get a Bike, you can get a rush through the route on Cycling Road.

To Mauville City (p. 89)

Berry Trees

Beauty Melissa

Fisherman Dale

To New Mauville (p. 253)

Triathlete Jacob

Triathlete Sloan

Psychic Edward

Collector Edwin

Triathlete Anthony

Triathlete Benjamin

Trick House (p. 83)

Youngster Timmy

To Route 103 (p. 32)

Poké Fan Isabel

Triathlete Dolph

To Slateport City (p. 73)

Hidden Items

- ❏ Full Heal
- ❏ Great Ball
- ❏ Poké Ball
- ❏ Revive

Vending Machine

Cycling Road gates

Fresh Water	200

Items

- ❏ Dire Hit

After obtaining a Bike

- ❏ Manectite

After learning Surf

- ❏ Elixir
- ❏ Rare Candy

Oddish Grass Poison
Ability: Chlorophyll

Plusle Electric
Ability: Plus

Tall Grass		
❑ Electrike	◎	
❑ Gulpin	△	
❑ Oddish	△	
❑ Minun	△	Ω
❑ Plusle	△	α
❑ Voltorb	▲	
❑ Wingull	△	
❑ Zigzagoon	△	

Horde Encounters		
❑ Magnemite (×5)	◎	
❑ Minun (×5)	○	Ω
❑ Plusle (×5)	○	α
❑ Minun (×4) Plusle (×1)	▲	Ω
❑ Plusle (×4) Minun (×1)	▲	α

Fishing		
Old Rod		
❑ Magikarp	◎	
❑ Tentacool	○	
Good Rod		
❑ Magikarp	◎	
❑ Tentacool	○	
❑ Wailmer	▲	
Super Rod		
❑ Wailmer	◎	

On the Water		
❑ Pelipper	▲	
❑ Tentacool	◎	
❑ Wingull	○	

◎ frequent ○ average
△ rare ▲ almost never

1 Take a stroll along the low road

As you enter Route 110 from Slateport City, Cycling Road's south gate stands before you. You don't have a Bike, however, so your explorations of Route 110 are limited to the lower, pedestrian path for now. That's just fine, as you'll get to battle Trainers for prize money and catch new species of wild Pokémon as you explore northward!

TIP

Although you can't pass through the south gate into Cycling Road, you can purchase Fresh Water from the indoor Vending Machine.

TIP

Once you get a Mach Bike, you'll be able to race along Cycling Road, dodging obstacles as you strive to record your best time!

2 Catch up to Team Magma / Team Aqua

Let's keep going through Route 110 and head for Mt. Chimney!

Let's keep going through Route 110 and head for Mt. Chimney!

As you stroll northward, you'll soon encounter a Team Magma / Team Aqua mob. They seem intent on heading for a place called Mt. Chimney, but not before resting in nearby Mauville City. Hey, if there's no rest for the wicked, then maybe these guys aren't so bad after all?

3 Check out the Trick House

Three steps → and two steps ↑ to reach the wondrous Trick House.

The road forks just beyond the spot where you spotted Team Magma / Team Aqua. The western trail leads to Route 103, while the eastern trail leads underneath Cycling Road, eventually bending north toward Mauville City. A place known as the Trick House lies at this junction. Head inside if you feel like puzzling your way toward prizes!

Rewards: Lava Cookies, TM12 Taunt, and more!

TIP

Although you can explore the Trick House right now, many of the Trainers inside are quite formidable. You only get one run through each of the Trick House's mazes, so consider leaving the Trick House for later and sticking to the main path for now. If you decide to give the Trick House a go, save your game and see the next few pages.

Orlando found a Guard Spec.!

Explore Route 103's east half

Remember Route 103 (p. 32)? Previously, you were only able to explore its western half (everything west of the bay that intersects it). Go west from the Trick House, however, and you can explore Route 103's eastern half. You'll find a few Trainers, some Berry Trees, and a Guard Spec. Once you learn the Surf field move, you'll be able to Surf across Route 103's central sea and use the route as a shortcut between Oldale Town and Slateport and Mauville Cities.

Trick House

Maze
Entrance

Exit
(to Trick House entrance)

Items
☐ Escape Rope
☐ Expert Belt

To Route 110 (p. 81)

Entrance
(from maze)

The Trick House is located on Route 110 and is owned by the Trick Master. He's a fun-loving prankster who's crafted a lot of entertaining tricks for travelers. Don't let the Trick Master's hard work go to waste! Experience his Trick House and you're sure to have fun!

How to challenge the Trick House

1. Find the Trick Master

When you enter the Trick House, you can't shake the feeling that someone is watching you. That's because the mischievous Trick Master is hiding somewhere! Search the whole room by pressing Ⓐ to check every object (the table, a cushion, and so on). Keep searching until you find the hidden Trick Master. Once you find him, he accepts your challenge and disappears. If this is your first visit, the Trick Master warns you that his tricks are quite difficult. He gives you a handy Escape Rope before he vanishes.

2. Enter the maze, find the scroll, open the door

After the Trick Master leaves, examine the hanging scroll on the wall. You'll discover a secret passage that leads into a devious maze! Battle Trainers and overcome obstacles as you navigate the maze in search of a rolled-up scroll with a secret code. Get to the back of the maze, where the exit is hidden behind another hanging scroll, and inscribe the secret code onto the scroll hiding the door. The door then opens, granting you access to the Trick Master's room! There's no going back into the maze once you've entered this room, so make sure you find everything the maze has to offer.

3. Enter the Trick Master's room to receive your reward

The Trick Master waits in his room beyond the maze. Speak to the Trick Master to receive your reward. You can also find an Expert Belt in this room.

4. Leave the Trick Master's room

Here's hoping you found everything the maze had to offer! Exit through the opening in the left corner of the Trick Master's room.

> **TIP**
>
> You will need field moves to clear most of these mazes. You will obtain the HM for Rock Smash after visiting Mauville City's Gym, and the HM for Strength will be available on Route 112.

Clear all six Trick House mazes!

The Trick Master has built six unique mazes for travelers to enjoy. The challenges you face in each maze are unique, but the general steps to clearing each maze are the same. Simply leave the Trick House and return to attempt the next maze.

Maze	Obstacles	Field moves needed	Items you can find	Rewards
1	Prickly thorns and Trainers	Cut	Lava Cookie (×2), Expert Belt (in Trick Master's room)	TM12 Taunt
2	Cracked boulders and Trainers	Rock Smash	Rage Candy Bar (×2)	Hard Stone
3	Fences and Trainers	Flash	Lumiose Galette (×2)	TM92 Trick Room
4	Big boulders	Strength	Casteliacone (×2)	Smoke Ball
5	Mechadolls	(None)	Old Gateau (×2), Escape Rope (from one of the Mechadolls)	Magnet
6	Rotating panels	(None)	Shalour Sable (×2), Big Nugget (check a cushion in the Trick Master's room)	Red Tent (Ω) / Blue Tent (α)

Maze 1: Prickly Thorn Puzzle

Battles with Trainers are inevitable. So come prepared to battle!

To Trick Master's Room

Scroll

Youngster Eddie
◉◉◉◉◉◉

Battle Girl Cora
◉◉◉◉◉◉

Lass Sally
◉◉◉◉◉◉

Entrance

Maze 2: Rock Smash Rally

You can avoid some of the Trainer battles if you want. Dart past them when they're not looking and avoid eye contact! Rock Smash is needed to clear this maze.

To Trick Master's Room

Black Belt Yuji
◉◉◉◉◉◉

Scroll

Pokémon Ranger Sebastian
◉◉◉◉◉◉

Pokémon Ranger Sophia
◉◉◉◉◉◉

Schoolkid Georgie
◉◉◉◉◉◉

Entrance

Maze 3: Dark Deception

The scroll looks like you should be able to reach it right away, but don't be fooled. Sometimes the long way around is the shortest way to what you want. Flash will help you clear this maze.

To Trick Master's Room

Schoolkid Ted

Ace Duo Pike & Shiel
★ Double Battle

Lass Robin

Scroll

Entrance

Maze 4: Test of Strength

Go around the room counterclockwise. Think very carefully before moving boulders. Once a boulder gets stuck in a position, you can't move it unless you leave the room and start over! Strength is needed to clear this maze.

To Trick Master's Room

Scroll

Entrance

TRAINER HANDBOOK

ADVANCED HANDBOOK

ADVENTURE DATA

Maze 5: Mechadolls' Mind Games

Mechadolls' quizzes are quite difficult. If you give one wrong answer, you have to restart from the beginning. On the bright side, each Mechadoll has only three quizzes, so eventually you'll get all correct answers. Take notes! Notice that the floor plan looks familiar?

To Trick Master's Room

Scroll

Entrance

Maze 6: Pesky Floor Panels

Pay attention to the gaps between the fences and walk through the gaps instead of stepping on the floor panels. Take note where the floor panels lead and avoid any panels that make you go into a loop!

To Trick Master's Room

Scroll

Entrance

After the last challenge, visit his house one more time to say good-bye to one of his Mechadolls. You should check his scroll, too.

4 Have a battle with May/Brendan

Go east from the Trick House and pass beneath Cycling Road. Collect the Dire Hit from near the Trainer Tips sign, and then proceed north until you encounter your friend May/Brendan. It seems like ages since you last met, and your friend wishes to see how far you've come as a Trainer by testing you in battle!

May/Brendan's Pokémon

If you chose Treecko

Combusken — Fire, Fighting
♀/♂ Lv. 20
Weak to: Water, Ground, Flying, Psychic

Shroomish — Grass
♀/♂ Lv. 18
Weak to: Fire, Ice, Poison, Flying, Bug

Wailmer — Water
♀/♂ Lv. 18
Weak to: Grass, Electric

If you chose Torchic

Marshtomp — Water, Ground
♀/♂ Lv. 20
Weak to: 4× Grass

Shroomish — Grass
♀/♂ Lv. 18
Weak to: Fire, Ice, Poison, Flying, Bug

Slugma — Fire
♀/♂ Lv. 18
Weak to: Water, Ground, Rock

If you chose Mudkip

Grovyle — Grass
♀/♂ Lv. 20
Weak to: Fire, Ice, Poison, Flying, Bug

Wailmer — Water
♀/♂ Lv. 18
Weak to: Grass, Electric

Slugma — Fire
♀/♂ Lv. 18
Weak to: Water, Ground, Rock

5 Receive the Dowsing Machine

Orlando obtained the Dowsing Machine!

May/Brendan is kind enough to heal your Pokémon after your friendly battle. He/she then hands you a very special tool called the Dowsing Machine. Armed with this Key Item, you can now search areas more thoroughly and discover hidden items!

TIP

The Dowsing Machine is a Key Item, so it can be registered to Ⓨ just like the Old Rod. Take a moment to register the Dowsing Machine by opening your Bag, selecting Key Items, highlighting the Dowsing Machine, and then choosing Register. Now you can easily equip and stow the Dowsing Machine by pressing Ⓨ as you explore!

6 Do a little Dowsing

Orlando found a Full Heal!

Pull out your Dowsing Machine and begin searching the area. Backtrack just a bit to the south to discover your first hidden item, a Full Heal, back near the previous Trainer Tips sign. It's just north of the sign.

Orlando found a Great Ball!

Proceed north after you've found the hidden Full Heal, continuing to dowse for fun and profit as you go. Battle a few more Trainers and discover three more hidden items with your Dowsing Machine as you head for Mauville City.

Dowsing Machine

The Dowsing Machine is a convenient tool that helps you track down hidden items, and it couldn't be easier to use. Just open your Bag, select the Key Items pocket, highlight the Dowsing Machine and choose Use. Or choose Register to map the Dowsing Machine to Ⓨ so you can quickly equip it by pressing Ⓨ in the field!

While using the Dowsing Machine, pay attention to the noises it makes and the color of the lights on top. The lights change color and the noises gain pitch as you near a hidden item. When the lights of the Dowsing Machine turn red and the noises go wild, you're right in front of a hidden item! Press Ⓐ to pocket your prize.

Color indicator chart

Far Close!

TIP

When you're standing right on top of a hidden item, the Dowsing Machine doesn't react to it.

Although you couldn't have known it at the time, several items are hidden in areas you've explored. If you'd like every advantage going forward, now is a good time to go back and find some hidden treats!

Route 104 (South) (p. 42): Antidote, Heart Scale, Potion
Petalburg Woods (p. 44): Poké Ball, Potion, Tiny Mushroom (×2)
Route 104 (North) (p. 46): Poké Ball, Super Potion
Route 116 (p. 58): Super Potion
Route 106 (p. 68): Heart Scale, Poké Ball, Stardust
Route 109 (p. 71): Ether, Great Ball, Heart Scale (×2), Revive

MAUVILLE CITY

This large city is located in the heart of the Hoenn region, at the crossroads of its nostalgic past and new technology.

Want to shop till you drop? You've come to the right place! Mauville City can be thought of as a sprawling mall with all sorts of specialty stores. This stacked city features three levels of fun, but the second floor is only accessible to tenants of Mauville Hills. TM89 U-turn is in Mauville Hills, so you cannot get it this time.

To Route 111 (South)
(p. 106)

1F

Mauville City Gym (p. 99)

TV Mauville

E M N G

Pokémon Reflexology Services

PokéMileage Center

Battle Institute Hoenn

Inverse Battle Stop

Ritzy Ribbon Retail

Narcissus Mirror Shop

Rydel's Cycles

C

To Route 117
(p. 102)

D

To Route 118
(p. 150)

Ultimate Move Studio

Failed Businessman

A

Pledge Move Dojo

Crooner's Café

Song and Sword Move Academy

Mauville Food Court

I K

To Route 110
(p. 81)

1F Courtyard

Pokémon Center

Poké Mart

B

C D

A

Poké Mart	
Antidote	100
Awakening	250
Burn Heal	250
Escape Rope	550
Great Ball	600
Ice Heal	250
Hyper Potion	1,200
Paralyze Heal	200
Poké Ball	200
Potion	300
Repel	350
Revive	1,500
Super Potion	700
Super Repel	500
After obtaining the Dynamo Badge	
Full Heal	600
Max Repel	700
Ultra Ball	1,200

Roof	
Suited man	
Metronome	1,000

Vending Machine	
Fresh Water	200
Lemonade	350
Soda Pop	300

2F

Items

1F

- ❑ Acro Bike / Mach Bike
- ❑ Globe
- ❑ HM06 Rock Smash
- ❑ Mudkip Doll
- ❑ TM48 Round
- ❑ TM58 Sky Drop
- ❑ Torchic Doll
- ❑ Treecko Doll
- ❑ Vs. Recorder
- ❑ X Speed

Roof

- ❑ Nugget
- ❑ Poké Toy

After obtaining seven Badges

- ❑ TM89 U-turn

Hidden Items

1F

- ❑ X Defense

Roof

- ❑ Luxury Ball
- ❑ Max Repel

Roof

PokéMileage Center

	Poké Miles
Berry Juice	10 miles
Ether	120 miles
Full Heal	30 miles
Full Restore	300 miles
Hyper Potion	60 miles
Max Potion	125 miles
Max Repel	35 miles
Max Revive	400 miles
Moomoo Milk	20 miles
PP Up	1,000 miles
Rare Candy	500 miles
Ultra Ball	60 miles

Poké Mart

Special Wares	
TM9 Venoshock	10,000
TM40 Aerial Ace	10,000
TM42 Facade	10,000
TM47 Low Sweep	10,000
TM57 Charge Beam	10,000
TM78 Bulldoze	10,000
TM82 Dragon Tail	10,000
TM98 Power-Up Punch	10,000

Ritzy Ribbon Retail

Gorgeous Ribbon	10,000
Royal Ribbon	100,000
Gorgeous Royal Ribbon	999,999

1 Spot Wally and his uncle

No, thank you!
I want to challenge the Gym right away!

Welcome to Mauville City! There's certainly plenty going on around here. As you stroll down the entrance, you catch sight of a familiar face. It's Wally, the boy you met back in Petalburg City! Wally is visiting Mauville City with his uncle, but he isn't interested in shopping. Instead, he streaks off to challenge the city's Gym Leader! Is this really the same timid boy who needed your help to catch his very first Pokémon?

2 Visit the Pokémon Center and Poké Mart

Orlando obtained a
Globe for his base!

Mauville City can seem overwhelming at first, so let's start with the basics. Head directly north, passing through some glass doors to reach the central courtyard. The Pokémon Center and Poké Mart are just ahead, where you can rest your party and restock your items. Check behind the central Square Tower with your Dowsing Machine to score an X Defense, and speak to the Backpacker in the courtyard to receive a Globe for decorating. What exactly can you decorate with this Globe? You'll find out before long!

TIP

The Poké Mart features two clerks, just like the one in Slateport City. The lower clerk peddles a familiar array of necessities, while the upper clerk offers a selection of valuable TMs. If you can afford it, TM78 Bulldoze will be a big help in the upcoming Gym!

3 Get some new O-Powers from Giddy

My name is Giddy!
I have a scintillating story for you!

Inside the Pokémon Center, talk to the bald old man. The man's name is Giddy, and he has a scintillating story to tell. Listen up as he pours out his deepest thoughts, and he'll teach you the O-Power Speed Power Lv. 1 at the end! Strike up another conversation with Giddy afterward. After you endure his second story, you'll then be taught the O-Power Critical Power Lv. 1! Giddy departs at this point, sparing you from further musings.

TIP

Speak to the girl in the Poké Mart and agree with her opinion to receive the TM58 Sky Drop for free.

Outstanding O-Powers

O-Powers are special powers that are activated through the PSS. You may use these powers on yourself or others at any time by opening the PSS from the PlayNav app. Open the PSS menu and then select O-Power. You can also use O-Powers on others who are playing at the same time by selecting their icon in the PSS and then tapping O-Power in the list of options that appear.

Each O-Power has its own special benefits, and you can share these benefits with other players. Sharing O-Powers is a great way to make new friends—and the more you use your O-Powers, the more powerful they'll become!

How to get O-Powers

Giddy is not the only man who appears in Mauville City's Pokémon Center and gives you O-Powers. After Giddy leaves, four more men will appear at the very same spot, one after the other: the Hipster, the Bard, the Trader, and the Storyteller. The point at which you can meet these colorful characters depends on your progress in the adventure (p. 406). After you meet them and receive their O-Powers, each of them will return to their apartment in Mauville Hills (yes, all five of them live in one apartment). Visit their apartment in Mauville Hills once you have access to the apartment complex to get the final O-Power (p. 250)!

Hey! Stay away from that chair! I saw it first!

Now that your Pokémon are all rested and your items are replenished, you're ready to explore Mauville City more thoroughly. Return to the entry hall and go east to find the Food Court, which will be right at the corner—but be ready to battle if you decide to order a meal!

Rewards: Nuggets, Berries, and more!

Mauville Food Court

Mauville's Food Court is packed with hungry Trainers who won't hesitate to battle you for a seat so they can sit down to eat their meal from one of the Food Court's three restaurants. Be ready to battle before placing your order! You can only order one meal per day at the Food Court, so make sure you're ready to chow.

TIP

Two of the Food Court's eateries are so popular that folks line up for hours, preventing you from ordering from them until later in the adventure.

Village Sub Combo

When you first arrive in Mauville, you'll only be able to order the Village Sub Combo. One order costs 1,000 and takes five turns to make. After ordering, you'll be given a buzzer and told to sit down and wait, but look out: hungry Trainers will come to challenge you to Single Battles for your chair! Finish up one of your battles at just the right time, and you'll get a free Nugget with your meal! Defeat all the pesky Trainers in exactly five turns, and you'll get one of either a Figy, Aguav, Mago, Wiki, or Iapapa Berry in addition to your Nugget. Tasty!

Magnemite Croquettes

Mauville Ramen Bowl

Come back once you've collected eight Gym Badges and the line for Magnemite Croquettes will have finally died down. Make sure you have at least two Pokémon in your party before you order, though. An order here costs 5,000 and takes six turns to make. Once again, you're given a buzzer and told to wait, and once again hungry Trainers come to battle you for your seat—only this time they're Double Battles! Finishing a Double Battle in exactly the right number of turns here earns you a Pearl String. Defeating all of the Trainers and still finishing in just the right number of turns gets you a Pearl String and a Metal Powder!

This eatery is so popular that it takes even longer for the crowd to thin out, so come back after you complete the Delta Episode. Before you can order ramen, you'll need at least three Pokémon in your party. A meal at Mauville Ramen Bowl costs 10,000 and takes eight turns to make. This time, you'll have to take on Trainers in Triple Battles to secure your seat. Rumor has it that there's one Trainer hanging around here who really doesn't want to lose to you for some reason. This time, finishing in just the right number of turns gets you a Big Nugget, while defeating all of the Trainers in exactly the right number of turns earns you a Deep Sea Tooth (*Pokémon Omega Ruby*) or a Deep Sea Scale (*Pokémon Alpha Sapphire*), too.

Menu Item	Cost	Main Reward	Can be sold for	Additional Rewards
Village Sub Combo	1,000	Nugget	5,000	Figy / Aguav / Mago / Wiki / Iapapa Berry
Magnemite Croquettes	5,000	Pearl String	7,500	Metal Powder
Mauville Ramen Bowl	10,000	Big Nugget	10,000	Deep Sea Tooth (Ω) / Deep Sea Scale (α)

TRAINER HANDBOOK

ADVANCED HANDBOOK

ADVENTURE DATA

Now that your stomach is full, burn some calories by exploring Mauville City's shop-lined halls. There are so many boutiques to see that you may work up an appetite again!

"Same Old Battles Got You Down? Turn It Up!"
Inverse Battle Stop

West Mauville Shop Guide

The following shops and vendors are all located along Mauville City's west hall.

Crooner's Café

"A Mellow Blend of Coffee & Music"
Crooner's Café

This quaint café is a favorite hangout for singers and song lovers. Speak to the barista to receive TM48 Round, which is an effective move to use in battles that feature multiple Pokémon, such as Double and Triple Battles. A Move Tutor who wishes to teach a special move to Keldeo or Meloetta also lounges here, but these Pokémon are not native to the Hoenn region. Be sure to visit this Move Tutor if you manage to receive Keldeo or Meloetta in a trade!

Failed Businessman

People used to come to my place and play games like crazy. Good times.

Speak to the man who stands just north of Crooner's Café to learn that his game store has recently gone out of business. How sad! All in all, the man isn't too dismayed, but he does have a few prizes left over that he needs to give out. Agree to take them off his hands, and you'll receive three dolls that can be used to decorate...something. You'll soon find out what that something is!

Narcissus Mirror Shop

Hi there. Welcome!
This is a specialty mirror store.

Many mirrors are displayed at this fancy stand. The proprietor says that her mirrors were all collected by her husband, and she's reluctant to sell any of them. However, she seems to have something that'd be perfect for Tornadus, Thundurus, or Landorus. If you manage to obtain any of these Pokémon in your adventure, remember to return here.

PokéMileage Center

Would you like to trade
Poké Miles for prizes?

Speaking of trades, did you know that you accumulate Poké Miles each time you trade Pokémon with another player? You also earn Poké Miles just by traveling around Hoenn. View your Trainer Card to see how many Poké Miles you've accumulated, and then visit the PokéMileage Center here in Mauville City to exchange your Poké Miles for prizes! The complete list of prizes can be found at the beginning of this section.

TIP

You can also use your Poké Miles on the Pokémon Global Link. See page 415 for more about that!

West Mauville Shop Guide (cont.)

Ritzy Ribbon Retail

Welcome to Ritzy Ribbon Retail. What would you like today?

Located on the west hall's west side, Ritzy Ribbon Retail sells a selection of pricey Ribbons designed especially "For Pokémon That Aim for a Higher Rank." Buy a Ribbon here, and it will be given to your lead Pokémon. Ribbons are collector's items that are displayed in your Pokémon's Summary page.

Pokémon Reflexology Services

This is where Pokémon can receive a massage treatment.

Who doesn't like a massage? Pokémon sure do! Visit the Pokémon Reflexology Services stand and speak to the friendly masseuse at the counter. She'll offer to give your lead Pokémon a nice relaxing massage. Getting your Pokémon a massage makes it more friendly toward you, which can have a variety of benefits (p. 76). Massages are free, but they take a lot of effort, so you only get one per day.

East Mauville Shop Guide

Now let's take a look at the shops and vendors you'll find along Mauville City's east hall.

Song and Sword Move Academy

Hm, no one's here! This must be the move academy that the sad man in the Crooner's Cafe was talking about. He said he wanted to teach Keldeo or Meloetta some moves. He must mean Relic Song and Secret Sword!

Pledge Move Dojo (Battle-Combo Move Tutor)

Talk to this Move Tutor to teach Pokémon that you've received from a professor (such as Professor Birch) a powerful battle-combo move! These moves are useful in battles that feature multiple Pokémon, such as Double and Triple Battles. When two Pokémon use synergistic battle-combo moves during the same turn, they'll power up each other's moves and inflict massive damage!

Ultimate Move Studio (Ultimate Move Tutor)

What do you say? Shall we teach your lovely little Pokémon some moves?

This Move Tutor can teach Ultimate Moves to the following final-Evolution Pokémon, but you likely won't have any of these high-level Pokémon on hand during your first visit to Mauville City. Keep working hard to level up and evolve your Pokémon to their final forms!

Fire-type Pokémon: Charizard, Typhlosion, Blaziken, Infernape, Emboar, Delphox

Water-type Pokémon: Blastoise, Feraligatr, Swampert, Empoleon, Samurott, Greninja

Grass-type Pokémon: Venusaur, Meganium, Sceptile, Torterra, Serperior, Chesnaught

Inverse Battle Stop

"Same Old Battles Got You Down? Turn It Up!" Inverse Battle Stop

Want to put a twist on your battles? Pop by the Inverse Battle Stop, where Proprietor Inver uses his ingenious Inverse-o-matic to flip the script on Pokémon battles. Agree to battle Proprietor Inver, and you'll be thrust into an intense Inverse Battle! Type matchups are flipped on their heads in these mind-bending matches, so use moves that would normally be ineffective against your opponent to seize victory. You can only battle Proprietor Inver once per day—impress him to win prize money and items! See the next page for details.

East Mauville Shop Guide (cont.)

Battle Institute Hoenn

"Test Your Battle Mettle!"
Battle Institute Hoenn

Located right next to the Inverse Battle Stop, the Battle Institute is a place where powerful Trainers can test their mettle in a series of challenging battles and see how good they really are. You can't do much here until you've beaten the Champion of the Hoenn region, so you'll have to return later. A friendly fellow forks over a free Vs. Recorder when you visit, however, so it's worth stopping by.

TIP

You can use the Vs. Recorder to record your Link Battles and battles in special facilities, like the Battle Institute itself. These videos can then be shared over the PSS feature of your PlayNav. You can also share your videos with friends by giving them the code for one of the videos you've recorded. What's even more amazing about this device is that it lets you put yourself in any battle video you watch. You can choose to reenact a battle using the Pokémon featured in the video. But you can choose to send out Pokémon in a different order or choose entirely different moves. This is a great opportunity to test strategies and see if you could have turned a lost battle in your favor some other way.

TIP

You may be able to participate in Download Tests at the Battle Institute, even before taking on the Champion. If any are currently available, download them to get your first taste of a Battle Test!

Rydel's Cycles

Located across from the Inverse Battle Shop, Rydel's Cycles is the place to go when you want to get your hands on some wheels. Seeing how filthy your poor old shoes are, the friendly shop owner, Rydel, gives you a free Bike to hasten your travels. Now you can explore the Hoenn region at top speed, with the wind blowing through your hair! Speak to the owner again to swap your Bike out for a different one, and flip ahead to page 97 to learn about the two different Bikes that Rydel stocks.

TV Mauville

Ever wondered where all of those fabulous BuzzNav programs are filmed? Right here at TV Mauville! Feel free to take a tour of the studio and browse the gift shop. You can even sit behind the news desk and read the latest bulletin before it airs! TV Mauville is located to the north of East Mauville shops, next to the Mauville City Gym.

Inverse Battles

Inverse Battles are unique and challenging affairs in which all type matchups are reversed. For example, the Grass type is normally super effective against the Water type—but in an Inverse Battle, the Grass type won't be very effective against the Water type at all! The Inverse Battle Type Matchup Chart on page 463 is a valuable asset, but it helps to know the following things before taking on Proprietor Inver at the Inverse Battle Stop.

It's super effective!

- You can only attempt one Inverse Battle per day. You can win some nice prizes, though, so keep coming back!
- Inverse Battles are always Single Battles, and up to three Pokémon can take part in them.
- Your opponent's Pokémon are Level 20—until you become Champion, that is. The Champion deserves an extra challenge!
- Ability effects don't change during Inverse Battles; only type matchups change.
- Moves that Pokémon are usually immune to will do double damage. For example, Fighting-type moves normally have no effect on Ghost-type Pokémon, but in Inverse Battles, they'll deal supereffective damage!

Inverse Battles (cont.)

Inverse Battle rewards

The items you're awarded after an Inverse Battle depend on how well you've performed. Dealing normal damage does nothing to improve your performance, and dealing ineffective damage actually lowers it. You'll need to deal supereffective damage to get the best items!

Proprietor Inver's Message	Reward
"Nice job! Though I think that you haven't quite grasped the trick of Inverse Battling. Still, I'll give you a little something, so be sure to come try again!"	Oran Berry
"Nice! Very, very nice! You've learned a fair bit about the beauty of Inverse Battling, hm? I've got a little something for an opponent like you! Here! Take it!"	Sitrus Berry
"Nice! Very, very nice! You've learned quite a bit about the beauty of Inverse Battling, hm? I've got a little something for an opponent like you! Here! Take it!"	Occa Berry / Passho Berry / Wacan Berry / Rindo Berry / Yache Berry / Tanga Berry / Charti Berry / Kasib Berry / Haban Berry / Colbur Berry / Babiri Berry / Roseli Berry / Chilan Berry
"Ohhh! Excellent! Just excellent! You have perfectly understood the beauty of the Inverse Battle! I've got a little something for an opponent like you! Here! Take it!"	Fire Stone / Water Stone / Leaf Stone / Thunder Stone / Moon Stone / Sun Stone / Shiny Stone / Dusk Stone / Dawn Stone / Everstone
"Oh, yes! Oh, just as I would expect! You are a true habitué of the Inverse Battle Stop! I've got a little gift for such a great regular. Here! Take it!"	Rare Candy

TIP
Proprietor Inver will triple your reward if you manage to win without any of your Pokémon's HP falling into the red!

6 Reap rewards around the rooftop

Orlando obtained a
Metronome!

Mauville City's elevators lead to the second floor, but that floor is restricted to the tenants of Mauville Hills. You can take the stairs all the way up to the rooftop, however, where you'll enjoy fresh air and meet several friendly folks. The suited man up north will sell you a Metronome for 1,000, while the young girl up north will give you a Poké Toy if you assure her that you love Pokémon. Keep running around the rooftop, and a man will eventually appear and hand you a Nugget, which can be sold at a high price to shops. Not a bad haul!

TIP
Search the roof with your Dowsing Machine to find even more goodies, including a Luxury Ball and a Max Repel!

TIP
Take the northeast stairs to the second floor, and you'll meet a man in the stairwell who's waiting for Genesect. This Pokémon is not native to the Hoenn region, so he could be waiting here for quite some time! Perhaps you should speak to this man again if you happen to receive a Genesect in trade.

Mach Bike and Acro Bike

Rydel's Cycles offers two types of Bike: the Mach Bike and the Acro Bike. You can swap one Bike for the other at any time by speaking with Rydel, so don't worry about picking the wrong one. Both Bikes help you travel much faster than walking or running, so they come in handy. Register your Bike to Ⓨ so that you can quickly use it at any time (p. 65).

The Mach Bike goes about three times as fast as you move on foot, but it can be tough to control and it can't make quick stops. The Acro Bike only goes about twice as fast as you move on foot, but you can perform all kinds of cool tricks on it.

> **TIP**
>
> You're slightly less likely to encounter wild Pokémon when riding a Bike—though it may feel like you meet more because you're going so much faster!

> **TIP**
>
> Bikes don't move quickly through deep sand, and you can't perform tricks while riding through this type of terrain.

Riding your Bike

To get on your Bike, select it in your Bag's Key Items pocket and choose Use. Repeat this to get off the Bike. You can also simply press Ⓨ to get on and off your Bike if you register your Bike to Ⓨ. Use the +Control Pad or the Circle Pad to move and make turns while riding your Bike.

Mach Bike moves

Speed up sandy slopes!

You can't climb sandy slopes on foot or with the Acro Bike, but the Mach Bike travels so fast that it can ride straight up these sorts of slopes. This lets you explore areas you otherwise couldn't reach, like certain areas of Granite Cave (p. 69)!

Acro Bike moves

Wheelie and bunny hop

Press Ⓑ to lean back and lift the Acro Bike's front wheel off the ground, a trick that's known as a wheelie. Keep holding Ⓑ to maintain the wheelie, and you'll soon begin to hop in place with your front wheel up in the air! This impressive maneuver is known as the bunny hop.

Use the bunny hop to cross stepping stones!

Use the +Control Pad or Circle Pad while hopping in place on your Acro Bike, and you'll start hopping in the direction that you press. This lets you hop up small stepping stones in locations like Jagged Pass (p. 130).

Hop sideways across bridge platforms!

Simultaneously press Ⓑ and a directional key to the left or right of your current direction, and you will perform a sideways hop in that direction. This can help you cross certain narrow bridges that have parallel sections.

> **TIP**
>
> Simultaneously press Ⓑ and the directional key that's opposite to the way you're facing to perform a sweet jumping turn!

◀◀ **BACKTRACK** ▌ **ROUTE 110** p. 81

Cycle to your heart's content!

Try a race on Route 110!

Now that you've got a Bike, you can use it to race along Cycling Road. Swap your Acro Bike for the Mach Bike if need be, and then speed back to Route 110. Pass through Cycling Road's north gate, and then speed southward along the track, battling Trainers for prize money as you breeze along! You'll have to avoid them if you want to get the best time, though.

> 🌐 **TIP**
>
> Before going uphill to Cycling Road's raised track, ride along the grass to find a hidden Trainer near a sparkling patch of ground. Beat the Trainer in battle, and then search those sparkles to score another mysterious Mega Stone called Manectite!

Finish raiding Granite Cave!

Your Mach Bike can also help you explore new areas of Granite Cave. Ride back to Route 109, then ask Mr. Briney to ferry you to Dewford Town. Take the north exit out of town to reach Route 106, then enter Granite Cave. Use your Mach Bike to scale the sandy slope inside the cave, then climb down the ladder to explore the dark depths below! You'll find many valuable items deep inside Granite Cave, including a Rare Candy, TM65 Shadow Claw, a Steelixite (search the sparkling patch), and more. The cave's depths are dark, however, so bring a Pokémon that can use Flash.

7 Accept Wally's battle challenge!

And have a battle with me!

Mauville City's Gym is located along its north hall. Go there to find young Wally and his uncle standing just outside the Gym. Wally really wants to challenge the Gym Leader, but his uncle is afraid that it might be too much of a challenge for him. Wally asks you to battle him so that he can test his skills. There's no need to feel timid—agree to the battle and show Wally what it means to be a Trainer!

Wally's Pokémon

○○○○○○

🔴 **Ralts** `Psychic` `Fairy`
♂ Lv. 17
Weak to: `Poison` `Ghost` `Steel`

8 Receive HM06 Rock Smash

Orlando obtained
HM06 Rock Smash!

Wally's a bit dismayed after the battle, but his spirits soon perk up. He knows he'll only get stronger from this point forward! Wally hurries back to Verdanturf, but his uncle pauses just long enough to thank you for taking the time to help his nephew. He gives you HM06 Rock Smash as a token of his appreciation—a move that you'll find very useful in the coming Gym battles!

9 Storm the Mauville City Gym!

You've now explored Mauville City fully, and you might have even done a little backtracking with your newfound Bike. Conquering the Mauville City Gym is all that's left! Save your game after the battle against Wally, and optionally return to the Pokémon Center to rest your party before entering the Gym.

TIP

If you'd like a bit more practice before entering the Gym, feel free to venture into the routes that surround Mauville City. You'll encounter more Trainers and wild Pokémon as you explore Routes 117 (p.102), 118 (p. 150), and 110 (p. 81), although you can't make it all the through the last two.

TRAINER HANDBOOK

ADVANCED HANDBOOK

ADVENTURE DATA

MAUVILLE CITY GYM BATTLE

Gym Battle Tips
- Bring lots of Cheri Berries and/or Paralyze Heals
- Teach TM78 Bulldoze to a Pokémon for a devastating move

Guitarist Kirk
ⓞⓞⓞⓞⓞⓞ

Gym Leader Wattson
ⓞⓞⓞⓞⓞⓞ

A

Entrance

A

Guitarist Shawn
ⓞⓞⓞⓞⓞⓞ

Battle Girl Vivian
ⓞⓞⓞⓞⓞⓞ

Youngster Ben
ⓞⓞⓞⓞⓞⓞ

1 Assemble your party before entering the Gym

Makuhita used Bulldoze!

Mauville City's Gym is filled with Trainers who favor Electric-type Pokémon. You'll therefore find Ground-type Pokémon and moves to be of incredible value. Ground-type Pokémon have been somewhat scarce up to this point, but Nincada, which you may have caught along Route 116, is one possible option. If you were very lucky, you may have encountered and caught a Geodude in Granite Cave. A Rock and Ground type, Geodude is a fantastic option for this Gym.

TIP

If you have neither a Nincada nor a Geodude, perhaps you were able to trade Slakoth for Makuhita (nicknamed Makit) back in Rustboro City. You might also have caught a Makuhita in Granite Cave. Makuhita (and its Evolution, Hariyama) can learn Ground-type moves such as TM78 Bulldoze, which can be bought here in Mauville City's Poké Mart. Ground-type moves like Bulldoze will devastate the Pokémon you face in this Gym!

2 Step on switches to open the way forward

Oh zap! Gym Leader Wattson has outfitted his Gym with a number of high-voltage electric fences. To get past these shocking obstacles, you'll need to alter the flow of the fences' currents by stepping on various floor switches. The red switches change the flow of the red fences' currents, and the blue switches alter the flow of the blue ones. You may need to step on the same switch multiple times in order to advance.

TIP

Don't forget that you can leave the Gym anytime and rest your party at the Pokémon Center. This is a good way to cure your Pokémon of the Paralysis status condition that's often caused by Electric-type moves.

📍 Mauville City Gym Leader

Wattson — Electric-type Pokémon User

Insulate yourself from damage with Ground-type Pokémon!

A highly charged Trainer, Wattson has all sorts of tricks up his sleeve. For starters, Wattson's Pokémon know the Volt Switch move. This move not only shocks your Pokémon for damage, but also causes Wattson's Pokémon to retreat back into its Poké Ball. Another of Wattson's Pokémon is then sent out during the same turn.

Not only can Wattson swap out Pokémon with Volt Switch, but some of his Pokémon's moves can also cause paralysis. Once paralyzed, your Pokémon may not be able to act. It's therefore wise to switch out paralyzed Pokémon, or heal them with Cheri Berries or Paralyze Heals.

As if that's not bad enough, Wattson's Magneton can also confuse your Pokémon with its Supersonic move. A confused Pokémon may end up hitting itself instead of its opponent, wasting its turn and inflicting damage to itself. This is even worse than being paralyzed! Be sure to swap out a confused Pokémon for another, or clear the confusion with a Persim Berry or a Full Heal.

Last, know that Wattson also has a Super Potion that can heal his Pokémon. Between that and those Volt Switch moves, Wattson has many ways of keeping his weary Pokémon from fainting. Expect a challenging battle if you're unable to exploit Wattson's weaknesses. If you were able to purchase and teach TM78 Bulldoze to one of your Pokémon, use that move exclusively to inflict supereffective damage each turn!

Wattson's Pokémon

Magnemite Lv. 19		Electric Steel
Weak to:	4× Ground	Fire Fighting
Magneton Lv. 21		Electric Steel
Weak to:	4× Ground	Fire Fighting
Voltorb Lv. 19		Electric
Weak to:	Ground	

🔘 Dynamo Badge
Pokémon up to Lv. 40, including those received in trades, will obey you. You can also use Rock Smash outside of battle.

💿 TM72 Volt Switch
After making its attack, the user rushes back to switch places with a party Pokémon in waiting.

TRAINER HANDBOOK

ADVANCED HANDBOOK

ADVENTURE DATA

10 | Get Befriending Power Lv. 1!

I'll give you an O-Power!
Here we go!

You've just battled your way through a tough Gym, so pay a visit to Mauville City's Pokémon Center and rest your weary Pokémon. While you're there, speak to a fellow with red hair who now stands where Giddy previously stood. He's the Hipster, and he'll teach you the O-Power Befriending Power Lv. 1!

TIP

Now that you've earned the Dynamo Badge, more items are available at Poké Marts. Check out the Poké Mart here in Mauville City to find Full Heals, Max Repels, and Ultra Balls for sale. Full Heals can heal any status condition and confusion, making them especially useful. Max Repels are great for keeping wild Pokémon at bay, and while Ultra Balls are nice, Great Balls are still a good choice for catching Pokémon for now.

◀◀ BACKTRACK | TRICK HOUSE p. 83

Three steps → and two steps ↑
to reach the wondrous Trick House.

Rewards: Hard Stone, Magnet, Red Tent Ω / Blue Tent α, Smoke Ball, TM12, Taunt, TM92 Trick Room

Clear more mazes at the Trick House!

Now that you've earned the Dynamo Badge, you can perform the Rock Smash field move and shatter any cracked rocks that get in your way. This gives you the power to clear the Trick House's second maze! The third maze merely requires Flash, so you can beat it as well if you like. You can return to the Trick House on Route 110 to tackle these mazes.

11 | Go north in pursuit of Team Magma / Team Aqua!

Mt. Chimney...

Mt. Chimney...

If you go north from Mauville City, you'll catch up with Team Magma / Team Aqua. They're up to something again, and you'll quickly be drawn into their intrigue. Flip ahead to page 106 if you feel like following them now. If you'd prefer to explore some optional areas for fun and profit first, just keep reading.

Optional ROUTE 117

A path where many Trainers gather to raise their Pokémon and train them for battle.

Route 117 is located west of Mauville City. This grassy path's Trainers throw lots of Pokémon at you, so be ready for tough battles. A Pokémon Day Care is located here. Consider dropping off a Pokémon or two for the Pokémon Day Care to raise while you continue with your journey.

Pokémon Breeder Lydia ⊛
Triathlete Dylan ⊛
Pokémon Day Care
To Verdanturf Town (p. 104)
To Mauville City (p. 89)
Berry Trees
Pokémon Breeder Isaac ⊛
Bug Maniac Derek
Teammates Anna & Meg ⊛
★ Double Battle

On the Water

❏ Azumarill	○
❏ Marill	◎
❏ Masquerain	▲
❏ Surskit	△

Horde Encounters

❏ Marill (×5)	▲
❏ Oddish (×4), Zigzagoon (×1)	◎
❏ Roselia (×5)	○

◎ frequent ○ average
△ rare ▲ almost never

Tall Grass

❏ Illumise	○	Ω
❏ Illumise	▲	α
❏ Marill	△	
❏ Oddish	△	
❏ Roselia	○	
❏ Surskit	▲	
❏ Volbeat	▲	Ω
❏ Volbeat	○	α
❏ Zigzagoon	○	

Items

❏ Great Ball
❏ Revive

Fishing

Old Rod	
❏ Goldeen	○
❏ Magikarp	◎
Good Rod	
❏ Corphish	▲
❏ Goldeen	○
❏ Magikarp	◎
Super Rod	
❏ Corphish	◎
❏ Crawdaunt	▲

Roselia `Grass` `Poison`
Abilities: Natural Cure, Poison Point

Illumise `Bug`
Abilities: Oblivious, Tinted Lens

Crawdaunt `Water` `Dark`
Abilities: Hyper Cutter, Shell Armor

Magikarp `Water`
Ability: Swift Swim

1 Pop by the Pokémon Day Care

₽ 14,714
Leave Pokémon
Cancel
Would you like us to raise one?

Battle with Trainers, catch wild Pokémon, collect a few items, and harvest some Berries as you explore this grassy path. Of course, the main attraction here is the Pokémon Day Care—stop by and drop off one or two Pokémon on your way through the route.

TIP

Take the southwest path beyond the south flower bed to discover a sparkling patch of ground. Search those sparkles to find a Mawilite! Whip out your Dowsing Machine afterward and find a hidden Repel here as well. Both of these items are technically found within the limits of Verdanturf Town, so they're listed in the next section.

Pokémon Day Care

A Pokémon Day Care is a special place that raises Pokémon for busy Trainers. For a small fee, you can leave up to two Pokémon at a Pokémon Day Care and let the Day-Care staff raise them for you.

TIP

You must have at least three Pokémon in your party in order to leave Pokémon at a Pokémon Day Care. The staff won't let you drop off a Pokémon if it would leave you without any Pokémon—it would be too dangerous out on the routes without a team!

Pokémon will level up and learn moves!

During their stay at a Pokémon Day Care, Pokémon will gradually level up and learn moves while you are exploring the Hoenn region. If the Pokémon already knows four moves, the move at the top will be forgotten, and a new move will be added at the bottom. This may result in a Pokémon forgetting moves you want it to keep, so be careful!

TIP

If your Pokémon forgets a move that you didn't want it to forget, visit the Move Maniac's House in Fallarbor town (p. 118). In exchange for a Heart Scale, he'll teach a forgotten move to a Pokémon. If it's a TM move, simply use the TM to teach it the move again.

A Pokémon Egg may be found!

When you leave two Pokémon of opposite gender at a Pokémon Day Care, nature may take its course, and a Pokémon Egg may be found. Whether or not an Egg will be found depends on how well your Pokémon get along. Two Pokémon of the same species tend to get along well, but even Pokémon of different species can learn to like one another (p. 349). Try leaving a variety of Pokémon at a Pokémon Day Care and see what develops!

Clues from the Day-Care Man

Those two would really rather play with other Pokémon, though, and not each other.

After you leave two Pokémon of different genders at the Pokémon Day Care, speak to the Day-Care Man who stands outside. His response hints at the likelihood of finding an Egg.

"Those two seem to get along like a house on fire."	Eggs are likely to be found.
"Those two seem peaceable enough toward each other."	Eggs might be found.
"Those two don't seem to like each other all that much."	Eggs are unlikely to be found.
"Those two would really rather play with other Pokémon, though, and not each other."	Eggs will not be found.

Whenever an Egg is found, the Day-Care Man will be eager to talk to you. He'll be facing the road and looking for you. Speak to him to receive the Egg!

Wynaut hatched from the Egg!

Once you receive an Egg, put it in your party and carry it with you on your journey. Eventually, a Pokémon will hatch from the Egg. The more you travel with an Egg, the faster the Pokémon will hatch.

Thanks to the prevailing wind pattern, this town is always kept clear of falling volcanic ash.

This small, vibrant town lies just west of Mauville City. Your friend Wally moved here to live with his uncle's family, in the hopes that Verdanturf Town's fresh, clean air would help his health.

To Rusturf Tunnel (p. 59)

Contest Spectacular Hall

Poké Mart

Pokémon Center

Wanda's House

To Route 117 (p. 102)

Poké Mart

Special Wares	
Heal Ball	300
Luxury Ball	1,000
Nest Ball	1,000

Items

- ☐ Mawilite
- ☐ TM45 Attract

Hidden Items

- ☐ Repel

Poké Mart

Antidote	100
Awakening	250
Burn Heal	250
Escape Rope	550
Full Heal	600
Great Ball	600
Ice Heal	250
Hyper Potion	1,200
Max Repel	700
Paralyze Heal	200
Poké Ball	200
Potion	300
Repel	350
Revive	1,500
Super Potion	700
Super Repel	500
Ultra Ball	1,200

1 Visit Wally's new home

My daughter's a little concerned, so she goes out to the tunnel a lot.

Rest at the Pokémon Center, do a little shopping at the Poké Mart, and then head south to find Wanda's House. When you go inside, you'll learn that Wanda is your friend Wally's cousin! This is where Wally is staying now, but the boy isn't around—seems that he's gone off to train his Pokémon. According to Wanda's mother, Wanda is concerned about her boyfriend, who is working nonstop to build Rusturf Tunnel. She often goes there to see him.

TIP

Speak with the girl in the house next to Wanda's, and she'll tell you how friendly your party's lead Pokémon is toward you. This is a great way to find out which of your Pokémon need a little TLC (tender loving care)!

2 Reunite a little girl with her Shroomish

Orlando obtained the Intriguing Stone!

The little girl near Wanda's House has lost her Shroomish. How sad! She said she lost Shroomish around the sign. Check the town sign to find her Shroomish. Once you find her Shroomish, you'll automatically take it back to the little girl. She'll be so happy that she'll hand you an Intriguing Stone!

Rewards: Intriguing Stone

TIP

That Intriguing Stone sure is... intriguing. Although its purpose is not yet clear, it's stored in your Key Items pocket, so it must be pretty valuable!

TIP

Talk to a girl inside the Contest Spectacular Hall to receive TM45 Attract. This move can be used to infatuate opposing Pokémon in battle, and can also help you wow the crowd during contests!

◀◀ BACKTRACK | RUSTURF TUNNEL | p. 59

Smash the rocks and reunite two lovers

On the other side of this rock...
My boyfriend labors day after day.

Now that you've obtained the Dynamo Badge, you can finally use Rock Smash to clear a path through Rusturf Tunnel. Go north and enter Rusturf Tunnel. Then go north, then west until you encounter some small, cracked rocks. Smash them with Rock Smash to open the tunnel and reunite Wanda with her hardworking boyfriend. He'll be so pleased that he'll give you an Aggronite that he found in the cave!

Reward: Aggronite

◀◀ BACKTRACK | ROUTE 116 | p. 58

Help a man find his glasses on Route 116

Orlando found Black Glasses!

After entering the Rusturf Tunnel from Verdanturf Town, go west, and take the middle exit out of Rusturf Tunnel to visit a new area of Route 116 that you've never been able to explore before. A man here has lost his glasses. Dig out your Dowsing Machine and use it to find a pair of Black Glasses. These aren't the glasses that the man has lost, so you get to keep them! Be sure to grab the HP Up on the ridge as well.

Reward: Black Glasses

Score a Repeat Ball from a Devon Researcher

Orlando obtained a Repeat Ball!

Travel through Rusturf Tunnel and leave through its west exit to return to Route 116. You've already explored this area thoroughly, but a Devon Researcher now stands just outside the tunnel. It's the same researcher you've helped before, and since you've delivered the Devon Parts to Captain Stern, he wishes to thank you with a Repeat Ball.

 TIP

Now that you've received a Repeat Ball from the researcher, a second clerk will sell you Repeat Balls, Net Balls, and Timer Balls at the Poké Mart in Rustboro City!

◀◀ BACKTRACK | RUSTBORO CITY | p. 51

That Intriguing Stone is Mega Intriguing

Hm? Ah. That Intriguing Stone you have...

Stop by Rustboro City at the end of Route 116 to visit Mr. Stone. He ought to be pleased to see you after all the favors you've done him. This time he'll do you a bit of a favor, by identifying the Intriguing Stone that you received in Verdanturf. It is actually a Pidgeotite, a Mega Stone for the Pokémon called Pidgeot!

Reward: Pidgeotite

ROUTE 111 (SOUTH)

Field Moves Needed
Rock Smash Surf

This expansive route includes a desert where sandstorms rage unceasingly and a mountain pass.

Route 111 is located north of Mauville City, and it's a unique path that's split into three sections by a mighty sandstorm. It features a southern segment, a northern segment, and the impassable sandstorm that covers the desert lying between them. You can't cut through the powerful sandstorm at present, so you're restricted to the route's southern half for now.

To Route 111
(Central Desert)
(p. 138)

Backpacker Emory
⊙⊙⊙⊙⊙⊙⊙⊙

To Route 112
(South)
(p. 109)

Camper Travis
⊙⊙⊙⊙⊙⊙

Picnicker Irene
⊙⊙⊙⊙⊙⊙⊙

Interviewers Gabby & Ty
★ Double Battle
⊙⊙⊙⊙⊙⊙⊙

The Winstrates' Victor
⊙⊙⊙⊙⊙⊙

The Winstrate
House

The Winstrates' Victoria
⊙⊙⊙⊙⊙⊙

The Winstrates' Vivi
⊙⊙⊙⊙⊙⊙

The Winstrates' Vicky
⊙⊙⊙⊙⊙⊙

To Mauville
City (p. 89)

Fishing

Old Rod		
☐ Goldeen	○	
☐ Magikarp	◎	
Good Rod		
☐ Barboach	▲	
☐ Goldeen	○	
☐ Magikarp	◎	
Super Rod		
☐ Barboach	◎	

On the Water

☐ Azumarill	○	
☐ Marill	◎	
☐ Masquerain	▲	
☐ Surskit	△	

Rock Smash

☐ Geodude	◎	

○ frequent ○ average
△ rare ▲ almost never

Items

After learning Surf	
☐ HP Up	

Barboach Water Ground
Abilities: Oblivious, Anticipation

Geodude Rock Ground
Abilities: Rock Head, Sturdy

Surskit Bug Water
Abilities: Swift Swim

1 Battle the Winstrate Family

What do you say to taking on our family of four in a series of Pokémon battles?

Yes
No

Climb the stairs to the north as you enter Route 111, and then go west to find the Winstrate House. This upstanding family just loves battling travelers with their beloved Pokémon. Speak to the man at the front door, and he'll ask if you'd like to take on his family in a series of four Pokémon battles. It won't be easy, so you can choose not to take part, but a valuable prize will be yours if you can wallop all four Winstrates in a row!

Reward: Macho Brace

Taking on the Winstrates

The Winstrates are a proud family of noble Pokémon Trainers. Visit their cozy home along Route 111 and accept their challenge! You'll have to best all four of the Winstrates in one go, battling back-to-back without any pause between battles to heal your team. After defeating all of them, make sure to go into the house and speak to Victoria to receive a Macho Brace. This stiff, heavy brace helps Pokémon grow strong by giving their base stats a boost (p. 325). But be careful—it cuts Speed in battle.

The Winstrates' Victor

Victor's Normal-type Pokémon are fairly straightforward. Electric- and Rock-type moves are super effective against Taillow, while any Fighting-type move will knock Zigzagoon for a loop.

Taillow ♂ Lv. 17 — Normal, Flying
Weak to: Electric, Ice, Rock

Zigzagoon ♂ Lv. 19 — Normal
Weak to: Fighting

The Winstrates' Victoria

Victoria has just one Pokémon, but it's a good one! Roselia can drain HP from your Pokémon to restore its own, all while poisoning your Pokémon to harm them each turn. Assuming you didn't pick Torchic as your first Pokémon, Flying-type Pokémon are likely to be your best options. Try Zubat, Golbat, Beautifly, Wingull, or Pelipper.

Roselia ♀ Lv. 20 — Grass, Poison
Weak to: Fire, Ice, Flying, Psychic

The Winstrates' Vivi

Vivi may be young, but she's got three Pokémon to throw at you. Amazingly, none of them share a common weakness—apart from their comparatively low levels, that is. Unleash your most powerful moves whenever you're unable to exploit their weaknesses.

Goldeen ♀ Lv. 16 — Water
Weak to: Grass, Electric

Shroomish ♀ Lv. 19 — Grass
Weak to: Fire, Ice, Poison, Flying, Bug

Numel ♀ Lv. 16 — Fire, Ground
Weak to: 4X Water, Ground

Taking on the Winstrates (cont.)

The Winstrates' Vicky

The Winstrates' matriarch pits you against a powerful Meditite. As with the battle against Victoria's Roselia, your best bet in this battle will likely be a Flying-type Pokémon such as those mentioned before.

Meditite
♀ Lv. 22
Fighting Psychic
Weak to: Flying Ghost Fairy

Build an unstoppable team!

Here are some recommendations to help you prepare for the Winstrates. If you put even a few of these Pokémon on your team and raise them up to around Level 20, you'll whoop the Winstrates without any worries!

Flying: A Flying-type Pokémon will be super effective against three of the Pokémon you'll face. If you have a Beautifly, evolved from Silcoon, its Flying-type moves Gust (learned at Level 10) or Air Cutter (Level 20) will be a great boon, while Absorb could work against Goldeen. Wingull is another good choice, as it has the Flying-type move Wing Attack as well as the Water Pulse move, both of which help against Numel.

Water: If you chose Mudkip at the start of the game, it can really help you out. Otherwise—and in case you didn't go with Wingull above—consider Tentacool with its Bubble Beam (Level 25) and many draining Poison-type moves.

Electric: Electrike can be caught on Route 110, and its Electric-type moves help against both Taillow and Goldeen. Have it hold a Persim Berry to combat the confusion that Goldeen may try to inflict.

Fighting: Combusken, if you started your journey with Torchic, or a Makuhita that you may have caught in Granite Cave or traded for back in Rustboro City, can both bring down Zigzagoon with their Fighting-type moves. Give them Persim Berries so they can recover from confusion.

TIP

Pick up some healing items back in Mauville City if you're having trouble tackling the Winstrates with your team members intact.

2 | Smash some rocks with Rock Smash

Would you like to use Rock Smash?

Several cracked rocks block the trail north of the Winstrate House. You've claimed the Dynamo Badge from Mauville City's Gym Leader, Wattson, so you're able to use Rock Smash in the field as long as you've taught it to one of your party Pokémon. Use Rock Smash to destroy one (or all) of the cracked rocks so you may advance.

TIP

Whenever you use Rock Smash to destroy a cracked rock, you have a random chance to discover an item or encounter a wild Pokémon. The Pokémon you might encounter by using Rock Smash are listed throughout this walkthrough. See page 456 for a list that shows the different items you might find.

3 | Battle Gabby and Ty, and have an interview

OK, roll camera!
Let's get this interview.

Did you meet intrepid reporter Gabby and her cameraman Ty back in Slateport City? Then you'll find them both standing along Route 111. If you're ready to put on a show for all of Hoenn, speak to them and take part in a daring Double Battle! Show Gabby and Ty how strong a Trainer you've become, and they'll beg you for an interview after the battle. Let them have a good one, and then tune into BuzzNav for a chance to hear about yourself on the news!

TRAINER HANDBOOK

ADVANCED HANDBOOK

ADVENTURE DATA

News flash! This Double Battle against Gabby and Ty can be won easily with Fighting-type moves, as both of their Pokémon are vulnerable to these attacks. Magnemite can also be wiped out with just about any Ground-type move, leaving you only Whismur to deal with.

Magnemite `Electric` `Steel`
Lv. 20
Weak to: 4x `Ground` `Fire` `Fighting`

Whismur `Normal`
♂ Lv. 20
Weak to: `Fighting`

4 **Head west to Route 112**

The sandstorm is vicious.
It's impossible to keep going.

Keep traveling north along Route 111, and you'll soon encounter a mighty sandstorm. The storm's fury proves too much for you to pass through. You'll need to find something that'll help you deal with the swirling sands before you can explore any further along Route 111. For now, simply head west to Route 112.

ROUTE 112

This route is popular among Trainers because it offers the chance to stroll while gazing up at Mt. Chimney.

Route 112 lies at the foot of Mt. Chimney, and features a Cable Car service up to the summit. A valuable Nugget can be found on the route's west hills, but you can't reach it until after you've descended from the mountain.

Route 112 (North)

Berry Trees

To Route 111 (North)
(p. 112)

Route 112 (South)

Cable Car
Base Station

To Mt.
Chimney
(p. 126)

To Fiery Path
(p. 111)
Street Thug Jaylin

Hiker Brice

Hiker Trent

To Jagged
Pass (p. 130)

Picnicker Carol

To Lavaridge
Town (p. 133)

To Route 111
(South)
(p. 106)

To Fiery Path
(p. 111) Camper Larry

TRAINER
HANDBOOK

ADVANCED
HANDBOOK

ADVENTURE
DATA

Items

☐ HM04 Strength

After the Team Magma / Team Aqua guards leave the Cable Car station

☐ Guard Spec

After descending from Mt. Chimney

☐ Nugget

Vending Machine

Cable Car station	
Fresh Water	400
Lemonade	700
Soda Pop	600

Horde Encounters

North and South	
☐ Machop (×5)	○
☐ Numel (×5)	◎

Tall Grass

North	
☐ Machop	○
☐ Numel	◎
South	
☐ Machop	◎
☐ Numel	◎

◎ frequent ○ average
△ rare ▲ almost never

Machop — Fighting
Abilities: Guts, No Guard

Numel — Fire Ground
Abilities: Oblivious, Simple

1 | Receive HM04 Strength from May/Brendan

A friendly face greets you on Route 112. It's May/Brendan! Enjoy the magnificent view of Mt. Chimney with your friend, who graciously restores your party back to full health. And that's not all! May/Brendan hands you HM04 Strength, a powerful battle move that will also let you move heavy boulders in the field after you've obtained your next Badge.

2 | Brave the Fiery Path

What happened to the others who went to Fallarbor? They're late...

What happened to the others who went to Fallarbor? They're late...

May/Brendan hurries off to Fallarbor Town, where she/he hopes to meet her/his father's friend, Professor Cozmo. Explore Route 112, eventually heading up to the Cable Car station. What's this? That rotten Team Magma / Team Aqua is guarding the station and keeping you from taking the Cable Car up to Mt. Chimney! You'll just have to take the roundabout route through the nearby Fiery Path. Enter the cave to the west to begin your trek.

FIERY PATH

The Pokémon that live in this area like to use the steam that erupts from the ground as a sort of bath.

This sweltering tunnel through the base of Mt. Chimney is filled with Pokémon that thrive in the heat. The Fiery Path leads to the top of Route 112, but the Strength field move is needed to fully explore its oppressive passages.

To Route 112 (North) (p. 109)

To Route 112 (South) (p. 109)

Items

After learning Strength
- ☐ Fire Stone
- ☐ TM06 Toxic

After the Mt. Chimney event
- ☐ TM96 Nature Power

Cave

☐ Grimer	▲	Ω
☐ Grimer	○	α
☐ Koffing	○	Ω
☐ Koffing	▲	α
☐ Machop	▲	
☐ Numel	◎	
☐ Slugma	△	
☐ Torkoal	△	

Horde Encounters

☐ Grimer (×5)	○	α
☐ Koffing (×5)	○	Ω
☐ Numel (×5)	◎	
☐ Slugma (×5)	▲	

◎ frequent ○ average
△ rare ▲ almost never

Grimer `Poison`
Abilities: Stench, Sticky Hold

Torkoal `Fire`
Ability: White Smoke

1 Make a dash through the Fiery Path

A big boulder draws your attention as you explore the furnace-like Fiery Path. It's not in your way, but it blocks a tantalizing side passage. You can't move this boulder until you've obtained the next Badge, so just dash straight through the Fiery Path for now, looping around to the northern half of Route 112.

◀◀ **BACKTRACK** ▏**ROUTE 112** ▕ p. 109

Harvest some Berries up on the hill

Upon exiting the Fiery Path, you find yourself exploring Route 112's north hill. Battle another Trainer and snatch some Berries off the nearby trees as you make your way east, heading into the northern half of Route 111.

ROUTE 111 (NORTH)

This expansive route includes a desert where sandstorms rage unceasingly and a mountain pass.

Taking the roundabout route through Route 112 and the Fiery Path has helped you circumvent Route 111's central sandstorm. You're now exploring Route 111's northern half, where you encounter a very special stranger.

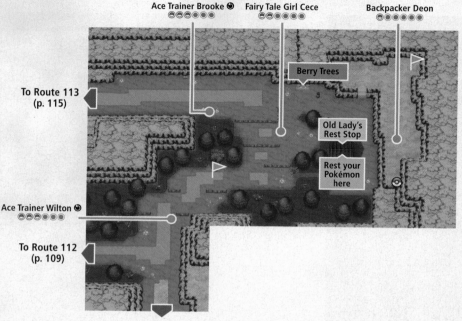

Ace Trainer Brooke ●○○○○●○○
Fairy Tale Girl Cece ●○○○○○○○
Backpacker Deon ●○○○○○○

Berry Trees

Old Lady's Rest Stop

Rest your Pokémon here

To Route 113 (p. 115)

Ace Trainer Wilton ●○○○○○○

To Route 112 (p. 109)

To Route 111 (Central Desert) (p. 138)

Items

- ☐ Comfortable Bed
- ☐ Elixir
- ☐ Fence ×5
- ☐ Poké Ball Poster
- ☐ Red Flower
- ☐ Small Chair
- ☐ Small Desk
- ☐ Surf Mat
- ☐ TM94 Secret Power
- ☐ Worn-Out Light

1 Meet Aarune and learn about Super-Secret Bases

A stranger catches your eye as you explore Route 111's grassy northern half. It's Aarune, a traveling adventurer with a passion for Super-Secret Bases (also called Secret Bases)! Seeing that you have no clue what a Secret Base is, Aarune takes you under his wing. He gives you TM94 Secret Power and teaches you the basics of Secret Bases.

Super-Secret Bases

A Secret Base is a special place that you can discover and decorate to your liking with a variety of furniture, dolls, and accessories. Search high and low for special locations, known as Secret Spots, where you can build your own Secret Base! Secret Spots are scattered all over Hoenn—in fact, most routes have more than one Secret Spot. All in all, there are 80 Secret Spots to choose from for your perfect Secret Base! Page 381 has a complete list of them, if you want to know more.

Secret Base Basics

This is exactly the kinda place to bust out with Secret Power!

The scruffy-looking fellow you've just encountered, Aarune, has given you a valuable TM called TM94 Secret Power. He demonstrates its power by using it on a nearby tree, revealing a Secret Base! Keep your eyes peeled for similar trees—they may also be Secret Spots. Besides trees, if you see a fishy-looking hole in a wall, or a suspicious clump of grass on the ground, get ready to use Secret Power—there's a good chance that you've just discovered a Secret Base! Different Secret Bases may have different layouts or different sizes, so get out there and find the Secret Base that suits you best.

Orlando received Decorations from Aarune!

Decorating your Secret Base

Aarune also explains the basics of decorating a base, and even gives you a bunch of free Decorations. You've already found a few other decorative items on your travels, including the Globe that the Hiker in Mauville City's courtyard handed you, and the three dolls that Mauville's failed businessman doled out. More Decorations will be available throughout the adventure, letting you decorate your Secret Base however you like!

Sources of Secret Base Decorations

This is the Pretty Petal flower shop. Spreading flowers throughout the world!

You can get decorative items from certain characters that you meet in your travels. This includes Aarune, Secret Pals, and other players' stand-ins in their Secret Bases. Now that you've met Aarune, you can also purchase Decorations directly at various shops. Different shops offer different Decorations, so be sure to shop around! There is a full list of Decorations on page 392, but here are some of the places to keep an eye out for.

Places that sell Secret Base Decorations:

1. Pretty Petal flower shop on Route 104 (p. 46)
2. Glass Workshop on Route 113 (p. 115)
3. Slateport City Market (p. 73)
4. Lilycove Department Store (p. 182)

You've got a Secret Base... Now what?

Orlando's Base
Flags collected 0

Decorate your base
Manage QR Code patterns
Delete favorites
Edit secret team settings
Secret Base list
Power off

Place Decorations and other touches around your base, or move those already in place.

When you first enter your Secret Base, you'll see a PC, a flag, and several Welcome Mats for future Secret Pals. Log on to the Secret PC, and you'll be able to start making your Secret Base into something truly spectacular. Use the items that Aarune gave you to decorate your Secret Base, along with any others you've found during your travels. Select "Decorate your base" from the PC menu and find the right place for everything. You can also use this option to adjust the spot where your stand-in and your Secret Pals will appear when other players visit your Secret Base. You will be represented by a Trainer type of your choosing when others visit your base. Pick the Trainer type you think best fits you by talking to the man in Rustboro City's Pokémon Center or by changing your profile image on the PSS. Change where he or she will be placed by moving the Your Location marker in your Secret Base.

Finding other Trainers' Secret Bases

AreaNav

Route 123

If you have StreetPass enabled for your game, the Secret Bases of any players you pass by will appear in your game, unless you have already favorited another base in the same location. When new Secret Bases turn up through StreetPass, you will see a flag icon appear on your AreaNav. Select Bases and look for routes with new bases on them. Hurry there and look high and low to find where your elusive passerby has hidden him- or herself. You can also find specific Secret Bases by scanning in QR Code patterns that players can generate and share. Turn to page 392 for more on these QR Code patterns and how to make your own to share.

TIP

When you battle other Trainers or Secret Pals in their bases, their teams will be that Trainer's real team at the time that you received their data. Their Pokémon's levels will be adjusted based on the number of Gym Badges that you currently have, ranging from Level 20 to Level 50.

TRAINER HANDBOOK

ADVANCED HANDBOOK

ADVENTURE DATA

Super-Secret Bases (cont.)

Inside other players' Secret Bases, you'll be able to battle that player's team, get items from him or her, and invite him or her to become one of your Secret Pals. Before you leave, make sure you talk to the base owner's Secret Pals, too. You can't recruit them, but you can battle them and gain some experience. One last thing before you go: be sure to check the flag every time you're in someone else's Secret Base! The number of flags you collect will decide your rank in the Secret Base Guild.

Favoriting other Trainers' Secret Bases

You can favorite Secret Bases, locking them in place so they will not be overwritten by new Secret Bases that you discover through StreetPass. If you find a Secret Base with gimmicks or a style you really love, or with a Trainer that's a real challenge to battle against, feel free to favorite it so you don't lose it. It's easy to add or remove Secret Bases from your favorites using the PC in a Secret Base.

Making Secret Pals

When you visit other players' Secret Bases, talk to the Trainers that represent them. You can battle them and their team once per day. You can also ask your host to be your Secret Pal. Secret Pals will come to stay in your Secret Base, where they can do all kinds of useful things for you, like handing out Berries, training your Pokémon, or finding valuable items. They can even be battled in your Secret Base once per day. Once you have one or more Secret Pals, talk to them in your Secret Base to form a Secret Team and try to become the top of the Secret Base Guild as well! For more on Secret Teams and the Secret Base Guild, turn to page 165. For more on the special skills your Secret Pals can use for you, turn to page 390.

> ### TIP
> The battle format in other players' Secret Bases will be decided by the Proclamation they have set, if they have chosen to do so. You'll receive a Proclamation of your own from Aarune later in the game. You may also be able to obtain a Decoration called the Level Release, which lets you negate any level limitations in battle if you set it up in your Secret Base.

> ### TIP
> Don't stress too much when picking a team name and motto. You can change either at any time from the PC in your Secret Base.

2 Catch your breath at the Rest Stop

Old Lady's Rest Stop
Come in and rest your tired bones.

Continue your explorations of Route 111 after your eye-popping meeting with Aarune concludes. Use Cut to slash through the prickly tree to the east and visit the Old Lady's Rest Stop. Speak to the kindly old lady inside to rest your weary Pokémon as often as you like.

> ### TIP
> If you don't have Cut, you can still reach the Old Lady's Rest Stop by going north and looping around the route's central trees.

3 Use the Mach Bike to reach an Elixir

Did you spy that item up on the east cliff? The Mach Bike is your means of reaching it. Ride your Mach Bike up the slippery slope to the north, and then loop around and grab the item. It's an Elixir, which can restore 10 PP to all of a Pokémon's moves, so it's worth the effort!

4 | Harvest Berries on your way to Route 113

Orlando obtained a
Razz Berry!

A trio of Berry Trees stands at Route 111's north end. Harvest their fruit, and speak to the nearby little girl to receive another random Berry. Proceed west to Route 113 after pocketing this delicious bounty.

ROUTE 113

The tall grass on this route is painted a dusty gray by the volcanic ash that pours from Mt. Chimney.

New species of Pokémon hide in Route 113's ashy grass, while hidden Trainers wait in the thick piles of soot strewn about the route. You'll find the Glass Workshop on this long path, where a gifted artist crafts useful items out of pure ash!

Ninja Boy Lao

Youngster Dillion Fairy Tale Girl Franny

Glass Workshop

To Fallarbor Town (p. 117)

To Route 111 (South) (p. 106)

Ninja Boy Lung Parasol Lady Madeline Youngster Neal

Items

- ❑ Hyper Potion
- ❑ Max Ether
- ❑ Soot Sack
- ❑ Super Repel
- ❑ TM32 Double Team

Hidden Items

- ❑ Ether
- ❑ Nugget

Glass Workshop

Blue Flute	250
Yellow Flute	500
Red Flute	500
White Flute	1,000
Black Flute	1,000
Elegant Chair	6,000
Elegant Desk	8,000

Tall Grass

❑ Sandshrew	◯
❑ Skarmory	▲
❑ Spinda	◎

Horde Encounters

❑ Skarmory (×5)	▲
❑ Spinda (×5)	◎

◎ frequent ◯ average
△ rare ▲ almost never

Sandshrew — Ground
Ability: Sand Veil

Skarmory — Steel Flying
Abilities: Keen Eye, Sturdy

Spinda — Normal
Abilities: Own Tempo, Tangled Feet

1 | Meet up with May/Brendan

Your team's health was restored!

You catch up with May/Brendan as you enter Route 113. Your friend is hurrying to meet Professor Cozmo at Fallarbor Town, but takes the time to kindly restore your Pokémon's health before racing off. How thoughtful!

2 Search the soot for hidden items and Trainers!

Even if there are no ashes, I leap! Hiyah! I challenge thee!

Route 113 features thick piles of ash and soot. Run through these dark piles to send the soot flying and potentially reveal some buried items! But be ready to battle, as sneaky Trainers may pop out of the ash instead.

TIP

Try to catch a couple of Spinda while you're exploring Route 113. Having them will come in handy later!

3 Receive a Soot Sack at the Glass Workshop

Glass Workshop
Turning volcanic ash into glass items

The Glass Workshop stands near Route 113's west end. Stop inside and speak with the man who runs the shop to receive a free Soot Sack. Now, when you run through Route 113's dark piles of ash, you'll fill your Soot Sack with valuable ash that the Glass Workshop owner can fashion into glass items! Proceed west into Fallarbor Town when you've finished frolicking around Route 113.

Soot Sack Action

Receive the Soot Sack

Route 113 takes on a whole new meaning once you've gotten the Soot Sack. Talk to the man in the Glass Workshop to receive the Soot Sack, and then dash through the big ash piles around Route 113 to fill your Soot Sack full of ash!

One of four things happens each time you dash through an ash pile:

- You discover an item (in certain locations) and also randomly collect 3–4 grams of ash.
- You collect a small random amount of ash (5–15 grams).
- You collect a large random amount of ash (20–100 grams).
- A Trainer jumps out to challenge you (in certain locations), and you get no ash at all!

Checking your Soot Sack's ash supply

If you have 181 more grams, I can make a Blue Flute!

Speak with the man in the Glass Workshop to see how much ash you've collected. If you've collected less than 250 grams of ash, he'll ask you to return after you've collected more. This isn't a problem, because the ash piles along Route 113 reappear every time you leave the route and return, even when you step in and out of the Glass Workshop. This makes it easy to collect all the ash you need!

Soot Sack Action (cont.)

Exchanging ash for items

Once you've filled your Soot Sack with plenty of ash, it's time to exchange it for some items. The man at the Glass Workshop can make five kinds of Flutes and two special pieces of furniture for you.

Blue Flute	250 grams of ash	Wakes up sleeping Pokémon.
Yellow Flute	500 grams of ash	Snaps Pokémon out of confusion.
Red Flute	500 grams of ash	Snaps Pokémon out of infatuation.
White Flute	1,000 grams of ash	Makes it easier to encounter weak Pokémon.
Black Flute	1,000 grams of ash	Makes it easier to encounter strong Pokémon.
Elegant Chair	6,000 grams of ash	A Decoration for your Secret Base.
Elegant Desk	8,000 grams of ash	A Decoration for your Secret Base.

FALLARBOR TOWN

A town formed by scholars who gather to research meteorites.

The rich soil surrounding this small town is prime for planting and gardening. Hoenn's leading meteor mogul, Professor Cozmo, has also built an impressive lab here, complete with a high-tech telescope!

Poké Mart

Special wares

Dive Ball	1,000
Dusk Ball	1,000
Quick Ball	1,000

Items

- ☐ Berry Blender
- ☐ Honey

After saving Professor Cozmo

- ☐ TM23 Smack Down

Hidden Items

- ☐ Nugget

Poké Mart

Normal wares

Antidote	100
Awakening	250
Burn Heal	250
Escape Rope	550
Full Heal	600
Great Ball	600
Ice Heal	250
Hyper Potion	1,200
Max Repel	700
Paralyze Heal	200
Poké Ball	200
Potion	300
Repel	350
Revive	1,500
Super Potion	700
Super Repel	500
Ultra Ball	1,200

1 Catch up with May/Brendan

Your friend May/Brendan calls out to you as you enter Fallarbor Town. It seems something has happened to Professor Cozmo! Follow your friend into the professor's lab to learn that the professor has fallen into trouble with Team Magma / Team Aqua. The group seems very interested in the Meteorite that Professor Cozmo has been researching—so interested that they're taking the poor professor with them to Mt. Chimney!

2 | Meet Lanette in the Pokémon Center

Oh, I'm sorry. I'm Lanette.

Professor Cozmo needs your help, but take a moment to explore Fallarbor Town before you rush off. The Poké Mart offers some special Poké Balls, and an intriguing woman named Lanette stands near the PC in the Pokémon Center. Introduce yourself to Lanette, and you'll learn that she developed the Pokémon Storage System that you've been using whenever you log on to a PC. Lanette invites you to visit her at her home along Route 114.

TIP

Log on to the Pokémon Center's PC to find that "Someone's PC" has changed to "Lanette's PC." So that's whose PC you've been accessing! Here's hoping she doesn't keep any confidential information on there...

TIP

Also, speak to a Bug Catcher in the Pokémon Center. He has plenty of Honey and gives some to you every day. How sweet!

3 | Receive a Berry Blender at the Contest Hall

Orlando obtained a Berry Blender for his base!

Fallarbor Town features one of Hoenn's four Contest Spectacular Halls. Enter the Contest Hall and speak to an elderly gentleman who stands near the machine on the left. He gives you a Berry Blender Decoration for your Secret Base and reminisces about how it used to take four people to make Pokéblocks with the old-fashioned Berry Blenders like the one next to him. Imagine that!

4 | Meet the Move Maniac

You'd like me to teach your Pokémon a move?

Enter the house next to the Contest Spectacular Hall to visit the Move Maniac. This helpful guy has a knack for teaching forgotten moves to Pokémon. His service isn't free, however. You'll need to part with a Heart Scale to entice the Move Maniac to do his thing.

◀◀ BACKTRACK | HAVE A HEART SCALE

Hard up for Heart Scales?
These rare items are often hidden, but the Dowsing Machine helps you discover them. You'll find Heart Scales along your journey, but if you need one right now, backtrack and collect Heart Scales in the following areas you've visited:

- Route 104 (South) (p. 42)
- Route 105 (p. 145)
- Route 106 (p. 68)
- Route 109 (p. 71)

ROUTE 114

Field Moves Needed — Rock Smash · Surf · Waterfall

This mountain path to Meteor Falls is so long and arduous that even Hikers have difficulty climbing it.

Pockmarked by fallen meteorites, Route 114 stretches between Fallarbor Town and Meteor Falls. The Fossil Maniac lives up north, and Lanette's House stands about halfway through the route. A variety of items and wild Pokémon can be found along this long and difficult path.

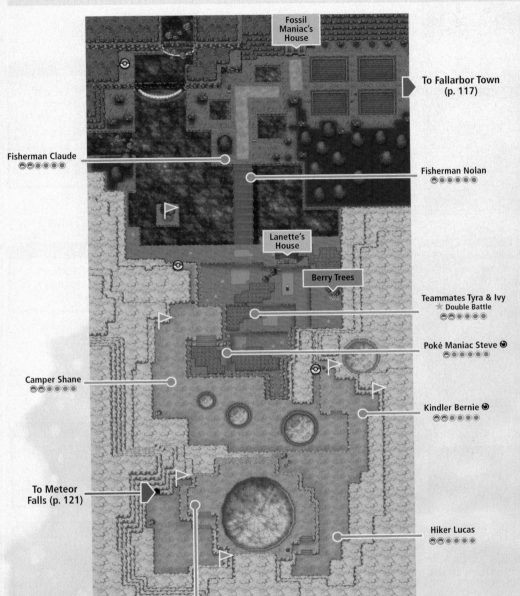

Fossil Maniac's House

To Fallarbor Town (p. 117)

Fisherman Claude
◎◎◎◎◎◎

Fisherman Nolan
◎◎◎◎◎◎

Lanette's House

Berry Trees

Teammates Tyra & Ivy
★ Double Battle
◎◎◎◎◎◎

Poké Maniac Steve ⬤
◎◎◎◎◎◎

Camper Shane
◎◎◎◎◎◎

Kindler Bernie ⬤
◎◎◎◎◎◎

To Meteor Falls (p. 121)

Hiker Lucas
◎◎◎◎◎◎

Hiker Lenny
◎◎◎◎◎◎

Swablu	Normal	Flying
Ability: Natural Cure		

Lotad	Water	Grass
Abilities: Swift Swim, Rain Dish		

Seedot	Grass	
Abilities: Chlorophyll, Early Bird		

Fishing

Old Rod		
❏ Goldeen	○	
❏ Magikarp	◎	
Good Rod		
❏ Barboach	▲	
❏ Goldeen	○	
❏ Magikarp	◎	
Super Rod		
❏ Barboach	◎	

Tall Grass

❏ Lombre	◎	α
❏ Nuzleaf	◎	Ω
❏ Seviper	△	α
❏ Surskit	▲	
❏ Swablu	◎	
❏ Zangoose	△	Ω

On the Water

❏ Azumarill	○
❏ Marill	◎
❏ Masquerain	▲
❏ Surskit	△

Horde Encounters

❏ Lotad (×4) Swablu (×1)	○	α
❏ Seedot (×5)	○	Ω
❏ Swablu (×5)	◎	

Rock Smash

❏ Geodude	◎

◎ frequent ○ average
△ rare ▲ almost never

Items

❏ Energy Powder	
❏ Lotad Doll	α
❏ Protein	
❏ Seedot Doll	Ω
❏ TM05 Roar	
❏ TM28 Dig	
After learning Surf and Waterfall	
❏ Rare Candy	

Hidden Items

❏ Carbos
❏ Comet Shard
❏ Rare Bone
❏ Revive

1 Meet the Fossil Maniac

Orlando obtained
TM28 Dig!

The Fossil Maniac's House stands right on the outskirts of Fallarbor Town. Head inside and speak with the Fossil Maniac's kid brother, who kindly gives you TM28 Dig. If you dare, delve into the cave at the back of the house, and you'll discover the Fossil Maniac hard at work. He won't fork over any Fossils, but he does hint that Fossils might be kicked up by Route 111's raging sandstorm.

TIP

TM28 Dig not only delivers a powerful Ground-type move, but it can also be used outside of battle to instantly return you to the entrance of a cave or dungeon, just like an Escape Rope. Dig it!

2 Score another TM

Orlando obtained
TM05 Roar!

Go west from the Fossil Maniac's House and speak to a man who stands nearby. It seems that his Pokémon's frightening roar always scares people away. The man can't stand it anymore, and asks that you relieve him of his TM05 Roar—a valuable move that can scare opposing Pokémon away, causing another to be dragged out or instantly ending battles against single wild Pokémon.

TIP

Roar is a great move for escaping an unwanted battle when your team isn't at their best. But you won't gain any Exp. Points from a battle ended by expelling your opponents as Roar does. Don't abuse it if you're hoping to see your team improve!

3 Harvest free Berries around Lanette's House

Harvested 2 Berries from the
Aspear Berry tree!

Go south across a bridge, optionally battling a few Fisherman along the way. Lanette's House stands just beyond the bridge, but before you enter, circle around behind the house to reach a couple of nearby Berry Trees that are ripe for the plucking.

TIP

The Rich Boy who walks around near Lanette's House will also give you a random Berry each day.

4 Get your PC organized by Lanette

Orlando obtained a
Seedot Doll for his base!

Enter Lanette's House to find Lanette struggling to organize her clutter. She's happy that you stopped by, but embarrassed at the state of her home. In exchange for your promise not to tell anyone what a mess she lives in, Lanette gives you a Seedot Doll (*Pokémon Omega Ruby*) or Lotad Doll (*Pokémon Alpha Sapphire*) to decorate your Secret Base!

TIP

Not seeing Lanette? That's because you needed to speak with her first back in Fallarbor Town's Pokémon Center!

TIP

After receiving your Decoration from Lanette, speak to her again, and she'll update your PC so that the handy "Organize Boxes" option is on top. Lanette can also undo this change—just talk to her again.

5 Use Rock Smash to find items on the ridge

Would you like to use Rock Smash?

Yes
No

Route 114 is just riddled with items. Many are hidden, requiring the Dowsing Machine to discover. Others, like the ones on the ridges, are positioned in places that require Rock Smash to reach. Make good use of your Dowsing Machine and keep your eyes peeled for each valuable find.

6 Catch sight of May/Brendan

As you continue along Route 114, you'll eventually catch sight of your friend May/Brendan—but only for a moment. She/he is rushing to rescue Professor Cozmo and races off in pursuit of Team Magma / Team Aqua. You can't let her/him go it alone! Pick up the pace as you explore.

7 Follow May/Brendan into Meteor Falls

The entrance to Meteor Falls isn't far from the spot where you saw May/Brendan. Battle a few more Trainers on your way there, and then dart into the cave to continue your frantic dash to rescue Professor Cozmo.

METEOR FALLS

Field Moves Needed — Surf · Waterfall

This waterfall is said to have been the site of a meteor shower. An ancient people once made their home here.

Your frenzied pursuit of Team Magma / Team Aqua has led you to Meteor Falls. This spacious cavern's rushing rapids require the Surf and Waterfall field moves to traverse fully. That means your explorations of Meteor Falls are somewhat limited for the time being.

Entrance

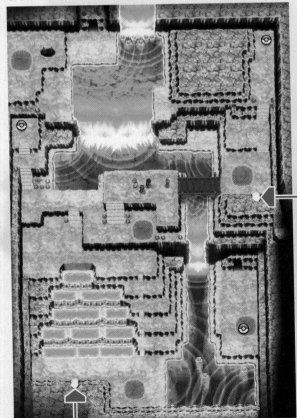

To Route 114 (p. 119)

To Route 115 (p. 124)

Fishing

Entrance		
Old Rod		
☐ Goldeen	○	
☐ Magikarp	◎	
Good Rod		
☐ Barboach	▲	
☐ Goldeen	○	
☐ Magikarp	◎	
Super Rod		
☐ Barboach	◎	

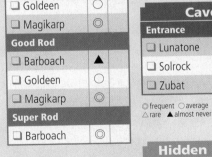

Lunatone Rock Psychic
Ability: Levitate

Solrock Rock Psychic
Ability: Levitate

Horde Encounters

Entrance	
☐ Zubat (×5)	◎

Cave

Entrance		
☐ Lunatone	○	α
☐ Solrock	○	Ω
☐ Zubat	◎	

○ frequent ○ average
△ rare ▲ almost never

Hidden Items

Entrance
☐ Great Ball

Items

Entrance
☐ Full Heal
☐ Moon Stone

TIP

There is more to explore in Meteor Falls, but you won't be able to reach its other chambers until you learn some more field moves. Once you know Surf and Waterfall, you'll be able to find everything Meteor Falls contains using the maps and guide beginning on page 248.

1 Go north and grab a Full Heal

Orlando found a Full Heal!

Before crossing the bridge in Meteor Falls, sprint up the north stairs to find a Full Heal. This valuable item cures all status conditions and confusion and may soon come in handy!

2 Help May/Brendan battle Team Magma / Team Aqua!

Orlando, please!
Battle together with me!

Orlando, please!
Battle together with me!

Now cross the nearby bridge to catch up with May/Brendan. She/he has finally managed to catch Team Magma / Team Aqua, but the bullies aren't about to let you rescue Professor Cozmo so easily. The time has come to team up with your friend and take on these brutes in a daring Multi Battle!

Team Magma Admin Tabitha's Pokémon ◎◎◎○○○○

Tabitha has two Pokémon, and sends one out after the other. Work with May/Brendan to defeat them along with the Pokémon used by the Team Magma Grunt. Be advised that Numel won't take any damage from Electric-type moves, while Mightyena won't take any damage from Psychic-type moves. Being aware of the types that don't affect other types is key in becoming a great Trainer, so try to learn and remember them all.

◎ **Mightyena** [Dark]
♂ Lv. 23
Weak to: [Fighting] [Bug] [Fairy]

◎ **Numel** [Fire] [Ground]
♂ Lv. 23
Weak to: 4× [Water] [Ground]

Team Magma Grunt's Pokémon ◎○○○○○

This Grunt sends out Koffing, a Poison-type Pokémon. Be careful, as its Levitate Ability makes it immune to Ground-type moves! Use Psychic-type moves instead to defeat it quickly.

◎ **Koffing** [Poison]
♀ Lv. 23
Weak to: [Psychic]

Team Aqua Admin Shelly's Pokémon ◎◎○○○○

Shelly's Pokémon share many similar weaknesses, so it's fairly easy to take them out. However, neither of Shelly's Pokémon shares any weaknesses with the Grimer sent out by the Team Aqua Grunt. Consider the strength of May/Brendan's Pokémon when choosing your target.

◎ **Carvanha** [Water] [Dark]
♀ Lv. 23
Weak to: [Grass] [Electric] [Fighting] [Bug] [Fairy]

◎ **Mightyena** [Dark]
♀ Lv. 23
Weak to: [Fighting] [Bug] [Fairy]

Team Aqua Grunt's Pokémon

The Team Aqua Grunt's Pokémon is resistant to most of the move types that Shelly's Pokémon are weak to. Avoid using Grass-, Fighting-, Bug-, and Fairy-type moves against it, but feel free to unleash these moves against Shelly's Pokémon.

◉ **Grimer**　　　　　　　　　**Poison**
♂ Lv. 23
Weak to: | Ground | Psychic | | |

3 | Get interrupted by a whole other team

Hyahya!
Even Team Aqua is making an appearance!

Even Team Magma showed their faces, huh?
There's nothing to be done about it...

Beaten, but far from defeated, Team Magma / Team Aqua quickly rallies their spirits with tough talk. Suddenly, a whole other team shows up—the opposing Team Aqua / Team Magma! There certainly seems to be a lot of interest in Professor Cozmo's Meteorite, and the team you've just battled uses the confusion to steal the Meteorite and make good their escape.

◀◀ **BACKTRACK** | **FALLARBOR TOWN** p. 117

Why don't you come with me, Orlando? To Mauville!

Yes
No

Choose your next move

The Meteorite has been lost, but at least Professor Cozmo has been saved. You and May/Brendan hurry the grateful professor back to his lab, where he hands you TM23 Smack Down. His Meteorite must be recovered, but May/Brendan is just eager to continue on her/his journey to the next Pokémon Gym. If you agree to go with her/him, you'll be whisked away to Mauville City (p. 89). If you decide not to go with her/him, you'll have an opportunity to explore more of Meteor Falls, plus a few other areas, as you take a roundabout route back to Mauville. Read on if you'd like to take the scenic route, or flip ahead to page 125 (the last step) and take May/Brendan up on that offer if you prefer to skip straight to Mauville City.

Optional | Explore more of Meteor Falls

Orlando found a Moon Stone!

If you've decided not to accompany May/Brendan back to Mauville City, make your way back through Route 114 and return to Meteor Falls. Explore past the point where you battled Team Magma / Team Aqua, and grab the Moon Stone that sits at the top of the west stairs. The Surf and Waterfall field moves are needed to obtain the cave's other goodies, so simply proceed south into Route 115 for now.

This trail to Rustboro City was broken by people who lived at Meteor Falls long ago.

Route 115 is located just north of Rustboro City. You may have visited and explored a small portion of this seaside route before, but now you can explore new areas. A complete search of Route 115 must wait until you've learned the Surf field move, however.

Berry Trees

Expert Timothy

Ruin Maniac Hayes

Black Belt Koichi

To Meteor
Falls (p. 121)

Battle Girl Cyndy

Black Belt Nob

Collector Hector

Berry Trees

To Rustboro
City (p. 51)

Items

- ☐ Zinc

After traveling through Meteor Falls

- ☐ Great Ball

After learning Surf

- ☐ Heal Powder
- ☐ Iron
- ☐ PP Up

Hidden Items

After traveling through Meteor Falls

- ☐ Heart Scale

Fishing

Old Rod		
☐ Magikarp	◎	
☐ Tentacool	○	
Good Rod		
☐ Magikarp	◎	
☐ Tentacool	○	
☐ Wailmer	▲	
Super Rod		
☐ Wailmer	◎	

Tall Grass

☐ Jigglypuff	△	
☐ Swablu	◎	
☐ Taillow	◎	
☐ Wingull	△	

Horde Encounters

☐ Swablu (×5)	◎	

On the Water

☐ Pelipper	▲	
☐ Tentacool	◎	
☐ Wingull	○	

◎ frequent ○ average
△ rare ▲ almost never

Jigglypuff `Normal` `Fairy`
Abilities: Cute Charm, Competitive

Pelipper `Water` `Flying`
Ability: Keen Eye

Swablu `Normal` `Flying`
Ability: Natural Cure

Wingull `Water` `Flying`
Ability: Keen Eye

TRAINER HANDBOOK

ADVANCED HANDBOOK

ADVENTURE DATA

1 Battle Trainers and claim some Berries

Orlando found a Heart Scale!

Having traveled through Meteor Falls, you can now explore Route 115 more thoroughly. Battle a few Trainers as you comb the hills, pocketing a Great Ball and harvesting some Berries. Use the Dowsing Machine to discover a Heart Scale on a portion of the beach you couldn't reach before.

◀◀ BACKTRACK RUSTBORO CITY p. 51

Money	In Bag:	1
ℙ 44,030	Repeat Ball	ℙ 1,000
	Timer Ball	ℙ 1,000
	Net Ball	ℙ 1,000
	Quit	

A somewhat different Poké Ball that works especially well on a Pokémon species that has been caught before.

Pick up some new Poké Balls

When you've finished exploring Route 115, head south to Rustboro City. Rest at the Pokémon Center, and then pop into the local Poké Mart to find that a second clerk now sells Net Balls, Repeat Balls, and Timer Balls. Not seeing this clerk? Go east to Route 116 and speak with the Devon Researcher near the entrance to Rusturf Tunnel.

◀◀ BACKTRACK ROUTE 117 p. 102

ℙ 122,682

Electrike♂ Lv. 32
Minun♂ Lv. 34
Cancel

You have mighty spirited Pokémon, you know. Are you here to take one back?

Check in on your growing Pokémon

Go east from Rustboro City to reach Route 116, and then travel through Rusturf Tunnel to visit Verdanturf Town. Rest and shop here before continuing east to Route 117. As you near Route 117's eastern end, stop by the Pokémon Day Care and check on the Pokémon you've left here (if any). They're likely to be growing strong by now! Feel free to leave them be, or pick up your Pokémon and leave a couple of new ones in their place.

◀◀ BACKTRACK MAUVILLE CITY p. 89

OK, no problem! Are you ready to switch Bikes?

Yes
No

Swap your Bike at Rydel's Cycles

Go east along Route 117 to reach Mauville City. You made it! Swing by Rydel's Cycles, located in the city's east hall, and swap your Mach Bike for an Acro Bike before proceeding north to Route 111 if you want. The Mach Bike is always useful, but the Acro Bike's special moves will soon come in handy.

TIP

If you wish to buy Secret Base Decorations, go south from Mauville City and make your way back to Slateport. Motor down to the market, and you'll find a selection of Secret Base Decorations for sale.

TRAINER HANDBOOK

ADVANCED HANDBOOK

ADVENTURE DATA

Take the Cable Car up to Mt. Chimney

From Mauville City, go north along Route 111 until you hit the impassible sandstorm, and then go west to Route 112. Hey, Team Magma / Team Aqua is no longer guarding the Cable Car station! Search the station's east side for a Guard Spec. Then enter the station and take the Cable Car up to Mt. Chimney.

MT. CHIMNEY

This volcano towers to a height of nearly 5,000 feet. The view from its peak is beyond compare.

Located in the heart of Hoenn, Mt. Chimney is a monstrous volcano that seethes with incredible power. Although their purpose isn't clear, Team Magma / Team Aqua is intent on bringing Professor Cozmo's Meteorite here. Stop them and reclaim the Meteorite!

Team Magma Leader Maxie /
Team Aqua Leader Archie
⊙⊙⊙⊙⊙⊙

Team Magma Admin
Tabitha / Team Aqua
Admin Shelly
⊙⊙⊙⊙⊙⊙

Team Magma /
Team Aqua Grunt
⊙⊙⊙⊙⊙⊙

Cable Car
Summit
Station

To Route
112 (South)
(p. 109)

To Jagged
Pass (p. 130)

Vending Machine	
Cable Car station	
Fresh Water	400
Lemonade	700
Soda Pop	600

Old Lady	
After visiting Lavaridge Town	
Lava Cookie	200

Items
❏ Meteorite
❏ TM59 Incinerate

Hidden Items
❏ Protein
❏ Zinc

1 | **Steer clear of Team Magma / Team Aqua Grunts**

Pfloosh!

Normally, you'd be able to go south from Mt. Chimney and descend into Jagged Pass to reach Lavaridge Town and your next Badge. You can't do so now, however, because Team Magma and Team Aqua are locked in battles all over the mountain. Let their Pokémon duke it out while you head up the north steps.

2 | Find Archie/Maxie battling farther up the mountain

Just west of the steps, you find the leader of the other team, Team Aqua (Archie) / Team Magma (Maxie), battling a group of the opposing team's Grunts. You're only here for the professor's Meteorite, so you'd better not get involved. Slip past the battle and work your way west, then north.

3 | Defeat a Team Magma / Team Aqua Grunt

You're soon drawn into battle against a Team Magma / Team Aqua Grunt. There's no avoiding it, but you're more than a match for just one lowly Grunt by now. Finish him off quickly and then continue exploring northward.

4 | Take the narrow stairs down to a TM

Beyond the Grunt lies an impressive bridge that extends over the mouth of Mt. Chimney. Ignore the bridge for the moment and descend the narrow west stairs instead. Loop around the narrow path afterward, going north, east, and then south to discover TM59 Incinerate tucked beneath the bridge.

5 | Battle Team Magma Admin Tabitha / Team Aqua Admin Shelly

Circle back around the narrow path after claiming TM59 Incinerate and start crossing the bridge. You'll be stopped by Tabitha/Shelly, who isn't about to let you pass so easily. There's nothing else for it—you've got to battle him/her if you want to cross!

Team Magma Admin Tabitha's Pokémon

This time around, Tabitha uses Koffing and Numel. They share a common weakness to Ground-type moves at a glance, but Koffing's Levitate Ability makes it immune to Ground-type moves, so use Psychic-type moves against Koffing instead. Numel is also extremely vulnerable to Water-type moves, but is not affected by Electric-type moves due to its Ground type.

Koffing — Poison
♂ Lv. 24
Weak to: Psychic

Numel — Fire | Ground
♂ Lv. 24
Weak to: 4× Water | Ground

Team Aqua Admin Shelly's Pokémon

Things are challenging if you're up against Shelly, as no common weakness can be found among her Pokémon. In fact, Grimer is resistant to most of the move types that Carvanha is weak against, so you'll definitely want to switch out your Pokémon mid-battle if you hope to exploit both Pokémon's weaknesses.

Carvanha — Water | Dark
♀ Lv. 24
Weak to: Grass | Electric | Fighting | Bug | Fairy

Grimer — Poison
♀ Lv. 24
Weak to: Ground | Psychic

6 | Battle Team Magma Leader Maxie / Team Aqua Leader Archie!

You've beaten Tabitha/Shelly, but the real threat lurks ahead. Heal your Pokémon and then finish crossing the bridge to find the leader of Team Magma / Team Aqua standing near some sort of high-tech device. After revealing a bit more of his organization's far-out plans, Maxie/Archie draws you into a dangerous battle!

Team Magma Leader Maxie's Pokémon

No weaknesses are shared by Maxie's Pokémon, so you'll need to switch out your own Pokémon throughout the battle and adapt to the ones he sends out. Fortunately, all of his Pokémon have multiple weaknesses that can be exploited. Show this worthy foe just how strong a Trainer you've become!

Camerupt — Fire | Ground
♂ Lv. 27
Weak to: 4× Water | Ground

Golbat — Poison | Flying
♂ Lv. 25
Weak to: Electric | Ice | Psychic | Rock

Mightyena — Dark
♂ Lv. 25
Weak to: Fighting | Bug | Fairy

Team Aqua Leader Archie's Pokémon

●●○○○○

Archie's Pokémon share several weaknesses, particularly Mightyena and Sharpedo. Favor Pokémon that unleash Electric-, Fighting-, or Fairy-type moves to bring Archie down faster than a falling anchor!

⬤ Golbat ♂ Lv. 25		Poison	Flying	
Weak to:	Electric	Ice	Psychic	Rock

⬤ Mightyena ♂ Lv. 25			Dark
Weak to:	Fighting	Bug	Fairy

⬤ Sharpedo ♂ Lv. 27		Water	Dark	
Weak to:	Grass	Electric	Fighting	Bug
	Fairy			

7 | Receive the Meteorite from Maxie/Archie

Orlando obtained the Meteorite!

Orlando obtained the Meteorite!

Having tasted defeat, Maxie/Archie prepares to unleash the full brunt of his Pokémon's Mega-Evolved power against you. But before battle can be joined once more, Maxie/Archie suddenly receives a call on his Holo Caster. After muttering something about Mt. Pyre, Maxie/Archie prepares to leave—but not before handing you the Meteorite that his team worked so hard to steal from Professor Cozmo!

8 | Have a run-in with the other team leader

Huh?
If it ain't that little scamp!

I've seen you before, child.

Team Magma / Team Aqua have made good their escape, so there's nothing holding you here any longer. As you turn to leave, you're suddenly halted by the other team's leader. He's shocked that his rival would hand over the Meteorite so easily, and seems fearful that the opposing team may have discovered where some special-sounding "orbs" are hidden. What could all of this mean?!

Opposing Plans

Team Magma / Team Aqua seems to have gotten whatever they needed out of Professor Cozmo's Meteorite, but what they wanted isn't exactly clear. It seems that they're searching for a means of generating extreme amounts of power and energy—enough to realize their wild dream of creating more land/water on the planet's surface. How the Meteorite factored into this isn't obvious, but one thing's for sure: it no longer seems to hold any interest for Maxie/Archie. Neither does Mt. Chimney—but didn't Maxie/Archie mention something about Mt. Pyre during his call? This could be an important lead. You'd better check it out!

Orlando found a Protein!

With the absence of Teams Magma and Aqua, things have finally settled down around Mt. Chimney. Time for a little dowsing! Loop around the volcano's mouth and use your Dowsing Machine to discover a Protein over to the east. Descend the central stairs and search behind the Cable Car station to locate a hidden Zinc, and then continue south into Jagged Pass.

JAGGED PASS

This mountain route is the result of a volcanic eruption in ages long past. It can only be traversed on an Acro Bike.

Your Bike gets a workout around Jagged Pass, for many parts here are too rough or too slippery to travel without the aid of a Bike. If you're aiming to collect all the items in this area, you'll need the Acro Bike. Explore this area thoroughly to claim a number of items on your way south to Lavaridge Town.

Items
☐ Full Heal
☐ Max Ether
☐ Super Repel
☐ TM43 Flame Charge
☐ TM69 Rock Polish
☐ X Defense

Hidden Items
☐ Full Heal
☐ Great Ball

Tall Grass	
☐ Machop	◎
☐ Numel	◎
☐ Spoink	○

Horde Encounters	
☐ Machop (×5)	◎
☐ Spoink (×5)	○

◎ frequent ○ average
△ rare ▲ almost never

To Mt. Chimney (p. 126)

Expert Shelby ◉

Hiker Eric

Camper Ethan ◉

Fairy Tale Girl Nellie

Picnicker Diana ◉

To Route 112 (South) (p. 109)

TRAINER HANDBOOK

ADVANCED HANDBOOK

ADVENTURE DATA

1 Go west at the first junction and bunny-hop down

Orlando found a Super Repel!

Jagged Pass presents you with several routes, many of which lead to valuable items. Take two sets of stairs, hop two ledges, and go west. You will spot a small, circular stone. If you have an Acro Bike, whip it out and hold Ⓑ until you begin to bunny-hop in place. Move while still holding Ⓑ to bunny-hop, and you'll hop down the stone. Continue hopping down the next stone to reach a Super Repel.

2 Go east and hop down to a TM

Orlando found TM43 Flame Charge!

Hop back up the small stones and return to the previous junction. This time, hop down another series of stones toward the east followed by one that leads to the south to reach TM43 Flame Charge—one of two TMs you can find around Jagged Pass. (There's no reaching this one without the Acro Bike.)

3 Go south and claim a Max Ether and a Great Ball

Orlando found a Max Ether!

Keep working your way southward, battling Trainers on your way to another item that's quite a ways down to the southeast. This one's a valuable Max Ether, which can restore PP to a Pokémon's move when resting isn't an option. To the north-east of the Max Ether, you can find a Great Ball next to a tree by using the Dowsing Machine, another great find!

4 Hop back up and dowse for a Full Heal

Orlando found a Full Heal!

Slide down the nearby slope after claiming the Max Ether, then make a long series of bunny-hops back up the ledges again, backtracking northward. When you reach a small patch of tall grass, go west and use your Dowsing Machine to discover a hidden Full Heal in a rock. This item can be reached without the Acro Bike if you're careful during your descent.

5 Go west and find another TM

Orlando found TM69 Rock Polish!

Return to the small patch of tall grass and scale the nearby steps. Bunny-hop up the nearby stone to the west, then continue going west and slide down the west slope. After sliding down, bunny-hop up the short series of stones to the north to reach TM69 Rock Polish. You can also ride the Mach Bike up the nearby narrow slope to reach this TM.

TIP

If you don't have the Acro Bike, you'll just have to make your way down Jagged Pass without finding every item for now (the Super Repel is beyond your reach, for example). You can reach a few items, though, so keep a lookout for slippery slopes that you can ride up to reach items with the Mach Bike.

TIP

Don't worry about making any false moves while exploring Jagged Pass if you have the Acro Bike. You can always bunny-hop your way back up to the top! You won't be able to return to the top with the Mach Bike, so don't hop down from a ledge until you've explored as much as you can.

6 | Go south and slide down to a Full Heal

Orlando found a Full Heal!

Slide down the nearby narrow slope and go south, battling a Hiker on your way to three slippery slopes that are lined up in a row. Slide down the middle slope to land on a ledge with a Full Heal. You can also reach this item by riding up the south slope if you've got the Mach Bike.

7 | Go southwest to find the last item

Orlando found an X Defense!

Head south from the Full Heal's ledge, traveling through tall grass and then hopping down two ledges. Turn west afterward, avoiding the stairs and hopping down two more stones on your way to an X Defense. That's the last of them.

8 | Proceed south to Lavaridge Town

Pat yourself on the back if you've managed to find every item around Jagged Pass—it takes some doing! Once you've cleaned out the area, take the south stairs down to a grassy path that leads to Route 112.

◀◀ BACKTRACK ▮ ROUTE 112 p. 109

Orlando found a Nugget!

Search the west bank for a Nugget

Jagged Pass's southern trail leads to Route 112's west bank. You've never been able to explore this portion of Route 112 before, so give it a quick search, and nab the nearby Nugget. Be careful not to drop from the east ledge, though—it's a long way back up to Mt. Chimney if you do! Proceed west to Lavaridge Town instead.

LAVARIDGE TOWN

A popular spot in the Hoenn region, thanks to its hot springs, said to cure any ailment.

Nestled next to mighty Mt. Chimney, Lavaridge Town is a welcome respite for travelers and tourists. It's renowned throughout Hoenn for its soothing hot springs, and it also features a special shop that sells bitter but beneficial herbs for Pokémon. Gym Leader Flannery looks to light a fire beneath all challengers at the local Pokémon Gym.

Pokémon Center

Poké Mart

Pokémon Herb Shop

Lavaridge City Gym (p. 135)

Poké Mart

Normal wares	
Antidote	100
Awakening	250
Burn Heal	250
Escape Rope	550
Full Heal	600
Great Ball	600
Ice Heal	250
Hyper Potion	1,200
Max Repel	700
Paralyze Heal	200
Poké Ball	200
Potion	300
Repel	350
Revive	1,500
Super Potion	700
Super Repel	500
Ultra Ball	1,200
After obtaining the Heat Badge	
Max Potion	2,500

Pokémon Herb Shop

Energy Powder	500
Energy Root	800
Heal Powder	450
Revival Herb	2,800

Woman in the Pokémon Center

Moomoo Milk	500

Items

- ❑ Charcoal
- ❑ Go-Goggles
- ❑ TM75 Swords Dance

Hidden Items

- ❑ Ice Heal

1　Learn to communicate with TM75 Swords Dance

You understand, yes?

A Poké Mart greets you as you stroll into Lavaridge Town. Before you head inside, speak to the Black Belt who paces near the shop. He has a passion for dancing, power, and karate, but his communication skills leave something to be desired. Answer no when he asks if you understand his words, and he'll give you TM75 Swords Dance in the hopes that the "Suh-words Dance" move will help you comprehend.

2　Take a rest and get some Moomoo Milk

It's ₽500 for one bottle!

Before you blow all your money on Super Potions in the Poké Mart, pop into the nearby Pokémon Center and speak to the red-clad woman who stands near the counter. She's selling delicious, nutritious Moomoo Milk for just 500 per bottle. Moomoo Milk restores 100 HP to a weary Pokémon, so it's a much better deal than the Poké Mart's Super Potions, which only restore 50 HP and cost 700 each.

Buy Lava Cookies from a nice old lady

If you're after another bargain, return to Mt. Chimney to find a nice old lady selling Lava Cookies near the Cable Car station. One of these tasty treats costs just 200 and will cure a Pokémon of all status conditions and confusion when consumed. In short, they're just like Full Heals—but they're delicious and cost a lot less!

3 | Lay claim to an Egg near the hot springs

The Pokémon Center's back doors lead to Lavaridge Town's steamy hot springs. Take a dip if you wish, using your Dowsing Machine to discover a hidden Ice Heal behind the door on the right. Use the Pokémon Center's PC to move a Pokémon out of your party afterward, so that you're carrying no more than five Pokémon with you. Leave the Pokémon Center and speak to the old woman who stands just south of the hot springs. She'll offer you a Pokémon Egg to take with you on your travels!

TIP

Pokémon Eggs won't hatch unless you carry them with you, so keep the Egg in your party as you explore.

4 | Chalk up some Charcoal at the Herb Shop

The Pokémon Gym beckons, but take a moment to visit the nearby Herb Shop first. Inside, an old man hands you a Charcoal, which boosts the power of Fire-type moves when held by a Pokémon. You won't be using such moves inside the Gym, but it's still a great item to grab. Feel free to do a little shopping afterward if you like.

TIP

Herbal medicines work well and are easy on your wallet, but their bitter taste won't make your Pokémon very happy. In fact, using herbs makes your Pokémon less friendly toward you, so use them only as a last resort. Each herb's description indicates how bitter it is. The more bitter the herb, the greater its effect, but the grosser it will be for your Pokémon to choke down.

LAVARIDGE TOWN GYM BATTLE

Gym Battle Tips

- Bring lots of HP-restoring items and Burn Heals to ensure your party can handle the heat.
- Filling your party with lots of Water-type Pokémon gives you an advantage. Catch some by fishing with your Old Rod.

Battle Girl Sadie
◉◉◉◉◉◉

Kindler Axle
◉◉◉◉◉◉

Gym Leader Roxanne
◉◉◉◉◉◉

Ace Trainer Zane
◉◉◉◉◉◉

Kindler Cole
◉◉◉◉◉◉

Entrance

Ninja Boy Shoji
◉◉◉◉◉◉

Kindler Andy
◉◉◉◉◉◉

Ninja Boy Hiromichi
◉◉◉◉◉◉

1 Assemble your party and enter the Gym

Leader: Flannery
One with a fiery passion that burns!

As you might have guessed, the Lavaridge Town Gym is filled with Trainers who favor Fire-type Pokémon. Water-type Pokémon are the perfect counter to these fiery foes, as Fire-type moves won't be very effective against them. Water-type moves will also make a big splash against Fire types, soaking them for supereffective damage. Pack your party with as many Water-type Pokémon as possible.

TIP

If you're short on Water-type Pokémon, use your Old Rod to reel some in wherever you find water. Routes 114 and 115 are good options.

Optional | Befriend Wingull and Pelipper

Wingull and Pelipper are also fantastic Pokémon to bring into this Gym. Not only are they both Water types, they're also both Flying types, which gives you an advantage against the Meditite that some Trainers in the Gym send out. You may have caught a Wingull back in Route 104. If not, you can catch one of a higher level in the tall grass of Route 115.

2 | Use the floor panels to navigate the Gym

Lavaridge Town's steamy Gym would be a nice place to relax and unwind, but that's not why you're here. You're here to battle for your next Badge! The humid Gym features two floors, both of which are brimming with Trainers. To move between the floors, you'll need to step on the many wooden floor panels. Stepping on a floor panel on the first floor causes you to drop to the basement, while stepping on a floor panel in the basement sends you soaring back up to the first floor by way of a geyser. Follow this guide's maps to find your way to Flannery!

TIP

For the shortest route to the battle against Leader Flannery, simply follow the icons on this guide's maps in alphabetical order, from A to B to C, and so on. You may miss out on a few Trainer battles if you take the short route, though, so feel free to give the Gym a thorough search and explore its every nook and cranny.

TIP

Some sneaky Trainers hide in the depths of the basement's steamy springs. Check the maps to see where each Trainer stands, even the hidden ones.

🎯 **Lavaridge Town Gym Leader**

Flannery Fire-type Pokémon User

Wash her away with Water-type moves!

Newly crowned Gym Leader Flannery is all fired up, burning with a yearning to prove her worth. Give her Fire-type Pokémon a chance to attack, and they'll unleash devastating moves that can instantly reduce your party to cinders. The Overheat move used by her Pokémon is just brutal, inflicting massive amounts of Fire-type damage. Overheat's only drawback is that it harshly lowers her Pokémon's Sp. Atk stat after each use—but one use is usually enough!

Unfortunately for Flannery, all of her Pokémon share weaknesses to Water- and Ground-type moves, and two of them are also weak to Rock-type moves. This gives you plenty of options to work with. Water-type moves are the obvious choice, but even a rugged Fighting-type Pokémon such as Makuhita or Hariyama can wipe out each of Flannery's Pokémon with Ground-type moves. Try Bulldoze, which is a TM you can buy in Mauville City.

Letting Flannery act first is unwise, so give the Quick Claw that you received in Rustboro City to your lead Pokémon to hold. It can help ensure that it acts first.

Flannery's Pokémon

🔘 **Slugma**			Fire
♀ Lv. 26			
Weak to:	Water	Ground	Rock

🔘 **Numel**		Fire	Ground
♀ Lv. 26			
Weak to:	4× Water	Ground	

🔘 **Torkoal**			Fire
♀ Lv. 28			
Weak to:	Water	Ground	Rock

Heat Badge

Pokémon up to Lv. 50, including those received in trades, will obey you. This Badge also lets you use the Strength field move to shove big boulders out of your way.

TM50 Overheat

The user attacks the target at full power. The attack's recoil harshly lowers the user's Sp. Atk stat.

5 | Meet May/Brendan outside of the Gym

Orlando obtained the
Go-Goggles!

Your friend May/Brendan greets you as you stroll out of Lavaridge Town Gym with your shiny new Heat Badge. She/he is shocked that you managed to defeat Team Magma / Team Aqua all on your own at Mt. Chimney, and even more surprised that you've already claimed another Gym Badge. May/Brendan graciously hands you a pair of Go-Goggles so that you can see through the sandstorm on Route 111. Then she/he invites you to travel with her/him back to Petalburg City. Flip ahead to page 140 if you decide to travel with May/Brendan and be whisked back to Petalburg City instantaneously, or just keep reading if you prefer to take the scenic route and test out your new Go-Goggles to grab some new Pokémon and prizes in Route 111's desert.

◀◀ BACKTRACK | FIERY PATH p. 111

Would you like to use Strength?

Use Strength to reach new items

If you're taking the scenic route back to Petalburg City, rest up and then leave Lavaridge Town, heading east to Route 112. Grab the Nugget here if you haven't yet, and consider taking the Cable Car up to Mt. Chimney to buy some Lava Cookies from the old lady at the summit. When you're ready, return to Route 112 and enter the Fiery Path. Inside, you meet Aarune, who gives you TM96 Nature Power. After Aarune departs, use Strength to shove the nearby boulder out of the way. Then explore the rest of the Fiery Path, collect TM06 Toxic and a Fire Stone, and backtrack out to Route 112 to the south.

◀◀ BACKTRACK | MAUVILLE CITY p. 89

You can now use Accuracy Power Lv. 1!

Get the Mach Bike and two new O-Powers

Travel east through Route 112, heading into the southern half of Route 111. Go south from there and enter Mauville City, and visit Rydel's Cycles to swap your Acro Bike for the Mach Bike. Speak to the Hipster in the Pokémon Center afterward to learn the Accuracy Power Lv. 1 and Encounter Power Lv. 1 O-Powers.

◀◀ BACKTRACK | TRICK HOUSE p. 83

The Trick Master!
Wahahaha! Glad to meet you!

Solve the Trick House's remaining mazes

Now that you have the Heat Badge, you can use the Strength field move to shove big boulders out of your way. This gives you the power to complete the Trick House's final three mazes. Plenty of puzzles and prizes await, so consider heading south out of Mauville City and clearing out the Trick House right now.

Rewards: Casteliacones, Smoke Ball, Old Gateaux, Magnet, Escape Rope, Shalour Sables, Red Tent (Ω) / Blue Tent (α), Big Nugget

This expansive route includes a desert where sandstorms rage unceasingly and a mountain pass.

A mighty sandstorm has always kept you from exploring Route 111's central desert, but now that your friend May/Brendan has given you the Go-Goggles, you're finally able to protect your eyes and explore this place, where Fossils are rumored to be found.

TRAINER HANDBOOK

ADVANCED HANDBOOK

ADVENTURE DATA

To Route 111 (North) (p. 112)

To Route 112 (North) (p. 109)

Black Belt Daisuke

Root Fossil / Claw Fossil

Camper Cliff

Picnicker Heidi

Camper Drew

To Route 111 (South) (p. 106)

Picnicker Becky

Ruin Maniac Dusty

Desert

❏ Baltoy	○
❏ Cacnea	○
❏ Sandshrew	◎
❏ Trapinch	○

Horde Encounters

❏ Sandshrew (×5)	◎

◎ frequent ○ average
△ rare ▲ almost never

Items

❏ Claw Fossil or Root Fossil
❏ Safety Goggles
❏ Stardust
❏ TM37 Sandstorm

Hidden Items

❏ PP Up
❏ Protein
❏ Rare Candy
❏ Revive
❏ Stardust

Baltoy Ground Psychic
Ability: Levitate

Cacnea Grass
Ability: Sand Veil

TIP

Restoring the Root Fossil gives you Lileep, a Rock- and Grass-type Pokémon, while restoring the Claw Fossil gives you Anorith, a Rock- and Bug-type Pokémon.

1 Find some Fossils

Orlando obtained a Root Fossil!

Ride your Mach Bike north out of Mauville City, heading for Route 111's central sandstorm area. Now that you've got the Go-Goggles, you can finally explore this windswept desert. Go north to find a Stardust, and then go east to locate a pair of Fossils lying in deep sand. Taking one Fossil causes the other to sink, so choose carefully!

2 | Get some goggles and a TM

Orlando obtained
Safety Goggles!

Go south from the Fossils and speak to a Bug Catcher. Seeing your stylish Go-Goggles, he assumes you'd like a pair of Safety Goggles for your Pokémon to wear, and gives you one. Stylin'! Continue exploring southward to discover TM37 Sandstorm. Whip out your Dowsing Machine afterward and discover a number of hidden items around the desert before heading north to Route 111's northern half.

TIP

These are not the only Fossils you might be able to find in the Hoenn region. Eventually you will learn about special Mirage spots, where more ancient Fossils might be waiting to be restored as Pokémon!

TIP

Be on the lookout for some Secret Spots in this desert! There are four of them, although two will require your Mach Bike to reach. Check them out to see if you'd like to move in!

◄◄ BACKTRACK PETALBURG CITY p. 38

You have a Fossil, don't you?
Shall I restore it for you?

Yes
No

Make your way back to Petalburg City

Petalburg City is your next stop. It's quite a long journey and you can choose different routes. Go north and then west through Route 111 to reach Route 113. Perhaps collect a bit more ash while you're there, if you haven't gotten all of the items the glass artist can make. Continue heading west to reach Fallarbor Town, then go west to Route 114. From there, go south to Meteor Falls. Continue south to Route 115, and keep going south to reach Rustboro City. Get your Fossil restored on the second floor of the Devon Corporation, and go upstairs to talk to Mr. Stone again. He'll notice the Intriguing Stone you got in Verdanturf and reveal that it's actually Pidgeotite! With another Mega Stone in your collection, proceed south to Route 104, keep going south through the Petalburg Woods to reach Route 104's southern half, then go east to arrive at last in Petalburg City. Whew!

Your other option is to head south from the desert and go back to Mauville, and then head west through Route 117 to reach Verdanturf. If you've never visited Verdanturf, turn back to page 104 to see what you can do there. Then cut through the Rusturf Tunnel and back to Route 116 and Rustboro. (Don't forget to restore your Fossil while there.) Head south through Route 104 and the Petalburg Woods to reach Petalburg City.

PETALBURG CITY GYM BATTLE

Gym Battle Tips
- Bring lots of HP-restoring items, like Super Potions, to keep your Pokémon in good health.
- Powerful Fighting-type Pokémon, such as Makuhita or Hariyama, can wreak havoc in this Gym.

TRAINER HANDBOOK

1 Assemble your party and enter the Gym

Hello, and welcome to the Pokémon Center. Would you like to rest your Pokémon?

Depending on the route you took, it might have been a long journey to Petalburg City. Catch some rest at the Pokémon Center, and use the PC to pick your party for the upcoming Gym battles. Your dad and Gym Trainers exclusively use Normal-type Pokémon, so their only weakness is Fighting-type moves. This makes picking your party short work—you want plenty of Fighting-type Pokémon at your side!

TIP

Fresh out of Fighting types? Find Machop around Route 112 and Jagged Pass. You can also catch Makuhita in Granite Cave.

2 Choose your path through the Gym

The sign says, "Accuracy Room."

Petalburg City's Gym is a traditional dojo consisting of multiple rooms. Each room contains a Trainer who uses special items and tactics to defeat you. Beat a Trainer, and you'll be able to advance to the next room and take on the next one. Check each door's sign for a clue as to what waits in the room beyond.

You must battle at least three Trainers on your way to your dad, but if you like, you can do some clever backtracking through the rooms and take on every Trainer in the Gym. The following table reveals the items that the Trainers use on their first turn to gain an advantage.

Tier 1 Rooms	
Speed Room	X Speed
Accuracy Room	X Accuracy
Tier 2 Rooms	
Zero Reduction Room	Guard Spec.
Defense Room	X Defense
Recovery Room	HP-restoring items (used as needed)
Tier 3 Rooms	
Strength Room	X Attack
One-Hit KO Room	Dire Hit

Leader's Room

K L

Gym Leader Norman
◉◉◉◉◉◉

Strength Room

K

G H

Ace Trainer Jody
◉◉◉◉◉◉

One-Hit KO Room

L

I J

Ace Trainer Berke
◉◉◉◉◉◉

Zero Reduction Room

G

C

Ace Trainer Parker
◉◉◉◉◉◉

Defense Room

H I

D E

Ace Trainer Lori
◉◉◉◉◉◉

Recovery Room

J

F

Ace Trainer George
◉◉◉◉◉◉

Speed Room

C D

A

Ace Trainer Randall
◉◉◉◉◉◉

Accuracy Room

E F

B

Ace Trainer Mary
◉◉◉◉◉◉

Entrance

A B

Entrance

Norman — Normal-type Pokémon User

Petalburg City Gym Leader

Norman's Pokémon

- **Vigoroth** ♂ Lv. 28 — Normal
 Weak to: Fighting
- **Slaking** ♂ Lv. 28 — Normal
 Weak to: Fighting
- **Slaking** ♂ Lv. 30 — Normal
 Weak to: Fighting

Use Fighting-type moves to thrash your dad!

You've ventured far and wide since you last spoke with your dad, and you've caught and raised all sorts of Pokémon. With four Gym Badges in your collection, you've finally earned the right to challenge your dad to a Pokémon battle!

Like the other Trainers you've faced on your way through the Gym, Norman sends out Normal-type Pokémon. He doesn't use fancy items to boost their stats, but he doesn't need to—his high-level Pokémon are quite powerful on their own. Though they seem somewhat sluggish in appearance, your dad's Pokémon often act first each turn, and they primarily use the move Retaliate, which inflicts large amounts of damage. This move may become more powerful as the battle wears on, for Retaliate's power increases dramatically when it's used immediately after an ally Pokémon has fainted. Be prepared for this, and use HP-restoring items to heal your Pokémon each time you succeed in defeating one of Norman's.

As Normal types, all of your dad's Pokémon are vulnerable to Fighting-type moves—in fact, it's their only weakness. Rock Smash is a good option, although you may have even more powerful Fighting-type moves at your disposal by now. Use Fighting-type moves exclusively to nail Norman's Normal-type Pokémon for supereffective damage each and every turn!

Balance Badge
Pokémon up to Lv. 60, including those received in trades, will obey you. This Badge also lets you use the move Surf outside of battle to cross bodies of water.

TM67 Retaliate
The user gets revenge for a fainted ally. If an ally fainted in the previous turn, this move becomes more powerful.

3 — Receive HM03 Surf from Wally's dad

Orlando obtained HM03 Surf!

As you and your dad leave the Gym, you find your pal Wally and his dad standing outside. Wally has just come to town to pick up a few things, and he seems in good health and high spirits. His dad thanks you for taking Wally under your wing and gives you HM03 Surf—a very valuable move. Excited at the new explorations ahead, you and Wally race off to Mauville City, while your fathers share a moment of bonding.

Surf's Up!

The water is deep, deep blue. Would you like to use Surf?

Yes
No

Surf is a damage-dealing Water-type move that's also useful outside of battle because it lets you travel across large bodies of water. Teach HM03 Surf to one of your party Pokémon, and you'll be ready to start Surfing!

Just move to a suitable spot, such as the edge of a river, lake, pond, or the sea. Press Ⓐ while standing near the water's edge, and you'll be prompted to use Surf. You can also press Ⓧ and select a Pokémon that's learned Surf and then choose Surf from the menu.

Moving on the water
While using Surf, most Pokémon will move you around twice as fast as you move on foot—the same speed as the Acro Bike. Just press the +Control Pad or tilt the Circle Pad to start moving.

TRAINER HANDBOOK

ADVANCED HANDBOOK

ADVENTURE DATA

Surfing subtleties

Special rules apply while you're Surfing. You can't use the field moves Rock Smash, Cut, or Strength while using Surf. You can use lots of other moves while Surfing, though, including Dig, Sweet Scent, Dive, Soft-Boiled, Teleport, Milk Drink, Fly, Waterfall, and Flash.

You can't use your Dowsing Machine to find hidden items while Surfing. You can use other items, however, like a fishing rod, an Escape Rope, or an Eon Flute. That's right, you can fish from the back of your Pokémon while Surfing!

TIP

Teach Surf to a Sharpedo, and you can travel at three times the speed that you would move on foot—the same speed as the Mach Bike. Sharpedo's speed boost comes with a price, though. You can't use a fishing rod from the back of Sharpedo like you can with other Pokémon.

Surfing encounters

Surfing isn't all fun and games. Encounters with wild Pokémon can and will occur while you're using Surf, just as when you're romping through tall grass. This includes encounters with hidden Pokémon that are visibly splashing about in the water, just like the hidden Pokémon you've spotted in tall grass. Use the same tactics to sneak up on hidden Pokémon while Surfing as you do when walking: lightly press the Circle Pad to sneak toward them. If you're not having much luck at being sneaky, don't worry! As mentioned, you'll still run into plenty of wild Pokémon through the normal kind of random encounters—although less frequently than when you're traveling through tall grass.

TIP

While Surfing, look out for shadows in the water where hidden Pokémon lurk just under the surface, and be ready to catch them as soon as they appear!

Special Pokémon appearances

Three Pokémon have their own special appearance when they use Surf.

The speedster Sharpedo is one of them, and Wailmer also has a unique appearance. So does the Legendary Pokémon Kyogre (p. 239). Try to get one of these special Surfers to see them in action!

Search the seas with Surf

Now that you know how to use Surf, get out there and use it! Surf lets you travel to new places and more thoroughly explore areas you've visited. Try heading back to Routes 105–110 to reach some spots you could never explore before, and be on the lookout for places to use Surf!

◄◄ BACKTRACK **MAUVILLE CITY** p. 89

You can now use Prize Money Power Lv. 1!

Rest up and receive a new O-Power

You haven't had a chance to restore your Pokémon since the big battle against your dad. Take a break here at the Mauville City Pokémon Center before speaking to the nearby man in blue, who calls himself the Bard. Listen to his unfinished song, and he'll reward you with the Prize Money Lv. 1 and the Exp. Point Power Lv. 1 O-Powers. If need be, swap your Acro Bike for the Mach Bike before heading south to Route 110.

Orlando found a Rare Candy!

Surf to items around Route 110

Now that you have Surf, you can reach a few new items around Route 110, including a Rare Candy, an Elixir, and a Secret Spot. Look for gaps in the railings where you can use Surf. You can also Surf to the entrance of a facility called New Mauville (p. 267), but you can't explore this mysterious facility just yet.

The water is deep, deep blue. Would you like to use Surf?

Surf across Route 103

Travel south along Route 110 to reach the Trick House, and consider solving its remaining mazes if you haven't already done so. Then go west to Route 103, which you can finally cross all at once thanks to Surf. Stand at the water's edge and press Ⓐ to use Surf, and then start across. You can catch wild Pokémon on the water as you head to Route 103's west side. From there, go south to Oldale Town.

Orlando obtained an Amulet Coin!

Visit your mom and score an Amulet Coin

Keep traveling south through Oldale Town, heading to Route 101 on your way back to your new home in Littleroot. You haven't visited your mom for a while, so check in on her. She's happy to see you and, not to be outdone by your dad's recent gifts, she gives you a precious item called an Amulet Coin. If you use a Pokémon that is holding this item in battle, you'll receive double the prize money from Trainer battles!

Orlando found an Ether!

Surf across the ponds to find items

Rest up at your home before striking out on the road. Return to Oldale Town and then go west to Route 102. Surf around the small pond on Route 102 and catch new species of Pokémon if you like, and then proceed to Petalburg City. Surf across the north and south ponds here to discover three valuable items, an Ether, a Max Revive, and a hidden Rare Candy. Head west to Route 104 next.

Get a White Herb and some Decorations

Orlando obtained a White Herb!

Resist the urge to Surf Route 104's western sea for the moment. You'll soon be doing so, but first, head north through Petalburg Woods and stop by the Pretty Petal flower shop up on Route 104's northern half. Speak to the girl outside the shop to receive a free White Herb, and then pop into the shop and find that the eldest sister in the shop is now standing behind the counter, ready to sell you special Decorations for your Secret Base. And don't forget to Surf east across the lake to pick up a PP Up!

 TIP

If you don't see a girl outside the Pretty Petal flower shop, perhaps you failed to talk to the eldest sister in the shop last time about her goal to fill the world with flowers. If so, go talk to her once and come back outside. (She's the Aroma Lady.) A young girl should have appeared just north of the Youngster who gave you your first TM ages ago. After you get her White Herb, you should find that the eldest sister in the shop is now behind the counter and waiting for you!

TRAINER HANDBOOK

ADVANCED HANDBOOK

ADVENTURE DATA

Orlando found a Heal Powder!

Complete your explorations of Route 115

Travel north through Route 104 to reach Rustboro City, and keep going north to Route 115. Now that you can Surf, you can totally explore this good-sized route. Surf the sea for fun and profit, reaching new areas of Route 115 and collecting Berries and several new items, including a PP Up and a Heal Powder. You can reach an Iron if you have the Mach Bike, and also find some Secret Spots. When you've completed your exploration of Route 115, backtrack to Route 104 and Surf its briny waters to reach a new area, Route 105.

Optional ROUTE 105

Field Moves Needed
Surf

This water route boasts gentle currents, which makes it safe even for poor swimmers to bask in.

This relaxing route features a few sandy islands surrounded by calm, warm waters. Route 105 can only be reached by using Surf from Route 104's southern half, or from Route 106. Exploring Route 105 is optional, but you'll find some worthy Trainers and items here.

Route 104 (South)
(p. 42)

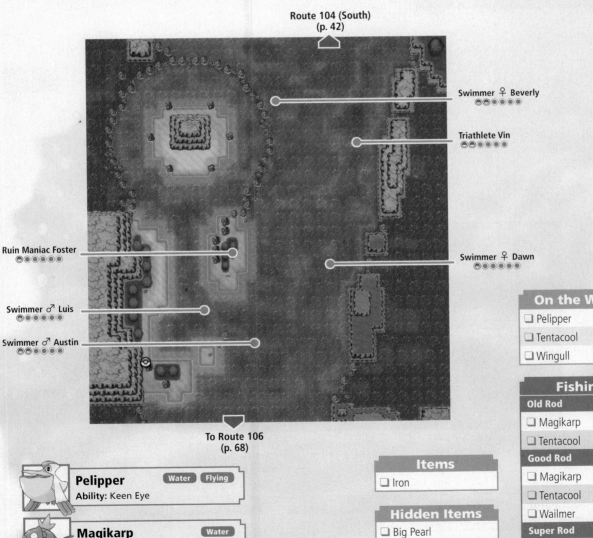

Swimmer ♀ Beverly

Triathlete Vin

Ruin Maniac Foster

Swimmer ♀ Dawn

Swimmer ♂ Luis

Swimmer ♂ Austin

To Route 106
(p. 68)

On the Water

❑ Pelipper	▲
❑ Tentacool	◎
❑ Wingull	○

Fishing

Old Rod		
❑ Magikarp	◎	
❑ Tentacool	○	
Good Rod		
❑ Magikarp	◎	
❑ Tentacool	○	
❑ Wailmer	▲	
Super Rod		
❑ Wailmer	◎	

Items

| ❑ Iron |

Hidden Items

| ❑ Big Pearl |
| ❑ Heart Scale |

Pelipper `Water` `Flying`
Ability: Keen Eye

Magikarp `Water`
Ability: Swift Swim

◎ frequent ○ average
△ rare ▲ almost never

TRAINER HANDBOOK

ADVANCED HANDBOOK

ADVENTURE DATA

1 Explore Route 105

Orlando found an Iron!

Battle numerous Trainers as you Surf Route 105's clear blue waters. Land on the sandy western shore to find an Iron, and then use your Dowsing Machine to discover a Big Pearl in the very same spot. Then walk through the shallows to the tiny islet directly east of you, where a Heart Scale is hidden. Keep Surfing to the south to Route 106.

◀◀ BACKTRACK ROUTE 106 p. 68

Surf the sea on your way to Dewford Town

You've already explored Route 106's main beach by now, as Granite Cave is located there. But now that you've got Surf, you can search Route 106's salty sea, where a few Trainers can be battled.

TIP

If you haven't yet revisited Granite Cave (p. 69) with the Mach Bike, consider doing so on your way to Dewford Town.

Optional ROUTE 107

Field Moves Needed

Surf Dive

The local children of Dewford Town practice long-distance swimming in the waters of this aquatic route.

You might have ducked into Route 107 during your initial explorations of Dewford Town, as doing so led to a Super Repel. You haven't been able to explore much of Route 107 until now, however, for Surf is needed to fully roam this watery route.

Swimmer ♀ Denise

Sis & Bro Lisa & Ray
★ Double Battle

To Dewford Town (p. 64)

Swimmer ♀ Beth

To Route 108 (p. 147)

Swimmer ♂ Tony ◉

Swimmer ♂ Darrin

To Route 107 (Underwater Trench) (p. 216)

Tentacool `Water` `Poison`
Abilities: Clear Body, Liquid Ooze

Items
- ☐ Super Repel

On the Water
☐ Pelipper	▲
☐ Tentacool	◎
☐ Wingull	○

Fishing
Old Rod		
☐ Magikarp	◎	
☐ Tentacool	○	
Good Rod		
☐ Magikarp	◎	
☐ Tentacool	○	
☐ Wailmer	▲	
Super Rod		
☐ Wailmer	◎	

◎ frequent ○ average △ rare ▲ almost never

1 Battle your way to Route 108

Route 108 lies just east of Route 107, and it's your next stop. Give Route 107 a thorough search as you head east toward Route 108, and you'll meet even more Trainers that can be battled along Route 107's briny sea. This includes an exciting Double Battle against Sis & Bro Lisa & Ray.

TIP

Did you notice that dark patch of deep water at Route 107's south-eastern edge? Once your Pokémon learn the Dive move, you'll be able to dive into deep underwater trenches that lie below such dark patches in the ocean. There you may find different Pokémon, items, and even Trainers! There may even be greater mysteries hiding in the deepest parts of Hoenn...

Optional ROUTE 108

Field Moves Needed — Surf

People come swimming from as far away as the Kalos region to see the site of Sea Mauville.

This watery route runs between Route 107 to the west and Route 109 to the east. The only way to reach Route 108 is by way of Surf—until you gain the use of Fly, that is. It's worth the trip, because the spectacular, half-sunken Sea Mauville facility is located here.

Swimmer ♂ Jerome
Swimmer ♀ Tara
To Sea Mauville (p. 148)
Swimmer ♂ Matthew
To Route 107 (p. 146)
To Route 109 (p. 71)
Ace Trainer Neville
Swimmer ♀ Missy
Ace Trainer Constance

Magikarp — Water
Ability: Swift Swim

Wailmer — Water
Abilities: Water Veil, Oblivious

Items
☐ Star Piece

Hidden Items
☐ Rare Candy

On the Water
☐ Pelipper	▲
☐ Tentacool	◎
☐ Wingull	○

○ frequent ○ average △ rare
▲ almost never

Fishing
Old Rod	
☐ Magikarp	◎
☐ Tentacool	○
Good Rod	
☐ Magikarp	◎
☐ Tentacool	○
☐ Wailmer	▲
Super Rod	
☐ Wailmer	◎

1 Search Route 108 for items

Orlando found a Star Piece!

More Trainers await battle around Route 108. Swim down south to find a small patch of sand, where a Star Piece sits. Collect the Star Piece, and then use the Dowsing Machine to detect a Rare Candy right nearby.

TRAINER HANDBOOK

ADVANCED HANDBOOK

ADVENTURE DATA

A half-sunken facility known as Sea Mauville lies to the north. This is one of Hoenn's big tourist attractions, and it's definitely worth checking out. Surf over to Sea Mauville when you've finished searching Route 108.

Optional | SEA MAUVILLE

Field Moves Needed
Surf Dive

A facility that was decommissioned dozens of years ago. It is now maintained as a natural preserve.

Sea Mauville was once a high-tech base where scientists and engineers dredged for natural resources beneath the waves. Now this half-sunken facility has been reborn as a natural refuge for water-dwelling Pokémon and a popular tourist attraction. The Surf field move is needed to reach Sea Mauville (or Fly, when you obtain it), and the Dive field move is required to probe its lower depths.

Sailor Duncan
◎◎◎◎◎◎

Tuber Charlie
◎◎◎◎◎◎

To Route 108 (p. 147)

Fishing	
All floors/areas	
Old Rod	
☐ Magikarp	◎
☐ Tentacool	○
Good Rod	
☐ Magikarp	◎
☐ Tentacool	○
☐ Wailmer	▲
Super Rod	
☐ Wailmer	◎

◎ frequent ○ average
△ rare ▲ almost never

On the Water	
Surface	
☐ Pelipper	▲
☐ Tentacool	◎
☐ Wingull	○
All other floors/areas	
☐ Tentacool	◎

Items
Surface
☐ Escape Rope
☐ TM18 Rain Dance
First interior floor
☐ Max Repel

Young Couple Lois & Hal ☻
★ **Double Battle**
◎◎◎◎◎◎

1 Explore Sea Mauville's surface

Orlando found
TM18 Rain Dance!

Surf up to the facility and scale the sloped walkway that sticks up from the water to reach Sea Mauville's exposed exterior. If you let the guide tell you about Sea Mauville, pay the nominal fee to help support the preservation of this historic preserve, and then battle a few Trainers as you explore the exterior of this decrepit place, you can collect an Escape Rope and TM18 Rain Dance.

2 Search Sea Mauville's interior

The ocean seems very deep here.
Maybe a Pokémon could dive underwater?

Enter Sea Mauville's interior to meet more Trainers, including a Double Battle challenge from a Young Couple. You can't fully explore the facility's interior at present, because the Dive field move is required to search its underwater areas. Grab a Max Repel near the water's edge, though, and feel free to start poking around to try to figure out the mystery of what happened at Sea Mauville to cause it to close. Then backtrack out to Route 108. Surf east to Route 109.

◄◄ **BACKTRACK** ▶ **ROUTE 109** p. 71

Orlando found a Big Pearl!

Surf the sea to score more items

Surf east along Route 108, and you'll soon enter Route 109. You've combed this area's big beach before, but now you can search its sea to battle new Trainers and discover some valuable items. A Big Pearl has washed up on a small island to the east, and your Dowsing Machine reveals a hidden Heart Scale on the island to the west, which features a Young Couple burning for a Double Battle.

◄◄ **BACKTRACK** ▶ **SLATEPORT CITY** p. 73

Buy
No thanks!

I've got a great array of Decorations for your Secret Base! Step right up and have a look!

Do some shopping and try a contest

When you've finished exploring Route 109, head north to Slateport City. Now that you've got TM94 Secret Power, two new market vendors will sell you Decorations for your Secret Base. Visit the market and speak with the south vendors to browse an assortment of Decorative mats, dolls, and more. Rest at the Pokémon Center, and consider visiting the Contest Hall before heading north to Route 110. If you stop by the shipyard, you'll also learn that good old Mr. Briney has agreed to help Dock and his fellows with building their ferry. Hopefully you'll be able to take it before too long!

◄◄ **BACKTRACK** ▶ **MAUVILLE CITY** p. 89

Orlando obtained the
Acro Bike!

Grab the Acro Bike on your way to Route 118

Either speed along Route 110's Cycling Road to quickly reach Mauville City, or take the pedestrian route if you still have unfinished puzzles awaiting you at the Trick House. If you didn't earlier, Surf across Route 110's large bodies of water to pick up an Elixir and a Rare Candy and catch some new Pokémon on the water. Rest up and restock your items when you reach Mauville—it's a long trek to the next town. Swing by Rydel's Cycles to swap your Mach Bike for the Acro Bike as well, and then head east to Route 118.

ROUTE 118

Field Moves Needed
Surf
Cut

This seaside route brings together the east and west sides of the Hoenn region.

There's nothing optional about this route—you must take it in order to advance toward Fortree City, where the next Gym Leader waits. Several new species of Pokémon can be found along Route 118, including Electric types that will be of great value in the upcoming Gym.

TRAINER HANDBOOK

ADVANCED HANDBOOK

ADVENTURE DATA

Aroma Lady Rose

To Route 119 (p. 157)

Berry Trees

To Mauville City (p. 89)

To Route 123 (p. 186)

Fisherman Wade

Fisherman Barny

Bird Keeper Perry

Delinquent Miley

Guitarist Dalton

Bird Keeper Chester

Kecleon *Normal*
Ability: Color Change

Electrike *Electric*
Abilities: Static, Lightning Rod

On the Water

❏ Pelipper	▲
❏ Tentacool	◎
❏ Wingull	○

Tall Grass

❏ Electrike	◎
❏ Kecleon	▲
❏ Linoone	◎
❏ Wingull	△

Fishing

Old Rod	
❏ Magikarp	◎
❏ Tentacool	○
Good Rod	
❏ Carvanha	▲
❏ Magikarp	◎
❏ Tentacool	○
Super Rod	
❏ Carvanha	◎
❏ Sharpedo	▲

Very Tall Grass

❏ Electrike	◎
❏ Kecleon	▲
❏ Linoone	◎
❏ Pelipper	△

Horde Encounters

❏ Electrike (×5)	◎
❏ Kecleon (×5)	▲
❏ Wingull (×5)	○

◎ frequent ○ average △ rare ▲ almost never

Items

❏ Hyper Potion
❏ Stardust

Hidden Items

❏ Heart Scale
❏ Iron

1 Search the west beach

Orlando found a Stardust!

You may have searched Route 118's western shore before, but you can explore a lot more of this route now that you've got Surf. Battle the Trainers around the western bank and collect a Stardust and Heart Scale if you haven't already.

2 Surf across the central bay

When you're ready to advance, approach the beach and press Ⓐ to use Surf. Let your Pokémon take you across to the route's eastern bank. Feel free to do a little fishing or battle some wild Pokémon along the way.

3 Get good with a Good Rod

The Fisherman on the eastern bank believes that Good Rods are really good. Agree with his statement, and he'll give you a Good Rod. Good! Now you can catch even more types of Pokémon while fishing! Then explore the rest of the beach to pick up a hidden Iron.

> **TIP**
>
> Open your Key Items and Register your Good Rod so that you'll always have it at the ready. You might want to unregister your Old Rod while you're at it, because the Good Rod lets you catch most of the Old Rod's Pokémon, too.

4 Battle Interviewers Gabby & Ty

This just in: Daring news team Gabby & Ty are out seeking scoops along Route 118's east shore. If you don't see them there, they're probably still back on Route 111. They only move to a new location after they've battled and interviewed a great Trainer—like you! Chat with Gabby & Ty to start up a Double Battle if you like. Just be sure to give them a great interview when the dust settles!

Gabby and Ty's Pokémon

Loudred ♂ Lv. 29 — Normal
Weak to: Fighting

Magneton Lv. 29 — Electric Steel
Weak to: 4× Ground Fire Fighting

5 Meet up with Steven

Go east along Route 118's east beach, and you'll soon run into Steven. You haven't seen him since your first meeting back in the Granite Cave, and he's pleased to see how much you've grown as a Trainer. He wonders if you'll concentrate on raising just a few types of Pokémon, or if you'll try to raise many different types. Of course, the choice is yours!

As Steven is about to leave, you hear the sudden shriek of a Pokémon. Looking up at the horizon, you see Latias *(Pokémon Omega Ruby)* / Latios *(Pokémon Alpha Sapphire)* soaring your way. There seems to be trouble brewing, and Steven asks you to come along to help. Allow Latias/Latios to Fly you to the source of the trouble.

SOUTHERN ISLAND

Field Moves Needed

Soar

This small island is surrounded by a mysterious veil that makes approach impossible for mere humans.

A Pokémon known as Latias *(Pokémon Omega Ruby)* or Latios *(Pokémon Alpha Sapphire)* flies you to this small, remote island, which sits in Hoenn's south sea. You aren't sure why you've been brought to this wondrous place, but it's definitely worth a thorough search!

1 | Arrive at the island with Steven

Arriving at Southern Island, Steven can't help but sense that something's in the air. He recounts an odd fable in which two Pokémon living on this island were rumored to guard a secret about Mega Evolution. Perhaps you should have a look around.

TIP

Speak with Steven again to leave Southern Island at any time. You can zip back to the mainland if you need to heal your Pokémon or do anything else, and then return to Southern Island by talking to Steven again along the shore of Route 118.

2 Encounter another Pokémon

> Latios...
> It's beautiful...

> Latias...
> It's beautiful...

A strange voice calls out as you approach the island's northern bush. Press onward to find another Pokémon in hiding. It's Latios/Latias! It seems the rumors Steven has heard of two Pokémon living here were right at least.

TIP

The Eon Pokémon Latias and Latios are a pair of Legendary Pokémon known to inhabit the Hoenn region. In *Pokémon Omega Ruby*, you're approached by Latias along Route 118 and flown to the Southern Island to help protect Latios. In *Pokémon Alpha Sapphire*, it is Latios that seeks your help in protecting Latias.

3 Battle Team Magma / Team Aqua

> I won't!
> Sure. Why not?

> I'm not moving!
> Go right ahead.

> Will you get away from me...
> or not?

> If you get out of our way,
> we won't rough you up.

The reason for the excitement around Southern Island soon becomes clear. It's Team Magma / Team Aqua! They're here to catch rare Pokémon and steal Mega Stones, and they can't be allowed to succeed. Join forces with Steven and take on Team Magma / Team Aqua in a Multi Battle!

Team Magma Admin Courtney's Pokémon

○○○○○○

Team Magma Admin Courtney sends out a powerful Fire- and Ground-type Pokémon, Camerupt. Exploit its great weakness to Water-type moves to wash it away!

Camerupt — Fire | Ground
♀ Lv. 31
Weak to: 4× Water | Ground

Team Magma Grunt's Pokémon

○○○○○○

You've battled against Koffing before, so you already know that it likes to poison your Pokémon, and it doesn't have many weaknesses. As before, Ground-type moves won't affect Koffing due to its Levitate Ability, so hit it with a Psychic-type move to win the battle quickly.

Koffing — Poison
♂ Lv. 29
Weak to: Psychic

Team Aqua Admin Matt's Pokémon

○○○○○○

The Sharpedo that Matt sends out has lots of weaknesses, making it easy prey. Focus on taking it out quickly so you can help Steven pile on Grimer.

Sharpedo — Water | Dark
♂ Lv. 31
Weak to: Grass | Electric | Fighting | Bug | Fairy

Team Aqua Grunt's Pokémon

The Team Aqua Grunt uses Grimer, a Poison-type Pokémon that's similar to Koffing. It doesn't have many weaknesses and doesn't share any weaknesses with Sharpedo, so it may help to focus on defeating Sharpedo first.

Grimer ♀ Lv. 29 — Poison

Weak to: Ground | Psychic

4 A new Pokémon joins your team

> I believe it is trying to show that it wants to go with you on your journey.

> I believe it is trying to show that it wants to go with you on your journey.

Shocked by their loss, Team Magma / Team Aqua has no choice but to flee the island. You've done it! Latios/Latias has been saved, and the grateful Pokémon repays you by joining you in your travels. What a wonderful new companion!

Latios Joins Your Team! Ω

Latios ♂ Lv. 30 — Dragon Psychic

Weak to: Ice | Bug | Ghost | Dragon | Dark | Fairy

Category: Eon Pokémon
Ability: Levitate
Signature Move: Luster Purge
The user lets loose a damaging burst of light. This may also lower the target's Sp. Def stat.

Latios has a higher Attack stat than Latias, but it is docile by nature. It can fly faster than a jet plane when it tucks its legs against its body to streamline its form, and it dislikes fighting and prefers to avoid it. Like Latias, it can also understand human speech and use its telepathic powers to sense emotions.

Latias Joins Your Team! α

Latias ♀ Lv. 30 — Dragon Psychic

Weak to: Ice | Bug | Ghost | Dragon | Dark | Fairy

Category: Eon Pokémon
Ability: Levitate
Signature Move: Mist Ball
A mist-like flurry of down envelops and damages the target. This may also lower the target's Sp. Atk stat.

Latias is said to be highly intelligent and empathic. It can understand human speech and can even communicate with humans using telepathic powers. The glassy down that covers its body is said to reflect light in a way that can make it nearly invisible in flight, which only increases the mystery surrounding this rare Pokémon.

TRAINER HANDBOOK

ADVANCED HANDBOOK

ADVENTURE DATA

5 | Receive the Mega Bracelet from Steven

Orlando obtained the
Mega Bracelet!

Latios/Latias has the potential to Mega Evolve, and it carries a Mega Stone called Latiosite/Latiasite. With the power of the Mega Bracelet that Steven hands you, Pokémon like Latios/Latias can Mega Evolve during battle. You'll definitely want to check out the awesome power of Mega Evolution!

TIP

Don't worry if your party's full. You'll be prompted to send a Pokémon from your party back to a PC Box to make room for Latios/Latias if need be.

TIP

Latios/Latias is not the only Pokémon in the Hoenn region that can Mega Evolve. If you've been following this guide carefully, you'll have already found Steelixite, Alakazite, Manectite, Mawilite, Pidgeotite, and Aggronite. These can be used to Mega Evolve Steelix, Alakazam, Manectric, Mawile, Pidgeot, and Aggron respectively.

Mega Evolution

If you've played *Pokémon X* or *Pokémon Y*, then you're already familiar with the powerful new kind of Evolution introduced in those games: Mega Evolution. It's important to understand how Mega Evolution differs from the more typical Evolutions from past games.

Unlocking Mega Evolution

A few things must occur before a Pokémon can Mega Evolve. First, you need a Key Stone. This item can be embedded in accessories like necklaces and bracelets worn by Trainers. The Mega Bracelet that Steven just gave you features a Key Stone, so you're all set.

A Mega Stone is also needed for each Pokémon that wishes to take advantage of Mega Evolution. Mega Stones are a type of held item that allow a Pokémon capable of Mega Evolution to Mega Evolve. Note that each Pokémon has its own unique Mega Stone—Venusaur needs to hold Venusaurite in order to Mega Evolve, for example. So make sure it's holding the right one!

Latios is carrying a piece of Latiosite!

Surf	Dragon Breath
WATER PP 15/15	PP 20/20 DRAGON
Dive	Waterfall
WATER PP 10/10	PP 15/15 WATER

MEGA EVOLUTION

Unleashing Mega Evolution

Once you have everything you need, you'll be ready to unleash Mega Evolution. Unlike other Evolutions, Mega Evolution is triggered during battle and is temporary. Choose the "Fight" option, and then tap the "Mega Evolution" button on the bottom of the Touch Screen before selecting a move. Your Pokémon will then Mega Evolve before unleashing its move, all in the same turn!

TRAINER HANDBOOK

ADVANCED HANDBOOK

ADVENTURE DATA

Mega Evolution (cont.)

Effects of Mega Evolution

Mega-Evolved Pokémon have an awesome appearance, but the effects of Mega Evolution are much more than skin deep. Mega Evolution can change a Pokémon's stats (with the exception of HP), Abilities (Gengar's Levitate becomes Shadow Tag when it becomes Mega Gengar, for example) or even its type (Charizard is Fire and Flying type, but Mega Charizard X is Fire and Dragon type, for example). These changes occur the moment you trigger Mega Evolution, making your Pokémon far more formidable for the duration of the battle.

Mega Evolution is temporary

Another unique trait of Mega Evolution is that it cannot be sustained outside of battle. When the battle is over, Mega Evolution ends, reverting your Pokémon to its previous Evolutionary state. Mega Evolution also ends if your Mega-Evolved Pokémon faints during battle. Each Trainer in a battle may only Mega Evolve one Pokémon one time per battle, even if you have more than one Pokémon capable of Mega Evolution. This is true even if your Mega-Evolved Pokémon faints and is revived. Be sure you're ready to take full advantage of Mega Evolution before you trigger it!

◄ BACKTRACK ▌ ROUTE 118 p. 150

Orlando found a Hyper Potion!

Finish exploring Route 118

With Team Magma / Team Aqua defeated and Latios/Latias saved, you and Steven catch a ride back to Route 118. Complete your explorations of this route by searching the very tall grass for items and hidden Trainers on your way north to Route 119. Along the way, you'll also find some Berry Trees to harvest.

Optional ▌ Route 123 p. 186

Berry Master's House

Take a peek at Route 123

If you like, before heading north to Route 119, you can head east through Route 118's very tall grass and pick up the trail to Route 123. Here you'll find more items, Trainers, and the Berry Master's House—an ideal place to visit when you're after rare Berries for Pokéblocks. There are literally dozens of Berries free for the picking in the fields near his house. Many are varieties you haven't yet encountered in the wild. Flip ahead to page 186 if you're interested in exploring some of Route 123 right now, or simply read on to learn what Route 119 has in store.

ROUTE 119

Field Moves Needed
Surf · Waterfall

> If you are not prepared for it, the harsh conditions of this tropical rain forest will defeat you in less than five minutes.

Famous for its sweltering heat and sudden rainfalls, this spacious route is filled with very tall grass, which Trainers and wild Pokémon just love to frolic in. The extreme weather conditions make this an ideal setting for the Weather Institute, which can only be reached by braving Route 119's thick brush.

Items

After learning Surf
- ❏ Elixir
- ❏ HM02 Fly
- ❏ Leaf Stone
- ❏ Max Repel
- ❏ PP Max
- ❏ Zinc

After learning Waterfall
- ❏ Rare Candy
- ❏ TM62 Acrobatics

Hidden Items
- ❏ Calcium
- ❏ Full Heal
- ❏ Max Ether
- ❏ Ultra Ball

On the Water

❏ Pelipper	▲
❏ Tentacool	◎
❏ Wingull	○

Fishing

Old Rod
❏ Feebas	▲
❏ Magikarp	◎
❏ Tentacool	○

Good Rod
❏ Carvanha	○
❏ Feebas	▲
❏ Magikarp	◎

Super Rod
❏ Carvanha	◎
❏ Sharpedo	○
❏ Feebas	▲

Tall Grass

❏ Gloom	◎
❏ Kecleon	▲
❏ Linoone	◎
❏ Tropius	△

Horde Encounters
- ❏ Oddish (×5) ◎

◎ frequent ○ average △ rare ▲ almost never

Map labels
- Berry Trees
- To Fortree City (p. 163)
- Ninja Boy Yasu
- Berry Trees
- The Weather Institute
- Rest your Pokémon here
- Bird Keeper Hugh
- Bird Keeper Phil
- Ninja Boy Takashi
- Pokémon Ranger Jackson
- Brains & Brawn Jael & Kael ★ Double Battle
- Berry Trees
- Fisherman Eugene
- Rest your Pokémon here
- Pokémon Ranger Catherine
- Bug Maniac Taylor
- Bug Maniac Brent
- Bug Catcher Kent
- Bug Catcher Greg
- Bug Maniac Donald
- Bug Catcher Doug

To Route 118 (p. 150)

1 Romp through the very tall grass

Route 119's very tall grass holds many secrets, so it's worth exploring thoroughly on foot. Hoof it around and give the first patch of very tall grass a good search to find a visible Max Repel, a hidden Full Heal, and plenty of Trainers to battle.

2 Outmaneuver the Mimic Circle

Did you notice that a handful of Route 119's Trainers mimic your movements? That's why they're called the Mimic Circle! They move when you move, so outmaneuver them to pin them down and start battling. The tables to the right sum up how the Mimic Circle Trainers move. It is also worth noting that they stay within a certain area in the route, which they won't budge beyond. This might help you corner them!

Kent and Doug	
You move	They move
Right	Up
Left	Down
Up	Right
Down	Left

Greg	
You move	They move
Right	Left
Left	Right
Up	Down
Down	Up

3 Restore your Pokémon at the cabin

A small cabin stands in the clearing beyond the very tall grass. Speak with the kind woman inside, and she'll let you rest up and restore your Pokémon. You could probably use a break by now!

4 Surf to a Secret Spot

Before scaling the steps near the cabin, go west and use Surf to reach a fishing spot across the water. Battle a Fisherman here if you like, and then go upstairs to find a unique Secret Spot. Check the nearby very tall grass to discover a visible Zinc that's obscured by the grass as well.

5 Cross the narrow bridge with the Acro Bike

Surf back over to the cabin and scale the north stairs. If you swapped your Mach Bike for the Acro Bike back in Mauville City, put it to use by riding the Acro Bike across the narrow bridge that spans the western water. Press Ⓑ and the Circle Pad or +Control Pad at the same time to hop across the broken sections you encounter halfway across. Keep going to reach a small area with two Secret Spots and a hidden Calcium.

6 | Continue searching the route

We're Brains & Brawn. Get ready, 'cause here we come!

Backtrack across the narrow bridge and grab some Berries, planting more in their place. Then go up the north stairs to reach the larger wooden bridge above. Take on a pair of Trainers in a Double Battle. Then cross the long bridge to continue your explorations up north, battling more Trainers and discovering more items, including a PP Max and an Elixir.

TIP

Try your hand against the Bird Keepers on this route. They might just give you a taste of the high-flying foes you'll be up against in the next city's Flying-type Gym. See if your team is ready for the challenge!

7 | Check out the Weather Institute

Hey, you! Please don't go near the Weather Institute!

Hey, you! Please don't go near the Weather Institute!

Venture onward until you reach a large, impressive building. It's the Weather Institute! Team Magma / Team Aqua is standing right nearby, so that's motivation enough to take a look. They must be up to something here! Head inside and see if everything's all right.

WEATHER INSTITUTE

Welcome to the Weather Institute, where we observe the weather in the Hoenn region with Pokémon.

Located along Route 119, the Weather Institute is a high-tech facility used to study and research the intricacies of weather patterns all over Hoenn. Team Magma / Team Aqua is clearly up to something here, so you'd better investigate!

Team Magma Admin Tabitha / Team Aqua Admin Shelly

Team Magma Grunt / Team Aqua Grunt

Team Magma Grunt / Team Aqua Grunt

Rest your Pokémon here

Team Magma Grunt / Team Aqua Grunt

To Route 119 (p. 157)

Team Magma Grunt / Team Aqua Grunt

Vending Machine	
Fresh Water	200
Lemonade	350
Soda Pop	300

Items
☐ Damp Rock
☐ Heat Rock
☐ Icy Rock
☐ Rocky Helmet
☐ Smooth Rock

1 Catch some rest and restore your Pokémon

The Weather Institute's receptionist hints that something's amiss upstairs, but she doesn't seem overly rattled. Visit the back room to find some Team Magma / Team Aqua Grunts searching the place. Before battling them, head into the northwest room to locate a PC and some comfy beds. Rest and restore your Pokémon here before continuing your investigation.

 TIP

The Vending Machine in the Weather Institute's lobby offers a selection of affordable HP-restoring items. And if you're lucky when making a purchase, you may get an extra bottle for free!

2 Beat back Team Magma / Team Aqua

Each Team Magma / Team Aqua Grunt you encounter challenges you to battle as you explore the Weather Institute. The Grunts aren't much tougher than the Trainers you've faced on your way here, so defeat each one for some extra Exp. Points and prize money.

3 Battle Tabitha/Shelly on the second floor

Upstairs, you'll discover the source of the disturbance. Team Magma Admin Tabitha / Team Aqua Admin Shelly is harassing the researchers on the second floor! He/she has come off the clock to have some questions answered. Tabitha/Shelly has learned something about what his/her leader's plans will bring about in the Hoenn region, and seems pretty shaken up by the results. Seeking a reprieve from his/her new doubts, he/she drags you into battle!

Team Magma Admin Tabitha's Pokémon

Tabitha's Camerupt has a strong weakness to Water-type moves, making it a prime target for your Pokémon that knows Surf, or your newfound Latios. Ground moves such as Bulldoze will also shake things up nicely.

Camerupt	Fire	Ground
♂ Lv. 32		
Weak to:	4× Water	Ground

Team Aqua Admin Shelly's Pokémon

Shelly sends out Sharpedo, which you've faced in previous battles. Sharpedo is dangerous but has many weaknesses, so exploit them and take down Sharpedo as fast as you can.

Sharpedo
♀ Lv. 32
Water | Dark

Weak to: Grass | Electric | Fighting | Bug | Fairy

4 Receive Castform after Tabitha/Shelly flees

It might seem an odd way of rewarding you, but please take this Pokémon as my thanks.

Your decisive actions have saved the Weather Institute's researchers, and one of them rewards you with a valuable new Pokémon, Castform. The scientists then reveal how Hoenn's ancient Legendary Pokémon caused a dramatic change in the weather thousands of years ago, due to a terrible transformation known as Primal Reversion. Sounds like scary stuff!

> **TIP**
>
> Use the PC downstairs to make room for Castform if need be. And don't forget to rest up on those nice soft beds!

After the Confrontation

The Leader should be headed for Mt. Pyre... Which means I...

Archie is probably on the way to Mt. Pyre... So I...

Your heroics send Tabitha/Shelly sprinting off, and it seems clear that the Weather Institute's research does not bode well for Team Magma / Team Aqua's plans. Before running away, he/she hints that Team Magma / Team Aqua is still intent on reaching Mt. Pyre, so that remains your next destination.

The researchers' data also indicated that the transformation thousands of years ago of two of Hoenn's ancient Legendary Pokémon generated cataclysmic weather events around the Hoenn region. Through Primal Reversion, these two Pokémon are able to regain terrible, primal powers that they do not normally have access to. Could Team Magma / Team Aqua be trying to harness the power of Primal Reversion to achieve their own destructive goals? The return of such extreme weather is truly a terrifying thought!

5 Nab some rockin' objects in the lobby

Orlando obtained a Rocky Helmet!

Head down to the Weather Institute's lobby and speak with the researcher near the Vending Machine to receive a Rocky Helmet, which a Pokémon can hold and use to damage attacking Pokémon upon contact. Speak to the receptionist as well to receive a random "rock" item souvenir. You will get one of the following items: a Damp Rock, a Heat Rock, an Icy Rock, or a Smooth Rock.

> **TIP**
>
> You can get all four of the items the receptionist has to offer by visiting the Weather Institute again on subsequent days. She'll give you one rock a day. Keep stopping by until you've received all four.
>
>

When held by Pokémon such as your newfound Castform, these items can increase the effectiveness of weather-based moves like Hail.

Hoenn is a diverse region with many different weather patterns. You'll encounter all sorts of weather during your journey, including rain, hail, sandstorms, and sunny weather. Not only can weather conditions change the appearance of areas you explore, but they can also influence the outcome of a battle.

Areas that feature lots of changing weather include Routes 119, 120, and 123. Route 119's weather follows a pattern: sun, rain, thunder, rain. Along Route 120, the weather changes to rain based on your location (it's always raining around the middle of the route). Meanwhile, the weather on Route 123 follows a pattern of being sunny most days but being rainy every fourth day.

Controlling the weather

Although the weather conditions in the current area will play a role in battle, there are also lots of ways that you can change the weather in battle. Doing so can have great advantages. Moves and Abilities that generate weather effects, such as Rain Dance and Sunny Day, persist for five turns or until overridden by a new weather condition. There are items that can extend the duration of a weather condition to eight turns—like those lovely souvenirs you can get from the Weather Institute's receptionist each day.

Reaping benefits from the weather

Some Abilities can give you great benefits from the weather. For example, Chlorophyll gives a Pokémon's Speed stat a boost in sunny weather, while Ice Body will cause a Pokémon to recover HP during hail. Dry Skin will make a Pokémon lose HP in sunshine, but regain HP in rain. In addition to such special Abilities, weather conditions also affect all battles in the following ways.

Major Effects of Weather in Battle	
Fog	Lowers the accuracy of all Pokémon
Hail	Damages all Pokémon that are not Ice type
Rain	Increases the power of Water-type moves by 50% and decreases the power of Fire-type moves by 50%
Sandstorm	Raises the Sp. Defense of Rock-type Pokémon by 50% and damages all Pokémon that are not Rock, Steel, or Ground type
Intense sunlight	Increases the power of Fire-type moves by 50% and decreases the power of Water-type moves by 50%

Castform's advantages

One of the Weather Institute's generous researchers has given you a Pokémon called Castform. Scientists use this amazing Pokémon and its Forecast Ability to aid them in their research. Forecast enables Castform to change its form and type based on the weather.

In calm weather, Castform is Normal type. However, in sunny weather it becomes Fire type; in rain it becomes Water type; and in hail it becomes Ice type.

Castform also has a move called Weather Ball that is affected by weather conditions, with even more variations than Castform itself. Like Castform, the move Weather Ball is Normal type under normal conditions, but becomes Water type in rain, Fire type in sunny weather, Ice type in hail, and Rock type in a sandstorm. The power of Weather Ball is doubled under any weather condition besides clear skies, and it can also get a same-type attack bonus in the appropriate situations (p. 433).

New weather conditions

Pokémon Omega Ruby and *Pokémon Alpha Sapphire* feature two new weather conditions: extremely harsh sunlight and heavy rain. Unlike other weather conditions, these two persist until the battle is over or until Groudon/Kyogre leave the battle, and they can't be overridden by any other type of weather except for each other (extremely harsh sunlight overrides heavy rain and vice versa). More information can be found on page 231, but read ahead only if you don't mind having some pretty big events spoiled.

In past games, Sweet Scent and Honey could only be used in clear weather, but they are now usable at all times regardless of the weather condition.

Are your Pokémon all ready?
Of course they are! Let's go!

Battle your friend en route to Fortree City and get Fly

Rest and restore your Pokémon at the Weather Institute before heading back out into Route 119. Cross the bridge that the Team Magma / Team Aqua Grunts had been guarding, and then Surf the south river to find two more Secret Spots, a Leaf Stone, and two hidden items: a Max Ether and an Ultra Ball. Then Surf north to find another Secret Spot west of the waterfall and a hidden Max Ether east of it. When you land back where you entered the water, go north up the stairs. May/Brendan will catch up with you and challenge you to battle. Defeat your friend and she/he will give you HM02 Fly. It is a pretty nice move for battle, but it will be much more impressive after you get the Gym Badge from the next city. Hurry on up the route to reach it!

May/Brendan's Pokémon

If you chose Treecko

⊙ **Combusken** Fire Fighting
♀/♂ Lv. 33
Weak to: Water Ground Flying Psychic

⊙ **Shroomish** Grass
♀/♂ Lv. 31
Weak to: Fire Ice Poison Flying Bug

⊙ **Wailmer** Water
♀/♂ Lv. 31
Weak to: Grass Electric

If you chose Torchic

⊙ **Marshtomp** Water Ground
♀/♂ Lv. 33
Weak to: 4x Grass

⊙ **Shroomish** Grass
♀/♂ Lv. 31
Weak to: Fire Ice Poison Flying Bug

⊙ **Slugma** Fire
♀/♂ Lv. 31
Weak to: Water Ground Rock

If you chose Mudkip

⊙ **Grovyle** Grass
♀/♂ Lv. 33
Weak to: Fire Ice Poison Flying Bug

⊙ **Wailmer** Water
♀/♂ Lv. 31
Weak to: Grass Electric

⊙ **Slugma** Fire
♀/♂ Lv. 31
Weak to: Water Ground Rock

FORTREE CITY

The people and the Pokémon of this city follow nature's cues to rise each morning and end each day.

You've visited some pretty green places before, but Fortree City takes the prize. This city's awesome arbors are so big that the townsfolk have managed to build atop them, crafting cozy homes among their boughs. All that climbing up and down these trees must really keep the locals in shape!

Pokémon Center

Secret Base Guild

To Route 119 (p. 157)

To Route 120 (p. 166)

Fortree City Gym (p. 170)

Poké Mart

TRAINER HANDBOOK

Poké Mart

Normal wares	
Antidote	100
Awakening	250
Burn Heal	250
Escape Rope	550
Full Heal	600
Great Ball	600
Ice Heal	250
Hyper Potion	1,200
Max Potion	2,500
Max Repel	700
Paralyze Heal	200
Poké Ball	200
Potion	300
Repel	350
Revive	1,500
Super Potion	700
Super Repel	500
Ultra Ball	1,200
After obtaining the Feather Badge	
Full Restore	3,000

Secret Base Guild

Lower clerk		Upper clerk	
Heavy Chair	1,000	Boppoyama	4,000
Heavy Desk	3,000	Comfortable Bed	6,000
Poké Ball Chair	1,000	Fence	500
Poké Ball Desk	2,000	Glitter Mat	2,000
Small Chair	1,000	Gym Statue	3000
Small Desk	2,000	Jump Mat	2,000
After reaching Bronze Rank		Makiwara	1,000
Rough Chair	1,000	Red Spin Panel	2,000
Rough Desk	3,000	Tall Grass	1,000
Soft Chair	1,000	**After reaching Bronze Rank**	
Soft Desk	3,000	Blue Spin Panel	2,500
After reaching Silver Rank		Pitfall Mat	2,000
Brick Chair	1,000	Spin Mat	2,000
Brick Desk	4,000	Toy PC	5,000
Hard Chair	1,000	**After reaching Silver Rank**	
Hard Desk	4,000	Red Warp Panel	2,500
Log Chair	1,000	Square-One Mat	2,000
Log Desk	4,000	Vending Machine	6,000
Yellow Spin Panel	3,000	**After reaching Gold Rank**	
After reaching Gold Rank		Blue Warp Panel	2,500
Icy Desk	5,000	Invisible Doll	4,000
		Yellow Warp Panel	2,500

Items

- ❏ Proclamation
- ❏ Stairs

After obtaining the Devon Scope

- ❏ TM86 Grass Knot

Hidden Items

- ❏ Super Repel
- ❏ Tiny Mushroom

1 Rest up and restock your items

Money	
₽ 123,366	

In Bag:	12
Poké Ball	₽ 200
Great Ball	₽ 600
Ultra Ball	₽ 1,200
Potion	₽ 300
Super Potion	₽ 700
Hyper Potion	₽ 1,200
Max Potion	₽ 2,500
Full Restore	₽ 3,000

An ultra-high-performance Poké Ball that provides a higher success rate for catching Pokémon than a Great Ball.

It's been a while since you've had a chance to do some real shopping. Take advantage of Fortree City's Pokémon Center and Poké Mart, resting your party and purchasing items for the adventures to come. And pick up that hidden Super Repel right outside the Poké Mart to save yourself 500!

2 Visit the Secret Base Guild

After leaving the Poké Mart, climb the nearby tree's ladder to explore Fortree City's south row of tree houses. A friendly girl inside the first house gives you Stairs to decorate your Secret Base. Cross the rope bridge to reach the next tree house to the east, which features a flag on top. It's the Secret Base Guild! Head inside to catch up with your pal Aarune. He'll give you a Proclamation to use in your base and tell you all about secret teams. You can use the Proclamation to set rules about the types of battles that go down in your Secret Base.

TIP

Ultra Balls are a worthwhile purchase at this point. They're more advanced than Great Balls, and they have a better chance to catch the higher-level Pokémon you'll be encountering in the wild from this point forward.

ADVANCED HANDBOOK

ADVENTURE DATA

Secret Base Guild

Aarune can always be found here in the Secret Base Guild, waiting to tell you how your team is doing and to check if you're ready to move up in rank in the Secret Base Guild. You can challenge Aarune to a Single Battle once per day.

Aarune's Pokémon ⦿○○○○○

🔴 **Flygon**　　　Ground　Dragon
♂ Lv. 23
Weak to: 4× Ice　Dragon　Fairy

TIP

The Pokémon Ranger in the back of the guild wants to know what kind of Trainer you think you look like. The Trainer type you choose will affect how your stand-in appears when other people visit your Secret Base, as well as your icon and profile on the PSS.

Buy
No thanks!

Must-have items for your Secret Base! We've got your desks and chairs right here!

The Secret Base Guild also features two shops that sell decorative items to help you deck out your Secret Base. The lower clerk sells chairs and desks, while the upper clerk sells tricks and other fun Decorations for your base. Each shop's inventory will grow as your rank in the guild goes up. See page 392 for the full list of all the Decorations you can buy!

Your secret team's rank

Orlando obtained a Proclamation for his base!

If you haven't yet formed a team, Aarune will recommend you do so by inviting some Secret Pals to your Secret Base. Turn back to page 114 for a review of how to recruit Secret Pals.

Once you've formed a secret team, it will be ranked in the Secret Base Guild. Your secret team's rank is based on how many flags you've collected from other players' bases.

Bronze Rank	30 flags
Silver Rank	100 flags
Gold Rank	500 flags
Platinum Rank	1,000 flags

Obtaining higher and higher ranks will enable you to buy more Decorations at the Secret Base Guild and even earn you rewards from Aarune.

Bronze Rank reward	Blackboard
Silver Rank reward	Jukebox
Gold Rank reward	Mood Lighting
Platinum Rank reward	Confetti Ball and Garchompite

Your team's flag also changes color as your rank increases, letting everyone who visits your base see how great your team is. Perhaps most important of all, though, higher ranks unlock more special skills for your Secret Pals. If you reach Platinum Rank, your Secret Pals will be able to use two skills per day! These special skills have some incredibly useful effects. Turn to page 390 for further details.

TIP

When you reach Gold Rank, Aarune will be so pumped that he'll insist on taking a commemorative photo of you and your team. This photo will be saved on your SD Card, and can always be retaken by talking to Aarune again. Remember to smile!

3 Catch sight of Steven

It looks as though that Pokémon can be found up on Route 120...

Descend the ladder near the Secret Base Guild, and go west and then north to explore more of Fortree City. You'll soon catch sight of Steven, the knowledgeable Trainer who gave you the Mega Bracelet and told you about Mega Evolution. Before you can catch Steven, he dashes off to Route 120, which is nearby. He is apparently seeking a specific Pokémon. Climb the nearby ladder afterward and begin visiting Fortree City's northern row of tree houses.

TIP

Speak to the Breeder in the first tree house (the northeast tree house), and he'll send his Wingull off to run an errand. Perhaps you should return later to see if it's successful!

4 Get blocked by an invisible object

There's an invisible obstacle in your way.

Fortree City's Pokémon Gym lies in the heart of town. Descend the central ladder to head toward it, but look out: you're suddenly blocked by an invisible object! There's no telling what the object might be, but it's definitely keeping you from reaching the Gym. And you were so close to grabbing your next Badge!

5 Obtain TM10 Hidden Power

Orlando obtained
TM10 Hidden Power!

A pair of old ladies lives in one of the northern tree houses. Speak to the one on the left, and she'll give you a simple quiz. The old lady is holding a coin in her hand—can you guess which hand it's in? Guess correctly three times in a row, and she'll give you TM10 Hidden Power! You can keep taking her challenge until you guess right, and she always goes in the same order, so a few rounds of trial and error should do it. But if you're having trouble, the correct answers are: right, right, left.

TIP

Hidden Power is listed as a Normal-type move, but its type actually varies depending on the Pokémon that learns it. Speak to the other old lady in the tree house, and she'll tell you what type of Hidden Power your party Pokémon have.

6 Swap your Spinda for a Skitty

I want a Spinda.
Do you have one?

Did you manage to catch a Spinda or two along Route 113? If so, visit the last tree house in the row (the northwest tree house) and trade your Spinda to the little girl who lives there. She'll give you Skitty (nicknamed Skitit) in return. You can't reach the Pokémon Gym yet, so you might as well go and see if you can catch up to Steven on Route 120. Maybe he'll let you in on another adventure.

ROUTE 120

Field Moves Needed

Cut Surf

Pokémon that can camouflage themselves hide in the rich wilds along this route.

Big and bursting with all sorts of Trainers, Route 120 runs east of Fortree City and leads to Route 121. You can't fully explore this route until you've obtained the Feather Badge, but you must partially explore it before you can challenge the Leader of Fortree City's Gym.

On the Water	
☐ Azumarill	◎
☐ Masquerain	▲
☐ Surskit	○

◎ frequent ○ average
△ rare ▲ almost never

Fishing (Lower areas)	
Old Rod	
☐ Goldeen	○
☐ Magikarp	◎
Good Rod	
☐ Barboach	▲
☐ Goldeen	○
☐ Magikarp	◎
Super Rod	
☐ Barboach	◎

Fishing (Upper areas)	
Old Rod	
☐ Magikarp	◎
☐ Tentacool	○
Good Rod	
☐ Barboach	▲
☐ Magikarp	◎
☐ Tentacool	○
Super Rod	
☐ Barboach	◎

Very Tall Grass	
☐ Absol	▲
☐ Gloom	◎
☐ Kecleon	▲
☐ Linoone	◎
☐ Tropius	△

Horde Encounters	
☐ Kecleon (×5)	▲
☐ Marill (×5)	○
☐ Oddish (×5)	◎

Gloom Grass Poison
Ability: Chlorophyll

Parasol Lady
Clarissa
●●●●●●

To Fortree City
(p. 163)

To Scorched Slab
(p. 273)

Bird Keeper Colin
●●●●●●

Parasol Lady Angelica
●●●●●●

Ruin Maniac Chip
●●●●●●

Delinquent Sharlene ☻
●●●●●●

Bird Keeper
Robert ☻
●●●●●●

Berry Trees

Ninja Boy Tsunao
●●●●●●

Ace Trainer Jennifer
●●●●●●

Berry Trees

Ninja Boy Keigo
●●●●●●

Bug Maniac
Brandon ☻
●●●●●●

Street Thug
Gomez ☻
●●●●●●

Berry Trees

Pokémon Ranger
Jenna
●●●●●●

To Route 121
(p. 174)

Pokémon Ranger
Carlos
●●●●●●

Items
- ❏ Blazikenite (if you chose Torchic)
- ❏ Devon Scope
- ❏ Nest Ball
- ❏ Sceptilite (if you chose Treecko)
- ❏ Swampertite (if you chose Mudkip)

After obtaining the Feather Badge
- ❏ Full Heal
- ❏ Light Ball
- ❏ Nugget
- ❏ Revive

Hidden Items
- ❏ Rare Candy
- ❏ Revive

After obtaining the Feather Badge
- ❏ Rare Candy
- ❏ Zinc

1 Cut the north trees to reach a Rare Candy

Route 120 features more of that fun-to-frolic-in very tall grass. Before searching the grass, go north and cut down two prickly trees with Cut to make your way down a narrow path that leads to a hidden Rare Candy. Whip out your Dowsing Machine to find it!

2 Find more items near the very tall grass

Pocket your Rare Candy and then search the very tall grass with your Dowsing Machine to discover a hidden Revive near the middle of the three little bare patches in the grass. Then head west, going past the Secret Spot located in a pile of grass. Descend the south steps afterward to find a visible Nest Ball near another Secret Spot. And hey, isn't that Steven up on the nearby bridge?

Optional | Search the Scorched Slab

p. 273

Surf the water below the bridge where Steven stands to reach a dark cave known as the Scorched Slab. Grab TM11 Sunny Day right by the stairs, and then head down the stairs. Light up the place with Flash and search it thoroughly to obtain a Full Heal and three hidden items: Escape Rope, Nugget, Super Potion. The cave's deepest chamber seems rather mysterious, but nothing's happening there yet. You'll have to return when the time is right! Turn to page 273 for maps and info on the Scorched Slab.

Rewards: TM11 Sunny Day, Full Heal, Escape Rope, Nugget, Super Potion

3 Give a scoop to Gabby & Ty

Northeast of the very tall grass, you may find that Interviewers Gabby & Ty are looking for potential Trainers to battle and interview. Speak to them if you'd like to try another Double Battle against Hoenn's hottest news duo!

Gabby & Ty's Pokémon

	Magneton Lv. 29	Electric	Steel
	Weak to: 4x Ground	Fire	Fighting

	Loudred ♂ Lv. 29	Normal
	Weak to: Fighting	

4 | Meet Steven on the bridge

Are you and your Pokémon ready for battle?

Yes
No

Cross the bridge and speak with Steven to learn that another mysterious invisible object is blocking the way forward. Fortunately, Steven has a way to solve this little mystery now!

5 | Catch or defeat the invisible Kecleon

Orlando slipped the Devon Scope on.

Steven lets you try on a new item: the Devon Scope. This high-tech set of eyewear is made to reveal invisible objects. And sure enough, they reveal an invisible Kecleon that's blocking the bridge! What won't Devon think of next? Catch or defeat the Kecleon to unblock the bridge, but watch out for its Camouflage move, which lets it change its type mid-battle to become Grass type when you battle it here.

Kecleon `Normal`
♂ Lv. 10
Ability: Color change

Weak to: `Fighting`

6 | Receive the Devon Scope and a Mega Stone

Orlando obtained the Devon Scope!

Pleased with your actions, Steven gives you the Devon Scope to keep. And that's not all! Steven also hands you a special Mega Stone that perfectly suits your first partner Pokémon. Now your first partner Pokémon can Mega Evolve during battle!

TIP

Steven gives you the Mega Stone Sceptilite if you chose Treecko, Blazikenite if you chose Torchic, and Swampertite if you chose Mudkip as your first partner Pokémon. If you want the other two stones, they'll be available for purchase later on.

Optional | Explore more of Route 120

p. 166

Ahead waits a natural labyrinth, far more fearsome than this route.

Now that you've got the Devon Scope, you can get past the invisible obstacle back in Fortree City and challenge the Gym Leader for your next Badge. Getting this Badge will let you use Fly in the field to zip all over Hoenn, so it's well worth returning to Fortree City right now. There's a bit more of Route 120 to explore, however, so feel free to venture onward if you'd prefer to raise your Pokémon a little more. You can even battle another Bird Keeper to prepare yourself for Winona's Flying-type Pokémon. You won't be allowed to advance very far, though.

FORTREE CITY GYM BATTLE

Gym Battle Tips

- Bring lots of strong HP-restoring items, like Moomoo Milk and Hyper Potions.
- Electric-type Pokémon, such as Electrike and Minun, will give you a big advantage.

Gym Leader Winona

Bird Keeper Bran

Bird Keeper Will

Camper Terrell

Picnicker Kylee

Bird Keeper Jared

Entrance

TRAINER HANDBOOK

ADVANCED HANDBOOK

ADVENTURE DATA

1 Use the Devon Scope to scare off Kecleon

Would you like to use the Devon Scope?

You've got to get rid of the invisible object that's blocking Fortree City's Gym. Cross the north tree houses and descend the central ladder to encounter the object. When it gets in your way, just slap on the Devon Scope to send a suddenly visible Kecleon sprinting off!

TIP

Loop around the Gym to reach the TM you could see when you were coming down the ladder. It's TM86 Grass Knot, which is an interesting move that becomes more powerful the heavier the target is. It's best used against large, lumbering opponents. The bigger they are, the harder they fall, right?

2 Assemble your party, then head to the Gym

Cross the northern tree houses to quickly reach the Pokémon Center. Rest up and pick your party for the upcoming Gym battles. The Trainers you'll meet inside the Fortree City Gym favor Flying-type Pokémon, so counter them with Electric-type Pokémon, whose Electric moves are super effective against the Flying type. Flying-type moves are also not very effective against Electric-type Pokémon, so you'll have a tremendous advantage.

3 Battle Trainers as you navigate the Gym

Behold the elegant battle style of bird Pokémon!

Fortree City's Gym is fairly straightforward, featuring ramps that lead steadily upward to Winona's lofty perch. Many Trainers must be battled during your ascent, but you can avoid some if you time your moves carefully and watch which way they are facing. You can always exit the Gym to restore your party at the Pokémon Center whenever you feel the need. The only obstacles are turnstiles, some of which can't be spun in certain directions. Whenever a turnstile won't budge, try looping around and approaching it from a different angle. If you find yourself feeling stuck, don't forget that you can turn the turnstiles back as well. Sometimes returning them to their starting position or approaching them from a different side might be the key to moving forward.

TIP

If you have no Electric-type Pokémon, you can catch Electrike on Route 118. Alternatively, use the TMs you've found along your journey to teach Electric- and Rock-type moves to other Pokémon. TM23 Smack Down, TM39 Rock Tomb, and TM72 Volt Switch are all great options. Each of these moves will be super effective against the Flying types you'll soon face (except for Altaria, which won't be hit as hard by Volt Switch).

Stuck on the Turnstiles?

If you're having trouble getting through the turnstiles as you progress through the Gym, the map below illustrates one path you could take.

The trickier turnstiles will require you to loop around and pass through them more than once. Each time you pass through, they will move 90 degrees, but sometimes that's not enough to keep going. Follow the arrows as indicated to get them in the final positions you need. The fifth turnstile is particularly tricky. Go south of the fifth turnstile the first time, then turn north to pass through it. That won't work the second time, though, as you wedged one of its sides against the large stump on your first pass through. On your second pass, go up to it and then move to the west to turn it back to its original position. Then you'll be able to head north through it again like you did the first time.

Winona Flying-type Pokémon User

Fortree City Gym Leader

Score a shocking victory with Electric-type moves!

Winona waits at the top of Fortree City's Gym, ready to swoop into battle. This Gym Leader has four Pokémon to send out—more than any other Gym Leader has thrown at you thus far. Winona's Pokémon are all Flying types, and most share weaknesses to Electric- and Rock-type moves. In addition, their Flying-type moves won't be very effective against Electric-, Rock-, and Steel-type Pokémon, provided you've brought some along.

Winona's most dangerous Pokémon is Altaria, because it's not weak to Electric and because it uses Earthquake: a mighty Ground-type move that's super effective against Electric-type Pokémon, which you likely intend to use. Fortree City's Gym Leader can also heal one of her wounded Pokémon with a Hyper Potion, which is likely to restore it back to full HP. Expect Winona to use her Hyper Potion on Altaria to keep her most effective Pokémon battling for as long as possible. Counter its devastating Earthquakes with Rock-type moves such as TM39 Rock Tomb, and don't hesitate to heal your Pokémon as often as needed.

Winona's Pokémon

Skarmory ♀ Lv. 33	Steel	Flying
Weak to:	Fire	Electric

Swellow ♀ Lv. 33	Normal	Flying	
Weak to:	Electric	Ice	Rock

Pelipper ♀ Lv. 33	Water	Flying
Weak to:	4x Electric	Rock

Altaria ♀ Lv. 35	Dragon	Flying		
Weak to:	4x Ice	Rock	Dragon	Fairy

Feather Badge
Pokémon up to Lv. 70, including those received in trades, will obey you. This Badge also lets you use Fly outside of battle to quickly travel around Hoenn.

 TM19 Roost
The user lands and rests its body. It restores the user's HP by up to half of its max HP.

Let's Fly!

Now that you've obtained the Feather Badge, you can finally use HM02 Fly as a field move. You've already seen that Fly is a handy move in battle, allowing you to escape nearly all attacks for one turn and then drop down on your opponent for some serious damage on the next turn. But this invaluable HM also makes getting around the region a breeze—even more of a breeze than ever before!

If you've played *Pokémon* before, you may recall that Fly can zip you back to Pokémon Centers in cities and towns you've visited, as long as you have a Pokémon that can use Fly in your party. Fly really gets its wings in *Pokémon Omega Ruby* and *Pokémon Alpha Sapphire*, though. Now Fly will take you back to nearly any route you've explored! It can also drop you right in front of caves or other special locations you've visited, like Rusturf Tunnel and Mt. Chimney! The only trick to flying back to a route is that you need to reach the next town or city first. So you can't fly back to Route 120 or Route 121 until you've visited Lilycove City.

When Flying to a route, you're often dropped off by the route sign. When you select a cave or other special location, you'll be dropped off wherever an Escape Rope would normally take you, usually the area's main entrance.

TIP

You may only Fly to places that you've already visited, and you still can't use Fly when you're inside a cave or building. Go outside if you wish to Fly!

Using Fly

Press Ⓧ to open the menu, and then choose "Pokémon." Pick a Pokémon that has learned Fly and select "Use a move," then choose "Fly."

Fly also works together with your AreaNav, letting you revisit areas in the blink of an eye. Open the AreaNav application (p. 29) to view the map of Hoenn. Then tap the buttons along the bottom of the Touch Screen (Places, Pokémon, Trainers, Bases, and Berries) to check for things like Trainers to rebattle, Pokémon to be caught, Secret Base locations to visit, and Berry Trees to harvest or tend. When you find something worth checking out, press Ⓐ to Fly there at once—provided you have a Pokémon in your party that knows Fly. Happy adventuring!

◀◀ **BACKTRACK** **MAUVILLE CITY** p. 89

Get another O-Power at the Pokémon Center

Now that you can Fly all over Hoenn, getting around couldn't be easier. If you haven't already done this, teach HM02 Fly to a Pokémon, and then open your AreaNav and select Mauville City. Press Ⓐ to Fly back to Mauville's Pokémon Center, and then go inside to find the blue-haired Bard hanging around. Listen to his song to receive a new O-Power that will help your Pokémon level up even faster: Exp. Point Power Lv. 1!

TIP

If you haven't tried backtracking to explore optional areas and the like, now's a great time, with Fly to make it easy. So consider exploring any optional areas you might have skipped, and wrap up your exploration of areas you've visited but haven't fully searched. You can flip back through this walkthrough and look for Optional Areas and Backtrack Boxes. Your AreaNav is a great resource as well—use it to track down routes and other areas where there are still wild Pokémon to catch, Berries to harvest, and Trainers to rebattle (p. 328)!

Explore more of Route 120

By obtaining the Feather Badge, you've proven your strength and skill as a Trainer. This means that the fellow who blocked you along Route 120 won't stop you anymore. Route 120 is large, and it's filled with items to find and Trainers to battle, so give it a thorough search. Cut down the tree in its middle to reach some new Berries and a Secret Spot. And don't forget to dowse for hidden items along the way, including a Zinc in the northwest corner of the maze of very tall grass.

Orlando obtained a
Wiki Berry!

Score a rare Berry from an Aroma Lady

Route 120 splits at its south end, with the west trail leading up to a plateau. Go west and speak to the Aroma Lady near the plateau's steps, and she'll tell you the best way to snack on a tasty Pokéblock—use a little relish! No matter if you agree with her or not, she'll give you a rare Berry, one of the Figy, Wiki, Mago, Aguav, or Iapapa Berries. Be sure to plant it! You can get this rare Berry from the Aroma Lady every day.

> **TIP**
>
> See page 310 for a complete list of people and places that you can visit for special treats or activities every day, like the Aroma Lady on Route 120.

Marvel at an ancient ruin

Explore the plateau to find more Trainers, and Surf across the small pond to reach a Full Heal. Surf back across and go north through very tall grass to notice a large, pyramid-shaped rock. A nearby Ruin Maniac has been drawn to this rock and believes a ruin must lie beneath it, but he can't seem to find the entrance. Perhaps you'll have a means of discovering it someday! Until then, there are a number of new Secret Spots to uncover and explore, and don't forget to get a Revive and harvest Berries nearby. Then head east to reach Route 121!

ROUTE 121

Field Moves Needed Cut

This road leads to both the Safari Zone and Mt. Pyre. Many people set out along this route from Lilycove City.

Head to the southeastern corner of Route 120 to reach Route 121. Smaller and more straightforward than Route 120, Route 121 still offers a fair share of goodies. It connects to Route 122 and Lilycove City, and also features the Safari Zone—an exciting place that attracts Pokémon fanatics from all over Hoenn.

Beauty Jessica ◉
●●●●●●

Teammate Kate & Joy
★ Double Battle
●●●●●●

Poké Fan Vanessa
●●●●●●

Berry Trees

Safari Zone
(p. 176)

Hex Maniac Tammy
●●●●●●

To Route 120
(p. 166)

Berry Trees

Rest your
Pokémon
here

To Lilycove
City (p. 178)

To Route 122
(p. 185)

Gentleman Walter ◉
●●●●●●

Tall Grass / Very Tall Grass	
❑ Gloom	○
❑ Kecleon	▲
❑ Linoone	○
❑ Pelipper	▲
❑ Shuppet	○

Horde Encounter		
❑ Kecleon (×5)		▲
❑ Shuppet (×5)		◎
❑ Wingull (×5)		○

Items
❑ Carbos
❑ Max Repel
❑ Shiny Stone
❑ Zinc

Hidden Items
❑ Full Heal
❑ HP Up
❑ Max Revive
❑ Nugget

◎ frequent ○ average △ rare ▲ almost never

Shuppet Ghost
Abilities: Insomnia, Frisk

1 Catch sight of Team Magma / Team Aqua

All right!
We are leaving for Mt. Pyre!

OK!
We're moving out to Mt. Pyre!

Battle a couple of Trainers and harvest some Berries as you make your way east through Route 121. Swing south of the blue fence to find a hidden HP Up, which you can use to increase one Pokémon's base HP. You'll soon catch a glimpse of Team Magma / Team Aqua. They're in a rush to reach Mt. Pyre, and they roar off to the south. Why would they be in such a hurry to go there?

Optional SAFARI ZONE p. 176

Welcome to the Safari Zone!

Swing by the Safari Zone

Team Magma / Team Aqua must be stopped, but there's a lot more to see around Route 121. Go down the first flight of stairs, then west past one prickly tree to get a Zinc and a Secret Spot. Then head east to reach the Safari Zone. Inside, you can participate in fun and exciting Pokémon safaris! You can catch rare Pokémon during safaris, so check out the Safari Zone guide on pages 176–178 to learn all about it!

TIP

If you can't resist chasing after Team Magma / Team Aqua, go south in pursuit of them and flip ahead to Route 122's section on page 185. Make sure to speak to the wandering Pokémon Center employee on Route 121's south stone pier as you go. She'll restore your Pokémon's health to help prepare them for the challenges ahead.

Optional LILYCOVE CITY p. 178

Lilycove City

Visit Lilycove City

Whether or not you visit the Safari Zone, you should consider a trip to nearby Lilycove City. You'll find a giant department store that's well worth browsing. You can finish your exploration of Route 121 along the way as you head east toward Lilycove City, picking up some more handy items, like a Max Repel and a Full Heal. There's even a valuable Nugget hidden there that you'll be able to sell to fund your shopping spree. Flip ahead to page 178 if you feel like checking out Lilycove now, or turn to page 185 if you prefer to pursue Team Magma / Team Aqua south into Route 122 on your way to Mt. Pyre.

Safari Zone

The Safari Zone is a special place that offers Hoenn's Trainers a chance to encounter all sorts of Pokémon. An admission fee used to be required, but luckily for you, the Safari Zone is now supported by volunteers and totally free! Explore the Safari Zone and catch Pokémon to your heart's content. Some rare Pokémon are easier to catch here at the Safari Zone, and some species can be caught only here.

Field Moves Needed

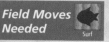
Surf

A B

C D

To Route 121
(p. 174)

TIP

The Safari Zone features varied terrain, and some areas can be reached only with a Mach Bike or an Acro Bike, or both. You need a Mach Bike to zip up the sandy slopes, and you need an Acro Bike to bunny-hop across the stepping stones and zip along narrow bridges. You'll also need to be able to switch between both Bikes in order to fully explore the Safari Zone, but you won't be able to carry both Bikes with you for a while yet. See page 97 to learn all about Bikes.

Doduo `Normal` `Flying`
Abilities: Run Away, Early Bird

Pikachu `Electric`
Ability: Static

Tall Grass	
All areas	
☐ Doduo	○
☐ Gloom	○
☐ Psyduck	○
Area A (Mach Bike required)	
☐ Rhyhorn	○
Area B (Acro Bike required)	
☐ Donphan	○
Area C (no Bike required)	
☐ Xatu	○
Area D (no Bike required)	
☐ Pikachu	○

Very Tall Grass	
All areas	
☐ Doduo	○
☐ Gloom	○
☐ Psyduck	○
Area A (Acro Bike required)	
☐ Heracross	○
Area B (Mach Bike required)	
☐ Pinsir	○
Area C (Mach Bike required)	
☐ Wobbuffet	○
Area D (Acro Bike required)	
☐ Girafarig	○

Fishing	
Mach or Acro Bike required to reach area	
Old Rod	
☐ Goldeen	○
☐ Magikarp	◎
Good Rod	
☐ Goldeen	○
☐ Magikarp	◎
Super Rod	
☐ Seaking	◎

Horde Encounter	
All areas	
☐ Doduo (×5)	◎
☐ Oddish (×5)	○
☐ Psyduck (×5)	▲

On the Water	
Mach or Acro Bike required to reach area	
☐ Psyduck	◎

○ frequent ○ average
△ rare ▲ almost never

Hidden Items

☐ Protein
☐ Rare Candy
☐ Revive
☐ Ultra Ball

Vending Machine	
Fresh Water	200
Lemonade	350
Soda Pop	300

Items	
Building	
☐ TM85 Dream Eater	
Area A	
☐ Absolite	
☐ Big Pearl	
☐ Nugget	
Area B	
☐ TM22 Solar Beam	
☐ TM93 Wild Charge	
Area C	
☐ Max Revive	
Area D	
☐ Calcium	
☐ TM53 Energy Ball	

Speak to people inside the building

Orlando obtained
TM85 Dream Eater!

Talk to a Street Thug inside the Safari Zone building, and he'll give you TM85 Dream Eater. The Preschooler near the entrance to the Safari gives you a very useful tip as well: Bring either an Acro Bike or a Mach Bike with you into the Safari Zone, because some areas in the Safari Zone are accessible only by Bike.

TIP

Don't have a Bike? Fly back to Mauville City (p. 89) and visit Rydel's Cycles! You can swap your Bike there anytime.

Safari Zone (cont.)

Map 1: Areas you can reach without a Bike

If you don't have a Bike, then the only thing you can explore is the tall grass in Areas C and D, and a little bit further. Don't be discouraged, though! Even without a Bike, you can catch Doduo, Gloom, and Psyduck in the tall grass in Areas C and D, and you can also catch Pikachu in Area D. The Safari Zone is the only place you can catch Doduo, Psyduck, and Pikachu in the entire Hoenn region, so don't miss your chance to catch them here!

You can also catch Xatu in the tall grass in Area C. Xatu usually live in places where you can't reach simply by walking, so this is another don't-miss opportunity!

Map 2: Areas you can reach with a Mach Bike

With a Mach Bike, explore the Safari Zone's areas clockwise—in the order of D, C, A, and then B.

Wobbuffet can be found only in the very tall grass in Area C, and Rhyhorn only appears in the tall grass in Area A. Pinsir only shows up in the very tall grass in Area B. These are the only places to catch these rare Pokémon in Hoenn, so don't leave these areas without them!

Also be sure to collect a Nugget, a Big Pearl, and TM22 Solar Beam in these areas.

Map 3: Areas you can reach with an Acro Bike

There are many ways to explore the Safari Zone on an Acro Bike, so feel free to start wherever you like.

You can find Girafarig in the very tall grass in Area D, and there's a Calcium near the grass as well. Search the tall grass in Area B to find Donphan. Like the Xatu found in Area C, these Pokémon live in places that can't easily be reached outside of the Safari Zone— Girafarig are especially difficult to find. So catch them while you're here! You can also catch Heracross in the very tall grass in Area A, and this is the only place where Heracross appear in Hoenn. After you've caught one, go all the way south to find a Max Revive.

TIP

To access the areas framed by blue squares in Maps 2 and 3, you'll need both a Mach Bike and an Acro Bike. Return to the Safari Zone when you're able to carry both Bikes at once, and you can obtain two TMs from these areas, TM53 Energy Ball and TM93 Wild Charge, which contain powerful moves! See page 97 to learn how to get both Bikes.

TIP

When you get a Super Rod (p. 65), return to the Safari Zone and use it to catch Seaking. The Safari Zone is the only place where you can catch Seaking in the Hoenn region.

LILYCOVE CITY

Field Moves Needed — Rock Smash, Surf

This tourist destination is undergoing a revival, thanks to the popularity of its Pokémon Contest Spectaculars.

Lilycove City is one of the larger cities in Hoenn. A port city, Lilycove mirrors Slateport with its impressive size, its scenic lighthouse, and its spacious harbor. One of the main attractions here is the Lilycove Department Store, where Trainers can buy just about anything they could ever want.

TRAINER HANDBOOK

ADVANCED HANDBOOK

ADVENTURE DATA

Lilycove City Map

- Lilycove Museum
- Lilycove Department Store (p. 182)
- Move Deleter's House
- Pokémon Center
- Contest Spectacular Trainer Fan Club
- Contest Spectacular Hall
- Cove Lily Motel
- Lilycove City Harbor
- Lighthouse

To Team Magma Hideout Ω (p. 194)

To Team Aqua Hideout α (p. 199)

To Route 124 (p. 204)

To Route 121 (p. 174)

Items
- ❏ Max Repel
- ❏ Poké Flute
- ❏ TM44 Rest
- ❏ TM88 Sleep Talk

Hidden Items
- ❏ Heart Scale
- ❏ Poké Ball
- ❏ PP Up

Vending Machine

Cove Lily Motel	
Fresh Water	200
Lemonade	350
Soda Pop	300
Harbor	
Soda Pop	300

Fishing

Old Rod	
❏ Magikarp	◎
❏ Tentacool	○
Good Rod	
❏ Magikarp	◎
❏ Tentacool	○
❏ Wailmer	▲
Super Rod	
❏ Staryu	▲
❏ Wailmer	◎

Rock Smash
❏ Graveler	◎

On the Water
❏ Pelipper	▲
❏ Tentacool	◎
❏ Wingull	○

◎ frequent ○ average
△ rare ▲ almost never

TIP

Lilycove City features a massive department store that sells all sorts of items, including the familiar wares you've seen at Poké Marts all over Hoenn. Turn to the "Lilycove Department Store" section on page 182 to discover the vast array of items you can buy there!

1 Rest and reminisce with the Memory Girl

I'm the Memory Girl! I can read Pokémon memories.

A Pokémon Center will soon catch your eye as you stroll into Lilycove City, but take a moment to talk to the Memory Girl outside before you enter. Show the Memory Girl any of your Pokémon, and she'll tell you some of its fondest memories of your journey. Then head inside for some well-deserved rest after your long trip.

2 Show off an Altaria and receive an Altarianite

What Pokémon does Lisia the contest idol always have with her? Try and show me!

Keep going east from the Pokémon Center to find the Contest Spectacular Trainer Fan Club (CSTFC for short). The man outside quizzes you about Lisia's Pokémon pal, Ali. He asks you to show him a Pokémon that's the same species as Ali. Show him an Altaria to pass his test, and he'll give you an Altarianite—the very Mega Stone that Altaria needs to Mega Evolve during battle!

Reward: Altarianite

TIP

Don't have an Altaria? Catch a Swablu along Route 114 or 115 and raise it to Level 35 to evolve into Altaria.

3 Visit the Contest Spectacular Trainer Fan Club

The most popular contest idols now are Lisia and Ali!

Pop into the Contest Spectacular Trainer Fan Club, and you'll find the place packed with contest fans. Perhaps it seems like everyone is in love with Lisia and her Pokémon pal, Ali. And what's not to love? They're both super cute and spectacular contest performers! But if you've been taking part in contests, you may discover a growing number of fans have joined your camp instead.

4 Check out the Motel and Contest Hall

Enter
Do not enter
Info

Here, you can participate in a contest with people nearby.

Head south from the CSTFC to find the Cove Lily Motel to the east and the Contest Hall to the west. The Motel isn't very lively at the moment, thanks to the presence of Team Magma / Team Aqua in town, but there's a Vending Machine upstairs if you're thirsty. Feel free to try some contests at the Contest Hall, too, if you're in the mood. Who knows? Maybe you'll convert some of those fans you met at the CSTFC!

5 Meet the Pokéblock Master

Yes
No

Would you like to learn from me, a Pokéblock Master?

Continue west from the Contest Hall to find the Pokéblock Master's house. Visit with the Pokéblock Master, her husband, and her four kids. Speak with the Pokéblock Master, and she'll give you tips that will help you craft potent Pokéblocks. See page 358 for even more tips and advice on this important subject. You can then continue south to the harbor if you wish, but there's not much there yet except a Vending Machine. Head back north to find the real heart of the city: the shops!

6 Scope the Department Store with May/Brendan

Don't tell me...
Are you here for the shopping, too, Orlando?

Backtrack to Lilycove City's north end. Your pal May/Brendan races toward you as you near the north steps. Finally, a friendly face! Marvel at the nearby Lilycove Department Store with your buddy, but don't get complacent. She/he soon challenges you to a battle!

May/Brendan's Pokémon

May/Brendan has really been working hard, and her/his Pokémon have grown quite powerful. In fact, they've all evolved since your last battle! You'll now face the final Evolutions of her/his previous Pokémon, along with a new opponent: Swellow. With four well-trained Pokémon for you to battle, you'll really have your hands full this time!

If you chose Treecko

Blaziken — Fire / Fighting
♀/♂ Lv. 39
Weak to: Water · Ground · Flying · Psychic

Breloom — Grass / Fighting
♀/♂ Lv. 37
Weak to: 4× Flying · Fire · Ice · Poison · Psychic · Fairy

Wailord — Water
♀/♂ Lv. 37
Weak to: Grass · Electric

Swellow — Normal / Flying
♀/♂ Lv. 37
Weak to: Electric · Ice · Rock

If you chose Torchic

Swampert — Water / Ground
♀/♂ Lv. 39
Weak to: 4× Grass

Breloom — Grass / Fighting
♀/♂ Lv. 37
Weak to: 4× Flying · Fire · Ice · Poison · Psychic · Fairy

Magcargo — Fire / Rock
♀/♂ Lv. 37
Weak to: 4× Water · 4× Ground · Fighting · Rock

Swellow — Normal / Flying
♀/♂ Lv. 37
Weak to: Electric · Ice · Rock

If you chose Mudkip

Sceptile — Grass
♀/♂ Lv. 39
Weak to: Fire · Ice · Poison · Flying · Bug

Wailord — Water
♀/♂ Lv. 37
Weak to: Grass · Electric

Magcargo — Fire / Rock
♀/♂ Lv. 37
Weak to: 4× Water · 4× Ground · Fighting · Rock

Swellow — Normal / Flying
♀/♂ Lv. 37
Weak to: Electric · Ice · Rock

7 Meet the Move Deleter

You're here so I can make your Pokémon forget a move, um-hmm?

Yes / No

Go upstairs after your battle with May/Brendan and enter the Move Deleter's House that is just to the east. Inside lives the absent-minded Move Deleter, who has the power to make your Pokémon forget any moves that they've learned. This is super useful if you wish to have a Pokémon forget HM moves, which can't be forgotten without the Move Deleter's help. Unlike the Move Maniac in Fallarbor Town, he won't even charge you a Heart Scale for his service.

TIP

With the aid of Fly, you can easily travel between Fallarbor Town and Lilycove City. Make use of Fly to travel quickly between the Move Deleter and Move Maniac. Exploit their special talents to ensure that your Pokémon know all the best moves available to them.

8 Receive a random Berry

Orlando obtained a Lum Berry!

Head east from the Move Deleter's House to find a Gentleman out for a seaside stroll. Talk to the Gentleman, and he'll hand you a random Berry. You might get a Cheri, Chesto, Pecha, Rawst, Aspear, Leppa, Oran, Persim, Lum, or Sitrus Berry. This kind Gentleman will give you one of these Berries every day. See page 310 for a complete list of people and places in Hoenn that are worth visiting each day!

9 Score a Poké Flute and two TMs

Orlando obtained TM44 Rest!

After speaking with the Gentleman, jump down the nearby ledges to reach a small house. Enter and speak with the men inside to receive a decorative Poké Flute for your Secret Base, along with TM44 Rest and TM88 Sleep Talk. Speak to the sleepy fellow twice to get both TMs.

TIP

TM44 Rest and TM88 Sleep Talk work hand in hand. Teach both of them to a Pokémon, and then use Rest to make it sleep during battle for two turns. During the first turn, its HP will be fully restored and any status conditions will be healed. On the second turn, the sleeping Pokémon will automatically use Sleep Talk to randomly unleash one of the moves it knows. This clever combo lets your Pokémon heal up while still taking action in battle.

10 | Encounter Grunts around the beach

Keep going south to reach the beach and lighthouse. Those awful Team Magma / Team Aqua Grunts are everywhere around here, and speaking with them reveals that they have a secret hideout nearby. One Grunt is busily training Wailmer down by the water, creating a blockade that's keeping you from Surfing to Route 124. Just what are these clowns up to?!

11 | Check out Team Magma / Team Aqua's secret hideout

Surf north from the Wailmer blockade to find a cave. Surf inside to discover Team Magma / Team Aqua's secret hideout! A group of Grunts won't let you pass, since their boss isn't around. Still, this is clearly an important discovery!

12 | Explore the Lilycove Department Store

Ready to do some shopping? Make your way back north again, and this time turn to the west to reach the Lilycove Department Store, where you can buy just about anything you could want. The items sold on floors 2F, 3F, and 4F will be especially useful in the coming challenges on Mt. Pyre.

 TIP

Comb the beach with your Dowsing Machine to find a hidden Heart Scale, a Poké Ball, and a PP Up. Use Rock Smash to shatter the cracked rocks on the beach and potentially find even more items. A Max Repel can be seen near the lighthouse as well. Reach it by heading up the stairs that lie at the southwest corner of the beach.

Lilycove Department Store

Welcome to the Lilycove Department Store! This multi-floor mega-center is filled with amazing merchandise amid an air of excitement.

First Floor: Service Counter and Lottery Corner

The department store's first floor is a welcome center. The receptionist on the left greets you, while the receptionist on the right runs the Pokémon Lottery Corner. Speak to her to draw a random Pokémon Loto Ticket. If the ticket's number matches even part of the ID number of any of your Pokémon, you win a prize! You can draw one Loto Ticket each day. The more numbers the two have in common, the better the prize you'll get!

Matching Digits	Prize
1 digit	Moomoo Milk
2 digits	PP Up
3 digits	PP Max
4 digits	Rare Candy
5 digits	Master Ball

TIP

Every Pokémon you catch will have the same ID, so you'll need to trade Pokémon with other players to increase your chance of winning. Wonder Trade is a great way to do this. Fire up your PlayNav's PSS application and start trading!

Lilycove Department Store (cont.)

Second Floor: Trainers' Zone

Welcome to Lilycove Department Store!
Are you looking for anything in particular?

The department store's second floor offers items that are useful during battles. You'll find a familiar selection of goods that are sold to you at Poké Marts all over Hoenn, plus a few other special items.

Left Clerk's Wares

Item	Price
Fluffy Tail	1,000
Poké Doll	1,000
Poké Toy	1,000

Right Clerk's Wares

Item	Price	Item	Price	Item	Price	Item	Price
Antidote	100	Full Restore	3,000	Max Repel	700	Revive	1,500
Awakening	250	Great Ball	600	Paralyze Heal	200	Super Potion	700
Burn Heal	250	Hyper Potion	1,200	Poké Ball	200	Super Repel	500
Escape Rope	550	Ice Heal	250	Potion	300	Ultra Ball	1,200
Full Heal	600	Max Potion	2,500	Repel	350		

Third Floor: Battle Collection

Items are the best option for making your Pokémon stronger in a rush.

Head to the third floor when you're looking for items that will raise your Pokémon's stats, either permanently by adding to their base stats or temporarily during battles.

Left Clerk's Wares

Item	Price
Calcium	9,800
Carbos	9,800
HP Up	9,800
Iron	9,800
Protein	9,800
Zinc	9,800

Right Clerk's Wares

Item	Price	Item	Price
Dire Hit	650	X Defense	550
Guard Spec.	700	X Sp. Atk	350
X Accuracy	950	X Sp. Def	350
X Attack	500	X Speed	350

Fourth Floor: TM Corner

Welcome to Lilycove Department Store!
Are you looking for anything in particular?

If you're after TMs, then you've come to the right place! The fourth floor features two clerks: one who sells TMs for offense and another who sells defensive TMs.

Upper Clerk's Wares

TM	Price	TM	Price
TM14 Blizzard	30,000	TM52 Focus Blast	30,000
TM15 Hyper Beam	50,000	TM68 Giga Impact	50,000
TM25 Thunder	30,000	TM71 Stone Edge	30,000
TM38 Fire Blast	30,000		

Lower Clerk's Wares

TM	Price
TM16 Light Screen	10,000
TM17 Protect	10,000
TM20 Safeguard	10,000
TM33 Reflect	10,000

Fifth Floor: Decoration Floor

The store's fifth and final floor is dedicated to Secret Base fanatics. You'll find a wide selection of cool Decorations to help you deck out your Secret Base, including cushions, posters, mats, and dolls.

Far-Right Clerk's Wares

Item	Price	Item	Price	Item	Price
Azurill Doll	3,000	Gulpin Doll	3,000	Skitty Doll	3,000
Baltoy Doll	3,000	Jigglypuff Doll	3,000	Smoochum Doll	3,000
Chikorita Doll	3,000	Kecleon Doll	3,000	Substitute Doll	3,000
Clefairy Doll	3,000	Marill Doll	3,000	Swablu Doll	3,000
Cyndaquil Doll	3,000	Meowth Doll	3,000	Togepi Doll	3,000
Ditto Doll	3,000	Pichu Doll	3,000	Totodile Doll	3,000
Duskull Doll	3,000	Pikachu Doll	3,000	Wynaut Doll	3,000

Lilycove Department Store (cont.)

Far-Left Clerk's Wares

Diamond Cushion	1,000	Poké Ball Cushion	1,000
Fire Cushion	1,000	Round Cushion	1,000
Grass Cushion	1,000	Spin Cushion	1,000
Kiss Cushion	1,000	Water Cushion	1,000
Pika Cushion	1,000		

Middle-Left Clerk's Wares

Blue Poster	1,000
Cute Poster	1,000
Green Poster	1,000
Kiss Poster	1,500
Long Poster	1,500
Pika Poster	1,500
Poké Ball Poster	1,000
Red Poster	1,000
Sea Poster	1,500
Sky Poster	1,500

Middle-Right Clerk's Wares

Attract Mat	2,000
Blue Mat	3,000
Fire Blast Mat	2,000
Fissure Mat	2,000
Flat Mat	3,500
Green Mat	3,000
Powder Snow Mat	2,000
Red Mat	3,000
Spikes Mat	2,000
Surf Mat	2,000
Thunder Mat	2,000

Rooftop Plaza

Welcome, welcome! What timing! We're now holding our regular Clearance Sale!

Buy
No thanks!

Take the stairs up to Lilycove Department Store's rooftop. If it's Saturday, you'll find that a major Clearance Sale is being held up here, where special Secret Base Decorations are sold. There are also two Vending Machines that sell a familiar selection of beverages. Move behind the face board of heroine Lilycove Viridian of the Hoenn Rangers Coexistence Force for a neat view!

Vending Machines

Fresh Water	200
Lemonade	350
Soda Pop	300

Clearance Sale (Saturdays only)

Berry Tree	2,000	Cute TV	4,000	Red Scroll	4,500	Stand	3,500
Blastoise Doll	6,000	Dad's Scroll	4,500	Rhydon Doll	6,000	Standing Stone	3,000
Blue Scroll	4,500	Green Scroll	4,500	Round TV	4,000	Tire	800
Breakable Door	3,000	Lapras Doll	6,000	Sand Ornament	2,000	Trash Can	500
Candlestick	4,000	Mini Castelia	6,000	Slide	3,500	TV	3,000
Cardboard Boxes	200	Mini Lumiose	6,000	Snorlax Doll	6,000	Venusaur Doll	6,000
Charizard Doll	6,000	Mud Ball	200	Solid Board	2,000	Wailmer Doll	6,000

13 Visit the Museum

I'll specially sell my art for ₽100,000 a piece to you.

When you've finished blowing your savings at the Lilycove Department Store, take a moment to unwind at the nearby Lilycove Museum. There's no admittance fee, and the exhibits are truly inspiring. The museum's curator stands near the stairs to the second floor, but he won't let you pass if you haven't yet made it through a Master Rank contest because he hasn't yet decided on what sort of exhibit to showcase upstairs. To the left stands a Kindler who'll sell you one of his modern art pieces, provided you've got the cash. His "masterpieces" really catch the eye. They can be used as Decorations in your base.

TIP

Want to make it up to the museum's second floor and see your Pokémon featured there? You'll need to win a Master Rank contest in a Contest Spectacular. It might even earn you a reward! See page 358 for more info.

Proceed to Mt. Pyre

After you've given Lilycove City a thorough search, it's time to get back on track to pursue Team Magma / Team Aqua to Mt. Pyre. The mighty mountain rises up from Route 122, which is south of Route 121. Backtrack west through Route 121 and cross the south pier to reach Route 122.

TIP

Speak to the wandering Pokémon Center employee as you cross Route 121's south pier, and she'll restore your Pokémon to full health.

Field Moves Needed Surf

ROUTE 122

People make their way to Mt. Pyre over this water route, reliving many precious memories as they traverse it.

Mighty Mt. Pyre reaches up from the depths of this briny blue route, which stretches between Route 121 to the north and Route 123 to the south. Besides the north and south piers, the only land to be found on Route 122 is a small patch of sand up north near the route sign and the bit of grass in front of Mt. Pyre's yawning entrance.

To Route 121
(p. 174)

To Mt. Pyre
(p. 188)

To Route 123
(p. 186)

On the Water	
☐ Pelipper	▲
☐ Tentacool	◎
☐ Wingull	○

◎ frequent ○ average
△ rare ▲ almost never

Fishing	
Old Rod	
☐ Magikarp	◎
☐ Tentacool	○
Good Rod	
☐ Magikarp	◎
☐ Tentacool	◎
☐ Wailmer	▲
Super Rod	
☐ Wailmer	◎

Wailmer `Water`
Abilities: Water Veil, Oblivious

1 **Choose your next stop**

Mt. Pyre is located in the middle of Route 122. Surf up to the mountain's south side and enter the cave to begin your pursuit of Team Magma / Team Aqua. If you prefer, you can Surf down to the route's south pier and travel south to complete your exploration of Route 123 before tackling Mt. Pyre.

TIP

Land on Mt. Pyre and go inside. Once you've gone in, you can easily return to Route 122 in the future by way of Fly. If you're up for more exploration, check out the next pages to return to Route 123 and collect more items, Berries, and even a Mega Stone. Otherwise, skip ahead to page 188 to rush straight into Mt. Pyre.

TRAINER HANDBOOK

ADVANCED HANDBOOK

ADVENTURE DATA

Field Moves Needed — Cut, Surf

This route offers a convenient path back to Mauville City from Mt. Pyre, but be aware that it is a one-way road.

This large, optional route is filled with items and Berries, making it a rewarding route to explore. It slopes downward from east to west, so enter Route 123 from Route 122 if you wish to explore the area fully.

Horde Encounter

☐ Kecleon (×5)	▲
☐ Shuppet (×5)	◎
☐ Wingull (×5)	○

◎ frequent ○ average
△ rare ▲ almost never

On the Water

☐ Azumarill	△
☐ Marill	◎
☐ Masquerain	▲
☐ Surskit	○

Very Tall Grass

☐ Gloom	○
☐ Kecleon	▲
☐ Linoone	○
☐ Pelipper	▲
☐ Shuppet	○

Fishing

Old Rod	
☐ Goldeen	○
☐ Magikarp	◎
Good Rod	
☐ Corphish	▲
☐ Goldeen	○
☐ Magikarp	◎
Super Rod	
☐ Corphish	◎
☐ Crawdaunt	▲

Items

☐ Elixir
☐ Eviolite
☐ Gyaradosite
☐ PP Up
☐ Revival Herb
☐ TM99 Dazzling Gleam
☐ Ultra Ball
☐ Wide Lens

Hidden Items

☐ Hyper Potion
☐ PP Up
☐ Rare Candy
☐ Revive
☐ Super Repel

Berry Trees · Berry Trees · Berry Trees · Berry Trees — A

Gloom Grass Poison
Ability: Chlorophyll

Corphish Water
Abilities: Hyper Cutter, Shell Armor

To Route 118 (p. 150)

Fisherman Timin
Fisherman Finley
123 Go Fish
Street Thug Hannibal
Ace Trainer Julie
Berry Master's House
A
Berry Trees
Berry Trees
To Route 122 (p. 185)

Aroma Lady Violet
Fisherman Fisher
Twins Miu & Yuki
★ Double Battle
Ace Trainer Clyde
Delinquent Kylie
Ace Trainer Wendy
Picnicker Martha
Psychic Cameron

1 | Get a Big Root

Orlando obtained a Big Root!

Route 123 has all sorts of goodies! Assuming you've entered from Route 122, speak to the little girl near the Berry Trees. She'll give you a Big Root if you've got a Grass-type Pokémon in your party. This held item boosts the power of HP-stealing moves, causing the user to recover more HP when using moves like Absorb, Mega Drain, and Giga Drain, which many Grass Pokémon can learn.

Reward: Big Root

2 ▸ Cut trees and dowse to find items

Would you like to use Cut?

Cut down the prickly tree to the east to reach a Trainer and a Revival Herb. Use your Dowsing Machine afterward to locate a couple of hidden items in the vicinity. Cut down another prickly tree near the very tall grass to the west, and then go north to find more Berry Trees. After reaping your harvest, jump down the west ledge and then down the south ledge to reach an Elixir.

3 ▸ Fly back to this route to get a PP Up

Orlando found a PP Up!

TIP

If you didn't go inside Mt. Pyre before coming to Route 123, you can't Fly back to Route 122 yet. Try to get the item after visiting Mt. Pyre.

Jump down the south ledge after claiming the Elixir and battle Trainers as you explore to the west. When you spy an item on a north ledge that's out of reach, it's time to use Fly. Fly back to Route 122 and Surf back to Route 123. This time, after cutting down the prickly trees near the very tall grass, go north where Berry Trees are, and then jump down a ledge to the west. Then keep going west until you can't go any farther. Jump down two ledges to the south and battle Ace Trainer Julie near the Secret Spot to the northwest. After the battle, jump down another ledge to the west and move through the very tall grass to reach the item that you couldn't reach before: a PP Up.

4 ▸ Fish up some more items

Could you give it a little scratch?

Backtrack north through the very tall grass and jump down the ledge to the west. You'll land near a small pond and a small house. Enter it to visit the 123 Go Fish supply store. You can't buy anything here, but you can get a Mega Stone called Gyaradosite by giving the shack's guard Pokémon, Chomper, a good scratch. Tell the nearby Fisherman that you like Magikarp as well, and he'll give you an Eviolite.

5 ▸ Score TM99 Dazzling Gleam

Orlando obtained
TM99 Dazzling Gleam!

Battle the Fishermen around the pond if you want, and collect the Wide Lens lying on the nearby ground. Hop down from the ledge, and you'll be on Route 123's lowest trail. You may have explored this area before on your way to Route 119, but if you didn't, be sure to speak with the little Fairy Tale Girl to receive TM99 Dazzling Gleam.

6 ▸ Visit the Berry Master

Orlando obtained a
Hondew Berry!

Last on the list of Route 123's attractions is the Berry Master and the great Berry garden that he tends. Talk to the Berry Master and he'll randomly give you two of the following Berries each day: Pomeg, Kelpsy, Qualot, Hondew, Grepa, Tamato, Cornn, Magost, Rabuta, or Nomel.

TIP

The Berry Master's wife will give you a Berry each day as well, but the type depends on whether you succeed in helping her recall a certain phrase. If you don't get the phrase exactly right, then you'll get one of the following common Berries: Cheri, Chesto, Pecha, Rawst, Aspear, Leppa, Oran, Persim, Lum, or Sitrus. The following table tells you how to complete her phrases, and the rare Berries you'll receive when you do.

Wife's Phrase	Your Answer*	Berry Received
SOMETHING BATTLE	GREAT	Spelon Berry
CHALLENGE SOMETHING	CONTEST	Pamtre Berry
SOMETHING LATIAS	OVERWHELMING	Watmel Berry
COOL SOMETHING	LATIOS	Durin Berry
SUPER SOMETHING	HUSTLE	Belue Berry
Note: Answers are case-sensitive. Use all caps!		

If you accidentally give her the wrong answer, or if you've already helped her recall all five sayings, she'll give you a common Berry once a day.

Another man in the Berry Master's House mentions the Gracidea flower. If you happen to have the Pokémon Shaymin, which is not found in the Hoenn region, show it to him for a thanks-inspiring treat: Gracidea!

MT. PYRE

Field Moves Needed — Surf

The mountain is where the spirits of Pokémon have rested and will always rest: past, present, and future.

This towering mountain exists to soothe the spirits of Pokémon that have passed on. Hoenn's most beloved Pokémon have been laid to rest here, making Mt. Pyre a very sacred place.

1F

Hex Maniac Valerie ◉

Psychic William

Poké Maniac Mark

To Route 122 (p. 185)

Fairy Tale Girl Momo ◉

2F

Black Belt Atsushi

Young Couple Dez & Luke ★ Double Battle

3F

Mysterious Sisters Elle & Aya ★ Double Battle

Hex Maniac Tasha

Backpacker Darnell

4F

Interior		
❑ Shuppet	◎	
❑ Duskull	○	

Horde Encounter		
Interior		
❑ Shuppet (×5)	◎	
Exterior Wall and Summit		
❑ Meditite (×5)	○	
❑ Shuppet (×5)	◎	
❑ Vulpix (×5)	▲	

◎ frequent ○ average
△ rare ▲ almost never

Tall Grass

Exterior Wall	
❑ Meditite	◎
❑ Shuppet	◎
❑ Vulpix	△
❑ Wingull	▲

Summit	
❑ Chimecho	▲
❑ Meditite	◎
❑ Shuppet	◎
❑ Vulpix	△

◎ frequent ○ average
△ rare ▲ almost never

Items

1F	Exterior Wall	
❑ Cleanse Tag	❑ Max Potion	
❑ Ultra Ball	❑ TM61 Will-O-Wisp	
2F	**Summit**	
❑ Super Repel	❑ Banettite	
3F	❑ Blue Orb	Ω
❑ Lax Incense	❑ Red Orb	α
❑ Sea Incense		
4F		
❑ Medichamite		
❑ TM30 Shadow Ball		

Hidden Items

Exterior Wall	
❑ Max Ether	
❑ Ultra Ball	
Summit	
❑ Carbos	
❑ Dire Hit	
❑ Rare Candy	
❑ Zinc	

Exterior Wall

Summit

Team Magma /
Team Aqua Grunt
◎◎◎○○○

Team Magma
Admin Courtney /
Team Aqua
Admin Matt
◎◎◎○○○

Team Magma /
Team Aqua Grunt
◎◎○○○

Team Magma /
Team Aqua Grunt
◎◎○○○○

1 Battle Trainers as you explore

Hey! Are you searching for Pokémon?
You came along after me! How rude!

Surf around to Mt. Pyre's south side, and then land on the grass. Enter the mountain to begin your exploration of its interior. Mt. Pyre is full of Pokémon Trainers who have come to pay their respects to the departed Pokémon. Many just have stories to share, but some of them will gladly battle you unless you find a way around them through the headstones.

2 Obtain the Cleanse Tag

Orlando obtained a
Cleanse Tag!

Speak to the old lady who stands in the first floor's lower-left corner. She is aware that Mt. Pyre is filled with wild Pokémon, so she gives you a Cleanse Tag out of concern for your safety. Have your lead Pokémon hold the Cleanse Tag, and it will reduce the chances of wild Pokémon encounters as you explore, working much like a Repel except that it will never wear off.

🔖 TIP

Mt. Pyre is filled with Ghost-type Pokémon, making it a perfect place to raise your Dark-type Pokémon, which are strong against Ghost types. Dark-type Pokémon will be of great use to you in the upcoming Pokémon Gym, so consider stashing the Cleanse Tag and giving your Pokémon plenty of training as you climb Mt. Pyre. Just remember that Normal- and Fighting-type moves will have no effect whatsoever on Ghost types.

3 | Find items as you ascend

Orlando found a Super Repel!

Mt. Pyre features four interior floors, each of which contains at least one valuable item. Keep an eye out for these items as you battle Trainers and ascend Mt. Pyre. Luckily they're all visible, so there's no need for your Dowsing Machine within these eerie halls. But not everything is visible here. Did you happen to spot any wisps of purple smoke? Those are hidden Pokémon, so use your DexNav in Detector Mode to try to catch a few!

4 | Search the fourth floor, and then go outside

Orlando found
TM30 Shadow Ball!

When you reach the third floor, you have the option to go outside or continue up to the fourth floor. Go up to the fourth floor first to claim TM30 Shadow Ball. Inspect the sparkling spot in the upper-right corner to discover a Mega Stone called Medichamite. Your Mega Stone collection just keeps on growing!

5 | Go outside and collect TM61 Will-O-Wisp

Orlando found
TM61 Will-O-Wisp!

After searching the fourth floor, backtrack down to the third floor and go outside. Navigate the mountain's exterior wall and collect more items as you head for the summit. Be sure to grab TM61 Will-O-Wisp, a Fire-type move that can inflict the target with a Burn. There's also a Max Potion here.

TIP

More Pokémon can be caught in the tall grass along Mt. Pyre's exterior wall, including Meditite, Vulpix, and Wingull. Meditite will be able to use that Medichamite you just found once it evolves into Medicham at Level 37!

6 | Dowse to find hidden items as you climb

In addition to visible items, you can also use your Dowsing Machine to discover hidden items outside. Dowse around Mt. Pyre's exterior wall to find a hidden Max Ether and an Ultra Ball.

7 | Battle Grunts on the summit

Keep climbing Mt. Pyre until you reach some stairs that lead up to the summit. At last, you finally catch up with Team Magma / Team Aqua. Show the first two Grunts no mercy as you advance toward the north steps.

8 | Search east and west for hidden goodies

Orlando found a Banettite!

Don't climb the north steps after you've beaten the second Grunt. Instead, search the west side trail to find a hidden Zinc. Then search the east side trail to discover a sparkling patch of ground where a Mega Stone called Banettite can be found. Hopefully you caught one of the Shuppet inside, because they'll evolve into Banette starting at Level 37. If you didn't, try to catch one before you leave this place. Chimecho can be caught in the tall grass to the east as well.

9 | Confront Maxie/Archie on the summit

Defeat one more Grunt on your way north. When you reach the very top of Mt. Pyre, you'll arrive just in time to witness Maxie/Archie, the leader of Team Magma / Team Aqua, stealing the Red Orb / Blue Orb from its sacred altar! This must be the Orb that Archie/Maxie mentioned back at Mt. Chimney.

10 | Battle Team Magma Admin Courtney / Team Aqua Admin Matt

...Hah. ♪

Oohh... Ha! Ha! Hah!

As in your previous encounter atop Mt. Chimney, Maxie/Archie hasn't much time to waste on you. Having obtained the Red Orb / Blue Orb, the leader of Team Magma / Team Aqua quickly departs, leaving you to battle his capable Admin, Courtney/Matt. Time for a showdown!

Team Magma Admin Courtney's Pokémon ⊙○○○○○

Camerupt | Fire | Ground
♀ Lv. 38
Weak to: 4× Water | Ground

Team Aqua Admin Matt's Pokémon ⊙○○○○○

Sharpedo | Water | Dark
♂ Lv. 38
Weak to: Grass | Electric | Fighting | Bug | Fairy

11 Obtain the Blue Orb / Red Orb

Beaten, Team Magma / Team Aqua Admin Courtney/Matt is forced to flee. The elderly caretakers of the Orbs then entrust the remaining Blue Orb / Red Orb to you, saying that the two Orbs belong together and must never be separated as they are now. Your task is clear: You must go after Maxie/Archie and reunite the Orbs. Speak to the caretakers after obtaining the Blue Orb / Red Orb to learn more about the Orbs' purpose.

Walking Away with the Orb

Despite your best efforts to stop him, Team Magma / Team Aqua Leader Maxie/Archie has succeeded in stealing the Red Orb / Blue Orb from the top of Mt. Pyre. Maxie/Archie seems confident that this sparkling artifact holds the key to waking Hoenn's ancient Legendary Pokémon—a deed that Maxie/Archie believes will bring about the great future he dreams of. All evidence indicates that awakening Hoenn's ancient Pokémon will result in disaster, but there's no reasoning with this driven dreamer!

12 Finish searching the summit, and then Fly to Slateport

Orlando found Carbos!

Before taking his leave, Maxie/Archie hinted that he needed to use the submarine that's moored at the harbor in Slateport City. Now that he has the Red Orb / Blue Orb, he must be planning to probe the depths of Hoenn's ocean for the slumbering ancient Pokémon he plans to awaken! You'd better Fly to Slateport City and see if you can catch him. But before you take flight, give the summit a thorough search to discover hidden Carbos, Dire Hit, and Rare Candy.

TIP

If you didn't explore Route 123 earlier (p. 186), consider doing so now instead of Flying directly to Slateport City. You'll find lots of useful items and gain some valuable Exp. Points for your Pokémon along the way. Head down through Mt. Pyre's levels or Fly to Route 122, and Surf southward to reach Route 123.

◀◀ BACKTRACK ▌ SLATEPORT CITY

p. 73

Yes, indeed. And that is why we intend to move ahead with our expedition.

Rest your party, and then head for the Harbor

When you arrive in Slateport City, enter the Pokémon Center and rest your Pokémon. Shop at the nearby market and Poké Mart if you want. When you're ready to move on, go north and then east from the Pokémon Center to find Captain Stern giving a TV interview near the harbor.

Confront Maxie/Archie near the submarine

After Captain Stern's interview draws to a close, you catch up to him for a little chat—but as soon as you do, a voice booms out from a megaphone somewhere. It's Maxie/Archie! The villain mocks Captain Stern, thanking him for the use of his submarine. Hurry inside to find Maxie/Archie standing near the sub, ready to depart.

Battle two Team Magma / Team Aqua Grunts

Maxie/Archie has come too far to be stopped by you now. His faithful Admin, Tabitha/Shelly, orders two Grunts to keep you busy while he/she and his/her fearless leader make off with Captain Stern's sub. You'll be drawn into battle against each in turn, but their Pokémon are pretty standard and you should be good at handling Grunts by now. Take care of them so that you can quickly figure out what to do about that stolen sub.

Let Captain Stern ferry you to the harbor

After you've defeated the Grunts, Captain Stern begs you to pursue Team Magma / Team Aqua to their hideout in Lilycove City. That's where Maxie/Archie intends to modify Stern's sub before seeking out the ancient Legendary Pokémon that sleeps in the depths of the sea. Agree to help Captain Stern, and he'll ferry you directly to the harbor in Lilycove City. Otherwise you can make your own way there, if you'd like.

Prepare your party and then head for the hideout

Team Magma / Team Aqua's hideout can be found in the cave north of Lilycove City's east beach. You must storm their hideout in order to retrieve Captain Stern's submarine, so prepare a party that can handle plenty of battles against Team Magma / Team Aqua. When picking out your team, remember that Team Magma often uses Fire types and Dark-type Pokémon, while Team Aqua often uses Water types and Dark-type Pokémon. When you're ready, head to the east beach and Surf into the north cave.

Field Moves Needed

Surf

This inconspicuous cave has been transformed into a base of operations by Team Magma.

While the good people of Hoenn have been enjoying their daily lives, Team Magma has been working hard to build an impressive hideout in a spacious cave near Lilycove City. Storming this heavily guarded base won't be easy, but you must risk it all to prevent Maxie's misguided vision from becoming reality!

TIP

If you're playing *Pokémon Alpha Sapphire*, then this section doesn't apply to you. Please flip ahead to page 199 for a similar walkthrough for the Team Aqua Hideout.

Tentacool `Water` `Poison`
Abilities: Clear Body, Liquid Ooze

Magikarp `Water`
Ability: Swift Swim

Entrance

A

To Lilycove City
(p. 178)

On the Water

Tentacool	◎	

Fishing

Old Rod		
☐ Magikarp	◎	
☐ Tentacool	○	
Good Rod		
☐ Magikarp	◎	
☐ Tentacool	○	
☐ Wailmer	▲	
Super Rod		
☐ Staryu	▲	
☐ Wailmer	◎	

◎ frequent ○ average
△ rare ▲ almost never

Vending Machine

Fresh Water	150
Lemonade	300
Soda Pop	250

Items

1F	
☐ Full Restore	
☐ Max Elixir	
☐ Nugget	
B1F	
☐ Escape Rope	
☐ Nest Ball	
B2F	
☐ TM97 Dark Pulse	
B3F	
☐ Master Ball	
☐ Nugget	
B4F	
☐ Max Revive	
☐ PP Max	

1F

Team Magma Grunt ◎◎◎◎◎◎
Team Magma Grunt ◎◎◎◎◎◎

B1F

Team Magma Grunt ◎◎◎◎◎◎

Team Magma Grunt ◎◎◎◎◎◎
Team Magma Grunt ◎◎◎◎◎◎

B2F

B3F

Team Magma Admin Courtney
◎◎◎◎◎◎

B4F

P

K

J

O

Team Magma Grunts
★ Horde Battle
◎◎◎◎◎◎

Team Magma Grunt
◎◎◎◎◎◎

N

1 Use green warp panels to navigate the base

Team Magma's high-tech hideout is a complex facility crammed with various labs and offices. Navigating the base isn't easy. You must use a number of green warp panels to make your way around the compound. Step on the first warp panel (on your right after climbing the entry stairs), which is labeled **B** on the map, and you'll be whisked away to a small storage room that contains a Nugget.

2 Rest up in the barracks

Orlando found a Full Restore!

Use the next warp panel at the hall's north end (warp panel **C**) to reach the first floor's security room. Battle a couple of Grunts here if you want, and then use the room's other warp panel (**D**) to reach the barracks and mess hall (also located on the first floor). Rest in a bed here to restore your Pokémon. Make sure to grab the Full Restore near the sink in the kitchen.

3 Go downstairs to reach the Meteorite lab

It's a machine for irradiating a Meteorite with lasers.

Warp back to the security room and go downstairs to reach the first basement floor (B1F). Snatch the Escape Rope near the Vending Machine, and consider buying a few beverages before searching the nearby lab, where a scientist has been attempting to create a Red Orb out of a meteorite. So that's why these creeps were after Professor Cozmo's Meteorite!

TIP

Some Grunts will battle you in the hideout, while others are too busy with their duties to be bothered with you.

4 | Warp to TM97 Dark Pulse

Orlando found
TM97 Dark Pulse!

After inspecting the Meteorite in the lab, use the lab's top-right warp panel (F) to return to the first floor. Take the next warp panel ahead (G) to reach the second basement floor's east wing, where you'll discover TM97 Dark Pulse—a powerful Dark-type move that could be a great help in the next Gym.

5 | Grab a Max Elixir in the library

Orlando found a Max Elixir!

Backtrack to the Meteorite lab, and this time, use the top-left warp panel (H) to visit the library on the first floor. Collect a Max Elixir and inspect the bookshelves to read up on something called Project AZOTH. File No. 1 is located here, while File No. 2 is located in the Meteorite lab you were just in. You may want to check it out as well to learn more about Team Magma's plans.

TIP

The goal of Project AZOTH is to return the world—return everything—to the beginning. The project hinges on Primal Reversion: a potential of Pokémon Evolution that's made possible by natural energy. Primal Reversion is similar to Mega Evolution in that both states significantly enhance the Pokémon's power—the difference lies in the source of the energy required.

6 | Check out the other lab

Sturdy protective gear is attached to the machine.

Return to the Meteorite lab, and this time, use warp panel I at the east end of the hall near the lab to zip over to another lab on the first basement floor's west side. Here, a scientist is running tests on some sturdy protective gear called a Magma Suit. Check out the Magma Suit, and then collect the Nest Ball in the lab's top-right corner.

7 | Warp to a PP Max

Orlando found a PP Max!

Use the Magma Suit lab's right warp panel (J) to reach a short hall with another warp panel (K). Use warp panel K to reach the fourth basement floor. This floor is your ultimate destination, but you're only able to explore its east walkway from this vantage. Still, there's a valuable PP Max to be had.

8 | Navigate the warp panel maze

Backtrack to the Magma Suit lab. You can ignore the lab's other warp panel, which leads to Tabitha's room, but he's not there now. Instead, head south into the hallway again and then turn west. Make your way past a Grunt to the hall's north warp panel (L). Take this warp panel to reach a room with two warp panels, one to the west and one to the south. Step on the south warp panel (M) to reach four rows of warp panels on the second basement floor. Here's how to navigate them:

First (top) row: Step on the left or right warp panel to reach the second row.

Second row: Step on the middle warp panel to reach the third row.

Third row: Step on the right warp panel to reach the fourth row.

Fourth (bottom) row: Avoid the middle warp panel and step on the right warp panel (N) to reach the third basement floor.

9 | Secure a stash of items

Orlando found a Nugget!

Successfully navigating the warp panel maze brings you to Maxie's small, private office. Loot the place to collect a Nugget and a precious Master Ball—but beware that the other two items are actually wild Electrodes in disguise! After claiming the items, backtrack through the warp panel maze by doing the following:

Fourth (bottom) row: Step on the middle warp panel to reach the second row.

Second row: Step on the left or right warp panel to reach the top row.

10 | Battle a horde of Grunts on the fourth basement floor

Brace yourself! We'll show you the power of quintuplets!

Backtrack out of the warp panel maze to return to the first basement floor's hall. This time, step on the top-left warp panel (O) to reach the fourth basement floor, where Team Magma has nearly finished their modifications to Captain Stern's sub. Get set to battle a single Grunt down here, followed by a group of not one, but five Grunts at once!

Team Magma Grunts' Pokémon

Whoa, it's a whole horde of Poochyena! Fortunately, they're quite low level. Moves that strike all opposing Pokémon will make short work of these ruffians. Use moves like Bulldoze, Surf, Air Cutter, or Dazzling Gleam to end the battle rapidly.

Poochyena (×5) — Dark
♂ Lv. 18
Weak to: Fighting | Bug | Fairy

11 | Confront Courtney near the sub

...It's all over now. ♪
...The submarine has been upgraded.

Grab the Max Revive that's tucked away near the crate beyond the Grunts, and then go north to confront Team Magma Admin Courtney. She's the only thing standing between you and Maxie's modified sub, but you'll have to get past her before you can stop Maxie's getaway!

Team Magma Admin Courtney's Pokémon

Camerupt `Fire` `Ground`
♀ Lv. 39
Weak to: 4x `Water` `Ground`

12 | Escape the hideout

Your battle against Courtney lasts just long enough to let Maxie escape in his souped-up submarine. Oh no! You've got to pursue Maxie to the Seafloor Cavern, but you've no means of diving underwater like he can in his sub. For now, you'll have to keep to the surface. Head north, then east, and use warp panel **P** to bounce back to the hideout's first floor. Then sprint south and Surf out of the hideout to return to Lilycove City.

◀◀ BACKTRACK | LILYCOVE CITY p. 178

Rest up and then Surf east to Route 124

Now that you've cleared out Team Magma's hideout, the Grunt's Wailmer, which had been blocking the east channel, are no longer an obstacle. Restore your party at Lilycove City's Pokémon Center before Surfing east into Route 124 in search of some way to prevent Team Magma from fulfilling their plans to free the super-ancient Pokémon.

TEAM AQUA HIDEOUT α

Field Moves Needed Surf

This inconspicuous cave has been transformed into a base of operations by Team Aqua.

While the good people of Hoenn have been enjoying their daily lives, Team Aqua has been working hard to build an impressive hideout in a spacious cave near Lilycove City. Storming this heavily guarded base won't be easy, but you must risk it all to prevent Archie's misguided vision from becoming reality!

TIP

If you're playing *Pokémon Omega Ruby*, then this section doesn't apply to you. Please turn back to page 194 for a similar walkthrough of the Team Magma Hideout.

On the Water

☐ Tentacool	◎	

Vending Machine

Fresh Water	150
Lemonade	300
Soda Pop	250

Items

1F
- ☐ Full Restore
- ☐ Max Elixir
- ☐ Nugget

B1F
- ☐ Escape Rope
- ☐ Nest Ball

B2F
- ☐ TM97 Dark Pulse

B3F
- ☐ Master Ball
- ☐ Nugget

B4F
- ☐ Max Revive
- ☐ PP Max

Fishing

Old Rod

☐ Magikarp	◎
☐ Tentacool	○

Good Rod

☐ Magikarp	◎
☐ Tentacool	○
☐ Wailmer	▲

Super Rod

☐ Staryu	▲
☐ Wailmer	◎

◎ frequent ○ average
△ rare ▲ almost never

Wailmer `Water`
Abilities: Water Veil, Oblivious

Staryu `Water`
Abilities: Illuminate, Natural Care

Entrance

A

To Lilycove City (p. 178)

1F

Team Aqua Grunt ◎◎◎◎◎◎

Team Aqua Grunt ◎◎◎◎◎◎

E

C

F

C

D

C

B/P

Rest your Pokémon here

D

B

I

H

Q

R

A

TRAINER HANDBOOK

ADVANCED HANDBOOK

ADVENTURE DATA

B1F

Q F L O K J L J H G M E G

Team Aqua Grunt

Team Aqua Grunt

Team Aqua Grunt

B2F

M N R I

B3F

N

B4F

P K O

Team Aqua Admin Matt

Team Aqua Grunt

Team Aqua Grunts
★ Horde Battle

1 Use green warp panels to navigate the base

Team Aqua's high-tech hideout is a complex facility crammed with labs and offices. Navigating the base isn't easy. You must use a number of green warp panels to make your way around the compound. Step on the first warp panel (on your left after climbing the entry stairs), which is labeled **B** on the map, and you'll be whisked away to a small storage room that contains a Nugget.

2 Rest up in the barracks

Orlando found a Full Restore!

Use the next warp panel (**C**) at the hall's north end to reach the first floor's security room. Battle a couple of Grunts here if you want, then use the room's other warp panel (**D**) to reach the barracks and mess hall (also located on the first floor). Rest in a bed here to restore your Pokémon. Make sure to grab the Full Restore near the table in the dining area.

3 Go downstairs to reach the Meteorite lab

It's a machine for irradiating a Meteorite with lasers.

Warp back to the security room and go downstairs to reach the first basement floor (B1F). Pick up the Escape Rope near the Vending Machine, and consider buying a few beverages before searching the nearby lab, where a scientist has been attempting to create a Blue Orb out of a meteorite. So that's why these creeps were after Professor Cozmo's Meteorite!

4 Grab a Max Elixir in the library

Orlando found a Max Elixir!

Use the lab's top-right warp panel (**F**) to visit the library on the first floor. Collect a Max Elixir, and then inspect the bookshelves to read up on something called Project AZOTH. File No. 1 is located here, while File No. 2 is located in the Meteorite lab you were just in. You may want to check it out as well to learn more about Team Aqua's plans.

5 Check out the other lab

Sturdy protective gear is attached to the machine.

Return to the Meteorite lab, and this time, use warp panel **G** at the west end of the hall near the lab to zip over to another lab on the first basement floor's east side. (You can ignore the lab's other warp panel—it leads to Matt's room, but he's not there now.) Here, a scientist is running tests on some sturdy protective gear called an Aqua Suit. Check out the Aqua Suit, and then collect the Nest Ball in the lab's top-left corner.

TIP

Some Grunts will battle you in the hideout, while others are too busy with their duties to be bothered with you.

TIP

The goal of Project AZOTH is to return the world—return everything—to the beginning. The project hinges on Primal Reversion: a potential of Pokémon Evolution that's made possible by natural energy. Primal Reversion is similar to Mega Evolution in that both states significantly enhance the Pokémon's power—the difference lies in the source of the energy required.

6 Warp to TM97 Dark Pulse

Orlando found
TM97 Dark Pulse!

After inspecting the Aqua Suit in the lab, use the lab's right warp panel () to return to the first floor. Take the next warp panel ahead () to reach the second basement floor's east wing, where you'll discover TM97 Dark Pulse—a powerful Dark-type move that could be a great help in the next Gym.

7 Warp to a PP Max

Orlando found a PP Max!

Return to the Aqua Suit lab, and this time, use the left warp panel () to reach a short hall with another warp panel (). Use warp panel K to reach the fourth basement floor. This floor is your ultimate destination, but you're only able to explore its west walkway from this vantage. Still, there's a valuable PP Max to be had.

8 Navigate the warp panel maze

Backtrack to the Aqua Suit lab. Head south into the hallway and then turn east past the Grunt on your way to the hall's north warp panel (). Take this warp panel to reach the first basement floor's central hall, where you can challenge another Grunt. After the battle, step on the south warp panel () to reach four rows of warp panels on the second basement floor. Here's how to navigate them:

First (top) row: Step on the left or right warp panel to reach the second row.

Second row: Step on the middle warp panel to reach the third row.

Third row: Step on the left warp panel to reach the fourth row.

Fourth (bottom) row: Avoid the middle warp panel and step on the left warp panel () to reach the third basement floor.

9 Secure a stash of items

Orlando found a Nugget!

Successfully navigating the warp panel maze brings you to Archie's small, private office. Loot the place to collect a Nugget and a precious Master Ball—but beware that the other two items are actually wild Electrode in disguise! After claiming the items, backtrack through the warp panel maze by doing the following:

Fourth (bottom) row: Step on the middle warp panel to reach the second row.

Second row: Step on the left or right warp panel to reach the top row.

TIP

Electrode are weak to Ground-type moves, which you could use to quickly defeat them, but see if you can catch one of these rare enemies instead of knocking it out!

10 | Battle a horde of Grunts on the fourth basement floor

Brace yourself!
We'll show you the power of quintuplets!

Backtrack out of the warp panel maze to return to the first basement floor's hall. This time, step on the top-right warp panel (◯) to reach the fourth basement floor, where Team Aqua has nearly finished their modifications to Captain Stern's sub. Get set to battle a single Grunt down here, followed by a group of not one, but five Grunts at once!

Team Aqua Grunts' Pokémon

Whoa, it's a whole horde of Poochyena! Fortunately, they're quite low level. Moves that strike all opposing Pokémon will make short work of these ruffians. Use moves like Bulldoze, Surf, Air Cutter, or Dazzling Gleam to end the battle rapidly.

◯ **Poochyena (×5)** **Dark**
♀ Lv. 18
Weak to: **Fighting** **Bug** **Fairy**

11 | Battle Matt near the sub

We already completely
finished upgrading the ship!

Grab the Max Revive that's tucked away near the crate beyond the Grunts, and then go north to confront Team Aqua Admin Matt. He's the only thing standing between you and Archie's modified sub, but you'll have to get past him before you can stop Archie's getaway!

Team Aqua Admin Matt's Pokémon

◯ **Sharpedo** **Water** **Dark**
♂ Lv. 39
Weak to: **Grass** **Electric** **Fighting**
 Bug **Fairy**

12 | Escape the hideout

Your battle against Matt lasts just long enough to let Archie escape in his souped-up submarine. Oh no! You've got to pursue Archie to the Seafloor Cavern, but you've no means of diving underwater like he can in his sub. For now, you'll have to keep to the surface. Head north, then west, and use warp panel **P** to bounce back to the hideout's first floor. Then sprint south and Surf out of the hideout to return to Lilycove City.

Rest up and then Surf east to Route 124

Now that you've cleared out Team Aqua's hideout, the Grunt's Wailmer, which had been blocking the east channel, are no longer an obstacle. Restore your party at Lilycove City's Pokémon Center before Surfing east to Route 124 in search of some way to prevent Team Aqua from fulfilling their plan to free the super-ancient Pokémon.

ROUTE 124

Field Moves Needed — Surf | Dive

This great stretch of ocean connects the cities of Lilycove, Mossdeep, and Sootopolis.

Route 124's blue depths hold all sorts of secrets, but you must be able to use Dive outside of battle in order to discover what's down there. The Treasure Hunter lives along this route, but again, without the aid of Dive, you can't do much besides chat with him on your way to Mossdeep City.

Swimmer ♀ Jenny ◉
◎◎◎◎◎◎

Swimmer ♂ Roland
◎◎◎◎◎◎

Swimmer ♀ Grace
◎◎◎◎◎◎

To Lilycove City (p. 178)

Sis & Bro Rita & Sam ◉
★ Double Battle
◎◎◎◎◎◎

Treasure Hunter's House

Swimmer ♂ Chad
◎◎◎◎◎◎

Swimmer ♂ Spencer
◎◎◎◎◎◎

To Route 126 (p. 231)

To Mossdeep City (p. 205)

Fishing		
Old Rod		
❑ Magikarp	◎	
❑ Tentacool	○	
Good Rod		
❑ Magikarp	◎	
❑ Tentacool	○	
❑ Wailmer	▲	
Super Rod		
❑ Wailmer	◎	

On the Water		
❑ Pelipper	○	
❑ Tentacool	◎	
❑ Tentacruel	△	

◎ frequent ○ average
△ rare ▲ almost never

1 Surf to Mossdeep City

The ocean seems very deep here. Maybe a Pokémon could dive underwater?

Route 124 holds plenty of secrets, but most lie deep underwater. You can't fully explore this route until you're able to Dive, so simply Surf eastward to Mossdeep City, battling Trainers as you go. You'll pass the Treasure Hunter's House along the way, but you can't do much there until you learn Dive, either. If you're itching to know more about the Treasure Hunter, flip ahead to page 218.

MOSSDEEP CITY

Research is underway day and night in this city, all in the hope of understanding the distant reaches of space.

Perched on an island near Hoenn's eastern edge, where winds are mild and weather conditions are stable, Mossdeep City is the perfect place for rocket-launching. That's why the Mossdeep Space Station has been built here! Mossdeep also features a tricky Gym that's run by twin Psychics, Liza and Tate.

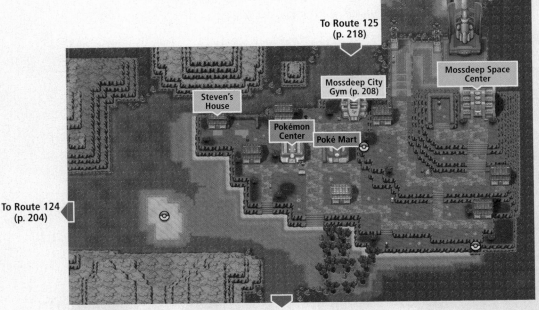

To Route 125 (p. 218)

Steven's House

Mossdeep City Gym (p. 208)

Mossdeep Space Center

Pokémon Center

Poké Mart

To Route 124 (p. 204)

To Route 127 (p. 222)

Vending Machine

Space Center	
Fresh Water	200
Lemonade	350
Soda Pop	300

Hidden Items

- ❏ Iron
- ❏ Star Piece

Items

- ❏ Big Pearl
- ❏ Devon Scuba Gear
- ❏ HM07 Dive
- ❏ King's Rock
- ❏ Net Ball
- ❏ Revive
- ❏ Sun Stone
- ❏ Super Rod
- ❏ TM60 Quash

Poké Mart

Antidote	100	Max Repel	700
Awakening	250	Paralyze Heal	200
Burn Heal	250	Poké Ball	200
Escape Rope	550	Potion	300
Full Heal	600	Repel	350
Full Restore	3,000	Revive	1,500
Great Ball	600	Super Potion	700
Ice Heal	250	Super Repel	500
Hyper Potion	1,200	Ultra Ball	1,200
Max Potion	2,500		

On the Water

❏ Pelipper	○	
❏ Tentacool	◎	
❏ Tentacruel	△	

Fishing

Old Rod		
❏ Magikarp	◎	
❏ Tentacool	○	
Good Rod		
❏ Magikarp	◎	
❏ Tentacool	○	
❏ Wailmer	▲	
Super Rod		
❏ Wailmer	◎	

◎ frequent ○ average
△ rare ▲ almost never

Wailmer `Water`
Abilities: Water Veil, Oblivious

Magikarp `Water`
Ability: Swift Swim

1 Rest up and receive TM60 Quash

Orlando obtained
TM60 Quash!

Collect the Big Pearl on the sandy island that's just west of Mossdeep's mainland, and then sprint across the shallows to reach Mossdeep proper. Take the first stairway you see leading up from the shore to reach the Pokémon Center and Poké Mart. Rest and speak to a girl inside the Poké Mart to receive TM60 Quash, a Dark-type move that causes the target to move last in battle.

2 Collect a King's Rock and a Star Piece

Orlando obtained a
King's Rock!

Go north from the Pokémon Center, and then head west to speak to the boy standing near some old stone walls. Your friend Steven has given this lad a King's Rock, but the boy doesn't want it. Agree to take it and you'll receive the King's Rock: a very useful held item that can cause opposing Pokémon to flinch when they take damage in battle. Use your Dowsing Machine to discover a nearby Star Piece as well.

3 Meet the Secret Base Expert

I'm waiting impatiently for a Secret Base to appear just beyond that door.

Head south from the Pokémon Center to find a yellow-roofed house. The man who lives inside claims to be a Secret Base Expert, and he's certain that there's space for an impressive Secret Base behind his back door. The door is locked tight, but perhaps you'll be able to open it one day.

4 Grab a Net Ball and have your Badges checked

Yes
No

Can I see one of your Gym Badges?

Go east from the Secret Base Expert's house, descend a few steps, and continue going east to find a Net Ball, which is good for catching Water-type and Bug-type Pokémon. Loop back around and enter the house north of the Net Ball to meet three Hex Maniacs. One of them can tell you which Pokémon were in your party when you won each of your Badges.

5 Meet the Fortree Breeder's girlfriend

Even though I can't see my dear friend in Fortree, a Pokémon carries mail back and forth for us.

Visit the house that's north of the Hex Maniacs' house to meet a young woman who uses a Wingull to send letters to a friend in Fortree City. Hey, this sounds familiar... Didn't you meet a Breeder in Fortree City who used a Wingull to send messages, too? Talk to the Wingull and it will take flight, off to deliver another note.

◀◀ BACKTRACK Fortree City p. 163

Orlando obtained a
Mental Herb!

Receive a Mental Herb from the Breeder

After you've met the young woman in Mossdeep City who uses a Wingull to send messages to her friend in Fortree City, Fly back to Fortree City and visit the Breeder who lives in the northeast tree house. This is the young woman's friend, and his Wingull has returned with a Mental Herb in its beak. The Breeder doesn't need the Mental Herb, so he'll give it to you. Score!

Reward: Mental Herb

6 Score a Sun Stone in the Space Center

Orlando obtained a
Sun Stone!

Climb the stairs north of the young woman's house to reach the Mossdeep Space Center. Check out the cool exhibits inside, and try moving behind the astronaut face board and sitting near the lookout windows for some neat views. More important, the Sailor near the Vending Machine will give you a Sun Stone that he found on the beach. This rare item can be used to make certain species of Pokémon, such as Gloom, evolve. Gloom evolves into Bellossom when it's given a Sun Stone. (It could also evolve into Vileplume instead if it's given a Leaf Stone.) Gloom can be easily found in the very tall grass on Route 119.

TIP

The Scientist near the Space Center's viewing area tells you how many rockets have been launched so far. This number is equal to the number of days you've been playing *Pokémon Omega Ruby / Pokémon Alpha Sapphire*. The longer you've been playing, the more rockets will have been launched!

7 Grab a Revive and get the Super Rod

Orlando obtained the
Super Rod!

Exit the Space Center and sprint downstairs. Go west and then north to find a Revive lying on the grass. Afterward, enter the nearby house to the north. You'll find a Fisherman who gives you the ultimate fishing rod: the Super Rod! Now you can catch every species of Pokémon that are available through fishing!

TIP

Remember to Register your Super Rod to ⓨ so it's easy to use whenever you like.

8 Explore the launchpad and find an Iron

Orlando found an Iron!

Your explorations of Mossdeep City are nearly complete. Go north from the Fisherman's house to check out the Space Center's launchpad. You can't do much around here, but you can give your Dowsing Machine a whirl and discover an Iron on the rocket's right side. Here's hoping it didn't come from the rocket!

TRAINER HANDBOOK

ADVANCED HANDBOOK

ADVENTURE DATA

MOSSDEEP CITY GYM BATTLE

Gym Battle Tips

- Bring lots of HP-restoring items like Moomoo Milk and Hyper Potions.
- If you've raised Dark-type Pokémon, or if you've caught Ghost-type Pokémon on Mt. Pyre, you'll have a big advantage.

Gym Leaders Liza & Tate
★ Double Battle

Hex Maniac Patricia

Hex Maniac Kindra

Psychic Fritz

Psychic Preston

Entrance

Psychic Joshua

Psychic Virgil

1 Assemble your party and then enter the Gym

Mossdeep City's Pokémon Gym is filled with gifted Trainers who send out a variety of Psychic-type Pokémon. Dark-type Pokémon are therefore your biggest advantage, because Psychic-type moves are completely ineffective against Dark-type Pokémon, and Dark-type moves are super effective against Psychic-type Pokémon. This makes Mightyena (evolved from Poochyena) one of your best Pokémon going in to this Gym. However, having any Dark-type Pokémon is an edge. You face a tough Double Battle at the end of this Gym, so try to bring as many Dark-type Pokémon as possible.

TIP

If you managed to obtain TM97 Dark Pulse in the Team Magma / Team Aqua Hideout, see if any of your Pokémon can learn it. If you can teach it to a Dark-type Pokémon, great! But look for Psychic- and Steel-type Pokémon that can learn Dark Pulse as well. These types are resistant to Psychic-type moves, so they won't take as much damage from the Psychic-type attacks they'll face in this Gym. And if they can counter with Dark Pulse, they'll be quite formidable!

Mt. Pyre is a great place to train your Dark-type Pokémon, because Dark-type Pokémon are strong against the wild Ghost types and Psychic types you'll encounter on Mt. Pyre. The Ghost-type and Psychic-type Pokémon that you can catch on Mt. Pyre are also useful in this Gym, because Ghost-type moves are super effective against Psychic-type Pokémon, and the opposing Pokémon's Psychic-type moves won't be very effective against your Psychic-type Pokémon.

2 Battle Trainers as you navigate the Gym

Mossdeep City Gym is a somewhat eerie place. Here, several small platforms float over a seemingly endless void. Each platform features a Trainer that sends out Psychic-type Pokémon. On most of the platforms, you will find a special stone that must be activated to open the passage to the next platform. Many of the Gym's Trainers can be bypassed if you're careful to avoid eye contact with them, but you must visit most of the floating platforms in order to activate the stones and advance through the Gym.

If this Gym's Psychic-type Pokémon are giving you headaches, remember that you can leave the Gym to rest your party at any time. You won't have to rebattle any Trainers that you've beaten when you return, and any stones that you've activated will remain active. So there's no reason not to leave the Gym and rest up as needed!

⚓ **Mossdeep City Gym Leaders**

Liza & Tate Psychic-type Pokémon Users

Nullify their attacks with Dark-type Pokémon!

Mossdeep City's Gym is unique in that you face not one, but two Leaders when you reach its end. Twins Liza & Tate send out two Pokémon, Lunatone and Solrock, drawing you into a challenging Double Battle. These are the only two Pokémon that they've got, but they're each quite powerful and they work well together as a team.

Expect Lunatone to cast a Light Screen on the first turn. This move protects both Lunatone and Solrock by reducing the damage from special moves for five turns. The opposing Pokémon can further increase their resistance to special moves by using Calm Mind, a move that raises the user's Sp. Def and Sp. Atk stats.

With all of this resistance to special moves, it's best to unleash physical attacks whenever possible. If you're using Dark-type Pokémon, try physical moves like Assurance and Feint Attack instead of special moves like Dark Pulse. Of course, moves that can damage both Lunatone and Solrock at once are also great, such as Surf. But know that both are immune to Ground-type attacks due to their Levitate Ability.

This battle can spiral out of control if you let Liza and Tate build momentum, so focus on exploiting their key weakness: their lack of backup Pokémon. With only two Pokémon at their disposal, it's fairly easy to defeat one of them early on. Single out Solrock or Lunatone and pile on your most powerful attacks to defeat it as quickly as possible. Once it falls, the other is sure to follow before long.

Liza & Tate's Pokémon

🔵 Lunatone Lv. 45		Rock	Psychic	
Weak to:	Water	Grass	Bug	Ghost
	Dark	Steel		

🔵 Solrock Lv. 45		Rock	Psychic	
Weak to:	Water	Grass	Bug	Ghost
	Dark	Steel		

Mind Badge

Pokémon up to Lv. 80, including those received in trades, will obey you. This Badge also lets you use Dive outside of battle to explore underwater.

TM04 Calm Mind

The user quietly focuses its mind and calms its spirit to raise its Sp. Atk and Sp. Def stats.

Step onto the warp panel near Liza and Tate to zip back to the Gym's entrance. A great rumble rocks Mossdeep City as you step outside, and a huge pillar of light bursts up from the distant sea. Oh no! The Seafloor Cavern's seal has been broken!

4 **Receive HM07 Dive from Steven**

Orlando obtained
HM07 Dive!

Spotting you outside the Gym, your mentor Steven races over and asks you to join him in his nearby house. Inside, Steven confirms that Team Magma / Team Aqua has succeeded in breaching the Seafloor Cavern. He asks you to help him stop Team Magma / Team Aqua, and he gives you HM07 Dive so you can visit the vast depths of Hoenn's seas. Steven also gives you the Devon Scuba Gear to ensure your safety as you explore underwater. The stage is set for you to pursue Team Magma / Team Aqua to the bottom of the sea!

Optional **Hoenn's seas** p. 212

Something serious is definitely going down in Hoenn, but you also just got your hands on an HM move that enables you to explore a whole new level of Hoenn: the underwater world! From here, your path could take several different forms. You could immediately head south to Route 127 (p. 222) to try to find the Seafloor Cavern and stop Team Magma / Team Aqua in their tracks. You might want to follow the pages between here and there, though, as they will net you some handy items and Pokémon, an O-Power, and even a cache of Nuggets and Big Nuggets to sell. And if you want to explore even further, you'll find that there's more for you to do before confronting your misguided foes. On page 225 you'll find a list of the optional areas to explore after you've completed everything the next few pages have to offer.

Let's Dive!

Yes
No

The ocean seems very deep here.
Would you like to use Dive?

HM07 Dive lets you explore the deepest parts of the sea. Just Surf out onto the water and look for spots that are darker than the surrounding water. Surf onto a dark spot, and then press Ⓐ to see if you can use Dive. Chances are good that there's an underwater trench or some great depth below you. If you have a Pokémon in your party that has learned Dive, you'll slap on the Devon Scuba Gear and duck under the waves.

TIP	**TIP**
You can also use Dive by pressing Ⓧ, choosing "Pokémon," selecting a Pokémon that knows Dive, and choosing "Use a Move."	Even if a Pokémon that knows Dive has fainted and is unable to battle, you can still use Dive in the field.

Returning to the surface

While exploring underwater with Dive, you'll notice light patches of water. Sunlight appears to be filtering down from above. Try surfacing at every sunlit spot you see. You just might pop up in a place that you couldn't have reached without using Dive! Many underwater trenches let you slip past rocks and other surface obstacles, so using Dive can be the key to reaching rare items up on the surface.

Underwater battles

While exploring underwater with Dive, look for patches of seaweed that flourish on the seafloor. Wild Pokémon love to hide in seaweed, and you may encounter wild Pokémon when you Surf over this aquatic plant life. If you want to avoid encounters, simply avoid seaweed beds. You'll also meet other Trainers while using Dive, so be ready to battle them as well! Luckily, all of your Pokémon can participate in battles underwater—you're not limited to battling with Pokémon that know Dive.

Sneaking up on hidden Pokémon

Hidden Pokémon can be caught while exploring underwater, just like they can be caught in the tall grass on land. Whenever hidden Pokémon appear in the seaweed, push lightly on the Circle Pad to swim slowly and sneak up on them. Don't hold Ⓑ or you'll move too quickly and scare away hidden Pokémon, regardless of how lightly you push on the Circle Pad.

Hidden items underwater

The Dowsing Machine doesn't function underwater, but there are still hidden items for you to discover. To search for hidden items underwater, keep tapping Ⓐ as you explore. If you press Ⓐ while moving over the location of a hidden item, you'll pluck it up from the seafloor and stuff it in your pocket.

> **TIP**
>
> Thoroughly search suspicious underwater areas with Ⓐ, such as dead-end passages or bare spots in the seaweed. This is where hidden items tend to be found!

Other things you can do while using Dive

Certain field moves can be used while using Dive, including Sweet Scent, Milk Drink, and Soft-Boiled. You can also save your progress at any time while exploring underwater, which is handy.

Things you can't do while using Dive

Most field moves can't be used while using Dive, including Dig, Strength, Cut, Fly, Waterfall, Teleport, and Flash. You can't use a fishing rod or the Dowsing Machine while using Dive, nor can you use Escape Ropes to return to the surface. Find a sunlit spot and swim toward the light if you wish to surface!

Special Pokémon Divers

Most Pokémon are represented with a generic model when using Dive, but some Pokémon have a special appearance. Check out Wailmer, Sharpedo, and even Kyogre! In fact, Kyogre is so big and scary that other Trainers won't challenge you to battle when you're using Dive with it. Its larger size also means that you can search a greater area with every movement, so Kyogre is handy to use when sweeping underwater areas for hidden items. However, squeezing into tighter locations with Kyogre can be a bit challenging!

Duskull Doll
Poké Ball Cushion
Tire
Flowering Plant

If you see anything that you want among my decorative items, let me know.

Obtain a new O-Power at the Pokémon Center

Before you begin your great Dive expedition, consider using Fly to Mauville City and speaking with the green-haired Trader in the Pokémon Center. He'll give you a neat Secret Base Decoration in exchange for an affordable item like a Potion, an Antidote, or a Poké Ball. Trade with the Trader to receive a Duskull Doll, a Poké Ball Cushion, a Tire, or a Flowering Plant, but choose carefully because you can only make one trade each day. As a bonus, after you make your first trade, the Trader teaches you a new O-Power: Stealth Power Lv. 1!

Rewards: Duskull Doll, Poké Ball Cushion, Tire, Flowering Plant

TIP

You may also want to purchase some Dive Balls at Fallarbor Town or Net Balls at Rustboro City. You can buy the Net Balls if you have obtained the Repeat Ball from the researcher in Rusturf Tunnel (p. 105) near the end. They're both great for catching the wild Pokémon that you'll soon be encountering underwater.

Optional | ROUTE 107 (UNDERWATER TRENCH)

Field Moves Needed

Surf Dive

The local children of Dewford Town practice long-distance swimming in the waters of this aquatic route.

Do you recall the very first patch of dark water you noticed while using Surf on the sea? It was near the eastern end of Route 107 (p. 146). Fly to Route 107 and Surf over to the patch. Then press Ⓐ and use Dive to explore your first underwater trench.

Surface

To Dewford Town (p. 64)

To Route 108 (p. 147)

TIP

Turn back to page 146 for the full map of Route 107's surface and information about its Trainers.

Underwater trench

Scuba Diver Keaton
◉◉◉◉◉◉

Free Diver Hollie
◉◉◉◉◉◉

Seaweed	
☐ Chinchou	◎
☐ Clamperl	○
☐ Lanturn	△
☐ Relicanth	▲

◎ frequent ○ average
△ rare ▲ almost never

Hidden Items
☐ Flame Plate
☐ Yellow Shard

Items
Surface
☐ Super Repel*

*You may have already found this item if you explored Route 107 earlier in the adventure, before you obtained Dive.

Chinchou `Water` `Electric`
Abilities: Volt Absorb, Illuminate

1 Dive and explore Route 107's underwater trench

Orlando found a Flame Plate!

Route 107's underwater trench features two Trainers. Battle them both as you swim around the seaweed in search of wild Pokémon to catch! Also, keep tapping Ⓐ as you explore to scour the entire trench for hidden items. You can find a Flame Plate up north near Free Diver Hollie and there's a Yellow Shard just to the south of the patch of light. When you're finished frolicking under the sea, return to the sunlight and go back up to the surface. Surf eastward to go through Route 108 on your way to Sea Mauville.

Optional SEA MAUVILLE

Field Moves Needed — Surf, Dive

A facility that was decommissioned dozens of years ago. It is now maintained as a natural preserve.

Now that you can Dive, you can complete your exploration of Sea Mauville: an optional area that you may have visited during your initial Surf explorations (p. 142). This section covers everything you can do in Sea Mauville now that you've got Dive.

Surface

Key to Room 4

Tuber Charlie

To Route 108 (p. 147)

Sailor Duncan

Items

Surface
- ❑ Escape Rope*
- ❑ Key to Room 4
- ❑ TM18 Rain Dance*

Interior
- ❑ Key to Room 1
- ❑ Key to Room 2
- ❑ Key to Room 6
- ❑ Max Repel*

After learning Dive
- ❑ Dive Ball
- ❑ Revive
- ❑ Storage Key
- ❑ White Herb

Storage
- ❑ Beedrillite
- ❑ Big Nugget ×8
- ❑ Luxury Ball
- ❑ Nugget ×4
- ❑ TM13 Ice Beam

On the Water

Surface
❑ Pelipper	▲
❑ Tentacool	◎
❑ Wingull	○

All other areas
❑ Tentacool	◎

Fishing

All areas
Old Rod
❑ Magikarp	◎
❑ Tentacool	○

Good Rod
❑ Magikarp	◎
❑ Tentacool	○
❑ Wailmer	▲

Super Rod
❑ Wailmer	◎

◎ frequent ○ average
△ rare ▲ almost never

*You may have already found these items if you explored Sea Mauville earlier in the adventure, before you obtained Dive.

Interior

Key to Room 1

Storage

1F (western rooms)

Key to
Room 2

H B

Key to
Room 6

I

Mysterious Sisters Scall & Ion 🔄
★ Double Battle
○○●●●●

Young Couple Lois & Hal 🔄
★ Double Battle
○○●●●●

1F (eastern rooms)

Storage
Key

L J K

G F

B2F

E

B1F

C D

E

1 Explore Sea Mauville's exterior

What is this place?
What is there to do?
I'm good.

Is there anything you would like me
to tell you about Sea Mauville?

Surf over to the half-sunken facility and
walk up the sloping walkway to reach
Sea Mauville's exposed exterior. If you
haven't been here before, let the guide
tell you about Sea Mauville, and consider
paying the nominal fee to help support
the preservation of this historic preserve.
Then battle a few Trainers as you explore
the exterior of this decrepit place. You can
also collect an Escape Rope and TM18 Rain
Dance if you haven't already.

2 Search Sea Mauville's interior

▶ Yes
No

The ocean seems very deep here.
Would you like to use Dive?

Enter Sea Mauville's interior to meet more
Trainers, including a Double Battle challenge
from a Young Couple. Grab a Max Repel
near the water's edge—you may have
grabbed it earlier—and then Surf onto the
water. Dive at the dark patch to explore Sea
Mauville's sunken depths.

TRAINER
HANDBOOK

ADVANCED
TRAINER'S GUIDE

ADVENTURE
DATA

3 | Obtain the Key to Room 1

Orlando obtained the Key to Room 1!

Sea Mauville features two underwater areas. The deeper level to the south is currently empty, so ignore it and head for the patch of light at the first passage's right end. Surface and go north to find a Tuber who gives you the Key to Room 1. Collect the nearby White Herb, and then search the unlocked side rooms.

4 | Find more Keys as you search the rooms

Orlando obtained the Key to Room 2!

Dive back underwater and return to Sea Mauville's left side. Use the Key to Room 1 to open the door to Room 1, where you'll discover a Dive Ball. Search the file cabinet afterward to discover the Key to Room 2. Scavenger hunt time! Follow these steps to obtain the remaining keys to Sea Mauville's other locked rooms:

1. Go down from Room 1 to find Room 2. Enter and talk to one of the girls in Room 2 to obtain the Key to Room 6. Don't forget to grab a Revive from the room.

2. Dive and cross back over to Sea Mauville's right side. Open the door to Room 6, and then step outside and explore a new section of Sea Mauville's exterior. Surf over to a Fisherman on a tiny island and ask him if he's caught anything. He will give you the Key to Room 4.

3. Re-enter Sea Mauville and enter Room 4, which is located on the facility's right side. Collect the Storage Key lying on the ground in this room.

TIP

Search each room thoroughly to discover several interesting documents in file cabinets and on bookshelves. The documents are old and worn, but they indicate that Captain Stern and Gym Leader Wattson were involved in the Sea Mauville project many years ago, along with a man named Raizoh Cozmo...before something went very wrong.

5 | Raid the Storage Room

Orlando used the Storage Key!

Once you've found the Storage Key in Room 4, return to Room 6 and go back outside. Surf over to the sandy patch near Sea Mauville and use the Storage Key to open the door to the Storage Room, which is filled with items. Wait for the Street Thug and Mr. Raizoh to leave, then raid the Storage Room to obtain a bunch of Nuggets and Big Nuggets, along with a Luxury Ball and TM13 Ice Beam. Surf over to the sparkling patch in the Storage Room as well, and get a Mega Stone called Beedrillite. Perhaps you'll want to sell some Nuggets to fund another shopping spree in Lilycove, because Route 124 is next on the list!

Field Moves Needed
Surf Dive

This great stretch of ocean connects the cities of Lilycove, Mossdeep, and Sootopolis.

You've passed through Route 124 before, but now that you can use Dive, you can search Route 124 more thoroughly and discover all of its many secrets. The array of valuables you can find here with Dive makes revisiting Route 124 a profitable venture!

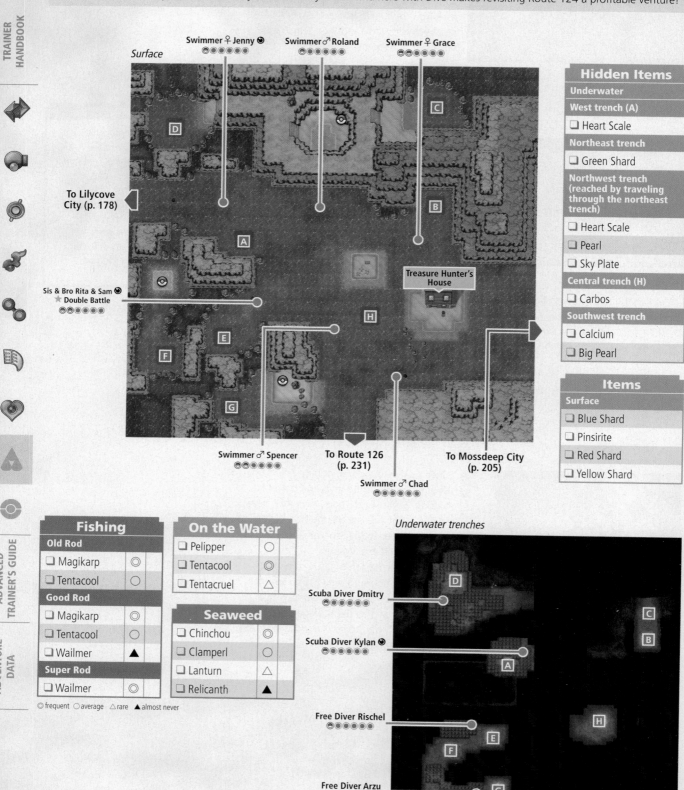

Surface

Swimmer ♀ Jenny ●
Swimmer ♂ Roland
Swimmer ♀ Grace

To Lilycove City (p. 178)

Sis & Bro Rita & Sam ●
★ Double Battle

Treasure Hunter's House

Swimmer ♂ Spencer
To Route 126 (p. 231)
To Mossdeep City (p. 205)
Swimmer ♂ Chad

Hidden Items

Underwater

West trench (A)
- ☐ Heart Scale

Northeast trench
- ☐ Green Shard

Northwest trench (reached by traveling through the northeast trench)
- ☐ Heart Scale
- ☐ Pearl
- ☐ Sky Plate

Central trench (H)
- ☐ Carbos

Southwest trench
- ☐ Calcium
- ☐ Big Pearl

Items

Surface
- ☐ Blue Shard
- ☐ Pinsirite
- ☐ Red Shard
- ☐ Yellow Shard

Fishing		
Old Rod		
☐ Magikarp	◎	
☐ Tentacool	○	
Good Rod		
☐ Magikarp	◎	
☐ Tentacool	○	
☐ Wailmer	▲	
Super Rod		
☐ Wailmer	◎	

On the Water		
☐ Pelipper	○	
☐ Tentacool	◎	
☐ Tentacruel	△	

Seaweed		
☐ Chinchou	◎	
☐ Clamperl	○	
☐ Lanturn	△	
☐ Relicanth	▲	

◎ frequent ○ average △ rare ▲ almost never

Underwater trenches

Scuba Diver Dmitry
Scuba Diver Kylan ●
Free Diver Rischel
Free Diver Arzu

1 Search the west trench for a hidden Heart Scale

Orlando found a Heart Scale!

Route 124 features several underwater trenches, some of which lead to new areas on Route 124's surface. Begin by using Surf to go north and then Dive into the west trench. Battle a Trainer underwater, then search north of the Trainer (keep tapping Ⓐ while moving around) to discover a hidden Heart Scale. Although you can see another trench in the distance, you can't swim across the depths separating it from you. You'll have to find another place to Dive to reach it.

2 Travel the northeast trench to find a Green and a Red Shard

Orlando found a Red Shard!

Surface from the west trench and then Surf to Route 124's northeast trench, which is a short, straight passage. Again, keep tapping Ⓐ while moving down the trench to find a hidden Green Shard near the center of the trench. Surface at the trench's northern sunlit spot afterward to reach a new portion of Route 124, including a rocky island where you'll discover a Red Shard.

TIP

After collecting the Red Shard, head west and Dive into the nearby trench. Here you'll discover a hidden Pearl and a Heart Scale by searching the bare patches in the seaweed. You'll find a hidden Sky Plate in the trench's east tunnel, too.

3 Search the central trench to find a Carbos

Orlando found Carbos!

Backtrack through the northeast trench and return to Route 124's main surface area. Surf down and Dive into the central trench located to the west of the Treasure Hunter's House. Find a Carbos to the west of the sunlit spot.

4 Take the southwest trench to find a Blue Shard

Orlando found a Blue Shard!

Return to Route 124's main surface area. Surf westward and Dive into Route 124's southwest trench next. Then surface at the trench's central sunlit spot to reach another new area up on the surface, where a Blue Shard sits on a small patch of sand. Inspect the sparkling patch of sand near the Blue Shard to discover a Mega Stone called Pinsirite.

Orlando found a Yellow Shard!

Return to the underwater trench, and this time, head for its southern sunlit spot. As you go, search the edge of the seaweed to the west of Free Diver Arzu to find a Big Pearl. Next, search the bare patch of seaweed to the south of the Trainer to find a hidden Calcium. Surface at the southern sunlit spot afterward to reach a new portion of Route 124's surface, where a Yellow Shard sits on the sand. Backtrack through the trench afterward and use the northern sunlit spot to return to Route 124's main surface area.

6 Trade in your shards at the Treasure Hunter's House

Yes
No

Oh, man, you've got to trade that to me! I'll give you something good!

Your Bag is bursting with shards by now, so Surf over to the Treasure Hunter's House and trade them in for items! Trade in the Green Shard for a Leaf Stone, the Red Shard for a Fire Stone, the Blue Shard for a Water Stone, and the Yellow Shard for a Thunder Stone.

Rewards: Fire Stone, Leaf Stone, Thunder Stone, Water Stone

TIP

Curious what those stones are for? They make certain Pokémon evolve! Try using the stones on the following Pokémon and see what happens:

Leaf Stone: Gloom, Nuzleaf (Ω)

Fire Stone: Vulpix

Thunder Stone: Pikachu

Water Stone: Staryu, Lombre (α)

Optional | ROUTE 125

Field Moves Needed Surf

Small children are allowed to play in the waters of this sea route as far as Shoal Cave—but no further!

This watery route is filled with Secret Spots and Trainers. Visiting Route 125 is completely optional, but it's a smart idea, because Shoal Cave is located here—another optional area filled with goodies!

Items
- ☐ Big Pearl

Fishing

Old Rod	
☐ Magikarp	◎
☐ Tentacool	○
Good Rod	
☐ Magikarp	◎
☐ Tentacool	○
☐ Wailmer	▲
Super Rod	
☐ Wailmer	◎

On the Water

☐ Pelipper	○
☐ Tentacool	◎
☐ Tentacruel	△

◎ frequent ○ average
△ rare ▲ almost never

Sailor Ernest ●
Teammates Kim & Iris ★ Double Battle
Swimmer ♀ Sharon
Swimmer ♂ Cody
To Shoal Cave (p. 219)
Swimmer ♂ Stan
To Mossdeep City (p. 205)
Swimmer ♀ Tanya

1 Battle Trainers on your way to Shoal Cave

There are plenty of Trainers to battle along Route 125. Show off your powerful Pokémon as you Surf around, scoping out Secret Spots and snagging the Big Pearl lying on the eastern isle. If you're in the mood for more adventure, enter Shoal Cave and explore its mysterious depths.

Optional SHOAL CAVE

Field Moves Needed
Surf Strength Rock Smash

This cave's appearance changes greatly between high tide and low tide.

A number of mysteries await you in the depths of this waterlogged cave, but you'll need to visit it during both high tide and low tide in order to explore every nook. The Mach Bike is also needed to fully probe Shoal Cave.

High tide: 9 A.M.–3 P.M. & 9 P.M.–3 A.M.

Low tide: 3–9 A.M. & 3–9 P.M.

Entrance (high tide)

To Route 125 (p. 218)

Second cavern (high tide)

Entrance (low tide)

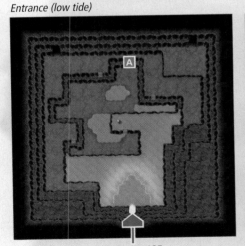

To Route 125 (p. 218)

Second cavern (low tide)

Third cavern (low tide)

Fourth cavern (low tide)

Ice cavern (low tide)

Fishing		
High tide		
Old Rod		
☐ Magikarp	◎	
☐ Tentacool	○	
Good Rod		
☐ Magikarp	◎	
☐ Tentacool	○	
☐ Wailmer	▲	
Super Rod		
☐ Wailmer	◎	

Horde Encounter		
High tide		
Entrance & second cavern		
☐ Spheal (×5)	◎	
☐ Zubat (×5)	○	
Low tide		
All areas except ice cavern		
☐ Spheal (×5)	○	
☐ Zubat (×5)	◎	
Ice cavern		
☐ Spheal (×5)	○	
☐ Snorunt (×5)	▲	
☐ Zubat (×5)	◎	

◎ frequent ○ average
△ rare ▲ almost never

Cave		
High tide		
Entrance & second cavern		
☐ Golbat	◎	
☐ Sealeo	◎	
☐ Spheal	○	
Low tide		
All areas except ice cavern		
☐ Golbat	◎	
☐ Sealeo	○	
☐ Snorunt	▲	
☐ Spheal	○	
Ice cavern		
☐ Golbat	○	
☐ Sealeo	○	
☐ Snorunt	◎	
☐ Spheal	△	

On the Water		
High tide		
☐ Golbat	○	
☐ Tentacool	◎	
☐ Tentacruel	△	

Items
High tide
Entrance
☐ Big Pearl
Second cavern
☐ Rare Candy
☐ Shoal Shell ×4
Low tide
Second cavern
☐ Shoal Salt ×2
Third cavern
☐ Focus Band
☐ Shoal Salt
☐ TM79 Frost Breath
Fourth cavern
☐ Ice Heal
☐ Shoal Salt
Ice cavern
☐ Glalitite
☐ Never-Melt Ice
☐ TM07 Hail

Hidden Items
High tide
Entrance
☐ Star Piece
Low tide
Entrance
☐ Pearl
Ice cavern
☐ Ice Heal

Snorunt — Ice
Abilities: Inner Focus, Ice Body

Spheal — Ice · Water
Abilities: Thick Fat, Ice Body

1 Surf Shoal Cave at high tide

How about bringing me back some
Shoal Salt and Shoal Shells?

You can't delve into Shoal Cave's depths during high tide, but you can Surf to several spots around the surface—places you can't reach during low tide. Surf and search the cave's entrance during high tide to find a hidden Star Piece. Then explore the second cavern to find four Shoal Shells, which the old man in the entrance desires.

TIP

During high tide, when you visit the second cavern, don't forget to use the eastern exit. A Big Pearl is accessible only from the exit.

2 Probe Shoal Cave at low tide

Orlando obtained a
Shoal Salt!

Return to Shoal Cave during the hours of low tide, and you'll be able to delve much deeper into its depths. Find a hidden Pearl in the entrance, then visit the second cavern to discover that you can now explore the cave's lower floors. Climb and descend every ladder you see during low tide to explore each cavern and discover lots of Shoal Salt—another resource sought by the old man in the entrance.

TIP

During low tide, use the Mach Bike to scale the sandy slopes of Shoal Cave's third cavern and reach TM79 Frost Breath. After that, use Strength to shove a boulder out of your way and reach a Black Belt who will give you a Focus Band.

3 Slide around the ice cavern

Orlando found
TM07 Hail!

During low tide, descend the third cavern's southeast ladder to reach the frigid ice cavern. Several goodies can be found down here, including TM07 Hail, a Never-Melt Ice, a Mega Stone called Glalitite, and a hidden Ice Heal. You must slide across the icy floor to reach them, and you can't change course after you start sliding. Use stalagmites and patches of snow to stop sliding, and be creative in looking for ways to get where you want to go.

TIP

Need help navigating the ice cavern? Here's one way to do it:

1. Go south from the entry ladder, sliding across two big patches of ice.
2. To the west lies an even bigger ice patch. Slide westward and land on the patch of snow that's closest to you.
3. Slide west again to stop at a stalagmite.
4. Slide south to stop against the south wall.
5. Slide west to stop at a stalagmite.
6. Slide north to reach a large patch of snow. You're now past the large ice patch, and a wide set of stairs is just ahead of you.
7. Go up the wide stairs and then slide north, landing on the small patch of snow that's right next to the narrow stairs ahead.
8. A small ice patch in front of the narrow stairs prevents you from easily climbing them. Slide west instead.
9. Slide south to stop at the nearby stalagmite.
10. Slide east to stop at the stalagmite near the narrow stairs. Now you can slide north and go up the stairs to explore the cavern's central plateau.
11. Go south along the plateau and collect a Never-Melt Ice.
12. Go north along the plateau and search at the sparkling patch to find a Mega Stone called Glalitite.
13. Backtrack down the narrow stairs. You'll automatically slide to the nearby stalagmite that's just south of the stairs.
14. Slide west to stop at a stalagmite near the west wall.
15. Slide north to stop at a stalagmite near the north wall.
16. Go west, north, and then slide east to reach another stalagmite.
17. Slide south to reach a small patch of snow near the central plateau. Whip out your Dowsing Machine and discover a hidden Ice Heal here.
18. Slide north after collecting the Ice Heal to reach a nearby patch of snow.
19. Slide east to stop at a stalagmite.
20. Go south and collect TM07 Hail. That's it—you're done!

4 Have the old man make you a Shell Bell

Orlando obtained a
Shell Bell!

Your pockets should be packed full of Shoal Salt and Shoal Shells by the time you finish exploring Shoal Cave. Return to the entrance and give the old man four Shoal Shells and four Shoal Salts. He'll use these resources to fashion a Shell Bell for you. Give the Shell Bell to a Pokémon to hold, and it will recover HP each time it deals damage in battle. After handing you the Shell Bell, the old man gives you a bonus gift: a Mega Stone called Slowbronite!

TIP

Shoal Cave's natural resources, Shoal Salt and Shoal Shells, reappear each day. If for any reason you can't find enough materials for the Shell Bell during a single day, return to Shoal Cave on another day and collect more. The old man will also make more Shell Bells for you—just bring him the resources and he'll make as many as you like!

ROUTE 127

> With no place to stop and rest in these waters, it is very hard for a swimmer to make it across this route.

When you've finished exploring optional areas with Dive, it's time to begin your search for the Seafloor Cavern, where the super-ancient Pokémon is said to slumber. Surf south from Mossdeep City to reach Route 127—an aquatic route that leads to Route 128, where the pillar of light burst forth from the ocean.

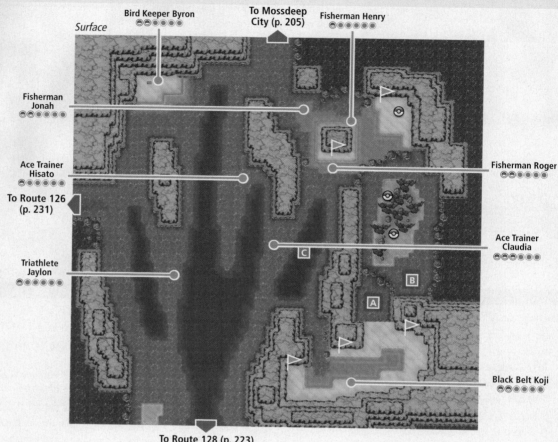

Surface

- Bird Keeper Byron
- To Mossdeep City (p. 205)
- Fisherman Henry
- Fisherman Jonah
- Fisherman Roger
- Ace Trainer Hisato
- To Route 126 (p. 231)
- Ace Trainer Claudia
- Triathlete Jaylon
- **C**
- **B**
- **A**
- Black Belt Koji
- To Route 128 (p. 223)

Underwater trenches

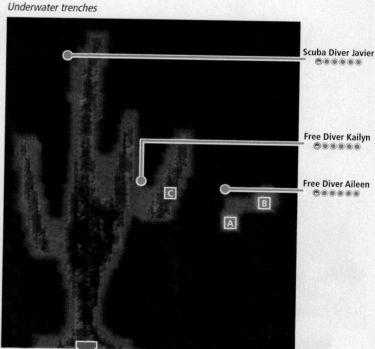

- Scuba Diver Javier
- Free Diver Kailyn
- Free Diver Aileen
- **C**
- **B**
- **A**
- To Route 128 (p. 223)

On the Water

☐ Pelipper	◯
☐ Tentacool	◎
☐ Tentacruel	△

Items

☐ Carbos
☐ Heracronite
☐ Rare Candy
☐ Zinc

Fishing

Old Rod

☐ Magikarp	◎
☐ Tentacool	◯

Good Rod

☐ Magikarp	◎
☐ Tentacool	◯
☐ Wailmer	▲

Super Rod

☐ Wailmer	◎

◎ frequent ◯ average
△ rare ▲ almost never

Hidden Items

Underwater trenches

Eastern trench

☐ Heart Scale

Main trench

☐ Dread Plate
☐ HP Up
☐ Insect Plate
☐ Red Shard
☐ Spooky Plate
☐ Star Piece

1 Surf the surface for items and Trainers

Orlando found a Heracronite!

Stick to the surface for now, and Surf around Route 127 in search of Trainers to battle. Go east to find a beach with several Fisherman and a Zinc. Then head south to find another beach where a Black Belt is practicing, and where a sparkling patch of sand hides a Mega Stone called Heracronite.

2 Dive to find even more plunder

The ocean seems very deep here.
Would you like to use Dive?

Surf the water to the north of the Black Belt to find a Dive spot. Dive there to enter a small underwater trench with a Free Diver. Battle her, and then search the trench to find a hidden Heart Scale. Surface at the trench's eastern sunlit spot to reach a mangrove, where a Carbos and a Rare Candy can be found.

3 Explore Route 127's giant trench

Orlando found an HP Up!

A cavernous trench runs beneath Route 127's main body of water, reachable by any of its long dark water patches. Two Trainers and six valuable hidden items can be found, but finding all the hidden items across such a wide space isn't easy. Return to the surface and head south or continue underwater to Route 128, which is your next destination.

TIP

Need help finding all of those hidden underwater treasures in Route 127's main trench? No problem!

Dread Plate: Go northeast from the eastern Free Diver and search around the eastern trench's north end.

Spooky Plate: Go northwest from the eastern Free Diver and search the north end of the east-central trench.

HP Up: Go west from the eastern Free Diver and search between the two long stretches of sunlight.

Star Piece: Search just northeast of the northern Scuba Diver.

Red Shard: Go directly south from the northern Scuba Diver and search between another two long stretches of sunlight.

Insect Plate: Go north from the Red Shard and search the trench's northwest tip.

ROUTE 128

Field Moves Needed — Surf, Dive

The ocean floor beneath this water route is rumored to contain an undiscovered ruin.

Captain Stern mentioned that he'd found an underwater cave in this area while exploring it in his submarine, *Explorer 1*. Could the cave that Stern discovered be the same one that Team Magma / Team Aqua has apparently breached with their stolen, souped-up sub? Whatever mysteries lie beneath Route 128, one thing is certain: this is the place where that giant pillar of light burst forth from the ocean, so something big must be happening here!

Surface

To Route 127 (p. 222)

Ace Trainer Cornelius

Tuber Delmar

A C B

To Ever Grande City (p. 277)

To Route 129 (p. 254)

Fisherman Wayne

Tuber Marlene

Underwater trenches

Fishing		
Old Rod		
❑ Magikarp	◎	
❑ Tentacool	○	
Good Rod		
❑ Luvdisc	○	
❑ Magikarp	◎	
❑ Wailmer	▲	
Super Rod		
❑ Corsola	▲	
❑ Luvdisc	◎	
❑ Wailmer	○	

On the Water	
❑ Pelipper	○
❑ Tentacool	◎
❑ Tentacruel	△

Seaweed	
Underwater trenches	
❑ Chinchou	◎
❑ Clamperl	○
❑ Corsola	▲
❑ Lanturn	△
❑ Relicanth	▲

◎ frequent ○ average
△ rare ▲ almost never

To Seafloor Cavern (p. 225)

Free Diver Mayu
◉◉◉◉◉◉

	Corsola	Water Rock
	Abilities: Hustle, Natural Cure	

	Luvdisc	Water
	Ability: Swift Swim	

Hidden Items
Surface
❑ Heart Scale ×3
Underwater trenches
Western plateau trench
❑ Adamant Orb
Eastern seaweed trench
❑ Protein
❑ Pearl
Big central trench
❑ Draco Plate
❑ Pixie Plate
❑ Stone Plate

1 Find hidden Heart Scales on the surface

Orlando found a Heart Scale!

More Trainers await battle on the surface of Route 128. Surf around and battle them all for fun and profit. Each time you reach land, deploy your Dowsing Machine and sweep the area for hidden Heart Scales. There are three of them to find around Route 128's surface.

2 Search underwater for hidden booty

Orlando found a Pearl!

Like Route 127, Route 128 features a giant underwater trench. It also features a smaller trench to the east. You can also Dive at the center of Route 128's western rock ring to reach an underwater plateau. Dive and search the underwater plateau first to discover a hidden Adamant Orb. Then surface and Dive into the smaller eastern trench to battle a Trainer and find a hidden Protein and a Pearl. Give the big central trench a thorough sweep afterward to find Route 128's remaining underwater treasures.

TIP

Now that you're flush with Heart Scales, consider Flying back to the Move Maniac in Fallarbor Town (p. 117). The Move Deleter in Lilycove City (p. 178) may also be of service!

TIP

While searching Route 128's big central trench, you'll find a Pixie Plate just southeast of the underwater plateau, a Stone Plate just northwest of the plateau, and a Draco Plate just west of the plateau (south of where you find the Stone Plate).

3 Enter the Seafloor Cavern

When you've finished exploring Route 128, it's time to advance to the Seafloor Cavern. Some serious danger awaits you there, so take stock of your Pokémon and consider using Fly to go to a city or town to rest up before tackling this next segment. When you're ready, Dive into Route 128's main trench and locate the entrance to the Seafloor Cavern, which is found underwater, on the south side of the underwater plateau.

You're hot on the heels of Team Magma / Team Aqua now, and the Seafloor Cavern is ready to be explored. However, at this point in the adventure, you have the option of leaving the Seafloor Cavern for later and exploring a host of optional routes and areas around Hoenn. Exploring these areas now gives you an advantage going into the Seafloor Cavern to pursue Team Magma / Team Aqua in the Seafloor Cavern. Or, if you feel like undertaking a number of worthwhile optional ventures, flip ahead to page 231, where the coverage of Hoenn's remaining optional routes and areas begins. You'll also be able to visit all of these locations later.

Optional areas to visit now:

SEAFLOOR CAVERN

Field Moves Needed — Dive · Surf · Strength · Rock Smash

It is said that a Pokémon once dwelled here in the ancient mists of a time long lost.

An underwater cave found in the depths of Route 128 leads to this long-forgotten cavern. Maxie/Archie has gone to great lengths to breach the seal that has protected this place for ages, in the hope of awakening the super-ancient Pokémon that is rumored to dwell here. Maxie/Archie believes this Pokémon has the power to bring about the great future he desires, but the risks seem far too great.

Entrance Ω

To Route 128
(p. 223)

Entrance α

To Route 128
(p. 223)

Room 1

Team Magma /
Team Aqua Grunt

Team Magma /
Team Aqua Grunt

Team Magma /
Team Aqua Grunt

Room 2

Room 3

Team Magma /
Team Aqua Grunt

Room 4

Room 5

H

I

G

Room 6

L

J

H

Team Magma /
Team Aqua Grunt
◎◎◎◎◎◎

Room 7

J

K

Room 8

M

L

Room 9 Ω

M

N

Room 9 α

M

N

Room 10 Ω

N

Team Magma
Leader Maxie
◎◎◎◎◎◎

Room 10 α

N

Team Aqua
Leader Archie
◎◎◎◎◎◎

Graveler `Rock` `Ground`
Abilities: Rock Head, Sturdy

Items

Room 7	
❑ TM55 Scald	
Room 9	
❑ TM26 Earthquake	

Hidden Items

Entrance	
❑ Heart Scale	
Room 3	
❑ Escape Rope	

Cave

❑ Golbat	◎

Horde Encounter

❑ Zubat (×5)	◎

On the Water

Entrance	
❑ Golbat	◎
❑ Tentacruel	◎
All other areas	
❑ Golbat	○
❑ Tentacruel	◎

Fishing

Old Rod	
❑ Magikarp	◎
❑ Tentacool	○
Good Rod	
❑ Magikarp	◎
❑ Tentacool	○
❑ Wailmer	▲
Super Rod	
❑ Wailmer	◎

Rock Smash

❑ Graveler	◎

◎ frequent ○ average △ rare ▲ almost never

TRAINER HANDBOOK

ADVANCED TRAINER'S GUIDE

ADVENTURE DATA

1. Shove the first two southern boulders into the nearby pits to get them out of your way.
2. Shove the second western boulder **once** to the east.
3. Loop around the second western boulder and shove the second eastern boulder **once** to the east, pushing it closer to the east wall.
4. Loop back around to the second western boulder's west side and shove it **once more** to the east.
5. Loop back around the second western boulder and go north. Carefully move past the boulders without shoving them, heading north.
6. Approach the third western boulder from the north, and shove it **twice** to the south. You can only do this if you've shoved the previous western boulder twice to the east as instructed.
7. You should now be able to shove the northwestern boulder twice to the north, dropping it into a pit. Now you may advance past it and reach Room 9.

TIP

If you accidentally shove the wrong boulder or move a boulder in the wrong direction, exit and re-enter Room 8 to reset the boulders and try again. The boulders shoved into pits will stay in the pits even if you exit the room.

11 | In Room 9, grab a TM on your way to Room 10

Orlando found
TM26 Earthquake!

There's only one way through Room 9. Make a big loop around the room, grab TM26 Earthquake from the southwest corner, and descend the nearby stairs to enter Room 10.

12 | In Room 10, square off against Maxie/Archie

This great form slumbering in defiance of even the broiling lava surrounding it!

That beautiful form so long resting at peace within the azure sea!

Down in the Seafloor Cavern's deepest depths, you finally catch up with Team Magma / Team Aqua's driven leader, Maxie/Archie. He has discovered the fabled resting place of the super-ancient Pokémon, Groudon/Kyogre, and stands ready to restore the super-ancient Pokémon with his stolen Red Orb / Blue Orb. With his ruinous plan so close to fruition, Maxie/Archie is not about to let anything stop him—not even you!

Team Magma Leader Maxie's Pokémon

Team Magma's Leader pulls out all the stops in this climactic battle. Not only does he send out four high-level Pokémon against you, but Maxie also uses Mega Evolution to transform his Camerupt into Mega Camerupt! Exploit his Pokémon's weaknesses, using powerful Water-type moves like Surf and Dive to wipe out his Mega Camerupt as fast as you can.

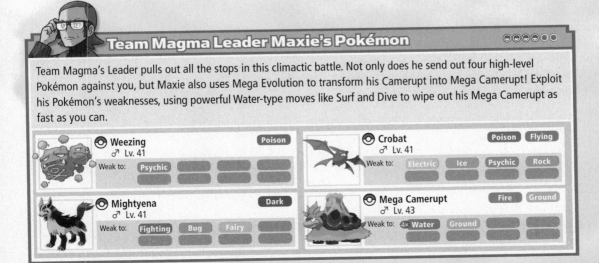

Weezing ♂ Lv. 41	Poison
Weak to: Psychic	

Crobat ♂ Lv. 41	Poison · Flying
Weak to: Electric · Ice · Psychic · Rock	

Mightyena ♂ Lv. 41	Dark
Weak to: Fighting · Bug · Fairy	

Mega Camerupt ♂ Lv. 43	Fire · Ground
Weak to: 4× Water · Ground	

Team Aqua Leader Archie's Pokémon ⊝⊝⊝⊝◯◯

Archie storms you with four powerful Pokémon during this epic clash. He even uses Mega Evolution to transform his Sharpedo into Mega Sharpedo toward the battle's end! Several of Archie's Pokémon share common weaknesses to Electric-, Fighting-, and Psychic-type moves, so take advantage and punish them with these types of moves as often as possible.

⊙ **Muk**		Poison
♂ Lv. 41		
Weak to:	Ground	Psychic

⊙ **Crobat**		Poison	Flying	
♂ Lv. 41				
Weak to:	Electric	Ice	Psychic	Rock

⊙ **Mightyena**		Dark	
♂ Lv. 41			
Weak to:	Fighting	Bug	Fairy

⊙ **Mega Sharpedo**		Water	Dark	
♂ Lv. 43				
Weak to:	Grass	Electric	Fighting	Bug
	Fairy			

13 Witness the awakening of Groudon/Kyogre

Even after suffering defeat, Maxie/Archie isn't about to let his dreams fall apart. Despite the pleas of his second-in-command, Maxie/Archie calls forth the power of the Red Orb / Blue Orb to rouse the super-ancient Pokémon.

14 Observe the weather change on the surface

Groudon/Kyogre emerges from the Seafloor Cavern and sets off to the west. The massive energy generated by the super-ancient Pokémon has an immediate and dramatic impact on Hoenn's weather. The effects are obvious, and even Maxie/Archie can't deny that he may have made a grave mistake.

TRAINER HANDBOOK

ADVANCED TRAINER'S GUIDE

ADVENTURE DATA

Groudon/Kyogre hasn't even undergone Primal Reversion yet, and already its power is beyond expectations. Grudgingly, Maxie/Archie agrees to work with his rival, Archie/Maxie, to help put things to rights. After Maxie and Archie depart, your friend Steven swoops down and he needs your help. He's heading west for Sootopolis City, where Groudon/Kyogre seems to be going. That's your next stop! Surf north to Route 127 and then west to Route 126.

What's Up with the Weather?

If you're playing *Pokémon Omega Ruby*, then Groudon's great power has vastly intensified the sun. From this point forward, when you participate in battles on the surface, the "extremely harsh sunlight" weather condition will be in effect, greatly boosting the power of Fire-type moves, and nullifying any Water-type moves by evaporating them on the spot!

On the other hand, if you're playing *Pokémon Alpha Sapphire*, then Kyogre's mighty influence has just started a massive downpour of rain all over Hoenn. The "heavy rain" weather condition is now in effect during battles you undertake on the surface, boosting Water-type moves and nullifying any Fire-type move by dowsing their flames!

ROUTE 126 & SECRET ISLET

Field Moves Needed — Surf, Dive

Even a pro swimmer would need three entire days to swim a circuit around the crater containing Sootopolis City.

This wide, watery route surrounds a massive crater, inside of which bustling Sootopolis City has been established. There's no way of reaching Sootopolis City from Route 126's surface, so the secret must be submerged within the depths of Route 126's underwater trenches.

Items
Surface
❑ Green Shard

Hidden Items
Underwater trenches
Northern trench
❑ Heart Scale
❑ Ultra Ball
Main trench
❑ Big Pearl
❑ Iron
❑ Mind Plate
❑ Pearl
❑ Stardust
❑ Yellow Shard
Western trench
❑ Blue Shard

On the Water	
❑ Pelipper	○
❑ Tentacool	◎
❑ Tentacruel	△

Seaweed	
Chinchou	◎
Clamperl	○
Lanturn	△
Relicanth	▲

Fishing	
Old Rod	
❑ Magikarp	◎
❑ Tentacool	○
Good Rod	
❑ Magikarp	◎
❑ Tentacool	○
❑ Wailmer	▲
Super Rod	
❑ Wailmer	◎

◎ frequent ○ average
△ rare ▲ almost never

Surface

To Route 124
(p. 204)

C

D

B

Triathlete Denzel
◉◉◉◉◉◉

A

Swimmer ♂ Barry
◉◉◉◉◉◉

To Route 127
(p. 222)

Swimmer ♀ Brenda
◉◉◉◉◉◉

E

Swimmer ♀ Nikki
◉◉◉◉◉◉

Ace Trainer Leopold
◉◉◉◉◉◉

Swimmer ♂ Dean
◉◉◉◉◉◉

F

Ace Trainer Harriet
◉◉◉◉◉◉

G

H

Underwater trenches

C

D

B

A

E

F

G

Scuba Diver Tristan
◉◉◉◉◉◉

Free Diver Jillian
◉◉◉◉◉◉

Scuba Diver Yutaka
◉◉◉◉◉◉

Secret Islet

H

TIP

The Secret Islet is one of three locations in the Hoenn region that serious Secret Base enthusiasts seek out. Remember that the farther away a Secret Base is from civilization, the better its layout tends to be. You can check out the full Secret Spot location guide on pages 381–390 to learn more.

TRAINER HANDBOOK

ADVANCED TRAINER'S GUIDE

ADVENTURE DATA

1 Surf the surface in search of Trainers

Route 126's surface area is big—big enough to surround a whole city built inside a crater! Surf the surface in search of Trainers to battle, getting a feel for how big Route 126 really is.

TIP

Dive into the trench located to the west of the island with a sign (north of Sootopolis City), resurface from the sunlit spot located to the northwest, and then head northeast. Dive in the deep water there, and head west. Resurface from there to reach a small northwest beach, where a Green Shard and Secret Spot await discovery.

2 Dive underwater and find hidden plunder

Route 126's underwater trenches rival the size of its surface. One main trench surrounds the route's central crater, with smaller trenches appearing to the northwest and southwest. Search every square inch of Route 126's underwater depths to discover an array of hidden items, tapping Ⓐ as you explore to discover them all.

TIP

Having trouble finding all of those underwater items? Here are some clues:

 Iron: Bare spot in the seaweed near the entrance to Sootopolis City (east side of the entrance)

 Stardust: Tiny bare spot in the seaweed near the entrance to Sootopolis City (west side of the entrance)

 Yellow Shard: Bare spot in the seaweed that's just east of the central crater

 Pearl: Bare spot in the seaweed that's just west of the central crater (south of Scuba Diver Yutaka)

 Big Pearl: Bare spot in the seaweed that's just north of the central crater

 Mind Plate: West end of the northern dead-end passage, near a school of Luvdisc

 Blue Shard: Northern clearing of the western Dive spot

 Heart Scale: Bare spot in the seaweed in the separate northern trench. Use the main trench's northern Dive spot to get there

 Ultra Ball: Southeast of the northwestern Dive spot that leads to the small northwest beach where you can find a Green Shard

3 Locate the entrance to Sootopolis City

Sootopolis City stands within Route 126's central crater, but there's no way in from the surface. Surf to the crater's south end, then Dive underwater to discover a large cave that leads into Sootopolis City. Head into the cave and then surface in Sootopolis after you've finished giving Route 126 a thorough search.

SOOTOPOLIS CITY

Field Moves Needed — Surf — Dive

This city, which rises from the crater of a great meteoroid crash, can only be reached through the sea or from the sky.

At last, you've discovered Sootopolis City! Getting here wasn't easy, but then again, neither is the task you now face. With Hoenn's weather growing more and more intolerable, you must race to the Cave of Origin and stop the super-ancient Pokémon from achieving Primal Reversion—and the vast power that's sure to come with it.

Underwater entrance

To Route 126
(p. 231)

Sootopolis City

Labels on map: Dragon Move Tutor · Cave of Origin · Poké Mart · Pokémon Center · Sootopolis City Gym

Poké Mart

Antidote	100
Awakening	250
Burn Heal	250
Escape Rope	550
Full Heal	600
Full Restore	3,000
Great Ball	600
Ice Heal	250
Hyper Potion	1,200
Max Potion	2,500
Max Repel	700
Paralyze Heal	200
Poké Ball	200
Potion	300
Repel	350
Revive	1,500
Super Potion	700
Super Repel	500
Ultra Ball	1,200

Items

- ❏ Eon Flute
- ❏ Magma Suit / Aqua Suit
- ❏ Red Orb / Blue Orb
- ❏ Sablenite
- ❏ TM31 Brick Break
- ❏ TM83 Infestation
- ❏ Wailmer Doll

Hidden Items

- ❏ Protein
- ❏ Super Potion

On the Water

❏ Magikarp	◎

Fishing

Old Rod

❏ Magikarp	◎

Good Rod

❏ Magikarp	◎

Super Rod

❏ Gyarados	▲
❏ Magikarp	◎

◎ frequent ○ average
△ rare ▲ almost never

Magikarp — Water
Ability: Swift Swim

Gyarados — Water Flying
Ability: Intimidate

TRAINER HANDBOOK · ADVANCED TRAINER'S GUIDE · ADVENTURE DATA

1 Rest up at the Pokémon Center

Surface in Sootopolis City, and Surf north to reach the local Pokémon Gym. The Gym is closed, so Surf east to reach the Pokémon Center. Rest up and then check behind the nearby house to the southeast with your Dowsing Machine to discover a hidden Protein.

2 Visit the Poké Mart and meet Steven

Surf all the way to the west, past the Gym island, to reach a grassy shore, where a little dowsing can help you detect a hidden Super Potion. Climb the north stairs to reach the local Poké Mart, and then go back down and take the other stairs to the north until you run into Steven. He's not alone: Sootopolis City's Gym Leader, Wallace, is also standing nearby!

3 Receive the Magma Suit / Aqua Suit

Wallace has been entrusted with guarding the Cave of Origin, where Groudon/Kyogre has gone to complete its Primal Reversion. Armed with the Blue Orb / Red Orb, you alone have the power to stop this from happening and save the world from destruction. Devoted to helping you see things through, Maxie/Archie gives you the Magma Suit / Aqua Suit, which will protect you from the elements as you delve into the Cave of Origin's deepest reaches.

4 Enter the Cave of Origin

Your course is now clear, and everyone is standing behind you. Team Magma and Team Aqua have put aside their differences to lend their support, and even your friend May/Brendan has arrived to wish you luck and help in any way that she/he can. No one can stop Groudon/Kyogre except for you, however. Steel yourself for the great battle to come. Then enter the Cave of Origin and begin your vital mission for Hoenn's survival!

TIP

The recent shift in Hoenn's weather has frightened all of Sootopolis's citizens, and they've all taken shelter inside their homes. Their doors are locked tight, so you can't visit with most of the locals right now.

TRAINER HANDBOOK

ADVANCED HANDBOOK

ADVENTURE DATA

CAVE OF ORIGIN

A long-sleeping Pokémon will descend upon this cavern in order to awaken its true powers.

This deep cave is said to hold a great source of ancient power. Whatever lies within its uncharted depths, the Cave of Origin has roused the interest of Groudon/Kyogre—the super-ancient Pokémon that Team Magma / Team Aqua has foolishly awakened. Groudon/Kyogre must be stopped, and only you can save Hoenn from its destructive influence!

1F Entrance

To Sootopolis City (p. 234)

B1F

B2F

B3F

B4F

B5F Ω

B5F α

Final chamber Ω

Primal Groudon

Final chamber α

Primal Kyogre

Hidden passage

Cave		
☐ Golbat	◎	
☐ Mawile	○	Ω
☐ Sableye	○	α

◎ frequent ○ average
△ rare ▲ almost never

Horde Encounter		
☐ Zubat (×5)	◎	

Hidden Items
B1F
☐ X Attack
B2F
☐ Revive

TRAINER HANDBOOK

ADVANCED TRAINER'S GUIDE

ADVENTURE DATA

1 Find a hidden X Attack on the first basement floor

Orlando found an X Attack!

There isn't a moment to lose! Sprint down the entry hall to reach the Cave of Origin's first floor. Dowse to find a hidden X Attack on the first basement floor, and then take the north stairs down to the second basement floor. (The first basement floor's west passage leads to a side area that can't be explored due to impassable rocks.)

2 Descend into the depths

Orlando found a Revive!

Great quakes rock the Cave of Origin as you descend to its lower floors, and a thick mist swirls around you. This place is anything but inviting, but there's nothing else for it—you've got to keep going. Dowse to discover a hidden Revive on B2F, and then race through the linear passages, looping around each floor as you delve deeper and deeper into the cave's foreboding depths.

3 Ride Groudon/Kyogre to the cave's deepest point

Terrible roars echo as you near the Cave of Origin's lowest floor. You must be close! After you put on the Magma Suit / Aqua Suit, you'll receive a message from Maxie/Archie, instructing you to hop onto the back of Groudon/Kyogre and ride the super-ancient Pokémon into the cave's deepest reaches. The message soon cuts out, but your course is clear.

4 Battle Primal Groudon / Primal Kyogre!

Maxie/Archie was right: coupled with the Blue Orb / Red Orb, the Magma Suit / Aqua Suit shields you from harm as you ride Groudon/Kyogre deeper into the cave. After making the journey, approach Groudon/Kyogre and watch in awe as it draws vast power from a mysterious crystal, undergoing Primal Reversion. There isn't a second to lose! Battle Primal Groudon / Primal Kyogre and save Hoenn from its destructive power! You'll definitely want to save before approaching this foe!

TIP

See if you can catch Groudon/Kyogre! It isn't easy, but this is your rare chance to catch it. If you found the Master Ball back in the Team Magma Hideout / Team Aqua Hideout, simply throw it to catch this Legendary Pokémon without any fuss. If you don't have a Master Ball or don't wish to use one, you'll have a tough time catching Groudon/Kyogre. Weaken it and inflict status conditions on it, like Sleep and Paralysis, to increase your chances of catching it. Exploit Groudon's tendency to use the move Rest, too—it makes Groudon fall asleep, increasing your chances of catching it. If you saved before approaching, you can restart your game to try again if you accidentally defeat the Legendary Pokémon or if your Pokémon all faint before you can catch it.

Groudon — Ground
Lv. 45

Weak to: Water | Grass | Ice

Category: Continent Pokémon
Ability: Drought
Moves: Lava Plume Fire
Rest Psychic
Earthquake Ground
Precipice Blades Ground

Primal Groudon — Ground Fire
Lv. 45

Weak to: 4× Water | Ground

Category: Continent Pokémon
Ability: Desolate Land
Moves: Lava Plume Fire
Rest Psychic
Earthquake Ground
Precipice Blades Ground

Mighty Groudon is a super-ancient Pokémon. Long having slumbered in the depths of the Seafloor Cavern, it has now, through the misguided efforts of Team Magma, been awakened. Drawing on instinct, Groudon has sought out a great source of power within the depths of the Cave of Origin—a power source so great that it has caused Groudon to undergo Primal Reversion and become Primal Groudon!

Primal Groudon has the Desolate Land Ability—a new Ability that brings on extremely harsh sunlight for as long as Primal Groudon remains in the battle. Unlike other Abilities or moves that affect the weather, the effects of Desolate Land don't end after a certain number of turns, and they can't be overridden by most other Abilities or moves. Turn back to page 162 for a refresher on Abilities and their effects on weather. Desolate Land has all the effects of normal harsh sunlight, but goes one step further: it completely evaporates any Water-type attack!

In addition to its Desolate Land Ability, Groudon also has a new move called Precipice Blades. This Ground-type physical attack can damage multiple Pokémon, and Primal Groudon uses it to great effect, wiping out whole groups of opposing Pokémon with brutal efficiency.

Summoning vast power, Groudon's stats have improved now that it has undergone Primal Reversion. Its Attack, Defense, and Sp. Atk stats have all grown much greater, making Primal Groudon an incredibly formidable opponent. Primal Groudon's type has changed as well, from Ground type to Ground and Fire type. Exploit its weakness to Ground-type moves, and bring down Primal Groudon before Hoenn goes up in flames! Be sure to try and catch it if you get its HP low after a few attacks.

TIP

If you defeat Groudon/Kyogre and save the game after that, don't worry too much. You'll have a chance to catch it after you enter the Hall of Fame.

TRAINER HANDBOOK

ADVENTURE DATA | ADVANCED TRAINER'S GUIDE

Primal Kyogre α

Kyogre — Water
Lv. 45

Weak to: Grass Electric

Category: Sea Basin Pokémon
Ability: Drizzle
Moves: Body Slam [Normal]
Aqua Ring [Water]
Ice Beam [Ice]
Origin Pulse [Water]

Primal Kyogre — Water
Lv. 45

Weak to: Grass Electric

Category: Sea Basin Pokémon
Ability: Primordial Sea
Moves: Body Slam [Normal]
Aqua Ring [Water]
Ice Beam [Ice]
Origin Pulse [Water]

Mighty Kyogre is a super-ancient Pokémon. Long having slept in the depths of the Seafloor Cavern, it has now, through the foolish efforts of Team Aqua, been awakened. Drawing on instinct, Kyogre has sought out a great source of power within the depths of the Cave of Origin—a power source so great that it has caused Kyogre to undergo Primal Reversion and become Primal Kyogre!

A heavy rain began to fall!

Primal Kyogre has the Primordial Sea Ability—a new Ability that causes heavy rain to fall for as long as Primal Kyogre remains in the battle. Unlike other Abilities or moves that affect the weather, the effects of Primordial Sea don't end after a certain number of turns, and they can't be overridden by most other Abilities or moves. Turn back to page 162 for a refresher on Abilities and their effects on weather. Primordial Sea has all the effects of normal rainy weather, but goes one step further: it completely douses any Fire-type attack!

In addition to its Primordial Sea Ability, Kyogre also has a new move called Origin Pulse. This Water-type special attack can damage multiple Pokémon, and Primal Kyogre uses it to great effect as this already powerful move gets a boost by matching Primal Kyogre's type.

Summoning vast power, Kyogre's stats have improved now that it has undergone Primal Reversion. Its Attack, Sp. Atk, and Sp. Def have all grown much greater, making Primal Kyogre a vastly formidable opponent. Unlike Groudon, Kyogre's type doesn't change when it undergoes Primal Reversion—it remains Water type. Exploit its weakness to Grass- and Electric-type moves, and sink Primal Kyogre before the whole world is drowned in a flood! And seize your opportunity to catch this powerful Pokémon once its HP is low.

AFTER STOPPING GROUDON/KYOGRE

Well done, brave Trainer! You've stopped Primal Groudon's / Primal Kyogre's rampage and saved the land of Hoenn from a terrible fate. This heroic feat marks a major accomplishment in your adventure. Read on to learn all about the many changes you'll discover in Hoenn now that the threat posed by Groudon/Kyogre has been quashed.

TRAINER HANDBOOK

1 Witness Hoenn's rebirth

Whether you managed to catch or defeat Groudon/Kyogre, the result is the same: Hoenn's skies quickly clear, and the climate returns to normal. Better than normal, in fact, for the land has now been enriched by the energy released within the Cave of Origin—the very same energy that Groudon/Kyogre draws on for the power needed to undergo Primal Reversion.

2 Score the Red Orb / Blue Orb

Orlando obtained a
Red Orb!

Orlando obtained a
Blue Orb!

Amazed by your success, Maxie/Archie still can't help but wish that he'd never stirred the slumbering super-ancient Pokémon. Seeing that you can handle the Blue Orb / Red Orb, he gives you the Red Orb / Blue Orb to keep as well. If you managed to catch it, you can now give this Orb to Groudon/Kyogre to hold, so you can unleash the Legendary Pokémon's power of Primal Reversion during battle!

3 Receive the Eon Flute

Orlando obtained the
Eon Flute!

Team Magma and Team Aqua depart, leaving you and your friends May/Brendan and Steven to catch up. Proud of all you've accomplished, Steven bestows a great gift upon you: the Eon Flute. By using this Key Item, you can now summon Latios/Latias and Soar through Hoenn's skies. Steven suggests that you do just that, because Hoenn has now been enriched by the energy released. May/Brendan can't believe how far you've come, and couldn't be happier to have shared so many adventures with you. Everything has turned out all right!

ADVANCED TRAINER'S GUIDE

ADVENTURE DATA

Let's Soar!

With the Eon Flute that Steven gave you, your Latios or Latias can now take to the skies and Soar high above Hoenn. Soar is a special variation of flying that only Latios and Latias can use. With Soar, you can fly to all of the same locations that you can visit with Fly—but that's not all. As you freely Soar over the vast richness of Hoenn, you can also stumble upon new locations that are not accessible by any other means—and catch more species of Pokémon that you can't encounter in any other way!

Using Soar

Orlando used the Eon Flute.

Open the Key Items Pocket of your Bag and select the Eon Flute. You may want to register the Eon Flute to Ⓨ so that you can quickly use it at any time. Once you use the Eon Flute, Latios or Latias will appear and whisk you up into the skies high above Hoenn.

Special features of Soar

Rustboro City
YES
NO
Would you like to land here?

Soar lets you get around Hoenn just like Fly, so you no longer need to keep a Pokémon in your party that knows Fly—unless you want to, of course! You can even use Soar when Latios or Latias is not in your party, because using the Eon Flute will summon Latios or Latias from your PC Box if necessary.

TIP
Some bonds are too strong to ever be broken. Even if you happen to release Latios or Latias, or trade it away, it will still always answer your call when you blow the Eon Flute. That's true loyalty!

Soaring screens

Sootopolis City
Ⓐ Land

The top screen shows the action as you Soar over Hoenn. Use the Circle Pad to choose where you want to go. At the same time, the Touch Screen displays a map that shows your location over Hoenn. The yellow arrow represents your current location, and it moves whenever you do.

Soaring controls

As you Soar over locations, their names will appear in the upper-left corner of the top screen. Press Ⓐ to land there if you like, or don't press Ⓐ and just keep going. Other buttons can be used to perform different functions while using Soar, too.

Circle Pad Up	Move forward
Circle Pad Down	Move backward
Let go of Circle Pad	Stop
Circle Pad + Ⓑ	Perform a spin and Soar faster than usual. Hold Ⓑ to maintain top speed.
Circle Pad + Ⓨ	Dive to fly at lower elevations
Circle Pad + Ⓧ	Pull up to fly higher
Circle Pad + Ⓡ	Perform a loop
Circle Pad + Ⓛ	Perform a spin

TIP
If you try to fly outside the map, your Latios/Latias will perform an Immelmann turn to get you back on course.

Encounters in the sky

While using Soar, you'll notice flocks of Pokémon that are flying through the sky. Soar into contact with a Pokémon flock, and you'll be drawn into battle! Although many Pokémon appear to be flying together, you're normally drawn into battle with only one opponent. Seek out Pokémon flocks when you're eager for battle! Otherwise, try to avoid these passing Pokémon.

Soaring Encounters	
❑ Braviary	△
❑ Drifloon	△
❑ Murkrow	△
❑ Pelipper	○
❑ Swablu	○
❑ Taillow	○
❑ Wingull	○

◎ frequent ○ average △ rare ▲ almost never

Mirage spots

Each day, a different Mirage spot will appear somewhere in Hoenn. Mirage spots always appear as sparkling red beacons on the top screen as you Soar around. Soar over to a Mirage spot, and you'll be able to land there and explore.

At Mirage spots, you can find valuable items and unusual Pokémon. You can sometimes find Legendary Pokémon, if you fulfill certain conditions. Turn to page 381 for a full list of Mirage spots and what you can find at these special sites.

TIP

If you use StreetPass, you'll find that the daily Mirage spots from other players' games become accessible in your game as well, allowing you to explore far more than the one a day you would be limited to on your own. Another great reason to turn on StreetPass!

Hoenn Has Been Enriched!

The tremendous energy released by Groudon/Kyogre's Primal Reversion has blanketed the entire region of Hoenn, transforming the land into a rich, fertile habitat for Pokémon to enjoy. This key event marks the appearance of new Pokémon and Mega Stones all over Hoenn! The walkthrough mentions these new species and stones from this point forward, but you've already explored so much of Hoenn by now. Use the following tables to see where you can find new Pokémon species and Mega Stones in old areas now that Hoenn has been enriched! Please note that these new Pokémon will be found hiding in the field, so fire up your DexNav's Detector Mode and look for rustling grass and other signs of a Pokémon hiding nearby!

New Hidden Pokémon appearing after the Groudon/Kyogre battle

Location	New Pokémon						
Route 101 (p. 27)	Lillipup	◎	Sewaddle	▲	Zorua	○	
Route 102 (p. 36)	Gothita	○	Lillipup	◎	Tympole	▲	
Route 103 (p. 32)	Chatot	○	Lillipup	◎	Shellos	▲	
Route 104 (South) (p. 42)	Chatot	○	Pidove	◎	Sewaddle	▲	
Petalburg Woods (p. 44)	Cottonee	◎	Paras	○	Phantump	▲	
Route 104 (North) (p. 46)	Chatot	▲	Pidove	◎	Sewaddle	○	
Routes 105–109 (p. 145, 68, 146, 147, 71)	Clauncher (α)	○	Frillish	◎	Krabby	▲	Skrelp (Ω) ○
Granite Cave (p. 69)	Axew	○	Onix	▲	Timburr	◎	
Route 110 (p. 81)	Chatot	○	Shellos	▲	Trubbish	◎	
Route 111 (Central Desert) (p. 138)	Dwebble	○	Gible	▲	Sandile	◎	

New Hidden Pokémon appearing after the Groudon/Kyogre battle (cont.)

Location	New Pokémon							
Route 112 (p. 109)	Ponyta	◎	Sawk (α)	○	Throh (Ω)	○	Tyrogue	▲
Fiery Path (p. 111)	Diglett	○	Roggenrola	◎	Tyrogue	▲		
Jagged Pass (p. 130)	Mankey	○	Ponyta	◎	Tyrogue	▲		
Route 113 (p. 115)	Bouffalant	▲	Klefki	○	Scraggy	◎		
Route 114 (p. 119)	Misdreavus	○	Skorupi	◎	Tympole	▲		
Meteor Falls (p. 121)	Clefairy	▲	Deino	◎	Druddigon	○		
Route 115 (p. 124)	Clefairy	▲	Misdreavus	○	Pidove	◎		
Route 116 (p. 58)	Eevee	▲	Joltik	○	Pidove	◎		
Route 117 (p. 102)	Deerling	○	Rattata	◎	Tympole	▲		
Route 118 (p. 150)	Aipom	▲	Luxio	○	Raticate	◎		
Route 121 (p. 174)	Aipom	▲	Elgyem	◎	Hypno	○		
Safari Zones A and B (p. 176)	Buneary	▲	Kakuna	◎	Pidgeotto	○		
Safari Zones C and D (p. 176)	Buneary	○	Kakuna	◎	Pidgeotto	▲		
Routes 122 (p. 185), 124 (p. 204), 126–134 (pp. 222–260)	Alomomola	▲	Finneon	○	Frillish	◎		
Mt Pyre (Exterior Wall and Summit) (p. 189)	Bronzor	○	Elgyem	◎	Growlithe	▲		
Route 125 (p. 218)	Finneon	○	Frillish	◎	Seel	▲		
Shoal Cave (all areas except icy chamber) (p. 219)	Cubchoo	◎	Delibird	○	Dewgong	▲		

◎ frequent ○ average △ rare ▲ almost never

New Mega Stones appearing after the Groudon/Kyogre battle

Mega Stone	Location	Notes
Mewtwonite X	Littleroot Town	Find it on the ground.
Scizorite	Petalburg Woods	Find it on the ground.
Ampharosite	New Mauville	Find it on the ground.
Charizardite X	Fiery Path	Find it on the ground.
Tyranitarite	Jagged Pass	Find it on the ground.
Houndoominite	Lavaridge Town	Find it on the ground.

Mega Stone	Location	Notes
Abomasite	Route 123	Find it in the Berry fields.
Aerodactylite	Meteor Falls	Find it on the ground.
Venusaurite	Route 119	Find it on the ground.
Charizardite Y	Route 120	Find it on the ground in Scorched Slab.
Kangaskhanite	Pacifidlog Town	Find it on the ground.
Mewtwonite Y	Pokémon League	Find it on the ground.

4 | Explore more of Sootopolis City

Orlando found a Sablenite!

Now that the weather has cleared and the great threat has passed, Sootopolis City can be fully explored. Whether you've resisted the urge to Soar, or already exhausted its new vistas and returned to Sootopolis, it's time to give Sootopolis a thorough search. Start by heading south from the Cave of Origin to reach an isle with a giant tree. Go east from the tree to find a small area with a sparkling patch of ground. Search at the sparkling patch to discover a Mega Stone called Sablenite.

5 | Obtain two TMs

Orlando obtained
TM83 Infestation!

Go west from the giant tree and begin chatting with Sootopolis's citizens. Enter every house and speak with everyone you meet to obtain special gifts, including TM31 Brick Break from the Black Belt in the northwest house and TM83 Infestation from one of Lisia's biggest fans, who's shopping for items in the local Poké Mart.

6 | Receive a random Berry from Kiri

Orlando obtained a
Rabuta Berry!

Surf over to Kiri, the girl who strolls around Sootopolis City's grassy western shore, and she'll give you two random Berries each day. The first Berry you get from Kiri might be a Pomeg, Kelpsy, Qualot, Hondew, Grepa, Tamato, Cornn, Magost, Rabuta, or Nomel Berry. The second Berry you receive might be a Figy, Wiki, Mago, Aguav, Razz, or Iapapa Berry.

> **TIP**
>
> See page 310 for a complete list of people and places that are worth visiting each day!

> **TIP**
>
> Fun fact: Kiri was named after game director Junichi Masuda's daughter, who was born around the release of the original *Pokémon Ruby Version* and *Pokémon Sapphire Version* games.

7 | Make off with some Max Elixirs

Hunh? Do you have a Barboach?
P-p-please show it to me!

Surf to Sootopolis City's east bank and catch a breather at the Pokémon Center, and then visit the nearby houses afterward to find a pair of brothers arguing over which Pokémon is cuter: Barboach or Shroomish. Show the Fisherman brother a Barboach that has strong affection for you, and he'll give you a Max Elixir. Score another Max Elixir by showing the Hiker brother a Shroomish that has strong affection for you. See page 76 to learn about Pokémon affection and how to increase it.

Reward: Max Elixir ×2

8 | Grab a Wailmer Doll

Orlando obtained a
Wailmer Doll for his base!

A nice lady who loves dolls lives in another home near the Pokémon Center. Considering how tough it is to reach Sootopolis City, she's not used to having many visitors. She decides to give you a gift just for stopping by: a Wailmer Doll! Use this plush Decoration to spruce up your Secret Base.

9 | Meet the Dragon Move Tutor

If you wish, I can teach your Pokémon
the strongest Dragon-type move.

Enter the northeast house to visit the home of Sootopolis City's Move Tutor. This aged Expert will teach your Pokémon the most powerful Dragon-type move, Draco Meteor. Only certain Pokémon can learn this mighty move, including Latios and Latias, but they may need to forget a move in order to make room for it. Visit the Move Deleter in Lilycove City if you want your Pokémon to forget HM moves.

SOOTOPOLIS CITY GYM BATTLE

Gym Battle Tips
- Bring lots of strong HP-restoring items, like Moomoo Milk and Hyper Potions.
- Pokémon that are strong against Water types, such as Grass- and Electric-type Pokémon, will give you an advantage.

1F

Gym Leader Wallace
⊙⊙⊙⊙⊙⊙⊙

Poké Fan Marissa
⊙⊙⊙⊙⊙⊙

Lass Crissy
⊙⊙⊙⊙⊙⊙

BF

Beauty Olivia
⊙⊙⊙⊙⊙

Lady Brianna
⊙⊙⊙⊙⊙

Beauty Connie
⊙⊙⊙⊙⊙⊙

Beauty Bridget
⊙⊙⊙⊙⊙⊙

Beauty Tiffany
⊙⊙⊙⊙⊙⊙

Lass Andrea
⊙⊙⊙⊙⊙⊙

1 Assemble your party and enter the Gym

When you've finished searching Sootopolis City, Surf to its central isle to reach the local Pokémon Gym. You'll be facing lots of Water-type Pokémon inside, so pack your party full of Grass- and Electric-type Pokémon to counter them. This Gym's a breeze if you chose Treecko as your first partner Pokémon and have been journeying with it all along, but any Grass-type Pokémon can give you a big advantage. The Electric-type Pokémon you may have used to storm Fortree City Gym can also be a big help in this Gym.

Sootopolis City Gym is filled with flowing water, but there's more than that to worry about. The Gym also features fragile icy floors that must be traversed in order to reach Gym Leader Wallace. Stepping on an ice tile cracks it, and if you step on a cracked ice tile, it will shatter, plunging you into the watery depths below! Plenty of Trainers await you in the Gym's watery underbelly, so be ready to battle if you fall.

You must cross the Gym's icy floors in order to reach Gym Leader Wallace. Carefully crack all of the ice tiles without shattering any of them, and stairs will appear that lead up to the next icy platform. Remember that once you've revealed the stairs, you still need to reach them, so make sure to plan your path so that you step on the central top ice tiles last!

TIP

If you fall, go south to find the stairs that lead back up to the Gym's entry ledge. The icy tiles will all be restored when you return to them. However, you may wish to battle all the Trainers down below for Exp. Points and prize money!

TIP

You can move diagonally across the ice tiles by pressing two directions at once (up and left, for example). Use this little trick to navigate the icy platforms with less stress!

Wallace
Water-type Pokémon User

 Sootopolis City Gym Leader

Sink him with Grass- and Electric-type moves!

A master of water and illusion, Wallace waits on top of Sootopolis City Gym's tallest platform. Reaching him wasn't easy, so make him pay for the struggle you've endured!

Wallace sends out five Pokémon during this battle—the most Pokémon you've faced in any challenge so far. Although his Pokémon are quite formidable, all five of them share a common weakness to Grass-type moves, and all but one of them is vulnerable to Electric-type moves as well. Many of the moves used by Wallace's Pokémon won't be very effective against Grass-type Pokémon, either, although they'll still inflict normal damage against Electric types. Still, the lack of diversity in Wallace's Pokémon affords you a clear advantage in this battle, especially if you've got powerful Grass-type Pokémon in your party. Take care of Wallace's Pokémon one after the other, using items as needed to keep your Pokémon in good health throughout the clash. Don't relent until you've proven your worth and claimed the eighth and final Gym Badge!

Wallace's Pokémon

Seaking ♀ Lv. 44 — Water
Weak to: Grass · Electric

Whiscash ♂ Lv. 44 — Water · Ground
Weak to: 4× Grass

Milotic ♀ Lv. 46 — Water
Weak to: Grass · Electric

Sealeo ♂ Lv. 44 — Ice · Water
Weak to: Grass · Electric · Fighting · Rock

Luvdisc ♀ Lv. 44 — Water
Weak to: Grass · Electric

 Rain Badge
All Pokémon, including those received in trades, will obey you, regardless of their level. This Badge also lets you use the move Waterfall outside of battle to climb and descend waterfalls.

HM05 Waterfall
The user charges at the target and may make it flinch. This can also be used to climb a waterfall.

TRAINER HANDBOOK

ADVANCED TRAINER'S GUIDE

ADVENTURE DATA

Choose Your Path

Congratulations! You've saved Hoenn from the destructive influence of Groudon/Kyogre, won the eighth and final Gym Badge, and received HM05 Waterfall from Gym Leader Wallace. Several exciting options are now available to you, all of which are covered in complete detail in the next pages of this walkthrough. All you need to do is choose the path you want to follow!

Option 1: Backtrack for fun and profit

Orlando found
TM02 Dragon Claw!

Completists should begin by backtracking and using their newfound Waterfall move to complete their explorations of previous areas. You'll encounter new Trainers by revisiting these old areas, and you'll discover new items and receive a major update to your Pokédex. Just keep reading this walkthrough if you prefer to begin with some profitable backtracking.

Option 2: Explore more optional areas

Orlando found a Star Piece!

Ever Grande City is your next destination, but before you go there, consider exploring Hoenn's remaining optional areas, including Route 129 and beyond. You'll encounter more Trainers, find more items, and catch more Pokémon as you explore these areas, including several Legendary Pokémon! Skip ahead to page 254 if you'd prefer not to do any optional backtracking and would rather cut straight to exploring Hoenn's remaining optional areas, starting with Route 129.

Option 3: Head directly to Ever Grande City

In a rush to get going? Head directly to Ever Grande City (p. 277), and then brave the dangers of Victory Road en route to challenging the Pokémon League! Beating the Champion and entering the Hall of Fame is your ultimate objective, so you'll want to get to it sooner or later! Flip ahead to page 277 now if you prefer to skip the optional backtracking and explorations in favor of advancing to Ever Grande City and Victory Road.

◀◀ BACKTRACK LITTLEROOT TOWN p. 26

The National Pokédex has now been added to Orlando's Pokédex!

Get your Pokédex updated

The immense energy released after your recent battle with Groudon/Kyogre has enriched all of Hoenn. The region has now become a far more hospitable place for Pokémon to live, and many new species of Pokémon can now be caught all over Hoenn! Return to Professor Birch's Pokémon Lab in Littleroot Town, and he'll update your Pokédex to include the National Pokédex. Now get out there and catch those Pokémon!

TIP

Once Hoenn has been enriched and your Pokédex has been updated, your DexNav app reveals new species of Pokémon that can be caught all over Hoenn. Fire up your DexNav and use it to track down and catch each new Pokémon species. Check the lists on page 242 to see exactly which species of Pokémon can be caught in each area of Hoenn now that the region has been enhanced!

TIP

As Steven mentioned to you, Hoenn seems richer than ever, thanks to the infusion of natural energy that poured out of the Cave of Origin when you defeated Groudon/Kyogre. Pokémon that have not been recorded before in Hoenn now seem to popping out all over! They may be shy, though, and try to hide from you, but the Detector Mode on your DexNav should take care of that. In all future sections, these Pokémon will be shown in the Pokémon lists under the title "Hidden Pokémon," since they all are found hiding in the field.

Scale the northwest waterfall

Now that you've got your National Pokédex, Route 114 is your next stop. Fly or Soar straight there, and Surf onto Route 114's northwest river. Surf upstream to find a big waterfall, and use your newfound Waterfall move to climb it by way of geyser. Surf to the west bank after scaling the waterfall and collect the Rare Candy that you discover there.

p. 119

Optional ▎ METEOR FALLS

Field Moves Needed
Surf Waterfall

This waterfall is said to have been the site of a meteoroid shower. An ancient people once made their home here.

With Surf and Waterfall, you are finally able to fully explore Meteor Falls. Collect more items and catch Bagon—it doesn't appear anywhere else in Hoenn!

Entrance

To Route 114
(p. 119)

To Route 115
(p. 124)

B1F Lower chamber

Back chamber

Old Couple
John & Jay ◉
★ Double Battle
◉◉◉◉◉◉

Dragon Tamer
Nicolas ◉
◉◉◉◉◉◉

B1F

Dragon Tamer Dray
◉◉◉◉◉◉

Battle Girl Tess
◉◉◉◉◉

TRAINER HANDBOOK

ADVANCED HANDBOOK

ADVENTURE DATA

Cave

Entrance		
☐ Lunatone	○	α
☐ Solrock	○	Ω
☐ Zubat	◎	

B1F		
☐ Golbat	◎	
☐ Lunatone	○	α
☐ Solrock	○	Ω

B1F Lower chamber		
☐ Bagon	○	
☐ Golbat	◎	
☐ Lunatone	○	α
☐ Solrock	○	Ω

Back chamber		
☐ Golbat	◎	
☐ Lunatone	○	α
☐ Solrock	○	Ω

◎ frequent ○ average
△ rare ▲ almost never

Fishing

Entrance		
Old Rod		
☐ Goldeen	○	
☐ Magikarp	◎	
Good Rod		
☐ Barboach	▲	
☐ Goldeen	○	
☐ Magikarp	◎	
Super Rod		
☐ Barboach	◎	

Fishing

All other floors/areas		
Old Rod		
☐ Goldeen	○	
☐ Magikarp	◎	
Good Rod		
☐ Barboach	▲	
☐ Goldeen	○	
☐ Magikarp	◎	
Super Rod		
☐ Barboach	◎	
☐ Whiscash	▲	

On the Water

Entrance		
☐ Golbat	▲	
☐ Lunatone	△	α
☐ Solrock	△	Ω
☐ Zubat	◎	

All other floors/areas		
☐ Golbat	◎	
☐ Lunatone	○	α
☐ Solrock	○	Ω

Hidden Pokémon

☐ Deino	◎	
☐ Druddigon	○	
☐ Clefairy	▲	

Horde Encounter

B1F Lower chamber		
☐ Zubat (×5)	◎	
☐ Bagon (×5)	▲	
All other floors/areas		
☐ Zubat (×5)	◎	

Items

Entrance
☐ Full Heal*
☐ Moon Stone*
☐ PP Max

B1F Lower chamber
☐ TM02 Dragon Claw

Hidden Items

Entrance
☐ Great Ball
☐ Stardust

B1F
☐ Super Repel

Back chamber
☐ Star Piece

*You may have found them when you visited Meteor Falls before.

1 Finish exploring Meteor Falls

The water is deep, deep blue.
Would you like to use Surf?

Remember Meteor Falls? It's the place where you helped May/Brendan rescue Professor Cozmo from Team Magma / Team Aqua. You couldn't explore much of Meteor Falls before, but now that you know both Surf and Waterfall, you can sweep the place's deepest reaches. Refer to these handy maps, which will keep you on course as you explore. As you give Meteor Falls a thorough search, you can battle new Trainers and collect valuable items and hidden items, including TM02 Dragon Claw and a Mega Stone called Aerodactylite.

TIP

Find Bagon on the same bit of land where you found TM02 Dragon Claw in the final chamber of Meteor Falls' first basement floor. Bagon can evolve into Shelgon and then Salamence. And Salamence might be capable of even more Evolution... like Mega Evolution!

◀◀ BACKTRACK ROUTE 119 p. 157

Find items above the northern waterfall

Ensure that you've got the Acro Bike, and then Fly or Soar to Route 119. (Make a quick stop at Rydel's Cycles in Mauville City if you need to grab the Acro Bike.) Once you reach Route 119, go south from the route sign, heading downstairs until you reach water. Surf west and then north to reach a big waterfall, then climb the falls to explore Route 119's northwest corner, where you can plunder some Berry Trees. You'll need the Acro Bike to cross the narrow rails above the waterfall, but first you must use the Devon Scope to detect and battle an invisible Kecleon that's standing in your way. Cross the narrow rails afterward to find TM62 Acrobatics and a Rare Candy, and you'll run into a few Trainers to battle!

Located on the second floor of Mauville City, these plush accommodations are leased to Mauville's most elite citizens.

You've never been able to visit the Mauville Hills apartments before, but a recent event has created an opportunity for you to do so. Why not take a moment to see what's happening around Mauville Hills?

To Mauville City's first floor (p. 89)

To Mauville City's first floor (p. 89)

Apt. 1 Rotation Frump's Home

Apt. 2 Ribbon Belle's Home

Apt. 9 A Cold Woman's Home

Apt. 10 Home of the Man Who Keeps an Eye on the Corridor

Apt. 11 A Powerless Man's Home

Apt. 3 Old Guys' Home

Apt. 8 Vacant

Apt. 16 Vacant

Apt. 7 A Dreaming Man's Home

Apt. 15 Vacant

Apt. 12 A Frightened Man's Home

Apt. 4 Vacant

Apt. 14 An Ice-Cream Lover's Home

Apt. 13 Wattson's Home

Apt. 6 A Devoted Woman's Home

Apt. 5 A Composer's Home

Items
- ☐ Alert Ribbon
- ☐ Careless Ribbon
- ☐ Downcast Ribbon
- ☐ Lopunnite
- ☐ Relax Ribbon
- ☐ Shock Ribbon
- ☐ Smile Ribbon
- ☐ Snooze Ribbon

Ice-Cream Lover
with Regice in party

Casteliacone	200

TIP

You can find the full maps for Mauville City's first floor and roof on page 89.

1 Meet Wattson by the Square Tower

Go and speak to Gym Leader Wattson standing near the Square Tower in front of the Pokémon Center and Poké Mart. Boy, is that tower ever shining brightly! Wattson explains that the Square Tower is actually a sort of alert system for New Mauville, which is an unfinished facility located beneath the foundation of Mauville City itself. The fact that the Square Tower is lit up indicates that something may be wrong in New Mauville. Wattson asks you to visit him in his apartment in Mauville Hills to discuss the matter further.

2 Take the elevator to Mauville Hills

WELCOME TO MAUVILLE HILLS. PLEASE ENTER THE ELEVATOR.

Wattson has updated your security clearance, enabling you to use Mauville City's elevators to ride up to the city's second floor. Go north out of the courtyard, heading toward the Mauville City Pokémon Gym. Go west from the Gym to find an elevator. Enter the elevator and ride up to the second floor, where the Mauville Hills apartments are located. The other elevator to the east, near TV Mauville, can also bring you up to Mauville Hills.

3 Battle the Rotation Frump

Oh, I reckon you're another one fixin' for a Rotation Battle?

After stepping off the elevator, go east and enter the first apartment you see to the north, which is home to an old lady named Circie who used to be a mighty Rotation Battler back in her day. She has been known as Rotation Girl and even the Rotation Fiend, but Circie's getting on in years. Still, she'll still treat you to a Rotation Battle once per day. Succeed in stumping the Rotation Frump, and her granddaughter will give you an Elixir. Stop by for another Rotation Battle and Elixir each day!

Reward: Elixir

> **TIP**
>
> Press Ⓐ to check the nameplate next to each apartment's door. You can also try the intercoms and see if anyone responds.

> **TIP**
>
> Rattled by Rotation Battles? Turn to page 320 to learn all about them!

Rotation Girl Circie's Pokémon

Simisage ♂ Lv. 42 — Grass
Weak to: Fire | Ice | Poison | Flying | Bug

Simisear ♂ Lv. 42 — Fire
Weak to: Water | Ground | Rock

Simipour ♂ Lv. 42 — Water
Weak to: Grass | Electric

4 Visit the Ribbon Belle

Orlando received the Relax Ribbon!

The next apartment to the east is home to the Ribbon Belle. Enter and speak to the lady who lives here to receive a free Ribbon. The Ribbon that you're given depends on the day of the week. Pin it on your favorite Pokémon! You can also receive the Best Friends Ribbon by talking to the other girl who lives here—provided your party's lead Pokémon is very affectionate toward you. See page 412 to learn about Pokémon-Amie, which is a great way to increase your Pokémon's affection.

Reward: Best Friends Ribbon

Ribbon Belle's Ribbons

Monday	Alert Ribbon
Tuesday	Shock Ribbon
Wednesday	Downcast Ribbon
Thursday	Careless Ribbon
Friday	Relax Ribbon
Saturday	Snooze Ribbon
Sunday	Smile Ribbon

5 | Explore the east hall

If you don't pay what you owe, I'll take everything you have, including your Pokémon!

Continue going east and enter the east hallway. The first apartment to the west is home to a powerless man who seems to be lacking in self-confidence. Across the hall you'll find the old guys who have been teaching you O-Powers at the city's Pokémon Center. Yup, they all live together. Rent must be rough! Keep going south down the hall to find a businessman harassing a frightened man who is hiding in his apartment because he can't repay a loan. Keep talking to the businessman until the frightened man appears, and the two will enter the apartment together to work it out.

TIP

Go out on the balcony from the powerless man's room, and you'll find TM89 U-turn!

6 | Visit Wattson in his apartment

That's why I called you here. I want you to go check on things in New Mauville.

Wattson's apartment (#13) is not far ahead, in the south hall. Go there to continue your chat with Wattson. He asks you to check out the trouble in New Mauville and takes a picture of your eyes to scan into the computer. Now, when you enter New Mauville, the security system that scans your iris should let you pass! You're all ready to investigate, and Wattson advises you to Surf around Route 110 to find the entrance to New Mauville.

7 | Receive a Lopunnite from the businessman

Orlando obtained a Lopunnite!

After talking to Wattson, return to Mauville Hills' east hall to find that the scary-looking businessman has returned. Speak with him, and he'll give you a Mega Stone called Lopunnite. Apparently, he received this from the frightened man as collateral for the loan he took out but couldn't repay. His loss is your gain!

8 | Head to New Mauville

Finish exploring Mauville Hills to meet a few more interesting characters, but you can't accomplish much more around here at present, and the mystery of New Mauville beckons. Fly or Soar to Route 110 and Surf its northern lake to discover the entrance to New Mauville over to the east. Enter the facility to begin your investigation for Wattson.

Optional | NEW MAUVILLE

Though it was planned to be a subterranean city extending 69 floors underground, this project died in development.

You may have discovered New Mauville while Surfing around Route 110 earlier in the adventure, but you've never been able to get inside it before. Now that you've spoken with Wattson in his plush Mauville Hills apartment, you've been cleared to enter and investigate a possible disturbance in New Mauville.

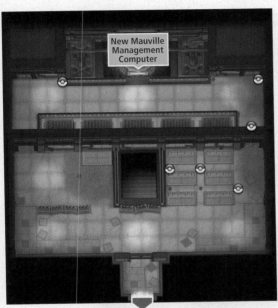

New Mauville
Management
Computer

To Route 110
(p. 81)

Horde Encounter

☐ Magnemite (×5)	○
☐ Voltorb (×5)	◎

Facility

☐ Magnemite	◎
☐ Voltorb	◎

◎ frequent ○ average
△ rare ▲ almost never

Items

☐ Ampharosite
☐ Escape Rope
☐ Full Heal
☐ Metal Coat
☐ Paralyze Heal
☐ Thunder Stone
☐ Ultra Ball

Hidden Items

☐ Max Repel

Magnemite `Electric` `Steel`
Abilities: Magnet Pull, Sturdy

Voltorb `Electric`
Abilities: Soundproof, Static

1 | Check the management computer

NO UNUSUAL ACTIVITY NOTED IN NEW MAUVILLE.
TRANSMITTING THE SURVEILLANCE RESULT...

Wattson's as good as his word—New Mauville's security system grants you clearance. Once you're past the gate, search New Mauville to find a few items—but beware of sneaky Voltorb in disguise! Don't miss the hidden Max Repel to the southwest or the sparkling Ampharosite to the northeast. When you've finished searching the place, check the computer in the back room to perform a security scan and verify that there are no unusual threats present in New Mauville.

TIP

Look out for glowing orbs, which indicate hidden Pokémon waiting to be snuck up on. This place has one other Pokémon secret: see what happens when a Magneton or a Nosepass gain a level here!

◀◀ BACKTRACK | MAUVILLE HILLS | p. 250

Receive your reward from Wattson

Orlando obtained
TM24 Thunderbolt!

Now that you've solved the mystery of New Mauville, return to Mauville City and ride the elevators back up to Mauville Hills. Visit with Wattson again to let him know that everything's all right in New Mauville. The grateful Gym Leader rewards your efforts with TM24 Thunderbolt, a very powerful Electric-type move.

Reward: TM24 Thunderbolt

TRAINER
HANDBOOK

ADVANCED
HANDBOOK

ADVENTURE
DATA

Many Pokémon Trainers visit this route to train their Pokémon before challenging the Pokémon League.

Located just south of Route 128, this optional water route stretches west into Route 130. Visiting Route 129 is totally optional but can really pay off, as you'll find worthy Trainers to battle and more treasures to collect.

Surface

Swimmer ♀ Tisha ◎◎◎◎◎◎

Swimmer ♂ Reed ◎◎◎◎◎◎

Fisherman Sheaffer ◎◎◎◎◎◎

To Route 128 (p. 223)

To Route 130 (p. 255)

A

B

C

D

E

Triathlete Chase ◎◎◎◎◎◎

Ace Trainer Honor ◎◎◎◎◎◎

Fisherman Fisk ◎◎◎◎◎◎

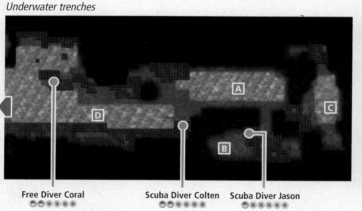

Underwater trenches

To Route 130 (p. 255)

A

B

C

D

Free Diver Coral ◎◎◎◎◎◎

Scuba Diver Colten ◎◎◎◎◎◎

Scuba Diver Jason ◎◎◎◎◎◎

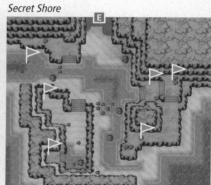

Secret Shore

E

On the Water	
❏ Pelipper	◯
❏ Tentacool	◎
❏ Tentacruel	△

Hidden Pokémon	
❏ Alomomola	▲
❏ Finneon	◯
❏ Frillish	◎

Fishing		
Old Rod		
❏ Magikarp	◎	
❏ Tentacool	◯	
Good Rod		
❏ Magikarp	◎	
❏ Tentacool	◯	
❏ Wailmer	▲	
Super Rod		
❏ Wailmer	◎	

Seaweed	
❏ Chinchou	◎
❏ Clamperl	◯
❏ Lanturn	△
❏ Relicanth	▲

Hidden Items	
Surface	
❏ Big Pearl	
❏ Heart Scale	
Underwater trenches	
❏ Blue Shard	
❏ Lustrous Orb	
❏ Splash Plate	
❏ Toxic Plate	
❏ Zap Plate	

◎ frequent ◯ average
△ rare ▲ almost never

TRAINER HANDBOOK

ADVANCED HANDBOOK

ADVENTURE DATA

1 Search Route 129 for treasures and Trainers

Orlando found a Big Pearl!

Familiar sights greet you around Route 129. Battle Swimmers and Fishermen on the surface, and Dive into the underwater trenches to discover more Trainers and sunken treasures. Surface at the south sunlit patch to reach a small beach, where a hidden Heart Scale and a Big Pearl can be found by dowsing. Surface at the east sunlit patch to reach a southeast path to the Secret Shore.

TIP

Route 129's sunken treasures are fairly easy to find, as they all lie in the seaweed's bare patches. But in case you're having trouble, here are some hints on where these hidden items can be found:

- **Lustrous Orb**: Northeast bare spot, in the northeast seaweed.
- **Blue Shard**: Bare spot in the seaweed that's just west of the east sunlit spot.
- **Zap Plate**: Central bare spot in the central seaweed (east of Free Diver Coral).
- **Splash Plate**: Second bare spot in the seaweed that's southeast of Scuba Diver Jason.
- **Toxic Plate**: Southwest bare spot, in the southern seaweed.

Optional ROUTE 130 & SECRET MEADOW

Field Moves Needed — Surf, Dive

This route was once a big topic of conversation due to a strange island that seemed to appear and then disappear.

Route 130 is much like Route 129. It's short and straightforward, and it features a sizable network of underwater trenches. A thorough exploration of this watery route will lead you to the Secret Meadow—another optional area where Secret Bases can be established.

Surface

Swimmer ♀ Katie ⊚⊚⊚⊚⊚⊚⊚

D

C

A

To Route 129 (p. 254)

To Route 131 (p. 257)

B

Swimmer ♂ Rodney ⊚⊚⊚⊚⊚⊚

Triathlete Karsen ⊚⊚⊚⊚⊚⊚

Secret Meadow

Underwater trenches

C

A

To Route
129
(p. 254)

B

Free Diver Cordura
⊙⊙⊙⊙⊙⊙

Scuba Diver Silas
⊙⊙⊙⊙⊙⊙

Fishing		
Old Rod		
❑ Magikarp	◎	
❑ Tentacool	○	
Good Rod		
❑ Magikarp	◎	
❑ Tentacool	○	
❑ Wailmer	▲	
Super Rod		
❑ Horsea	○	
❑ Seadra	▲	
❑ Wailmer	◎	

On the Water		
❑ Pelipper	○	
❑ Tentacool	◎	
❑ Tentacruel	△	

Hidden Pokémon		
❑ Alomomola	▲	
❑ Finneon	○	
❑ Frillish	◎	

◎ frequent ○ average
△ rare ▲ almost never

Seaweed		
❑ Chinchou	◎	
❑ Clamperl	○	
❑ Lanturn	△	
❑ Relicanth	▲	

Hidden Items	
Underwater trenches	
❑ Earth Plate	
❑ Fist Plate	
❑ Green Shard	
❑ Griseous Orb	
❑ Icicle Plate	
❑ Meadow Plate	

Horsea `Water`
Abilities: Swift Swim, Sniper

1 Find more items around Route 130

Orlando found a Fist Plate!

Like Route 129, Route 130 features more Trainers to battle and more hidden underwater goodies to salvage. Dive into the main trench, and surface at the northwest sunlit spot to reach a path that leads to a small, secret area called the Secret Meadow.

◀ TIP ▶

Here's where you'll find all of Route 130's submerged goodies:

Griseous Orb: In the small northeast trench, north and a little west of the trench's sunlit spot.

Green Shard: Northwest bare spot in the northeast seaweed.

Fist Plate: Down south, just south of Scuba Diver Silas.

Earth Plate: In the middle of the wide bare spot that's south of Free Diver Cordura.

Meadow Plate: Bare spot at the dead-end just east of Free Diver Cordura.

Icicle Plate: Bare spot down south, in the southern seaweed.

Field Moves
Needed
Surf

It is the custom in Pacifidlog Town to swim a lap around this route before breakfast.

This sizable stretch of sea lies just east of Pacifidlog Town. There are no underwater trenches to be explored along Route 131, but a number of Trainers await battle as you Surf the surface. To the north stands the towering Sky Pillar, but it can't be visited or explored until later in your adventure.

To Sky Pillar
(p. 292)

Swimmer♂ Richard

To Pacifidlog
Town
(p. 258)

Swimmer♂ Herman

To Route 130
(p. 255)

Sis & Bro Rell & Ian
★ Double Battle

Swimmer♀ Susie

Swimmer♀ Kara

TRAINER
HANDBOOK

ADVANCED
HANDBOOK

ADVENTURE
DATA

On the Water	
❏ Pelipper	○
❏ Tentacool	◎
❏ Tentacruel	△

Hidden Pokémon	
❏ Alomomola	▲
❏ Finneon	○
❏ Frillish	◎

◎ frequent ○ average
△ rare ▲ almost never

Fishing	
Old Rod	
❏ Magikarp	◎
❏ Tentacool	○
Good Rod	
❏ Magikarp	◎
❏ Tentacool	○
❏ Wailmer	▲
Super Rod	
❏ Horsea	○
❏ Seadra	▲
❏ Wailmer	◎

Pelipper `Water` `Flying`
Ability: Keen Eye

Seadra `Water`
Abilities: Poison Point, Sniper

Wailmer `Water`
Abilities: Water Veil, Oblivious

1 Battle Trainers on the way to Pacifidlog Town

Your optional explorations continue here on Route 131. Surf westward across this route's calm waters, battling Trainers you meet on the surface as you head for Pacifidlog Town. You can Surf up north to discover the imposing Sky Pillar, but a woman prevents you from entering or exploring that mysterious place until you've proven your worthiness. You'll just have to return later!

Optional PACIFIDLOG TOWN

Field Moves Needed
Surf

This town first came into being as a floating storehouse used by people living on the ocean's surface.

Pacifidlog Town is a humble community built atop the calm waters of eastern Hoenn. It features a collection of floating homes that surround a central Pokémon Center, where weary Trainers can rest up and catch a break from the waves.

Pokémon Center

To Route 132 (p. 260)

To Route 131 (p. 257)

On the Water

❏ Pelipper	○
❏ Tentacool	◎
❏ Tentacruel	△

Fishing

Old Rod	
❏ Magikarp	◎
❏ Tentacool	○
Good Rod	
❏ Magikarp	◎
❏ Tentacool	○
❏ Wailmer	▲
Super Rod	
❏ Wailmer	◎

◎ frequent ○ average
△ rare ▲ almost never

Items

❏ Kangaskhanite
❏ TM56 Fling
❏ TM21 Frustration
❏ TM03 Psyshock
❏ TM27 Return

Hidden Items

❏ Big Pearl
❏ Heart Scale

1 Rest up and discover a Kangaskhanite

Orlando found a Kangaskhanite!

You've been journeying for quite some time, so catch some rest at Pacifidlog Town's convenient Pokémon Center. After resting up, Surf to the Pokémon Center's west side and search at the sparkling spot behind the nearby town sign to discover a Mega Stone called Kangaskhanite. Dowse afterward to discover a nearby Big Pearl that's hidden behind the town's sign.

2 Hear of an old legend

Grandpa used to say that, but I don't know what he meant.

Before moving on, stop in at the house to the east of the Pokémon Center. The girl living there will tell you a mysterious bit of wisdom passed down from her grandfather: "Six dots open three doors." What could it mean? Her father also remembers tales of three Pokémon representing the power of rock, ice, and steel. Sounds like Hoenn still has some secrets to discover!

3 Receive some TMs

Orlando obtained TM27 Return!

Speak with the man in the house to the southwest of the Pokémon Center to receive TM56 Fling, which he no longer has any use for. Visit the house to the south afterward to meet none other than the brother of the chairman of the Pokémon Fan Club. He'll evaluate your relationship with your lead Pokémon and give you TM27 Return if it's very friendly toward you. If the Pokémon is unfriendly toward you, he'll give you TM21 Frustration instead.

Rewards: TM21 Frustration, TM27 Return

> ### TIP
> Return and Frustration are both Normal-type moves that deal greater damage the more friendly (in the case of Return) or unfriendly (in the case of Frustration) the user is toward you. You can receive both of these TMs from the chairman's brother—just leave his home and switch out your lead Pokémon, then re-enter and speak with him again. How do you make a Pokémon unfriendly? One quick way is by feeding it lots of herbal medicine!

4 Trade a Bellossom for a Corsola

Do you have a Bellossom? I'll trade you my Corsola for it.

Visit the house that's south of the Pokémon Center to speak with a woman who's having trouble catching different Pokémon around Pacifidlog Town. She wishes to trade her Corsola for a Bellossom. Corsola can be caught on Route 128 by fishing with the Super Rod or by using Dive and searching the seaweed, but they almost never appear. On the other hand, Bellossom evolves from Gloom, which can be caught very easily by searching the very tall grass on Routes 119, 120, 121, and 123, and also in the Safari Zone. You'll have to use a Sun Stone on it, like the one you may have gotten at Mossdeep's Space Center (p. 207). Sun Stones are also sometimes held by wild Solrock.

> ### TIP
> As an added bonus, the Corsola you get by trade is holding a Heart Scale!

5 Find a Heart Scale and receive TM03 Psyshock

Orlando obtained TM03 Psyshock!

Get out your trusty Dowsing Machine and search near the next house to the east to find a hidden Heart Scale. Enter the house afterward and speak to a man who has a fascination with Mirage spots, and even thinks he once discovered one—he just can't remember where. He's so shocked that he forgot where it was that he gives you TM03 Psyshock! Proceed west to Route 132 after obtaining this final item from Pacifidlog Town.

Trainers gather in these stretches of sea in search of something beyond the fierce currents.

Surfers, beware! Routes 132, 133, and 134 feature strong, forceful currents that send you sailing this way and that—sometimes against your will. The crazy currents make these water routes tricky to navigate and explore fully. Outlined below are four main passes that will allow you to battle every last Trainer and collect all the items to be found amid these treacherous waters.

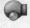

Dragon Tamer Aaron

Swimmer ♀ Laurel

Swimmer ♂ Jack

Bird Keeper Alex

To Slateport City (p. 73)

Ace Trainer Elaine

Black Belt Hitoshi

Swimmer ♀ Sheryl

To Route 134

To Slateport City (p. 73)

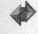

Fishing

Old Rod

❏ Magikarp	◎
❏ Tentacool	○

Good Rod

❏ Magikarp	◎
❏ Tentacool	○
❏ Wailmer	▲

Super Rod

❏ Horsea	○
❏ Seadra	▲
❏ Wailmer	◎

◎ frequent ○ average
△ rare ▲ almost never

On the Water

Routes 132 and 133

❏ Pelipper	○
❏ Tentacool	◎
❏ Tentacruel	△

Route 134

❏ Pelipper	▲
❏ Tentacool	◎
❏ Wingull	○

Hidden Pokémon

❏ Alomomola	▲
❏ Finneon	○
❏ Frillish	◎

Items

Route 132

❏ Protein
❏ Rare Candy
❏ TM34 Sludge Wave

Route 133

❏ Big Pearl
❏ Calcium
❏ Max Revive
❏ Star Piece
❏ TM77 Psych Up

Route 134

❏ Carbos
❏ Star Piece
❏ TM80 Rock Slide

Hidden Items

Route 134

❏ Heart Scale ×3

Magikarp `Water`
Ability: Swift Swim

Tentacool `Water` `Poison`
Abilities: Clear Body, Liquid Ooze

Seadra `Water`
Abilities: Poison Point, Sniper

Horsea `Water`
Abilities: Swift Swim, Sniper

Ace Trainer Warren
◉◉◉◉◉◉◉

Fisherman River
◉◉◉◉◉◉

Swimmer ♀ Debra
◉◉◉◉◉◉

Swimmer ♀ Linda
◉◉◉◉◉

To the Sealed
Chamber (p. 263)

Swimmer ♂ Gilbert
◉◉◉◉◉◉

To
Pacifidlog
Town
(p. 258)

Backpacker Grayson
◉◉◉◉◉◉◉

Swimmer ♂ Franklin
◉◉◉◉◉◉

Bird Keeper Beck
◉◉◉◉◉◉◉

Fisherman Ronald
◉◉◉◉◉◉

Black Belt Kiyo
◉◉◉◉◉◉◉

To Route 133

1 Take the north route for battles and glory

Orlando obtained
TM77 Psych Up!

Follow these instructions carefully and you'll explore the whole area with minimum fuss. Your first pass through these long routes will skirt along their northern edges:

1. From the Route 132 sign, Surf into the northwest currents to reach Swimmer ♂ Gilbert.

2. Surf directly west of Gilbert into the west-flowing currents to reach a Rare Candy on the north side of Fisherman Ronald's isle.

3. Take the northernmost current you can from Fisherman Ronald's isle, right beneath the large rocky island. You will reach the northern shallows in Route 133, where three more Trainers wait.

4. Surf west from Route 133's "three-Trainer shallows" to reach the northern half of Route 133's northwestern island. Here, a wise Psychic would rather just hand you TM77 Psych Up than challenge you to battle. Collect the nearby Star Piece as well, and then Surf west into Route 134.

5. When you land in the calm waters up north on Route 134, battle a couple of Swimmers first. Then jump into the current to your south, which will drive you to the shores of a long, thin island.

6. Go south and then east along these islands to find a Carbos and to battle Black Belt Hitoshi. Scan the long sandy stretch with your Dowsing Machine afterward to discover two hidden Heart Scales.

7. After you've finished searching the central islands, Surf west along the current to reach some nearby shallows, where Dragon Tamer Aaron awaits.

8. Swim west to exit Route 134 and come out alongside Slateport City. Now that you've reached the next city, you can Fly back to the route signs at Routes 132, 133, and 134 in a flash!

TRAINER
HANDBOOK

ADVANCED
HANDBOOK

ADVENTURE
DATA

2 Find balance on the middle path

1. Fly or Soar back to Route 132. This time, set out from the bottom of the island with the route sign and go down while skirting the currents to the west. You'll see a large rocky island. Jump into the currents on its lower half to be whisked around its southern edge.

2. Come out between two sandy islands. You can ignore the southern one for now. Go north to the island with a visible Poké Ball to grab a Protein.

3. Surf into the westerly current straight west of the one rock on this island, and you'll be swept to an isle where Fisherman Ronald is casting away. Battle Fisherman Ronald if you like.

4. Surf directly south from Fisherman Ronald, and let the currents take you to Route 133. You'll land on a small, shallow spot on Route 133, near a Big Pearl.

5. From Route 133's Big Pearl shallow, Surf west to land on the southern end of Route 133's northwestern island. Battle Swimmer ♀ Sheryl here.

6. Jump in the currents south of the island and you'll be whisked to another on Route 134 where Bird Keeper Alex waits for a battle in the shallows.

7. After battling Alex, don't jump back in the water just yet. Fly back to Route 132 instead, and land in front of its route sign.

3 Get some southern exposure

Orlando found a Heart Scale!

1. Head into the currents running south around the same rocky island in Route 132 as in your second pass. This time, though, explore the south isle, which features a Black Belt who is itching for battle.

2. Surf the current that's directly west of the big gray rock on the Black Belt's isle, and you'll land on a tiny islet to the west, which features TM34 Sludge Wave.

3. Surf directly west from the tiny islet with TM34 Sludge Wave to reach Route 133 again. You should land on a small isle that features the route sign and a Max Revive.

4. Go through the break in the rocks northwest of the Route 133 sign, and the westerly currents will sweep you to Route 133's central island, where you can battle Fisherman River and collect a Calcium.

5. Surf west from Fisherman River's island to reach Route 134's route-sign isle, and move to its northwestern tip. Surf directly west to reach a tiny patch of sand, where your Dowsing Machine will help you discover a Heart Scale. Surf west to the shallows you can already see. There, you can battle Ace Trainer Elaine and collect a Star Piece.

4 One last sweep before the depths

Orlando found
TM80 Rock Slide!

1. Fly or Soar back to Route 133 and land in front of its route sign. This time, leave from its western or southern side. Both will take you to the next large patch of shallows, where three Trainers lurk.

2. After you wrap up with Backpacker Grayson, jump into the westerly currents again. You'll land at some large abandoned shallows. See how there are two nubs sticking out of its western side? Wade out onto the northern one and jump in the westerly current. It will take you to a patch of calm water, and if you follow its circular path, you'll find TM80 Rock Slide.

3. Are you ready for more? The next page will take you into the depths beneath Route 134. You may want to Fly to a city to rest up your team. Then Fly back to Route 133 and follow the previous two numbered bullet points once more to return to the large shallows on Route 134. This time, head west between the two protrusions to land at that deep, dark pit of water...

Use Dive at the dark spot on Route 134. Once you're underwater, go south along the underwater trenches until you reach a sunlit spot. The markings on the nearby wall are visual braille. It's OK if you can't decipher the symbols right now, so surface at the sunlit spot to begin exploring an ancient ruin known as the Sealed Chamber.

Optional SEALED CHAMBER

Field Moves Needed Surf Dive

Found in the watery depths of Route 134, this old ruin might hold the key to unraveling many mysteries around Hoenn.

If you're skilled at using Surf through the currents on Routes 132, 133, and 134, you can reach a Dive spot on Route 134 that leads to this mysterious underwater ruin. Get your thinking cap ready, because you'll need to decode some mind-bending mysteries from Hoenn's ancient past and be sure to bring along a Wailmer and a Relicanth if you want to make it all the way through!

First chamber

Second chamber

To Route 134 (p. 260)

On the Water	
❑ Golbat	▲
❑ Tentacool	◎
❑ Zubat	○

◎ frequent ○ average
△ rare ▲ almost never

Fishing		
Old Rod		
❑ Magikarp	◎	
❑ Tentacool	○	
Good Rod		
❑ Magikarp	◎	
❑ Tentacool	○	
❑ Wailmer	▲	
Super Rod		
❑ Horsea	◎	
❑ Wailmer	◎	

1 **Explore the Sealed Chamber**

What's this? The mysterious writing that you spotted underwater also appears on the many stone tablets around the Sealed Chamber! You seem to have discovered a code that has been used since days long past, and the key to solving the Sealed Chamber's mysteries hinges on deciphering this ancient system.

Deciphering the Braille

The raised dots that you discover on the many tablets throughout the Sealed Chamber are visual braille. Although it's not immediately obvious, the standing tablets in the Sealed Chamber's entry cavern act as a chart to help you read the braille characters. You can simply follow this walkthrough to get fast answers if you want to, but if you feel like decoding the Sealed Chamber's messages on your own, here's how to decipher them:

A B C D E F G H I J K L M N O

P Q R S T U V W X Y Z . ,

2 Decipher the braille code

Discovering the meaning behind the Sealed Chamber's braille symbols is only half the trick—you also need to know how to put the information to use! Inspect the markings on the cavern's north wall to discover a phrase in braille. The tablets around the room teach you how to read this phrase. If you'd rather just have the answer, then you've come to the right place. The north wall's phrase reads: "Dig here."

3 Dig to reach the next chamber

"Dig here"... OK, but how do you dig? By using the move Dig, of course! If you've been following this walkthrough, then you received TM28 Dig while visiting the Fossil Maniac on Route 114. Teach this TM to a Pokémon, and have that Pokémon use Dig while you're standing right near the north braille markings. Use Dig at this exact spot to open a secret passage that leads deeper into the Sealed Chamber!

TIP

Don't have Dig? Don't worry! Just backtrack out of the Sealed Chamber, Fly or Soar to Route 114, and visit the Fossil Maniac, who lives in the northern house (p. 120). Speak to the Fossil Maniac's younger brother inside the house to receive TM28 Dig.

4 | Decode the second riddle

After using Dig to delve deeper into the Sealed Chamber, you'll arrive at another mysterious, tablet-filled cavern. If you want to learn more about the legends that were sealed away around Hoenn, read the tablets that encircle the central ruins. Or you can head straight for the braille message on the north wall. Once translated, this braille message reads: "First comes Relicanth. Last comes Wailord." It must be another clue!

TIP

If you are having trouble deciphering the braille tablets, here is a translation of the tablets as they lead around the room, from the northwest corner to the southeast corner. "Long did we live here in this cave. All thanks to the powerful Pokémon living alongside us. Yes, we sealed that Pokémon away, alone in the dark. We feared it. If you have the courage, if you still hold to hope, open the door. For beyond it, the eternal Pokémon waits." It sounds quite portentous. This is probably a Pokémon really worth getting!

5 | Solve the second riddle

It sounded as if doors opened somewhere far away.

To get any further, you must make Relicanth the lead Pokémon in your party and put Wailord in the very last position. Examine the north wall again with your party prepped like this, and a mighty earthquake will rock the Sealed Chamber. It sounds a lot like doors opening in faraway places. You've definitely done something special!

TIP

Wailmer can be caught with your Good Rod or even more easily with your Super Rod in many places around Hoenn, such as Slateport City and Lilycove City. Catch a Wailmer and level it up to Level 40 to evolve it to a Wailord. Relicanth can be caught in the seaweed down in underwater trenches, such as on Route 128. It's hard to find a Relicanth, but it's there!

6 | Search for the Legendary Pokémon of Hoenn

You may not realize it yet, but the earthquake that you've just caused has opened a number of ancient ruins around Hoenn. This means you can now quest to catch Legendary Pokémon! Just keep reading to learn how to catch them all!

◀◀ **BACKTRACK** | **ROUTE 105** p. 145

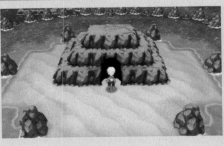

Unlock the Island Cave

Now that you've solved the Sealed Chamber's riddles, you're ready to begin an exciting quest to catch a number of Legendary Pokémon around Hoenn. Your first stop is the Island Cave—an ancient ruin that has opened on Route 105. Backtrack out of the Sealed Chamber, and Fly or Soar to Route 105. Then Surf to the cave on the northwestern island that's surrounded by rocks.

TIP

Not seeing the new cave on Route 105? You might not have solved the riddles of the Sealed Chamber. Make sure that you've triggered the earthquake in the Sealed Chamber by inspecting the back cavern's north braille message with Relicanth leading your party and Wailord in last position. That's the trick to opening the Island Cave on Route 105!

Optional ISLAND CAVE

Field Moves Needed
Surf Dive

This rock formation on Route 105 has long been thought to be the site of an ancient ruin.

Solving the secrets of the Sealed Chamber (p. 263) has revealed a cave in Route 105's mysterious northern rock formation. It almost goes without saying that anything you find in a place this unusual will be worth discovering!

Back cavern

1 Decipher the braille code

The Island Cave is a small, chilly place that has snow on the floor and more of that mysterious braille writing on the northern wall. Stand before the braille and inspect it to begin working at decoding it. Turn back to the guide on page 264 if you need to refer to the key there.

2 Solve the riddle

Don't worry if the braille is giving you trouble—it translates as follows: "Stop and wait unmoving as time passes you by twice." But what could it mean? Close the braille message in the game and then remain stationary. Stand still in front of the north wall for a full two minutes. After two minutes pass, your patience will be rewarded when a secret passage appears out of nowhere!

Entrance

To Route 105
(p. 145)

3 Battle and catch Regice!

Save your game and then go through the secret passage to visit the Island Cave's back cavern, where a Legendary Pokémon known as Regice awaits. This is your only chance to catch Regice right now—if you lose, flee, or defeat it by mistake, you'll have to wait until you've entered the Hall of Fame before you can try again. Save your game before the battle, just in case things don't go your way!

Catch Regice!

Regice	Ice
Lv. 40	

Weak to: Fire | Fighting | Rock | Steel

Discover the Desert Ruins

After catching Regice, your next stop is the Desert Ruin—another ancient cave that has opened in the stormy desert of Route 111. Fly or Soar to Route 111 and enter its central desert. Then explore the desert, going east and south to locate the entrance to the Desert Ruins.

Optional | DESERT RUINS

This rock formation in Route 111's desert has long been thought to be the site of an ancient ruin.

Solving the secrets of the Sealed Chamber (p. 263) has revealed a cave in Route 111's stormy desert. Whatever you might find in this unusual place is sure to be of value!

Entrance

To Route 111
(Central Desert)
(p. 138)

Back cavern

Regirock

1 Decipher the braille code

The Desert Ruins features a sandy floor and more of that mysterious braille writing on the northern wall. Stand in front of the braille and inspect it to begin working at decoding it. Once again, you can flip back to page 264 if you need to refer to the key.

2 Solve the riddle

Don't worry if the braille is giving you trouble—it translates as follows: "Right, right, down, down, then use your strength." What does it mean? Close the braille message in the game, and then move exactly as instructed: Take two steps to the right (east) and two steps down (south). After moving exactly like this, use the Strength field move to expose a secret passage in the north wall!

TRAINER HANDBOOK

ADVANCED HANDBOOK

ADVENTURE DATA

3 Battle and catch Regirock!

Save your game and then go through the secret passage to visit the Desert Ruins' back cavern, where a Legendary Pokémon known as Regirock waits. Again, this is your only chance to catch Regirock right now—if you lose, flee, or defeat it by mistake, you'll have to wait until you've entered the Hall of Fame before you can try again. So be sure to save your game before the battle, just in case things don't go your way!

Catch Regirock!

Regirock		Rock
Lv. 40		

Weak to:

Water	Grass	Fighting
Ground	Steel	

◄◄ **BACKTRACK** ▌ **ROUTE 120** p. 166

Explore the Ancient Tomb

After catching Regirock, your next stop is the Ancient Tomb—a forgotten ruin that has opened on Route 120. To go there, first Fly or Soar to Route 121, then go west to reach Route 120 and the south-western plateau, where you will find the cave entrance to the Ancient Tomb.

Optional ANCIENT TOMB

This rock formation on Route 120 has long been thought to be the site of an ancient ruin.

Solving the secrets of the Sealed Chamber (p. 263) has revealed a cave in Route 120's mysterious northern rock formation. Maybe you'll find another Legendary Pokémon here!

Entrance

To Route 120
(p. 166)

Back cavern

Registeel

1 Decipher the braille code

You guessed it: the Ancient Tomb is a small cavern with more of that mysterious braille writing on its northern wall. Stand before the braille and inspect it to begin decoding it. Use the key on page 264 if you wish to decode each symbol yourself.

2 Solve the riddle

Don't worry if the braille is giving you grief—it translates as follows: "Stand center. Aim to the sky with love and hope and time." But what could it mean? After reading the braille, close the message in the game and then move to the exact center of the cave. Use the field move Fly to reveal a secret passage that leads to the back cavern! If you can't use Fly, you're not standing in quite the right spot—move a bit and try again.

3 Battle and catch Registeel!

Save your game and then go through the secret passage to visit the Ancient Tomb's back cavern, where a Legendary Pokémon called Registeel waits. As before, you'll now have one chance to catch Registeel—if you lose, flee, or defeat it by mistake, you'll have to wait until you've entered the Hall of Fame before you can try again. Save your game before the battle in case things don't go your way.

TRAINER
HANDBOOK

ADVANCED
HANDBOOK

ADVENTURE
DATA

Catch Registeel!

Registeel
Lv. 40 — Steel

Weak to: **Fire** **Fighting** **Ground**

Catch Regigigas!

Pat yourself on the back if you've managed to catch Regice, Regirock, and Registeel—you're now able to go after another Legendary Pokémon named Regigigas!

But you'll need to have something cold to meet it...

Begin by using Fly or Soar to get back to Pacifidlog Town. Speak to the girl who lives in the house to the east of the Pokémon Center. Now that you've caught Regice, Regirock, and Registeel, the girl tells you something special that she heard from her grandfather—hints about an elusive Legendary Pokémon called Regigigas. The girl tells you one of four stories, but you'll only hear one of them in your game. You can swap tales with friends who are also playing *Pokémon Omega Ruby* or *Pokémon Alpha Sapphire*. If that's not an option, you can read them all below:

Grandpa used to say that this huge Pokémon sometimes visits our region...

1. *But he said you'll need to wait in the middle when it's bright and Hoenn is overflowing with natural energy. I wonder if he meant you can't meet it at night.*
2. *But you'll need to have three of its friends with you to meet it... I wonder what Pokémon they are. Does it have to do with the six dots?*
3. *But you'll need to have something cold to meet it... I wonder what he meant. Ice cream, maybe?*
4. *He told me that it comes to visit this iceberg kind of Pokémon. I can only think of one kind of iceberg Pokémon...*

Conditions for finding Regigigas

₱ 190,840

Yes
No

So I'll give you a special deal! Just ₱200 for a Casteliacone! ♪

Can't find Regigigas based on the hints above? No worries! Here are all the special conditions that must be met in order to meet Regigigas:

1. The Hoenn region must be enriched by the energy released by the Primal Reversion of Groudon/Kyogre. This special change to the region occurs after you catch or defeat Groudon/Kyogre in the Cave of Origin.
2. Regice, Registeel, and Regirock must all be in your party.
3. Regice must be given a Never-Melt Ice, a Casteliacone, an Icy Rock, an Icicle Plate, or a Snowball to hold.
4. Regice must have a nickname. Visit the Name Rater in Slateport City (p. 77) if you need to give it a nickname.
5. You may need to let a day pass, if you just got Regice, Registeel, and Regirock right in a row. Wait until the sun rises on a bright new day, then set out!

TIP

In need of an item for Regice to hold? Fly to Mauville City and take the elevator up to Mauville Hills (p. 250) on the city's second floor. Go to the south hall and enter the apartment next to Wattson's, which is home to a girl who'll sell you a Casteliacone for just 200—but she only sells it if you have Regice in your party! Casteliacones are also nice to have because they can heal all status conditions for a Pokémon in battle.

Catch Regigigas! (cont.)

Finding Regigigas

The very earth is quaking!
Is something approaching?!

Once you've satisfied the above conditions, Fly to Route 105 and revisit the Island Cave (p. 266)—the very same cave where you recently caught the Iceberg Pokémon Regice. Save your game and ensure that you're ready, then enter the cave's back cavern and move into the center of the room during daytime. As long as it isn't night, the ground will quake and Regigigas will appear!

Catch Regigigas!

🔴 Regigigas	Normal
Weak to: Fighting	

TIP

Regigigas disappears if you lose the battle, defeat it, or run away from it, so be ultra-sure to save before the battle. If you couldn't catch Regigigas, restart the game and try again. If you save after failing to catch Regigigas, it won't reappear until after you've entered the Hall of Fame.

Optional — SEA MAUVILLE

Field Moves Needed: Surf, Dive

A facility that was decommissioned dozens of years ago. It is now maintained as a natural preserve.

Since you're in the right spirit for catching Legendary Pokémon, there's another at Sea Mauville, as well as a very rare Pokémon that can only be found here in Hoenn. You may have thought you had uncovered them all, but there were more secrets yet to be found at the old site of Sea Mauville. Fly or Soar back there and follow the steps below to finally exhaust this sunken treasure trove. Flip back to the maps on page 148 if you need them for reference.

1 Find the Scanner for Stern

Orlando obtained the Scanner!

If you talk to the Scientist up top, he'll now tell you a bit more about what Stern sent him here to investigate. He is supposed to find a certain Scanner, and he claims to have searched high and low for it—everywhere but the underwater portions of the facility. Use Dive once again in the waters below decks, and this time go all the way down to the lowest level. You'll find some kind of control panel. Head southeast of it, and you'll find the Scanner near the eastern stairwell.

2 Catch Spiritomb!

Head back up to the first underwater level, and this time surface on the right side of the building. Enter the first door on your left. You'll get the feeling you're being watched! Save your game first, and then search the bookshelf in the room's top-left corner to get that feeling again. Open your Bag and check your Pokémon or items so that the top screen is covered by a menu. Then close the menu—to find that Spiritomb has suddenly appeared behind you! Battle and catch this rare Pokémon.

Catch Spiritomb!

⊙ **Spiritomb** `Ghost` `Dark`
Lv. 50

Weak to: `Fairy`

◀◀ **BACKTRACK** **SLATEPORT CITY** p. 73

> Would you do me a favor and let me take that Scanner off your hands?

> Yes
> No

Deliver the Scanner to Stern

Talk to the Scientist up top again, and he'll ask you to deliver the Scanner you found to Captain Stern in Slateport City. Fly back there and find Stern in the harbor. As a reward, he will give you either the Clear Bell or the Tidal Bell (depending on which game you're playing). This bell figures into some old legends in the Johto region. Stern says he used to sometimes see it glow when standing on the decks of Sea Mauville. That sounds worth checking out. Back to Sea Mauville!

Reward: Clear Bell (Ω) / Tidal Bell (α)

3 Catch Ho-Oh/Lugia

> Would you like to examine it?

> Yes
> No

Pokémon Omega Ruby Ω

Climb up the slanted deck of Sea Mauville and the Clear Bell in your Bag will start to glow. Head up the incline until you reach the highest point on the deck. Then go even further, climbing up one of the metal arms protruding over the water. A mysterious ring is floating in the area. Save your game before examining it, because within it waits the Legendary Pokémon Ho-Oh. Catch it now or you'll have to clear the Pokémon League before it appears again!

> Would you like to examine it?

> Yes
> No

Pokémon Alpha Sapphire α

Enter the Sea Mauville building, and use Dive to reach the underwater areas. Take the stairs to go down even deeper, and the Tidal Bell in your Bag will start to glow. Go around the stairs, and you'll see a mysterious ring floating in the water. Save your game before examining it, because within it waits the Legendary Pokémon Lugia. Catch it now or you'll have to clear the Pokémon League before it appears again!

Catch Ho-Oh!

Ho-Oh Lv. 50 — Fire / Flying
Weak to: 4× Rock, Water, Electric

Catch Lugia!

α

Lugia Lv. 50 — Psychic / Flying
Weak to: Electric, Ice, Rock, Ghost, Dark

◀◀ **BACKTRACK** ▸ **ROUTE 120** p. 166

Catch Heatran in Scorched Slab

We're not out of rare Pokémon yet! Remember Scorched Slab? It's the cave that you can reach by using Surf across Route 120's northern lake. You may have explored this mysterious ruin before, but now that Hoenn has been enriched by the release of Primal Energy, you can find a new Mega Stone here, along with a Legendary Pokémon!

Optional | SCORCHED SLAB

Field Moves Needed: Surf, Flash, Strength

This cave is rumored to be the hiding place of an elusive Fire-type Pokémon.

Jutting up from Route 120's northern lake, Scorched Slab can be visited during your first trip through Route 120—just Surf into the lake cave and explore. However, since Hoenn has been enriched by the release of Primal Energy, a Legendary Pokémon now appears in the depths of these dark, stifling ruins.

1F

To Route 120 (p. 166)

B1F

Fishing		
Old Rod		
☐ Goldeen	○	
☐ Magikarp	◎	
Good Rod		
☐ Barboach	▲	
☐ Goldeen	○	
☐ Magikarp	◎	
Super Rod		
☐ Barboach	◎	

On the Water		
☐ Golbat	◎	
☐ Zubat	◎	

Cave		
☐ Golbat	◎	

Horde Encounter		
All areas but 1F		
☐ Zubat (×5)	◎	

◎ frequent ○ average
△ rare ▲ almost never

B2F

B3F

1 Meet Flannery inside the ruin

You may have already plundered Scorched Slab during your initial visit to Route 120. This time, however, you find Gym Leader Flannery of Lavaridge Town searching the Slab for rare Pokémon. Flannery isn't quite ready for the task, however, and departs to prepare herself, leaving the explorations to you. Use Flash to light up the Scorched Slab's darker floors as you explore.

2 Catch Heatran

Search the sparkling spot on Scorched Slab's second basement floor to discover a Mega Stone called Charizardite Y. This Mega Stone wasn't here before—it must have appeared as a result of Hoenn's enrichment! Afterward, take the northern stairs down to the lowest basement floor, which is sweltering with oppressive heat. Save your game and then approach the mysterious ring that hangs in the air. Reach into the ring to battle the Legendary Pokémon Heatran!

Catch Heatran!

⊙ Heatran	Fire	Steel
♀/♂ Lv. 50		
Weak to: Ground	Water	Fighting

Legendary Mirage Spots

Many more Legendary Pokémon can be caught before you enter the Hall of Fame, and they're all discovered by using Soar through Hoenn's skies and visiting the special Mirage spots that appear. You'll need to fulfill specific conditions to make these Mirage spots appear. Read on to see which Pokémon you can encounter, and hints on how to find them. You can also refer to pages 351–357 for more on Mirage spots. If you'd prefer to get on with the main adventure, flip to Ever Grande City's section, beginning on page 277.

How to encounter

Try Soaring with different Legendary Pokémon in your party to find the Trackless Forest. Then visit it at different times!

How to encounter

Try Soaring with some friendly Pokémon in your party to find the Nameless Cavern. Then visit it at different times!

How to encounter

Try Soaring with a certain Psychic trio to find Dialga or Palkia in the Dimension Rift. Finding Giratina will require both temporal and spatial finesse!

How to encounter

Try Soaring with a Pokémon that reacts to the weather to encounter Tornadus or Thundurus. You'll need the power of both lightning and storms on your side to find Landorus!

Legendary Mirage Spots (cont.)

Catch Cobalion!

Cobalion — Steel / Fighting
Lv. 50

Weak to: Fire | Fighting | Ground

Catch Terrakion!

Terrakion — Rock / Fighting
Lv. 50

Weak to: Water | Grass | Fighting
Ground | Psychic | Steel | Fairy

Catch Virizion!

Virizion — Grass / Fighting
Lv. 50

Weak to: 4×! | Flying | Fire | Ice
Poison | Psychic | Fairy

How to encounter

Try Soaring with some well-trained Pokémon in your party to find the Pathless Plain. Then revisit it on different days of the week!

Catch Reshiram!

Reshiram Ω — Dragon / Fire
Lv. 50

Weak to: Ground | Rock | Dragon

Catch Zekrom!

Zekrom α — Dragon / Electric
Lv. 50

Weak to: Ice | Ground | Dragon
Fairy

Catch Kyurem!

Kyurem — Dragon / Ice
Lv. 50

Weak to: Fighting | Rock | Dragon
Steel | Fairy

How to encounter

Try Soaring with a very high-level Pokémon in your party to find the Fabled Cave. Gather the vast white and deep black to your side to find the Gnarled Den!

Catch Cresselia!

Cresselia — Psychic
♀ Lv. 50

Weak to: Bug | Ghost | Dark

How to encounter

Crescent Isle appears very rarely. Keep Soaring every day and hope it appears. Remember that StreetPass can help (p. 11)!

TRAINER HANDBOOK

ADVANCED HANDBOOK

ADVENTURE DATA

276 Legendary Mirage Spots

EVER GRANDE CITY

This city is blanketed in a profusion of colorful blooms. It plays host to the grand Pokémon League.

At long last, your journey has led you to Ever Grande City—the final stop on your path to Victory Road! Enjoy your stay in this vibrant village before braving Victory Road on your way to the Pokémon League.

To Victory Road (p. 278)

Pokémon Center

From Victory Road (p. 278)

To Route 128 (p. 223)

Hidden Items
- [] Revive

Items
- [] TM29 Psychic

On the Water

❏ Pelipper	○
❏ Tentacool	◎
❏ Tentacruel	△

Fishing

Old Rod	
❏ Magikarp	◎
❏ Tentacool	○

Good Rod	
❏ Luvdisc	○
❏ Magikarp	◎
❏ Wailmer	▲

Super Rod	
❏ Corsola	▲
❏ Luvdisc	◎
❏ Wailmer	○

◎ frequent ○ average
△ rare ▲ almost never

1 — Use Waterfall to reach the city

Orlando found a Revive!

If you've never visited Ever Grande City before, you'll need to Surf east from Route 128 to reach it. Use Waterfall to scale the big falls that get in your way and reach the city itself. The TM on the east bank is out of your reach, but you can dowse to discover a hidden Revive near the north stairs. Take a break at the Pokémon Center afterward and prepare your party for the challenges ahead on Victory Road.

TIP

Victory Road leads to the Pokémon League, where Hoenn's Elite Four and the Champion await. Before entering, ask yourself: have you found all of the Mega Stones that you want (p. 318)? Have you caught all of the Pokémon that you need (p. 338)? If you think you're ready, then it's time to see where you stand in the world of Pokémon!

◀◀ BACKTRACK ▎ MAUVILLE CITY

p. 89

Score a new O-Power

You can now use PP Restoring Power Lv. 1!

Once you've reached Ever Grande City, you can find the pink-haired Story-teller standing in the Pokémon Center in Mauville City. Fly back to Mauville City and speak to the Storyteller who recounts the many amazing deeds of a renowned Trainer. He'll teach you a new O-Power after concluding his yarn—PP Restoring Power Lv. 1.

VICTORY ROAD

Field Moves Needed — Surf, Strength, Flash

This challenging path forces Trainers who hope to overcome the Pokémon League to first surpass their own limits.

One final challenge must be faced before you can visit the Pokémon League: Victory Road. Think of this long, tough trail as a means of weeding out those Trainers who have little hope of succeeding against the Elite Four and the Champion. If you can make it through Victory Road, you just might have what it takes to enter the Hall of Fame!

1F Entrance

To Ever Grande City
(p. 277)

1F Interior

Ace Trainer Hope ⚫⚫⚫⚫⚫⚫

Brains & Brawn Aden & Finn
★ Double Battle ⚫⚫⚫⚫⚫⚫

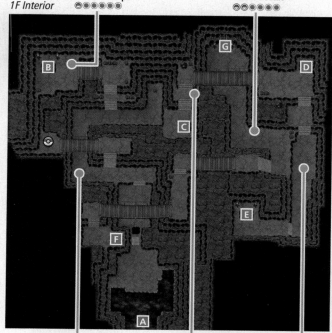

Ace Trainer Albert ⚫⚫⚫⚫⚫⚫

Ace Trainer Edgar ⚫⚫⚫⚫⚫⚫

Street Thug Regan ⚫⚫⚫⚫⚫⚫

B1F

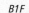

Ace Trainer Vito ⚫⚫⚫⚫⚫⚫

Expert Bryn ⚫⚫⚫⚫⚫⚫

Dragon Tamer Egon ⚫⚫⚫⚫⚫⚫

Ace Duo Jude & Rory 🌀
★ Double Battle ⚫⚫⚫⚫⚫⚫

Expert Theodore ⚫⚫⚫⚫⚫⚫

To Ever Grande City
(p. 277)

To Ever Grande City
(p. 277)

2F

2F Final bridge

To Pokémon League (p. 282)

Pokémon Trainer Wally

On the Water		
1F and B1F areas		
☐ Golbat	○	
☐ Tentacool	◎	
☐ Tentacruel	△	
1F areas		
☐ Golbat	◎	

Horde Encounter		
All areas		
☐ Aron (×5)	○	
☐ Loudred (×5)	▲	
☐ Zubat (×5)	◎	

Cave		
1F and B1F areas		
☐ Golbat	○	
☐ Hariyama	△	
☐ Lairon	○	
☐ Loudred	○	
☐ Mawile	△	Ω
☐ Medicham	△	
☐ Sableye	△	α

Items	
1F Interior	
☐ Full Heal	
B1F	
☐ Full Restore	
☐ Max Elixir	
☐ PP Up	
☐ TM35 Flamethrower	
2F	
☐ TM81 X-Scissor	
2F Final bridge	
☐ Dawn Stone	

Hidden Items	
1F Interior	
☐ Elixir	
☐ Max Repel	
B1F	
☐ Ultra Ball	
1F Interior	
☐ Iron	

Fishing		
All areas		
Old Rod		
☐ Magikarp	◎	
☐ Tentacool	○	
Good Rod		
☐ Luvdisc	○	
☐ Magikarp	◎	
☐ Wailmer	▲	
Super Rod		
☐ Luvdisc	◎	
☐ Wailmer	◎	

Fishing		
2F		
Old Rod		
☐ Goldeen	○	
☐ Magikarp	◎	
Good Rod		
☐ Barboach	▲	
☐ Goldeen	○	
☐ Magikarp	◎	
Super Rod		
☐ Barboach	◎	

◎ frequent ○ average
△ rare ▲ almost never

1 | Find a Full Heal and a Max Repel

Orlando found a Full Heal!

Surf across Victory Road's entrance to reach the first floor. Shove a boulder into a hole with Strength, then battle Ace Trainer Albert a bit further ahead. Scale the nearby steps after battling Albert to reach a Full Heal. Backtrack down the steps and head north, dowsing to find a hidden Max Repel on your way to the northwest ladder, which leads down to the first basement floor.

2 | Discover an Ultra Ball and a PP Up

Orlando found a PP Up!

Use Flash to light up the first basement floor, then dowse to find a hidden Ultra Ball in the nearby rock. Use Strength to shove the nearby boulders out of your way afterward so that you may travel south and then east. Move the northeast boulders as well so you can reach the PP Up in the corner, then ascend the nearby plateau and battle Expert Bryn on your way to a ladder that leads back up to the first floor.

TRAINER HANDBOOK

ADVANCED HANDBOOK

ADVENTURE DATA

3 | Locate a hidden Elixir and a Max Elixir

Orlando found a Max Elixir!

Battle Ace Trainer Edgar back on the first floor, then dowse to discover a hidden Elixir. Cross the nearby bridge afterward to find a ladder that leads down to the first basement floor again. You could keep going south to reach another ladder, but take this one first to visit another small section of the first basement floor, where a Max Elixir is found.

4 | Surf outside to find TM29 Psychic

Orlando found
TM29 Psychic!

Backtrack up to the first floor and head south to battle Street Thug Regan and reach another ladder. Descend the ladder to return to the first basement floor, then have a Double Battle with Ace Duo Jude & Rory. Surf into the south channel afterward to exit Victory Road and briefly return to an otherwise inaccessible part of Ever Grande City. Collect TM29 Psychic, which lies on Ever Grande City's east bank.

5 | Move boulders to claim TM35 Flamethrower

Orlando found
TM35 Flamethrower!

Surf back into Victory Road and land on the west bank. Go north and battle Expert Theodore, then keep heading north to find two big boulders. Shove the first boulder to the east so that you may reach the second boulder, then shove the second boulder twice to the north and twice to the east so that you may claim TM35 Flamethrower.

6 | Battle your way to the second floor

Head west from the TM and battle Ace Trainer Vito to reach a Full Restore. Head south and battle or avoid Dragon Tamer Egon on your way to a ladder that leads back up to the first floor. Up there, navigate a series of bridges on your way to a Double Battle against Brains & Brawn Aden & Finn. Climb the ladder beyond them to reach a watery cavern up on Victory Road's second floor.

TRAINER HANDBOOK

ADVANCED HANDBOOK

ADVENTURE DATA

7 | Find a TM above a waterfall

You're treated to a stunning view of surrounding waterfalls as you enter Victory Road's second floor. Cross the nearby bridge, then dowse to discover a hidden Iron before sprinting up the nearby stairs. Cross the next bridge, then Surf onto the nearby pool of water and scale the waterfall to reach TM81 X-Scissor. Descend the waterfall afterward and go east and then north to reach Victory Road's last stretch.

8 | Battle Wally before the final bridge

I bet you must be surprised to see me in a place like this!

You've made it! The challenges of Victory Road are behind you, and a familiar face pops up amid the flowering fields that mark the exit from this grueling path: Wally has made it here to the pinnacle of Victory Road! He isn't here to congratulate you, however—he's here to show you how much he's grown as a Trainer since your last battle!

Wally's Pokémon

Wally has come a long way—and so have his Pokémon. The young Trainer sends out five different Pokémon to oppose you, including Gallade, which Wally transforms into Mega Gallade through the power of Mega Evolution. A mixture of Fighting-, Flying-, and Fairy-type moves can be super effective against his Pokémon, so be creative and mix things up!

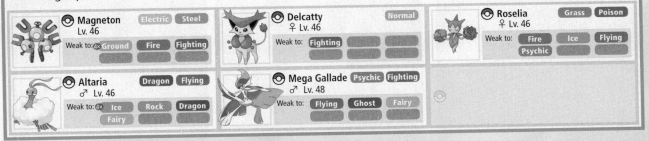

Magneton — Electric | Steel
Lv. 46
Weak to: 4× Ground | Fire | Fighting

Delcatty — Normal
♀ Lv. 46
Weak to: Fighting

Roselia — Grass | Poison
♀ Lv. 46
Weak to: Fire | Ice | Flying | Psychic

Altaria — Dragon | Flying
♂ Lv. 46
Weak to: 4× Ice | Rock | Dragon | Fairy

Mega Gallade — Psychic | Fighting
♂ Lv. 48
Weak to: Flying | Ghost | Fairy

9 | Receive a Dawn Stone from Wally

Orlando obtained a Dawn Stone!

Frustrated by his defeat, but grateful for all you've done for him, Wally thanks you for the battle and gives you a Dawn Stone, which he hopes you'll use to evolve a male Kirlia to Gallade. In the meantime, Wally plans to keep improving his skills around Victory Road, and looks forward to your next battle. Stow away his gift and proceed north—the Pokémon League awaits!

POKÉMON LEAGUE

A revered site that can only be visited by those Trainers who have dominated every last Pokémon Gym.

This is it: the Pokémon League! You've won countless battles during your adventures across Hoenn, and by mastering all eight of Hoenn's Gym Leaders and surviving Victory Road, you've earned the right to challenge the Elite Four and the Champion. Beat these last five Trainers, and you'll be inducted into Hoenn's Hall of Fame!

Pokémon League (interior)

Pokémon League (exterior)

Poké Mart			
Antidote	100	Max Repel	700
Awakening	250	Paralyze Heal	200
Burn Heal	250	Poké Ball	200
Escape Rope	550	Potion	300
Full Heal	600	Repel	350
Full Restore	3,000	Revive	1,500
Great Ball	600	Super Potion	700
Ice Heal	250	Super Repel	500
Hyper Potion	1,200	Ultra Ball	1,200
Max Potion	2,500		

Sidney's room

Phoebe's room

Glacia's room

Drake's room

Champion's room

After all that battling around Victory Road, the Pokémon League comes as a sight for sore eyes. Search the sparkling spot near the building to find a Mega Stone called Mewtwonite Y, then enter and rest your Pokémon at the Pokémon Center before preparing them for the coming showdown against the Elite Four and the Champion. Use the following techniques to give yourself every advantage!

TIP
Now that you've discovered the Pokémon League, you can Fly or Soar here anytime. Feel free to revisit locations around Hoenn to buy items, teach your Pokémon new moves, or train your Pokémon for the challenging battles ahead.

Defeat the Elite Four with These Techniques!

Once you challenge the Pokémon League, you won't be able to leave until you either win against the Elite Four and the Champion, or you are defeated. It's therefore vital that you prepare with care before challenging the Pokémon League!

Technique 1: Examine your party with an expert eye

Take a look at the moves that the Pokémon in your party know. It's important that they know moves that will be effective against the Pokémon used by the Elite Four and the Champion. In addition to using TMs, enlist the aid of the Move Tutors in Mauville City (p. 89) and Sootopolis City (p. 234) and the Move Maniac in Fallarbor Town (p. 117), who can all teach your Pokémon moves that will exploit the weaknesses of your opponent's Pokémon.

Technique 2: Give Pokémon items to hold in battle

Give your Pokémon items that are useful in battle if they aren't already holding some. For example, if one of your Pokémon has a low Speed stat, give it a Quick Claw to hold. If it has moves with low accuracy ratings, give it a Wide Lens. Read through all the descriptions of all the many held items you have accumulated in your Bag during your long adventure, and see if any of them might be worth swapping in for the upcoming battles.

Technique 3: Stock up on medicine

Healing is important during battles, but you'll also want to have plenty of healing items on hand to restore your Pokémon's HP and help them recover from any status conditions after each battle. Ensure that you have lots of Full Restores and Revives before you begin. If you're running low on cash, remember handy options like the Lava Cookies available for just 200 atop Mt. Chimney. There is no cheap replacement for a Revive, though.

Technique 4: Bring items that raise your Pokémon's stats

Raising the stats of your Pokémon can be just as important as healing them. Do some shopping at Slateport City's Market (p. 73) and Lilycove City's Department Store (p. 182), and buy items that give your Pokémon temporary or even permanent stat increases, such as X Defense or Carbos. Stat-boosting items like these can help your Pokémon make up for lower levels, stat weaknesses, or moves with only mediocre power. And of course, you can always boost your Pokémon's base stats through Super Training (p. 409)! Train them into Fully Trained Pokémon to give them every advantage.

Technique 5: Use Rare Candies to level up your Pokémon

If you are having trouble against even the first member of the Elite Four you chose to challenge, try using Rare Candies to raise the levels of the Pokémon in your party. Your Secret Pals may also be able to help you gain a few quick levels (p. 390). The higher a Pokémon's level, the stronger it becomes. You can obtain more Rare Candies even after you enter the Hall of Fame, so don't worry about using up all the ones you have at this point.

TIP

Each of the Elite Four has two Full Restores to use in battle, and the Champion has three. This heightens the importance of landing powerful moves that take out Pokémon without giving their Trainer the chance to heal them.

Sidney Dark-type Pokémon User

Light him up with Fighting-, Bug-, and Fairy-type moves!

Sidney is the first member of the Elite Four that you must face on your way to the Champion. There's no choosing the order in which you face the Elite Four—Sidney always comes first. Fortunately, all five of Sidney's Pokémon share common weaknesses to Fighting-, Bug-, and Fairy-type moves, so you have lots of options for mopping the floor with Sidney.

The opposing Mightyena used Swagger!

That isn't to say that Sidney's a pushover—far from it. For starters, all of his Pokémon are immune to Psychic-type moves, so don't even bother using Psychic attacks. His Mightyena uses Swagger, which harshly raises your Pokémon's Attack stat before inflicting it with confusion. You don't want your Pokémon harming itself with a harshly raised Attack stat, so use a Persim Berry, a Lava Cookie, a Full Heal, or a Full Restore to heal your Pokémon and make it instantly snap out of its confusion—with its Attack stat still boosted! You could even give it a Persim Berry to hold before the battle, if you don't have another held item that you think will help more in this battle. You can always change held items between battling Elite Four members.

Also, beware of the Psychic-type attacks employed by some of Sidney's Pokémon, like Absol. These attacks can be super effective against Fighting-type Pokémon, which you might be using to exploit Sidney's weakness to Fighting-type moves. Don't hesitate to switch out your Fighting types if those Psychic-type attacks are causing you headaches!

Elite Four Sidney's Pokémon

Mightyena — Dark
♂ Lv. 50
Weak to: Fighting | Bug | Fairy

Shiftry — Grass | Dark
♂ Lv. 50
Weak to: 4× Bug | Fire | Ice | Fighting | Poison | Flying | Fairy

Sharpedo — Water | Dark
♂ Lv. 50
Weak to: Grass | Electric | Fighting | Bug | Fairy

Cacturne — Grass | Dark
♂ Lv. 50
Weak to: 4× Bug | Fire | Ice | Fighting | Poison | Flying | Fairy

Absol — Dark
♂ Lv. 52
Weak to: Fighting | Bug | Fairy

Phoebe Ghost-type Pokémon User

Scare up an easy victory with Ghost- and Dark-type moves!

This carefree island girl may not look very serious about Pokémon at first—but first looks can be deceiving! Phoebe enjoys spending lots of time around Mt. Pyre, and she has picked up a number of powerful Ghost-type Pokémon in the process. Her bond with her Pokémon is very strong, so don't expect them to back down from anything!

What will Mightyena do?

As Ghost types, Phoebe's Pokémon are totally immune to Normal- and Fighting-type moves. Keep this in mind and don't bother using these types of moves against them. You'll only waste your turn, which you can't afford to do against such a worthy opponent. Dark-type Pokémon will be your best bet against her pure Ghost-type opponents, since Dark-type attacks are super effective against Ghost types, while Ghost-type attacks are not very effective against Dark types in return.

The opposing Dusknoir is exerting its pressure!

Two of Phoebe's Pokémon, Dusclops and Dusknoir, have the Pressure Ability, which causes your Pokémon to burn through extra PP each time they use a move against Dusclops or Dusknoir. This Ability, coupled with the Spite move used by Phoebe's two Banette, can dramatically reduce the PP of your Pokémon and prevent them from using their most powerful moves (which typically have low PP values). Counter Phoebe's sneaky PP-draining techniques by using Ethers and Elixirs to restore your Pokémon's PP and keep their best moves coming.

Elite Four Phoebe's Pokémon

Sableye ♂ Lv. 51			**Dark**	**Ghost**
Weak to:	**Fairy**			
Banette ♀ Lv. 51				**Ghost**
Weak to:	**Ghost**	**Dark**		
Banette ♂ Lv. 51				**Ghost**
Weak to:	**Ghost**	**Dark**		
Dusclops ♀ Lv. 51				**Ghost**
Weak to:	**Ghost**	**Dark**		
Dusknoir ♀ Lv. 53				**Ghost**
Weak to:	**Ghost**	**Dark**		

Glacia Ice-type Pokémon User

Melt her down with Fire-, Rock-, and Steel-type moves!

Glacia has journeyed to Hoenn in the hopes of honing her Ice-type Pokémon. Sadly, she's been woefully unimpressed with the Trainers that she's met in the region thus far. Glacia's eager for a serious battle, so turn up the heat and give her one she won't gloss over so easily!

Although Glacia sends out five Pokémon, her party lacks variety, featuring two Glalie, two Froslass, and a Walrein. Her Pokémon favor Ice-type moves, so avoid using Grass-, Ground-, Flying-, or Dragon-type Pokémon against them. Both of her Glalie can use Hail, which damages your Pokémon every turn for five turns. Her two Froslass also use Confuse Ray to put your Pokémon at risk of harming themselves. As in the battle against Sidney, use a Persim Berry, a Lava Cookie, a Full Heal, or a Full Restore to make your Pokémon snap out of its confusion.

What will Hariyama do?

With only three different species of Pokémon for you to worry about, you can rely on fairly straightforward tactics against Glacia. Punish her Pokémon with moves that target their many common weaknesses. Fire-type moves work well, but beware of Walrein's Surf move if you're using Fire-type Pokémon. A strong Fire-type Pokémon that knows Fighting-, Rock-, or Steel-type moves may be your best bet for shattering this ice queen's expectations.

Elite Four Glacia's Pokémon

Glalie ♂ Lv. 52 — Ice
Weak to: Fire | Fighting | Rock | Steel

Glalie ♂ Lv. 52 — Ice
Weak to: Fire | Fighting | Rock | Steel

Walrein ♂ Lv. 54 — Ice | Water
Weak to: Grass | Electric | Fighting | Rock

Froslass ♀ Lv. 52 — Ice | Ghost
Weak to: Fire | Rock | Ghost | Dark | Steel

Froslass ♀ Lv. 52 — Ice | Ghost
Weak to: Fire | Rock | Ghost | Dark | Steel

TRAINER HANDBOOK

ADVANCED HANDBOOK

ADVENTURE DATA

Drake Dragon-type Pokémon User

Tame him with Ice-, Rock-, Dragon-, and Fairy-type moves!

The Elite Four's final member is Drake, the Dragon master. This fiery soul believes that Trainers need a true and virtuous heart in order to influence their Pokémon and help them grow strong. Prove to Drake that you've got the heart of a Champion by dominating his Dragon-type Pokémon in an epic battle!

All of Drake's Pokémon are weak to Dragon- and Fairy-type moves, and most are extremely vulnerable to Ice-type moves as well. This means that a Dragon-type Pokémon like Latios/Latias can inflict great damage on all of Drake's Pokémon with its Dragon-type moves, but it will be weak to any Dragon-type moves that Drake uses in return. This makes using Dragon-type Pokémon against Drake quite risky, so be sure to use Mega Evolution on Latios/Latias and give it every advantage if you decide to use it.

Be aware that Drake's Pokémon will unleash a variety of moves that inflict status conditions and confusion. Kingdra uses Yawn, which puts your Pokémon to sleep at the end of the following turn. His two Flygon can inflict confusion with Supersonic, and they can also harshly reduce your Pokémon's Defense stat with Screech. After your Pokémon's Defense has been harshly reduced by Screech, it will suffer great damage from Flygon's Earthquake attacks. Use Flying-type Pokémon, or those that have the Levitate Ability, to avoid taking any damage from Earthquake as you counter with devastating moves of your own.

Elite Four Drake's Pokémon

Kingdra ♂ Lv. 53 — Water / Dragon
Weak to: Dragon, Fairy

Flygon ♂ Lv. 53 — Ground / Dragon
Weak to: Ice 4×, Dragon, Fairy

Flygon ♀ Lv. 53 — Ground / Dragon
Weak to: Ice 4×, Dragon, Fairy

Altaria ♀ Lv. 53 — Dragon / Flying
Weak to: Ice 4×, Rock, Dragon, Fairy

Salamence ♂ Lv. 55 — Dragon / Flying
Weak to: Ice 4×, Rock, Dragon, Fairy

Steven Multi-type Pokémon User

Switch out your Pokémon as needed to best exploit his Pokémon's weaknesses!

Beating the Elite Four has earned you the right to challenge Hoenn's illustrious Champion. Entering the Champion's hall, you're stunned to discover none other than your mentor Steven waiting for you. It seems that you've been sharing adventures with Hoenn's Champion all along!

Steven is curious to see how much you've learned during your travels across Hoenn, and he asks that you battle him with all your might. In return, he and his Pokémon will respond with all that they know. The stage is set for a legendary showdown!

As Champion, Steven is well aware of the advantages that a diverse team of Pokémon provides. As such, his Pokémon are of many different types, and they don't share nearly as many weaknesses as the Elite Four's teams. He does still show a bias toward his beloved Steel types, though, and most of his Pokémon share the Ground or Rock types—no surprise from this well-known stone collector. You'll need to adapt your strategies throughout the battle, switching out your Pokémon as needed to capitalize on the weaknesses of Steven's Pokémon.

Steven's Skarmory is a resilient Pokémon whose high Defense lessens the impact of physical moves. Strike Skarmory with special moves instead to inflict impressive damage. Beware of Skarmory's Toxic move, which badly poisons your Pokémon. Don't leave your Pokémon poisoned—be quick to use an Antidote, a Pecha Berry, a Lava Cookie, a Full Heal, or a Full Restore to stop the damage.

Aggron is another tough nut to crack. It has high Defense and lashes out with Dragon Claw, which can deal great damage to Latios/Latias, or to any other Dragon-type Pokémon that you might use. Be aware of this and avoid sending out Dragon types against Aggron. Smash Aggron fast with Fighting- or Ground-type moves, exploiting its greatest weaknesses.

Claydol uses Light Screen to boost its party's Sp. Def stat, along with Reflect to raise its team's Defense stat. Both of these moves remain in effect for five turns, and they protect Steven's entire team. Even if Claydol switches out, the Pokémon that takes its place will still enjoy the benefits of Light Screen and Reflect. If you obtained TM31 Brick Break from the Black Belt in Sootopolis City, use it to inflict damage and shatter Claydol's barriers.

Like Skarmory, Cradily can also inflict poison with its Sludge Bomb attack, but it's not a guarantee that your Pokémon will be poisoned. In addition, Cradily can also use Confuse Ray to confuse your Pokémon and cause them to hurt themselves. Be quick to counter Cradily's status conditions and confusion with Lava Cookies, Full Heals, or Full Restores, which can all cure multiple status conditions at once.

Armaldo's Crush Claw is not only a powerful attack, but it can also lower your Pokémon's Defense stat, causing them to suffer more damage from subsequent Crush Claw blows or any other physical move. Use X Defense items or moves that boost the Defense stat to overcome Crush Claw's effects.

Steven's heaviest hitter is Metagross, a high-level Steel- and Psychic-type Pokémon. After sending out Metagross, Steven immediately transforms it into Mega Metagross through the power of Mega Evolution. This increases its Attack, Speed, and Sp. Def stats, making Metagross far more powerful.

Mega Metagross has devastating physical attacks, including Meteor Mash and Giga Impact, so battle it with a Pokémon that has high HP and Defense stats. Use X Defense items to boost your Pokémon's Defense stat even further, and don't leave your Pokémon wounded—switch them out or use medicine to restore their HP as fast as possible. A great time to do this is after Mega Metagross unleashes Giga Impact, for it must spend the next turn recharging after it uses Giga Impact, giving you a perfect chance to recover.

Champion Steven's Pokémon

Skarmory — Steel / Flying
♂ Lv. 57
Weak to: Fire, Electric

Aggron — Steel / Rock
♂ Lv. 57
Weak to: 4× Fighting, 4× Ground, Water

Claydol — Ground / Psychic
Lv. 57
Weak to: Water, Grass, Ice, Bug, Ghost, Dark

Cradily — Rock / Grass
♀ Lv. 57
Weak to: Ice, Fighting, Bug, Steel

Armaldo — Rock / Bug
♂ Lv. 57
Weak to: Water, Rock, Steel

Mega Metagross — Steel / Psychic
Lv. 59
Weak to: Fire, Ground, Ghost, Dark

Congratulations, Trainer!

Congratulations on becoming Pokémon League Champion!

Once you've won your rightful place in the Hall of Fame, you may feel like your adventure is over. But the Hoenn region still has much more to offer! Face off against May/Brendan in one last battle, then turn the page to read on about the Delta Episode, the Battle Resort, and all that's left for you to explore! Collect the last Mega Stones (p. 318), get any of those Legendary Pokémon you missed (p. 275), and complete your story in Hoenn!

THE DELTA EPISODE

A new story is brewing in the region you now call home. It is a harrowing episode involving a mysterious Dragon-type Pokémon user named Zinnia, the true origins of Mega Evolution, and an asteroid hurtling through space to collide with the Hoenn region!

Zinnia takes the stage

Is she friend or foe? Zinnia's enigmatic smile is hard to judge, but determination burns in those dark eyes. With a Dragon-type team led by Salamence and a Key Stone that she sports on an anklet winding around her leg, this young lady can surely create trouble for anyone who gets in her way.

"How much of the truth do you think you know?"

Legendary encounters

Asteroids? Space? You can't talk about either one in the Pokémon world without thinking of some of Hoenn's greatest legends. Rayquaza, the great Dragon Pokémon once said to have stood between Groudon and Kyogre, lives high in the atmosphere and feeds on the meteorites it catches there. And Deoxys, a Pokémon that has multiple forms, allowing it to focus on different stat strengths, is believed to have risen from some mutation of a space virus. You will be encountering both before this crisis is averted!

Rayquaza

Type: Dragon Flying
Ability: Air Lock
Height: 23'00"
Weight: 455.2 lbs.

Deoxys

Type: Psychic
Ability: Pressure
Height: 5'07"
Weight: 134.0 lbs.

A Legendary Mega Evolution!?

You've seen Primal Groudon and Primal Kyogre, but Primal Reversion is not the same as Mega Evolution. Now meet Mega Rayquaza, the most ancient true Mega Evolution of a Legendary Pokémon! It gains the awesome new Ability Delta Stream, which triggers the strong winds weather condition that eliminates all of the Flying type's weaknesses. What's more, this Ability can even overwhelm the extremely harsh sunlight and heavy rains that Primal Groudon and Primal Kyogre summon with their Abilities!

Mega Rayquaza

Type: Dragon Flying
Ability: Delta Stream
Height: 35'05"
Weight: 864.2 lbs.

The dragon ascends

Mega Rayquaza holds no Mega Stone. But it does know a move that no other Pokémon can learn: Dragon Ascent. This move can devastate a target, although it does lower the user's Defense and Sp. Defense at the same time. Does this unique move have something to do with its not needing a Mega Stone? Why does this ancient Pokémon alone need no stone, and what does that signify about the true nature of Mega Stones? Many answers are in store in the Delta Episode!

Adventure awaits you!

The Delta Episode will take you around the Hoenn region once more as you try to discover Zinnia's many secrets in your efforts to save your world from destruction!

This isn't something we should discuss in public. Let's continue this inside.

You are challenged by Pokémon Trainer Zinnia!

Now tell me...
Are you prepared?
Yes
No

This is one adventure that you should experience for yourself, but if you ever feel lost about where to go next, the recommended route that follows will get you right back on track! The page numbers listed below will help you find maps of the areas, and you will see detailed information about the Sky Pillar on the next page.

RECOMMENDED ROUTE

The Delta Episode

Littleroot Town (pp. 26, 296)
- Get a pair of tickets from Norman
- Meet Zinnia
- Visit your friend's house to hear her/his tale
- Visit Wally and lend him a hand

Petalburg City (p. 38)

Rustboro City (p. 51)
- Talk to the Stones at the Devon Corporation

Granite Cave (p. 69)
- Get drawn into battle and claim a Meteorite Shard

Mossdeep City (p. 205)
- Learn a great deal at the Space Center

Meteor Falls (p. 248)
- Find Steven within to learn Hoenn's history

Rustboro City (p. 51)
- Run into trouble outside the Devon headquarters

Mossdeep City (p. 205)
- Battle alongside Steven and try to run off your enemies

Team Magma Hideout (Ω) (p. 194)
- Receive a Mega Stone from a former foe

Team Aqua Hideout (α) (p. 199)
- Receive a Mega Stone from a former foe

Mossdeep City (p. 205)
- Lay plans with Steven

Sootopolis City (p. 234)
- Find Wallace near the Cave of Origin

Route 131 (p. 257)
- Battle your way into the Sky Pillar

Sky Pillar (p. 292)
- Learn the full history of the Draconids
- Take on Rayquaza and Deoxys to settle things at last!

SKY PILLAR

This tower was created for the veneration of a Legendary Pokémon that lives far above in the heavens.

The Delta Episode will reach its climax in a location you haven't yet seen in Hoenn: the Sky Pillar—a towering altar built on Route 131 for the ascension of Hoenn's ageless protector, the Legendary Pokémon Rayquaza. It's said that only Draconids have the power and knowledge needed to summon Rayquaza from the Sky Pillar's apex. You will only be able to enter this great pillar when you have completed all the previous steps in the Delta Episode, as outlined in the recommended route on the previous page.

Entrance

1F

3F

2F

4F

5F

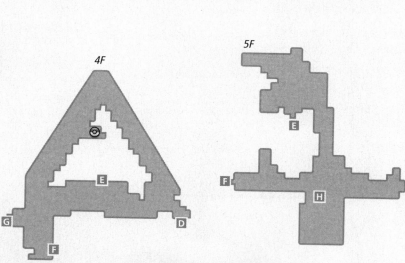

Interior		
❏ Ariados	◯	
❏ Claydol	◯	
❏ Golbat	◯	
❏ Mawile	△	Ω
❏ Sableye	△	α

Horde Encounter		
❏ Ariados (×5)	◯	
❏ Golbat (×5)	◎	
❏ Swablu (×5)	▲	

◎ frequent ◯ average
△ rare ▲ almost never

Items
❏ Dragon Scale
❏ Full Restore
❏ TM64 Explosion

Sableye α `Dark` `Ghost`
Abilities: Keen Eye, Stall

Mawile Ω `Steel` `Fairy`
Abilities: Hyper Cutter, Intimidate

1 Enter the Sky Pillar

Orlando found a Dragon Scale!

Navigate the Sky Pillar's short entry cavern to reach the tower's main entrance. Enter the tower to find you aren't alone. Before you follow this enigmatic figure, loop around the tower's ground floor and discover another ladder up north. Climb that one to reach a Dragon Scale. After pocketing it, climb back down the ladder and return to the one that your fellow pilgrim just used to head up through the second and third levels.

2 Grab a hard-to-see item

Orlando found a Full Restore!

Follow your fellow pilgrim again, reaching the Sky Pillar's fourth floor. Go north and loop around the floor's triangular north end. Round the tip of the triangle, and as you head back to the south, look for an item near the tip. It's difficult to see due to fifth floor's remains hanging overhead, but it's there! You'll be standing beneath the fifth floor when you grab the item—a Full Restore.

3 Climb higher and closer to get a TM

Orlando found
TM64 Explosion!

With the Full Restore resting safely in your Bag, continue winding your way up through the final floors. On the fifth floor, go west after hearing the conclusion of an ancient tale, and descend two ladders to reach a TM perched on some rubble. Pocket TM64 Explosion, then backtrack and climb the final ladder to reach the tower's apex.

4 Reach the apex of your journey

Ever since I was a little girl, I have always turned my eyes up to the sky.

High atop the Sky Pillar, your fellow pilgrim stares wistfully at the Litleonids that fill the night sky. Here, high in the sky, everything is about to come to a head. Come equipped with restorative items and the best Poké Balls you can get. Be ready for tough battles and even tougher captures, and dive into your last great adventure in the Hoenn region!

TIP

If you accidentally defeat Deoxys instead of catching it, Deoxys will return to the Sky Pillar—but only after you've beaten the Pokémon League all over again!

MORE TO DO AROUND HOENN

There are a few things you can do around Hoenn while also making progress through the Delta Episode. Whenever you need a bit of a break from the action, consider checking out these new options around the region.

◀◀ BACKTRACK MAUVILLE CITY | p. 89

"Test Your Battle Mettle!"
Battle Institute Hoenn

Battle Institute Action

One of the most exciting places you can experience after entering the Hall of Fame is the Battle Institute. Fly or Soar to Mauville City, and then locate the Battle Institute in the city's east hall. Head inside to take on a challenging series of Pokémon battles for fun and prizes!

The Battle Institute

You've probably stopped by the Battle Institute in Mauville City before, but you weren't able to take up its challenge until you proved your worthiness in the Pokémon League. Now that you've entered the Hall of Fame, you can participate in exciting Battle Tests held at the Battle Institute! Battle Tests throw you into a series of back-to-back matches, in which you must face off against five Trainers in a row. Performing well can earn you precious rewards and bragging rights!

Battle Test basics

Single Battle Test
Battle Format | Single Battle
All Pokémon will be set to Lv. 50.
Three Pokémon may enter.
No duplicate items or Pokémon.
Pokémon limitations exist.
Item limitations exist.

Pokémon rules

Battle Tests are similar to official competitions in that they require you to use all-different Pokémon on your team. You cannot have two or more Pokémon of the same species. You also cannot have any two or more Pokémon on your team hold the same kind of item. Finally, none of your Pokémon can hold the Soul Dew item.

All of your Pokémon are set to Lv. 50 during Battle Tests. Pokémon that are lower than Lv. 50 will have their level raised, while those higher than Lv. 50 will have their level lowered. All of your Pokémon's moves will stay the same, though, as will any gains they've earned from base-stat training. Don't worry, this level change is temporary—your Pokémon will return to their usual levels once the Battle Test is complete.

> **TIP**
>
> You can use Mega Evolution during Battle Tests, but just like any other battle, you can only Mega Evolve one Pokémon per battle.

I was born, raised, and live in the mountains.
I'm an Ace Hiker, I tells ya.

Battle formats

Battle Tests pit you against five Trainers, one after another, in the battle format specified by the Battle Test type (Single or Double Battle). You choose three Pokémon for your team in Single Battles and four in Double Battles. Your Pokémon are fully restored between each battle, so there's no need to worry about using up their best moves' PP, or to fear that everything is over if some of the Pokémon on your team faint during a battle.

> **TIP**
>
> You can also use the special download option. Download Tests are sometimes available, and they allow you to challenge special battle formats. You can take Download Tests even before you enter the Hall of Fame.

Other rules

You can't use any items from your Bag during a Battle Test, and you can't quit a Battle Test once it begins. If you really want to end a Battle Test quickly, run from each battle so that you can quickly get through any remaining Trainers and reach the end of the test. Running from a battle counts as a loss, however, so keep in mind that it's better to stand and fight, hoping to turn things around.

> **TIP**
>
> The following special Pokémon cannot participate in Battle Tests: Mewtwo, Mew, Ho-Oh, Lugia, Celebi, Kyogre, Groudon, Rayquaza, Jirachi, Deoxys, Dialga, Palkia, Giratina, Phione, Manaphy, Darkrai, Shaymin, Arceus, Victini, Reshiram, Zekrom, Kyurem, Keldeo, Meloetta, Genesect, Xerneas, Yveltal, Zygarde, Diancie, and Eggs.

The Battle Institute (cont.)

Battle Institute rewards

Orlando obtained a Resist Wing!

Why bother with the Battle Institute? Well, besides all of the useful battle experience you'll receive, you'll also earn BP and special rewards based on the rank that you achieve!

Results	Rank	Points	BP Reward	Item Reward
★★★★★★★	Master Rank	6,000 points or more	15 BP	PP Up
★★★★★★★	Elite Rank	5,000–5,999 points	13 BP	Protein, Calcium, Iron, Zinc, Carbos, or HP Up
★★★★★★★	Hyper Rank	4,000–4,999 points	11 BP	Protein, Calcium, Iron, Zinc, Carbos, or HP Up
★★★★★★★	Super Rank	3,000–3,999 points	9 BP	Protein, Calcium, Iron, Zinc, Carbos, or HP Up
★★★★★★★	Normal Rank	2,000–2,999 points	7 BP	Health Wing, Muscle Wing, Resist Wing, Genius Wing, Clever Wing, or Swift Wing
★★★★★★★	Novice Rank	1,000–1,999 points	5 BP	Health Wing, Muscle Wing, Resist Wing, Genius Wing, Clever Wing, or Swift Wing
★★★★★★★	Beginner Rank	Up to 999 points	3 BP	Health Wing, Muscle Wing, Resist Wing, Genius Wing, Clever Wing, or Swift Wing

Improving your rank

Some actions earn you more points toward your Battle Test rank, while other actions make you lose points. The following table will help you earn the highest ranks. Avoid doing the actions on the right while doing as many of those on the left as possible!

How to Earn Points	How to Lose Points
Defeat the opposing Trainer	Let your Pokémon faint
Defeat a Pokémon on the opposing Trainer's team	Let more turns pass
Swap in different Pokémon from your team	Let your Pokémon lose HP
Make your opponents use ineffective moves	Use not-very-effective moves on targets
Make your opponents use not-very-effective moves	Use ineffective moves on targets
Use supereffective moves on your opponents	—
Have your Pokémon use different moves	—

◀◀ BACKTRACK ┃ LILYCOVE CITY p. 178

I'm the Game Director.

Cove Lily Motel Meetings

Swing by the Cove Lily Motel in Lilycove City to find that a big group has made a reservation. It's GAME FREAK! Looks like Pokémon's hardworking team of artists, programmers, and other gifted individuals are enjoying a well-deserved vacation. Speak with them all, including the Game Director, who will give you special prizes if you manage to complete your Pokédex!

TIP

If you haven't already done so, try moving in front of the motel manager. Something's in the way—slap on the Devon Scope to discover an invisible Kecleon! There's no need to battle this one—at the manager's request, it happily agrees to stay on staff at the motel.

◀◀ BACKTRACK ┃ SLATEPORT CITY p. 73

Money	In Bag:	8
₽ 314,950	Protein	₽ 4,900
	Iron	₽ 4,900
	Calcium	₽ 4,900
	Zinc	₽ 4,900
	Carbos	₽ 4,900
	HP Up	₽ 4,900
	Quit	

A nutritious drink for Pokémon. When consumed, it raises the base Attack stat of a single Pokémon.

Slateport Market Mondays

Every Monday, Slateport City's Energy Guru holds a special half-off sale. This special Mondays-only sale is broadcast over BuzzNav, and the prices can't be beat! Swing over to Slateport Market every Monday and speak with the Energy Guru to find that his prices have been chopped in half. Spend some money on the Energy Guru's goods, and use them to increase your Pokémon's base stats in seconds flat.

1 Receive a ferry ticket

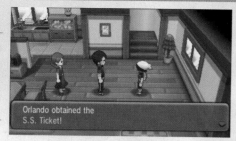

Orlando obtained the
S.S. Ticket!

When the dust settles on the Delta Episode, you awaken in your room the day after the Litleonid shower. Head downstairs and your dad hands you a letter from Mr. Briney that contains a S.S. Ticket. Now you can ride Captain Stern's new ferry! Your dad advises you to jump aboard, because the *S.S. Tidal* can take you to an exciting new place called the Battle Resort.

2 Save Professor Birch

I've got some Poké Balls in my Bag there!

The unexpected sounds of a person's screams greet you as you step outside. Professor Birch is in trouble! Rushing to Route 101, you may find the professor being chased by a stirred-up Shroomish, if you haven't done so before. Grab a Poké Ball from the professor's Bag to help him out. He'll let you keep the Pokémon you chose: an exotic new partner from the Johto region!

3 Score a Mega Stone from your mom

Orlando obtained a
Latiasite!

Head back to your house and speak with your mom. She hands you a Mega Stone that she discovered on the lawn this morning: Latiasite (*Pokémon Omega Ruby*) / Latiosite (*Pokémon Alpha Sapphire*)! Perhaps someday you may obtain the elusive Eon Ticket that will take you back to Southern Island and enable you to catch the second Pokémon in this legendary pair!

4 Save the professor...again!

I've got some Poké Balls in my Bag there!

Leaving your house again, your ears are once more accosted by the shrill sound of Professor Birch's screams. This time, a burly Machoke is chasing after Professor Birch! Grab another Poké Ball from the professor, and once again he lets you keep the Pokémon you chose from his Bag, just for being quick on the scene. This one's from the Unova region!

5 Ride the *S.S. Tidal*

That's all the excitement there is to be had around Littleroot—and besides, that S.S. Ticket is burning a hole in your Bag! Fly or Soar to Slateport or Lilycove City, and then head for the harbor building. Show your ticket to the woman near the ferry, and she'll ask where you'd like to go. The Battle Resort beckons, but first, say that you'd like to travel to either Lilycove or Slateport (whichever is available).

TIP

Now that you've cleared the Delta Episode, do a little exploring around the Hoenn region to find some surprises and familiar faces. You'll want to pop by Steven's house in Mossdeep City to see what he's left you, and keep an eye out for Gym Leaders and Elite Four members around Hoenn. They are out and about all around the region, and you can run into most of them if you keep a keen eye out as you explore!

TIP

Last night's Litleonid shower has left new Mega Stones all over Hoenn! Keep your eyes peeled for new sparkling spots that betray the presence of Mega Stones—or just turn to page 318 for a complete list of new Mega Stones that have appeared.

TIP

Beat Steven in battle at the Pokémon League once more, and you'll even have the chance to obtain a Pokémon native to the Sinnoh region from the good professor next time you're back in town!

TIP

At some point, you may be able to obtain a very rare Eon Ticket through a special event. If you do, your father, Norman, will recognize it and encourage you to use it to visit Southern Island once more. There, you may encounter an Eon Pokémon again!

TRAINER HANDBOOK

ADVANCED HANDBOOK

ADVENTURE DATA

S.S. TIDAL

This mighty vessel ferries Hoenn's citizens between Slateport City, Lilycove City, and the Battle Resort.

The excitement of the Battle Resort can't be beat—but choose to ride the *S.S. Tidal* between Slateport and Lilycove (or vice versa), and you can delve below the decks of Captain Stern's mighty ship itself!

1F

To Slateport City / Lilycove City / Battle Resort

Cabins

Young Couple Lea & Jed
★ Double Battle

Rest your Pokémon here

Rich Boy Garret

Gentleman Tucker

Items		
Cabins		
❏ TM63 Embargo		
Deck		
❏ Blastoisinite		
Storage		
❏ Leftovers		
❏ Sharp Beak		

Poké Fan Colton

Lady Anette

Gentleman Thomas

Deck

Storage

Sailor Leonard

Sailor Phillip

1 Witness Drake and Mr. Briney's reunion

Briney, it's like the good old days, having you guide the rudder again after all this time.

As you step aboard the *S.S. Tidal*, you'll find that you've arrived just in time to watch a jovial reunion between Elite Four Drake and Mr. Briney. The two happy sailors seem to know one another well, and they take a moment to catch up before Drake steps out to enjoy the bracing sea breeze.

2 Battle Trainers as you explore the ship

Orlando obtained TM63 Embargo!

Give the *S.S. Tidal* a thorough search, entering every cabin along the hall and battling Trainers as you marvel at Stern's masterpiece of nautical engineering. The traveling Trainers you face on the ferry send out a variety of exotic Pokémon, making each battle quite entertaining. The startled Bug Maniac in the bottom-right cabin doesn't battle you, but hands over TM63 Embargo instead.

TIP

Eager to arrive at your destination? Catch some shut-eye by curling up in bed in your cabin. You'll restore your Pokémon, and time will pass, advancing you to your arrival time.

3 Grab a Blastoisinite on the deck

Orlando found a Blastoisinite!

After you've finished exploring the cabins, head outside to soak up some sun on the ship's deck. Search the sparkling spot up north to claim a Mega Stone called Blastoisinite. Drake stands on the bow, taking in all of the ocean's rolling majesty. Catch up with him before heading back inside.

4 Help yourself to some Leftovers in storage

Orlando found Leftovers!

Back in the ship, conclude your inspection by heading downstairs to visit the ship's spacious storage. This place provides plenty of room for Pokémon battles to play out, and the two hardworking sailors down here will happily oblige you. Speak to the backpacker in the corner, and tell him that you understand his rough speech, to receive a Sharp Beak to sharpen your favorite Flying-type moves. Search the northwest corner to discover some Leftovers as well.

TIP

When you're ready to leave the ship, speak to the sailor who stands near the boarding stairs. If you haven't yet reached your destination, visit your cabin (the only one that's unoccupied) and rest in your bed. Time will pass and you'll be able to disembark from the *S.S. Tidal* afterward by speaking to the sailor near the boarding stairs again.

BATTLE RESORT

This grand resort was built with the aim of allowing Trainers to enjoy every kind of Pokémon battle.

The many shops, attractions, and skilled Trainers found on this tropical island make the Battle Resort an ideal destination for Trainers who seek to improve their Pokémon battling skills—and also their tans. Only a select few Trainers will ever visit this scenic getaway. To reach the Battle Resort, head to the harbor in either Slateport or Lilycove City, and then book passage on the *S.S. Tidal*.

Rich Boy Antoin

Fairy Tale Girl Josephine

Battle Maison

Move Tutors

Poké Maniac Kelvin

Pokémon Center

Pokémon Day Care Annex

Aroma Lady Carnation

Bug Maniac Felix

To Slateport City / Lilycove City

Items

Pier
- ❏ Cameruptite (α)
- ❏ Sharpedonite (Ω)

Custodian's cabin
- ❏ Calcium
- ❏ Carbos
- ❏ Gengarite
- ❏ HP Up
- ❏ Iron
- ❏ Protein
- ❏ Zinc

Stilt houses
- ❏ Audinite
- ❏ Level Release

Hidden Items
- ❏ Big Pearl
- ❏ Full Restore
- ❏ HP Up

On the Water

❏ Mantine	▲
❏ Mantyke	○
❏ Pelipper	△
❏ Tentacruel	◎

◎ frequent ○ average
△ rare ▲ almost never

Mantine `Water` `Flying`
Abilities: Swift Swim, Water Absorb

Remoraid `Water`
Abilities: Hustle, Sniper

Fishing

Old Rod
❏ Magikarp	◎	
❏ Tentacool	○	

Good Rod
❏ Magikarp	◎	
❏ Remoraid	▲	
❏ Tentacool	○	

Super Rod
❏ Remoraid	◎	
❏ Octillery	▲	

1 Catch up with Wally

I'm getting pumped just standing here! Let's check it out!

Stepping off the *S.S. Tidal*, you're surprised to find your friend Wally standing on the pier. The little guy sure does get around! Wally's bursting with excitement and can't wait to explore everything that the Battle Resort has to offer—especially now that you're here to enjoy it with him!

2 Receive a Mega Stone

Orlando obtained a
Sharpedonite!

Orlando obtained a
Cameruptite!

Wally's excitement nearly lands him in hot water as he sprints through a throng of high-ranking Team Aqua / Team Magma members, including Archie/Maxie! The boy apologizes, and no harm is done, but Archie/Maxie has a few words for you—and also, a new Mega Stone! Pocket the Sharpedonite/Cameruptite that Matt/Courtney hands you and then hurry after Wally.

3 Learn of the Battle Maison

Make sure you visit the Battle Maison that's
up on top of this island's main hill!

A Collector catches your attention as you and Wally reach the mainland. He can sense that you're not merely here to spectate, and urges that you check out the Battle Maison—the big building on top of the island's main hill. It sure sounds like a great place for Trainers to visit, but there's so much more to see here first!

4 Meet the Judge

You can call me the Judge.

Pop into the Pokémon Center to rest up, and then speak to the Ace Trainer who stands in the corner. This fellow is known as the Judge, because he has the power to judge a Pokémon's individual potential for greatness. Show the Judge any Pokémon, and he'll tell you whether or not it has the potential to become one of the mightiest Pokémon of its species. Have the Judge check each of your Pokémon to discover whether or not you've caught Pokémon that are suitable for intense, competitive training!

5 Explore the Battle Resort's many attractions

Orlando obtained
TM87 Swagger!

There's plenty to see around the Battle Resort, so give the island a thorough search and leave the Battle Maison for last. Start by going east from the Pokémon Center to find the Pokémon Day Care Annex. What a great place for such a convenient service! Inside, give a rather pompous Lady some money to help her out of a jam, and she'll give you TM87 Swagger in return. Then decide if you'd like to drop off a couple of Pokémon to have them raised at the Pokémon Day Care and possibly discover an Egg. It works just like the Pokémon Day Care that you've visited on Route 117.

Reward: TM87 Swagger

Battle Resort Masters

The Battle Resort truly is where the strongest Trainers like to gather. Here you'll find Trainers who are as strong as—or even stronger than—Hoenn's Elite Four! Five master Trainers wander around the Battle Resort, each one specializing in a particular Pokémon type. Combined with the eight Gym Leaders, the Elite Four, and the region's Champion, Steven, you can now face master users for each of the 18 Pokémon types in *Pokémon Omega Ruby* and *Pokémon Alpha Sapphire*!

Each of the following Battle Resort masters can be battled once per day. They'll switch up their teams a bit each day, so keep coming back for more!

Aroma Lady Carnation
Grass-type master

My favorite type, of course, is Grass. Now, battle me!

Carnation is a master of Grass-type Pokémon. Each day that you battle her, Carnation's team will be made up of four of the following Pokémon. Be ready to face any four of them!

Carnation's Pokémon: Tangrowth, Jumpluff, Ludicolo, Victreebel, Ferrothorn, Exeggutor, Roserade (all Level 60, all ♀)

Rich Boy Antoin
Poison-type master

I'm a Poison-type expert. Why don't you have a thrilling battle with me?

Antoin has mastered the use of Poison-type Pokémon. His team will be made up of four of the following Pokémon, so prepare your team accordingly.

Antoin's Pokémon: Crobat, Drapion, Weezing, Muk, Scolipede, Toxicroak, Dragalge (all Level 60, all ♂)

Fairy Tale Girl Josephine
Fairy-type master

I'd love my Fairy-type Pokémon to go wild to their heart's content.

Although she's quite young, Josephine has already mastered the delicate intricacies of battling with Fairy-type Pokémon. Battle her every day, anticipating that her team will be made up of four of the following Pokémon.

Josephine's Pokémon: Whimsicott, Wigglytuff, Slurpuff, Granbull, Aromatisse, Azumarill, Florges (all Level 60, all ♀)

Poké Maniac Kelvin
Ground-Type master

Uh, uh, are you challenging me to battle, knowing I'm a Ground-type-Pokémon user?

A well-known Poké Maniac, Kelvin has his sights set on becoming the most able Ground-type Pokémon user to have ever lived. You can battle him once per day, and each day he'll send out four of his favorite Pokémon.

Kelvin's Pokémon: Mamoswine ♂, Nidoqueen ♀, Rhyperior ♂, Hippowdon ♂, Gastrodon ♂, Nidoking ♂, Garchomp ♂ (all Level 60)

Bug Maniac Felix
Bug-Type master

Now be my Bug-type Pokémon's warm-up, will ya?

Bugs are Felix's buddies, and he's really got the hang of using Bug-type Pokémon in battle. Each day he'll swarm you with four of his best Bug-type Pokémon.

Felix's Pokémon: Scizor, Galvantula, Heracross, Pinsir, Ninjask, Leavanny, Crustle (all Level 60, all ♂)

6 Change that tune

Hello! Would you like to change the music and enjoy a different atmosphere?

Yes
No

Tiring of the Battle Resort's unrelenting anthem? Speak to the Parasol Lady who stands just south of the Pokémon Day Care Annex, and she'll change the background music for you. Yeah, that's more like it!

7 Talk Bikes with a Triathlete on the beach

Wow! That's a Rydel Bike! It looks very cool.

Go to the resort's southeast corner to find a Bike-riding Triathlete staring out to sea. Speak to this obvious Bike enthusiast, and he'll be blown away by the Bike that you've got from Rydel's Cycles. In fact, he's been thinking of buying a Bike from Rydel himself! Dowse to discover a hidden Big Pearl in the nearby ledge after chatting with the Triathlete.

TIP

Although it isn't obvious, meeting this Triathlete has triggered something special. If you also talked to a particular Hex Maniac in Route 111's central desert and a certain Bird Keeper on Route 119, who were both equally impressed by your Bikes, then return to Rydel's Cycles in Mauville City. You'll find that Rydel will now let you keep both the Mach Bike and the Acro Bike at the same time. No more swapping Bikes, and you can reach two valuable TMs in the Safari Zone now!

8 Head north and meet a real Looker

Hoenn region
Battle Resort

Where...where am I?

Go north up the beach from the Triathlete, and you'll soon meet a man in a trench coat who's doubled over near the shore. He looks all washed up! Pokémon fans may recognize this coat-wearing castaway as Looker, a hard-boiled detective who solved many mysteries and crimes around Lumiose City before leaving the Kalos region for new adventures. You don't get the chance to help Looker, though, as he's rescued by an all-too-eager Beauty.

9 | Stock up on goodies at the custodian's cabin

I'm the custodian here at the Battle Resort. All I do is take the trash out in the morning.

Continue going north (right) from the spot where you met Looker, battling Fairy Tale Girl Josephine and dowsing to find a Full Restore on your way to the island's small, northeast cabin. This cabin belongs to the Battle Resort's elderly custodian, and he's collected a number of valuable, stat-boosting items that people have carelessly left around the island. The custodian invites you to take whatever you like, so stuff your pockets full. Be sure to search the sparkling spot as well to find a Mega Stone called Gengarite!

10 | Meet the west shore's Move Tutors

Want me to teach your Pokémon a move in return for some BP?

Yes
No

Go west (right) from the custodian's cabin, optionally battling Rich Boy Antoin on your way to the island's west shore. Here, a number of Move Tutors have set up stands. In exchange for a few BP, these Move Tutors will teach your Pokémon all sorts of different moves! Aroma Lady Carnation also stands on the nearby shore, ready to battle with her Grass-type Pokémon once per day.

TIP

How do you earn BP? By battling at the Battle Maison! Flip ahead to page 305 and learn all about it. You can also earn BP by performing well at the Battle Institute in Mauville City (p. 89). Save up a bunch of BP, then spend it all here at the Battle Resort!

TIP

Slip between the Move Tutors' stalls and dowse to discover a hidden HP Up behind them!

11 | Check out the main hill

You've come full circle and are now back near the Pokémon Center. The time has come for you to head uphill! Scale the north stairs, and you'll face the Battle Maison. You'll check out that awesome spot soon enough, but finish exploring the island first, battling Poké Maniac Kelvin and Bug Maniac Felix, who are standing right nearby.

12 | Visit the east cabins

Orlando obtained a Grepa Berry!

Go down the east stairs from the Battle Maison to reach a lower level of the hill, where a couple of cabins stand. Speak to the woman in the first cabin, who turns out to be a Berry enthusiast. She'll give you one of the following Berries each day: Pomeg, Kelpsy, Qualot, Hondew, Grepa, or Tamato.

13 | Barge in on a Grunt couple

If we're going to get caught anyway, then let's get caught together!

Entering the other cabin, your eyes are met by a startling sight. A Team Magma Grunt and a Team Aqua Grunt seem to have booked their own private cabin! You've caught them flat-footed, and more Team Magma and Team Aqua members soon arrive. After a kerfuffle, it turns out that nobody's upset over the two Grunts getting together. Times have changed, and there are no hard feelings.

14 Receive Camerupt and Sharpedo

You received Camerupt!

Leave the Grunts' cabin to let them recover from their shocking discovery, taking the opportunity to visit the Pokémon Center and free up two slots in your party. Return to the Grunts' cabin afterward to learn that they've decided to call off their relationship after all. C'est l'amour! Relieved to have everything out in the open—and eager to put their unhappy past behind them—the Grunts each give you a Pokémon: Camerupt and Sharpedo!

15 Scope out the stilt homes

Orlando obtained an Audinite!

Head east from the Grunts' cabin, crossing the east bridge to reach some tall houses built upon stilts. Show a Pokémon you raised at least 30 levels to a Collector in the first house, and he'll give you the Footprint Ribbon. Speak to the nearby Battle Girl afterward to receive a Level Release for your Secret Base. Look in on Looker next, who's resting comfortably with the Beauty in the neighboring house, and he'll give you an Audinite as thanks for looking out for him back there on the beach.

Rewards: Audinite, Footprint Ribbon, Level Release

16 Watch the famous Whismur show

That Whismur is holding a Big Mushroom, right?

Yes
No

You can't enter the other stilt homes, so backtrack to the Grunts' cabin and go up the nearby stairs to reach the hill's highest point. An impressive model of the proposed Battle Frontier is prominently displayed up here, and to the west of it lies the Battle Resort's happiest attraction—the Whismur show! Watch the Whismur dance each day, and see if you can pick out the one that's holding a Big Mushroom. You get to keep the Big Mushroom if you guess right, which may then be sold to stores for a tidy sum.

Reward: Big Mushroom

17 Check out the Battle Maison

You've given the entire island a thorough search. Now it's time to check out the Battle Maison! You'll be doing plenty of battling inside, but don't worry about resting up your team beforehand. The receptionist in the main hall will heal your Pokémon before each battle, and you'll also find a handy PC to rearrange the Pokémon in your party or in your Battle Box if needed. Enter the Battle Maison and read on to discover all that waits within!

Exchange BP for items and moves

Would you like to trade in your BP for some fabulous prizes?

What's there to do with all of the BP your battles have brought you? Exchange it for items at the two Exchange Service Corners in the Battle Maison's front hall! You can also spend your BP to teach your Pokémon some choice moves by visiting the Move Tutors who have set up stalls along the Battle Resort's west shore. The moves that they can teach are listed on page 435.

Left Exchange Service Corner

Protein	2 BP	Power Weight	16 BP
Calcium	2 BP	Protector	32 BP
Iron	2 BP	Whipped Dream	32 BP
Zinc	2 BP	Sachet	32 BP
Carbos	2 BP	Electirizer	32 BP
HP Up	2 BP	Magmarizer	32 BP
Power Bracer	16 BP	Reaper Cloth	32 BP
Power Belt	16 BP	Up-Grade	32 BP
Power Lens	16 BP	Dubious Disc	32 BP
Power Band	16 BP	Rare Candy	48 BP
Power Anklet	16 BP	Ability Capsule	200 BP

Right Exchange Service Corner

Toxic Orb	16 BP	Wide Lens	48 BP
Flame Orb	16 BP	Muscle Band	48 BP
White Herb	32 BP	Focus Band	48 BP
Power Herb	32 BP	Choice Band	48 BP
Absorb Bulb	32 BP	Choice Scarf	48 BP
Luminous Moss	32 BP	Assault Vest	48 BP
Cell Battery	32 BP	Focus Sash	48 BP
Snowball	32 BP	Expert Belt	48 BP
Red Card	32 BP	Razor Claw	48 BP
Eject Button	32 BP	Razor Fang	48 BP
Weakness Policy	32 BP	Bright Powder	48 BP
Ring Target	32 BP	Life Orb	48 BP
Wise Glasses	48 BP	Iron Ball	48 BP
Choice Specs	48 BP	Air Balloon	48 BP
Scope Lens	48 BP	Binding Band	48 BP
Zoom Lens	48 BP	Safety Goggles	48 BP

The Battle Chatelaines

Successfully battling your way through the Battle Maison means you'll be facing off against the Battle Chatelaines before long. They're no pushovers, so prepare yourself by checking out their lineups on the following pages.

Battle Chatelaine Nita

Nita's Single Battle team is made up of Pokémon with varying weaknesses—and Pokémon with the pesky habit of making your team fall asleep. Be ready to combat both when you take her on. Her Super Single Battle team consists of three Pokémon with a weakness to Ice, so come prepared with a powerful Ice type to try to bring them down!

Nita's Pokémon (Single Battle)

Wigglytuff — Normal / Fairy
♀/♂ Lv. 50
Weak to: Poison, Steel

Grumpig — Psychic
♀/♂ Lv. 50
Weak to: Bug, Ghost, Dark

Purugly — Normal
♀/♂ Lv. 50
Weak to: Fighting

Nita's Pokémon (Super Single Battle)

Tornadus — Flying
♂ Lv. 50
Weak to: Electric, Ice, Rock

Landorus — Ground / Flying
♂ Lv. 50
Weak to: 4x Ice, Water

Thundurus — Electric / Flying
♂ Lv. 50
Weak to: Ice, Rock

TRAINER HANDBOOK

ADVANCED HANDBOOK

ADVENTURE DATA

Battle Chatelaine Evelyn

Evelyn's Pokémon tend to not share many weaknesses, but a diverse lineup helps you deal with them. These battles can drag on as a result—and remember, you can't use any healing items from your Bag. Plan ahead and bring along Pokémon with excellent Defense and Sp. Defense stats!

Evelyn's Pokémon (Double Battle)

Pachirisu ♀/♂ Lv. 50	Electric	Primeape ♀/♂ Lv. 50	Fighting	Lumineon ♀/♂ Lv. 50	Water
Weak to: Ground		Weak to: Flying Psychic Fairy		Weak to: Grass Electric	
Persian ♀/♂ Lv. 50	Normal				
Weak to: Fighting					

Evelyn's Pokémon (Super Double Battle)

Latios ♂ Lv. 50	Dragon Psychic	Suicune Lv. 50	Water	Raikou Lv. 50	Electric
Weak to: Ice Bug Ghost Dragon Dark Fairy		Weak to: Grass Electric		Weak to: Ground	
Entei Lv. 50	Fire				
Weak to: Water Ground Rock					

Battle Chatelaine Dana

Dana's teams have a number of shared weaknesses, which help you get through your battles with her. Fighting- and Fire-type moves will be effective against at least half of her team members. Rock is a weakness for many members of her Super Triple Battle team, too.

Dana's Pokémon (Triple Battle)

Magcargo ♀/♂ Lv. 50	Fire Rock	Whimsicott ♀/♂ Lv. 50	Grass Fairy	Girafarig ♀/♂ Lv. 50	Normal Psychic
Weak to: 4× Water 4× Ground Fighting Rock		Weak to: 4× Poison Fire Ice Flying Steel		Weak to: Bug Dark	
Piloswine ♀/♂ Lv. 50	Ice Ground	Dragalge ♀/♂ Lv. 50	Poison Dragon	Magneton Lv. 50	Electric Steel
Weak to: Fire Water Grass Fighting Steel		Weak to: Ice Ground Psychic Dragon		Weak to: 4× Ground Fire Fighting	

Dana's Pokémon (Super Triple Battle)

◉ Articuno	Ice	Flying
Lv. 50		
Weak to: 4× Rock	Fire	Electric
Steel		

◉ Zapdos	Electric	Flying
Lv. 50		
Weak to: Ice	Rock	

◉ Moltres	Fire	Flying
Lv. 50		
Weak to: 4× Rock	Water	Electric

◉ Registeel	Steel	
Lv. 50		
Weak to: Fire	Fighting	Ground

◉ Regice	Ice	
Lv. 50		
Weak to: Fire	Fighting	Rock
Steel		

◉ Regirock	Rock	
Lv. 50		
Weak to: Water	Grass	Fighting
Ground	Steel	

Battle Chatelaine Morgan

Rotation Battles are tough, because you can't know for certain which Pokémon your attack will land on, based on the opponent's moves. Luckily, Morgan's team shares at least a few weaknesses. Ground- and Fire-type moves are great when facing her in a normal Rotation Battle, while Fairy-type moves will definitely come in handy if you reach the Super Rotation Battle stage!

Morgan's Pokémon (Rotation Battle)

◉ Klefki	Steel	Fairy
♀/♂ Lv. 50		
Weak to: Fire	Ground	

◉ Swalot	Poison	
♀/♂ Lv. 50		
Weak to: Ground	Psychic	

◉ Mantine	Water	Flying
♀/♂ Lv. 50		
Weak to: 4× Electric	Rock	

◉ Sawsbuck	Normal	Grass
♀/♂ Lv. 50		
Weak to: Fire	Ice	Fighting
Poison	Flying	Bug

Morgan's Pokémon (Super Rotation Battle)

◉ Latias	Dragon	Psychic
♀ Lv. 50		
Weak to: Ice	Bug	Ghost
Dragon	Dark	Fairy

◉ Virizion	Grass	Fighting
Lv. 50		
Weak to: 4× Flying	Fire	Ice
Poison	Psychic	Fairy

◉ Terrakion	Rock	Fighting	
Lv. 50			
Weak to: Water	Grass	Fighting	
Ground	Psychic	Steel	Fairy

◉ Cobalion	Steel	Fighting
Lv. 50		
Weak to: Fire	Fighting	Ground

TIP

You can also take on the four Battle Chatelaines in Multi Battles. Choose to take part in Multi Battles, and after you make it through 19 battles in row, you'll face both Dana and Evelyn together. If you then try your hand at Super Multi Battles and win your way through 49 straight battles, you'll find yourself taking on Nita and Morgan! In either case, each Chatelaine will pick two Pokémon from her usual line-up at that level. For example, Dana will choose from her Triple Battle team, while Nita will choose from her Super Single Battle team.

THINGS TO DO DAILY

There are many places all over Hoenn that you'll want to go back to visit on a daily basis. People are just waiting to give you free stuff, so go out there and get it!

Pretty Petal flower shop (Route 104)

On Route 104 you can find the Pretty Petal flower shop. Go inside and talk to the little girl. She'll give you one Berry every day from among Cheri, Chesto, Pecha, Rawst, Aspear, Leppa, Oran, or Persim. Be sure to talk to everyone else, too, as they have other one-time-only goodies for you!

Mauville City

Revisit Circie, the Rotation Battle master who lives in Mauville Hills, to try another Rotation Battle each day. You can receive Elixirs from her granddaughter for your trouble!

Face an unusual battle format by revisiting the Inverse Battle Stop each day for another Inverse Battle with the Proprietor! You can win all kinds of prizes, as detailed on page 96.

TRAINER HANDBOOK

ADVANCED HANDBOOK

ADVENTURE DATA

Route 111

Orlando obtained a Razz Berry!

At the north end of Route 111, you'll find the Old Lady's Rest Stop. Just behind the Old Lady's Rest Stop, you'll find a plot of soft soil and a little girl. Talk to the little girl for a free Razz Berry each day.

Route 114

Orlando obtained a Bluk Berry!

The man who lingers right in front of Lanette's house on Route 114 will give you one random Berry each day: Razz, Bluk, Nanab, Wepear, or Pinap. Just ask him!

The Weather Institute (Route 119)

Orlando obtained a Smooth Rock!

You'll have to stop by the Weather Institute on Route 119 at some point during the adventure. That one visit won't be enough, though. Return to the Weather Institute after you have Castform. Each day, you can talk to the receptionist and collect a souvenir of substance: Heat Rock, Smooth Rock, Damp Rock, or Icy Rock.

Route 120

Orlando obtained a Wiki Berry!

All the way at the southwest corner of Route 120, near stairs that lead up to a plateau, you'll find a woman who'll give you a Berry each day—a Figy, Wiki, Mago, Aguav, or Iapapa Berry. She'll only give you one kind of Berry, though, so check with your friends to see what they got from her. Maybe you can trade!

Lilycove City

Orlando obtained a Lum Berry!

In the northeast corner of the city, you'll find a Gentleman. Talk to him each day to receive one of the following Berries at random: Cheri, Chesto, Pecha, Rawst, Aspear, Leppa, Oran, Persim, Lum, or Sitrus Berry.

Lilycove Department Store

This is the Pokémon Lottery Corner.

Play the Pokémon Loto by visiting the Lilycove Department Store and talking to the Lottery Corner receptionist on the right on the first floor. She draws a random number every day—if even part of the number matches the ID number of any of your Pokémon, you'll win a fabulous prize: Moomoo Milk, PP Up, PP Max, Rare Candy, or Master Ball.

Lilycove Department Store (Saturday only!)

Buy
No thanks!

Welcome, welcome! What timing! We're now holding our regular Clearance Sale!

Visit the roof of the Lilycove Department Store every Saturday to find a Clearance Sale with special items at low prices.

The Berry Master's House (Route 123)

Orlando obtained a Nomel Berry!

Talk to the Berry Master every day, and he'll give you two of the following Berries at random: Pomeg, Kelpsy, Qualot, Hondew, Grepa, Tamato, Cornn, Magost, Rabuta, or Nomel Berry. Talk to his wife next. She'll give you one of the following common Berries: Cheri, Chesto, Pecha, Rawst, Aspear, Leppa, Oran, Persim, Lum, or Sitrus, assuming you already helped her remember certain key phrases (p. 188).

Sootopolis City

Orlando obtained a Hondew Berry!

A young girl named Kiri frolics on Sootopolis City's west bank. From the Sootopolis City Gym, use Surf to cross the water to the west and find Kiri. She'll give you two random Berries each day from the following: Pomeg, Kelpsy, Qualot, Hondew, Grepa, Tamato, Cornn, Magost, Rabuta, Wiki, Figy, Mago, Aguav, Razz, Iapapa, or Nomel.

Fallarbor Town Pokémon Center

Orlando obtained Honey!

Inside the Pokémon Center, speak to the man by the bookshelf, who's reading the latest copy of the Aha! Pokémon Journal. He'll give you some free Honey every day. How sweet is that?!

Around Hoenn

Fabled Cave

YES
NO

Would you like to land here?

Go Soaring each day to discover what new Mirage spot has appeared! If you're very lucky, you might find the ultra-rare Crescent Isle (p. 357)!

Your Secret Base

Orlando's Base

Visit your Secret Base, which you have hopefully packed with Secret Pals (p. 114), and have them do their thing for you each day! You can battle them once a day, too!

Others' Secret Bases

Alpha: Please take this as a little thank-you for coming to play in my Secret Base!

Check out the Secret Bases you've discovered through StreetPass or the PGL, or those that you've made favorites. You can battle the Trainers inside them once a day!

Battle Resort activities

OK! Whismur!
Everyone, gather round!

As you've just discovered, the Battle Resort has plenty of activities to keep you occupied. Visit the Battle Resort daily to take on those five wandering masters, and don't forget to grab a free Berry from the nice woman in the cabin to the east of the Battle Maison. You can also watch the Whismur dance each day in an effort to guess which one has a Big Mushroom. And of course, there's always plenty to do within the Battle Maison itself!

Trainer Card Upgrades

Your Trainer Card will be upgraded and will change color as you reach different milestones in the game. The three milestones are as follows.

Congratulations on becoming Pokémon League Champion!

1. Entering the Hall of Fame

Hoenn Pokédex
National Pokédex
Cancel

Oh? Have you come to show me how your Pokédex is coming along?

2. Having seen all of the Pokémon in the Hoenn Pokédex

3. Having at least one monument put up in the Battle Maison

Your card will be upgraded to a Bronze Card when you have cleared one of these conditions. You'll get a Silver Card when you've cleared two of them. And you will be able to show off a prestigious Gold Card if you manage to fulfill all three conditions!

Welcome to the Advanced Handbook! This section is dedicated to helping players who've mastered the basics step up their game and learn what it takes to rank among the very best Pokémon Trainers in the world.

TIP

You've clearly mastered all of the basics by this point—or have you? If you feel the need to brush up on fundamentals, review the Trainer Handbook (p. 6). You can also turn to any of the articles covering specific game features in the walkthrough. A complete list of them can be found on pages 2-3.

ADVANCED BATTLE GUIDE

Struggling with Pokémon battles? You've come to the right place! This is the advanced guide to Pokémon battling techniques. You learned the basics back on pages 6-20. Over these next few pages, you will learn more about the ways in which advanced players prepare themselves for Pokémon battles.

Ways to increase damage

Increasing the damage that your Pokémon inflict with their attacks is a key strategy in any Pokémon battle. Fortunately, there are many ways to increase your Pokémon's damage.

Damage technique 1: Match move types with Pokémon types

Sceptile used Leaf Blade!

Using moves of the same type as the move user is an easy way to increase damage. For example, if your Pokémon is Grass type, it will inflict more damage when it uses Grass-type moves. If your Pokémon has two types, you have twice the variety of moves available to you, because you receive this bonus for both of its types.

TIP

Note the way that weaknesses change for dual-type Pokémon. A weakness and a resistance will cancel each other out (for example, Grass types are weak to Fire-type moves, but Water types are resistant to them—so a Water-and-Grass-type Pokémon like Lotad will just take normal damage from Fire-type moves, not more or less). Two weaknesses can also stack, so the Grass- and Ice-type Snover will take 4 times the normal damage from a Fire-type move, because Grass types and Ice types are both weak to Fire-type moves.

Damage technique 2: Use moves that the target is weak against

It's super effective!

A great way to inflict massive damage is to use moves that the opposing Pokémon is weak against, which will deal twice the usual damage. The Type Matchup Chart on page 463 is an invaluable resource, for it shows the strengths and weaknesses for all Pokémon and move types. Combine this with the Pokémon Native to the Hoenn Region list on page 338, and you'll be able to exploit the weaknesses of any Pokémon you encounter in the region!

Damage technique 3: Abilities that increase damage

Dex No.	307
Name	Meditite
Type	FIGHTING PSYCHIC
OT	Orlando
ID No.	60311
Exp. Points	
	125
To Next Lv.	
	91

HP	18 / 18
Attack	9
Defense	13
Sp. Atk	9
Sp. Def	9
Speed	11

Pure Power
Boosts the Pokémon's Attack stat.

Matching Pokémon types and move types is a great start, but there are other ways to increase your overall damage. For instance, some Abilities like Blaze, Overgrow, and Torrent can increase damage for moves of a certain type. Below are some other examples.

TIP

See page 436 for a list of Pokémon Abilities and descriptions of their effects.

Swarm (ex. Volbeat): Bug-type moves receive a 50 percent boost when the user's HP is reduced to 1/3 or less.

Hustle (ex. Corsola): Raises the Attack stat by 50 percent but lowers the accuracy of physical moves by 20 percent.

Pure Power (ex. Meditite): Doubles the Pokémon's Attack stat.

Damage technique 4: Items that increase damage

Items can be used to increase a Pokémon's damage output as well. Here are some examples of items you use on your Pokémon during battle to temporarily raise the damage it can deal.

 X Attack: An item that boosts the Attack stat of a Pokémon during a battle. It wears off once the Pokémon is withdrawn.

 X Sp. Atk: An item that boosts the Sp. Atk stat of a Pokémon during a battle. It wears off once the Pokémon is withdrawn.

 Dire Hit: An item that raises the critical-hit ratio greatly. It can be used only once per battle and wears off if the Pokémon is withdrawn.

If you're looking for more permanent stat-boosting solutions, the following items and others can be used outside of battle to increase damage by permanently raising your Pokémon's base stats (p. 325).

 Protein: A nutritious drink for Pokémon. When consumed, it raises the base Attack stat of a single Pokémon.

Calcium: A nutritious drink for Pokémon. When consumed, it raises the base Sp. Atk stat of a single Pokémon.

Damage technique 5: Held items that increase damage

Various plates, such as the Pixie Plate, and other held items like the Miracle Seed and Metal Coat, can be held by Pokémon to increase the damage dealt by a particular type of move. Just read the item's description in your Bag to see which type of move it boosts. Here are some examples of other held items that increase damage.

TIP

Open your Bag and select the Items Pocket. Then tap the icon that looks like two arrows chasing each other to sort your items. Sort them by type, and any items your Pokémon can hold will be sorted to the top of the list. Check out those items to see how useful in battle they might be.

 Expert Belt: Found in the Trick House, it increases any move's damage by 20 percent, but only if the move deals supereffective damage.

 Muscle Band: Increases the damage dealt by physical moves by 10 percent.

 Wise Glasses: Increases the damage dealt by special moves by 10 percent.

Some held items can greatly increase damage—for a cost. Here are some examples.

 Life Orb: Increases damage from the holder's moves, but at a cost of losing HP with each move.

 Choice Band: Boosts Attack by 50 percent, but only allows the holder to use one of its moves.

Choice Specs: Boosts Sp. Atk by 50 percent, but only allows the holder to use one of its moves.

TIP

See page 444 for a list of items, with descriptions of what each can do for your Pokémon.

Understand Abilities and get the edge in battle

Pokémon Abilities don't just increase damage from moves. They can have a variety of effects, such as protecting a Pokémon from some types of harm or inflicting status conditions on the attacker when receiving an attack. If you can master Abilities, you can gain an edge over others in battle.

Ability technique 1: A Pokémon's Ability is determined by its species

Every Pokémon has an Ability, which is determined by that Pokémon's species. Even if the species has two possible Abilities, each individual Pokémon will have only one of those Abilities. Check your Pokémon's Summary page to find its Ability and look for ways to take advantage of its effects in battle.

Mightyena's Intimidate!

Ability technique 2: Use Abilities that activate when entering battle

Some Abilities activate as soon as the Pokémon enters a battle. For example, when a Pokémon with the Intimidate Ability comes into battle, the opposing Pokémon's Attack goes down one level. These Abilities activate when the battle starts or when a Pokémon with this sort of Ability is switched into battle. Consider these Abilities when choosing a Pokémon to lead your party or when developing tactics that include mid-battle switching.

Dex No.		290
Name		Nincada
Type	BUG GROUND	
OT		Orlando
ID No.		60311
Exp. Points		
		32,244
To Next Lv.		
		2,388

HP	64 / 64
Attack	38
Defense	64
Sp. Atk	30
Sp. Def	30
Speed	36

Compound Eyes
Boosts the Pokémon's accuracy.

Ability technique 3: Use Abilities that activate when attacking

Certain Abilities activate when a Pokémon uses a move. For example, if a Pokémon has the Compound Eyes Ability, it raises the accuracy of its moves. Combine this Ability with powerful but low-accuracy moves to increase the odds of landing a devastating attack.

Latios's Levitate!

It doesn't affect Latios...

Ability technique 4: Use damage-preventing Abilities to get an edge

Some Abilities prevent damage from particular move types. For example, Pokémon with the Levitate Ability don't take damage from Ground-type attacks. Knowing these Abilities is essential when switching Pokémon or setting up combos in Double and Triple Battles.

Silcoon's Shed Skin!

Silcoon was cured of its poisoning.

Ability technique 5: Battle with reliable Abilities that prevent or heal status conditions

Some Abilities can prevent certain status conditions or heal them after they are inflicted. For example, the Insomnia Ability prevents the Sleep status condition, and the Shed Skin Ability can sometimes heal status conditions. These Abilities can save your skin when you are facing a foe that's trying to inflict status conditions.

Geodude's Sturdy!

Geodude endured the hit!

Ability technique 6: Use creative move and Ability combinations

Creatively combining moves and Abilities is a key strategy. For example, the Sturdy Ability allows your Pokémon to endure a move that would have normally knocked it out. Instead of being defeated, the Pokémon survives by holding onto just 1 HP. Combine this with a move like Reversal, which increases in power as your HP drops, and you'll pay your opponent back with a vengeance. There are endless ways to combine Abilities and moves like this, so put on your thinking cap and start reviewing the move and Ability lists at the end of this book for inspiration!

Using held items wisely

You'll find many different items that your Pokémon can be given to hold during your journey across Hoenn, all with different uses and characteristics. For example, some items will work their effects when they are held by a Pokémon, while other items are consumable and vanish after their effects are triggered once. In addition, some items can enhance a Pokémon's strengths, while others will compensate for its weaknesses. Many species of Pokémon can excel in battle if they are given the right item to hold.

Item technique 1: Held items can power up attacks

Many held items can boost the power of attacks. For example, when a Pokémon holds Charcoal, it raises the power of its Fire-type moves. These kinds of items can speed up battles by reducing the number of turns needed to defeat the opposing Pokémon.

Item technique 2: Held items can help with defense

Some held items can prevent your Pokémon from fainting, or can reduce the damage received from moves that your Pokémon is weak against. For example, a Focus Band has a 10 percent chance of leaving the holder with 1 HP when it receives damage that would cause it to faint. Have your Pokémon hold items that help when they are hit by moves to keep your team out of trouble.

Item technique 3: Combine held items with moves

There are many ways to build effective strategies by combining held items with moves. Obvious combinations include pairing a Razor Claw, a held item that increases the holder's critical hit ratio, with a move like Shadow Claw, a move that already has a higher critical hit ratio. But try to think of ways of reversing disadvantages, too. For example, the move Rest puts your Pokémon to sleep in order to restore its HP. Give your Pokémon a Lum Berry to hold before the battle, and it will automatically use the Lum Berry to awaken from sleep after fully restoring its HP. Another example is to combine a harmful held item like a Flame Orb, which burns the holder, with a move like Switcheroo, which will steal your opponent's held item and replace it with yours. Look through the items list starting on page 444 to get some inspiration of your own!

Item technique 4: Heal HP and status conditions with held items

Some held items can heal HP and status conditions. For example, Leftovers restore a little HP every turn. Many Berries allow your Pokémon to heal status conditions on their own as well—they'll automatically consume the Berry that they're holding when the time is right. If you use these items, you can get out of a bad situation or stand tough with Pokémon that are hard to knock out.

Using Mega Evolution

Mega Evolution is a powerful transformation that certain Pokémon can undergo during battle—provided they're holding the right Mega Stone. In general, Mega Evolution boosts Pokémon stats, but it often bestows very powerful Abilities, too. You can Mega Evolve your Pokémon anytime you'd like during battle, letting you make use of the Pokémon's unique traits both before and after Mega Evolution. With all of these advantages, Mega Evolution can be devastating if used properly.

Think carefully about whether you want to Mega Evolve at once, which might be the case for Mega Aggron, which becomes a defensive powerhouse upon Mega Evolving. Or you may wish to keep it in reserve for strategic reasons, like you can with a Mewtwo holding Mewtwonite Y. If your Mewtwo knows the move Rest, have it do some damage before using Mega Evolution. Then, when its strength is flagging and its HP is low, use Rest the turn before it Mega Evolves into Mega Mewtwo Y, which gives it the Insomnia Ability. Insomnia will wake Mega Mewtwo Y up with a full HP gauge, ready for another round of attacks! These are the kinds of ideas you should keep in mind to use Mega Evolution to the fullest.

All that said, Mega Evolution has its disadvantages, too. Your Pokémon must hold a Mega Stone to undergo Mega Evolution, so it can't hold anything else, such as Berries or held items that increase its defenses or damage. This can leave your Pokémon vulnerable to status conditions and supereffective attacks. You also won't be able to let your Pokémon hold powerful items such as the Life Orb, and the Speed stat boosts don't kick in until the turn after Mega Evolution. Plus, Mega Evolution is not true Evolution, and its effects last only for the span of one battle. Still, when used properly, Mega Evolution is a great way to achieve victory. Turn back to page 155 if you need a refresher on how to trigger Mega Evolution in battle.

Mega Evolution rules

There are a few things to remember about using Mega Evolution in battle.

- You can only Mega Evolve one Pokémon per battle. Even if you switch that Pokémon out or it faints, you cannot Mega Evolve a second Pokémon. So choose carefully!
- Your Pokémon will not return to its normal state during battle. Even if you switch it out, it will retain its Mega-Evolved state if you switch it back in.
- If your Mega-Evolved Pokémon faints, it will return to its normal state. If you then revive it during the same battle, it will remain in its normal state and cannot achieve Mega Evolution again during the battle.
- A Pokémon's Mega Stone cannot be taken by moves like Thief or Abilities like Pickpocket. No other known Abilities or moves can prevent Mega Evolution.

Collecting Mega Stones

Orlando found a Manectite!

Mega Stones can be found all around Hoenn. Many have been lying along routes and buried deep in caves for ages—perhaps since the last great meteorite shower rained down on the region. More Mega Stones appear after you resolve the crisis of the super-ancient Pokémon, and even more become available when you avert the astronomical disaster that awaits you in the Delta Episode! Mega Stones can be recognized by the telltale sparkling spots you see on the ground in various locations. Examine these sparkling spots with Ⓐ and collect them all!

Mega Stones that appear from the start

	Mega Stone	Location	Notes
	Absolite	Safari Zone	Find it within the area.
	Aggronite	Rusturf Tunnel	Get it as a reward for smashing rocks with Rock Smash.
	Alakazite	Slateport City	Find it in the market.
	Altarianite	Lilycove City	Show an Altaria to Lisia's fan.
	Banettite	Mt. Pyre	Find it at the summit
	Beedrillite	Sea Mauville	Find it in Storage.
	Blazikenite	Route 120 or Route 114	Get it from Steven on Route 120 if you chose Torchic. Otherwise, buy it from a seller on Route 114 after subduing the super-ancient Pokémon.
	Garchompite	Fortree City	Get it from Aarune when your team reaches Platinum Rank in the Secret Base Guild (p. 165).
	Glalitite	Shoal Cave	Find it in the ice cavern.
	Gyaradosite	Route 123	Scratch Poochyena in 123 Go Fish.
	Heracronite	Route 127	Find it on an island.
	Latiasite	Southern Island (α)	Receive through story events.
	Latiosite	Southern Island (Ω)	Receive through story events.
	Lucarionite	Any Contest Hall	Beat Lisia in a Master Rank contest (p. 362).

	Mega Stone	Location	Notes
	Manectite	Route 110	Find it near Cycling Road.
	Mawilite	Verdanturf Town	Find it on the ground.
	Medichamite	Mt. Pyre	Find it within the area.
	Pidgeotite	Verdanturf Town	Find Shroomish for the little girl in Verdanturf Town, then show the Intriguing Stone she gives you to Mr. Stone in Rustboro City.
	Pinsirite	Route 124	Find it on the ground.
	Sablenite	Sootopolis City	Find it near the bridge to the Cave of Origin.
	Sceptilite	Route 120 or Route 114	Get it from Steven on Route 120 if you chose Treecko. Otherwise, buy it from a seller on Route 114 after subduing the super-ancient Pokémon.
	Slowbronite	Shoal Cave	Receive it from the old man the first time he makes you a Shell Bell.
	Steelixite	Granite Cave	Find it in the lower levels.
	Swampertite	Route 120 or Route 114	Get it from Steven on Route 120 if you chose Mudkip. Otherwise, buy it from a seller on Route 114 after subduing the super-ancient Pokémon.

Mega Stones that appear after you subdue the super-ancient Pokémon

Mega Stone	Location	Notes
Abomasite	Route 123	Find it in the Berry fields.
Aerodactylite	Meteor Falls	Find it on the ground.
Ampharosite	New Mauville	Find it on the ground.
Charizardite X	Fiery Path	Find it on the ground.
Charizardite Y	Scorched Slab	Find it on the ground.
Gardevoirite	Verdanturf Town	Talk to Wanda in her house.
Houndoominite	Lavaridge Town	Find it on the ground.
Kangaskhanite	Pacifidlog Town	Find it on the ground.
Lopunnite	Mauville City	Get it from a businessman in Mauville Hills.
Mewtwonite X	Littleroot Town	Find it on the ground.
Mewtwonite Y	Pokémon League	Find it on the ground.
Scizorite	Petalburg Woods	Find it on the ground.
Tyranitarite	Jagged Pass	Find it on the ground.
Venusaurite	Route 119	Find it on the ground.
Red Orb* (Ω)	Sootopolis City	Obtain through story events.
Blue Orb** (α)	Sootopolis City	Obtain through story events.

Mega Stones appearing during or after the Delta Episode

Mega Stone	Location	Notes
Audinite	Battle Resort	Talk to Looker at the Battle Resort.
Blastoisinite	S.S. Tidal	Find it on the ground.
Cameruptite	Team Magma's Hideout (Ω) or Battle Resort (α)	Get it during the Delta Episode (Ω) or get it from a Team Magma Grunt at the Battle Resort (α).
Galladite	Fallarbor Town	Talk to Professor Cozmo in his lab.
Gengarite	Battle Resort	Find it on the ground.
Latiasite	Littleroot Town (Ω)	Talk to your Mom in your house.
Latiosite	Littleroot Town (α)	Talk to your Mom in your house.
Metagrossite	Pokémon League	Defeat Steven once again.
Salamencite	Meteor Falls	Talk to the old woman there.
Sharpedonite	Battle Resort (Ω) or Team Aqua's Hideout (α)	Get it from a Team Aqua Grunt at the Battle Resort (Ω) or get it during the Delta Episode (α).

Mega Stones available through other means

Mega Stone	Location	Notes
Diancite	—	Visit a Pokémon Center when you have Diancie distributed through past special events in your party.

* Although not true Mega Evolution, the Red Orb allows Groudon to achieve Primal Reversion through a similar process.

** Although not true Mega Evolution, the Blue Orb allows Kyogre to achieve Primal Reversion through a similar process.

Battle formats

During your adventures in *Pokémon Omega Ruby* or *Pokémon Alpha Sapphire*, you'll experience the following eight battle formats: Single Battle, Double Battle, Multi Battle, Triple Battle, Rotation Battle, Horde Battle, Horde Encounter, and Inverse Battle. If you want to win, you'll need to learn the rules of every format.

What will Treecko do?

Single Battle
Each side battles with one Pokémon at a time

Each Pokémon Trainer sends out one Pokémon with which to battle. The straightforward nature of Single Battle, in which you focus on attacking and exploiting your opponent's weaknesses, is what makes this such a fun battle format. But if you want to become a Pokémon battle master, you'll need to think carefully about how to raise your Pokémon, what items to give them to hold, and much more. You can get an explanation of a move if you hold ⊡ when choosing the move.

What will Treecko do?

Double Battle
Each side battles with two Pokémon at a time

You send out two Pokémon with which to battle. In Double Battles, attacks that can hit both of the opposing Pokémon become very useful. Double Battles require you to know more about moves and their effects than you need for Single Battles. It's important to come up with good ways to combine a Pokémon's moves, held item, and Ability in order to achieve victory in Double Battles.

What will Sceptile do?

Multi Battle
Four Trainers battle it out

Four Trainers can take part in Multi Battles. Like Double Battles, there are two Pokémon on each side, but because you are battling alongside an ally, you will only be able to control the actions of your own Pokémon. Try to use Pokémon, moves, and Abilities that will complement those of your partner.

What will Wingull do?

Triple Battle
Each side battles with three Pokémon at a time

Each Pokémon Trainer sends out three Pokémon with which to battle. The Pokémon in the middle can target any of the opposing Trainer's three Pokémon. The Pokémon on the left and right have a limited range depending on the moves they have. Triple Battles can be extremely demanding, as they require you to shift your Pokémon around in order to exploit your opponent's weaknesses.

Rotation Battle
In this evolved form of the Single Battle format, each side battles with three Pokémon at a time

The Rotation Battle is an evolved form of the Single Battle format. Each Pokémon Trainer sends out three Pokémon with which to battle. Only one Pokémon can attack per turn, but you can choose to use a move from any of your Pokémon. What makes Rotation Battles unique is that Pokémon can change location and attack on the same turn. For example, if you choose a move from a Pokémon in the back, it will rotate to the front and use its move on the same turn. You won't know which Pokémon your opponent will send to the front next, though, so predicting these battles' outcomes takes real skill.

What will Latios do?

Horde Battles and Horde Encounters
Take on a horde of Pokémon

Horde Battles are new to *Pokémon Omega Ruby* and *Pokémon Alpha Sapphire*, and require you to send out one Pokémon with which to battle against five opposing Pokémon, sent out by five Trainers. In a Horde Encounter, you send out one Pokémon with which to battle against five opposing wild Pokémon. The odds seems unfair, but the Pokémon you encounter in such battles are often far less experienced than your Pokémon. In both, moves that target multiple Pokémon are extremely useful. Try to take out the whole horde in one move! If you want to catch one of the wild Pokémon in a Horde Encounter, you'll need to defeat them individually, because you can't throw a Poké Ball while more than one opponent still stands against you.

It's super effective!

Inverse Battle
Experience a reverse type matchup

This battle format flips the Type Matchup Chart (p. 463) on its head by reversing the strengths and weaknesses of Pokémon types and move types. For example, Fire-type moves are usually super effective against Grass-type Pokémon, but in an Inverse Battle, they will not be very effective at all. It seems like a simple twist, but one false move could lead to defeat. Inverse Battles play out just like Single Battles, with each Trainer sending out one Pokémon with which to battle.

Choosing the right Pokémon

HP + 2
ATTACK + 1
DEFENSE + 0
SP. ATK + 1
SP. DEF + 0
SPEED + 2

Taillow grew to Lv. 7!

During your adventure, your Pokémon will gain Exp. Points through battling. When they gain enough Exp. Points, their level will increase and their stats will go up. A Pokémon's stats affect how well it performs in battle, so it's important to understand the factors that determine how quickly a Pokémon's stats will increase.

Dex No. 276
Name Taillow
Type NORMAL FLYING
OT Orlando
ID No. 60311
Exp. Points
 258
To Next Lv.
 56

HP 23 / 23

Attack 11
Defense 9
Sp. Atk 9
Sp. Def 10
Speed 17

Guts
Boosts the Attack stat if the Pokémon has a status condition.

Your Pokémon's final stats (the ones that you see on its Summary page) are decided by three main factors, some of which you can affect and some of which you cannot.

1. **Species strengths:** Each Pokémon species has its own unique strengths. For example, some species of Pokémon will naturally develop higher Attack stats than others, because their Attack stat increases by greater amounts each time it levels up. You can't change or affect species strengths; you can only choose the right species to take advantage of their strengths. Read on to learn more.

2. **Individual strengths:** In addition to its species strengths, each Pokémon also has its own, unique individual strengths. Even Pokémon of the same species have individual strengths that help make them unique. By catching or breeding lots of Pokémon from the same species, you can try to get the individual stat strengths that you want for that species. Turn to page 324 to learn more.

3. **Base stats:** Base stats also affect how your Pokémon's final stats grow and measure up, and they are the one factor that you can directly affect even after catching or receiving a Pokémon. Through the use of certain items and Super Training, you can increase a Pokémon's base stats however you like. Turn to page 325 to learn more.

🔵 TIP

Some held items, like Eviolite, can also help boost stats. Unlike the factors listed above, which have permanent effects on your Pokémon's stats, any boosts provided by held items will only last as long as that item is held. Browse the item lists on pages 444–453 to find held items that you'd like to give to your Pokémon to carry into battle.

Species strengths

Each of your Pokémon has stats that grow as it levels up, and each Pokémon's species affects how quickly its stats will grow with each new level. The strengths of each Pokémon species are illustrated in official Pokédexes by a number of colored boxes or dots that represent the species' stat growth rates. This helps you see how strong a species' stat growth is when compared to the average stat growth of all other Pokémon species. The more boxes or dots you see, the greater that Pokémon species' stats will increase each time it levels up. Species strengths greatly influence a Pokémon's final stats, so it's wise to pay attention to them if you hope to create an unstoppable team. Super Training alone can't make up for these differences!

STAT GROWTH RATES
HP
Attack
Defense
Sp. Atk
Sp. Def
Speed

Mightyena

STAT GROWTH RATES
HP
Attack
Defense
Sp. Atk
Sp. Def
Speed

Flygon

STAT GROWTH RATES
HP
Attack
Defense
Sp. Atk
Sp. Def
Speed

Absol

While Mightyena may look like the tougher opponent, Flygon actually has more stats that grow at a quicker rate than Mightyena, allowing it to be raised into a stronger all-around Pokémon (if you choose to go that route). Meanwhile, Absol's Attack stat will grow incredibly fast and will put the other two to shame at higher levels.

Get Pokémon with great species strengths in your party

This section shows off some particularly impressive Pokémon that can be found in the Hoenn region. Consider how to raise them, battle with them, and battle against them.

Pokémon whose HP grows quickly

Wobbuffet `Psychic` **Wailord** `Water` **Hariyama** `Fighting`

Pokémon whose Attack grows quickly

Slaking `Normal` **Rhyperior** `Ground` `Rock` **Salamence** `Dragon` `Flying`

Pokémon whose Sp. Atk grows quickly

Alakazam `Psychic` **Magnezone** `Electric` `Steel` **Roserade** `Grass` `Poison`

Pokémon whose Defense grows quickly

Aggron `Steel` `Rock` **Probopass** `Rock` `Steel` **Skarmory** `Steel` `Flying`

Pokémon whose Sp. Def grows quickly

Probopass `Rock` `Steel` **Dusknoir** `Ghost` `Steel`

Pokémon whose Speed grows quickly

Ninjask `Bug` `Flying` **Electrode** `Electric` **Crobat** `Poison` `Flying`

Building a balanced team

Imagine that the first Pokémon you send out faints after getting hit by a supereffective move. Would you send out a Pokémon of the same type as the first one, knowing that it'll be vulnerable to the same move? Of course not! Ideally, the second Pokémon should be strong against it. That's how you build a balanced team. Basically, your team should form a rock-paper-scissors kind of relationship, with each Pokémon compensating for its allies' weaknesses.

Here is an example with Pokémon. As an Electric-type Pokémon, Electrike is weak against Ground-type moves. That's why you want Wailmer to add its Water-type moves to the team—they are especially good against Ground-type Pokémon, which might get sent in by your opponent to deal with Electrike. Wailmer is weak against Grass-type moves. That's why you want to have Slugma with its Fire-type moves, to deal with any Grass-type Pokémon that are switched in to wash the floor with Wailmer. But Slugma is weak against Water-type moves. For those Water-type Pokémon that might get sent against it, you have Electrike with its Electric-type moves!

The importance of move variety

If you make a team of Pokémon whose moves are all of the same type or even just a few types, what will you do if you face a Pokémon that's strong against those types of move? You want plenty of variety in the types of moves that your team uses. Ideally, if one move isn't very effective against a particular type, another move should be supereffective against that type. Similarly, your team should be able to use both physical moves and special moves. A few status moves never hurt, either.

Forming a balanced team with variety of moves

Here's an example of a balanced team whose diversity in Pokémon types and move types gives it a chance to beat any rival.

Gardevoir
Psychic **Fairy**

Mightyena
Dark

Hariyama
Fighting

Combine a Gardevoir (Psychic and Fairy type) that knows special Psychic-type moves with a Mightyena (Dark type) that knows physical Dark moves and a Makuhita (Fighting type) that knows physical Fighting-type moves. That would prepare you to do supereffective damage to eight different Pokémon types with just three of your Pokémon, plus be ready for opponents with high Defense as well as those with high Sp. Def!

Send out Pokémon that have immunities

Some Pokémon types are not affected at all by moves of certain types. For example, Ghost-type Pokémon are not affected by Normal- or Fighting-type moves, and Flying-type Pokémon are not affected by Ground-type moves. Also, some Pokémon types prevent certain status conditions. For instance, Fire-type Pokémon cannot be Burned, and Ice-type Pokémon cannot be Frozen. Armed with this knowledge, you can nullify certain moves and stay one step ahead during battle.

	Pokémon type immunities
Normal	Immune to all Ghost-type moves.
Fire	Does not become Burned.
Grass	Immune to Leech Seed. Also immune to powder and spore moves.
Electric	Does not become Paralyzed.
Ice	Does not become Frozen and takes no damage from the Hail weather condition.
Poison	Immune to the Poison and Badly Poisoned conditions. Also nullifies the effect of Toxic Spikes as it gets sent out.*
Ground	Immune to all Electric-type moves. Also immune to Thunder Wave.** Also takes no damage from the Sandstorm weather condition.
Flying	Immune to all Ground-type moves. Also not affected by Spikes or Toxic Spikes.
Rock	Takes no damage from the Sandstorm weather condition.
Ghost	Immune to Normal- and Fighting-type moves. Also immune to moves and Abilities that make it impossible to escape from battle or switch out of battle.
Dark	Immune to all Psychic-type moves.
Steel	Immune to all Poison-type moves and takes no damage from the Sandstorm weather condition. Also immune to the Poison and Badly Poisoned conditions.

*Poison-type Pokémon with the Levitate Ability, and Pokémon that are both Poison and Flying type, will not nullify the effect of Toxic Spikes.

**Normally, status moves are not affected by types. The exception to this rule is Thunder Wave. It has no effect on Ground-type Pokémon.

Individual strengths

Have you ever wondered if your Poochyena is the fastest in the world or not? Do you think you can randomly catch a wild Poochyena and expect it to be the fastest? Of course not! If you want to catch a Poochyena that will become the fastest in the world after proper training, you need to know about your Pokémon's individual strengths.

What are individual strengths?

You learned about species strengths on page 321, but even within the same species, you'll find that Pokémon differ in how quickly their stats grow. This difference is due to the individual strengths possessed by each Pokémon. Individual strengths affect stat growth—but just like species strengths, you can't do anything to change them. Catching or obtaining a Pokémon with your desired individual strengths is the only way to get the best of the best!

> **TIP**
> Every Pokémon has individual strengths, whether it is caught, hatched from an Egg, or received from someone.

How to tell if a wild Pokémon has good individual strengths

Fire up your DexNav app and try using Detector Mode (p. 35). Sneak up on a wild Pokémon, and you'll notice that Detector Mode sometimes shows "Potential" with some stars below it. If you see one, two, or three stars, it means that the wild Pokémon has the highest possible individual strengths for one, two, or three stats. If a Pokémon has just one star, it's quite easy to tell which stat it excels at. The clue is in the Pokémon's Characteristic (p. 441), shown in the table on the right.

Characteristic	Individual strength
Takes plenty of siestas	Excellent HP growth
Likes to thrash about	Excellent Attack growth
Capable of taking hits	Excellent Defense growth
Mischievous	Excellent Sp. Atk growth
Somewhat vain	Excellent Sp. Def growth
Alert to sounds	Excellent Speed growth

I've caught a wild Pokémon with two or three stars under Potential! Which of its individual strengths are the highest?

A Pokémon's Characteristic only reveals one individual strength, so you can't use it to determine the rest. Instead, you'll need to encounter a man who calls himself the Judge. This character appears in the Battle Resort, and he can tell you how high all of your Pokémon's individual strengths are. If he says, "Stats like those... They simply can't be beat!" then you'll know that the Pokémon's individual strength for that stat is as high as is possible.

Pokémon come with different Natures

Another individual factor that affects each Pokémon is its Nature. Pokémon Natures affect how quickly your Pokémon's stats grow, just like species strengths and individual strengths. Knowing what Nature is best for the stats you want to focus on will help you catch the Pokémon with the right Nature to join your team.

There are 25 different Natures, as you can see in the table on page 441. Some Natures do nothing, such as Docile and Quirky, but most affect Pokémon stat growth. Typically, a Nature will make one stat grow faster and one stat grow slower. Adamant, for example, helps Attack go up but makes it difficult for Sp. Atk to go up. Below are some of the more useful Natures.

Adamant: Good for physical move users.

Modest: Good for special move users.

Jolly: Good for physical move users that need to be fast.

Timid: Good for special move users that need to be fast.

Can't remember all of the Natures and how they affect stats?

That's OK! It's a lot to remember, so just check the Summary of a Pokémon. Look at each of the six stat names (Attack, etc.) very closely. Do you see that sometimes one stat is faintly colored pink and another is a very light blue? The stat that is tinged pink is the one that is positively affected by your Pokémon's Nature, whereas the light-blue stat is affected negatively. Now check the Pokémon's Nature and you'll have learned how that particular Nature affects stats! Note that no Natures affect how HP grows.

Catching Pokémon with the right Nature

The Synchronize Ability is a great way to catch Pokémon with desired Natures. A lead Pokémon that has the Synchronize Ability gives you a 50/50 chance of encountering wild Pokémon with the same Nature. Ralts, found on Route 102, is a good candidate for this method. Catch Ralts and then check its Ability and Nature. Once you get a Ralts with the desired Nature and the Synchronize Ability, have it lead your team, and you should be catching Pokémon with that same Nature in no time!

What do Characteristics do?

A Pokémon's Characteristic tells you which stat is inherently high. Unlike Nature, a Pokémon's Characteristic doesn't affect stat growth. Instead, it only tells you which stat has a "good head start," so to speak. Like Natures, there are 25 Characteristics to be aware of—and just like Natures, there's no need to memorize them. Take a look at the five Characteristics that indicate the Pokémon's HP is inherently high as an example.

> ### TIP
>
> Catching wild Pokémon isn't the only way to affect individual strengths, Natures, and Characteristics—they can also be passed down through breeding. Turn to page 349 to begin learning about the intricacies of finding Pokémon Eggs—and how to find Eggs that will hatch into your ideal Pokémon!

- Loves to eat
- Takes plenty of siestas
- Nods off a lot
- Scatters things often
- Likes to relax

Did you notice that most of these Characteristics have to do with either eating or sleeping? That's how you achieve a lot of HP! Some of the other Characteristics are harder to guess, but take a look at them on page 441 and try to come up with patterns that make sense to you.

If you find the right Pokémon that has the ideal Nature and Characteristic (such as Adamant + Likes to thrash about), your search is over—unless you want the absolute best of the best! For that, you'll have to learn about training your Pokémon correctly, which is covered on the next few pages.

Training your Pokémon right

Base stats

You've learned that your Pokémon's stats are affected by its species' strengths, its individual strengths, its Characteristic, and its Nature. Catching the right Pokémon, or perhaps finding the right Eggs, is the only way for you to influence these stat-impacting elements. But what about the one thing that you can actively do to change your Pokémon's stats? It's time to look at base stats!

What are base stats?

A base stat is a number that underlies your Pokémon's final stats, seen on its Summary page. Base stats factor into the final stats, affecting how high those stats turn out to be. For example, your Mudkip's base Attack stat affects how high its final Attack stat ends up being—just as species strengths and individual strengths do.

Say that you and your opponent have each caught a Zigzagoon with the highest possible individual strengths for Attack, along with the best Natures. The two should be an even match, right? Wrong! A Zigzagoon with a base Attack stat of 0 will have a lower Attack than one with a base Attack stat of 100. This is why training your Pokémon's base stats is so important. It can give you the edge you need in tough battles.

Base stats can be trained in two ways

Of all the things that can affect your Pokémon's stats, their base stats are the only ones that can be quickly and easily changed at any time. There are two main ways to increase base stats: through battle, or with the Super Training feature in your PlayNav app.

Training base stats through battle

Each time you defeat another Pokémon in battle, the Pokémon you send out will earn a set number of points for a certain base stat. Which base stat will be increased depends on the species of the opposing Pokémon (see page 442 for this info as a table). Your Pokémon will earn zero to three points from each Pokémon, although this number can be increased with the strategies you're about to learn. The tricky part to raising base stats through battle is finding the right Pokémon to battle—ones that will increase the stats you're trying to train. Of course, one clear benefit to battling is that your Pokémon will also earn Exp. Points at the same time.

TIP

Link Battles with other players will not increase your Pokémon's base stats, nor will battles in the Battle Institute (available after entering the Hall of Fame) or the Battle Maison (available after the Delta Episode).

TIP

Try Horde Encounters and use moves that deal damage to multiple Pokémon at once for quick base stat gain!

Use items when training through battle

If you're raising your Pokémon's base stats by battling other Pokémon, be aware that there are special items that your Pokémon can hold to help speed the process along. These items have no effect in Super Training. They matter only when training your Pokémon through battle. Please note that these items halve the holder's Speed.

Macho Brace	Doubles all base stat gains earned through battle.
Power Weight	Adds an extra 4 points to the holder's base HP stat for each Pokémon defeated.
Power Bracer	Adds an extra 4 points to the holder's base Attack stat for each Pokémon defeated.
Power Belt	Adds an extra 4 points to the holder's base Defense stat for each Pokémon defeated.
Power Lens	Adds an extra 4 points to the holder's base Sp. Atk stat for each Pokémon defeated.
Power Band	Adds an extra 4 points to the holder's base Sp. Def stat for each Pokémon defeated.
Power Anklet	Adds an extra 4 points to the holder's base Speed stat for each Pokémon defeated.

Exp. Share

If you have your Exp. Share (p. 15) turned on, all of the Pokémon who earn Exp. Points from it will also earn base-stat gains. This lets you quickly help multiple Pokémon increase their base stats at once—but make sure you have the right Pokémon in your party. Otherwise, you may increase stats that you don't want increased for some party members, meaning that you'll have to find a way to decrease them again.

Pokérus Does a Body Good

Oh... It looks like your Pokémon may be infected with the Pokérus.

Pokérus is a curious, microscopic life-form that Pokémon sometimes catch from the wild. It doesn't harm your Pokémon, but it does make all of its base stats grow more quickly. If your Pokémon manages to catch it, you'll want to spread it around your team for a great boost. The virus can spread to any Pokémon that are positioned next to the infected Pokémon on your team. If you do end up with it in your team, the clerk at the Pokémon Center will make note of it when you drop your Pokémon off for some care.

Pokémon recover from the Pokérus virus in a few days, meaning that it can no longer infect other Pokémon— but the base-stat-boosting effects will stay with that Pokémon forever. An infected Pokémon will not recover while it is resting in your PC Box. It's therefore wise to keep an infected Pokémon in your PC Box and to take it out occasionally to spread the virus to future team members.

Training base stats with Super Training

The Super Training feature of your PlayNav lets you focus on and train only the stats that you want to increase. Using special training regimens and training bags, you can increase a Pokémon's base stat by up to 12 points for each regimen you complete or training bag you work on. Each Super Training regimen may take you a minute or two to complete, although you may blast through them in seconds as your Pokémon become better trained. Learn more about Super Training on page 409. You don't gain any Exp. Points through Super Training, and you have to train your Pokémon one by one, but it does offer speed, control, and convenience.

TIP

You can also have your Secret Pals help you train your Pokémon's base stats, if they have the Coach skill. See page 390 for more information.

Use special training bags when training through S.T.

In Super Training, regular training bags can be used to increase your Pokémon's base stats directly (p. 325), but you can also use special bags to gain a boost during future Super Training regimens.

Double-Up Bag	Doubles base-stat gains from the next regimen you take part in.
Strength Bag	Makes your shots deal more damage, so you can defeat targets more quickly.
Swiftness Bag	Makes your shots travel faster, so you can hit elusive targets.
Toughen-Up Bag	Reduces the damage you take from shots, so you can make it through tough regimens against hard-hitting opponents.

Reducing base stats

If you find that your Pokémon already has some points in base stats you're not interested in—and that these points are preventing you from maxing out other stats that you want to increase—you can reduce base stats in the ways below.

Reset Bag: This unusual bag can be found while using Super Training. If you let your Pokémon use it, all of its base stats will be reset to zero.

Pomeg Berry: Lowers the base HP stat slightly.

Kelpsy Berry: Lowers the base Attack stat slightly.

Qualot Berry: Lowers the base Defense stat slightly.

Hondew Berry: Lowers the base Sp. Atk stat slightly.

Grepa Berry: Lowers the base Sp. Def stat slightly.

Tamato Berry: Lowers the base Speed stat slightly.

TIP

You can get these Berries from the Berry Master on Route 123 or from the young girl in Sootopolis who gives out Berries. Plant them and gather good harvests to have plenty on hand.

Maxing out base stats

Through training, you can opt to max out a couple of your Pokémon's base stats by pumping them full of points. This results in a very strong Pokémon in your desired areas. On the other hand, you can choose to spread smaller base-point boosts across more stats, training up a well-rounded Pokémon in the process. You can see how your Pokémon's base stats are growing by looking at the Effort-o-Meter shown for each Pokémon in Super Training (p. 409).

Examples of different strategies when maxing out base stats

Making up for weaknesses: Max Swampert's base HP stat and boost its Defense and Sp. Def stats. It gains massive Attack when it Mega Evolves, plus its Swift Swim Ability doubles its Speed in rain. Give it some more HP and defensive buffs to withstand hits, and it'll be a tank in battle.

Improving existing strengths: Boost Sceptile's Sp. Atk and Speed base stats. It gets a huge Sp. Atk and Speed boost after it Mega Evolves. Further enhance its strengths to deal quick, nasty damage rather than relying on defense. Although the Speed boost from Mega Evolution won't affect its move on the turn it Mega Evolves, the extra boost to its base Speed stat may still help it move first.

Adding new strengths: Max out Blaziken's base HP and Sp. Atk stats. Blaziken learns mostly physical moves and has a huge Attack stat when it Mega Evolves, but teach it some special moves and take your opponents by surprise with a solid Sp. Atk stat, too. The extra HP will help it stay in battle longer.

Benefits of affection in battle

Having affectionate Pokémon makes battles more fun. Affectionate Pokémon show different sides of themselves and act differently during battle—their gestures are so cute! But that's not all: affectionate Pokémon can have numerous benefits in battle, too. If you want all of the possible advantages you can get in battle, show your Pokémon some love in Pokémon-Amie (p. 412).

What happens when your Pokémon's affection level is...

Heart ×2

- The Pokémon moves a little when it enters a battle, showing it's eager to battle.
- The Pokémon earns 1.2 times more Exp. Points from battles.
- The message you see when the Pokémon is waiting for an instruction may change.

Heart ×3

All of the above and...

- The Pokémon hops a little when it enters a battle, showing it's bursting with enthusiasm.
- The message when the Pokémon enters a battle or returns from a battle may change, showing closeness to you.

Heart ×4

All of the above and...

- The Pokémon turns its face to you at certain times.
- The Pokémon may cure itself of a status condition at the end of a turn.
- The message when the Pokémon is sleeping changes.
- You can pet the Pokémon when it makes the opposing Pokémon faint.
- The Pokémon may spontaneously dodge an opponent's attack.

Heart ×5

All of the above and...

- The Pokémon will land more critical hits, which deal approximately 50 percent more damage.

TIP
In addition, if a Pokémon's affection level is Heart ×3 or more, it may be able to withstand a move that would normally have made it faint, holding onto just 1 HP out of its desire to do well for you. The more affectionate the Pokémon gets, the more often this can happen. However, the chances of dodging moves or curing status conditions do not increase with the number of hearts.

TRAINER'S EYE AND REMATCHES

The Trainer's Eye feature on your AreaNav will allow you to rebattle Trainers around the Hoenn region. This is a great way to get valuable experience, since your Pokémon earn more Exp. Points in Trainer battles than in battles against wild Pokémon. It also provides you with some nice savings to spend around town!

The Trainers registered in your Trainer's Eye really love to battle and will be up for battle again and again during your adventure. After you defeat one, you'll probably find them looking for another rematch after you run around a bit on your adventure. You aren't the only one working hard on your journey, though; as you gain more Badges, you'll find that these Trainers' teams are also leveling up! When they reach their highest level, there is also a chance that they will give you items for beating them.

On the following pages you will find a list of all the Trainers that can be registered in your Trainers' Eye, along with their teams (and how they will change based on your progress), what possible rewards they give out, and an approximate key to whether they pay out big bucks in prize money.

Example

1 Ace Trainer **Brooke** 2
ROUTE 111 (NORTH) 3 4

5 **INITIAL PARTY**
Wingull Lv. 20 | Numel Lv. 20 | Roselia Lv. 20

4 GYM BADGES
Pelipper Lv. 26 | Numel Lv. 26 | Roselia Lv. 26

6 GYM BADGES
Pelipper Lv. 33 | Camerupt Lv. 33 | Roselia Lv. 33

8 GYM BADGES
Pelipper Lv. 44 | Camerupt Lv. 44 | Roserade Lv. 44

HALL OF FAME
Purugly Lv. 50 | Pelipper Lv. 51 | Camerupt Lv. 51 | Roserade Lv. 51 | Lapras Lv. 52

6 POSSIBLE REWARD: PP Up (10%)

1 Trainer's image

2 Trainer's type and name

3 Location of the Trainer

4 Prize money level (the more dots, the greater the payout)

5 Trainer's team based on progress

6 Possible reward after the Hall of Fame with likelihood

Youngster Calvin
ROUTE 102 ◆

INITIAL PARTY	Zigzagoon Lv. 4		
1 GYM BADGE	Zigzagoon Lv. 12		
3 GYM BADGES	Taillow Lv. 13	Zigzagoon Lv. 15	
5 GYM BADGES	Swellow Lv. 25	Linoone Lv. 27	
HALL OF FAME	Swellow Lv. 47	Linoone Lv. 47	Lickilicky Lv. 47

POSSIBLE REWARD: Ultra Ball (20%)

Poké Fan Miguel
ROUTE 103 ◆◆

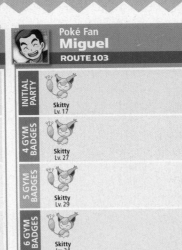

INITIAL PARTY	Skitty Lv. 17
4 GYM BADGES	Skitty Lv. 27
5 GYM BADGES	Skitty Lv. 29
6 GYM BADGES	Skitty Lv. 34
HALL OF FAME	Delcatty Lv. 51

POSSIBLE REWARD: Heal Ball (20%)

Twins Amy & Liv
ROUTE 103 ◆

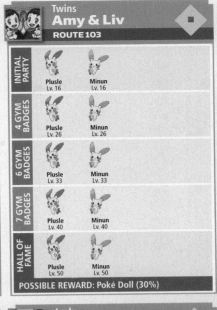

INITIAL PARTY	Plusle Lv. 16	Minun Lv. 16
4 GYM BADGES	Plusle Lv. 26	Minun Lv. 26
6 GYM BADGES	Plusle Lv. 33	Minun Lv. 33
7 GYM BADGES	Plusle Lv. 40	Minun Lv. 40
HALL OF FAME	Plusle Lv. 50	Minun Lv. 50

POSSIBLE REWARD: Poké Doll (30%)

Rich Boy Winston
ROUTE 104 (SOUTH) ◆◆◆

INITIAL PARTY	Zigzagoon Lv. 8	
1 GYM BADGE	Zigzagoon Lv. 13	
3 GYM BADGES	Zigzagoon Lv. 17	
5 GYM BADGES	Linoone Lv. 29	
HALL OF FAME	Linoone Lv. 49	Pyroar Lv. 49

POSSIBLE REWARD: Luxury Ball (20%)

Bug Catcher James
PETALBURG WOODS ◆

INITIAL PARTY	Nincada Lv. 8			
1 GYM BADGE	Surskit Lv. 10	Nincada Lv. 10		
2 GYM BADGES	Surskit Lv. 12	Nincada Lv. 12		
4 GYM BADGES	Surskit Lv. 24	Nincada Lv. 24		
HALL OF FAME	Masquerain Lv. 46	Ariados Lv. 46	Ninjask Lv. 46	Ledian Lv. 46

POSSIBLE REWARD: Net Ball (20%)

Lady Cindy
ROUTE 104 (NORTH) ◆◆◆

INITIAL PARTY	Zigzagoon Lv. 10	
1 GYM BADGE	Zigzagoon Lv. 13	
3 GYM BADGES	Zigzagoon Lv. 17	
5 GYM BADGES	Linoone Lv. 29	
HALL OF FAME	Linoone Lv. 49	Pyroar Lv. 49

POSSIBLE REWARD: Luxury Ball (20%)

Lass Haley
ROUTE 104 (NORTH) ◆

INITIAL PARTY	Lotad Lv. 6	Shroomish Lv. 8
1 GYM BADGE	Lotad Lv. 9	Shroomish Lv. 11
3 GYM BADGES	Lombre Lv. 14	Shroomish Lv. 15
4 GYM BADGES	Lombre Lv. 23	Breloom Lv. 25
HALL OF FAME	Whimsicott Lv. 47	Breloom Lv. 47 / Ludicolo Lv. 47

POSSIBLE REWARD: Ultra Ball (20%)

Backpacker Graeme
ROUTE 106 ◆

INITIAL PARTY	Slakoth Lv. 13
3 GYM BADGES	Slakoth Lv. 17
4 GYM BADGES	Vigoroth Lv. 27
6 GYM BADGES	Vigoroth Lv. 34
HALL OF FAME	Slaking Lv. 51

POSSIBLE REWARD: Max Repel (20%)

Fisherman Elliot
ROUTE 106 ◆◆

INITIAL PARTY	Magikarp Lv. 10	Tentacool Lv. 12		
2 GYM BADGES	Magikarp Lv. 12	Tentacool Lv. 14		
5 GYM BADGES	Tentacool Lv. 26	Gyarados Lv. 28		
7 GYM BADGES	Tentacruel Lv. 37	Whiscash Lv. 38	Gyarados Lv. 39	
HALL OF FAME	Tentacruel Lv. 46	Octillery Lv. 47	Whiscash Lv. 47	Gyarados Lv. 48

POSSIBLE REWARD: Water Stone (5%)

Swimmer ♂ Tony — ROUTE 107

INITIAL PARTY	Tentacool Lv. 27
6 GYM BADGES	Tentacruel Lv. 34
7 GYM BADGES	Tentacruel Lv. 41
8 GYM BADGES	Tentacruel Lv. 45
HALL OF FAME	Tentacruel Lv. 49 / Jellicent Lv. 49

POSSIBLE REWARD: Pearl (20%)

Ace Trainer Neville — ROUTE 108 (WATER SURFACE)

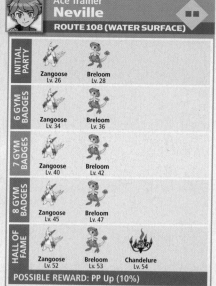

INITIAL PARTY	Zangoose Lv. 26	Breloom Lv. 28	
6 GYM BADGES	Zangoose Lv. 34	Breloom Lv. 36	
7 GYM BADGES	Zangoose Lv. 40	Breloom Lv. 42	
8 GYM BADGES	Zangoose Lv. 45	Breloom Lv. 47	
HALL OF FAME	Zangoose Lv. 52	Breloom Lv. 53	Chandelure Lv. 54

POSSIBLE REWARD: PP Up (10%)

Mysterious Sisters Scall & Ion — SEA MAUVILLE (ROOM 1)

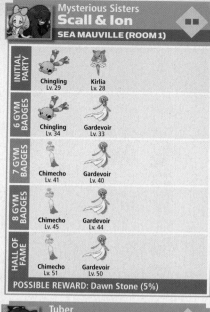

INITIAL PARTY	Chingling Lv. 29	Kirlia Lv. 28
6 GYM BADGES	Chingling Lv. 34	Gardevoir Lv. 33
7 GYM BADGES	Chimecho Lv. 41	Gardevoir Lv. 40
8 GYM BADGES	Chimecho Lv. 45	Gardevoir Lv. 44
HALL OF FAME	Chimecho Lv. 51	Gardevoir Lv. 50

POSSIBLE REWARD: Dawn Stone (5%)

Young Couple Lois & Hal — SEA MAUVILLE (ROOM 4)

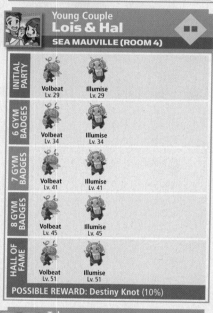

INITIAL PARTY	Volbeat Lv. 29	Illumise Lv. 29
6 GYM BADGES	Volbeat Lv. 34	Illumise Lv. 34
7 GYM BADGES	Volbeat Lv. 41	Illumise Lv. 41
8 GYM BADGES	Volbeat Lv. 45	Illumise Lv. 45
HALL OF FAME	Volbeat Lv. 51	Illumise Lv. 51

POSSIBLE REWARD: Destiny Knot (10%)

Ace Trainer Portia — ROUTE 109 (WATER SURFACE)

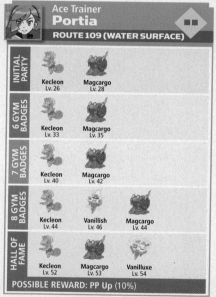

INITIAL PARTY	Kecleon Lv. 26	Magcargo Lv. 28	
6 GYM BADGES	Kecleon Lv. 33	Magcargo Lv. 35	
7 GYM BADGES	Kecleon Lv. 40	Magcargo Lv. 42	
8 GYM BADGES	Kecleon Lv. 44	Vanillish Lv. 46	Magcargo Lv. 44
HALL OF FAME	Kecleon Lv. 53	Magcargo Lv. 53	Vanilluxe Lv. 54

POSSIBLE REWARD: PP Up (10%)

Tuber Lola — ROUTE 109 (BEACH)

INITIAL PARTY	Azurill Lv. 14
4 GYM BADGES	Marill Lv. 26
6 GYM BADGES	Marill Lv. 33
7 GYM BADGES	Marill Lv. 40
HALL OF FAME	Azumarill Lv. 50

POSSIBLE REWARD: Stardust (20%)

Tuber Ricky — ROUTE 109 (BEACH)

INITIAL PARTY	Zigzagoon Lv. 14
4 GYM BADGES	Linoone Lv. 26
6 GYM BADGES	Linoone Lv. 33
7 GYM BADGES	Linoone Lv. 40
HALL OF FAME	Linoone Lv. 50

POSSIBLE REWARD: Stardust (20%)

Collector Edwin — ROUTE 110 (FOOTPATH)

INITIAL PARTY	Lombre Lv. 15	Nuzleaf Lv. 15
4 GYM BADGES	Lombre Lv. 25	Nuzleaf Lv. 25
7 GYM BADGES	Ludicolo Lv. 39	Shiftry Lv. 39
8 GYM BADGES	Ludicolo Lv. 43	Shiftry Lv. 43
HALL OF FAME	Ludicolo Lv. 49	Shiftry Lv. 49

POSSIBLE REWARD: Repeat Ball (20%)

Poké Fan Isabel — ROUTE 110 (FOOTPATH)

INITIAL PARTY	Plusle Lv. 15	Minun Lv. 15
4 GYM BADGES	Plusle Lv. 25	Minun Lv. 25
5 GYM BADGES	Plusle Lv. 27	Minun Lv. 27
6 GYM BADGES	Plusle Lv. 32	Minun Lv. 32
HALL OF FAME	Plusle Lv. 49	Minun Lv. 49

POSSIBLE REWARD: Heal Ball (20%)

Triathlete Benjamin ◆◆
ROUTE 110 (CYCLING ROAD)

INITIAL PARTY	Voltorb Lv. 17	
4 GYM BADGES	Voltorb Lv. 27	
6 GYM BADGES	Electrode Lv. 34	
8 GYM BADGES	Electrode Lv. 42	Klang Lv. 42
HALL OF FAME	Electrode Lv. 49	Klinklang Lv. 49

POSSIBLE REWARD: Iron (15%)

Ace Trainer Brooke ◆◆
ROUTE 111 (NORTH)

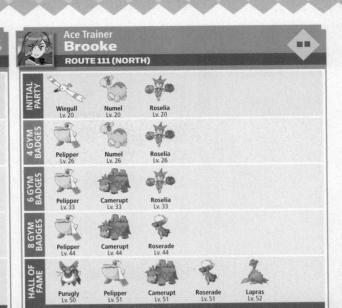

INITIAL PARTY	Wingull Lv. 20	Numel Lv. 20	Roselia Lv. 20		
4 GYM BADGES	Pelipper Lv. 26	Numel Lv. 26	Roselia Lv. 26		
6 GYM BADGES	Pelipper Lv. 33	Camerupt Lv. 33	Roselia Lv. 33		
8 GYM BADGES	Pelipper Lv. 44	Camerupt Lv. 44	Roserade Lv. 44		
HALL OF FAME	Purugly Lv. 50	Pelipper Lv. 51	Camerupt Lv. 51	Roserade Lv. 51	Lapras Lv. 52

POSSIBLE REWARD: PP Up (10%)

Ace Trainer Wilton ◆◆
ROUTE 111 (NORTH)

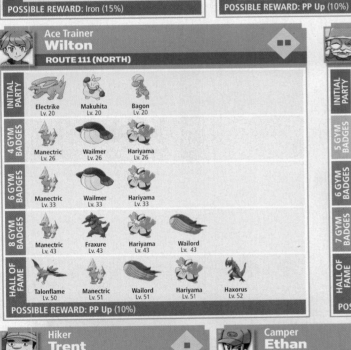

INITIAL PARTY	Electrike Lv. 20	Makuhita Lv. 20	Bagon Lv. 20		
4 GYM BADGES	Manectric Lv. 26	Wailmer Lv. 26	Hariyama Lv. 26		
6 GYM BADGES	Manectric Lv. 33	Wailmer Lv. 33	Hariyama Lv. 33		
8 GYM BADGES	Manectric Lv. 43	Fraxure Lv. 43	Hariyama Lv. 43	Wailord Lv. 43	
HALL OF FAME	Talonflame Lv. 50	Manectric Lv. 51	Wailord Lv. 51	Hariyama Lv. 51	Haxorus Lv. 52

POSSIBLE REWARD: PP Up (10%)

Ruin Maniac Dusty ◆◆
ROUTE 111 (CENTRAL DESERT)

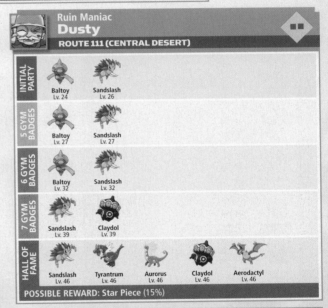

INITIAL PARTY	Baltoy Lv. 24	Sandslash Lv. 26			
5 GYM BADGES	Baltoy Lv. 27	Sandslash Lv. 27			
6 GYM BADGES	Baltoy Lv. 32	Sandslash Lv. 32			
7 GYM BADGES	Sandslash Lv. 39	Claydol Lv. 39			
HALL OF FAME	Sandslash Lv. 46	Tyrantrum Lv. 46	Aurorus Lv. 46	Claydol Lv. 46	Aerodactyl Lv. 46

POSSIBLE REWARD: Star Piece (15%)

Hiker Trent ◆
ROUTE 112 (SOUTH)

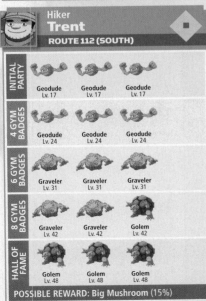

INITIAL PARTY	Geodude Lv. 17	Geodude Lv. 17	Geodude Lv. 17
4 GYM BADGES	Geodude Lv. 24	Geodude Lv. 24	Geodude Lv. 24
6 GYM BADGES	Graveler Lv. 31	Graveler Lv. 31	Graveler Lv. 31
8 GYM BADGES	Graveler Lv. 42	Graveler Lv. 42	Golem Lv. 42
HALL OF FAME	Golem Lv. 48	Golem Lv. 48	Golem Lv. 48

POSSIBLE REWARD: Big Mushroom (15%)

Camper Ethan ◆
JAGGED PASS

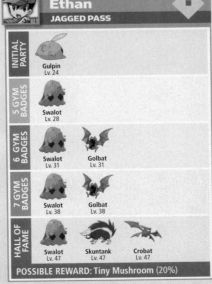

INITIAL PARTY	Gulpin Lv. 24		
5 GYM BADGES	Swalot Lv. 28		
6 GYM BADGES	Swalot Lv. 31	Golbat Lv. 31	
7 GYM BADGES	Swalot Lv. 38	Golbat Lv. 38	
HALL OF FAME	Swalot Lv. 47	Skuntank Lv. 47	Crobat Lv. 47

POSSIBLE REWARD: Tiny Mushroom (20%)

Expert Shelby ◆◆
JAGGED PASS

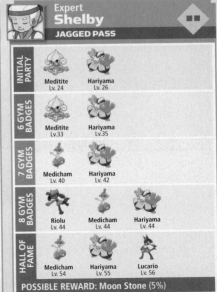

INITIAL PARTY	Meditite Lv. 24	Hariyama Lv. 26	
6 GYM BADGES	Meditite Lv. 33	Hariyama Lv. 35	
7 GYM BADGES	Medicham Lv. 40	Hariyama Lv. 42	
8 GYM BADGES	Riolu Lv. 44	Medicham Lv. 44	Hariyama Lv. 44
HALL OF FAME	Medicham Lv. 54	Hariyama Lv. 55	Lucario Lv. 56

POSSIBLE REWARD: Moon Stone (5%)

TRAINER HANDBOOK
ADVANCED HANDBOOK
ADVENTURE DATA

Picnicker Diana — JAGGED PASS ◆

INITIAL PARTY	Gloom Lv. 22	Swablu Lv. 22
5 GYM BADGES	Gloom Lv. 26	Swablu Lv. 26
6 GYM BADGES	Gloom Lv. 31	Swablu Lv. 31
7 GYM BADGES	Gloom Lv. 38	Altaria Lv. 38
HALL OF FAME	Vileplume Lv. 48	Altaria Lv. 48

POSSIBLE REWARD: Tiny Mushroom (20%)

Ninja Boy Lao — ROUTE 113 ◆

INITIAL PARTY	Koffing Lv. 16	Koffing Lv. 17	Koffing Lv. 18
4 GYM BADGES	Koffing Lv. 22	Koffing Lv. 23	Koffing Lv. 24
6 GYM BADGES	Koffing Lv. 29	Koffing Lv. 30	Koffing Lv. 31
8 GYM BADGES	Weezing Lv. 40	Weezing Lv. 41	Weezing Lv. 42
HALL OF FAME	Weezing Lv. 46	Weezing Lv. 47	Weezing Lv. 48

POSSIBLE REWARD: Revive (20%)

Parasol Lady Madeline — ROUTE 113 ◆◆

INITIAL PARTY	Numel Lv. 22		
4 GYM BADGES	Numel Lv. 27		
6 GYM BADGES	Staryu Lv. 31	Spheal Lv. 31	Numel Lv. 31
8 GYM BADGES	Starmie Lv. 42	Sealeo Lv. 42	Camerupt Lv. 42
HALL OF FAME	Starmie Lv. 48	Walrein Lv. 48	Camerupt Lv. 48

POSSIBLE REWARD: Max Repel (20%)

Kindler Bernie — ROUTE 114 ◆

INITIAL PARTY	Slugma Lv. 20	Wingull Lv. 22
4 GYM BADGES	Slugma Lv. 24	Pelipper Lv. 26
6 GYM BADGES	Slugma Lv. 31	Pelipper Lv. 33
7 GYM BADGES	Magcargo Lv. 38	Pelipper Lv. 40
HALL OF FAME	Magcargo Lv. 48	Pelipper Lv. 50

POSSIBLE REWARD: Fire Stone (5%)

Poké Maniac Steve — ROUTE 114 ◆◆

INITIAL PARTY	Aron Lv. 23			
6 GYM BADGES	Lairon Lv. 32	Rhyhorn Lv. 32		
7 GYM BADGES	Rhyhorn Lv. 39	Lairon Lv. 39		
8 GYM BADGES	Rhydon Lv. 43	Aggron Lv. 43		
HALL OF FAME	Ampharos Lv. 47	Slowbro Lv. 47	Aggron Lv. 47	Rhyperior Lv. 47

POSSIBLE REWARD: Quick Ball (20%)

Dragon Tamer Nicolas — METEOR FALLS (BACK CHAMBER) ◆◆

INITIAL PARTY	Flygon Lv. 47		
HALL OF FAME	Noivern Lv. 50	Druddigon Lv. 50	Flygon Lv. 50

POSSIBLE REWARD: Full Restore (20%)

Old Couple John & Jay — METEOR FALLS (BACK CHAMBER) ◆◆◆

INITIAL PARTY	Medicham Lv. 47	Hariyama Lv. 47
HALL OF FAME	Medicham Lv. 58	Hariyama Lv. 58

POSSIBLE REWARD: PP Max (5%)

Battle Girl Cyndy — ROUTE 115 ◆◆

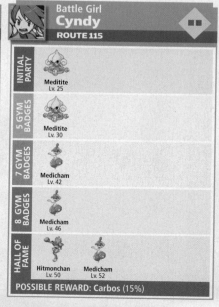

INITIAL PARTY	Meditite Lv. 25	
5 GYM BADGES	Meditite Lv. 30	
7 GYM BADGES	Medicham Lv. 42	
8 GYM BADGES	Medicham Lv. 46	
HALL OF FAME	Hitmonchan Lv. 50	Medicham Lv. 52

POSSIBLE REWARD: Carbos (15%)

Black Belt Nob — ROUTE 115 ◆◆

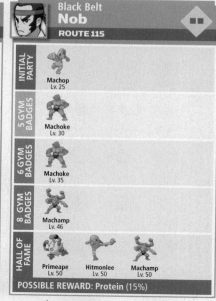

INITIAL PARTY	Machop Lv. 25		
5 GYM BADGES	Machoke Lv. 30		
6 GYM BADGES	Machoke Lv. 35		
8 GYM BADGES	Machamp Lv. 46		
HALL OF FAME	Primeape Lv. 50	Hitmonlee Lv. 50	Machamp Lv. 50

POSSIBLE REWARD: Protein (15%)

Expert Timothy — ROUTE 115

INITIAL PARTY	Hariyama Lv. 26
5 GYM BADGES	Hariyama Lv. 31
7 GYM BADGES	Hariyama Lv. 43
8 GYM BADGES	Gurdurr Lv. 45 / Hariyama Lv. 45
HALL OF FAME	Hawlucha Lv. 54 / Hariyama Lv. 55 / Conkeldurr Lv. 56

POSSIBLE REWARD: Sun Stone (5%)

Schoolkid Jerry — ROUTE 116

INITIAL PARTY	Ralts Lv. 10
2 GYM BADGES	Ralts Lv. 14
4 GYM BADGES	Kirlia Lv. 26
6 GYM BADGES	Kirlia Lv. 32 / Meditite Lv. 30
HALL OF FAME	Gardevoir Lv. 48 / Medicham Lv. 47 / Bisharp Lv. 46

POSSIBLE REWARD: Nest Ball (20%)

Schoolkid Karen — ROUTE 116

INITIAL PARTY	Shroomish Lv. 8 / Whismur Lv. 8
2 GYM BADGES	Shroomish Lv. 12 / Whismur Lv. 12
4 GYM BADGES	Breloom Lv. 24 / Loudred Lv. 24
6 GYM BADGES	Breloom Lv. 31 / Loudred Lv. 31
HALL OF FAME	Breloom Lv. 47 / Dewgong Lv. 47 / Exploud Lv. 47

POSSIBLE REWARD: Nest Ball (20%)

Pokémon Breeder Isaac — ROUTE 117

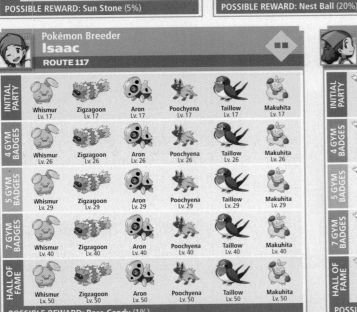

	Whismur	Zigzagoon	Aron	Poochyena	Taillow	Makuhita
INITIAL PARTY	Lv. 17	Lv. 17	Lv. 17	Lv. 17	Lv. 17	Lv. 17
4 GYM BADGES	Lv. 26	Lv. 26	Lv. 26	Lv. 26	Lv. 26	Lv. 26
5 GYM BADGES	Lv. 29	Lv. 29	Lv. 29	Lv. 29	Lv. 29	Lv. 29
7 GYM BADGES	Lv. 40	Lv. 40	Lv. 40	Lv. 40	Lv. 40	Lv. 40
HALL OF FAME	Lv. 50	Lv. 50	Lv. 50	Lv. 50	Lv. 50	Lv. 50

POSSIBLE REWARD: Rare Candy (1%)

Pokémon Breeder Lydia — ROUTE 117

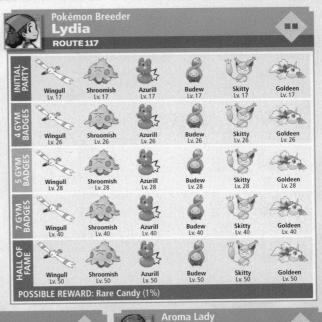

	Wingull	Shroomish	Azurill	Budew	Skitty	Goldeen
INITIAL PARTY	Lv. 17	Lv. 17	Lv. 17	Lv. 17	Lv. 17	Lv. 17
4 GYM BADGES	Lv. 26	Lv. 26	Lv. 26	Lv. 26	Lv. 26	Lv. 26
5 GYM BADGES	Lv. 28	Lv. 28	Lv. 28	Lv. 28	Lv. 28	Lv. 28
7 GYM BADGES	Lv. 40	Lv. 40	Lv. 40	Lv. 40	Lv. 40	Lv. 40
HALL OF FAME	Lv. 50	Lv. 50	Lv. 50	Lv. 50	Lv. 50	Lv. 50

POSSIBLE REWARD: Rare Candy (1%)

Teammates Anna & Meg — ROUTE 117

INITIAL PARTY	Zigzagoon Lv. 17 / Makuhita Lv. 18
4 GYM BADGES	Linoone Lv. 26 / Hariyama Lv. 27
5 GYM BADGES	Linoone Lv. 28 / Hariyama Lv. 29
7 GYM BADGES	Linoone Lv. 40 / Hariyama Lv. 41
HALL OF FAME	Linoone Lv. 50 / Hariyama Lv. 51

POSSIBLE REWARD: Ultra Ball (20%)

Triathlete Dylan — ROUTE 117

INITIAL PARTY	Doduo Lv. 18
4 GYM BADGES	Doduo Lv. 27
6 GYM BADGES	Doduo Lv. 34
8 GYM BADGES	Doduo Lv. 41
HALL OF FAME	Doduo Lv. 48 / Arcanine Lv. 50

POSSIBLE REWARD: HP Up (15%)

Aroma Lady Rose — ROUTE 118

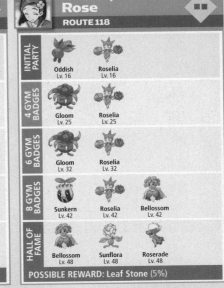

INITIAL PARTY	Oddish Lv. 16 / Roselia Lv. 16
4 GYM BADGES	Gloom Lv. 25 / Roselia Lv. 25
6 GYM BADGES	Gloom Lv. 32 / Roselia Lv. 32
8 GYM BADGES	Sunkern Lv. 42 / Roselia Lv. 42 / Bellossom Lv. 42
HALL OF FAME	Bellossom Lv. 48 / Sunflora Lv. 48 / Roserade Lv. 48

POSSIBLE REWARD: Leaf Stone (5%)

Guitarist Dalton
ROUTE 118

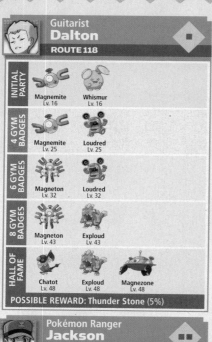

INITIAL PARTY	Magnemite Lv. 16	Whismur Lv. 16
4 GYM BADGES	Magnemite Lv. 25	Loudred Lv. 25
6 GYM BADGES	Magneton Lv. 32	Loudred Lv. 32
8 GYM BADGES	Magneton Lv. 43	Exploud Lv. 43
HALL OF FAME	Chatot Lv. 48	Exploud Lv. 48 / Magnezone Lv. 48

POSSIBLE REWARD: Thunder Stone (5%)

Brains & Brawn — Jael & Kael
ROUTE 119 (SOUTH)

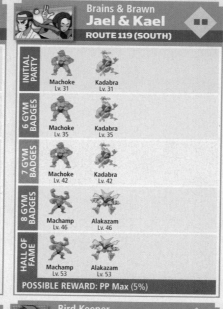

INITIAL PARTY	Machoke Lv. 31	Kadabra Lv. 31
6 GYM BADGES	Machoke Lv. 35	Kadabra Lv. 35
7 GYM BADGES	Machoke Lv. 42	Kadabra Lv. 42
8 GYM BADGES	Machamp Lv. 46	Alakazam Lv. 46
HALL OF FAME	Machamp Lv. 53	Alakazam Lv. 53

POSSIBLE REWARD: PP Max (5%)

Pokémon Ranger Catherine
ROUTE 119 (SOUTH)

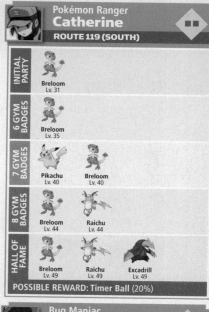

INITIAL PARTY	Breloom Lv. 31	
6 GYM BADGES	Breloom Lv. 35	
7 GYM BADGES	Pikachu Lv. 40	Breloom Lv. 40
8 GYM BADGES	Breloom Lv. 44	Raichu Lv. 44
HALL OF FAME	Breloom Lv. 49	Raichu Lv. 49 / Excadrill Lv. 49

POSSIBLE REWARD: Timer Ball (20%)

Pokémon Ranger Jackson
ROUTE 119 (NORTH)

INITIAL PARTY	Seviper Lv. 29	Vigoroth Lv. 29
6 GYM BADGES	Seviper Lv. 33	Vigoroth Lv. 33
7 GYM BADGES	Seviper Lv. 40	Slaking Lv. 40
8 GYM BADGES	Seviper Lv. 44	Slaking Lv. 44
HALL OF FAME	Seviper Lv. 49	Unfezant Lv. 49 / Slaking Lv. 49

POSSIBLE REWARD: Timer Ball (20%)

Bird Keeper Robert
ROUTE 120 (NORTH)

INITIAL PARTY	Swablu Lv. 34	
7 GYM BADGES	Altaria Lv. 41	
8 GYM BADGES	Fearow Lv. 43	Altaria Lv. 43
HALL OF FAME	Fearow Lv. 47	Altaria Lv. 48 / Staraptor Lv. 49

POSSIBLE REWARD: Full Restore (20%)

Bug Maniac Brandon
ROUTE 120 (NORTH)

INITIAL PARTY	Masquerain Lv. 34		
7 GYM BADGES	Masquerain Lv. 39	Pinsir Lv. 39	
8 GYM BADGES	Masquerain Lv. 43	Pinsir Lv. 43	
HALL OF FAME	Masquerain Lv. 47	Kricketune Lv. 47	Pinsir Lv. 47 / Vespiquen Lv. 47

POSSIBLE REWARD: Net Ball (20%)

Delinquent Sharlene
ROUTE 120 (SOUTH)

INITIAL PARTY	Sharpedo Lv. 34	
7 GYM BADGES	Sharpedo Lv. 41	
8 GYM BADGES	Sharpedo Lv. 43	Sneasel Lv. 43
HALL OF FAME	Sharpedo Lv. 49	Weavile Lv. 49

POSSIBLE REWARD: Dusk Ball (20%)

Street Thug Gomez
ROUTE 120 (SOUTH)

INITIAL PARTY	Cacturne Lv. 34	
7 GYM BADGES	Cacturne Lv. 41	
8 GYM BADGES	Murkrow Lv. 43	Cacturne Lv. 43
HALL OF FAME	Houndoom Lv. 48	Cacturne Lv. 48 / Honchkrow Lv. 48

POSSIBLE REWARD: Dusk Ball (20%)

Beauty Jessica
ROUTE 121

INITIAL PARTY	Kecleon Lv. 32	Seviper Lv. 34
7 GYM BADGES	Kecleon Lv. 38	Seviper Lv. 40
8 GYM BADGES	Kecleon Lv. 42	Seviper Lv. 44
HALL OF FAME	Kecleon Lv. 47	Seviper Lv. 48 / Krookodile Lv. 49

POSSIBLE REWARD: Pearl (20%)

Gentleman Walter
ROUTE 121 ◆◆◆

INITIAL PARTY	Manectric Lv. 35	
7 GYM BADGES	Manectric Lv. 41	
8 GYM BADGES	Manectric Lv. 45	
HALL OF FAME	Manectric Lv. 48	Stoutland Lv. 50

POSSIBLE REWARD: Nugget (15%)

Hex Maniac Valerie
MT. PYRE (1F) ◆

INITIAL PARTY	Sableye Lv. 36		
7 GYM BADGES	Sableye Lv. 41		
8 GYM BADGES	Sableye Lv. 41	Banette Lv. 42	Misdreavus Lv. 43
HALL OF FAME	Sableye Lv. 47	Banette Lv. 48	Mismagius Lv. 49

POSSIBLE REWARD: Dusk Stone (5%)

Fairy Tale Girl Momo
MT. PYRE (2F) ◆

INITIAL PARTY	Jigglypuff Lv. 35	
7 GYM BADGES	Wigglytuff Lv. 40	
8 GYM BADGES	Wigglytuff Lv. 42	Clefairy Lv. 42
HALL OF FAME	Wigglytuff Lv. 48	Clefable Lv. 48

POSSIBLE REWARD: Shiny Stone (5%)

Psychic Cameron
ROUTE 123 ◆◆

INITIAL PARTY	Kadabra Lv. 34	Solrock Lv. 36	
7 GYM BADGES	Solrock Lv. 40	Alakazam Lv. 42	
8 GYM BADGES	Exeggcute Lv. 42	Solrock Lv. 43	Alakazam Lv. 44
HALL OF FAME	Solrock Lv. 49	Exeggutor Lv. 50	Alakazam Lv. 51

POSSIBLE REWARD: Calcium (15 %)

Free Diver Arzu
ROUTE 124 (SEAFLOOR) ◆

INITIAL PARTY	Clamperl Lv. 39	Clamperl Lv. 39	
8 GYM BADGES	Huntail Lv. 43	Gorebyss Lv. 43	
HALL OF FAME	Huntail Lv. 48	Gorebyss Lv. 48	Cloyster Lv. 48

POSSIBLE REWARD: Heart Scale (10%)

Scuba Diver Kylan
ROUTE 124 (SEAFLOOR) ◆◆

INITIAL PARTY	Seadra Lv. 41	
8 GYM BADGES	Seadra Lv. 45	
HALL OF FAME	Kingler Lv. 49	Kingdra Lv. 49

POSSIBLE REWARD: Heart Scale (10%)

Sis & Bro Rita & Sam
ROUTE 124 ◆

INITIAL PARTY	Pelipper Lv. 39	Whiscash Lv. 38
7 GYM BADGES	Pelipper Lv. 41	Whiscash Lv. 39
8 GYM BADGES	Pelipper Lv. 45	Whiscash Lv. 44
HALL OF FAME	Pelipper Lv. 51	Whiscash Lv. 50

POSSIBLE REWARD: Big Pearl (15%)

Swimmer ♀ Jenny
ROUTE 124 ◆

INITIAL PARTY	Luvdisc Lv. 39	
8 GYM BADGES	Luvdisc Lv. 45	
HALL OF FAME	Luvdisc Lv. 49	Alomomola Lv. 49

POSSIBLE REWARD: Pearl (20%)

Sailor Ernest
ROUTE 125 ◆◆

INITIAL PARTY	Wailmer Lv. 36	Tentacruel Lv. 36	Machoke Lv. 36
8 GYM BADGES	Tentacruel Lv. 42	Machoke Lv. 42	Wailord Lv. 42
HALL OF FAME	Tentacruel Lv. 48	Wailord Lv. 48	Machamp Lv. 48

POSSIBLE REWARD: Dive Ball (20%)

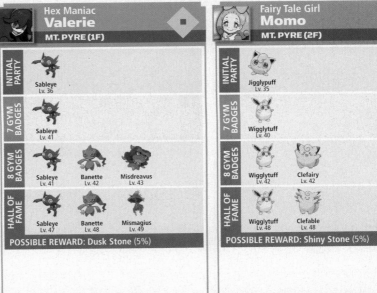
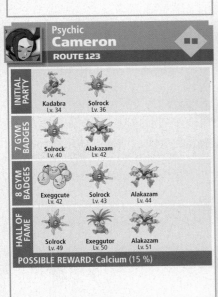
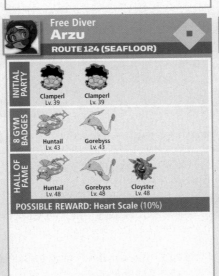
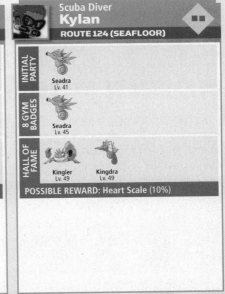
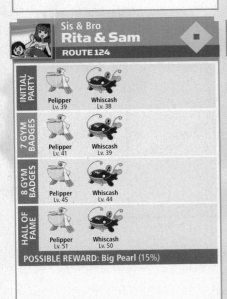
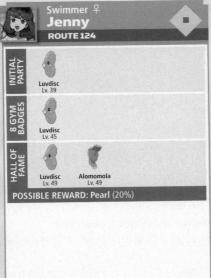
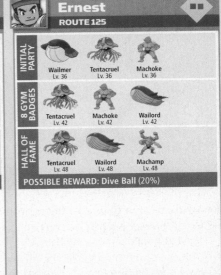

TRAINER HANDBOOK

Triathlete Isaiah
ROUTE 128

INITIAL PARTY	Starmie Lv. 36	
7 GYM BADGES	Starmie Lv. 41	
8 GYM BADGES	Starmie Lv. 45	
HALL OF FAME	Floatzel Lv. 49	Starmie Lv. 49

POSSIBLE REWARD: Zinc (15%)

Ace Duo Jude & Rory
VICTORY ROAD (B1F)

INITIAL PARTY	Armaldo Lv. 47	Cradily Lv. 47
HALL OF FAME	Armaldo Lv. 56	Cradily Lv. 56

POSSIBLE REWARD: PP Max (5%)

Pokémon Trainer Wally
BATTLE RESORT

HALL OF FAME	Altaria Lv. 64	Roserade Lv. 64	Gallade Lv. 66
	Delcatty Lv. 64	Magnezone Lv. 64	

POSSIBLE REWARD: Ability Capsule (1%)

To battle Wally in the Battle Resort, you first need to defeat 50 Trainers in a row at the Battle Maison in a Super Battle Format. Wally will show up at the entrance of the building. After the meeting, leave and re-enter to battle your old friend!

COMPLETING YOUR HOENN POKÉDEX

Complete the Hoenn Pokédex by finding 208 species of Pokémon

To complete the Hoenn region Pokédex, you have to find 208 species of Pokémon. Catching them all is the ideal, but simply seeing them across the battle field will register their basic data in your Pokédex.

Oh? Have you come to show me how your Pokédex is coming along?

Professor Birch will always provide advice on completing your Pokédex, along with words of support. You can speak to him in his lab, or have him evaluate your Pokédex using the PC in any Pokémon Center.

Have Professor Birch rate your Pokédex
1. Visit any Pokémon Center and access the PC.
2. Choose "Professor's PC," and then choose "Hoenn Pokédex."

TIP
You don't need to see Pokémon No. 209–211 (Rayquaza, Jirachi, and Deoxys) to complete the Hoenn Pokédex.

Rewards people give you for completing the Hoenn Pokédex
- Visit Professor Birch's lab, and he'll give you an Oval Charm. Having the Oval Charm increases your chance of finding Eggs at the Pokémon Day Care.
- Visit the Game Director on the second floor in the Cove Lily Motel in Lilycove City after entering the Hall of Fame. He'll give you the Regional Award to decorate your Secret Base.

ADVANCED HANDBOOK

ADVENTURE DATA

Tips for completing your Pokédex

Technique 1: Catch wild Pokémon

A wild Slakoth appeared!

Many Pokémon can be encountered simply by running around through the tall grass, very tall grass, deserts, and caves that fill the Hoenn region. You will also obtain fishing rods during the game that will enable you to fish for certain Pokémon. Once you have a fishing rod, use it to catch Pokémon in ponds, rivers, and even the sea!

Technique 2: Evolve Pokémon

Congratulations! Your Grovyle evolved into Sceptile!

Many Pokémon can be registered in the Hoenn Pokédex just by being evolved. There are many different ways to evolve Pokémon. See page 20 for a review of how to evolve Pokémon.

Technique 3: Link Trade Pokémon

Doing a Link Trade with other players is the only way to evolve some Pokémon, such as Alakazam. Some of them also require a held item to evolve when traded, such as Dusknoir (must be holding a Reaper Cloth). Trading is the only way to get Pokémon that are available only in one version of the game (see the list starting on page 338). For more on how to set up a Link Trade, see page 404.

Technique 4: Smash rocks

Would you like to use Rock Smash?

Once you have obtained HM Rock Smash and the Dynamo Badge, Pokémon who learn the move will be able to smash cracked rocks that you find in the field. These rocks may yield items! At other times, a wild Pokémon may spring out. Some Pokémon, such as Graveler and Boldore, can be found only by smashing cracked rocks to smithereens.

Technique 5: Hatch Pokémon Eggs

Wynaut hatched from the Egg!

Some Pokémon can only be obtained by finding an Egg and hatching it. This includes Pokémon like Azurill, Budew, and Pichu, which will not appear in the wild in the Hoenn region. If you want one for your Pokédex, turn to the section on Pokémon Eggs, beginning on page 349.

Technique 6: Explore the Safari Zone

A wild Pikachu appeared!

Located on Route 121, the Safari Zone contains Pokémon that you can't find anywhere else in the Hoenn region, such as Doduo and Psyduck. It also contains Pokémon that are hard to find, such as Girafarig and Xatu. Turn to page 176 of the walkthrough for more information on the Safari Zone.

Technique 7: Trade Pokémon with people in towns

Would you trade it for my Skitty?

Some people are looking to trade Pokémon around the Hoenn region. These folks are quite generous, for when they trade with you, they give you a Pokémon that's holding an item. Skitty and Corsola are difficult to find in the wild, and the Corsola that you can obtain through a trade in Pacifidlog Town has a Hidden Ability, Regenerator. Be sure to make these trades if you have the right Pokémon to offer in return!

Technique 8: Restore Fossils

I restored the Fossil you gave me, turning it back into a Pokémon!

Fossils, such as the Root Fossil and Claw Fossil that can be found in the desert of Route 111 (p. 138), can be restored to living, breathing Pokémon. Just take them to the Scientist on the second floor of the Devon Corporation building in Rustboro City.

Pokémon and item you receive	Pokémon you must offer	Location of trader
Makuhita with an X Attack	Slakoth	A house to the east of the Rustboro City Gym
Skitty with a Magost Berry	Spinda	A northwestern house in Fortree City
Corsola with a Heart Scale	Bellossom	A southern house in Pacifidlog Town

POKÉMON NATIVE TO THE HOENN REGION

This is the list of 208 Pokémon you have to see to complete the Hoenn Region Pokédex. There are three more Pokémon that can also be registered to the Hoenn region's Pokédex, but these are rare or Mythical Pokémon and you don't need to have them registered for your Pokédex to be considered complete.

Many Pokémon can be caught in the natural areas around the Hoenn region or evolved from the Pokémon you have caught by leveling them up (p. 13). But some Pokémon will have to be received in a trade from another player to obtain them for your Pokédex. Turn to page 404 if you need a refresher on how to perform trades. In addition, sometimes a Pokémon that is first in its evolutionary line cannot be caught in the wild. You will have to obtain these Pokémon by either trading another player for them, or by discovering Pokémon Eggs that will hatch into them. Turn back to page 349 if you need a review of how to find Eggs at the Pokémon Day Care and how to ensure that the Pokémon Egg you hatch is of the species you want!

Turn to page 404
page 349

Example Box

1 Hoenn Pokédex No. 057

Azumarill

2 TYPE
Water | Fairy

3 EGG GROUP
Water 1 | Fairy

4 ABILITIES
Thick Fat
Huge Power

5 HIDDEN ABILITY
Sap Sipper

6 MAIN WAY TO OBTAIN FOR THE HOENN REGION POKÉDEX
Catch on the water on Route 120

1 Hoenn Pokédex Number

2 Type(s)

3 Egg Group(s): This section shows the Egg Group the Pokémon belongs to. This information is important for finding Eggs at a Pokémon Day Care. For more information on Pokémon Eggs, please see page 349.

4 Possible Abilities

5 Hidden Ability: Pokémon sometimes have a rare Ability called a Hidden Ability. If you keep using Detector Mode in the DexNav, it will become more likely that you will encounter Pokémon with a Hidden Ability. See page 35 for more information.

6 Main way to obtain for the Hoenn Region Pokédex: One main way to obtain the Pokémon is listed here, but it is not necessarily the only way to obtain the Pokémon. There may be different ways or different locations in which you can obtain it.

Hoenn Pokédex No. 001
Treecko

TYPE
Grass

EGG GROUPS
Monster | Dragon

ABILITY
Overgrow

HIDDEN ABILITY
Unburden

MAIN WAY TO OBTAIN FOR THE HOENN REGION POKÉDEX
Receive from Professor Birch or receive in a trade from another player

Hoenn Pokédex No. 002
Grovyle
TYPE
Grass

EGG GROUPS
Monster | Dragon

ABILITY
Overgrow

HIDDEN ABILITY
Unburden

MAIN WAY TO OBTAIN FOR THE HOENN REGION POKÉDEX
Level up Treecko to Lv. 16

Hoenn Pokédex No. 003
Sceptile
TYPE
Grass

EGG GROUPS
Monster | Dragon

ABILITY
Overgrow

HIDDEN ABILITY
Unburden

MAIN WAY TO OBTAIN FOR THE HOENN REGION POKÉDEX
Level up Grovyle to Lv. 36

Hoenn Pokédex No. 004
Torchic
TYPE
Fire

EGG GROUP
Field

ABILITY
Blaze

HIDDEN ABILITY
Speed Boost

MAIN WAY TO OBTAIN FOR THE HOENN REGION POKÉDEX
Receive from Professor Birch or receive in a trade from another player

Hoenn Pokédex No. 005
Combusken

TYPE
Fire | Fighting

EGG GROUP
Field

ABILITY
Blaze

HIDDEN ABILITY
Speed Boost

MAIN WAY TO OBTAIN FOR THE HOENN REGION POKÉDEX
Level up Torchic to Lv. 16

Hoenn Pokédex No. 006
Blaziken

TYPE
Fire | Fighting

EGG GROUP
Field

ABILITY
Blaze

HIDDEN ABILITY
Speed Boost

MAIN WAY TO OBTAIN FOR THE HOENN REGION POKÉDEX
Level up Combusken to Lv. 36

Hoenn Pokédex No. 007
Mudkip

TYPE
Water

EGG GROUPS
Monster | Water 1

ABILITY
Torrent

HIDDEN ABILITY
Damp

MAIN WAY TO OBTAIN FOR THE HOENN REGION POKÉDEX
Receive from Professor Birch or receive in a trade from another player

Hoenn Pokédex No. 008
Marshtomp

TYPE
Water | Ground

EGG GROUPS
Monster | Water 1

ABILITY
Torrent

HIDDEN ABILITY
Damp

MAIN WAY TO OBTAIN FOR THE HOENN REGION POKÉDEX
Level up Mudkip to Lv. 16

Hoenn Pokédex No. 009
Swampert

TYPE
Water | Ground

EGG GROUPS
Monster | Water 1

ABILITY
Torrent

HIDDEN ABILITY
Damp

MAIN WAY TO OBTAIN FOR THE HOENN REGION POKÉDEX
Level up Marshtomp to Lv. 36

Hoenn Pokédex No. 010
Poochyena

TYPE
Dark

EGG GROUP
Field

ABILITIES
Run Away
Quick Feet

HIDDEN ABILITY
Rattled

MAIN WAY TO OBTAIN FOR THE HOENN REGION POKÉDEX
Catch in the tall grass on Route 103

Hoenn Pokédex No. 011
Mightyena

TYPE
Dark

EGG GROUP
Field

ABILITIES
Intimidate
Quick Feet

HIDDEN ABILITY
Moxie

MAIN WAY TO OBTAIN FOR THE HOENN REGION POKÉDEX
Level up Poochyena to Lv. 18

Hoenn Pokédex No. 012
Zigzagoon

TYPE
Normal

EGG GROUP
Field

ABILITIES
Pickup
Gluttony

HIDDEN ABILITY
Quick Feet

MAIN WAY TO OBTAIN FOR THE HOENN REGION POKÉDEX
Catch in the tall grass on Route 103

Hoenn Pokédex No. 013
Linoone

TYPE
Normal

EGG GROUP
Field

ABILITIES
Pickup
Gluttony

HIDDEN ABILITY
Quick Feet

MAIN WAY TO OBTAIN FOR THE HOENN REGION POKÉDEX
Catch in the tall grass on Route 118

Hoenn Pokédex No. 014
Wurmple

TYPE
Bug

EGG GROUP
Bug

ABILITY
Shield Dust

HIDDEN ABILITY
Run Away

MAIN WAY TO OBTAIN FOR THE HOENN REGION POKÉDEX
Catch in the tall grass on Route 104

Hoenn Pokédex No. 015
Silcoon

TYPE
Bug

EGG GROUP
Bug

ABILITY
Shed Skin

HIDDEN ABILITY
—

MAIN WAY TO OBTAIN FOR THE HOENN REGION POKÉDEX
Catch in the tall grass on Petalburg Woods

Hoenn Pokédex No. 016
Beautifly

TYPE
Bug | Flying

EGG GROUP
Bug

ABILITY
Swarm

HIDDEN ABILITY
Rivalry

MAIN WAY TO OBTAIN FOR THE HOENN REGION POKÉDEX
Level up Silcoon to Lv. 10

Hoenn Pokédex No. 017
Cascoon

TYPE
Bug

EGG GROUP
Bug

ABILITY
Shed Skin

HIDDEN ABILITY
—

MAIN WAY TO OBTAIN FOR THE HOENN REGION POKÉDEX
Catch in the tall grass on Petalburg Woods

Hoenn Pokédex No. 018
Dustox
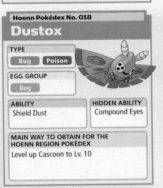

TYPE
Bug | Poison

EGG GROUP
Bug

ABILITY
Shield Dust

HIDDEN ABILITY
Compound Eyes

MAIN WAY TO OBTAIN FOR THE HOENN REGION POKÉDEX
Level up Cascoon to Lv. 10

Hoenn Pokédex No. 019
Lotad
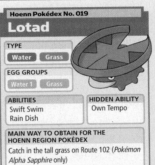

TYPE
Water | Grass

EGG GROUPS
Water 1 | Grass

ABILITIES
Swift Swim
Rain Dish

HIDDEN ABILITY
Own Tempo

MAIN WAY TO OBTAIN FOR THE HOENN REGION POKÉDEX
Catch in the tall grass on Route 102 (*Pokémon Alpha Sapphire* only)

Hoenn Pokédex No. 020
Lombre
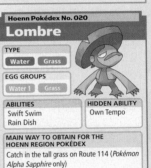

TYPE
Water | Grass

EGG GROUPS
Water 1 | Grass

ABILITIES
Swift Swim
Rain Dish

HIDDEN ABILITY
Own Tempo

MAIN WAY TO OBTAIN FOR THE HOENN REGION POKÉDEX
Catch in the tall grass on Route 114 (*Pokémon Alpha Sapphire* only)

Hoenn Pokédex No. 021
Ludicolo

TYPE
Water | Grass

EGG GROUPS
Water 1 | Grass

ABILITIES
Swift Swim
Rain Dish

HIDDEN ABILITY
Own Tempo

MAIN WAY TO OBTAIN FOR THE HOENN REGION POKÉDEX
Use Water Stone on Lombre

Hoenn Pokédex No. 022
Seedot

TYPE
Grass

EGG GROUPS
Field | Grass

ABILITIES
Chlorophyll
Early Bird

HIDDEN ABILITY
Pickpocket

MAIN WAY TO OBTAIN FOR THE HOENN REGION POKÉDEX
Catch in the tall grass on Route 102 (*Pokémon Omega Ruby* only)

Hoenn Pokédex No. 023
Nuzleaf

TYPE
Grass | Dark

EGG GROUPS
Field | Grass

ABILITIES
Chlorophyll
Early Bird

HIDDEN ABILITY
Pickpocket

MAIN WAY TO OBTAIN FOR THE HOENN REGION POKÉDEX
Catch in the tall grass on Route 114 (*Pokémon Omega Ruby* only)

Hoenn Pokédex No. 024
Shiftry

TYPE
Grass | Dark

EGG GROUPS
Field | Grass

ABILITIES
Chlorophyll
Early Bird

HIDDEN ABILITY
Pickpocket

MAIN WAY TO OBTAIN FOR THE HOENN REGION POKÉDEX
Use Leaf Stone on Nuzleaf

Hoenn Pokédex No. 025
Taillow

TYPE
Normal | Flying

EGG GROUP
Flying

ABILITY
Guts

HIDDEN ABILITY
Scrappy

MAIN WAY TO OBTAIN FOR THE HOENN REGION POKÉDEX
Catch in the tall grass on Route 115

Hoenn Pokédex No. 026
Swellow
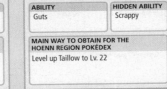

TYPE
Normal | Flying

EGG GROUP
Flying

ABILITY
Guts

HIDDEN ABILITY
Scrappy

MAIN WAY TO OBTAIN FOR THE HOENN REGION POKÉDEX
Level up Taillow to Lv. 22

Hoenn Pokédex No. 027
Wingull
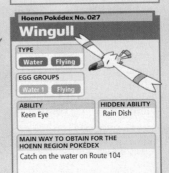

TYPE
Water | Flying

EGG GROUPS
Water 1 | Flying

ABILITY
Keen Eye

HIDDEN ABILITY
Rain Dish

MAIN WAY TO OBTAIN FOR THE HOENN REGION POKÉDEX
Catch on the water on Route 104

Hoenn Pokédex No. 028
Pelipper
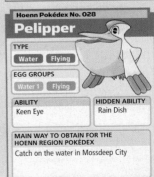

TYPE
Water | Flying

EGG GROUPS
Water 1 | Flying

ABILITY
Keen Eye

HIDDEN ABILITY
Rain Dish

MAIN WAY TO OBTAIN FOR THE HOENN REGION POKÉDEX
Catch on the water in Mossdeep City

Hoenn Pokédex No. 029
Ralts

TYPE
Psychic · Fairy

EGG GROUP
Amorphous

ABILITIES
Synchronize
Trace

HIDDEN ABILITY
Telepathy

MAIN WAY TO OBTAIN FOR THE HOENN REGION POKÉDEX
Catch in the tall grass on Route 102

Hoenn Pokédex No. 030
Kirlia

TYPE
Psychic · Fairy

EGG GROUP
Amorphous

ABILITIES
Synchronize
Trace

HIDDEN ABILITY
Telepathy

MAIN WAY TO OBTAIN FOR THE HOENN REGION POKÉDEX
Level up Ralts to Lv. 20

Hoenn Pokédex No. 031
Gardevoir

TYPE
Psychic · Fairy

EGG GROUP
Amorphous

ABILITIES
Synchronize
Trace

HIDDEN ABILITY
Telepathy

MAIN WAY TO OBTAIN FOR THE HOENN REGION POKÉDEX
Level up Kirlia to Lv. 30

Hoenn Pokédex No. 032
Gallade

TYPE
Psychic · Fighting

EGG GROUP
Amorphous

ABILITY
Steadfast

HIDDEN ABILITY
Justified

MAIN WAY TO OBTAIN FOR THE HOENN REGION POKÉDEX
Use Dawn Stone on a male Kirlia

Hoenn Pokédex No. 033
Surskit

TYPE
Bug · Water

EGG GROUPS
Water 1 · Bug

ABILITY
Swift Swim

HIDDEN ABILITY
Rain Dish

MAIN WAY TO OBTAIN FOR THE HOENN REGION POKÉDEX
Catch on the water on Route 120

Hoenn Pokédex No. 034
Masquerain

TYPE
Bug · Flying

EGG GROUPS
Water 1 · Bug

ABILITY
Intimidate

HIDDEN ABILITY
Unnerve

MAIN WAY TO OBTAIN FOR THE HOENN REGION POKÉDEX
Level up Surskit to Lv. 22

Hoenn Pokédex No. 035
Shroomish

TYPE
Grass

EGG GROUPS
Fairy · Grass

ABILITIES
Effect Spore
Poison Heal

HIDDEN ABILITY
Quick Feet

MAIN WAY TO OBTAIN FOR THE HOENN REGION POKÉDEX
Catch in the tall grass in Petalburg Woods

Hoenn Pokédex No. 036
Breloom

TYPE
Grass · Fighting

EGG GROUPS
Fairy · Grass

ABILITIES
Effect Spore
Poison Heal

HIDDEN ABILITY
Technician

MAIN WAY TO OBTAIN FOR THE HOENN REGION POKÉDEX
Level up Shroomish to Lv. 23

Hoenn Pokédex No. 037
Slakoth

TYPE
Normal

EGG GROUP
Field

ABILITY
Truant

HIDDEN ABILITY
—

MAIN WAY TO OBTAIN FOR THE HOENN REGION POKÉDEX
Catch in the tall grass in Petalburg Woods

Hoenn Pokédex No. 038
Vigoroth

TYPE
Normal

EGG GROUP
Field

ABILITY
Vital Spirit

HIDDEN ABILITY
—

MAIN WAY TO OBTAIN FOR THE HOENN REGION POKÉDEX
Level up Slakoth to Lv. 18

Hoenn Pokédex No. 039
Slaking

TYPE
Normal

EGG GROUP
Field

ABILITY
Truant

HIDDEN ABILITY
—

MAIN WAY TO OBTAIN FOR THE HOENN REGION POKÉDEX
Level up Vigoroth to Lv. 36

Hoenn Pokédex No. 040
Abra

TYPE
Psychic

EGG GROUP
Human-Like

ABILITIES
Synchronize
Inner Focus

HIDDEN ABILITY
Magic Guard

MAIN WAY TO OBTAIN FOR THE HOENN REGION POKÉDEX
Catch in Granite Cave (B1F and below)

Hoenn Pokédex No. 041
Kadabra

TYPE
Psychic

EGG GROUP
Human-Like

ABILITIES
Synchronize
Inner Focus

HIDDEN ABILITY
Magic Guard

MAIN WAY TO OBTAIN FOR THE HOENN REGION POKÉDEX
Level up Abra to Lv. 16

Hoenn Pokédex No. 042
Alakazam

TYPE
Psychic

EGG GROUP
Human-Like

ABILITIES
Synchronize
Inner Focus

HIDDEN ABILITY
Magic Guard

MAIN WAY TO OBTAIN FOR THE HOENN REGION POKÉDEX
Link Trade Kadabra

Hoenn Pokédex No. 043
Nincada

TYPE
Bug · Ground

EGG GROUP
Bug

ABILITY
Compound Eyes

HIDDEN ABILITY
Run Away

MAIN WAY TO OBTAIN FOR THE HOENN REGION POKÉDEX
Catch in the tall grass on Route 116

Hoenn Pokédex No. 044
Ninjask

TYPE
Bug · Flying

EGG GROUP
Bug

ABILITY
Speed Boost

HIDDEN ABILITY
Infiltrator

MAIN WAY TO OBTAIN FOR THE HOENN REGION POKÉDEX
Level up Nincada to Lv. 20

Hoenn Pokédex No. 045
Shedinja

TYPE
Bug · Ghost

EGG GROUP
Mineral

ABILITY
Wonder Guard

HIDDEN ABILITY
—

MAIN WAY TO OBTAIN FOR THE HOENN REGION POKÉDEX
Level up Nincada to Lv. 20 with an extra Poké Ball on hand and an opening in your team

Hoenn Pokédex No. 046
Whismur
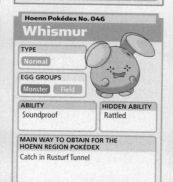

TYPE
Normal

EGG GROUPS
Monster · Field

ABILITY
Soundproof

HIDDEN ABILITY
Rattled

MAIN WAY TO OBTAIN FOR THE HOENN REGION POKÉDEX
Catch in Rusturf Tunnel

Hoenn Pokédex No. 047
Loudred

TYPE
Normal

EGG GROUPS
Monster · Field

ABILITY
Soundproof

HIDDEN ABILITY
Scrappy

MAIN WAY TO OBTAIN FOR THE HOENN REGION POKÉDEX
Catch on Victory Road

Hoenn Pokédex No. 048
Exploud

TYPE
Normal

EGG GROUPS
Monster · Field

ABILITY
Soundproof

HIDDEN ABILITY
Scrappy

MAIN WAY TO OBTAIN FOR THE HOENN REGION POKÉDEX
Level up Loudred to Lv. 40

Hoenn Pokédex No. 049
Makuhita

TYPE
Fighting

EGG GROUP
Human-Like

ABILITIES
Thick Fat
Guts

HIDDEN ABILITY
Sheer Force

MAIN WAY TO OBTAIN FOR THE HOENN REGION POKÉDEX
Catch in Granite Cave (1F)

Hoenn Pokédex No. 050
Hariyama

TYPE
Fighting

EGG GROUP
Human-Like

ABILITIES
Thick Fat
Guts

HIDDEN ABILITY
Sheer Force

MAIN WAY TO OBTAIN FOR THE HOENN REGION POKÉDEX
Catch on Victory Road (Cave)

Hoenn Pokédex No. 051
Goldeen

TYPE
Water

EGG GROUP
Water 2

ABILITIES
Swift Swim
Water Veil

HIDDEN ABILITY
Lightning Rod

MAIN WAY TO OBTAIN FOR THE HOENN REGION POKÉDEX
Catch using an Old Rod on Route 102

Hoenn Pokédex No. 052
Seaking

TYPE
Water

EGG GROUP
Water 2

ABILITIES
Swift Swim
Water Veil

HIDDEN ABILITY
Lightning Rod

MAIN WAY TO OBTAIN FOR THE HOENN REGION POKÉDEX
Catch using a Super Rod on Route 102

Hoenn Pokédex No. 053
Magikarp

TYPE
Water

EGG GROUPS
Water 2 Dragon

ABILITY
Swift Swim

HIDDEN ABILITY
Rattled

MAIN WAY TO OBTAIN FOR THE HOENN REGION POKÉDEX
Catch using an Old Rod on Route 102

Hoenn Pokédex No. 054
Gyarados

TYPE
Water Flying

EGG GROUPS
Water 2 Dragon

ABILITY
Intimidate

HIDDEN ABILITY
Moxie

MAIN WAY TO OBTAIN FOR THE HOENN REGION POKÉDEX
Level up Magikarp to Lv. 20

Hoenn Pokédex No. 055
Azurill
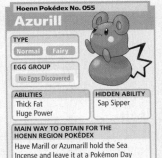

TYPE
Normal Fairy

EGG GROUP
No Eggs Discovered

ABILITIES
Thick Fat
Huge Power

HIDDEN ABILITY
Sap Sipper

MAIN WAY TO OBTAIN FOR THE HOENN REGION POKÉDEX
Have Marill or Azumarill hold the Sea Incense and leave it at a Pokémon Day Care, and then hatch the Egg that is found

Hoenn Pokédex No. 056
Marill
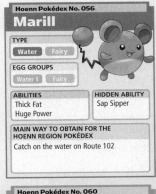

TYPE
Water Fairy

EGG GROUPS
Water 1 Fairy

ABILITIES
Thick Fat
Huge Power

HIDDEN ABILITY
Sap Sipper

MAIN WAY TO OBTAIN FOR THE HOENN REGION POKÉDEX
Catch on the water on Route 102

Hoenn Pokédex No. 057
Azumarill
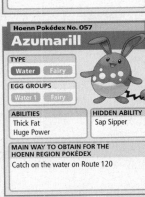

TYPE
Water Fairy

EGG GROUPS
Water 1 Fairy

ABILITIES
Thick Fat
Huge Power

HIDDEN ABILITY
Sap Sipper

MAIN WAY TO OBTAIN FOR THE HOENN REGION POKÉDEX
Catch on the water on Route 120

Hoenn Pokédex No. 058
Geodude
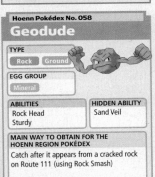

TYPE
Rock Ground

EGG GROUP
Mineral

ABILITIES
Rock Head
Sturdy

HIDDEN ABILITY
Sand Veil

MAIN WAY TO OBTAIN FOR THE HOENN REGION POKÉDEX
Catch after it appears from a cracked rock on Route 111 (using Rock Smash)

Hoenn Pokédex No. 059
Graveler

TYPE
Rock Ground

EGG GROUP
Mineral

ABILITIES
Rock Head
Sturdy

HIDDEN ABILITY
Sand Veil

MAIN WAY TO OBTAIN FOR THE HOENN REGION POKÉDEX
Catch after it appears from a cracked rock in Lilycove City (using Rock Smash)

Hoenn Pokédex No. 060
Golem

TYPE
Rock Ground

EGG GROUP
Mineral

ABILITIES
Rock Head
Sturdy

HIDDEN ABILITY
Sand Veil

MAIN WAY TO OBTAIN FOR THE HOENN REGION POKÉDEX
Link Trade Graveler

Hoenn Pokédex No. 061
Nosepass

TYPE
Rock

EGG GROUP
Mineral

ABILITIES
Sturdy
Magnet Pull

HIDDEN ABILITY
Sand Force

MAIN WAY TO OBTAIN FOR THE HOENN REGION POKÉDEX
Catch after it appears from a cracked rock in Granite Cave (B2F) (using Rock Smash)

Hoenn Pokédex No. 062
Probopass

TYPE
Rock Steel

EGG GROUP
Mineral

ABILITIES
Sturdy
Magnet Pull

HIDDEN ABILITY
Sand Force

MAIN WAY TO OBTAIN FOR THE HOENN REGION POKÉDEX
Level up Nosepass in New Mauville

Hoenn Pokédex No. 063
Skitty

TYPE
Normal

EGG GROUPS
Field Fairy

ABILITIES
Cute Charm
Normalize

HIDDEN ABILITY
Wonder Skin

MAIN WAY TO OBTAIN FOR THE HOENN REGION POKÉDEX
Catch in the tall grass on Route 116

Hoenn Pokédex No. 064
Delcatty

TYPE
Normal

EGG GROUPS
Field Fairy

ABILITIES
Cute Charm
Normalize

HIDDEN ABILITY
Wonder Skin

MAIN WAY TO OBTAIN FOR THE HOENN REGION POKÉDEX
Use Moon Stone on Skitty

Hoenn Pokédex No. 065
Zubat

TYPE
Poison Flying

EGG GROUP
Flying

ABILITY
Inner Focus

HIDDEN ABILITY
Infiltrator

MAIN WAY TO OBTAIN FOR THE HOENN REGION POKÉDEX
Catch in Granite Cave

Hoenn Pokédex No. 066
Golbat

TYPE
Poison Flying

EGG GROUP
Flying

ABILITY
Inner Focus

HIDDEN ABILITY
Infiltrator

MAIN WAY TO OBTAIN FOR THE HOENN REGION POKÉDEX
Catch at Meteor Falls

Hoenn Pokédex No. 067
Crobat

TYPE
Poison Flying

EGG GROUP
Flying

ABILITY
Inner Focus

HIDDEN ABILITY
Infiltrator

MAIN WAY TO OBTAIN FOR THE HOENN REGION POKÉDEX
Level up Golbat with high friendship

Hoenn Pokédex No. 068
Tentacool

TYPE
Water Poison

EGG GROUP
Water 3

ABILITIES
Clear Body
Liquid Ooze

HIDDEN ABILITY
Rain Dish

MAIN WAY TO OBTAIN FOR THE HOENN REGION POKÉDEX
Catch on the water in Lilycove City

Hoenn Pokédex No. 069
Tentacruel

TYPE
Water | Poison

EGG GROUP
Water 3

ABILITIES
Clear Body
Liquid Ooze

HIDDEN ABILITY
Rain Dish

MAIN WAY TO OBTAIN FOR THE HOENN REGION POKÉDEX
Catch on the water in the Seafloor Cavern (Entrance)

Hoenn Pokédex No. 070
Sableye

TYPE
Dark | Ghost

EGG GROUP
Human-Like

ABILITIES
Keen Eye
Stall

HIDDEN ABILITY
Prankster

MAIN WAY TO OBTAIN FOR THE HOENN REGION POKÉDEX
Catch in Granite Cave (B2F) (*Pokémon Alpha Sapphire* only)

Hoenn Pokédex No. 071
Mawile

TYPE
Steel | Fairy

EGG GROUPS
Field | Fairy

ABILITIES
Hyper Cutter
Intimidate

HIDDEN ABILITY
Sheer Force

MAIN WAY TO OBTAIN FOR THE HOENN REGION POKÉDEX
Catch in Granite Cave (B2F) (*Pokémon Omega Ruby* only)

Hoenn Pokédex No. 072
Aron
TYPE
Steel | Rock

EGG GROUP
Monster

ABILITIES
Sturdy
Rock Head

HIDDEN ABILITY
Heavy Metal

MAIN WAY TO OBTAIN FOR THE HOENN REGION POKÉDEX
Catch in Granite Cave (B1F)

Hoenn Pokédex No. 073
Lairon

TYPE
Steel | Rock

EGG GROUP
Monster

ABILITIES
Sturdy
Rock Head

HIDDEN ABILITY
Heavy Metal

MAIN WAY TO OBTAIN FOR THE HOENN REGION POKÉDEX
Catch on Victory Road (Cave)

Hoenn Pokédex No. 074
Aggron

TYPE
Steel | Rock

EGG GROUP
Monster

ABILITIES
Sturdy
Rock Head

HIDDEN ABILITY
Heavy Metal

MAIN WAY TO OBTAIN FOR THE HOENN REGION POKÉDEX
Level up Lairon to Lv. 42

Hoenn Pokédex No. 075
Machop

TYPE
Fighting

EGG GROUP
Human-Like

ABILITIES
Guts
No Guard

HIDDEN ABILITY
Steadfast

MAIN WAY TO OBTAIN FOR THE HOENN REGION POKÉDEX
Catch in the tall grass on Jagged Pass

Hoenn Pokédex No. 076
Machoke

TYPE
Fighting

EGG GROUP
Human-Like

ABILITIES
Guts
No Guard

HIDDEN ABILITY
Steadfast

MAIN WAY TO OBTAIN FOR THE HOENN REGION POKÉDEX
Level up Machop to Lv. 28

Hoenn Pokédex No. 077
Machamp
TYPE
Fighting

EGG GROUP
Human-Like

ABILITIES
Guts
No Guard

HIDDEN ABILITY
Steadfast

MAIN WAY TO OBTAIN FOR THE HOENN REGION POKÉDEX
Link Trade Machoke

Hoenn Pokédex No. 078
Meditite

TYPE
Fighting | Psychic

EGG GROUP
Human-Like

ABILITY
Pure Power

HIDDEN ABILITY
Telepathy

MAIN WAY TO OBTAIN FOR THE HOENN REGION POKÉDEX
Catch in the tall grass on Mt. Pyre (Exterior)

Hoenn Pokédex No. 079
Medicham

TYPE
Fighting | Psychic

EGG GROUP
Human-Like

ABILITY
Pure Power

HIDDEN ABILITY
Telepathy

MAIN WAY TO OBTAIN FOR THE HOENN REGION POKÉDEX
Catch on Victory Road (Cave)

Hoenn Pokédex No. 080
Electrike

TYPE
Electric

EGG GROUP
Field

ABILITIES
Static
Lightning Rod

HIDDEN ABILITY
Minus

MAIN WAY TO OBTAIN FOR THE HOENN REGION POKÉDEX
Catch in the tall grass on Route 118

Hoenn Pokédex No. 081
Manectric

TYPE
Electric

EGG GROUP
Field

ABILITIES
Static
Lightning Rod

HIDDEN ABILITY
Minus

MAIN WAY TO OBTAIN FOR THE HOENN REGION POKÉDEX
Level up Electrike to Lv. 26

Hoenn Pokédex No. 082
Plusle

TYPE
Electric

EGG GROUP
Fairy

ABILITY
Plus

HIDDEN ABILITY
Lightning Rod

MAIN WAY TO OBTAIN FOR THE HOENN REGION POKÉDEX
Catch in a Horde Encounter on Route 110 (very rare in *Pokémon Omega Ruby*)

Hoenn Pokédex No. 083
Minun
TYPE
Electric

EGG GROUP
Fairy

ABILITY
Minus

HIDDEN ABILITY
Volt Absorb

MAIN WAY TO OBTAIN FOR THE HOENN REGION POKÉDEX
Catch in a Horde Encounter on Route 110 (very rare in *Pokémon Alpha Sapphire*)

Hoenn Pokédex No. 084
Magnemite

TYPE
Electric | Steel

EGG GROUP
Mineral

ABILITIES
Magnet Pull
Sturdy

HIDDEN ABILITY
Analytic

MAIN WAY TO OBTAIN FOR THE HOENN REGION POKÉDEX
Catch in a Horde Encounter on Route 110

Hoenn Pokédex No. 085
Magneton

TYPE
Electric | Steel

EGG GROUP
Mineral

ABILITIES
Magnet Pull
Sturdy

HIDDEN ABILITY
Analytic

MAIN WAY TO OBTAIN FOR THE HOENN REGION POKÉDEX
Level up Magnemite to Lv. 30

Hoenn Pokédex No. 086
Magnezone

TYPE
Electric | Steel

EGG GROUP
Mineral

ABILITIES
Magnet Pull
Sturdy

HIDDEN ABILITY
Analytic

MAIN WAY TO OBTAIN FOR THE HOENN REGION POKÉDEX
Level up Magneton in New Mauville

Hoenn Pokédex No. 087
Voltorb

TYPE
Electric

EGG GROUP
Mineral

ABILITIES
Soundproof
Static

HIDDEN ABILITY
Aftermath

MAIN WAY TO OBTAIN FOR THE HOENN REGION POKÉDEX
Catch in New Mauville (1F)

Hoenn Pokédex No. 088
Electrode

TYPE
Electric

EGG GROUP
Mineral

ABILITIES
Soundproof
Static

HIDDEN ABILITY
Aftermath

MAIN WAY TO OBTAIN FOR THE HOENN REGION POKÉDEX
Level up Voltorb to Lv. 30

Hoenn Pokédex No. 089
Volbeat
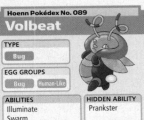

TYPE
Bug

EGG GROUPS
Bug | Human-Like

ABILITIES
Illuminate
Swarm

HIDDEN ABILITY
Prankster

MAIN WAY TO OBTAIN FOR THE HOENN REGION POKÉDEX
Catch in the tall grass on Route 117 (very rare in *Pokémon Omega Ruby*)

Hoenn Pokédex No. 090
Illumise
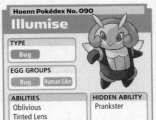

TYPE
Bug

EGG GROUPS
Bug | Human-Like

ABILITIES
Oblivious
Tinted Lens

HIDDEN ABILITY
Prankster

MAIN WAY TO OBTAIN FOR THE HOENN REGION POKÉDEX
Catch in the tall grass on Route 117 (very rare in *Pokémon Alpha Sapphire*)

Hoenn Pokédex No. 091
Oddish
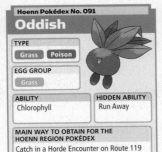

TYPE
Grass | Poison

EGG GROUP
Grass

ABILITY
Chlorophyll

HIDDEN ABILITY
Run Away

MAIN WAY TO OBTAIN FOR THE HOENN REGION POKÉDEX
Catch in a Horde Encounter on Route 119

Hoenn Pokédex No. 092
Gloom
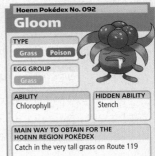

TYPE
Grass | Poison

EGG GROUP
Grass

ABILITY
Chlorophyll

HIDDEN ABILITY
Stench

MAIN WAY TO OBTAIN FOR THE HOENN REGION POKÉDEX
Catch in the very tall grass on Route 119

Hoenn Pokédex No. 093
Vileplume

TYPE
Grass | Poison

EGG GROUP
Grass

ABILITY
Chlorophyll

HIDDEN ABILITY
Effect Spore

MAIN WAY TO OBTAIN FOR THE HOENN REGION POKÉDEX
Use Leaf Stone on Gloom

Hoenn Pokédex No. 094
Bellossom
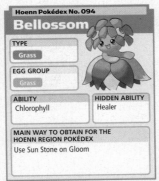

TYPE
Grass

EGG GROUP
Grass

ABILITY
Chlorophyll

HIDDEN ABILITY
Healer

MAIN WAY TO OBTAIN FOR THE HOENN REGION POKÉDEX
Use Sun Stone on Gloom

Hoenn Pokédex No. 095
Doduo

TYPE
Normal | Flying

EGG GROUP
Flying

ABILITIES
Run Away
Early Bird

HIDDEN ABILITY
Tangled Feet

MAIN WAY TO OBTAIN FOR THE HOENN REGION POKÉDEX
Catch in a Horde Encounter in the Safari Zone

Hoenn Pokédex No. 096
Dodrio

TYPE
Normal | Flying

EGG GROUP
Flying

ABILITIES
Run Away
Early Bird

HIDDEN ABILITY
Tangled Feet

MAIN WAY TO OBTAIN FOR THE HOENN REGION POKÉDEX
Level up Doduo to Lv. 31

Hoenn Pokédex No. 097
Budew

TYPE
Grass | Poison

EGG GROUP
No Eggs Discovered

ABILITIES
Natural Cure
Poison Point

HIDDEN ABILITY
Leaf Guard

MAIN WAY TO OBTAIN FOR THE HOENN REGION POKÉDEX
Have Roselia or Roserade hold Rose Incense and leave it at a Pokémon Day Care, and then hatch the Egg that is found

Hoenn Pokédex No. 098
Roselia

TYPE
Grass | Poison

EGG GROUPS
Fairy | Grass

ABILITIES
Natural Cure
Poison Point

HIDDEN ABILITY
Leaf Guard

MAIN WAY TO OBTAIN FOR THE HOENN REGION POKÉDEX
Catch in the tall grass on Route 117

Hoenn Pokédex No. 099
Roserade

TYPE
Grass | Poison

EGG GROUPS
Fairy | Grass

ABILITIES
Natural Cure
Poison Point

HIDDEN ABILITY
Technician

MAIN WAY TO OBTAIN FOR THE HOENN REGION POKÉDEX
Use Shiny Stone on Roselia

Hoenn Pokédex No. 100
Gulpin

TYPE
Poison

EGG GROUP
Amorphous

ABILITIES
Liquid Ooze
Sticky Hold

HIDDEN ABILITY
Gluttony

MAIN WAY TO OBTAIN FOR THE HOENN REGION POKÉDEX
Catch in the tall grass on Route 110

Hoenn Pokédex No. 101
Swalot
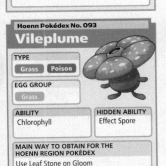

TYPE
Poison

EGG GROUP
Amorphous

ABILITIES
Liquid Ooze
Sticky Hold

HIDDEN ABILITY
Gluttony

MAIN WAY TO OBTAIN FOR THE HOENN REGION POKÉDEX
Level up Gulpin to Lv. 26

Hoenn Pokédex No. 102
Carvanha

TYPE
Water | Dark

EGG GROUP
Water 2

ABILITY
Rough Skin

HIDDEN ABILITY
Speed Boost

MAIN WAY TO OBTAIN FOR THE HOENN REGION POKÉDEX
Catch using a Super Rod on Route 118

Hoenn Pokédex No. 103
Sharpedo

TYPE
Water | Dark

EGG GROUP
Water 2

ABILITY
Rough Skin

HIDDEN ABILITY
Speed Boost

MAIN WAY TO OBTAIN FOR THE HOENN REGION POKÉDEX
Catch using a Super Rod on Route 119

Hoenn Pokédex No. 104
Wailmer

TYPE
Water

EGG GROUPS
Field | Water 2

ABILITIES
Water Veil
Oblivious

HIDDEN ABILITY
Pressure

MAIN WAY TO OBTAIN FOR THE HOENN REGION POKÉDEX
Catch using a Super Rod in Slateport City

Hoenn Pokédex No. 105
Wailord

TYPE
Water

EGG GROUPS
Field | Water 2

ABILITIES
Water Veil
Oblivious

HIDDEN ABILITY
Pressure

MAIN WAY TO OBTAIN FOR THE HOENN REGION POKÉDEX
Level up Wailmer to Lv. 40

Hoenn Pokédex No. 106
Numel

TYPE
Fire | Ground

EGG GROUP
Field

ABILITIES
Oblivious
Simple

HIDDEN ABILITY
Own Tempo

MAIN WAY TO OBTAIN FOR THE HOENN REGION POKÉDEX
Catch in the tall grass on Route 112

Hoenn Pokédex No. 107
Camerupt

TYPE
Fire | Ground

EGG GROUP
Field

ABILITIES
Magma Armor
Solid Rock

HIDDEN ABILITY
Anger Point

MAIN WAY TO OBTAIN FOR THE HOENN REGION POKÉDEX
Level up Numel to Lv. 33

Hoenn Pokédex No. 108
Slugma

TYPE
Fire

EGG GROUP
Amorphous

ABILITIES
Magma Armor
Flame Body

HIDDEN ABILITY
Weak Armor

MAIN WAY TO OBTAIN FOR THE HOENN REGION POKÉDEX
Catch on the Fiery Path

Hoenn Pokédex No. 109
Magcargo

TYPE
Fire | Rock

EGG GROUP
Amorphous

ABILITIES
Magma Armor
Flame Body

HIDDEN ABILITY
Weak Armor

MAIN WAY TO OBTAIN FOR THE HOENN REGION POKÉDEX
Level up Slugma to Lv. 38

Hoenn Pokédex No. 110
Torkoal

TYPE
Fire

EGG GROUP
Field

ABILITY
White Smoke

HIDDEN ABILITY
Shell Armor

MAIN WAY TO OBTAIN FOR THE HOENN REGION POKÉDEX
Catch on the Fiery Path

Hoenn Pokédex No. 111
Grimer

TYPE
Poison

EGG GROUP
Amorphous

ABILITIES
Stench
Sticky Hold

HIDDEN ABILITY
Poison Touch

MAIN WAY TO OBTAIN FOR THE HOENN REGION POKÉDEX
Catch on the Fiery Path (very rare in *Pokémon Omega Ruby*)

Hoenn Pokédex No. 112
Muk

TYPE
Poison

EGG GROUP
Amorphous

ABILITIES
Stench
Sticky Hold

HIDDEN ABILITY
Poison Touch

MAIN WAY TO OBTAIN FOR THE HOENN REGION POKÉDEX
Level up Grimer to Lv. 38

Hoenn Pokédex No. 113
Koffing

TYPE
Poison

EGG GROUP
Amorphous

ABILITY
Levitate

HIDDEN ABILITY
—

MAIN WAY TO OBTAIN FOR THE HOENN REGION POKÉDEX
Catch on the Fiery Path (very rare in *Pokémon Alpha Sapphire*)

Hoenn Pokédex No. 114
Weezing

TYPE
Poison

EGG GROUP
Amorphous

ABILITY
Levitate

HIDDEN ABILITY
—

MAIN WAY TO OBTAIN FOR THE HOENN REGION POKÉDEX
Level up Koffing to Lv. 35

Hoenn Pokédex No. 115
Spoink

TYPE
Psychic

EGG GROUP
Field

ABILITIES
Thick Fat
Own Tempo

HIDDEN ABILITY
Gluttony

MAIN WAY TO OBTAIN FOR THE HOENN REGION POKÉDEX
Catch in the tall grass on Jagged Pass

Hoenn Pokédex No. 116
Grumpig

TYPE
Psychic

EGG GROUP
Field

ABILITIES
Thick Fat
Own Tempo

HIDDEN ABILITY
Gluttony

MAIN WAY TO OBTAIN FOR THE HOENN REGION POKÉDEX
Level up Spoink to Lv. 32

Hoenn Pokédex No. 117
Sandshrew

TYPE
Ground

EGG GROUP
Field

ABILITY
Sand Veil

HIDDEN ABILITY
Sand Rush

MAIN WAY TO OBTAIN FOR THE HOENN REGION POKÉDEX
Catch on Route 111 (Central Desert)

Hoenn Pokédex No. 118
Sandslash

TYPE
Ground

EGG GROUP
Field

ABILITY
Sand Veil

HIDDEN ABILITY
Sand Rush

MAIN WAY TO OBTAIN FOR THE HOENN REGION POKÉDEX
Level up Sandshrew to Lv. 22

Hoenn Pokédex No. 119
Spinda

TYPE
Normal

EGG GROUPS
Field | Human-Like

ABILITIES
Own Tempo
Tangled Feet

HIDDEN ABILITY
Contrary

MAIN WAY TO OBTAIN FOR THE HOENN REGION POKÉDEX
Catch in the tall grass on Route 113

Hoenn Pokédex No. 120
Skarmory

TYPE
Steel | Flying

EGG GROUP
Flying

ABILITIES
Keen Eye
Sturdy

HIDDEN ABILITY
Weak Armor

MAIN WAY TO OBTAIN FOR THE HOENN REGION POKÉDEX
Catch in the tall grass on Route 113

Hoenn Pokédex No. 121
Trapinch

TYPE
Ground

EGG GROUP
Bug

ABILITIES
Hyper Cutter
Arena Trap

HIDDEN ABILITY
Sheer Force

MAIN WAY TO OBTAIN FOR THE HOENN REGION POKÉDEX
Catch on Route 111 (Central Desert)

Hoenn Pokédex No. 122
Vibrava

TYPE
Ground | Dragon

EGG GROUP
Bug

ABILITY
Levitate

HIDDEN ABILITY
—

MAIN WAY TO OBTAIN FOR THE HOENN REGION POKÉDEX
Level up Trapinch to Lv. 35

Hoenn Pokédex No. 123
Flygon

TYPE
Ground | Dragon

EGG GROUP
Bug

ABILITY
Levitate

HIDDEN ABILITY
—

MAIN WAY TO OBTAIN FOR THE HOENN REGION POKÉDEX
Level up Vibrava to Lv. 45

Hoenn Pokédex No. 124
Cacnea

TYPE
Grass

EGG GROUPS
Grass | Human-Like

ABILITY
Sand Veil

HIDDEN ABILITY
Water Absorb

MAIN WAY TO OBTAIN FOR THE HOENN REGION POKÉDEX
Catch on Route 111 (Central Desert)

Hoenn Pokédex No. 125
Cacturne

TYPE
Grass | Dark

EGG GROUPS
Grass | Human-Like

ABILITY
Sand Veil

HIDDEN ABILITY
Water Absorb

MAIN WAY TO OBTAIN FOR THE HOENN REGION POKÉDEX
Level up Cacnea to Lv. 32

Hoenn Pokédex No. 126
Swablu

TYPE
Normal | Flying

EGG GROUPS
Flying | Dragon

ABILITY
Natural Cure

HIDDEN ABILITY
Cloud Nine

MAIN WAY TO OBTAIN FOR THE HOENN REGION POKÉDEX
Catch in the tall grass on Route 114

Hoenn Pokédex No. 127
Altaria

TYPE
Dragon | Flying

EGG GROUPS
Flying | Dragon

ABILITY
Natural Cure

HIDDEN ABILITY
Cloud Nine

MAIN WAY TO OBTAIN FOR THE HOENN REGION POKÉDEX
Level up Swablu to Lv. 35

Hoenn Pokédex No. 128
Zangoose

TYPE
Normal

EGG GROUP
Field

ABILITY
Immunity

HIDDEN ABILITY
Toxic Boost

MAIN WAY TO OBTAIN FOR THE HOENN REGION POKÉDEX
Catch in the tall grass on Route 114 (*Pokémon Omega Ruby* only)

Hoenn Pokédex No. 129
Seviper

TYPE
Poison

EGG GROUPS
Field | Dragon

ABILITY
Shed Skin

HIDDEN ABILITY
Infiltrator

MAIN WAY TO OBTAIN FOR THE HOENN REGION POKÉDEX
Catch in the tall grass on Route 114 (*Pokémon Alpha Sapphire* only)

Hoenn Pokédex No. 130
Lunatone

TYPE
Rock | Psychic

EGG GROUP
Mineral

ABILITY
Levitate

HIDDEN ABILITY
—

MAIN WAY TO OBTAIN FOR THE HOENN REGION POKÉDEX
Catch at Meteor Falls (*Pokémon Alpha Sapphire* only)

Hoenn Pokédex No. 131
Solrock

TYPE
Rock | Psychic

EGG GROUP
Mineral

ABILITY
Levitate

HIDDEN ABILITY
—

MAIN WAY TO OBTAIN FOR THE HOENN REGION POKÉDEX
Catch at Meteor Falls (*Pokémon Omega Ruby* only)

Hoenn Pokédex No. 132
Barboach

TYPE
Water | Ground

EGG GROUP
Water 2

ABILITIES
Oblivious
Anticipation

HIDDEN ABILITY
Hydration

MAIN WAY TO OBTAIN FOR THE HOENN REGION POKÉDEX
Catch using a Super Rod at Meteor Falls

Hoenn Pokédex No. 133
Whiscash

TYPE
Water | Ground

EGG GROUP
Water 2

ABILITIES
Oblivious
Anticipation

HIDDEN ABILITY
Hydration

MAIN WAY TO OBTAIN FOR THE HOENN REGION POKÉDEX
Level up Barboach to Lv. 30

Hoenn Pokédex No. 134
Corphish

TYPE
Water

EGG GROUPS
Water 1 | Water 3

ABILITIES
Hyper Cutter
Shell Armor

HIDDEN ABILITY
Adaptability

MAIN WAY TO OBTAIN FOR THE HOENN REGION POKÉDEX
Catch using a Super Rod on Route 102

Hoenn Pokédex No. 135
Crawdaunt

TYPE
Water | Dark

EGG GROUPS
Water 1 | Water 3

ABILITIES
Hyper Cutter
Shell Armor

HIDDEN ABILITY
Adaptability

MAIN WAY TO OBTAIN FOR THE HOENN REGION POKÉDEX
Level up Corphish to Lv. 30

Hoenn Pokédex No. 136
Baltoy

TYPE
Ground | Psychic

EGG GROUP
Mineral

ABILITY
Levitate

HIDDEN ABILITY
—

MAIN WAY TO OBTAIN FOR THE HOENN REGION POKÉDEX
Catch on Route 111 (Central Desert)

Hoenn Pokédex No. 137
Claydol

TYPE
Ground | Psychic

EGG GROUP
Mineral

ABILITY
Levitate

HIDDEN ABILITY
—

MAIN WAY TO OBTAIN FOR THE HOENN REGION POKÉDEX
Catch at the Sky Pillar

Hoenn Pokédex No. 138
Lileep

TYPE
Rock | Grass

EGG GROUP
Water 3

ABILITY
Suction Cups

HIDDEN ABILITY
Storm Drain

MAIN WAY TO OBTAIN FOR THE HOENN REGION POKÉDEX
Have a Root Fossil restored at the Devon Corporation

Hoenn Pokédex No. 139
Cradily

TYPE
Rock | Grass

EGG GROUP
Water 3

ABILITY
Suction Cups

HIDDEN ABILITY
Storm Drain

MAIN WAY TO OBTAIN FOR THE HOENN REGION POKÉDEX
Level up Lileep to Lv. 40

Hoenn Pokédex No. 140
Anorith

TYPE
Rock | Bug

EGG GROUP
Water 3

ABILITY
Battle Armor

HIDDEN ABILITY
Swift Swim

MAIN WAY TO OBTAIN FOR THE HOENN REGION POKÉDEX
Have a Claw Fossil restored at the Devon Corporation

Hoenn Pokédex No. 141
Armaldo

TYPE
Rock | Bug

EGG GROUP
Water 3

ABILITY
Battle Armor

HIDDEN ABILITY
Swift Swim

MAIN WAY TO OBTAIN FOR THE HOENN REGION POKÉDEX
Level up Anorith to Lv. 40

Hoenn Pokédex No. 142
Igglybuff

TYPE
Normal | Fairy

EGG GROUP
No Eggs Discovered

ABILITIES
Cute Charm
Competitive

HIDDEN ABILITY
Friend Guard

MAIN WAY TO OBTAIN FOR THE HOENN REGION POKÉDEX
Leave Jigglypuff or Wigglytuff at a Pokémon Day Care, and then hatch the Egg that is found

Hoenn Pokédex No. 143
Jigglypuff

TYPE
Normal | Fairy

EGG GROUP
Fairy

ABILITIES
Cute Charm
Competitive

HIDDEN ABILITY
Friend Guard

MAIN WAY TO OBTAIN FOR THE HOENN REGION POKÉDEX
Catch in the tall grass on Route 115

Hoenn Pokédex No. 144
Wigglytuff

TYPE
Normal | Fairy

EGG GROUP
Fairy

ABILITIES
Cute Charm
Competitive

HIDDEN ABILITY
Frisk

MAIN WAY TO OBTAIN FOR THE HOENN REGION POKÉDEX
Use Moon Stone on Jigglypuff

Hoenn Pokédex No. 145
Feebas

TYPE
Water

EGG GROUPS
Water 1 | Dragon

ABILITIES
Swift Swim
Oblivious

HIDDEN ABILITY
Adaptability

MAIN WAY TO OBTAIN FOR THE HOENN REGION POKÉDEX
Catch using an Old Rod in certain places on Route 119

Hoenn Pokédex No. 146
Milotic

TYPE
Water

EGG GROUPS
Water 1 | Dragon

ABILITIES
Marvel Scale
Competitive

HIDDEN ABILITY
Cute Charm

MAIN WAY TO OBTAIN FOR THE HOENN REGION POKÉDEX
Level up Feebas with a high Beauty condition (p. 80)

Hoenn Pokédex No. 147
Castform

TYPE
Normal

EGG GROUPS
Fairy | Amorphous

ABILITY
Forecast

HIDDEN ABILITY
—

MAIN WAY TO OBTAIN FOR THE HOENN REGION POKÉDEX
Receive at the Weather Institute on Route 119

Hoenn Pokédex No. 148
Staryu

TYPE
Water

EGG GROUP
Water 3

ABILITIES
Illuminate
Natural Cure

HIDDEN ABILITY
Analytic

MAIN WAY TO OBTAIN FOR THE HOENN REGION POKÉDEX
Catch using a Super Rod in Lilycove City

Hoenn Pokédex No. 149
Starmie

TYPE
Water Psychic

EGG GROUP
Water 3

ABILITIES
Illuminate
Natural Cure

HIDDEN ABILITY
Analytic

MAIN WAY TO OBTAIN FOR THE HOENN REGION POKÉDEX
Use Water Stone on Staryu

Hoenn Pokédex No. 150
Kecleon

TYPE
Normal

EGG GROUP
Field

ABILITY
Color Change

HIDDEN ABILITY
Protean

MAIN WAY TO OBTAIN FOR THE HOENN REGION POKÉDEX
Catch on the bridge on Route 120

Hoenn Pokédex No. 151
Shuppet

TYPE
Ghost

EGG GROUP
Amorphous

ABILITIES
Insomnia
Frisk

HIDDEN ABILITY
Cursed Body

MAIN WAY TO OBTAIN FOR THE HOENN REGION POKÉDEX
Catch on Mt. Pyre (1F)

Hoenn Pokédex No. 152
Banette

TYPE
Ghost

EGG GROUP
Amorphous

ABILITIES
Insomnia
Frisk

HIDDEN ABILITY
Cursed Body

MAIN WAY TO OBTAIN FOR THE HOENN REGION POKÉDEX
Level up Shuppet to Lv. 37

Hoenn Pokédex No. 153
Duskull

TYPE
Ghost

EGG GROUP
Amorphous

ABILITY
Levitate

HIDDEN ABILITY
Frisk

MAIN WAY TO OBTAIN FOR THE HOENN REGION POKÉDEX
Catch on Mt. Pyre (1F)

Hoenn Pokédex No. 154
Dusclops

TYPE
Ghost

EGG GROUP
Amorphous

ABILITY
Pressure

HIDDEN ABILITY
Frisk

MAIN WAY TO OBTAIN FOR THE HOENN REGION POKÉDEX
Level up Duskull to Lv. 37

Hoenn Pokédex No. 155
Dusknoir

TYPE
Ghost

EGG GROUP
Amorphous

ABILITY
Pressure

HIDDEN ABILITY
Frisk

MAIN WAY TO OBTAIN FOR THE HOENN REGION POKÉDEX
Receive a Dusclops with a Reaper Cloth by Link Trade

Hoenn Pokédex No. 156
Tropius

TYPE
Grass Flying

EGG GROUPS
Monster Grass

ABILITIES
Chlorophyll
Solar Power

HIDDEN ABILITY
Harvest

MAIN WAY TO OBTAIN FOR THE HOENN REGION POKÉDEX
Catch in the very tall grass on Route 119

Hoenn Pokédex No. 157
Chingling

TYPE
Psychic

EGG GROUP
No Eggs Discovered

ABILITY
Levitate

HIDDEN ABILITY
—

MAIN WAY TO OBTAIN FOR THE HOENN REGION POKÉDEX
Have Chimecho hold Pure Incense and leave it at a Pokémon Day Care, and then hatch the Egg that is found

Hoenn Pokédex No. 158
Chimecho

TYPE
Psychic

EGG GROUP
Amorphous

ABILITY
Levitate

HIDDEN ABILITY
—

MAIN WAY TO OBTAIN FOR THE HOENN REGION POKÉDEX
Catch in the tall grass on Mt. Pyre (Summit)

Hoenn Pokédex No. 159
Absol

TYPE
Dark

EGG GROUP
Field

ABILITIES
Pressure
Super Luck

HIDDEN ABILITY
Justified

MAIN WAY TO OBTAIN FOR THE HOENN REGION POKÉDEX
Catch in the tall grass on Route 120

Hoenn Pokédex No. 160
Vulpix

TYPE
Fire

EGG GROUP
Field

ABILITY
Flash Fire

HIDDEN ABILITY
Drought

MAIN WAY TO OBTAIN FOR THE HOENN REGION POKÉDEX
Catch in the tall grass on Mt. Pyre (Exterior)

Hoenn Pokédex No. 161
Ninetales

TYPE
Fire

EGG GROUP
Field

ABILITY
Flash Fire

HIDDEN ABILITY
Drought

MAIN WAY TO OBTAIN FOR THE HOENN REGION POKÉDEX
Use Fire Stone on Vulpix

Hoenn Pokédex No. 162
Pichu

TYPE
Electric

EGG GROUP
No Eggs Discovered

ABILITY
Static

HIDDEN ABILITY
Lightning Rod

MAIN WAY TO OBTAIN FOR THE HOENN REGION POKÉDEX
Leave Pikachu or Raichu at a Pokémon Day Care, and then hatch the Egg that is found

Hoenn Pokédex No. 163
Pikachu

TYPE
Electric

EGG GROUPS
Field Fairy

ABILITY
Static

HIDDEN ABILITY
Lightning Rod

MAIN WAY TO OBTAIN FOR THE HOENN REGION POKÉDEX
Catch in the tall grass in Safari Zone D

Hoenn Pokédex No. 164
Raichu

TYPE
Electric

EGG GROUPS
Field Fairy

ABILITY
Static

HIDDEN ABILITY
Lightning Rod

MAIN WAY TO OBTAIN FOR THE HOENN REGION POKÉDEX
Use Thunderstone on Pikachu

Hoenn Pokédex No. 165
Psyduck

TYPE
Water

EGG GROUPS
Water 1 Field

ABILITIES
Damp
Cloud Nine

HIDDEN ABILITY
Swift Swim

MAIN WAY TO OBTAIN FOR THE HOENN REGION POKÉDEX
Catch on the water in the Safari Zone

Hoenn Pokédex No. 166
Golduck

TYPE
Water

EGG GROUPS
Water 1 Field

ABILITIES
Damp
Cloud Nine

HIDDEN ABILITY
Swift Swim

MAIN WAY TO OBTAIN FOR THE HOENN REGION POKÉDEX
Level up Psyduck to Lv. 33

Hoenn Pokédex No. 167
Wynaut

TYPE
Psychic

EGG GROUP
No Eggs Discovered

ABILITY
Shadow Tag

HIDDEN ABILITY
Telepathy

MAIN WAY TO OBTAIN FOR THE HOENN REGION POKÉDEX
Hatch the Egg given to you by the old lady in Lavaridge Town

Hoenn Pokédex No. 168
Wobbuffet

TYPE
Psychic

EGG GROUP
Amorphous

ABILITY
Shadow Tag

HIDDEN ABILITY
Telepathy

MAIN WAY TO OBTAIN FOR THE HOENN REGION POKÉDEX
Catch in the very tall grass in Safari Zone C

Hoenn Pokédex No. 169
Natu

TYPE
Psychic | Flying

EGG GROUP
Flying

ABILITIES
Synchronize
Early Bird

HIDDEN ABILITY
Magic Bounce

MAIN WAY TO OBTAIN FOR THE HOENN REGION POKÉDEX
Leave Xatu at a Pokémon Day Care, and then hatch the Egg that is found

Hoenn Pokédex No. 170
Xatu

TYPE
Psychic | Flying

EGG GROUP
Flying

ABILITIES
Synchronize
Early Bird

HIDDEN ABILITY
Magic Bounce

MAIN WAY TO OBTAIN FOR THE HOENN REGION POKÉDEX
Catch in the tall grass in Safari Zone C

Hoenn Pokédex No. 171
Girafarig

TYPE
Normal | Psychic

EGG GROUP
Field

ABILITIES
Inner Focus
Early Bird

HIDDEN ABILITY
Sap Sipper

MAIN WAY TO OBTAIN FOR THE HOENN REGION POKÉDEX
Catch in the very tall grass on Safari Zone D

Hoenn Pokédex No. 172
Phanpy

TYPE
Ground

EGG GROUP
Field

ABILITY
Pickup

HIDDEN ABILITY
Sand Veil

MAIN WAY TO OBTAIN FOR THE HOENN REGION POKÉDEX
Leave Donphan at a Pokémon Day Care, and then hatch the Egg that is found

Hoenn Pokédex No. 173
Donphan

TYPE
Ground

EGG GROUP
Field

ABILITY
Sturdy

HIDDEN ABILITY
Sand Veil

MAIN WAY TO OBTAIN FOR THE HOENN REGION POKÉDEX
Catch in the tall grass in Safari Zone B

Hoenn Pokédex No. 174
Pinsir

TYPE
Bug

EGG GROUP
Bug

ABILITIES
Hyper Cutter
Mold Breaker

HIDDEN ABILITY
Moxie

MAIN WAY TO OBTAIN FOR THE HOENN REGION POKÉDEX
Catch in the very tall grass in Safari Zone B

Hoenn Pokédex No. 175
Heracross

TYPE
Bug | Fighting

EGG GROUP
Bug

ABILITIES
Swarm
Guts

HIDDEN ABILITY
Moxie

MAIN WAY TO OBTAIN FOR THE HOENN REGION POKÉDEX
Catch in the very tall grass in Safari Zone A

Hoenn Pokédex No. 176
Rhyhorn

TYPE
Ground | Rock

EGG GROUPS
Monster | Field

ABILITIES
Lightning Rod
Rock Head

HIDDEN ABILITY
Reckless

MAIN WAY TO OBTAIN FOR THE HOENN REGION POKÉDEX
Catch in the tall grass in Safari Zone A

Hoenn Pokédex No. 177
Rhydon

TYPE
Ground | Rock

EGG GROUPS
Monster | Field

ABILITIES
Lightning Rod
Rock Head

HIDDEN ABILITY
Reckless

MAIN WAY TO OBTAIN FOR THE HOENN REGION POKÉDEX
Level up Rhyhorn to Lv. 42

Hoenn Pokédex No. 178
Rhyperior

TYPE
Ground | Rock

EGG GROUPS
Monster | Field

ABILITIES
Lightning Rod
Solid Rock

HIDDEN ABILITY
Reckless

MAIN WAY TO OBTAIN FOR THE HOENN REGION POKÉDEX
Receive Rhydon with a Protector by Link Trade

Hoenn Pokédex No. 179
Snorunt

TYPE
Ice

EGG GROUPS
Fairy | Mineral

ABILITIES
Inner Focus
Ice Body

HIDDEN ABILITY
Moody

MAIN WAY TO OBTAIN FOR THE HOENN REGION POKÉDEX
Catch in Shoal Cave (Ice cavern)

Hoenn Pokédex No. 180
Glalie
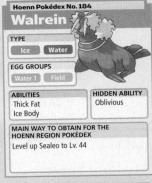

TYPE
Ice

EGG GROUPS
Fairy | Mineral

ABILITIES
Inner Focus
Ice Body

HIDDEN ABILITY
Moody

MAIN WAY TO OBTAIN FOR THE HOENN REGION POKÉDEX
Level up Snorunt to Lv. 42

Hoenn Pokédex No. 181
Froslass

TYPE
Ice | Ghost

EGG GROUPS
Fairy | Mineral

ABILITIES
Snow Cloak

HIDDEN ABILITY
Cursed Body

MAIN WAY TO OBTAIN FOR THE HOENN REGION POKÉDEX
Use Dawn Stone on a female Snorunt

Hoenn Pokédex No. 182
Spheal
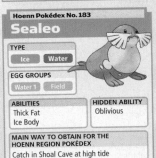

TYPE
Ice | Water

EGG GROUPS
Water 1 | Field

ABILITIES
Thick Fat
Ice Body

HIDDEN ABILITY
Oblivious

MAIN WAY TO OBTAIN FOR THE HOENN REGION POKÉDEX
Catch in a Horde Encounter in Shoal Cave at high tide

Hoenn Pokédex No. 183
Sealeo

TYPE
Ice | Water

EGG GROUPS
Water 1 | Field

ABILITIES
Thick Fat
Ice Body

HIDDEN ABILITY
Oblivious

MAIN WAY TO OBTAIN FOR THE HOENN REGION POKÉDEX
Catch in Shoal Cave at high tide

Hoenn Pokédex No. 184
Walrein

TYPE
Ice | Water

EGG GROUPS
Water 1 | Field

ABILITIES
Thick Fat
Ice Body

HIDDEN ABILITY
Oblivious

MAIN WAY TO OBTAIN FOR THE HOENN REGION POKÉDEX
Level up Sealeo to Lv. 44

Hoenn Pokédex No. 185
Clamperl
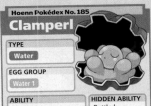

TYPE
Water

EGG GROUP
Water 1

ABILITY
Shell Armor

HIDDEN ABILITY
Rattled

MAIN WAY TO OBTAIN FOR THE HOENN REGION POKÉDEX
Catch in the seaweed on Route 107 underwater

Hoenn Pokédex No. 186
Huntail
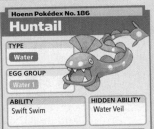

TYPE
Water

EGG GROUP
Water 1

ABILITY
Swift Swim

HIDDEN ABILITY
Water Veil

MAIN WAY TO OBTAIN FOR THE HOENN REGION POKÉDEX
Receive a Clamperl with a Deep Sea Tooth by Link Trade

Hoenn Pokédex No. 187
Gorebyss
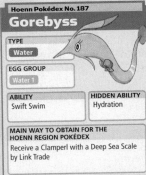

TYPE
Water

EGG GROUP
Water 1

ABILITY
Swift Swim

HIDDEN ABILITY
Hydration

MAIN WAY TO OBTAIN FOR THE HOENN REGION POKÉDEX
Receive a Clamperl with a Deep Sea Scale by Link Trade

Hoenn Pokédex No. 188
Relicanth
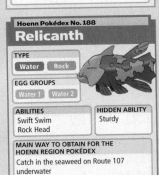

TYPE
Water | Rock

EGG GROUPS
Water 1 | Water 2

ABILITIES
Swift Swim
Rock Head

HIDDEN ABILITY
Sturdy

MAIN WAY TO OBTAIN FOR THE HOENN REGION POKÉDEX
Catch in the seaweed on Route 107 underwater

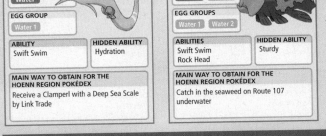

Hoenn Pokédex No. 189
Corsola

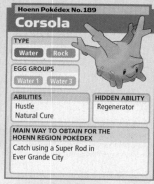

TYPE
Water | Rock

EGG GROUPS
Water 1 | Water 3

ABILITIES
Hustle
Natural Cure

HIDDEN ABILITY
Regenerator

MAIN WAY TO OBTAIN FOR THE HOENN REGION POKÉDEX
Catch using a Super Rod in Ever Grande City

Hoenn Pokédex No. 190
Chinchou

TYPE
Water | Electric

EGG GROUP
Water 2

ABILITIES
Volt Absorb
Illuminate

HIDDEN ABILITY
Water Absorb

MAIN WAY TO OBTAIN FOR THE HOENN REGION POKÉDEX
Catch in the seaweed on Route 107 underwater

Hoenn Pokédex No. 191
Lanturn

TYPE
Water | Electric

EGG GROUP
Water 2

ABILITIES
Volt Absorb
Illuminate

HIDDEN ABILITY
Water Absorb

MAIN WAY TO OBTAIN FOR THE HOENN REGION POKÉDEX
Catch in the seaweed on Route 107 underwater

Hoenn Pokédex No. 192
Luvdisc

TYPE
Water

EGG GROUP
Water 2

ABILITY
Swift Swim

HIDDEN ABILITY
Hydration

MAIN WAY TO OBTAIN FOR THE HOENN REGION POKÉDEX
Catch using a Super Rod in Ever Grande City

Hoenn Pokédex No. 193
Horsea

TYPE
Water

EGG GROUPS
Water 1 | Dragon

ABILITIES
Swift Swim
Sniper

HIDDEN ABILITY
Damp

MAIN WAY TO OBTAIN FOR THE HOENN REGION POKÉDEX
Catch using a Super Rod in the Sealed Chamber

Hoenn Pokédex No. 194
Seadra

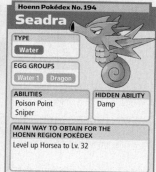

TYPE
Water

EGG GROUPS
Water 1 | Dragon

ABILITIES
Poison Point
Sniper

HIDDEN ABILITY
Damp

MAIN WAY TO OBTAIN FOR THE HOENN REGION POKÉDEX
Level up Horsea to Lv. 32

Hoenn Pokédex No. 195
Kingdra

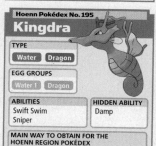

TYPE
Water | Dragon

EGG GROUPS
Water 1 | Dragon

ABILITIES
Swift Swim
Sniper

HIDDEN ABILITY
Damp

MAIN WAY TO OBTAIN FOR THE HOENN REGION POKÉDEX
Receive Seadra with a Dragon Scale by Link Trade

Hoenn Pokédex No. 196
Bagon

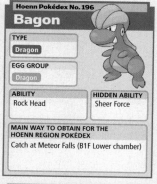

TYPE
Dragon

EGG GROUP
Dragon

ABILITY
Rock Head

HIDDEN ABILITY
Sheer Force

MAIN WAY TO OBTAIN FOR THE HOENN REGION POKÉDEX
Catch at Meteor Falls (B1F Lower chamber)

Hoenn Pokédex No. 197
Shelgon

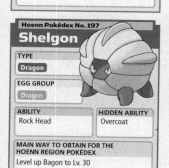

TYPE
Dragon

EGG GROUP
Dragon

ABILITY
Rock Head

HIDDEN ABILITY
Overcoat

MAIN WAY TO OBTAIN FOR THE HOENN REGION POKÉDEX
Level up Bagon to Lv. 30

Hoenn Pokédex No. 198
Salamence

TYPE
Dragon | Flying

EGG GROUP
Dragon

ABILITY
Intimidate

HIDDEN ABILITY
Moxie

MAIN WAY TO OBTAIN FOR THE HOENN REGION POKÉDEX
Level up Shelgon to Lv. 50

Hoenn Pokédex No. 199
Beldum

TYPE
Steel | Psychic

EGG GROUP
Mineral

ABILITY
Clear Body

HIDDEN ABILITY
Light Metal

MAIN WAY TO OBTAIN FOR THE HOENN REGION POKÉDEX
Find in Steven's house after the Delta Episode

Hoenn Pokédex No. 200
Metang

TYPE
Steel | Psychic

EGG GROUP
Mineral

ABILITY
Clear Body

HIDDEN ABILITY
Light Metal

MAIN WAY TO OBTAIN FOR THE HOENN REGION POKÉDEX
Level up Beldum to Lv. 20

Hoenn Pokédex No. 201
Metagross

TYPE
Steel | Psychic

EGG GROUP
Mineral

ABILITY
Clear Body

HIDDEN ABILITY
Light Metal

MAIN WAY TO OBTAIN FOR THE HOENN REGION POKÉDEX
Level up Metang to Lv. 45

Hoenn Pokédex No. 202
Regirock

TYPE
Rock

EGG GROUP
No Eggs Discovered

ABILITY
Clear Body

HIDDEN ABILITY
—

MAIN WAY TO OBTAIN FOR THE HOENN REGION POKÉDEX
Solve the mysteries of the Sealed Chamber, and find in the Desert Ruins on Route 111

Hoenn Pokédex No. 203
Regice

TYPE
Ice

EGG GROUP
No Eggs Discovered

ABILITY
Clear Body

HIDDEN ABILITY
—

MAIN WAY TO OBTAIN FOR THE HOENN REGION POKÉDEX
Solve the mysteries of the Sealed Chamber, and find in the Island Cave on Route 105

Hoenn Pokédex No. 204
Registeel

TYPE
Steel

EGG GROUP
No Eggs Discovered

ABILITY
Clear Body

HIDDEN ABILITY
—

MAIN WAY TO OBTAIN FOR THE HOENN REGION POKÉDEX
Solve the mysteries of the Sealed Chamber, and find in the Ancient Tomb on Route 120

Hoenn Pokédex No. 205
Latias

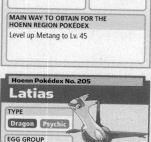

TYPE
Dragon | Psychic

EGG GROUP
No Eggs Discovered

ABILITY
Levitate

HIDDEN ABILITY
—

MAIN WAY TO OBTAIN FOR THE HOENN REGION POKÉDEX
Catch on Southern Island (*Pokémon Alpha Sapphire* only)

Hoenn Pokédex No. 206
Latios

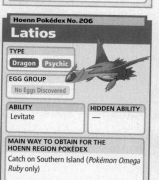

TYPE
Dragon | Psychic

EGG GROUP
No Eggs Discovered

ABILITY
Levitate

HIDDEN ABILITY
—

MAIN WAY TO OBTAIN FOR THE HOENN REGION POKÉDEX
Catch on Southern Island (*Pokémon Omega Ruby* only)

Hoenn Pokédex No. 207
Kyogre

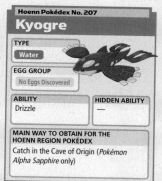

TYPE
Water

EGG GROUP
No Eggs Discovered

ABILITY
Drizzle

HIDDEN ABILITY
—

MAIN WAY TO OBTAIN FOR THE HOENN REGION POKÉDEX
Catch in the Cave of Origin (*Pokémon Alpha Sapphire* only)

Hoenn Pokédex No. 208
Groudon

TYPE
Ground

EGG GROUP
No Eggs Discovered

ABILITY
Drought

HIDDEN ABILITY
—

MAIN WAY TO OBTAIN FOR THE HOENN REGION POKÉDEX
Catch in the Cave of Origin (*Pokémon Omega Ruby* only)

POKÉMON EGGS

₽ 151,600

Leave Pokémon
Cancel

What can we do you for today?

Leave two Pokémon at the Pokémon Day Care on Route 117 (p. 102), and if they get along well, sometimes a Pokémon Egg (also called an Egg) will be discovered. The Day-Care Man outside the Day Care can tell you how your Pokémon are getting along with each other. Once you find an Egg, put it in an empty slot in your party and carry it around with you as you explore Hoenn on your adventure. After a while, the Egg will hatch into a new Pokémon! You can check how close an Egg seems to hatching on its Summary page.

Egg Groups

The easiest way to find Eggs is to leave two Pokémon of the same species but opposite genders at a Pokémon Day Care. However, you can also pair up Pokémon by Egg Group. Eggs can be found from two different species of Pokémon if they have opposite genders and belong to the same Egg Group.

Some Pokémon belong to more than one Egg Group. Consult the Pokémon list on pages 338–348 when you want to find an Egg after dropping off a pair of Pokémon at a Pokémon Day Care. The Egg Groups for each Pokémon are listed in their summaries. This information will be indispensable when you want to pass along Egg Moves!

All about Eggs

By hatching Pokémon from Eggs, you can obtain Pokémon with great potential. Here are the rules for hatching Pokémon.

The female decides the species found

When you drop off two Pokémon at the Pokémon Day Care, any Eggs you find will be from the same evolutionary line as the female Pokémon. The only exception is if you drop off a Pokémon (whether female, male, or gender unknown) with a Ditto. With Ditto, the Egg you discover will always hatch into a species from the other Pokémon's evolutionary line, unless the Pokémon belongs to the No Eggs Discovered Group. You can catch Ditto in one of the Mirage Caves or Mirage Islands (p. 351).

Rule 1: Eggs will normally hatch into a species from the same evolutionary line as the female Pokémon left at the Day Care.

Have Pokémon inherit moves

The two Pokémon you leave at the Pokémon Day Care can pass on a move they have learned to a Pokémon hatched from an Egg. Usually, newly hatched Pokémon only know the moves that the Pokémon would know at Lv. 1. However, if both of the two Pokémon you left at a Pokémon Day Care have learned a move that the hatched Pokémon can eventually learn by leveling up, the hatched Pokémon will know that move at Lv. 1. If the male Pokémon left at the Pokémon Day Care knows a move that the hatched Pokémon could learn from a TM, this can also be passed on at Lv. 1. These are great ways to give Pokémon powerful moves from the start!

Rule 2: If both Pokémon at the Day Care know the same level-up move, the hatched Pokémon will know that level-up move. If the male Pokémon knows a TM move that the hatched Pokémon can learn, the hatched Pokémon may know that level-up move.

Teach your Pokémon special Egg Moves

Pokémon that hatch from Eggs may already know moves they usually can't learn either by leveling up or by using a TM—these are called Egg Moves. For example, Ralts can't learn the move Mean Look by leveling up or by using a TM. But if a male Pokémon left at a Pokémon Day Care knows Mean Look, the Ralts that hatches from the Egg found there might know the move Mean Look. Many Egg Moves are unexpected, letting you take opponents by surprise. The Pokémon move tables on page 420 will help you find Egg Moves that you can pass on.

Rule 3: A move that the male Pokémon knows and which the hatched Pokémon can learn as an Egg Move can be passed on.

Abilities can be inherited, but you can't control which one

Pokémon hatched from an Egg will have an Ability native to the species of the female Pokémon you left at the Day Care. But you won't know which of the two possible Abilities a Pokémon hatched from an Egg will have until it hatches.

For example, Lotad can have either the Swift Swim or Rain Dish Ability. When you leave a female Lombre with the Swift Swim Ability at a Pokémon Day Care, the Egg that hatches could be a Lotad with the Rain Dish Ability, even though the female Pokémon left at the Pokémon Day Care did not have that Ability. This is the basic rule about the Abilities of Pokémon hatched from Eggs.

Rule 4: Either of the two Abilities that are available to the species of the female Pokémon can be passed down to the hatched Pokémon.

TIP

Although it's not guaranteed, it's more likely that the Ability of a Pokémon hatched from an Egg will be the same as the Ability of the female Pokémon left at a Pokémon Day Care.

Hidden Abilities can be inherited

Certain Pokémon have rare Abilities called Hidden Abilities. If you are lucky enough to get one, you can pass on these Hidden Abilities to hatched Pokémon. Leave a female Pokémon with a Hidden Ability at the Pokémon Day Care, and you may find an Egg that hatches into a Pokémon with the same Ability.

For example, Torchic can have the Hidden Ability Speed Boost. If you discover an Egg when you leave a female Torchic with the Speed Boost Ability at a Pokémon Day Care, you may find an Egg of a Torchic with the Blaze Ability, or it may have the same Hidden Ability, Speed Boost.

> **Rule 5:** You can sometimes hatch a Pokémon with a Hidden Ability if the female Pokémon left at a Pokémon Day Care had that Hidden Ability.

Pokémon may inherit Natures

The Pokémon hatched from an Egg may inherit the Nature of the female Pokémon that was left at a Pokémon Day Care—or it may have any of the other 24 possible Natures. However, if you have a Pokémon hold an Everstone, any Eggs that are found while it's at the Pokémon Day Care will have the same Nature as that Pokémon. This can be much easier than trying to find the ideal Nature in the wild.

> **Rule 6:** Pokémon hatched from Eggs can inherit Natures from the female Pokémon you left at the Pokémon Day Care.

Individual strengths can be inherited

An Egg will inherit some of the individual strengths of the Pokémon you leave at the Pokémon Day Care. Normally, the Egg will inherit three individual strengths at random, but using certain items can affect this. Some items, like the Power Anklet, make it certain that the individual strength for the stat it affects (in this case, Speed) will be passed down to any Eggs found. Give such items to your Pokémon before dropping them off.

> **Rule 7:** Pokémon hatched from Eggs inherit at least three individual strengths from the Pokémon you leave at the Pokémon Day Care.

Special pairings can result in two differing Eggs

It's usually a given that only one kind of Pokémon can be hatched from a particular Pokémon Day Care pairing, but certain special conditions can defy this common sense. For example, if you drop off an Illumise with a male Pokémon from either the Human-Like Group or the Bug Group, the Egg you find could be either an Illumise or a Volbeat. This also works if you leave the male Pokémon at the Day Care with a Ditto.

> **Rule 8:** Special pairings can result in two different Eggs.

Summary Table (assuming you didn't use a Ditto)

What Eggs can inherit from female Pokémon	What Eggs can inherit from male Pokémon	What Eggs can inherit from both
Species	Egg moves, TM moves	Individual strengths
Ability	Ability (when using Ditto only)	Level-up moves
Nature	Nature (with Everstone)	

TIP

If you leave a Ditto and a male Pokémon with a Hidden Ability at the Pokémon Day Care, the Egg you find has a chance of having that same Hidden Ability.

Useful Abilities, items, and O-Powers

Use the following Abilities, items, and O-Powers to hatch more powerful Pokémon from Eggs.

The Oval Charm helps you find Eggs

An item called an Oval Charm increases the chance of Pokémon Eggs being found at a Day Care. You receive this item from Professor Birch after you complete the Hoenn Pokédex.

Special Abilities and O-Powers to help hatching Eggs

The O-Power called Hatching Power will aid you by making Pokémon Eggs hatch faster than usual. For Egg enthusiasts, this O-Power is a great boon. And like all other O-Powers, the more you use it, the stronger it becomes. It is not an easy O-Power to obtain, though. You need to obtain every other O-Power first and fulfill certain other conditions as well. If you are up to this challenge, Mr. Bonding will bestow this power upon you. Don't forget that you can also use the O-Powers of those around you. See page 405 for more information.

Having a Pokémon in your party with certain Abilities will also help you hatch an Egg that you are carrying around. Abilities like Flame Body or Magma Armor will keep the Egg warm and make it hatch faster. In the Hoenn region, Slugma and Magcargo can have the Flame Body Ability or the Magma Armor Ability.

Use a Destiny Knot to hatch a Pokémon with great potential

Have a Pokémon hold a Destiny Knot when you leave it at a Pokémon Day Care. It will cause the hatched Pokémon to inherit five individual strengths from its parents, instead of the usual three.

Use an Everstone to have a Pokémon with a desired Nature

You can guarantee that a Pokémon's Nature will be passed on to an Egg by giving the Pokémon an Everstone to hold before you drop it off at the Pokémon Day Care. This is important because Natures affect how a Pokémon's stats grow upon leveling up. Find an Everstone by dowsing in Granite Cave (p. 69)

Use incense to hatch certain Pokémon

In general, the Pokémon hatched from Eggs you find at a Pokémon Day Care will be the first in their Evolutionary line. There are some exceptions, however. For example, dropping off a female Wobbuffet and a male Pokémon from the Amorphous Group will not result in finding a Wynaut Egg, although Wynaut is the pre-Evolution of Wobbuffet. Instead, it will be a Wobbuffet Egg. To get a Wynaut Egg, you'll need to give one of the Pokémon a Lax Incense to hold before you drop it off. Lax Incense can be found on Mt. Pyre (p. 188) and is also sold at the market in Slateport City (p. 73).

Eggs that require incense

Egg discovered	Female Pokémon	Male Pokémon	Necessary item
Azurill	Marill or Azumarill	Fairy Group or Water Group 1	Sea Incense
Wynaut	Wobbuffet	Amorphous Group	Lax Incense
Budew	Roselia or Roserade	Fairy Group or Grass Group	Rose Incense
Chingling	Chimecho	Amorphous Group	Pure Incense

Use an Ability Capsule to switch Abilities

An item called an Ability Capsule lets a Pokémon with two possible Abilities switch which Ability it has. It's not possible to switch to a Hidden Ability, but this item is still a great help in battle and when trying to pass along certain Abilities to hatched Pokémon. Rumor has it that you can get an Ability Capsule in exchange for 200 BP at the Exchange Service Corner in the Battle Maison, where you can go after the Delta Episode.

TIP

A Pichu hatched from an Egg will know the move Volt Tackle if either of the Pokémon you left at the Pokémon Day Care was given a Light Ball to hold.

MIRAGE SPOTS

Using Soar (p. 241), you can visit Mirage spots that appear at random around the Hoenn region. One spot will appear in your game each day, so try to Soar at least a little every day to see what new area you find. Mirage spots feature rare Pokémon that don't appear anywhere else in the region, so visiting them is crucial to completing your National Pokédex.

You can also use StreetPass to greatly increase the number of Mirage spots you can access. When you pass by other *Pokémon Omega Ruby* or *Pokémon Alpha Sapphire* players with StreetPass, you'll gain access to their Mirage spot for the day. Use StreetPass to visit more Mirage spots in a single day and increase your chances of finding rare items and Pokémon!

Mirage spot Fossils

Use Rock Smash on the cracked rocks you find in Mirage spots, and you'll have a random chance of discovering ancient Fossils. Note that Fossils can't be discovered by smashing other cracked rocks around Hoenn—only cracked rocks in Mirage spots have this potential. The kinds of Fossils you can discover depend on which game you're playing. The exception is Old Amber, which can be found in both *Pokémon Omega Ruby* and *Pokémon Alpha Sapphire*. Check the tables below for which Fossils you can find in which game. Once you find a Fossil, take it to the Scientist on the second floor of the Devon Corporation building in Rustboro City, and he'll restore your Fossil into an ancient Pokémon!

Pokémon Omega Ruby

Fossil type	Restores Pokémon
Old Amber	Aerodactyl
Dome Fossil	Kabuto
Armor Fossil	Shieldon
Plume Fossil	Archen

Pokémon Alpha Sapphire

Fossil type	Restores Pokémon
Old Amber	Aerodactyl
Helix Fossil	Omanyte
Skull Fossil	Cranidos
Cover Fossil	Tirtouga

Ω α

Hidden items at Mirage spots

Orlando found a Big Pearl!

One hidden item can be found at each Mirage spot each day. The table beginning on page 354 shows the hidden items that you can discover at each Mirage spot, along with the chances that those items will appear. Get that Dowsing Machine ready!

Note: Blue entries are regular Mirage spots, one of which will appear in each player's game at random each day. Red entries are special Mirage spots where you might encounter Legendary Pokémon. They often have requirements to be fulfilled before they appear, but when they do manifest, they appear as red lights on the map just like normal Mirage spots. The Storm Clouds and Dimensional Rift are both special Mirage spots that appear midair, rather than on the land.

1	Mirage Forest 1
2	Mirage Forest 2
3	Mirage Forest 3
4	Mirage Forest 4
5	Mirage Forest 5
6	Mirage Forest 6
7	Mirage Forest 7
8	Mirage Forest 8
9	Mirage Cave 1
10	Mirage Cave 2
11	Mirage Cave 3
12	Mirage Cave 4
13	Mirage Cave 5
14	Mirage Cave 6
15	Mirage Cave 7
16	Mirage Cave 8
17	Mirage Island 1
18	Mirage Island 2
19	Mirage Island 3
20	Mirage Island 4
21	Mirage Island 5
22	Mirage Island 6
23	Mirage Island 7
24	Mirage Island 8
25	Mirage Mountain 1
26	Mirage Mountain 2
27	Mirage Mountain 3
28	Mirage Mountain 4
29	Mirage Mountain 5
30	Mirage Mountain 6
31	Mirage Mountain 7
32	Mirage Mountain 8
33	Crescent Isle
34	Trackless Forest
35	Pathless Plain
36	Nameless Cavern
37	Fabled Cave
38	Gnarled Den
39	Storm Clouds
40	Dimensional Rift

LIST OF MIRAGE SPOTS

No.	Location name	Outside	Inside	Possible hidden items		Encounter type	Pokémon (Lv. 36–38)		Notes
1	Mirage Forest 1		—	Tiny Mushroom	◯	Tall Grass	Tangela	◯	—
				Big Mushroom	◯		Glameow	◯	
				Razor Claw	◯		Sunkern	◯	
							Minccino	△	
2	Mirage Forest 2		—	Tiny Mushroom	◯	Tall Grass	Tangela	◯	—
				Big Mushroom	◯		Purugly	◯	
				Razor Claw	◯		Sunkern	◯	
							Vulpix	△	
3	Mirage Forest 3		—	Tiny Mushroom	◯	Tall Grass	Tangela	◯	—
				Big Mushroom	◯		Purugly	◯	
				Razor Claw	◯		Sunkern	◯	
							Petilil	△	
4	Mirage Forest 4		—	Tiny Mushroom	◯	Tall Grass	Tangela	◯	—
				Big Mushroom	◯		Purugly	◯	
				Razor Claw	◯		Sunkern	◯	
							Cherrim	△	
5	Mirage Forest 5		—	Tiny Mushroom	◯	Tall Grass	Sunkern	◎	—
				Big Mushroom	◯		Petilil	◯	
				Razor Claw	◯		Audino	△	
6	Mirage Forest 6		—	Tiny Mushroom	◯	Tall Grass	Forretress	◎	Has cracked rocks to be broken apart with Rock Smash.
				Big Mushroom	◯		Happiny	◎	
				Razor Claw	◯				
7	Mirage Forest 7		—	Tiny Mushroom	◯	Tall Grass	Audino	◎	—
				Big Mushroom	◯		Sunkern	△	
				Razor Claw	◯				
8	Mirage Forest 8		—	Tiny Mushroom	◯	Tall Grass	Kricketune	◎	—
				Big Mushroom	◯		Larvesta	◎	
				Razor Claw	◯				
9	Mirage Cave 1			Red Shard	◯	Cave	Klink	◎	Has cracked rocks to be broken apart with Rock Smash.
				Blue Shard	◯		Tynamo	◎	
				Deep Sea Tooth	◯				

◎ frequent ◯ average △ rare ▲ almost never

No.	Location name	Outside	Inside	Possible hidden items		Encounter type	Pokémon (Lv. 36–38)		Notes
10	Mirage Cave 2			Red Shard	○	Cave	Klink	○	Has cracked rocks to be broken apart with Rock Smash.
				Blue Shard	○		Tynamo	○	
				Deep Sea Tooth	○		Excadrill	○	
							Onix	△	
11	Mirage Cave 3			Red Shard	○	Cave	Tynamo	◎	—
				Blue Shard	○		Cofagrigus	○	
				Deep Sea Tooth	○		Slowpoke	△	
12	Mirage Cave 4			Red Shard	○	Cave	Unown	◎	—
				Blue Shard	○				
				Deep Sea Tooth	○				
13	Mirage Cave 5			Red Shard	○	Cave	Klink	◎	Has cracked rocks to be broken apart with Rock Smash.
				Blue Shard	○		Cofagrigus	◎	
				Deep Sea Tooth	○				
14	Mirage Cave 6			Red Shard	○	Cave	Tynamo	○	—
				Blue Shard	○		Excadrill	○	
				Deep Sea Tooth	○		Ditto	◎	
15	Mirage Cave 7			Red Shard	○	Cave	Tynamo	◎	Has cracked rocks to be broken apart with Rock Smash.
				Blue Shard	○		Onix	◎	
				Deep Sea Tooth	○				
16	Mirage Cave 8			Red Shard	○	Cave	Tynamo	◎	—
				Blue Shard	○		Slowpoke	◎	
				Deep Sea Tooth	○				
17	Mirage Island 1		—	Pearl	○	Tall Grass	Venomoth	○	—
				Big Pearl	○		Zebstrika	○	
				Razor Fang	○		Xatu	○	
							Darmanitan	△	
18	Mirage Island 2		—	Pearl	○	Tall Grass	Venomoth	○	Has cracked rocks to be broken apart with Rock Smash.
				Big Pearl	○		Zebstrika	○	
				Razor Fang	○		Xatu	○	
							Maractus	△	

No.	Location name	Outside	Inside	Possible hidden items		Encounter type	Pokémon (Lv. 36–38)		Notes
19	Mirage Island 3		—	Pearl	○	Tall Grass	Venomoth	○	—
				Big Pearl	○		Zebstrika	○	
				Razor Fang	○		Xatu	○	
							Persian	△	
20	Mirage Island 4		—	Pearl	○	Tall Grass	Venomoth	○	—
				Big Pearl	○		Zebstrika	○	
				Razor Fang	○		Xatu	○	
							Tangela	△	
21	Mirage Island 5		—	Pearl	○	Tall Grass	Audino	◎	Has cracked rocks to be broken apart with Rock Smash.
				Big Pearl	○		Xatu	△	
				Razor Fang	○				
22	Mirage Island 6		—	Pearl	○	Tall Grass	Munna	◎	—
				Big Pearl	○		Ditto	◎	
				Razor Fang	○				
23	Mirage Island 7		—	Pearl	○	Tall Grass	Darmanitan	◎	—
				Big Pearl	○		Larvesta	◎	
				Razor Fang	○				
24	Mirage Island 8		—	Pearl	○	Tall Grass	Purugly	◎	—
				Big Pearl	○		Porygon	◎	
				Razor Fang	○				
25	Mirage Mountain 1		—	Yellow Shard	○	Tall Grass	Forretress	○	—
				Green Shard	○		Donphan	○	
				Deep Sea Scale	○		Kricketune	○	
							Stantler	△	
26	Mirage Mountain 2		—	Yellow Shard	○	Tall Grass	Forretress	○	—
				Green Shard	○		Donphan	○	
				Deep Sea Scale	○		Kricketune	○	
							Rufflet	△	
27	Mirage Mountain 3		—	Yellow Shard	○	Tall Grass	Forretress	○	—
				Green Shard	○		Donphan	○	
				Deep Sea Scale	○		Kricketune	○	
							Vullaby	△	
28	Mirage Mountain 4		—	Yellow Shard	○	Tall Grass	Forretress	○	—
				Green Shard	○		Donphan	○	
				Deep Sea Scale	○		Kricketune	○	
							Girafarig	△	
29	Mirage Mountain 5		—	Yellow Shard	○	Tall Grass	Darmanitan	◎	—
				Green Shard	○		Magby	◎	
				Deep Sea Scale	○				

No.	Location name	Outside	Inside	Possible hidden items		Encounter type	Pokémon (Lv. 36–38)		Notes
30	Mirage Mountain 6		—	Yellow Shard	○	Tall Grass	Zebstrika	◎	—
				Green Shard	○		Elekid	◎	
				Deep Sea Scale	○				
31	Mirage Mountain 7		—	Yellow Shard	○	Tall Grass	Xatu	◎	Has cracked rocks to be broken apart with Rock Smash.
				Green Shard	○		Munna	○	
				Deep Sea Scale	○		Porygon	△	
32	Mirage Mountain 8		—	Yellow Shard	○	Tall Grass	Audino	◎	Has cracked rocks to be broken apart with Rock Smash.
				Green Shard	○		Happiny	○	
				Deep Sea Scale	○		Tangela	△	
33	Crescent Isle		—	Heart Scale	○	Special	Cresselia		Appears very infrequently and at random. See page 275 for more information.
				Deep Sea Scale	▲				
				Deep Sea Tooth	▲				
				Razor Claw	▲				
				Razor Fang	▲				
34	Trackless Forest		—	N/A		Special	Raikou		Only appears when certain conditions are fulfilled. See page 275 for more information.
							Entei		
							Suicune		
35	Pathless Plain		—	N/A		Special	Cobalion		Only appears when certain conditions are fulfilled. See page 275 for more information.
							Terrakion		
							Virizion		
36	Nameless Cavern			N/A		Special	Uxie		Only appears when certain conditions are fulfilled. See page 275 for more information.
							Azelf		
							Mesprit		
37	Fabled Cave			N/A		Special	Reshiram (Ω)		Only appears when certain conditions are fulfilled. See page 275 for more information.
							Zekrom (α)		
38	Gnarled Den			N/A		Special	Kyurem		Only appears when certain conditions are fulfilled. See page 275 for more information.
39	Storm Clouds		—	N/A		Special	Thundurus (Ω)		Only appears when certain conditions are fulfilled. See page 275 for more information.
							Tornadus (α)		
							Landorus		
40	Dimensional Rift		—	N/A		Special	Palkia (Ω)		Only appears when certain conditions are fulfilled. See page 275 for more information.
							Dialga (α)		
							Giratina		

BECOME A CONTEST STAR!

You learned the basics of Hoenn's Contest Spectaculars back on pages 79–81. Now that you've mastered the basics, it's time to learn what it really takes to become a contest superstar!

Making great Pokéblocks

Feeding your Pokémon delicious snacks called Pokéblocks greatly increases their contest conditions, helping them wow the crowd during contests. You can make your own Pokéblocks using your Pokéblock Kit and the Berries that you've collected or harvested. You'll need a good stock of Berries to make Pokéblocks, so turn to page 49 if you need a refresher on how to grow more Berries around the region.

After Lisia gives you the Pokéblock Kit in Slateport City (p. 79), look for the Pokéblock Kit in the Key Items section of your Bag. Choose "Make Pokéblocks" to start making some Pokéblocks of your own. All you have to do is decide which Berries to add. Let the blender do the rest! That said, there are a few tricks to know about making great Pokéblocks.

Berry colors matter!

The color of the Berries you put into the blender determines what kind of Pokéblocks come out of it. If you use more than one color of Berry, then the color of Berry you used the most is likely to decide the color of the Pokéblocks made. If you make Pokéblocks out of two different colors of Berries or three different colors of Berries, the first Berry you added is slightly more likely to decide the color of the Pokéblocks. Use Berries of all the same color to guarantee that you'll get a Pokéblock of that color.

Making Pokéblocks+

The more Berries of the same color you use, the more likely you are to make Pokéblocks+, which increase your Pokémon's contest conditions by greater amounts than normal Pokéblocks. Use Berries that are all the same color to maximize your chance of getting these awesome blocks!

TIP

If you have a lot of Berries, or if you want to avoid mistakenly selecting the wrong color, press Ⓨ or tap the magnifying-glass icon in the upper-right corner of the Touch Screen. You can choose to display only one color of Berries or all Berries.

The number of Berries you add to the blender equals the number of Pokéblocks you'll make. For example, adding four Berries to the blender will yield four Pokéblocks. The more Berries you add of the same color, the greater your chance of getting Pokéblocks+. So trying to make two Blue Pokéblocks+ by mixing just two blue Berries is less likely to succeed than trying to make four Blue Pokéblocks+ with four blue Berries.

TIP

Some Berries are more likely to produce Pokéblocks+ than others. See the table on page 458 to choose Berries with higher success rates for making Pokéblocks+. You'll notice that the Berries with the highest success ratios have the smallest yields when grown, so you'll want to be diligent about planting and watering your Berry Trees if you need a lot of low-yield Berries.

Rainbow Pokéblocks

You created 4 Rainbow Pokéblocks!

You can also make Rainbow Pokéblocks by adding four Berries of different colors to the blender. These special Pokéblocks raise all five contest conditions for your Pokémon at one time. You can even make Rainbow Pokéblocks+, but they're even harder to make because you don't get the boost of using four Berries of the same color. The only way to increase your chances of making them is to use Berries with higher success ratios (p. 458).

(p. 458)

> **TIP**
>
> As your Pokémon's contest conditions increase, regular Pokéblocks will provide less improvement to their conditions. However, Pokéblocks+ will always have the same, higher effect. That's another reason to try to make Pokéblocks+!

Pokéblock recipes

Name	Effect	Suggested recipe
Red Pokéblock	Increases Coolness around 1–3%	Use more red Berries.
Blue Pokéblock	Increases Beauty around 1–3%	Use more blue Berries.
Pink Pokéblock	Increases Cuteness around 1–3%	Use more pink Berries.
Green Pokéblock	Increases Cleverness around 1–3%	Use more green Berries.
Yellow Pokéblock	Increases Toughness around 1–3%	Use more yellow Berries.
Red Pokéblock+	Increases Coolness around 6%	Use four red Berries with higher Pokéblock+ success rates.
Blue Pokéblock+	Increases Beauty around 6%	Use four blue Berries with higher Pokéblock+ success rates.
Pink Pokéblock+	Increases Cuteness around 6%	Use four pink Berries with higher Pokéblock+ success rates.
Green Pokéblock+	Increases Cleverness around 6%	Use four green Berries with higher Pokéblock+ success rates.
Yellow Pokéblock+	Increases Toughness around 6%	Use four yellow Berries with higher Pokéblock+ success rates.
Rainbow Pokéblock	Increases all conditions around 1–3%	Use four Berries of different colors.
Rainbow Pokéblock+	Increases all conditions around 6%	Use four Berries of different colors with higher Pokéblock+ success rates.

Feeding Pokéblocks to Pokémon

While using the Pokéblock Kit, choose the Give tab to give Pokéblocks to your Pokémon. Select a Pokéblock, and then choose a Pokémon.

The red highlighted area in the star on the top screen gives you an estimate of how much your Pokémon's condition will be increased by the Pokéblock. You can see this chart anytime by opening the contest tab in the Pokémon's Summary page. (Press ⊗, select a particular Pokémon, and then select Summary. Press right or tap the ribbon button on the Touch Screen to change the Summary page.) As your Pokémon improves in a certain condition, the point of the star related to that condition will fill until it's maxed out and the condition's icon shines brilliantly. You can also get some idea of how well your Pokémon is doing with its conditions by how the audience reacts in the Introduction Round. The higher its relevant condition is for that contest, the greater the crowd's reaction will be. Look for lots of glow sticks to know that you've won them over!

You learned the basics of appealing to the audience on page 80. Now it's time to discover what all those contest moves really do! As you'll discover, moves can have a number of effects in contests.

Appealing and jamming

As summarized on page 80, appealing and jamming are the basis of any contest. You want to increase your appeal (the number of hearts around your Pokémon) by using moves with high appeal, and reduce the appeal of other Pokémon by using moves with high jamming ability.

> **TIP**
>
> Using the same move two turns in a row will usually disappoint the audience, but there are a few moves that can be used repeatedly without boring the audience. Their descriptions will say so.

Sceptile's Coolness really excited the audience!

Exciting the audience

Appeal move no. 1!
Which move will you use?

See the stars in the upper-left corner of the screen during a contest? They represent the audience's excitement. If you use a move of the same condition as the contest, the audience's excitement usually grows, provided you didn't use the same move in the last round (and it is not one of the few moves that can be used twice in a row without disappointing the audience). More stars may appear. But beware, for using a move with a condition type that doesn't match the contest's condition may actually bring down the audience and decrease the number of stars you see! Use the following table to ensure that you're wowing the crowd (or at least, not disappointing them) each turn.

Contest condition matchups

Contest type	Increases excitement	Decreases excitement	No effect on excitement
Coolness	Coolness	Cuteness, Cleverness	Beauty, Toughness
Beauty	Beauty	Cleverness, Toughness	Coolness, Cuteness
Cuteness	Cuteness	Coolness, Toughness	Beauty, Cleverness
Cleverness	Cleverness	Coolness, Beauty	Cuteness, Toughness
Toughness	Toughness	Beauty, Cuteness	Coolness, Cleverness

If you manage to make the audience excited, your Pokémon will look more appealing, and you'll get a bonus heart for the turn. Some moves can also excite the audience even more than usual—these moves usually say something about how they excite the audience in their descriptions. Once the audience's excitement level peaks (5 stars), it will go back to zero so that you can start building it up again. But not before triggering a Spectacular Talent!

> **TIP**
>
> If the Pokémon that you've entered in the contest is able to Mega Evolve and is holding the proper Mega Stone, it will Mega Evolve before carrying out its Spectacular Talent to look even more impressive!

> **TIP**
>
> Some moves can prevent other Pokémon from affecting the excitement level for the turn. Consider using one of these moves if you're always having the other contestants steal your Spectacular Talent opportunity by maxing out the excitement level before you.

Spectacular Talents

This is it! Time for a Spectacular Talent!
Fresh Flower Garden

When a Pokémon manages to max out the crowd's excitement, it automatically performs a Spectacular Talent, which is decided by the Pokémon's type and the contest's condition. Spectacular Talents are all listed on page 379, and performing one in a contest adds a healthy bonus to your appeal. Watch the crowd's excitement carefully, and try to raise it to the max during your turn so you can bust out a Spectacular Talent!

> **TIP**
>
> If a Pokémon has more than one type, its primary type is often considered when it performs its Spectacular Talents—but the Pokémon has a chance of performing Spectacular Talents based on its secondary type, too.

Unnerving your rivals

Some moves' descriptions indicate that the move can make other Pokémon nervous. If you make a Pokémon nervous, it will be unable to use its move during the turn. Some affect only the Pokémon that will come next after you, and some affect all the remaining Pokémon. If you use an unnerving move that affects all the Pokémon after you, it will have a greater chance of success when there are fewer Pokémon remaining. You'll have to decide whether you want a smaller chance of unnerving more Pokémon, or a greater chance of unnerving fewer Pokémon.

Defending against negative effects

Prevent your Pokémon from becoming nervous by using moves that pump it up. The more stars you see under your Pokémon's icon, the more pumped up it is and the less likely to be affected by unnerving moves. Some moves can also prevent jamming effects in the same turn, either one time or for the rest of the turn. These moves are typically less appealing to the audience, however, so you'll have to decide whether you'd rather gamble on a move with big appeal, or sit safely on a move that provides less appeal but defends against negative effects.

Getting pumped up

Moves that pump up your Pokémon (shown by the stars under your Pokémon's icon) also net your Pokémon bonus hearts each turn. For each star that appears beneath your Pokémon's icon, it gains one extra heart per turn. For each star your Pokémon has, its chance of becoming nervous drops by 10 percent.

TIP

A few unusual moves are based on different factors, like how much appeal the other Pokémon have earned, or whether they've tried to start a combo during the turn. Try to develop strategies around these unique and unexpected moves!

Bringing down your opponents

If other competitors are pumped up, you can also use moves that will bring them down. Using these sorts of moves will make competitors more vulnerable to moves that can unnerve them and prevent them from acting. It will also prevent them from getting the extra bonus that being pumped up gives them.

Affecting the turn order

Some moves can also affect the order in which Pokémon get to act during the next turn. Since certain moves are more effective when used first or last in the turn, think ahead about your strategy and move yourself to the front or the back of the line to set up for your next move.

Combo moves

Anticipation is swelling for a combo on the next turn!

Using the right combination of moves can really wow the crowd. Begin a combo by using a particular move. You've triggered the start of a combo when you see this: "Anticipation is swelling for a combo on the next turn!" Use the right follow-up move during the next turn, and you'll complete your combo and show great appeal. See the combo move table on page 377 to find a pair of moves to suit your style!

Getting in the way of combos

Certain moves can either prevent another Pokémon from completing its combo, or jam a Pokémon that's trying to start a combo. Your combo was broken if you see this: "The audience, who was looking forward to seeing an appeal combo, looked away from the move!" You'll have to start again with the first move to try your luck a second time. Block your competitor's combos with moves like these to prevent them from running away with the show.

Gaining fans

Orlando obtained a
Figy Berry!

As you work your way up the contest ranks, you'll begin to pick up some of your own fans, who really admire your style. Up to 10 fans may appear near the Contest Hall's entrance after a performance, excited at their chance to meet you. Talk to them and you may be awarded prizes! As shown in the following table, the prizes you get depend on the rank of the contest you've just participated in. You'll find your adoring fans lining up in every Contest Spectacular Hall around Hoenn.

Contest Rank	Possible fan prizes
Normal Rank	Fresh Water, Old Gateau, Sweet Heart, Rage Candy Bar, Lumiose Galette, Shalour Sable, Cheri Berry, Chesto Berry, Pecha Berry, Rawst Berry, Aspear Berry, Leppa Berry, Oran Berry, Persim Berry
Super Rank	Soda Pop, Old Gateau, Stardust, Honey, Rage Candy Bar, Lumiose Galette, Shalour Sable, Sitrus Berry, Figy Berry, Wiki Berry, Mago Berry, Aguav Berry, Iapapa Berry, Razz Berry, Bluk Berry, Nanab Berry, Wepear Berry, Pinap Berry
Hyper Rank	Lemonade, Old Gateau, Star Piece, Heart Scale, Rage Candy Bar, Lumiose Galette, Shalour Sable, Pomeg Berry, Kelpsy Berry, Qualot Berry, Hondew Berry, Grepa Berry, Tamato Berry, Cornn Berry, Magost Berry, Rabuta Berry, Nomel Berry, Spelon Berry, Pamtre Berry, Watmel Berry, Durin Berry, Belue Berry
Master Rank	Moomoo Milk, Old Gateau, Rage Candy Bar, Comet Shard, Destiny Knot, Lumiose Galette, Shalour Sable, Occa Berry, Passho Berry, Wacan Berry, Rindo Berry, Yache Berry, Chople Berry, Kebia Berry, Shuca Berry, Coba Berry, Payapa Berry, Tanga Berry, Charti Berry, Kasib Berry, Haban Berry, Colbur Berry, Babiri Berry, Chilan Berry, Roseli Berry

Do you know Lissi?
Wow. I'm jealous.

Visit the Contest Spectacular Trainer Fan Club (CSTFC) in Lilycove City (p. 180), and you'll probably find around eight fans hanging out there—but their number could swell all the way to 12. Whether the fans cheer for Lisia or for you depends on how well you're doing in the contests. To max out your fans, you'll have to keep winning through Master Rank contests and showcasing your amazing skills. Do your best to win over all of the fans—if you do, and if you then manage to beat Lisia in a Master Rank Contest, race over to the Contest Spectacular Trainer Fan Club to witness a special appearance by Lissi herself!

TIP

You'll have to win your way through the Master Rank in every contest condition to compete against everyone's idol, Lisia. She might not be the only famous challenger you'll face, though. Word on the street is that her uncle was also a contest master at one time—and he's someone you've also met! To find out who this mysterious star may be, try appearing in a Master Rank Beauty Contest after you've faced Lisia in a contest and entered the Hall of Fame.

Cosplay Pikachu

Received Pikachu!

One of your first fans appears after you make your Contest Spectacular debut. This crafty Breeder makes costumes for a very special Pikachu that she knows. Cosplay Pikachu loves to dress up for contests, and will happily join your team if you welcome it. It can change costumes whenever you talk to the Breeder, who sets up camp in the green room to be available for you anytime. You can also initiate a costume change by examining the wardrobe standing behind her. Each of the five costumes that Cosplay Pikachu can wear will help show off its appeal in the different contest conditions—and that's not all! Changing costumes also lets Cosplay Pikachu learn a handy move for the contest condition that matches its costume. See the contest move table on page 364 for more about the effects of these moves.

Costume		Contest condition	Move learned
Pikachu Rock Star		Coolness	Meteor Mash
Pikachu Belle		Beauty	Icicle Crash
Pikachu Pop Star		Cuteness	Draining Kiss

Costume		Contest condition	Move learned
Pikachu, Ph.D.		Cleverness	Electric Terrain
Pikachu Libre		Toughness	Flying Press

TIP

Cosplay Pikachu will remain in costume, even in battles around Hoenn! It will also be able to use the fantastic moves it learned through cosplay, moves that a Pikachu would not normally be able to learn. Combine this with its outstanding stats and individual strengths (p. 325), and you'll definitely want to use this Pikachu both on and off the contest stage!

Capture your contests' best moments

Would you like to save the last photo to your SD Card?

YES

NO

During contests, you can take photos and save them in the Nintendo 3DS Camera application on your system. Just tap the camera button on the Touch Screen at any time to take a photo. At the end of the contest, you'll be asked if you wish to save your last photo.

TIP

You can take as many photos as you like, but you only have the option of saving the last one. If you think you've got a great shot, you may not want to take any more photos after it to prevent accidentally overwriting it.

Put yourself in your photos

If you'd like, I can create a special effect during the Talent Round in the Contest Hall.

Have you ever chatted with the Guitarist who hangs out by each Contest Hall's reception desk? He boasts that he can create some sort of special effect during the Talent Round. Ask him to do his thing, and the streaming video from your Nintendo 3DS Camera will be used as the background for your contest! You'll be able to get some really cool shots with this feature to share with your friends, although you won't be able to post them directly to the PGL (p. 415) or the Miiverse (p. 418).

Portrait parade

This is a portrait of Pikachu, who performed well in the Cuteness Contest!

You're not the only one hoping to capture your Pokémon's impressive performance. Once you start winning in the Master Rank, your Pokémon's portraits could begin appearing on the second floor of the Contest Spectacular Halls. A certain gentleman from the Lilycove Art Museum will become enamored of these portraits and ask your permission to put them on display in the museum. If you agree, up to 15 of your most recent Pokémon portraits will be kept there on display: three from each of the five contest conditions. More art fans will flock to the Lilycove Art Museum as you fill its walls with portraits. The museum director will be so thankful for the crowds you've brought to his museum that he'll give you something special after you supply him with all 15 portraits: a Glass Ornament for decorating your Secret Base!

Multiplayer mode

Here, you can participate in a contest with people nearby.

Contest Spectaculars are even better when experienced with others. Talk to the receptionist on the left, and she'll help you enter contests together with nearby friends! You'll need a system in the Nintendo 3DS family and a game for each player. All players need to have progressed far enough in the game to be able to take part in contests.

- Choose one person to act as leader.
- All players then talk to the receptionist and choose a Pokémon to enter in the contest.
- The player that's the leader should select "Become a leader."
- The rest of the players should select "Join a group."
- The leader sets the contest's condition and rank.
- When all the settings have been put in, line up your IR transceivers and get ready to be spectacular!

Explanation of the move list

The following tables show the effects of every move that Pokémon can use during Contest Spectaculars. The color of each move's row tells you the move's contest condition (Cool, Cute, etc.), and their complete effects are described in the "Move Effects" column.

The amount of Appeal or Jamming that a move has is also shown in the columns on the right. The more dots you see in the Appeal and Jamming columns, the more effective the move is at increasing your Pokémon's Appeal or Jamming the Appeal of other contestants.

Some moves target one or more rival Pokémon. If a move targets a rival Pokémon instead of your own Pokémon, then the target type is described on the farthest column, as follows:

Specific previous: A specific Pokémon that has already acted this round is targeted.

One previous: One non-specific Pokémon that has already acted this round is targeted.

All previous: All Pokémon that have already acted this round are targeted.

All remaining: All Pokémon that have yet to act this round are targeted.

CONTEST MOVE LIST

A

Guide to Colors	Cool	Beautiful
Cute	Clever	Tough

Move Name	Move Effects	Appeal	Jamming	Target
Absorb	No additional effects.	●●●●	—	—
Acid	If a previous contestant is pumped up, it will lose its stars (☆) and be returned to its normal state.	●●●	—	Specific previous
Acid Armor	User will be impervious to all jamming effects for the remainder of the turn.	●	—	—
Acid Spray	If any other contestant used a move of the same type that turn, its appeal will be reduced by 4 hearts. If no other contestants used a move of the same type, their appeal will be reduced by 1 heart.	●●	●	Specific previous
Acrobatics	Receives triple the base appeal as long as the user has at least 1 star (☆).	●	—	—
Acupressure	Receives an additional amount of appeal at random (varies from 1–8 extra hearts).	●	—	—
Aerial Ace	Receives triple the base appeal when used first in a turn.	●●	—	—
Aeroblast	Excites the audience even more than usual if it is used last in a turn and matches the contest condition.	●●●	—	—
After You	User will move last on the next turn.	●●●	—	—
Agility	User will move first on the next turn.	●●●	—	—
Air Cutter	No additional effects.	●●●●	—	—
Air Slash	Jamming effects fail if used first in a turn.	●	●●●●	One previous
Ally Switch	Randomizes the order in which contestants use moves in the next turn.	●●●	—	—
Amnesia	User will be impervious to all jamming effects for the remainder of the turn.	●	—	—
Ancient Power	Pumps up the user and awards it a star (☆). Each star (☆) lowers the likelihood of becoming nervous by 10%.	●	—	—
Aqua Jet	User will move first on the next turn.	●●●	—	—
Aqua Ring	Pumps up the user and awards it a star (☆). Each star (☆) lowers the likelihood of becoming nervous by 10%.	●	—	—

Move Name	Move Effects	Appeal	Jamming	Target
Aqua Tail	No additional effects.	●●●●	—	—
Arm Thrust	Receives an additional amount of appeal at random (varies from 1–8 extra hearts).	●	—	—
Aromatherapy	User will be impervious to all jamming effects for the remainder of the turn.	●	—	—
Aromatic Mist	Pumps up the user and awards it a star (☆). Each star (☆) lowers the likelihood of becoming nervous by 10%.	●	—	—
Assist	Receives an additional amount of appeal at random (varies from 1–8 extra hearts).	●	—	—
Assurance	The user will receive more hearts the later in a turn this move is used (1–6 max).	●	—	—
Astonish	Jamming effects fail if used first in a turn.	●●	●●●	One previous
Attack Order	Receives no penalty for being used multiple times in a row.	●●●	—	—
Attract	Can make remaining Pokémon nervous and unable to use moves.	●●	—	All remaining
Aura Sphere	Receives triple the base appeal when used first in a turn.	●●	—	—
Aurora Beam	Jamming effects fail if used first in a turn.	●●	●●●	One previous
Autotomize	Pumps up the user and awards it a star (☆). Each star (☆) lowers the likelihood of becoming nervous by 10%.	●	—	—
Avalanche	If the appeal of this move is greater than the appeal gained by the contestant immediately previous, it will be doubled. If less, it will become zero.	●●●	—	—

B

Move Name	Move Effects	Appeal	Jamming	Target
Baby-Doll Eyes	User will move first on the next turn.	●●●	—	—
Barrage	Receives an additional amount of appeal at random (varies from 1–8 extra hearts).	●	—	—
Barrier	User will be impervious to all jamming effects for the remainder of the turn.	●	—	—
Baton Pass	Receives triple the base appeal as long as the user has at least 1 star (☆).	●	—	—
Beat Up	Receives triple the base appeal as long as the user has at least 1 star (☆).	●	—	—
Belch	Receives triple the base appeal as long as the user has at least 1 star (☆).	●	—	—
Belly Drum	The user will lose twice the normal appeal from other contestants' jamming moves.	●●●●●●	—	—
Bestow	Total appeal will vary based on the excitement level in the hall.	●	—	—
Bide	User will move last on the next turn.	●●●	—	—
Bind	No other contestant's moves will affect the excitement level for the remainder of the turn.	●●●	—	—
Bite	Jamming effects fail if used first in a turn.	●●	●●●	One previous
Blast Burn	Cannot participate in the next turn.	●●●●	●●●●	All previous
Blaze Kick	Receives no penalty for being used multiple times in a row.	●●●	—	—
Blizzard	Jamming effects fail if used first in a turn.	●	●●●	All previous
Block	Can make remaining Pokémon nervous and unable to use moves.	●●	—	All remaining
Blue Flare	Receives no penalty for being used multiple times in a row.	●●●	—	—
Body Slam	Jamming effects fail if used first in a turn.	●	●●●●	One previous
Bolt Strike	Receives no penalty for being used multiple times in a row.	●●●	—	—
Bone Club	Receives no penalty for being used multiple times in a row.	●●●	—	—
Bone Rush	Receives an additional amount of appeal at random (varies from 1–8 extra hearts).	●	—	—
Bonemerang	If any other contestant used a move of the same type that turn, its appeal will be reduced by 4 hearts. If no other contestants used a move of the same type, their appeal will be reduced by 1 heart.	●●	●	Specific previous
Boomburst	Cannot participate in the next turn.	●●●●	●●●●	All previous
Bounce	User will be impervious to all jamming effects for the remainder of the turn.	●	—	—
Brave Bird	The user will lose twice the normal appeal from other contestants' jamming moves.	●●●●●●	—	—
Brick Break	No additional effects.	●●●●	—	—
Brine	If the appeal of this move is greater than the appeal gained by the contestant immediately previous, it will be doubled. If less, it will become zero.	●●●	—	—
Bubble	No additional effects.	●●●●	—	—
Bubble Beam	Jamming effects fail if used first in a turn.	●●	●●●	One previous
Bug Bite	If a previous contestant is pumped up, it will lose its stars (☆) and be returned to its normal state.	●●●	—	Specific previous
Bug Buzz	Jamming effects fail if used first in a turn.	●	●●●●	One previous
Bulk Up	Pumps up the user and awards it a star (☆). Each star (☆) lowers the likelihood of becoming nervous by 10%.	●	—	—
Bulldoze	Jamming effects fail if used first in a turn.	●●	●●	All previous
Bullet Punch	User will move first on the next turn.	●●●	—	—
Bullet Seed	Receives an additional amount of appeal at random (varies from 1–8 extra hearts).	●	—	—

Move Name	Move Effects	Appeal	Jamming	Target
Calm Mind	Pumps up the user and awards it a star (☆). Each star (☆) lowers the likelihood of becoming nervous by 10%.	●	—	—
Camouflage	The user also receives the equivalent of half of the cumulative appeal of any contestants that went before it.	●	—	—
Captivate	Decreases audience excitement even more than usual if it does not match the contest condition.	●●●●	—	—
Celebrate	Excites the audience regardless of contest condition.	●●	—	—
Charge	Pumps up the user and awards it a star (☆). Each star (☆) lowers the likelihood of becoming nervous by 10%.	●	—	—
Charge Beam	Receives triple the base appeal as long as the user has at least 1 star (☆).	●	—	—
Charm	Causes any contestants that began a combo that turn to lose 5 hearts. If no other contestants have started a combo, they will lose 1 heart.	●●	●	Specific previous
Chatter	If a previous contestant is pumped up, it will lose its stars (☆) and be returned to its normal state.	●●●	—	Specific previous
Chip Away	Excites the audience regardless of contest condition.	●●	—	—
Circle Throw	User will move last on the next turn.	●●●	—	—
Clamp	No other contestant's moves will affect the excitement level for the remainder of the turn.	●●●	—	—
Clear Smog	Receives triple the base appeal when used first in a turn.	●●	—	—
Close Combat	The user will lose twice the normal appeal from other contestants' jamming moves.	●●●●●●	—	—
Coil	Pumps up the user and awards it a star (☆). Each star (☆) lowers the likelihood of becoming nervous by 10%.	●	—	—
Comet Punch	Receives an additional amount of appeal at random (varies from 1–8 extra hearts).	●	—	—
Confide	If a previous contestant is pumped up, it will lose its stars (☆) and be returned to its normal state.	●●●	—	Specific previous
Confuse Ray	Causes any contestants that began a combo that turn to lose 5 hearts. If no other contestants have started a combo, they will lose 1 heart.	●●	●	Specific previous
Confusion	No additional effects.	●●●●	—	—
Constrict	If a previous contestant is pumped up, it will lose its stars (☆) and be returned to its normal state.	●●●	—	Specific previous
Conversion	Receives triple the base appeal if the previous contestant used a move of the same type.	●●	—	—
Conversion 2	Receives triple the base appeal if the previous contestant used a move of the same type.	●●	—	—
Copycat	User also gains the same number of hearts as the previous contestant.	●	—	—
Cosmic Power	Pumps up the user and awards it a star (☆). Each star (☆) lowers the likelihood of becoming nervous by 10%.	●	—	—
Cotton Guard	User will be impervious to all jamming effects for the remainder of the turn.	●	—	—
Cotton Spore	Causes any contestants that began a combo that turn to lose 5 hearts. If no other contestants have started a combo, they will lose 1 heart.	●●	●	Specific previous
Counter	Receives triple the base appeal when used last in a turn.	●●	—	—
Covet	User also gains the same number of hearts as the previous contestant.	●	—	—
Crabhammer	Receives no penalty for being used multiple times in a row.	●●●	—	—
Crafty Shield	Excites the audience even more than usual if it is used first in a turn and matches the contest condition.	●●●	—	—
Cross Chop	If the appeal of this move is greater than the appeal gained by the contestant immediately previous, it will be doubled. If less, it will become zero.	●●●	—	—
Cross Poison	If any other contestant used a move of the same type that turn, its appeal will be reduced by 4 hearts. If no other contestants used a move of the same type, their appeal will be reduced by 1 heart.	●●	●	Specific previous
Crunch	Jamming effects fail if used first in a turn.	●	●●●●	One previous
Crush Claw	Jamming effects fail if used first in a turn.	●	●●●●	One previous
Crush Grip	Receives no penalty for being used multiple times in a row.	●●●	—	—
Curse	User will move last on the next turn.	●●●	—	—
Cut	No additional effects.	●●●●	—	—

Move Name	Move Effects	Appeal	Jamming	Target
Dark Pulse	No additional effects.	●●●●	—	—
Dark Void	Can make remaining Pokémon nervous and unable to use moves.	●●	—	All remaining
Dazzling Gleam	No additional effects.	●●●●	—	—
Defend Order	User will be impervious to jamming effects one time that turn.	●●	—	—
Defense Curl	User will be impervious to jamming effects one time that turn.	●●	—	—
Defog	Receives triple the base appeal when used first in a turn.	●●	—	—
Destiny Bond	Cannot participate in any of the remaining turns. Receives no effects from jamming.	●●●●●●●●	—	—
Detect	User will be impervious to all jamming effects for the remainder of the turn.	●	—	—
Diamond Storm	Excites the audience even more than usual if it is used last in a turn and matches the contest condition.	●●●	—	—
Dig	User will be impervious to jamming effects one time that turn.	●●	—	—
Disable	Can make remaining Pokémon nervous and unable to use moves.	●●	—	All remaining
Disarming Voice	Receives triple the base appeal when used first in a turn.	●●	—	—
Discharge	Jamming effects fail if used first in a turn.	●●	—	All previous
Dive	User will be impervious to jamming effects one time that turn.	●●	●●	—

Move Name	Move Effects	Appeal	Jamming	Target
Dizzy Punch	Interrupts any combos that were begun that turn, preventing them from being completed on the next turn.	●●●	—	Specific previous
Doom Desire	Excites the audience even more than usual if it is used last in a turn and matches the contest condition.	●●●	—	—
Double Hit	If any other contestant used a move of the same type that turn, its appeal will be reduced by 4 hearts. If no other contestants used a move of the same type, their appeal will be reduced by 1 heart.	●●	●	Specific previous
Double Kick	If any other contestant used a move of the same type that turn, its appeal will be reduced by 4 hearts. If no other contestants used a move of the same type, their appeal will be reduced by 1 heart.	●●	●	Specific previous
Double Slap	Receives an additional amount of appeal at random (varies from 1–8 extra hearts).	●	—	—
Double Team	Pumps up the user and awards it a star (☆). Each star (☆) lowers the likelihood of becoming nervous by 10%.	●	—	—
Double-Edge	The user will lose twice the normal appeal from other contestants' jamming moves.	●●●●●●	—	—
Draco Meteor	The user will lose twice the normal appeal from other contestants' jamming moves.	●●●●●●	—	—
Dragon Ascent	The user will lose twice the normal appeal from other contestants' jamming moves.	●●●●●●	—	—
Dragon Breath	Jamming effects fail if used first in a turn.	●●	●●●	One previous
Dragon Claw	No additional effects.	●●●●	—	—
Dragon Dance	Pumps up the user and awards it a star (☆). Each star (☆) lowers the likelihood of becoming nervous by 10%.	●	—	—
Dragon Pulse	No additional effects.	●●●●	—	—
Dragon Rage	Receives no penalty for being used multiple times in a row.	●●●	—	—
Dragon Rush	If the appeal of this move is greater than the appeal gained by the contestant immediately previous, it will be doubled. If less, it will become zero.	●●●	—	—
Dragon Tail	User will move last on the next turn.	●●●	—	—
Drain Punch	User also gains the same number of hearts as the previous contestant.	●	—	—
Draining Kiss	The user also receives the equivalent of half of the cumulative appeal of any contestants that went before it.	●	—	—
Dream Eater	Receives triple the base appeal if the previous contestant used a move of the same type.	●●	—	—
Drill Peck	If the appeal of this move is greater than the appeal gained by the contestant immediately previous, it will be doubled. If less, it will become zero.	●●●	—	—
Drill Run	If the appeal of this move is greater than the appeal gained by the contestant immediately previous, it will be doubled. If less, it will become zero.	●●●	—	—
Dual Chop	If any other contestant used a move of the same type that turn, its appeal will be reduced by 4 hearts. If no other contestants used a move of the same type, their appeal will be reduced by 1 heart.	●●	●	Specific previous
Dynamic Punch	Causes any contestants that began a combo that turn to lose 5 hearts. If no other contestants have started a combo, they will lose 1 heart.	●●	●	Specific previous

E

Move Name	Move Effects	Appeal	Jamming	Target
Earth Power	No additional effects.	●●●●	—	—
Earthquake	Reduces all previous contestants' appeal by half. Contestants with no hearts or negative hearts will gain a negative heart marker.	●●	●	All previous
Echoed Voice	Receives no penalty for being used multiple times in a row.	●●●	—	—
Eerie Impulse	Jamming effects fail if used first in a turn.	●	●●●	All previous
Egg Bomb	No additional effects.	●●●●	—	—
Electric Terrain	Excites the audience even more than usual if it is used first in a turn and matches the contest condition.	●●●	—	—
Electrify	If any other contestant used a move of the same type that turn, its appeal will be reduced by 4 hearts. If no other contestants used a move of the same type, their appeal will be reduced by 1 heart.	●●	●	Specific previous
Electro Ball	Excites the audience even more than usual if it is used first in a turn and matches the contest condition.	●●●	—	—
Electroweb	Causes any contestants that began a combo that turn to lose 5 hearts. If no other contestants have started a combo, they will lose 1 heart.	●●	●	Specific previous
Embargo	If a previous contestant is pumped up, it will lose its stars (☆) and be returned to its normal state.	●●●	—	Specific previous
Ember	No additional effects.	●●●●	—	—
Encore	Can make remaining Pokémon nervous and unable to use moves.	●●	—	All remaining
Endeavor	Receives triple the base appeal when used last in a turn.	●●	—	—
Endure	User will move last on the next turn.	●●●	—	—
Energy Ball	No additional effects.	●●●●	—	—
Entrainment	If any other contestant used a move of the same type that turn, its appeal will be reduced by 4 hearts. If no other contestants used a move of the same type, their appeal will be reduced by 1 heart.	●●	●	Specific previous
Eruption	The user will lose twice the normal appeal from other contestants' jamming moves.	●●●●●●	—	—
Explosion	Cannot participate in any of the remaining turns. Receives no effects from jamming.	●●●●●●●●	—	—
Extrasensory	If any other contestant used a move of the same type that turn, its appeal will be reduced by 4 hearts. If no other contestants used a move of the same type, their appeal will be reduced by 1 heart.	●●	●	Specific previous
Extreme Speed	User will move first on the next turn.	●●●	—	—

Move Name	Move Effects	Appeal	Jamming	Target
Facade	Receives triple the base appeal when used last in a turn.	••	—	—
Fairy Lock	No other contestant's moves will affect the excitement level for the remainder of the turn.	•••	—	—
Fairy Wind	No additional effects.	••••	—	—
Fake Out	Jamming effects fail if used first in a turn.	••	•••	One previous
Fake Tears	Decreases audience excitement even more than usual if it does not match the contest condition.	••••	—	—
False Swipe	Decreases audience excitement even more than usual if it does not match the contest condition.	••••	—	—
Feather Dance	Receives triple the base appeal when used last in a turn.	••	—	—
Feint	User will move first on the next turn.	•••	—	—
Feint Attack	Receives triple the base appeal when used first in a turn.	••	—	—
Fell Stinger	Total appeal will vary based on the excitement level in the hall.	•	—	—
Fiery Dance	Receives triple the base appeal as long as the user has at least 1 star (☆).	•	—	—
Final Gambit	Cannot participate in any of the remaining turns. Receives no effects from jamming.	••••••••	—	—
Fire Blast	Total appeal will vary based on the excitement level in the hall.	•	—	—
Fire Fang	No additional effects.	••••	—	—
Fire Pledge	Excites the audience regardless of contest condition.	••	—	—
Fire Punch	No additional effects.	••••	—	—
Fire Spin	No other contestant's moves will affect the excitement level for the remainder of the turn.	•••	—	—
Fissure	Reduces all previous contestants' appeal by half. Contestants with no hearts or negative hearts will gain a negative heart marker.	••	•	All previous
Flail	The user will receive more hearts the later in a turn this move is used (1–6 max).	•	—	—
Flame Burst	Interrupts any combos that were begun that turn, preventing them from being completed on the next turn.	•••	—	Specific previous
Flame Charge	Receives triple the base appeal as long as the user has at least 1 star (☆).	•	—	—
Flame Wheel	If the appeal of this move is greater than the appeal gained by the contestant immediately previous, it will be doubled. If less, it will become zero.	•••	—	—
Flamethrower	No additional effects.	••••	—	—
Flare Blitz	The user will lose twice the normal appeal from other contestants' jamming moves.	••••••	—	—
Flash	Interrupts any combos that were begun that turn, preventing them from being completed on the next turn.	•••	—	Specific previous
Flash Cannon	No additional effects.	••••	—	—
Flatter	Can make remaining Pokémon nervous and unable to use moves.	••	—	All remaining
Fling	If a previous contestant is pumped up, it will lose its stars (☆) and be returned to its normal state.	•••	—	Specific previous
Flower Shield	User will be impervious to all jamming effects for the remainder of the turn.	•	—	—
Fly	User will be impervious to jamming effects one time that turn.	••	—	—
Flying Press	Excites the audience regardless of contest condition.	••	—	—
Focus Blast	No additional effects.	••••	—	—
Focus Energy	Pumps up the user and awards it a star (☆). Each star (☆) lowers the likelihood of becoming nervous by 10%.	•	—	—
Focus Punch	Receives triple the base appeal when used last in a turn.	••	—	—
Follow Me	No other contestant's moves will affect the excitement level for the remainder of the turn.	•••	—	—
Force Palm	No additional effects.	••••	—	—
Foresight	If any other contestant used a move of the same type that turn, its appeal will be reduced by 4 hearts. If no other contestants used a move of the same type, their appeal will be reduced by 1 heart.	••	•	Specific previous
Forest's Curse	Reduces all previous contestants' appeal by half. Contestants with no hearts or negative hearts will gain a negative heart marker.	••	•	All previous
Foul Play	User also gains the same number of hearts as the previous contestant.	•	—	—
Freeze Shock	If the appeal of this move is greater than the appeal gained by the contestant immediately previous, it will be doubled. If less, it will become zero.	•••	—	—
Freeze-Dry	Receives no penalty for being used multiple times in a row.	•••	—	—
Frenzy Plant	Cannot participate in the next turn.	••••	••••	All previous
Frost Breath	Decreases audience excitement even more than usual if it does not match the contest condition.	••••	—	—
Frustration	Jamming effects fail if used first in a turn.	••	•••	One previous
Fury Attack	Receives an additional amount of appeal at random (varies from 1–8 extra hearts).	•	—	—
Fury Cutter	Receives no penalty for being used multiple times in a row.	•••	—	—
Fury Swipes	Receives an additional amount of appeal at random (varies from 1–8 extra hearts).	•	—	—
Fusion Bolt	The user will receive more hearts the later in a turn this move is used (1–6 max).	•	—	—
Fusion Flare	The user will receive more hearts the later in a turn this move is used (1–6 max).	•	—	—
Future Sight	Receives triple the base appeal if the previous contestant used a move of the same type.	••	—	—

Move Name	Move Effects	Appeal	Jamming	Target
Gastro Acid	If a previous contestant is pumped up, it will lose its stars (☆) and be returned to its normal state.	●●●	—	Specific previous
Gear Grind	No additional effects.	●●●●	—	—
Geomancy	Pumps up the user and awards it a star (☆). Each star (☆) lowers the likelihood of becoming nervous by 10%.	●	—	—
Giga Drain	Jamming effects fail if used first in a turn.	●	●●●●	One previous
Giga Impact	Cannot participate in the next turn.	●●●●	●●●●	All previous
Glaciate	No other contestant's moves will affect the excitement level for the remainder of the turn.	●●●	—	—
Glare	Jamming effects fail if used first in a turn.	●	●●●	All previous
Grass Knot	The user will receive more hearts the later in a turn this move is used (1–6 max).	●	—	—
Grass Pledge	Excites the audience regardless of contest condition.	●●	—	—
Grass Whistle	User will be impervious to jamming effects one time that turn.	●●	—	—
Grassy Terrain	Excites the audience even more than usual if it is used first in a turn and matches the contest condition.	●●●	—	—
Gravity	Can make remaining Pokémon nervous and unable to use moves.	●●	—	All remaining
Growl	Receives triple the base appeal when used last in a turn.	●●	—	—
Growth	Pumps up the user and awards it a star (☆). Each star (☆) lowers the likelihood of becoming nervous by 10%.	●	—	—
Grudge	Cannot participate in the next turn.	●●●●	●●●●	All previous
Guard Split	The user also receives the equivalent of half of the cumulative appeal of any contestants that went before it.	●	—	—
Guard Swap	The user also receives the equivalent of half of the cumulative appeal of any contestants that went before it.	●	—	—
Guillotine	Reduces all previous contestants' appeal by half. Contestants with no hearts or negative hearts will gain a negative heart marker.	●●	●	All previous
Gunk Shot	Reduces all previous contestants' appeal by half. Contestants with no hearts or negative hearts will gain a negative heart marker.	●●	●	All previous
Gust	Jamming effects fail if used first in a turn.	●●	●●●	One previous
Gyro Ball	The user will receive more hearts the later in a turn this move is used (1–6 max).	●	—	—

Move Name	Move Effects	Appeal	Jamming	Target
Hail	Reduces all previous contestants' appeal by half. Contestants with no hearts or negative hearts will gain a negative heart marker.	●●	●	All previous
Hammer Arm	The user will lose twice the normal appeal from other contestants' jamming moves.	●●●●●●	—	—
Happy Hour	Excites the audience regardless of contest condition.	●●	—	—
Harden	User will be impervious to jamming effects one time that turn.	●●	—	—
Haze	If a previous contestant is pumped up, it will lose its stars (☆) and be returned to its normal state.	●●●	—	Specific previous
Head Charge	The user will lose twice the normal appeal from other contestants' jamming moves.	●●●●●●	—	—
Head Smash	The user will lose twice the normal appeal from other contestants' jamming moves.	●●●●●●	—	—
Headbutt	No additional effects.	●●●●	—	—
Heal Bell	User will be impervious to all jamming effects for the remainder of the turn.	●	—	—
Heal Block	No other contestant's moves will affect the excitement level for the remainder of the turn.	●●●	—	—
Heal Order	If any other contestant used a move of the same type that turn, its appeal will be reduced by 4 hearts. If no other contestants used a move of the same type, their appeal will be reduced by 1 heart.	●●	●	Specific previous
Heal Pulse	Excites the audience regardless of contest condition.	●●	—	—
Healing Wish	Cannot participate in any of the remaining turns. Receives no effects from jamming.	●●●●●●●●	—	—
Heart Stamp	Receives no penalty for being used multiple times in a row.	●●●	—	—
Heart Swap	The user also receives the equivalent of half of the cumulative appeal of any contestants that went before it.	●	—	—
Heat Crash	Excites the audience even more than usual if it is used last in a turn and matches the contest condition.	●●●	—	—
Heat Wave	Jamming effects fail if used first in a turn.	●●	●●	All previous
Heavy Slam	Excites the audience even more than usual if it is used last in a turn and matches the contest condition.	●●●	—	—
Helping Hand	No additional effects.	●●●●	—	—
Hex	If any other contestant used a move of the same type that turn, its appeal will be reduced by 4 hearts. If no other contestants used a move of the same type, their appeal will be reduced by 1 heart.	●●	●	Specific previous
Hidden Power	Receives no penalty for being used multiple times in a row.	●●●	—	—
High Jump Kick	The user will lose twice the normal appeal from other contestants' jamming moves.	●●●●●●	—	—
Hold Back	Decreases audience excitement even more than usual if it does not match the contest condition.	●●●●	—	—
Hold Hands	User will be impervious to all jamming effects for the remainder of the turn.	●	—	—
Hone Claws	Pumps up the user and awards it a star (☆). Each star (☆) lowers the likelihood of becoming nervous by 10%.	●	—	—
Horn Attack	No additional effects.	●●●●	—	—
Horn Drill	Reduces all previous contestants' appeal by half. Contestants with no hearts or negative hearts will gain a negative heart marker.	●●	●	All previous
Horn Leech	User also gains the same number of hearts as the previous contestant.	●	—	—

Move Name	Move Effects	Appeal	Jamming	Target
Howl	Receives triple the base appeal when used last in a turn.	●●	—	—
Hurricane	Reduces all previous contestants' appeal by half. Contestants with no hearts or negative hearts will gain a negative heart marker.	●●	●	All previous
Hydro Cannon	Cannot participate in the next turn.	●●●●	●●●●	All previous
Hydro Pump	Total appeal will vary based on the excitement level in the hall.	●	—	—
Hyper Beam	Cannot participate in the next turn.	●●●●	●●●●	All previous
Hyper Fang	Receives no penalty for being used multiple times in a row.	●●●	—	—
Hyper Voice	Jamming effects fail if used first in a turn.	●●	●●	All previous
Hypnosis	Jamming effects fail if used first in a turn.	●	●●●	All previous

I

Move Name	Move Effects	Appeal	Jamming	Target
Ice Ball	No other contestant's moves will affect the excitement level for the remainder of the turn.	●●●	—	—
Ice Beam	Jamming effects fail if used first in a turn.	●	●●●●	One previous
Ice Burn	If the appeal of this move is greater than the appeal gained by the contestant immediately previous, it will be doubled. If less, it will become zero.	●●●	—	—
Ice Fang	No additional effects.	●●●●	—	—
Ice Punch	No additional effects.	●●●●	—	—
Ice Shard	User will move first on the next turn.	●●●	—	—
Icicle Crash	Excites the audience even more than usual if it is used last in a turn and matches the contest condition.	●●●	—	—
Icicle Spear	Receives an additional amount of appeal at random (varies from 1–8 extra hearts).	●	—	—
Icy Wind	Decreases audience excitement even more than usual if it does not match the contest condition.	●●●●	—	—
Imprison	No other contestant's moves will affect the excitement level for the remainder of the turn.	●●●	—	—
Incinerate	Interrupts any combos that were begun that turn, preventing them from being completed on the next turn.	●●●	—	Specific previous
Inferno	Jamming effects fail if used first in a turn.	●	●●●●	One previous
Infestation	No other contestant's moves will affect the excitement level for the remainder of the turn.	●●●	—	—
Ingrain	Pumps up the user and awards it a star (☆). Each star (☆) lowers the likelihood of becoming nervous by 10%.	●	—	—
Ion Deluge	No other contestant's moves will affect the excitement level for the remainder of the turn.	●●●	—	—
Iron Defense	User will be impervious to all jamming effects for the remainder of the turn.	●	—	—
Iron Head	No additional effects.	●●●●	—	—
Iron Tail	No additional effects.	●●●●	—	—

J

Move Name	Move Effects	Appeal	Jamming	Target
Judgment	Receives no penalty for being used multiple times in a row.	●●●	—	—
Jump Kick	The user will lose twice the normal appeal from other contestants' jamming moves.	●●●●●●	—	—

K

Move Name	Move Effects	Appeal	Jamming	Target
Karate Chop	No additional effects.	●●●●	—	—
Kinesis	Receives no penalty for being used multiple times in a row.	●●●	—	—
King's Shield	User will be impervious to all jamming effects for the remainder of the turn.	●	—	—
Knock Off	Jamming effects fail if used first in a turn.	●●	●●●	One previous

L

Move Name	Move Effects	Appeal	Jamming	Target
Land's Wrath	Jamming effects fail if used first in a turn.	●●	●●	All previous
Last Resort	Receives triple the base appeal as long as the user has at least 1 star (☆).	●	—	—
Lava Plume	Jamming effects fail if used first in a turn.	●●	●●	All previous
Leaf Blade	Receives no penalty for being used multiple times in a row.	●●●	—	—
Leaf Storm	The user will lose twice the normal appeal from other contestants' jamming moves.	●●●●●●	—	—
Leaf Tornado	Receives no penalty for being used multiple times in a row.	●●●	—	—
Leech Life	User also gains the same number of hearts as the previous contestant.	●	—	—
Leech Seed	Pumps up the user and awards it a star (☆). Each star (☆) lowers the likelihood of becoming nervous by 10%.	●	—	—
Leer	Causes any contestants that began a combo that turn to lose 5 hearts. If no other contestants have started a combo, they will lose 1 heart.	●●	●	Specific previous
Lick	Jamming effects fail if used first in a turn.	●●	●●●	One previous

Move Name	Move Effects	Appeal	Jamming	Target
Light Screen	User will be impervious to jamming effects one time that turn.	●●	—	—
Lock-On	User will move first on the next turn.	●●●	—	—
Lovely Kiss	Decreases audience excitement even more than usual if it does not match the contest condition.	●●●●	—	—
Low Kick	The user will receive more hearts the later in a turn this move is used (1–6 max).	●	—	—
Low Sweep	Jamming effects fail if used first in a turn.	●●	●●●	One previous
Lucky Chant	Pumps up the user and awards it a star (☆). Each star (☆) lowers the likelihood of becoming nervous by 10%.	●	—	—
Lunar Dance	Cannot participate in any of the remaining turns. Receives no effects from jamming.	●●●●●●●	—	—
Luster Purge	If any other contestant used a move of the same type that turn, its appeal will be reduced by 4 hearts. If no other contestants used a move of the same type, their appeal will be reduced by 1 heart.	●●	●	Specific previous

M

Move Name	Move Effects	Appeal	Jamming	Target
Mach Punch	User will move first on the next turn.	●●●	—	—
Magic Coat	Receives triple the base appeal when used last in a turn.	●●	—	—
Magic Room	No other contestant's moves will affect the excitement level for the remainder of the turn.	●●●	—	—
Magical Leaf	Receives triple the base appeal when used first in a turn.	●●	—	—
Magma Storm	No other contestant's moves will affect the excitement level for the remainder of the turn.	●●●	—	—
Magnet Bomb	Receives triple the base appeal when used first in a turn.	●●	—	—
Magnet Rise	Can make remaining Pokémon nervous and unable to use moves.	●●	—	All remaining
Magnetic Flux	Pumps up the user and awards it a star (☆). Each star (☆) lowers the likelihood of becoming nervous by 10%.	●	—	—
Magnitude	Total appeal will vary based on the excitement level in the hall.	●	—	—
Mat Block	Jamming effects fail if used first in a turn.	●	●●●	All previous
Me First	User will move first on the next turn.	●●●	—	—
Mean Look	Can make remaining Pokémon nervous and unable to use moves.	●●	—	All remaining
Meditate	Pumps up the user and awards it a star (☆). Each star (☆) lowers the likelihood of becoming nervous by 10%.	●	—	—
Mega Drain	Jamming effects fail if used first in a turn.	●●	●●●	One previous
Mega Kick	Total appeal will vary based on the excitement level in the hall.	●	—	—
Mega Punch	Receives no penalty for being used multiple times in a row.	●●●	—	—
Megahorn	Receives no penalty for being used multiple times in a row.	●●●	—	—
Memento	Cannot participate in any of the remaining turns. Receives no effects from jamming.	●●●●●●●	—	—
Metal Burst	Receives triple the base appeal when used last in a turn.	●●	—	—
Metal Claw	No additional effects.	●●●●	—	—
Metal Sound	Jamming effects fail if used first in a turn.	●	●●●	All previous
Meteor Mash	Receives no penalty for being used multiple times in a row.	●●●	—	—
Metronome	Receives an additional amount of appeal at random (varies from 1–8 extra hearts).	●	—	—
Milk Drink	Receives triple the base appeal when used first in a turn.	●●	—	—
Mimic	User also gains the same number of hearts as the previous contestant.	●	—	—
Mind Reader	User will move first on the next turn.	●●●	—	—
Minimize	User will be impervious to all jamming effects for the remainder of the turn.	●	—	—
Miracle Eye	Receives triple the base appeal when used first in a turn.	●●	—	—
Mirror Coat	Receives triple the base appeal when used last in a turn.	●●	—	—
Mirror Move	User also gains the same number of hearts as the previous contestant.	●	—	—
Mirror Shot	Jamming effects fail if used first in a turn.	●●	●●●	One previous
Mist	User will be impervious to all jamming effects for the remainder of the turn.	●	—	—
Mist Ball	Reduces all previous contestants' appeal by half. Contestants with no hearts or negative hearts will gain a negative heart marker.	●●	●	All previous
Misty Terrain	Excites the audience even more than usual if it is used first in a turn and matches the contest condition.	●●●	—	—
Moonblast	Jamming effects fail if used first in a turn.	●	●●●●	One previous
Moonlight	Receives an additional amount of appeal at random (varies from 1–8 extra hearts).	●	—	—
Morning Sun	Receives an additional amount of appeal at random (varies from 1–8 extra hearts).	●	—	—
Mud Bomb	Jamming effects fail if used first in a turn.	●●	●●●	One previous
Mud Shot	No additional effects.	●●●●	—	—
Mud Sport	Excites the audience regardless of contest condition.	●●	—	—
Muddy Water	Jamming effects fail if used first in a turn.	●●	●●	All previous
Mud-Slap	If a previous contestant is pumped up, it will lose its stars (☆) and be returned to its normal state.	●●●	—	Specific previous
Mystical Fire	Receives no penalty for being used multiple times in a row.	●●●	—	—

N

Move Name	Move Effects	Appeal	Jamming	Target
Nasty Plot	Pumps up the user and awards it a star (☆). Each star (☆) lowers the likelihood of becoming nervous by 10%.	●	—	—
Natural Gift	Total appeal will vary based on the excitement level in the hall.	●	—	—
Nature Power	Total appeal will vary based on the excitement level in the hall.	●	—	—
Needle Arm	No additional effects.	●●●●	—	—
Night Daze	Receives no penalty for being used multiple times in a row.	●●●	—	—
Night Shade	Receives no penalty for being used multiple times in a row.	●●●	—	—
Night Slash	If the appeal of this move is greater than the appeal gained by the contestant immediately previous, it will be doubled. If less, it will become zero.	●●●	—	—
Nightmare	Jamming effects fail if used first in a turn.	●	●●●	All previous
Noble Roar	Receives triple the base appeal when used first in a turn.	●●	—	—
Nuzzle	If any other contestant used a move of the same type that turn, its appeal will be reduced by 4 hearts. If no other contestants used a move of the same type, their appeal will be reduced by 1 heart.	●●	●	Specific previous

O

Move Name	Move Effects	Appeal	Jamming	Target
Oblivion Wing	The user also receives the equivalent of half of the cumulative appeal of any contestants that went before it.	●	—	—
Octazooka	Receives no penalty for being used multiple times in a row.	●●●	—	—
Odor Sleuth	User will be impervious to jamming effects one time that turn.	●●	—	—
Ominous Wind	Pumps up the user and awards it a star (☆). Each star (☆) lowers the likelihood of becoming nervous by 10%.	●	—	—
Origin Pulse	Excites the audience even more than usual if it is used first in a turn and matches the contest condition.	●●●	—	—
Outrage	The user will lose twice the normal appeal from other contestants' jamming moves.	●●●●●●	—	—
Overheat	The user will lose twice the normal appeal from other contestants' jamming moves.	●●●●●●	—	—

P

Move Name	Move Effects	Appeal	Jamming	Target
Pain Split	The user also receives the equivalent of half of the cumulative appeal of any contestants that went before it.	●	—	—
Parabolic Charge	The user also receives the equivalent of half of the cumulative appeal of any contestants that went before it.	●	—	—
Parting Shot	Excites the audience even more than usual if it is used last in a turn and matches the contest condition.	●●●	—	—
Pay Day	Excites the audience regardless of contest condition.	●●	—	—
Payback	Receives triple the base appeal when used last in a turn.	●●	—	—
Peck	No additional effects.	●●●●	—	—
Perish Song	Decreases audience excitement even more than usual if it does not match the contest condition.	●●●●	—	—
Petal Blizzard	Jamming effects fail if used first in a turn.	●●	●●	All previous
Petal Dance	The user will lose twice the normal appeal from other contestants' jamming moves.	●●●●●●	—	—
Phantom Force	User will be impervious to all jamming effects for the remainder of the turn.	●	—	—
Pin Missile	Receives an additional amount of appeal at random (varies from 1–8 extra hearts).	●	—	—
Play Nice	Total appeal will vary based on the excitement level in the hall.	●	—	—
Play Rough	If a previous contestant is pumped up, it will lose its stars (☆) and be returned to its normal state.	●●●	—	Specific previous
Pluck	If a previous contestant is pumped up, it will lose its stars (☆) and be returned to its normal state.	●●●	—	Specific previous
Poison Fang	No additional effects.	●●●●	—	—
Poison Gas	Interrupts any combos that were begun that turn, preventing them from being completed on the next turn.	●●●	—	Specific previous
Poison Jab	No additional effects.	●●●●	—	—
Poison Powder	If a previous contestant is pumped up, it will lose its stars (☆) and be returned to its normal state.	●●●	—	Specific previous
Poison Sting	Jamming effects fail if used first in a turn.	●●	●●●	One previous
Poison Tail	If a previous contestant is pumped up, it will lose its stars (☆) and be returned to its normal state.	●●●	—	Specific previous
Pound	No additional effects.	●●●●	—	—
Powder	Decreases audience excitement even more than usual if it does not match the contest condition.	●●●●	—	—
Powder Snow	No additional effects.	●●●●	—	—
Power Gem	No additional effects.	●●●●	—	—
Power Split	The user also receives the equivalent of half of the cumulative appeal of any contestants that went before it.	●	—	—
Power Swap	The user also receives the equivalent of half of the cumulative appeal of any contestants that went before it.	●	—	—
Power Trick	Receives triple the base appeal if the previous contestant used a move of the same type.	●●	—	—
Power Whip	Total appeal will vary based on the excitement level in the hall.	●	—	—
Power-Up Punch	Receives triple the base appeal as long as the user has at least 1 star (☆).	●	—	—

Move Name	Move Effects	Appeal	Jamming	Target
Precipice Blades	Excites the audience even more than usual if it is used last in a turn and matches the contest condition.	●●●	—	—
Present	Receives no penalty for being used multiple times in a row.	●●●	—	—
Protect	User will be impervious to jamming effects one time that turn.	●●	—	—
Psybeam	Interrupts any combos that were begun that turn, preventing them from being completed on the next turn.	●●●	—	Specific previous
Psych Up	Receives triple the base appeal if the previous contestant used a move of the same type.	●●	—	—
Psychic	No additional effects.	●●●●	—	—
Psycho Boost	The user will lose twice the normal appeal from other contestants' jamming moves.	●●●●●●	—	—
Psycho Cut	No additional effects.	●●●●●	—	—
Psycho Shift	Receives triple the base appeal when used last in a turn.	●●	—	—
Psyshock	Jamming effects fail if used first in a turn.	●	●●●●	One previous
Psystrike	Receives no penalty for being used multiple times in a row.	●●●	—	—
Psywave	Receives an additional amount of appeal at random (varies from 1–8 extra hearts).	●	—	—
Punishment	Causes any contestants that began a combo that turn to lose 5 hearts. If no other contestants have started a combo, they will lose 1 heart.	●●	●	Specific previous
Pursuit	If any other contestant used a move of the same type that turn, its appeal will be reduced by 4 hearts. If no other contestants used a move of the same type, their appeal will be reduced by 1 heart.	●●	●	Specific previous

Move Name	Move Effects	Appeal	Jamming	Target
Quash	User will move first on the next turn.	●●●	—	—
Quick Attack	User will move first on the next turn.	●●●	—	—
Quick Guard	Receives triple the base appeal when used first in a turn.	●●	—	—
Quiver Dance	Pumps up the user and awards it a star (☆). Each star (☆) lowers the likelihood of becoming nervous by 10%.	●	—	—

Move Name	Move Effects	Appeal	Jamming	Target
Rage	Jamming effects fail if used first in a turn.	●	●●●	All previous
Rage Powder	No other contestant's moves will affect the excitement level for the remainder of the turn.	●●●	—	—
Rain Dance	Total appeal will vary based on the excitement level in the hall.	●	—	—
Rapid Spin	Total appeal will vary based on the excitement level in the hall.	●	—	—
Razor Leaf	No additional effects.	●●●●	—	—
Razor Shell	Receives no penalty for being used multiple times in a row.	●●●	—	—
Razor Wind	If the appeal of this move is greater than the appeal gained by the contestant immediately previous, it will be doubled. If less, it will become zero.	●●●	—	—
Recover	Receives triple the base appeal if the previous contestant used a move of the same type.	●●	—	—
Recycle	User also gains the same number of hearts as the previous contestant.	●	—	—
Reflect	User will be impervious to jamming effects one time that turn.	●●	—	—
Reflect Type	Receives triple the base appeal if the previous contestant used a move of the same type.	●●	—	—
Refresh	User will be impervious to jamming effects one time that turn.	●●	—	—
Relic Song	Can make remaining Pokémon nervous and unable to use moves.	●●	—	All remaining
Rest	User will be impervious to all jamming effects for the remainder of the turn.	●	—	—
Retaliate	If the appeal of this move is greater than the appeal gained by the contestant immediately previous, it will be doubled. If less, it will become zero.	●●●	—	—
Return	No additional effects.	●●●●	—	—
Revenge	Receives triple the base appeal when used last in a turn.	●●	—	—
Reversal	The user will receive more hearts the later in a turn this move is used (1–6 max).	●	—	—
Roar	User will move last on the next turn.	●●●	—	—
Roar of Time	Cannot participate in the next turn.	●●●●	●●●●	All previous
Rock Blast	Receives an additional amount of appeal at random (varies from 1–8 extra hearts).	●	—	—
Rock Climb	Interrupts any combos that were begun that turn, preventing them from being completed on the next turn.	●●●	—	Specific previous
Rock Polish	User will move first on the next turn.	●●●	—	—
Rock Slide	Jamming effects fail if used first in a turn.	●●	●●	All previous
Rock Smash	No additional effects.	●●●●	—	—
Rock Throw	No additional effects.	●●●●	—	—
Rock Tomb	Interrupts any combos that were begun that turn, preventing them from being completed on the next turn.	●●●	—	Specific previous
Rock Wrecker	Cannot participate in the next turn.	●●●●	●●●●	All previous
Role Play	User also gains the same number of hearts as the previous contestant.	●	—	—
Rolling Kick	No additional effects.	●●●●	—	—

Move Name	Move Effects	Appeal	Jamming	Target
Rollout	Receives no penalty for being used multiple times in a row.	●●●	—	—
Roost	Decreases audience excitement even more than usual if it does not match the contest condition.	●●●●	—	—
Rototiller	Pumps up the user and awards it a star (☆). Each star (☆) lowers the likelihood of becoming nervous by 10%.	●	—	—
Round	Receives triple the base appeal if the previous contestant used a move of the same type.	●●	—	—

S

Move Name	Move Effects	Appeal	Jamming	Target
Sacred Fire	Excites the audience even more than usual if it is used last in a turn and matches the contest condition.	●●●	—	—
Sacred Sword	Excites the audience regardless of contest condition.	●●	—	—
Safeguard	User will be impervious to jamming effects one time that turn.	●●	—	—
Sand Attack	Interrupts any combos that were begun that turn, preventing them from being completed on the next turn.	●●●	—	Specific previous
Sand Tomb	No other contestant's moves will affect the excitement level for the remainder of the turn.	●●●	—	—
Sandstorm	Reduces all previous contestants' appeal by half. Contestants with no hearts or negative hearts will gain a negative heart marker.	●●	●	All previous
Scald	Can make remaining Pokémon nervous and unable to use moves.	●●	—	All remaining
Scary Face	If a previous contestant is pumped up, it will lose its stars (☆) and be returned to its normal state.	●●●	—	Specific previous
Scratch	No additional effects.	●●●●	—	—
Screech	Interrupts any combos that were begun that turn, preventing them from being completed on the next turn.	●●●	—	Specific previous
Searing Shot	Receives no penalty for being used multiple times in a row.	●●●	—	—
Secret Power	Receives triple the base appeal as long as the user has at least 1 star (☆).	●	—	—
Secret Sword	Receives no penalty for being used multiple times in a row.	●●●	—	—
Seed Bomb	No additional effects.	●●●●	—	—
Seed Flare	The user will lose twice the normal appeal from other contestants' jamming moves.	●●●●●●	—	—
Seismic Toss	Receives no penalty for being used multiple times in a row.	●●●	—	—
Self-Destruct	Cannot participate in any of the remaining turns. Receives no effects from jamming.	●●●●●●●●	—	—
Shadow Ball	No additional effects.	●●●●	—	—
Shadow Claw	No additional effects.	●●●●	—	—
Shadow Force	User will be impervious to all jamming effects for the remainder of the turn.	●	—	—
Shadow Punch	Receives triple the base appeal when used first in a turn.	●●	—	—
Shadow Sneak	User will move first on the next turn.	●●●	—	—
Sharpen	Pumps up the user and awards it a star (☆). Each star (☆) lowers the likelihood of becoming nervous by 10%.	●	—	—
Sheer Cold	Reduces all previous contestants' appeal by half. Contestants with no hearts or negative hearts will gain a negative heart marker.	●●	●	All previous
Shell Smash	Excites the audience even more than usual if it is used last in a turn and matches the contest condition.	●●●	—	—
Shift Gear	Pumps up the user and awards it a star (☆). Each star (☆) lowers the likelihood of becoming nervous by 10%.	●	—	—
Shock Wave	Receives triple the base appeal when used first in a turn.	●●	—	—
Signal Beam	Interrupts any combos that were begun that turn, preventing them from being completed on the next turn.	●●●	—	Specific previous
Silver Wind	Pumps up the user and awards it a star (☆). Each star (☆) lowers the likelihood of becoming nervous by 10%.	●	—	—
Simple Beam	If a previous contestant is pumped up, it will lose its stars (☆) and be returned to its normal state.	●●●	—	Specific previous
Sing	Can make remaining Pokémon nervous and unable to use moves.	●●	—	All remaining
Sketch	User also gains the same number of hearts as the previous contestant.	●	—	—
Skill Swap	User also gains the same number of hearts as the previous contestant.	●	—	—
Skull Bash	If the appeal of this move is greater than the appeal gained by the contestant immediately previous, it will be doubled. If less, it will become zero.	●●●	—	—
Sky Attack	If the appeal of this move is greater than the appeal gained by the contestant immediately previous, it will be doubled. If less, it will become zero.	●●●	—	—
Sky Drop	No other contestant's moves will affect the excitement level for the remainder of the turn.	●●●	—	—
Sky Uppercut	If any other contestant used a move of the same type that turn, its appeal will be reduced by 4 hearts. If no other contestants used a move of the same type, their appeal will be reduced by 1 heart.	●●	●	Specific previous
Slack Off	Decreases audience excitement even more than usual if it does not match the contest condition.	●●●●	—	—
Slam	No additional effects.	●●●●	—	—
Slash	No additional effects.	●●●●	—	—
Sleep Powder	Jamming effects fail if used first in a turn.	●	●●●	All previous
Sleep Talk	Receives an additional amount of appeal at random (varies from 1–8 extra hearts).	●	—	—
Sludge	Jamming effects fail if used first in a turn.	●●	●●●	One previous
Sludge Bomb	Causes any contestants that began a combo that turn to lose 5 hearts. If no other contestants have started a combo, they will lose 1 heart.	●●	●	Specific previous
Sludge Wave	If a previous contestant is pumped up, it will lose its stars (☆) and be returned to its normal state.	●●●	—	Specific previous
Smack Down	Causes any contestants that began a combo that turn to lose 5 hearts. If no other contestants have started a combo, they will lose 1 heart.	●●	●	Specific previous
Smelling Salts	If the appeal of this move is greater than the appeal gained by the contestant immediately previous, it will be doubled. If less, it will become zero.	●●●	—	—

Move Name	Move Effects	Appeal	Jamming	Target
Smog	No additional effects.	●●●●	—	—
Smokescreen	Jamming effects fail if used first in a turn.	●●	●●●	One previous
Snarl	Decreases audience excitement even more than usual if it does not match the contest condition.	●●●●	—	—
Snatch	User also gains the same number of hearts as the previous contestant.	●	—	—
Snore	Decreases audience excitement even more than usual if it does not match the contest condition.	●●●●	—	—
Soak	Causes any contestants that began a combo that turn to lose 5 hearts. If no other contestants have started a combo, they will lose 1 heart.	●●	●	Specific previous
Soft-Boiled	Receives triple the base appeal when used first in a turn.	●●	—	—
Solar Beam	If the appeal of this move is greater than the appeal gained by the contestant immediately previous, it will be doubled. If less, it will become zero.	●●●	—	—
Sonic Boom	Receives no penalty for being used multiple times in a row.	●●●	—	—
Spacial Rend	The user will lose twice the normal appeal from other contestants' jamming moves.	●●●●●●	—	—
Spark	No additional effects.	●●●●	—	—
Spider Web	Can make remaining Pokémon nervous and unable to use moves.	●●	—	All remaining
Spike Cannon	Receives an additional amount of appeal at random (varies from 1–8 extra hearts).	●	—	—
Spikes	Can make remaining Pokémon nervous and unable to use moves.	●●	—	All remaining
Spiky Shield	User will be impervious to all jamming effects for the remainder of the turn.	●	—	—
Spit Up	Receives triple the base appeal as long as the user has at least 1 star (☆).	●	—	—
Spite	Reduces all previous contestants' appeal by half. Contestants with no hearts or negative hearts will gain a negative heart marker.	●●	●	All previous
Splash	Decreases audience excitement even more than usual if it does not match the contest condition.	●●●●	—	—
Spore	Jamming effects fail if used first in a turn.	●	●●●	All previous
Stealth Rock	Can make remaining Pokémon nervous and unable to use moves.	●●	—	All remaining
Steamroller	Receives no penalty for being used multiple times in a row.	●●●	—	—
Steel Wing	If the appeal of this move is greater than the appeal gained by the contestant immediately previous, it will be doubled. If less, it will become zero.	●●●	—	—
Sticky Web	Causes any contestants that began a combo that turn to lose 5 hearts. If no other contestants have started a combo, they will lose 1 heart.	●●	●	Specific previous
Stockpile	Pumps up the user and awards it a star (☆). Each star (☆) lowers the likelihood of becoming nervous by 10%.	●	—	—
Stomp	No additional effects.	●●●●	—	—
Stone Edge	If the appeal of this move is greater than the appeal gained by the contestant immediately previous, it will be doubled. If less, it will become zero.	●●●	—	—
Stored Power	Receives triple the base appeal as long as the user has at least 1 star (☆).	●	—	—
Storm Throw	Excites the audience regardless of contest condition.	●●	—	—
Strength	No additional effects.	●●●●	—	—
String Shot	Jamming effects fail if used first in a turn.	●●	●●●	One previous
Struggle Bug	Receives triple the base appeal when used last in a turn.	●●	—	—
Stun Spore	Reduces all previous contestants' appeal by half. Contestants with no hearts or negative hearts will gain a negative heart marker.	●●	●	All previous
Submission	The user will lose twice the normal appeal from other contestants' jamming moves.	●●●●●●	—	—
Substitute	User will be impervious to jamming effects one time that turn.	●●	—	—
Sucker Punch	Excites the audience even more than usual if it is used first in a turn and matches the contest condition.	●●●	—	—
Sunny Day	Total appeal will vary based on the excitement level in the hall.	●	—	—
Super Fang	Reduces all previous contestants' appeal by half. Contestants with no hearts or negative hearts will gain a negative heart marker.	●●	●	All previous
Superpower	The user will lose twice the normal appeal from other contestants' jamming moves.	●●●●●●	—	—
Supersonic	Interrupts any combos that were begun that turn, preventing them from being completed on the next turn.	●●●	—	Specific previous
Surf	Jamming effects fail if used first in a turn.	●●	●●	All previous
Swagger	If a previous contestant is pumped up, it will lose its stars (☆) and be returned to its normal state.	●●●	—	Specific previous
Swallow	User will be impervious to jamming effects one time that turn.	●●	—	—
Sweet Kiss	Can make remaining Pokémon nervous and unable to use moves.	●●	—	All remaining
Sweet Scent	User will be impervious to jamming effects one time that turn.	●●	—	—
Swift	Receives triple the base appeal when used first in a turn.	●●	—	—
Switcheroo	If any other contestant used a move of the same type that turn, its appeal will be reduced by 4 hearts. If no other contestants used a move of the same type, their appeal will be reduced by 1 heart.	●●	●	Specific previous
Swords Dance	Pumps up the user and awards it a star (☆). Each star (☆) lowers the likelihood of becoming nervous by 10%.	●	—	—
Synchronoise	Receives triple the base appeal if the previous contestant used a move of the same type.	●●	—	—
Synthesis	Receives an additional amount of appeal at random (varies from 1–8 extra hearts).	●	—	—

T

Move Name	Move Effects	Appeal	Jamming	Target
Tackle	No additional effects.	••••	—	—
Tail Glow	Pumps up the user and awards it a star (☆). Each star (☆) lowers the likelihood of becoming nervous by 10%.	•	—	—
Tail Slap	Receives an additional amount of appeal at random (varies from 1–8 extra hearts).	•	—	—
Tail Whip	Receives triple the base appeal when used last in a turn.	••	—	—
Tailwind	User will move first on the next turn.	•••	—	—
Take Down	The user will lose twice the normal appeal from other contestants' jamming moves.	••••••	—	—
Taunt	Causes any contestants that began a combo that turn to lose 5 hearts. If no other contestants have started a combo, they will lose 1 heart.	••	•	Specific previous
Techno Blast	Receives triple the base appeal as long as the user has at least 1 star (☆).	•	—	—
Teeter Dance	Cannot participate in the next turn.	••••	••••	All previous
Telekinesis	Can make remaining Pokémon nervous and unable to use moves.	••	—	All remaining
Teleport	User will be impervious to all jamming effects for the remainder of the turn.	•	—	—
Thief	User also gains the same number of hearts as the previous contestant.	•	—	—
Thrash	The user will lose twice the normal appeal from other contestants' jamming moves.	••••••	—	—
Thunder	Total appeal will vary based on the excitement level in the hall.	•	—	—
Thunder Fang	No additional effects.	••••	—	—
Thunder Punch	No additional effects.	••••	—	—
Thunder Shock	No additional effects.	••••	—	—
Thunder Wave	Jamming effects fail if used first in a turn.	•	•••	All previous
Thunderbolt	No additional effects.	••••	—	—
Tickle	If a previous contestant is pumped up, it will lose its stars (☆) and be returned to its normal state.	•••	—	Specific previous
Topsy-Turvy	Randomizes the order in which contestants use moves in the next turn.	•••	—	—
Torment	Can make remaining Pokémon nervous and unable to use moves.	••	—	All remaining
Toxic	If a previous contestant is pumped up, it will lose its stars (☆) and be returned to its normal state.	•••	—	Specific previous
Toxic Spikes	Can make remaining Pokémon nervous and unable to use moves.	••	—	All remaining
Transform	Receives no penalty for being used multiple times in a row.	•••	—	—
Tri Attack	Receives an additional amount of appeal at random (varies from 1–8 extra hearts).	•	—	—
Trick	If any other contestant used a move of the same type that turn, its appeal will be reduced by 4 hearts. If no other contestants used a move of the same type, their appeal will be reduced by 1 heart.	••	•	Specific previous
Trick Room	Randomizes the order in which contestants use moves in the next turn.	•••	—	—
Trick-or-Treat	If any other contestant used a move of the same type that turn, its appeal will be reduced by 4 hearts. If no other contestants used a move of the same type, their appeal will be reduced by 1 heart.	••	•	Specific previous
Triple Kick	Receives no penalty for being used multiple times in a row.	•••	—	—
Trump Card	The user will receive more hearts the later in a turn this move is used (1–6 max).	•	—	—
Twineedle	If any other contestant used a move of the same type that turn, its appeal will be reduced by 4 hearts. If no other contestants used a move of the same type, their appeal will be reduced by 1 heart.	••	•	Specific previous
Twister	No additional effects.	••••	—	—

U

Move Name	Move Effects	Appeal	Jamming	Target
Uproar	Causes any contestants that began a combo that turn to lose 5 hearts. If no other contestants have started a combo, they will lose 1 heart.	••	•	Specific previous
U-turn	Decreases audience excitement even more than usual if it does not match the contest condition.	••••	—	—

V

Move Name	Move Effects	Appeal	Jamming	Target
Vacuum Wave	User will move first on the next turn.	•••	—	—
V-create	The user will lose twice the normal appeal from other contestants' jamming moves.	••••••	—	—
Venom Drench	If a previous contestant is pumped up, it will lose its stars (☆) and be returned to its normal state.	•••	—	Specific previous
Venoshock	Receives triple the base appeal if the previous contestant used a move of the same type.	••	—	—
Vice Grip	No additional effects.	••••	—	—
Vine Whip	No additional effects.	••••	—	—
Vital Throw	Receives triple the base appeal when used last in a turn.	••	—	—
Volt Switch	Decreases audience excitement even more than usual if it does not match the contest condition.	••••	—	—
Volt Tackle	The user will lose twice the normal appeal from other contestants' jamming moves.	••••••	—	—

Move Name	Move Effects	Appeal	Jamming	Target
Wake-Up Slap	If the appeal of this move is greater than the appeal gained by the contestant immediately previous, it will be doubled. If less, it will become zero.	●●●	—	—
Water Gun	No additional effects.	●●●●	—	—
Water Pledge	Excites the audience regardless of contest condition.	●●	—	—
Water Pulse	Interrupts any combos that were begun that turn, preventing them from being completed on the next turn.	●●●	—	Specific previous
Water Shuriken	User will move first on the next turn.	●●●	—	—
Water Sport	Excites the audience regardless of contest condition.	●●	—	—
Water Spout	The user will lose twice the normal appeal from other contestants' jamming moves.	●●●●●●	—	—
Waterfall	No additional effects.	●●●●	—	—
Weather Ball	Receives no penalty for being used multiple times in a row.	●●●	—	—
Whirlpool	No other contestant's moves will affect the excitement level for the remainder of the turn.	●●●	—	—
Whirlwind	User will move last on the next turn.	●●●	—	—
Wide Guard	User will be impervious to all jamming effects for the remainder of the turn.	●	—	—
Wild Charge	The user will lose twice the normal appeal from other contestants' jamming moves.	●●●●●●	—	—
Will-O-Wisp	Interrupts any combos that were begun that turn, preventing them from being completed on the next turn.	●●●	—	Specific previous
Wing Attack	No additional effects.	●●●●	—	—
Wish	Excites the audience even more than usual if it is used last in a turn and matches the contest condition.	●●●	—	—
Withdraw	User will be impervious to jamming effects one time that turn.	●●	—	—
Wonder Room	Randomizes the order in which contestants use moves in the next turn.	●●●	—	—
Wood Hammer	The user will lose twice the normal appeal from other contestants' jamming moves.	●●●●●●	—	—
Work Up	Excites the audience even more than usual if it is used first in a turn and matches the contest condition.	●●●	—	—
Worry Seed	Can make remaining Pokémon nervous and unable to use moves.	●●	—	All remaining
Wrap	No other contestant's moves will affect the excitement level for the remainder of the turn.	●●●	—	—
Wring Out	If any other contestant used a move of the same type that turn, its appeal will be reduced by 4 hearts. If no other contestants used a move of the same type, its appeal will be reduced by 1 heart.	●●	●	Specific previous

X · Y · Z

Move Name	Move Effects	Appeal	Jamming	Target
X-Scissor	If any other contestant used a move of the same type that turn, its appeal will be reduced by 4 hearts. If no other contestants used a move of the same type, their appeal will be reduced by 1 heart.	●●	●	Specific previous
Yawn	Can make remaining Pokémon nervous and unable to use moves.	●●	—	All remaining
Zap Cannon	Reduces all previous contestants' appeal by half. Contestants with no hearts or negative hearts will gain a negative heart marker.	●●	●	All previous
Zen Headbutt	No additional effects.	●●●●	—	—

CONTEST COMBOS

Start a sleepy combo with...	Sing	Sleep Powder	Hypnosis	Lovely Kiss	Grass Whistle	Dark Void	Spore	Yawn
Then finish it up with...	Dream Eater	Nightmare	Wake-Up Slap	Hex				
Start a poisonous combo with...	Toxic	Poison Gas	Poison Powder	Toxic Spikes				
Then finish it up with...	Venoshock	Venom Drench	Hex					
Start a paralyzing combo with...	Thunder Wave	Nuzzle	Stun Spore	Glare	Zap Cannon	Force Palm		
Then finish it up with...	Smelling Salts	Hex						
Start a burning combo with...	Will-O-Wisp	Inferno						
Then finish it up with...	Hex							
Start a sunny combo with...	Sunny Day							
Then finish it up with...	Morning Sun	Synthesis	Moonlight	Solar Beam	Growth	Weather Ball		
Start a rainy combo with...	Rain Dance							
Then finish it up with...	Thunder	Hurricane	Water Sport	Soak	Weather Ball			
Start a hail combo with...	Hail							
Then finish it up with...	Blizzard	Icicle Crash	Powder Snow	Icy Wind	Glaciate	Weather Ball		
Start a sandstorm combo with...	Sandstorm							
Then finish it up with...	Sand Attack	Sand Tomb	Weather Ball					

Start a stockpiled combo with...	Stockpile							
Then finish it up with...	Swallow	Spit Up						
Start an enduring combo with...	Endure							
Then finish it up with...	Reversal	Endeavor	Flail	Pain Split				
Start a defensive combo with...	Defense Curl							
Then finish it up with...	Rollout	Ice Ball						
Start a resting combo with...	Rest							
Then finish it up with...	Snore	Sleep Talk						
Start a well-aimed combo with...	Lock-On	Mind Reader	Miracle Eye					
Then finish it up with...	Guillotine	Horn Drill	Fissure	Sheer Cold				
Start a synchronized combo with...	Reflect Type							
Then finish it up with...	Synchronoise							
Start a stat-boosting combo with...	Amnesia	Nasty Plot	Calm Mind	Hone Claws	Cotton Guard			
Then finish it up with...	Stored Power	Baton Pass						
Start a taunting combo with...	Taunt	Torment	Encore					
Then finish it up with...	Counter	Mirror Coat	Metal Burst	King's Shield	Spite	Grudge	Destiny Bond	
Start a speedy combo with...	Agility	Rock Polish	Autotomize	Shell Smash				
Then finish it up with...	Electro Ball	Baton Pass						
Start an entrapping combo with...	Block	Mean Look	Spider Web					
Then finish it up with...	Perish Song							
Start a critical-hit combo with...	Focus Energy							
Then finish it up with...	Blaze Kick	Poison Tail	Cross Poison	Leaf Blade	Night Slash	Shadow Claw	Psycho Cut	Stone Edge
	Attack Order	Spacial Rend	Drill Run	Karate Chop	Aeroblast			
Start a wishful combo with...	Wish	Covet	Celebrate	Happy Hour				
Then finish it up with...	Fling	Bestow	Present					
Start a whirlwind of a combo with...	Stealth Rock	Spikes	Toxic Spikes					
Then finish it up with...	Whirlwind	Roar	Circle Throw	Dragon Tail				
Start a stringy combo with...	String Shot							
Then finish it up with...	Sticky Web	Electroweb	Spider Web					
Start a horticultural combo with...	Rototiller							
Then finish it up with...	Seed Bomb	Bullet Seed	Worry Seed	Leech Seed				
Start a substitute combo with...	Play Nice	Hold Hands	Entrainment					
Then finish it up with...	Seismic Toss	Vital Throw	Wake-Up Slap	Smack Down	Storm Throw	Circle Throw	Sky Drop	
Start an inescapable combo with...	Block	Mean Look	Spider Web					
Then finish it up with...	Self-Destruct	Explosion	Memento					
Start a charged combo with...	Charge							
Then finish it up with...	Thunder Punch	Thunder	Thunder Shock	Thunderbolt	Spark	Volt Tackle	Shock Wave	Thunder Fang
	Discharge	Charge Beam	Electro Ball	Volt Switch	Bolt Strike	Fusion Bolt	Parabolic Charge	Nuzzle
Start a geared combo with...	Shift Gear							
Then finish it up with...	Gear Grind							
Start an electric combo with...	Parabolic Charge							
Then finish it up with...	Electrify							
Start an eggy combo with...	Soft-Boiled							
Then finish it up with...	Egg Bomb							

SPECTACULAR TALENTS

Type	Coolness	Beauty	Cuteness	Cleverness	Toughness
Normal	Incredible Shining Road	Graceful Shining Road	Pretty Shining Road	Bright Shining Road	Strong Shining Road
Fire	Splendid Inferno	Exquisite Inferno	Scintillating Inferno	Philosophical Inferno	Devouring Inferno
Water	Amazing Blessed Rain	Serene Blessed Rain	Pattering Blessed Rain	Clear Blessed Rain	Soaking Blessed Rain
Grass	Fresh Flower Garden	Cultured Flower Garden	Enchanting Flower Garden	Blooming Flower Garden	Impressive Flower Garden
Electric	Striking Chronicles	Lightning Dazzle	Glittering Rhapsody	Electrodynamic Archives	Thunderbolt Aftershock
Ice	Sublime Iceberg	Glistening Icicles	Twinkling Diamonds	Acute Frost	Powerful Blizzard
Fighting	Grand Advance	Uplifting Dawn	Charming Onslaught	Tactical Approach	Ballistic Bullet
Poison	Toxiquad CL	Venin Quartet BT	Poison Orbit CN	Vitriolic Division CV	Blighted Force TG
Ground	Planet Burst	Global Shuddering	Shaky Ground	Tectonic Shift	Supershear Quake
Flying	Glorious Skies	Celestial Skies	Pleasant Skies	Keen Skies	Intrepid Skies
Psychic	Techno	Serenade	Lullaby	Madrigal	Anthem
Bug	Cool Chrysalis	Radiant Emergence	Sweet Unfurling	Intellectual Awakening	Bold Transformation
Rock	Rising Above	Roaring Fantasia	Echo Ridge	Ambient World	These Stone Walls
Ghost	Accursed House	Nightmare Dawn	Midnight Revels	Evil Rituals	Agony Theater
Dragon	Doom Incarnate	Regal Courtesy	Passionate Archetype	Proven Sagacity	Agent of Divinity
Dark	Moonlit Pledge	Moonscape Reflection	Moonrise Beckoning	Moonbright Vision	Moonshadow Sorrow
Steel	Clarior E Tenebris	Luceat Lux Vestra	Amor Vincit Omnia	Scientia Potentia Est	Audaces Fortuna Iuvat
Fairy	Awesome ★ Adventure	Elegant ★ Outing	Delightful ★ Wandering	Intelligent ★ Expedition	Heroic ★ Journey

CONTEST TRAINER LIST

Contest Rank	Trainer	Pokémon	Pokémon's Gender	Move 1	Move 2	Move 3	Move 4
Normal	Aroma Lady Liliana	Guligan (Gulpin)	♀	Poison Gas	Toxic	Amnesia	Yawn
	Black Belt Jeremiah	Makuwaku (Makuhita)	♂	Arm Thrust	Smelling Salts	Force Palm	Focus Energy
	Bug Catcher Mateo	Nox (Dustox)	♂	Silver Wind	Moonlight	Struggle Bug	Protect
	Camper Martinus	Zoonby (Zubat)	♂	Haze	Mean Look	Confuse Ray	Leech Life
	Guitarist Camden	Bolt (Electrike)	♂	Spark	Howl	Bite	Light Screen
	Lady Shannon	Gonzer (Zigzagoon)	♀	Mud Sport	Tail Whip	Pin Missile	Odor Sleuth
	Lass Gianna	Tailster (Taillow)	♀	Wing Attack	Double Team	Aerial Ace	Echoed Voice
	Ninja Boy Declan	Ninny (Nincada)	♂	Leech Life	Mind Reader	Fury Swipes	Mud-Slap
	Picnicker Molly	Ronnie (Aron)	♀	Metal Claw	Headbutt	Harden	Take Down
	Poké Fan Asher	Visikoth (Slakoth)	♂	Strength	Counter	Yawn	Encore
	Poké Fan Lauren	Whizz (Whismur)	♀	Astonish	Sleep Talk	Substitute	Screech
	Schoolkid Carlton	Shrewmish (Shroomish)	♂	Absorb	Stun Spore	Leech Seed	Headbutt
	Schoolkid Jordyn	Seedottie (Seedot)	♀	Harden	Bide	Synthesis	Leech Seed
	Tuber Adeline	Win (Wingull)	♀	Water Gun	Growl	Water Pulse	Mist
	Youngster Micah	Poochin (Poochyena)	♂	Bite	Scary Face	Tackle	Fire Fang
Super	Ace Trainer Gabriella	Leon (Kecleon)	♀	Slash	Shadow Claw	Fury Swipes	Thief
	Aroma Lady Keira	Rosalie (Roselia)	♀	Magical Leaf	Growth	Sweet Scent	Grass Knot
	Bird Keeper Bentley	Dodon't (Doduo)	♂	Peck	Fury Attack	Rage	Acupressure
	Camper Rohan	Spinmaster (Spinda)	♂	Dizzy Punch	Teeter Dance	Hypnosis	Dream Eater
	Lady Alaina	Swellbell (Swablu)	♀	Astonish	Sing	Round	Mist
	Lass Plum	Tracy (Trapinch)	♀	Bite	Dig	Bulldoze	Feint Attack
	Parasol Lady Mila	Mel (Numel)	♀	Flame Burst	Earth Power	Ember	Amnesia
	Picnicker Alyssa	Sandyclaws (Sandshrew)	♀	Fury Cutter	Rapid Spin	Fury Swipes	Dig
	Pokémon Breeder Kaitlyn	Barbra (Barboach)	♀	Water Gun	Water Sport	Water Pulse	Round

Contest Rank	Trainer	Pokémon	Pokémon's Gender	Move 1	Move 2	Move 3	Move 4
Super	Pokémon Breeder Zachary	Succulus (Cacnea)	♂	Needle Arm	Poison Sting	Leech Seed	Sand Attack
	Pokémon Ranger Adalyn	Tad (Lotad)	♀	Mega Drain	Zen Headbutt	Growl	Bubble
	Psychic Tyler	Spearl (Spoink)	♂	Psybeam	Magic Coat	Attract	Rest
	Rich Boy Chaz	Macherie (Machoke)	♀	Attract	Bulk Up	Brick Break	Low Sweep
	Ruin Maniac Brody	Baltop (Baltoy)	—	Confusion	Rock Tomb	Mud-Slap	Harden
	Schoolkid Dominic	Snip (Corphish)	♂	Cut	Harden	Knock Off	Double Hit
	Triathlete Levi	Noone (Linoone)	♂	Cut	Surf	Rock Smash	Strength
Hyper	Beauty Twyla	Papi (Beautifly)	♀	Silver Wind	Morning Sun	Confide	Air Cutter
	Collector Yoshinari	Crawly (Seviper)	♂	Venoshock	Venom Drench	Glare	Thief
	Fisherman Gavin	The King (Seaking)	♂	Water Pulse	Waterfall	Horn Attack	Fury Attack
	Gentleman Nathan	Mighty (Mightyena)	♂	Odor Sleuth	Embargo	Assurance	Crunch
	Hiker Primo	Chopchop (Machop)	♂	Brick Break	Bulk Up	Karate Chop	Dual Chop
	Ninja Boy Nelson	Ninjackie (Ninjask)	♂	Fury Swipes	Harden	X-Scissor	Double Team
	Parasol Lady Lily	Camelot (Camerupt)	♀	Earth Power	Flame Burst	Amnesia	Growl
	Poké Maniac Landon	Wonwon (Lairon)	♂	Rock Tomb	Metal Sound	Iron Defense	Take Down
	Pokémon Breeder Alejandra	Nombre (Lombre)	♀	Fake Out	Water Sport	Natural Gift	Knock Off
	Pokémon Ranger Mckenzie	Nuzlad (Nuzleaf)	♀	Razor Leaf	Extrasensory	Explosion	Nature Power
	Psychic Addison	Moony (Lunatone)	—	Psychic	Future Sight	Hypnosis	Rock Polish
	Rich Boy Chaz	Macherie (Machoke)	♀	Return	Attract	Round	Sunny Day
	Sailor Jayce	Piper (Pelipper)	♂	Wing Attack	Stockpile	Swallow	Spit Up
	Swimmer ♂ Owen	Magi (Magikarp)	♂	Splash	Flail	Tackle	Bounce
	Triathlete Riley	Wollew (Swellow)	♀	Wing Attack	Air Slash	Focus Energy	Quick Attack
	Tuber Lacy	Bobble (Wailmer)	♀	Astonish	Rollout	Rest	Water Spout
Master	Aroma Lady Momo	Plumette (Vileplume)	♀	Petal Blizzard	Petal Dance	Grassy Terrain	Solar Beam
	Beauty Madelyn	Princess (Illumise)	♀	Wish	Play Nice	Zen Headbutt	Confuse Ray
	Black Belt Clayton	Heracles (Heracross)	♂	Fury Attack	Reversal	Endure	Giga Impact
	Delinquent Yoko	Gyalaxy (Gyarados)	♀	Dragon Dance	Hyper Beam	Crunch	Thrash
	Expert Jaylon	Slacker (Slaking)	♂	Bulk Up	Slack Off	Chip Away	Counter
	Fairy Tale Girl Julia	Elizabeth (Wobbuffet)	♀	Counter	Mirror Coat	Safeguard	Destiny Bond
	Free Diver Layla	Gorflir (Gorebyss)	♀	Whirlpool	Aqua Tail	Surf	Agility
	Guitarist Jeff	Louduff (Loudred)	♂	Hyper Voice	Retaliate	Howl	Echoed Voice
	Poké Fan Elsie	Mione (Delcatty)	♀	Fake Out	Double Slap	Disarming Voice	Safeguard
	Poké Fan Evan	Pinchurlink (Pichu)	♂	Sweet Kiss	Tail Whip	Charm	Confide
	Psychic Ruslan	Lia (Kirlia)	♂	Stored Power	Calm Mind	Psych Up	Trick Room
	Rich Boy Chaz	Macherie (Machoke)	♀	Return	Attract	Round	Sunny Day
	Sailor Elijah	Shargob (Sharpedo)	♂	Poison Fang	Assurance	Rage	Scald
	Street Thug Aiden	Topclops (Dusclops)	♂	Toxic	Hex	Spite	Curse
	Swimmer ♀ Hailey	Lovelynn (Luvdisc)	♀	Draining Kiss	Sweet Kiss	Psych Up	Substitute
	Triathlete Audrey	Trode (Electrode)	—	Sonic Boom	Electro Ball	Discharge	Explosion
Master (Beauty)	Pokémon Trainer Lisia	Ali (Altaria)	♂	Dazzling Gleam	Round	Mist	Draco Meteor
Master (Cleverness)			♂	Natural Gift	Power Swap	Sing	Dream Eater
Master (Coolness)			♂	Outrage	Aerial Ace	Dragon Dance	Tailwind
Master (Cuteness)			♂	Disarming Voice	Growl	Hone Claws	Attract
Master (Toughness)			♂	Earthquake	Take Down	Giga Impact	Aerial Ace
Master	Leader Wallace	Milotic (Milotic)	♀	Aqua Tail	Blizzard	Round	Aqua Ring

SECRET BASES

Secret Spot locations

You've learned the basics of finding Secret Spots (p. 112), decorating your base (p. 113), making Secret Pals (p. 114), and elevating your team through the ranks at the Secret Base Guild (p. 165). Now it's time to really run wild! The following pages provide the complete list of all Secret Base locations in Hoenn. The farther off the beaten path a Secret Spot is, the better its digs tend to be—so get out there and find your perfect spot!

Indent Secret Spot

Tree Secret Spot

Grass pile Secret Spot

The tables on the following pages will guide you to every Secret Spot to be found in the Hoenn region. A picture allows you to see what the Secret Spot looks like from the outside, and its entrance is marked with a yellow star. You can also get an idea of what kind of layout it has, even before you step foot in it! On the layout diagrams, the blue squares represent the location of the base's PC, and the green flags show where your team flag will be located. Any brown patches represent an obstacle, such as a change in elevation or a hole in the ground, that you will need special Decorations to tackle. The information about the location and the Secret Spot's appearance will help you find each Secret Spot in your adventure. Finally, the last column warns you if you'll need special moves or items to reach a Secret Spot.

TRAINER HANDBOOK

ADVANCED HANDBOOK

ADVENTURE DATA

No.	Exterior image	Layout	Location	Appearance	Details	Special requirements
1			Route 110 (#1)	Tree	Small island in the lake A Secret Base above a tree growing on an islet with a chic sign.	Surf
2			Route 111 (#1)	Indent	Northeast corner of the desert A Secret Base positioned in a tucked-away corner of a large desert.	Go-Go Goggles
3			Route 111 (#2)	Indent	North end of the desert A Secret Base in a romantic cave from which sandstorms may be admired.	Go-Go Goggles
4			Route 111 (#3)	Indent	In the middle of the rocky hills in the north of the desert A Secret Base in a cave that's popular with sand maniacs for its panoramic desert views.	Go-Go Goggles, Mach Bike
5			Route 111 (#4)	Indent	Far east part of the rocky hills in the north of the desert (beyond the Black Belt) A Secret Base in a cave where clouds of dust come blowing in from the desert and sting your eyes.	Go-Go Goggles, Mach Bike
6			Route 111 (#5)	Tree	Where you first met Aarune (west of the house where you can rest your team) A Secret Base above a tree that can truly be called regal and is standing nonchalantly along the road.	
7			Route 111 (#6)	Indent	Northeast corner of the rocky rise behind the house where you can rest your team A Secret Base in a cave just for Bike enthusiasts that can't be reached without a Mach Bike.	Mach Bike
8			Route 113 (#1)	Indent	Middle of the route (near the Parasol Lady) A Secret Base in a cave where the scenery and your mood will turn gray thanks to the piles of volcanic ash.	
9			Route 114 (#1)	Tree	Small island in the lake north of Lanette's house A Secret Base above a tree on a very suspicious-looking islet floating all alone in a lake.	Surf

No.	Exterior image	Layout	Location	Appearance	Details	Special requirements
10			Route 114 (#2)	Indent	Rocky hills southwest of Lanette's house (up the stairs) *A Secret Base in an exceedingly natural cave hiding casually between cliffs.*	
11			Route 114 (#3)	Indent	Rocky hills south of Lanette's house (surrounded by cracked boulders) *A Secret Base in a cave fortified by rocks that block the way.*	Rock Smash
12			Route 114 (#4)	Indent	Rocky hills south of Lanette's house (east of Route 114's #3) *A Secret Base in a cave so extremely ordinary that it needs no explanation at all.*	
13			Route 114 (#5)	Indent	Southeast of Meteor Falls entrance (at the base of the stairs) *A Secret Base in a cave that is said to have been formed by a crater where you can feel the cosmos.*	
14			Route 114 (#6)	Indent	Immediately east of Meteor Falls entrance *A Secret Base in a cave that is rumored to connect to Meteor Falls.*	Rock Smash
15			Route 115 (#1)	Indent	East of Meteor Falls entrance *A Secret Base in a humid cave that is said to be a part of Meteor Falls.*	Surf
16			Route 115 (#2)	Indent	Shore northwest of Meteor Falls entrance *A Secret Base in a cave where you can get your thrills and that seems like it would sink at high tide.*	Surf
17			Route 115 (#3)	Tree	Green hills at north end of the route (up the stairs from Route 115's #2) *A Secret Base above a tree, tucked away off Route 115 where the sea breeze feels great.*	Surf
18			Route 115 (#4)	Indent	Rocky hills at north end of the route (past the Ruin Maniac—northern indent) *A Secret Base in a cave that's said to have been a dwelling for people long ago.*	Surf
19			Route 115 (#5)	Indent	Rocky hills at north end of the route (past the Ruin Maniac—southern indent) *A Secret Base in a cave that's said to have long ago been the den of Pokémon that lived with people.*	Surf

No.	Exterior image	Layout	Location	Appearance	Details	Special requirements
20			Route 115 (#6)	Indent	Rocky hills at north end of the route (beyond the slippery slope) *A Secret Base in a cave that's said to have been lived in by a chief from a village long ago.*	Surf, Mach Bike
21			Route 116 (#1)	Indent	Rocky hills east of Rusturf Tunnel entrance (up the stairs on the Rustboro side) *A Secret Base in a cave that's connected to Rusturf Tunnel. It stays cool regardless of the season.*	
22			Route 116 (#2)	Indent	Southeast of Rusturf Tunnel entrance (on the Rustboro side) *A Secret Base in a cave that people can't usually find because it's hiding out in the open.*	
23			Route 116 (#3)	Indent	Rocky hills north of Rusturf Tunnel entrance (middle exit) *A Secret Base in a cave in the hills just beyond Rusturf Tunnel with a most amazing view.*	
24			Route 116 (#4)	Indent	Rocky wall east of Rusturf Tunnel entrance (middle exit) *A Secret Base in a cave that's a little exciting because it seems like a man who lost his glasses might find it.*	
25			Route 117 (#1)	Tree	Middle of the route (north of the Berry plots) *A Secret Base above a tree right in the middle of the route, as if it weren't a secret at all.*	
26			Route 118 (#1)	Indent	Rocky outcrop on west shore (Mauville side) *A Secret Base in a cave that's in danger of being found by the Guitarist on the big rock by the inlet.*	
27			Route 118 (#2)	Indent	Rocky outcrop on east shore (near Fisherman) *A Secret Base in a cave that's in danger of being found by the Fisherman on the big rock by the inlet.*	
28			Route 118 (#3)	Indent	Large rocky outcrop on east shore (southeast corner) *A Secret Base in a cave by the big rock by the inlet that's relatively difficult to find.*	
29			Route 118 (#4)	Tree	North of the thorny trees where you once met Steven *A Secret Base above a tree where you can watch the growth of trees with dangerous thorns.*	Cut

No.	Exterior image	Layout	Location	Appearance	Details	Special requirements
30			Route 118 (#5)	Indent	Northeast corner of the route *A Secret Base in the cave surrounded by grass that stands out the least on Route 118.*	
31			Route 119 (#1)	Grass Pile	East of Fortree City entrance (near the sign) *A Secret Base in a bush next to soft soil that gardeners can't get enough of.*	
32			Route 119 (#2)	Grass Pile	Southern landing off of the river that runs beside the Weather Institute (beyond the very tall grass) *A Secret Base in a bush over the river and through the tall grass that's popular for being hard to find.*	Surf
33			Route 119 (#3)	Tree	Southern landing off of the river that runs beside the Weather Institute (west of Route 119's #2) *A Secret Base above a tree by a river that's big with connoisseurs along Route 119.*	Surf
34			Route 119 (#4)	Indent	Northern landing off of the river that runs beside the Weather Institute (near the waterfall) *A Secret Base in a quietly refined cave where the sound of a waterfall soaks into your body.*	Surf
35			Route 119 (#5)	Grass Pile	Northwest corner of the highland above the Weather Institute (up the waterfall) *A Secret Base in a bush that the nearby Bird Keeper knows about even though it's in an out-of-the-way place.*	Surf, Waterfall, Acro Bike
36			Route 119 (#6)	Grass Pile	Southwest corner of the highland above the Weather Institute (up the waterfall) *A Secret Base in a bush at the end of a railing bridge.*	Surf, Waterfall, Acro Bike
37			Route 119 (#7)	Grass Pile	Far side of the river, west of the house where you can rest your team (up the stairs) *A Secret Base in a bush that's a little itchy and surrounded by long grass.*	Surf
38			Route 119 (#8)	Indent	Near the waterfall, on the level above the house where you can rest your team *A Secret Base in a cave that can be seen from a long bridge but takes a long time to reach.*	Acro Bike
39			Route 119 (#9)	Indent	East of Route 119's #8, on the opposite side of the waterfall *A Secret Base in a cave where you can kill time by watching people cross a long bridge.*	

No.	Exterior image	Layout	Location	Appearance	Details	Special requirements
40			Route 119 (#10)	Grass Pile	Southeast of Route 119's #9, beyond the very tall grass *A Secret Base in a bush with a slimy floor due to being in a place with a lot of rain.*	Surf or Acro Bike
41			Route 120 (#1)	Indent	Shore directly north of Scorched Slab (down the stairs) *A Secret Base in a cave that's apparently sometimes visited by people who mistake it for Scorched Slab.*	
42			Route 120 (#2)	Grass Pile	Beyond the very tall grass (east of Fortree City exit) *A Secret Base in a bush surrounded by tall grass where you can see Pokémon often.*	
43			Route 120 (#3)	Grass Pile	East of Scorched Slab (near the Berry plots) *A Secret Base in a bush in a small open area beyond a thorny tree.*	Cut
44			Route 120 (#4)	Grass Pile	East side of the very tall grass maze (south of Route 120's #3) *A Secret Base in a bush deep in the long grass that's perfect to hide out in.*	
45			Route 120 (#5)	Indent	Northern shore of the lake beneath the southern bridge *A Secret Base in a cave that boasts of a view of a clear lake right before your eyes.*	Surf
46			Route 120 (#6)	Grass Pile	Near entrance to Route 121 *A Secret Base in a bush that stinks of grass from being covered in long grass.*	
47			Route 120 (#7)	Grass Pile	South of Ancient Tomb *A Secret Base in a bush next to soft soil and a pond where gardening and fishing are enjoyed.*	
48			Route 120 (#8)	Tree	Northeast of Ancient Tomb *A Secret Base above a tree where the unusual aura from nearby mysterious ruins hangs thick in the air.*	
49			Route 121 (#1)	Indent	Southwest of Safari Zone entrance (beyond the pier) *A Secret Base in a cave blocked by a thorny tree and positioned along the water's edge.*	Cut

No.	Exterior image	Layout	Location	Appearance	Details	Special requirements
50			Route 121 (#2)	Tree	Immediately east of Safari Zone entrance *A Secret Base above a tree next to the Safari Zone where the smells of Pokémon sometimes come wafting over.*	
51			Route 121 (#3)	Indent	South of Safari Zone entrance (west of the Teammates) *A Secret Base in a cave near some stairs, so the footsteps of passersby are noisy.*	
52			Route 123 (#1)	Indent	Two ledges east and above 123 Go Fish (near Ace Trainer) *A Secret Base in a cave that doesn't leave much of an impression on a route with a gentle slope.*	
53			Route 123 (#2)	Indent	Rock wall east of 123 Go Fish *A Secret Base in a cave dedicated to Fishermen with outstanding access to 123 Go Fish.*	
54			Route 123 (#3)	Tree	East of Berry Master's house *A Secret Base above a tree that gardeners long for due to its outstanding access to the Berry fields.*	
55			Route 125 (#1)	Indent	Rocky outcrop on the island directly north of Mossdeep Pokémon Gym *A Secret Base in a cave positioned on a small beach where the winds blow in from the sea.*	Surf
56			Route 125 (#2)	Indent	Rocky outcrop on the island west of Shoal Cave *A Secret Base in a cave next to Shoal Cave, making it great for hunting for salt and seashells.*	Surf
57			Route 125 (#3)	Indent	Rocky outcrop on the island in the sea east of Shoal Cave (lefthand indent) *A Secret Base in a cave made in what would be the little brother of what everyone calls twin rocks.*	Surf
58			Route 125 (#4)	Indent	Rocky outcrop on the island in the sea east of Shoal Cave (righthand indent) *A Secret Base in a cave made in what would be the big brother of what everyone calls twin rocks.*	Surf
59			Route 126 (#1)	Indent	Small green shore northwest of Sootopolis City (must navigate deepsea trenches) *A Secret Base in a cave that can't be reached without using Dive, even though it looks like you could Surf there.*	Surf, Dive

No.	Exterior image	Layout	Location	Appearance	Details	Special requirements
60			Route 126 (#2)	Indent	Sandy shore in the center of a rocky island, northwest of Sootopolis City (must navigate deepsea trenches) *A Secret Base in a cave that's high level of secrecy stops it from being found just by using Surf as usual.*	Surf, Dive
61			Route 127 (#1)	Indent	Rocky outcrop on the small island surrounded by three Fishermen *A Secret Base in a cave you cannot relax in because it's always surrounded by Fishermen.*	Surf
62			Route 127 (#2)	Indent	Rocky wall on the island northeast of Route 127's #1 *A Secret Base in a cave fated to disappear as it continues to be eroded by the waves.*	Surf
63			Route 127 (#3)	Indent	Rocky wall on the large island south of Route 127's #1 and #2 (lefthand indent) *A Secret Base in a cave that still shows traces of having been the den of Water-type Pokémon long ago.*	Surf
64			Route 127 (#4)	Indent	Rocky wall on the large island south of Route 127's #1 and #2 (middle indent) *A Secret Base in a cave said to have been the hideout for a robber being pursued by the International Police.*	Surf
65			Route 127 (#5)	Indent	Rocky wall on the large island south of Route 127's #1 and #2 (righthand indent) *A Secret Base in a cave where the International Police held a stakeout to catch a robber.*	Surf
66			Rusturf Tunnel	Indent	Northeast corner inside the tunnel *A Secret Base in a cave where you can't fall asleep at night because of the wild Whismur going berserk every night.*	
67			Granite Cave	Indent	Granite Cave (B1F) *A Secret Base in a cave in a dark cellar that's popular with women who dislike getting a suntan.*	Flash, Mach Bike
68			Jagged Pass	Indent	West side of the middle of the pass (small cliff only reachable by Bike) *A Secret Base in a cave with an extremely comfortable interior despite it being on a dangerous path by a cliff.*	Acro Bike or Mach Bike
69			Fiery Path	Indent	Beside the TM for Toxic *A Secret Base in a cave that you can expect to have the same effects as a sauna due to the hot location.*	Strength

No.	Exterior image	Layout	Location	Appearance	Details	Special requirements
70			Secret Shore (No. 303)	Indent	Accessible through southeast corner of Route 129 (can be reached by Fly after your first visit) *A Secret Base in a cave commonly referred to as No. 303 due to the housing-development-like structure of the plot.*	Surf, Dive
71			Secret Shore (No. 301)	Indent	Accessible through southeast corner of Route 129 (can be reached by Fly after your first visit) *A Secret Base in a cave commonly referred to as No. 301 due to the housing-development-like structure of the plot.*	Surf, Dive
72			Secret Shore (No. 401)	Indent	Accessible through southeast corner of Route 129 (can be reached by Fly after your first visit) *A Secret Base in a cave commonly referred to as No. 401 due to the housing-development-like structure of the plot.*	Surf, Dive
73			Secret Shore (No. 201)	Indent	Accessible through southeast corner of Route 129 (can be reached by Fly after your first visit) *A Secret Base in a cave commonly referred to as No. 201 due to the housing-development-like structure of the plot.*	Surf, Dive
74			Secret Shore (No. 101)	Indent	Accessible through southeast corner of Route 129 (can be reached by Fly after your first visit) *A Secret Base in a cave commonly referred to as No. 101 due to the housing-development-like structure of the plot.*	Surf, Dive
75			Secret Shore (No. 302)	Indent	Accessible through southeast corner of Route 129 (can be reached by Fly after your first visit) *A Secret Base in a cave commonly referred to as No. 302 due to the housing-development-like structure of the plot.*	Surf, Dive
76			Secret Meadow (No. 102)	Indent	Accessible from north end of Route 130 (can be reached by Fly after your first visit) *A Secret Base in a cave commonly referred to as No. 102 due to the apartment-like structure of the plot.*	Surf, Dive
77			Secret Meadow (No. 101)	Indent	Accessible from north end of Route 130 (can be reached by Fly after your first visit) *A Secret Base in a cave commonly referred to as No. 101 due to the apartment-like structure of the plot.*	Surf, Dive
78			Secret Meadow (No. 202)	Indent	Accessible from north end of Route 130 (can be reached by Fly after your first visit) *A Secret Base in a cave commonly referred to as No. 202 due to the apartment-like structure of the plot.*	Surf, Dive
79			Secret Meadow (No. 401)	Indent	Accessible from north end of Route 130 (can be reached by Fly after your first visit) *A Secret Base in a cave commonly referred to as No. 401 due to the apartment-like structure of the plot.*	Surf, Dive

No.	Exterior image	Layout	Location	Appearance	Details	Special requirements
80			Secret Meadow (No. 301)	Indent	Accessible from north end of Route 130 (can be reached by Fly after your first visit) A Secret Base in a cave commonly referred to as No. 301 due to the apartment-like structure of the plot.	Surf, Dive
81			Secret Meadow (No. 201)	Indent	Accessible from north end of Route 130 (can be reached by Fly after your first visit) A Secret Base in a cave commonly referred to as No. 201 due to the apartment-like structure of the plot.	Surf, Dive
82			Secret Islet	Tree	Southwest of Route 126 (can be reached by Fly after your first visit) A Secret Base above a tree that feels too much like a resort to call it a Secret Base.	Surf, Dive

Secret Pals and special skills

Your Secret Pals can learn any of 10 special skills, as detailed in the following list and table. Each Secret Pal learns up to four different skills as your rank in the Secret Base Guild improves (see page 165). Talk to your Secret Pals in your base and say, "Show me a special skill!" to have them use their skills for you. Secret Pals can normally only use one skill a day, but you can keep coming back day after day to reap the great benefits of these expert skills.

TIP

Although your Secret Pals don't gain a fifth special skill when you hit Platinum, they might get something even better. Reach Platinum Rank in the Secret Base Guild, and you'll find that your Secret Pals can now use two of their special skills per day!

Skills that Secret Pals can learn

Skill	Select	Secret Pal action
Builder	Make some goods	Makes a Decoration for your Secret Base. (See the Complete Decoration List for what you can get from a Builder.)
Nester	Take care of an Egg	Strokes an Egg for you, bringing it closer to hatching.
Masseuse	Massage a Pokémon	Massages your Pokémon, making it friendlier toward you.
Picker-Upper	Pick something up	Finds a super useful item for your adventure, perhaps even an incredibly rare one (Escape Rope / Ultra Ball / Revive / Rare Candy / Elixir / PP Max / Heart Scale / Full Restore / Max Revive / PP Up / Master Ball)!
Berry Farmer	Gather Berries	Finds a Berry for you, perhaps even a rare one (Cheri / Chesto / Pecha / Rawst / Aspear / Leppa / Persim / Lum / Sitrus / Liechi / Ganlon / Salac / Petaya / Apicot / Kee / Maranga)!
Treasure Hunter	Search for treasure	Finds a valuable item that you can sell for more cash (Float Stone / Pearl / Big Pearl / Nugget / Rare Bone / Pearl String / Big Nugget / Comet Shard).
Stone Searcher	Pick up stones	Finds a great stone for you (Everstone / Fire Stone / Thunder Stone / Water Stone / Leaf Stone / Sun Stone / Moon Stone / Shiny Stone / Dusk Stone / Dawn Stone).
Personal Trainer	Do some training	Raises the level of a Pokémon of your choosing by one.
Coach	Do some exercise	Raises a base stat for a Pokémon of your choosing.
Fortune-Teller	Tell my fortune	Tells your fortune, effectively triggering an O-Power for you (Capture Power MAX / Prize Money Power MAX / Bargain Power MAX / Full Recovery Power).

Skills are determined by Trainer types

The skills that your Secret Pals can learn are decided by the Trainer type that they resemble. If there are particular skills that you want to make use of in your Secret Base, consult the following table when choosing your Secret Pals. If you already have a full team of Secret Pals and want to make room for some new ones, you can let some go by talking to them and selecting "Let's say good-bye."

Trainer type	Normal Rank skill	Bronze Rank skill	Silver Rank skill	Gold Rank skill
Ace Trainer (female)	Coach	Builder	Personal Trainer	Nester
Ace Trainer (male)	Coach	Builder	Personal Trainer	Nester
Aroma Lady	Masseuse	Builder	Picker-Upper	Nester
Battle Girl	Personal Trainer	Masseuse	Builder	Coach
Beauty	Builder	Stone Searcher	Berry Farmer	Picker-Upper
Black Belt	Personal Trainer	Masseuse	Builder	Coach
Camper	Berry Farmer	Builder	Picker-Upper	Treasure Hunter
Delinquent	Builder	Treasure Hunter	Stone Searcher	Personal Trainer
Expert (female)	Personal Trainer	Masseuse	Coach	Builder
Expert (male)	Personal Trainer	Masseuse	Coach	Builder
Fairy Tale Girl	Builder	Fortune-Teller	Stone Searcher	Treasure Hunter
Guitarist	Builder	Picker-Upper	Fortune-Teller	Treasure Hunter
Hex Maniac	Builder	Picker-Upper	Fortune-Teller	Treasure Hunter
Hiker	Masseuse	Builder	Picker-Upper	Nester
Lady	Builder	Treasure Hunter	Stone Searcher	Masseuse

Trainer type	Normal Rank skill	Bronze Rank skill	Silver Rank skill	Gold Rank skill
Lass	Builder	Picker-Upper	Fortune-Teller	Treasure Hunter
Ninja Boy	Builder	Stone Searcher	Berry Farmer	Picker-Upper
Picnicker	Berry Farmer	Builder	Picker-Upper	Treasure Hunter
Poké Fan (female)	Masseuse	Berry Farmer	Nester	Builder
Poké Fan (male)	Masseuse	Berry Farmer	Nester	Builder
Poké Maniac	Builder	Fortune-Teller	Stone Searcher	Treasure Hunter
Pokémon Breeder (female)	Masseuse	Coach	Nester	Builder
Pokémon Breeder (male)	Masseuse	Coach	Nester	Builder
Pokémon Ranger (female)	Berry Farmer	Stone Searcher	Builder	Coach
Pokémon Ranger (male)	Berry Farmer	Stone Searcher	Builder	Coach
Rich Boy	Builder	Treasure Hunter	Stone Searcher	Masseuse
Schoolkid (female)	Builder	Picker-Upper	Stone Searcher	Berry Farmer
Schoolkid (male)	Builder	Picker-Upper	Stone Searcher	Berry Farmer
Street Thug	Builder	Treasure Hunter	Stone Searcher	Personal Trainer
Swimmer ♂	Builder	Picker-Upper	Fortune-Teller	Treasure Hunter

Share your base via QR Code patterns

You can generate a QR Code for your Secret Base using the PC in your base. Save it on your SD Card, and from there, you can share it with anyone! QR Code patterns are unique codes that can be read by a system in the Nintendo 3DS family. By saving yours on your removable SD Card, you can share it in just about any format you want. Print it out and bring it to school, or email it to your friends so they can all scan it in and see your base for themselves.

You can also read in other people's QR Code patterns from your Secret Base PC. Select "Read in QR Code" when you have the code in front of you. Your system's outer camera will turn on and start displaying whatever it is pointing toward. Line it up with the QR Code so that it fits in the green square shown on the screen, and press Ⓐ.

Tips for successfully capturing QR Code patterns:

- Make sure you're in an area with bright light. A shadow falling over the QR Code will make it harder for the system to read.

- Make sure that you fit all of the code neatly inside the green square on the screen. Move your system closer or farther away until you get it right.

- It may be difficult to capture a QR Code that is being displayed on a screen due to glare. If that is the case, try printing it out to capture it on paper.

- Aligning the squares in the corners of the big green square with the ones on the QR Code being read increases the chances of its being read properly.

TIP

If you try to scan in a QR Code for a base that's located in the same spot as a base that you've designated as a favorite, it will fail to load. Your favorite bases will always take priority over bases received by either StreetPass or QR Code patterns.

Complete Decoration list

On these pages you'll find the complete list of all Decorations for your base and how to obtain them. Most items can be bought from shops, but you also have a chance of getting items inside Secret Bases. If you have a Secret Pal with the Builder skill, he or she will be able to make you one free Decoration each day. You can also get a free Decoration from the leaders of other Secret Bases that you visit—see page 113 for more on finding other Secret Bases through StreetPass, or see above for a guide on using QR Code patterns to share bases. Try to pick up as many of these free Decorations as you can, saving your prize money for Decorations that can't be obtained for free using these two methods.

SECRET BASE DECORATIONS

Category		Name	Description	How to obtain	Price	Can get from a Builder	Can get from other base owners
Appliances		Cute TV	A toy TV made with Skitty as its inspiration.	Lilycove Department Store (Clearance Sale)	4,000	–	–
		Jukebox	A machine that lets you listen to whatever music you like in the Secret Base.	Receive from Aarune at the Secret Base Guild in Fortree City after reaching Silver Rank	–	–	–
		Level Release	A suspicious machine that lets you remove the level limit of Pokémon battles.	Obtain from a Battle Girl at the Battle Resort	–	–	–
		Mood Lighting	A light that can change the mood of the room. Touch it to change colors.	Receive from Aarune at the Secret Base Guild in Fortree City after reaching Gold Rank	–	–	–
		Round TV	A toy TV made with Seedot as its inspiration.	Lilycove Department Store (Clearance Sale)	4,000	–	–
		TV	A toy TV made to look just like the real thing.	Lilycove Department Store (Clearance Sale)	3,000	–	–
		Vending Machine	A vending machine that sells Soda Pop. The Secret Base Guild manages it.	Secret Base Guild Shop (must be at least Silver Rank)	6,000	–	–
		Worn–Out Light	A lamp that looks ready to collapse. It might turn off if you touch it...	Obtain one from Aarune at first meeting	–	–	–

Category		Name	Description	How to obtain	Price	Can get from a Builder	Can get from other base owners
Chairs		Brick Chair	A small chair made of bricks.	Secret Base Guild Shop (must be at least Silver Rank)	1,000	Yes	Yes
		Elegant Chair	A small chair made of glass.	Glass Workshop (Route 113)	–	–	–
		Hard Chair	A small chair made of stone.	Secret Base Guild Shop (must be at least Silver Rank)	1,000	Yes	Yes
		Heavy Chair	A small chair made of metal.	Secret Base Guild Shop	1,000	Yes	Yes
		Log Chair	A small chair made from a log.	Secret Base Guild Shop (must be at least Silver Rank)	1,000	Yes	Yes
		Poké Ball Chair	A small chair shaped like a Poké Ball.	Secret Base Guild Shop	1,000	Yes	Yes
		Rough Chair	A small chair made of wood.	Secret Base Guild Shop (must be at least Bronze Rank)	1,000	Yes	Yes
		Small Chair	A small chair for one.	Secret Base Guild Shop / Obtain one from Aarune at first meeting	1,000	Yes	Yes
		Soft Chair	A small chair made of leaves.	Secret Base Guild Shop (must be at least Bronze Rank)	1,000	Yes	Yes
Cushions		Diamond Cushion	A Sableye cushion. It may be placed on top of a mat, desk, brick, or tire.	Lilycove Department Store (5F)	1,000	Yes	Yes
		Fire Cushion	A fire cushion. It may be placed on top of a mat, desk, brick, or tire.	Lilycove Department Store (5F)	1,000	Yes	Yes
		Grass Cushion	A grass cushion. It may be placed on top of a mat, desk, brick, or tire.	Lilycove Department Store (5F)	1,000	Yes	Yes
		Kiss Cushion	A Smoochum cushion. It may be placed on top of a mat, desk, brick, or tire.	Lilycove Department Store (5F)	1,000	Yes	Yes
		Pika Cushion	A Pikachu cushion. It may be placed on top of a mat, desk, brick, or tire.	Lilycove Department Store (5F)	1,000	Yes	Yes
		Poké Ball Cushion	A Poké Ball cushion. It may be placed on top of a mat, desk, brick, or tire.	Lilycove Department Store (5F)	1,000	Yes	Yes
		Round Cushion	An Azumarill cushion. It may be placed on top of a mat, desk, brick, or tire.	Lilycove Department Store (5F)	1,000	Yes	Yes
		Spin Cushion	A Spinda cushion. It may be placed on top of a mat, desk, brick, or tire.	Lilycove Department Store (5F)	1,000	Yes	Yes
		Water Cushion	A water cushion. It may be placed on top of a mat, desk, brick, or tire.	Lilycove Department Store (5F)	1,000	Yes	Yes
		Zigzag Cushion	A Zigzagoon cushion. It may be placed on top of a mat, desk, brick, or tire.	Lilycove Department Store (5F)	1,000	Yes	Yes

Category		Name	Description	How to obtain	Price	Can get from a Builder	Can get from other base owners
Desks		Brick Desk	A huge desk made of bricks. Many objects may be placed on top of it.	Secret Base Guild Shop (must be at least Silver Rank)	4,000	Yes	Yes
		Elegant Desk	A huge desk made of glass. Many objects may be placed on top of it.	Glass Workshop (Route 113)	–	–	–
		Hard Desk	A huge desk made of stone. Many objects may be placed on top of it.	Secret Base Guild Shop (must be at least Silver Rank)	4,000	Yes	Yes
		Heavy Desk	A large desk made of metal. Objects may be placed on top of it.	Secret Base Guild Shop	3,000	Yes	Yes
		Icy Desk	A huge, icy desk with Avalugg as its motif. Many objects may be placed on top of it.	Secret Base Guild Shop (must be at least Gold Rank)	5,000	–	–
		Log Desk	A huge desk made of logs. Many objects may be placed on top of it.	Secret Base Guild Shop (must be at least Silver Rank)	4,000	Yes	Yes
		Poké Ball Desk	A desk shaped like a Poké Ball. An object may be placed on top of it.	Secret Base Guild Shop	2,000	Yes	Yes
		Rough Desk	A large desk made of wood. Objects may be placed on top of it.	Secret Base Guild Shop (must be at least Bronze Rank)	3,000	Yes	Yes
		Small Desk	A small desk for one. An object may be placed on top of it.	Secret Base Guild Shop / Obtain one from Aarune at first meeting	2,000	Yes	Yes
		Soft Desk	A large desk made of leaves. Objects may be placed on top of it.	Secret Base Guild Shop (must be at least Bronze Rank)	3,000	Yes	Yes
Dolls		Azurill Doll	An Azurill doll. It may be placed on top of a mat, desk, brick, or tire.	Lilycove Department Store / Slateport Market (after obtaining TM Secret Power)	3,000	Yes	Yes
		Baltoy Doll	A Baltoy doll. It may be placed on top of a mat, desk, brick, or tire.	Lilycove Department Store (5F)	3,000	Yes	Yes
		Blastoise Doll	A large Blastoise doll. It may be placed on top of a mat, desk, or tire.	Lilycove Department Store (Clearance Sale)	6,000	–	–
		Charizard Doll	A large Charizard doll. It may be placed on top of a mat, desk, or tire.	Lilycove Department Store (Clearance Sale)	6,000	–	–
		Chikorita Doll	A Chikorita doll. It may be placed on top of a mat, desk, brick, or tire.	Lilycove Department Store (5F)	3,000	–	–
		Clefairy Doll	A Clefairy doll. It may be placed on top of a mat, desk, brick, or tire.	Lilycove Department Store (5F)	3,000	–	–
		Cyndaquil Doll	A Cyndaquil doll. It may be placed on top of a mat, desk, brick, or tire.	Lilycove Department Store (5F)	3,000	–	–
		Ditto Doll	A Ditto doll. It may be placed on top of a mat, desk, brick, or tire.	Lilycove Department Store (5F)	3,000	–	–
		Duskull Doll	A Duskull doll. It may be placed on top of a mat, desk, brick, or tire.	Lilycove Department Store (5F)	3,000	Yes	Yes
		Gulpin Doll	A Gulpin doll. It may be placed on top of a mat, desk, brick, or tire.	Lilycove Department Store (5F)	3,000	Yes	Yes
		Jigglypuff Doll	A Jigglypuff doll. It may be placed on top of a mat, desk, brick, or tire.	Lilycove Department Store (5F)	3,000	Yes	Yes

Category	Name	Description	How to obtain	Price	Can get from a Builder	Can get from other base owners
	Kecleon Doll	A Kecleon doll. It may be placed on top of a mat, desk, brick, or tire.	Lilycove Department Store (5F)	3,000	Yes	Yes
	Lapras Doll	A large Lapras doll. It may be placed on top of a mat, desk, or tire.	Lilycove Department Store (Clearance Sale)	6,000	–	–
	Lotad Doll	A Lotad doll. It may be placed on top of a mat, desk, brick, or tire.	Receive from Lanette in her house on Route 114 (*Pokémon Alpha Sapphire* only)	–	–	–
	Marill Doll	A Marill doll. It may be placed on top of a mat, desk, brick, or tire.	Lilycove Department Store / Slateport Market (after obtaining TM Secret Power)	3,000	Yes	Yes
	Meowth Doll	A Meowth doll. It may be placed on top of a mat, desk, brick, or tire.	Lilycove Department Store (5F)	3,000	–	–
	Mudkip Doll	A Mudkip doll. It may be placed on top of a mat, desk, brick, or tire.	Obtain from the failed businessman in Mauville City	–	–	–
	Pichu Doll	A Pichu doll. It may be placed on top of a mat, desk, brick, or tire.	Lilycove Department Store (5F)	3,000	Yes	Yes
	Pikachu Doll	A Pikachu doll. It may be placed on top of a mat, desk, brick, or tire.	Lilycove Department Store (5F)	3,000	Yes	Yes
Dolls	Regice Doll	A large Regice doll. It may be placed on top of a mat, desk, or tire.	Only available through special events	–	–	–
	Regirock Doll	A large Regirock doll. It may be placed on top of a mat, desk, or tire.	Only available through special events	–	–	–
	Registeel Doll	A large Registeel doll. It may be placed on top of a mat, desk, or tire.	Only available through special events	–	–	–
	Rhydon Doll	A large Rhydon doll. It may be placed on top of a mat, desk, or tire.	Lilycove Department Store (Clearance Sale)	6,000	–	–
	Seedot Doll	A Seedot doll. It may be placed on top of a mat, desk, brick, or tire.	Receive from Lanette in her house on Route 114 (*Pokémon Omega Ruby* only)	–	–	–
	Skitty Doll	A Skitty doll. It may be placed on top of a mat, desk, brick, or tire.	Lilycove Department Store / Slateport Market (after obtaining TM Secret Power)	3,000	Yes	Yes
	Smoochum Doll	A Smoochum doll. It may be placed on top of a mat, desk, brick, or tire.	Lilycove Department Store (5F)	3,000	–	–
	Snorlax Doll	A large Snorlax doll. It may be placed on top of a mat, desk, or tire.	Lilycove Department Store (Clearance Sale)	6,000	–	–
	Substitute Doll	A Substitute doll. It may be placed on top of a mat, desk, brick, or tire.	Lilycove Department Store (5F)	3,000	Yes	Yes
	Swablu Doll	A Swablu doll. It may be placed on top of a mat, desk, brick, or tire.	Lilycove Department Store (5F)	3,000	Yes	Yes
	Togepi Doll	A Togepi doll. It may be placed on top of a mat, desk, brick, or tire.	Lilycove Department Store (5F)	3,000	–	–
	Torchic Doll	A Torchic doll. It may be placed on top of a mat, desk, brick, or tire.	Obtain from the failed businessman in Mauville City	–	–	–
	Totodile Doll	A Totodile doll. It may be placed on top of a mat, desk, brick, or tire.	Lilycove Department Store (5F)	3,000	–	–

Category		Name	Description	How to obtain	Price	Can get from a Builder	Can get from other base owners
Dolls		Treecko Doll	A Treecko doll. It may be placed on top of a mat, desk, brick, or tire.	Obtain from the failed businessman in Mauville City	–	–	–
		Venusaur Doll	A large Venusaur doll. It may be placed on top of a mat, desk, or tire.	Lilycove Department Store (Clearance Sale)	6,000	–	–
		Wailmer Doll	A large Wailmer doll. It may be placed on top of a mat, desk, or tire.	Lilycove Department Store (Clearance Sale)	6,000	–	–
		Wynaut Doll	A Wynaut doll. It may be placed on top of a mat, desk, brick, or tire.	Lilycove Department Store (5F)	3,000	Yes	Yes
Mats		Attract Mat	A round mat inspired by Attract. Objects may be placed on top of it.	Lilycove Department Store (5F)	2,000	Yes	Yes
		Blue Mat	A square mat inspired by Piplup. Objects may be placed on top of it.	Lilycove Department Store (5F)	3,000	–	–
		Fire Blast Mat	A round mat inspired by Fire Blast. Objects may be placed on top of it.	Lilycove Department Store (5F)	2,000	Yes	Yes
		Fissure Mat	A round mat inspired by Fissure. Objects may be placed on top of it.	Lilycove Department Store (5F)	2,000	Yes	Yes
		Flat Mat	A round mat inspired by Stunfisk. Objects may be placed on top of it.	Lilycove Department Store (5F)	3,500	–	–
		Green Mat	A square mat inspired by Turtwig. Objects may be placed on top of it.	Lilycove Department Store (5F)	3,000	–	–
		Powder Snow Mat	A round mat inspired by Powder Snow. Objects may be placed on top of it.	Lilycove Department Store (5F)	2,000	Yes	Yes
		Red Mat	A square mat inspired by Chimchar. Objects may be placed on top of it.	Lilycove Department Store (5F)	3,000	–	–
		Spikes Mat	A round mat inspired by Spikes. Objects may be placed on top of it.	Lilycove Department Store (5F)	2,000	Yes	Yes
		Surf Mat	A round mat inspired by Surf. Objects may be placed on top of it.	Lilycove Department Store (5F) / Obtain one from Aarune at first meeting	2,000	Yes	Yes
		Thunder Mat	A round mat inspired by Thunder. Objects may be placed on top of it.	Lilycove Department Store (5F)	2,000	Yes	Yes
		Welcome Mat	A mat for welcoming Secret Pals.	Automatically placed in your Secret Base	–	–	–
Objects		Berry Blender	A machine that was used to mix Berries in this region long ago.	Obtain from a man at the Fallarbor Contest Spectacular Hall	–	–	–
		Blackboard	A large blackboard on which you can write freely.	Receive from Aarune at the Secret Base Guild in Fortree City after reaching Bronze Rank	–	–	–
		Blue Brick	A blue brick. An object may be placed on top of it.	Slateport Market (after obtaining TM Secret Power)	500	Yes	Yes
		Blue Tent	A large blue tent. You can go inside.	Obtain in the Trick House (*Pokémon Alpha Sapphire* only)	–	–	–
		Boppoyama	A toy that lets you compete with others at how much you can punch in a short amount of time.	Secret Base Guild Shop	4,000	–	–

Category		Name	Description	How to obtain	Price	Can get from a Builder	Can get from other base owners
Objects		Candlestick	An ornament with Litwick as its motif. The light turns on when you touch it.	Lilycove Department Store (Clearance Sale)	4,000	—	—
		Cardboard Boxes	Some empty cardboard boxes.	Lilycove Department Store (Clearance Sale)	200	—	—
		Comfortable Bed	A bed with a wonderful design. You can sleep soundly in this comfy bed.	Secret Base Guild Shop / Obtain one from Aarune at first meeting	6,000	—	—
		Confetti Ball	The words written inside this large ball come jumping out at you when you examine it.	Receive from Aarune at the Secret Base Guild in Fortree City after reaching Platinum Rank	—	—	—
		Fence	A small fence that you can't go through.	Secret Base Guild Shop / Obtain five from Aarune at first meeting	500	Yes	Yes
		Glass Ornament	A work of glass modeled after a famous sculpture from the art museum.	Receive in Lilycove Museum after you win a Master Rank contest and have 15 of your Pokémon's portraits put on display	—	—	—
		Globe	A big, solid globe. Something about it makes you nostalgic.	Receive from Backpacker standing in Mauville City's central courtyard	—	—	—
		Gym Statue	A replica of the stone statues at the entrances to Pokémon Gyms.	Secret Base Guild Shop	3,000	—	—
		Heterarchical Loop	An original work of art you can spread out on the floor and enjoy.	Obtain from the struggling artist in Lilycove Museum	100,000	—	—
		Makiwara	A tightly wrapped straw post used for practice by master swordsmen.	Secret Base Guild Shop	1,000	Yes	—
		Meditative Seat	An original work of art you can place on the floor and enjoy.	Obtain from the struggling artist in Lilycove Museum	100,000	—	—
		Mini Castelia	A model of Castelia City in the Unova region.	Lilycove Department Store (Clearance Sale)	6,000	—	—
		Mini Lumiose	A model of Lumiose City in the Kalos region.	Lilycove Department Store (Clearance Sale)	6,000	—	—
		Poké Flute	A replica that has been made to look just like a Poké Flute from another region.	Obtain from a man in Lilycove City	—	—	—
		Proclamation	A sign that can decide the rules of a Pokémon battle.	Receive from Aarune at the Secret Base Guild in Fortree City	—	—	—
		Red Brick	A red brick. An object may be placed on top of it.	Slateport Market (after obtaining TM Secret Power)	500	Yes	Yes
		Red Tent	A large red tent. You can go inside.	Obtain in the Trick House (*Pokémon Omega Ruby* only)	—	—	—
		Sand Ornament	This sand ornament will crumble if you touch it.	Lilycove Department Store (Clearance Sale)	2,000	Yes	Yes
		Slide	You can slide from the top to the bottom.	Lilycove Department Store (Clearance Sale)	3,500	—	—
		Solid Board	You can place this over holes to cross over them.	Lilycove Department Store (Clearance Sale)	2,000	Yes	
		Stairs	You can place this by a crumbled cliff to climb to a higher floor.	Obtain from a woman in Fortree City	—	—	—

Category		Name	Description	How to obtain	Price	Can get from a Builder	Can get from other base owners
Objects		Stand	You can climb the stairs to the top.	Lilycove Department Store (Clearance Sale)	3,500	–	–
		Standing Stone	A piece of a large stone pillar. It has an air of mystery.	Lilycove Department Store (Clearance Sale)	3,000	–	–
		Star Light	A stand in praise of Trainers who excelled in the contest.	Receive from Lisia after winning in a Master Rank contest	–	–	–
		Tire	A big, old tire. Objects may be placed on top of it.	Lilycove Department Store (Clearance Sale)	800	–	–
		Trash Can	An empty trash can just like you would find anywhere.	Lilycove Department Store (Clearance Sale)	500	–	Yes
		Yellow Brick	A yellow brick. An object may be placed on top of it.	Slateport Market (after obtaining TM Secret Power)	500	Yes	Yes
Plants		Berry Tree	A replica that looks just like a Berry Tree you would find on a route.	Lilycove Department Store (Clearance Sale)	2,000	Yes	Yes
		Big Plant	A large pot shaped like an umbrella.	Pretty Petal Flower Shop (after obtaining Balance Badge)	3,000	Yes	Yes
		Colorful Plant	A pot with many kinds of flowers growing in it.	Pretty Petal Flower Shop (after obtaining Balance Badge)	3,000	Yes	Yes
		Elegant Bonsai	A large pot that has been meticulously cared for.	Pretty Petal Flower Shop (after obtaining Balance Badge)	3,000	Yes	Yes
		Flowering Plant	A pot with cute flowers growing in it.	Pretty Petal Flower Shop (after obtaining Balance Badge)	2,000	Yes	Yes
		Red Flower	A pot with a bright-red flower growing in it.	Pretty Petal Flower Shop (after obtaining Balance Badge) / Obtain one from Aarune at first meeting	2,000	Yes	Yes
		Tropical Plant	A pot with a tropical plant growing in it.	Pretty Petal Flower Shop (after obtaining Balance Badge)	2,000	Yes	Yes
Tricks		A Note Mat	A mat that plays the note "la" when you step on it. When you turn it, the note changes.	Slateport Market (after obtaining TM Secret Power)	500	Yes	Yes
		B Note Mat	A mat that plays the note "ti" when you step on it. When you turn it, the note changes.	Slateport Market (after obtaining TM Secret Power)	500	Yes	Yes
		Blue Balloon	A blue water balloon. It will burst if you step on it.	Slateport Market (after obtaining TM Secret Power)	500	Yes	Yes
		Blue Spin Panel	A mysterious panel that spins and moves when you step on it. It can be used three times.	Secret Base Guild Shop (must be at least Bronze Rank)	2,500	Yes	–
		Blue Warp Panel	A mysterious panel that will teleport you to a Blue Warp Panel when you step on it.	Secret Base Guild Shop (must be at least Gold Rank)	2,500	Yes	–
		Breakable Door	A weird door through which you can pass.	Lilycove Department Store (Clearance Sale)	3,000	Yes	Yes
		D Note Mat	A mat that plays the note "re" when you step on it. When you turn it, the note changes.	Slateport Market (after obtaining TM Secret Power)	500	Yes	Yes
		E Note Mat	A mat that plays the note "mi" when you step on it. When you turn it, the note changes.	Slateport Market (after obtaining TM Secret Power)	500	Yes	Yes

Category		Name	Description	How to obtain	Price	Can get from a Builder	Can get from other base owners
Tricks		F Note Mat	A mat that plays the note "fa" when you step on it. When you turn it, the note changes.	Slateport Market (after obtaining TM Secret Power)	500	Yes	Yes
		G Note Mat	A mat that plays the note "so" when you step on it. When you turn it, the note changes.	Slateport Market (after obtaining TM Secret Power)	500	Yes	Yes
		Glitter Mat	A mysterious mat that sparkles when you step on it.	Secret Base Guild Shop	2,000	Yes	Yes
		High C Note Mat	A mat that plays the high note "do" when you step on it. When you turn it, the note changes.	Slateport Market (after obtaining TM Secret Power)	500	Yes	Yes
		Invisible Doll	A doll that becomes invisible when set down. It becomes visible again when you examine it.	Secret Base Guild Shop (must be at least Gold Rank)	4,000	–	–
		Jump Mat	A mischievous mat that makes you jump when you step on it.	Secret Base Guild Shop	2,000	Yes	Yes
		Low C Note Mat	A mat that plays the note "do" when you step on it. When you turn it, the note changes.	Slateport Market (after obtaining TM Secret Power)	500	Yes	Yes
		Mud Ball	A round mud ball. It will burst if you step on it.	Lilycove Department Store (Clearance Sale)	200	Yes	Yes
		Pitfall Mat	A mischievous mat that may be used once. You'll be stuck in a pit if you step on it carelessly.	Secret Base Guild Shop (must be at least Bronze Rank)	2,000	Yes	–
		Red Balloon	A red water balloon. It will burst if you step on it.	Slateport Market (after obtaining TM Secret Power)	500	Yes	Yes
		Red Spin Panel	A mysterious panel that spins and moves when you step on it. It can be used once.	Secret Base Guild Shop	2,000	Yes	–
		Red Warp Panel	A mysterious panel that will teleport you to a Red Warp Panel when you step on it.	Secret Base Guild Shop (must be at least Silver Rank)	2,500	Yes	–
		Spin Mat	A mischievous mat that spins in place to push you back when you step on it.	Secret Base Guild Shop (must be at least Bronze Rank)	2,000	Yes	Yes
		Square-One Mat	When visitors step on this mat, they'll be sent back to the entrance, but only once.	Secret Base Guild Shop (must be at least Silver Rank)	2,000	Yes	–
		Tall Grass	A surprisingly accurate replica of the tall grass you would find on a route.	Secret Base Guild Shop	1,000	Yes	–
		Toy PC	It looks just like a real PC. It's often used for pranks.	Secret Base Guild Shop (must be at least Bronze Rank)	5,000	Yes	–
		Yellow Balloon	A yellow water balloon. It will burst if you step on it.	Slateport Market (after obtaining TM Secret Power)	500	Yes	Yes
		Yellow Spin Panel	A mysterious panel that spins and moves when you step on it. It can be used five times.	Secret Base Guild Shop (must be at least Bronze Rank)	3,000	Yes	–
		Yellow Warp Panel	A mysterious panel that will teleport you to a Yellow Warp Panel when you step on it.	Secret Base Guild Shop (must be at least Gold Rank)	2,500	Yes	–

Category	Name	Description	How to obtain	Price	Can get from a Builder	Can get from other base owners
Wall art	Blue Poster	A small poster with Mudkip printed on it.	Lilycove Department Store (5F)	1,000	Yes	Yes
	Blue Scroll	A magnificent scroll depicting Kyogre.	Lilycove Department Store (Clearance Sale) after resolving the crisis with the Super-Ancient Pokémon	4,500	–	–
	Cute Poster	A small poster with Azurill printed on it.	Lilycove Department Store (5F)	1,000	Yes	Yes
	Dad's Scroll	A scroll that is identical to the one hanging in the Petalburg Gym.	Lilycove Department Store (Clearance Sale)	4,500	–	–
	Green Poster	A small poster with Treecko printed on it.	Lilycove Department Store (5F)	1,000	Yes	Yes
	Green Scroll	A magnificent scroll depicting Rayquaza.	Lilycove Department Store (Clearance Sale) after resolving the crisis with the Super-Ancient Pokémon	4,500	–	–
	Kiss Poster	A large poster with Smoochum printed on it.	Lilycove Department Store (5F)	1,500	–	–
	Long Poster	A large poster with Seviper printed on it.	Lilycove Department Store (5F)	1,500	Yes	Yes
	National Award	A special award for completing the National Pokédex.	Get from Game Director in Lilycove City by showing him your completed National Pokédex	–	–	–
	Paradoxical Popper	An original work of art you can hang on the wall and enjoy.	Obtain from the struggling artist in Lilycove Museum	100,000	–	–
	Pika Poster	A large poster with Pikachu and Pichu printed on it.	Lilycove Department Store (5F)	1,500	Yes	Yes
	Poké Ball Poster	A small poster with a Poké Ball printed on it.	Lilycove Department Store (5F) / Obtain one from Aarune at first meeting	1,000	Yes	Yes
	Red Poster	A small poster with Torchic printed on it.	Lilycove Department Store (5F)	1,000	Yes	Yes
	Red Scroll	A magnificent scroll depicting Groudon.	Lilycove Department Store (Clearance Sale) after resolving the crisis with the Super-Ancient Pokémon	4,500	–	–
	Regional Award	A special award for completing a regional Pokédex.	Get from Game Director in Lilycove City by showing him your completed Hoenn Regional Pokédex	–	–	–
	Sea Poster	A large poster with Relicanth printed on it.	Lilycove Department Store (5F)	1,500	Yes	Yes
	Sky Poster	A large poster with Wingull printed on it.	Lilycove Department Store (5F)	1,500	Yes	Yes
	Time Travel Award	A special award in praise of those Pokémon that traveled through time to get here.	Get from Game Director in Lilycove City by showing him a Pokémon from *Pokémon Ruby*, *Pokémon Sapphire*, or *Pokémon Emerald*	–	–	–

Category		Name	Description	How to obtain	Price	Can get from a Builder	Can get from other base owners
Tricks		F Note Mat	A mat that plays the note "fa" when you step on it. When you turn it, the note changes.	Slateport Market (after obtaining TM Secret Power)	500	Yes	Yes
		G Note Mat	A mat that plays the note "so" when you step on it. When you turn it, the note changes.	Slateport Market (after obtaining TM Secret Power)	500	Yes	Yes
		Glitter Mat	A mysterious mat that sparkles when you step on it.	Secret Base Guild Shop	2,000	Yes	Yes
		High C Note Mat	A mat that plays the high note "do" when you step on it. When you turn it, the note changes.	Slateport Market (after obtaining TM Secret Power)	500	Yes	Yes
		Invisible Doll	A doll that becomes invisible when set down. It becomes visible again when you examine it.	Secret Base Guild Shop (must be at least Gold Rank)	4,000	–	–
		Jump Mat	A mischievous mat that makes you jump when you step on it.	Secret Base Guild Shop	2,000	Yes	Yes
		Low C Note Mat	A mat that plays the note "do" when you step on it. When you turn it, the note changes.	Slateport Market (after obtaining TM Secret Power)	500	Yes	Yes
		Mud Ball	A round mud ball. It will burst if you step on it.	Lilycove Department Store (Clearance Sale)	200	Yes	Yes
		Pitfall Mat	A mischievous mat that may be used once. You'll be stuck in a pit if you step on it carelessly.	Secret Base Guild Shop (must be at least Bronze Rank)	2,000	Yes	–
		Red Balloon	A red water balloon. It will burst if you step on it.	Slateport Market (after obtaining TM Secret Power)	500	Yes	Yes
		Red Spin Panel	A mysterious panel that spins and moves when you step on it. It can be used once.	Secret Base Guild Shop	2,000	Yes	–
		Red Warp Panel	A mysterious panel that will teleport you to a Red Warp Panel when you step on it.	Secret Base Guild Shop (must be at least Silver Rank)	2,500	Yes	–
		Spin Mat	A mischievous mat that spins in place to push you back when you step on it.	Secret Base Guild Shop (must be at least Bronze Rank)	2,000	Yes	Yes
		Square-One Mat	When visitors step on this mat, they'll be sent back to the entrance, but only once.	Secret Base Guild Shop (must be at least Silver Rank)	2,000	Yes	–
		Tall Grass	A surprisingly accurate replica of the tall grass you would find on a route.	Secret Base Guild Shop	1,000	Yes	–
		Toy PC	It looks just like a real PC. It's often used for pranks.	Secret Base Guild Shop (must be at least Bronze Rank)	5,000	Yes	–
		Yellow Balloon	A yellow water balloon. It will burst if you step on it.	Slateport Market (after obtaining TM Secret Power)	500	Yes	Yes
		Yellow Spin Panel	A mysterious panel that spins and moves when you step on it. It can be used five times.	Secret Base Guild Shop (must be at least Bronze Rank)	3,000	Yes	–
		Yellow Warp Panel	A mysterious panel that will teleport you to a Yellow Warp Panel when you step on it.	Secret Base Guild Shop (must be at least Gold Rank)	2,500	Yes	–

Category		Name	Description	How to obtain	Price	Can get from a Builder	Can get from other base owners
Wall art		Blue Poster	A small poster with Mudkip printed on it.	Lilycove Department Store (5F)	1,000	Yes	Yes
		Blue Scroll	A magnificent scroll depicting Kyogre.	Lilycove Department Store (Clearance Sale) after resolving the crisis with the Super-Ancient Pokémon	4,500	–	–
		Cute Poster	A small poster with Azurill printed on it.	Lilycove Department Store (5F)	1,000	Yes	Yes
		Dad's Scroll	A scroll that is identical to the one hanging in the Petalburg Gym.	Lilycove Department Store (Clearance Sale)	4,500	–	–
		Green Poster	A small poster with Treecko printed on it.	Lilycove Department Store (5F)	1,000	Yes	Yes
		Green Scroll	A magnificent scroll depicting Rayquaza.	Lilycove Department Store (Clearance Sale) after resolving the crisis with the Super-Ancient Pokémon	4,500	–	–
		Kiss Poster	A large poster with Smoochum printed on it.	Lilycove Department Store (5F)	1,500	–	–
		Long Poster	A large poster with Seviper printed on it.	Lilycove Department Store (5F)	1,500	Yes	Yes
		National Award	A special award for completing the National Pokédex.	Get from Game Director in Lilycove City by showing him your completed National Pokédex	–	–	–
		Paradoxical Popper	An original work of art you can hang on the wall and enjoy.	Obtain from the struggling artist in Lilycove Museum	100,000	–	–
		Pika Poster	A large poster with Pikachu and Pichu printed on it.	Lilycove Department Store (5F)	1,500	Yes	Yes
		Poké Ball Poster	A small poster with a Poké Ball printed on it.	Lilycove Department Store (5F) / Obtain one from Aarune at first meeting	1,000	Yes	Yes
		Red Poster	A small poster with Torchic printed on it.	Lilycove Department Store (5F)	1,000	Yes	Yes
		Red Scroll	A magnificent scroll depicting Groudon.	Lilycove Department Store (Clearance Sale) after resolving the crisis with the Super-Ancient Pokémon	4,500	–	–
		Regional Award	A special award for completing a regional Pokédex.	Get from Game Director in Lilycove City by showing him your completed Hoenn Regional Pokédex	–	–	–
		Sea Poster	A large poster with Relicanth printed on it.	Lilycove Department Store (5F)	1,500	Yes	Yes
		Sky Poster	A large poster with Wingull printed on it.	Lilycove Department Store (5F)	1,500	Yes	Yes
		Time Travel Award	A special award in praise of those Pokémon that traveled through time to get here.	Get from Game Director in Lilycove City by showing him a Pokémon from *Pokémon Ruby*, *Pokémon Sapphire*, or *Pokémon Emerald*	–	–	–

PLAYER SEARCH SYSTEM (PSS)

Interact with players all over the world!

The PSS (Player Search System) is one of the PlayNav features of your PokéNav Plus. It helps you interact with other players, whether they're playing nearby or in another part of the world.

Main PSS Screen

1 **PSS Menu button**: Tap this button to open the PSS menu and call up a list of the various actions you can perform through the PSS.

2 **Internet / local connection**: Tap this button to connect to and disconnect from the Internet.

3 **Friends**: Players whom you've registered as Friends will appear here. You can choose to register other players as Friends after you've battled or traded with them a couple of times. You'll also see different icons indicating what your Friends are currently doing.

4 **Acquaintances**: Any players with whom you've traded or battled will automatically become your Acquaintances and appear here whenever they're playing. This helps you find these players and trade or battle with them again.

5 **Passersby**: Players who are playing in your area or who happen to be online at the same time as you are listed here. Go ahead and say hello!

6 **Menu buttons**: For convenience, the buttons along the bottom row call up the same menus that can be visited by pressing ⊗ (Pokémon, Pokédex, Bag, and so on).

> **TIP**
>
> The icons of players who are currently playing will appear brighter and farther to the left. Players who are not currently playing will appear farther to the right, and their icons will be shaded. When there are more player icons than can fit on a single screen, drag your stylus across the screen to scroll through multiple screens of icons.

Player status icons

 Battling *Using Game Chat* *Shout-Out*

 Trading *Busy* *Birthday*

> **TIP**
>
> The busy icon is displayed when the player is using functions like Battle Spot, GTS, or Wonder Trade.

Enjoy the many features of the PSS

The PSS is your gateway to the many communication features of *Pokémon Omega Ruby* and *Pokémon Alpha Sapphire*. In addition to Link Battle and Link Trade, you can enjoy all of the following features on the PSS.

What you can do on the PSS

 Battle
Battle with other players. You can adjust a variety of settings to create the desired battle experience.

 Trade
Offer a Pokémon to another player, and make the trade if you're both happy with the offer.

 Battle Spot
Connect to another player in the world who is looking for a battle at the same time as you.

 Wonder Trade
Offer one Pokémon for trade, and you'll receive another player's Pokémon. The Pokémon you receive is chosen at random from the ones offered for trade.

 Shout-Out
Send out a brief, 16-character message to the world. Tell everyone about what's made you happy or your latest victory.

 Holo Caster
Stay clued in on all the latest news and events by SpotPass.

 GTS
Trade Pokémon with players all over the world. There are two ways to trade via GTS.

 Game Sync
Game Sync lets you connect to the PGL (Pokémon Global Link), a website linked with *Pokémon Omega Ruby* and *Pokémon Alpha Sapphire*.

O-Power
Use your O-Powers—mysterious powers that are useful in battles, while shopping, and more—on either yourself or another player.

Favorites List
Browse your list of up to 100 favorite players. This makes them easy to find.

Profile
View and change your Trainer icon and default greeting, and answer some cool Mini Survey questions to help personalize your profile.

PSS Settings
Change which people you can use communication features with, and enable or disable PSS communications and Game Chat.

Making and managing friends

Making friends in *Pokémon Omega Ruby* and *Pokémon Alpha Sapphire* is easy! Keep the following rules in mind.

- After battling or trading with a player who is an Acquaintance, you can register that player in your friend list.
- Once a player is registered in your friend list, the player will be displayed as a Friend.
- You can also register players from the friend list on your Nintendo 3DS system.

Battle with players all over the world!

Battling other players is a fine way to hone your skills and discover new tactics that you never knew were possible. Here's how to battle players via the PSS.

Battle

Choose Battle on the PSS screen, and you can have a battle with a player of your choice (if the other player agrees to battle, of course). You can battle with nearby players, players who are in your area, and players far away. Here's how to do it.

1. Choose a communication method
Tap Battle on the PSS menu, and choose a communication method.

 Infrared Connection: Battle with someone in front of you.

 Local Wireless: Battle with players in your area.

 Internet: Battle with people far away.

2. Choose the details of the battles
Choose number of players, battle formats, and so on, and then confirm.

3. Choose an opponent
Tap the icon of an opponent, and wait for his or her reply (or align your Nintendo 3DS systems while using Infrared Connection).

4. Choose the participating Pokémon
If the opponent agrees to battle, select "Battle, Start!" You may then either choose your party Pokémon or your Battle Box (if you have Pokémon in your Battle Box). Select your participating Pokémon, and then confirm.

5. Battle starts!

How to Enjoy a Multi Battle via Infrared Connection

There are two ways to set up Multi Battles via Infrared Connection.

1 Two people pair up first, and the leaders of each team will pair up

2 One person pairs up the rest of the three people

Learn the battle rules

While setting up battles over the PSS, you can choose the rules, determine the battle formats, and adjust other options. Learn the rules here, and then select the battle you want.

Common rules for all battles
- **Time limit for selecting a Pokémon:** 99 seconds
- **Battle time:** 60 minutes
- **Command time:** 99 seconds

Rules you can set for battles	Normal rules	Flat rules	No restrictions
Number of Pokémon (Single Battle)	No restrictions	3	No restrictions
Number of Pokémon (Double Battle)	2 or more	4	2 or more
Number of Pokémon (Triple Battle)	3 or more	6	3 or more
Number of Pokémon (Rotation Battle)	3 or more	4	3 or more
Number of Pokémon (Multi Battle)	1 to 3	3	1 to 3
Pokémon Level	All are set to Lv. 50	Up to Lv. 50	No restrictions
Special Pokémon	Permitted	Banned	Permitted
Two or more of the same Pokémon	Permitted	Banned	Permitted
Two or more of the same held items	Permitted	Banned	Permitted

Special Pokémon: Mewtwo, Mew, Lugia, Ho-Oh, Celebi, Kyogre, Groudon, Rayquaza, Jirachi, Deoxys, Palkia, Dialga, Giratina, Phione, Manaphy, Darkrai, Shaymin, Arceus, Victini, Zekrom, Reshiram, Kyurem, Keldeo, Meloetta, Genesect, Xerneas, Yveltal, Zygarde, Diancie

Use handicaps when there are gaps in the skills of players
By setting a handicap, players with different levels can have fun battling each other. The handicap will be set by choosing Strong, Average, or Weak before a battle. The handicap will adjust the number of participating Pokémon. Weak players will be allowed more Pokémon than strong players.

Change the background music during battle
While you're viewing the screen on which "Battle, Start!" is displayed, press START/SELECT to change the background music during the battle. The communication method determines which players this will affect.

Infrared Connection / Local Wireless: The player who hosts the battle can choose the background music. The players who were invited to the battle will hear the music that the host has chosen.

Internet: Everyone can choose their own background music. It's a party!

Battle Spot

Battle Spot uses your Internet connection to connect you instantly to another player in the world who's looking for a battle at the same time you are. Even if you can't find anyone nearby or on the PSS screen to battle, you still can find a player to battle with Battle Spot. There are two types of battles you can enjoy.

Random Matchup
You will battle with a player randomly chosen for you. There are two types of Random Matchups: Free Battle and Rating Battle.

Free Battle: You can freely participate in Free Battle without registering at the Pokémon Global Link (PGL) (p. 415).

Rating Battle: Your rating will go up or down depending on your battle results. You need to register at the PGL. Your rating will be shown on the PGL website.

Random Matchup rules	
Pokémon Level	All are set to Lv. 50
Two or more of the same Pokémon	Banned
Two or more of the same held items	Banned
Battle time	30 minutes
Command time	60 seconds
Number of Pokémon (Single Battle)	3
Number of Pokémon (Double Battle)	4
Number of Pokémon (Triple Battle)	6
Number of Pokémon (Rotation Battle)	4

TIP

The following Pokémon cannot participate in Rating Battles: Mewtwo, Mew, Lugia, Ho-Oh, Celebi, Kyogre, Groudon, Rayquaza, Jirachi, Deoxys, Palkia, Dialga, Giratina, Phione, Manaphy, Darkrai, Shaymin, Arceus, Victini, Zekrom, Reshiram, Kyurem, Keldeo, Meloetta, Genesect, Xerneas, Yveltal, Zygarde, Diancie

TIP

Pokémon holding Soul Dew cannot participate in Free Battles.

TIP

Rules may change at the beginning of a season or at other times.

Online Competition

You can also use Battle Spot to participate in competitions held on the Internet. Please check www.pokemon-gl.com for details or turn to page 417 to learn some of the basics right away.

The joys of trading

The PSS provides several ways to trade Pokémon with players around the world. Try them out in your quest to collect Pokémon!

Trade

Choose Trade on the PSS screen, and you can trade with a player you choose, or with a player with whom you agree to trade while interacting with the player. Here's how.

1. Choose a communication method
Tap Trade on the PSS menu, and choose a communication method.

> **Infrared Connection:** You can trade with someone in front of you
> **Local Wireless:** You can trade with players in your area
> **Internet:** You can trade with players far away

TIP

If you tap a player on the PSS screen and choose Trade, the communication method will be chosen automatically.

2. Choose a person you want to trade with
Tap the icon of a player and wait for his or her reply (or align your Nintendo 3DS systems when you use Infrared Connection).

3. Choose a Pokémon
Choose a Pokémon from your party or PC Boxes, and then tap Show.

4. Trade Pokémon
A Pokémon that the other party chose will be shown on the upper screen. If you are happy with the trade, click Offer. If your trading partner is registered as a Friend, you can trade while talking to him or her using Game Chat. Enable Game Chat in the PSS Settings.

Wonder Trade

With Wonder Trade, you don't know what kind of Pokémon you'll get. Select a Pokémon of your own to offer for trade, and you'll receive a Pokémon chosen at random from among all of the Pokémon that players around the world have offered. It's a very exciting way to trade Pokémon!

TIP

You need at least two Pokémon to trade, and you can't trade Pokémon that know any HM moves.

GTS

Welcome to the GTS!
What would you like to do?

Seek Pokémon

Deposit Pokémon

Quit the GTS

With the GTS (Global Trade Station), you can trade Pokémon with people all over the world. You can search for the exact Pokémon that you want from among all of the Pokémon that other players have offered. Other players can specify the Pokémon that they want—if you have the Pokémon they want and you're willing to trade it, go ahead and make the trade! You can also simply deposit a Pokémon for trading and input certain conditions for the Pokémon you would like to receive in return.

To use the Global Trade Station, tap GTS on the PSS screen (and connect to the Internet if you haven't already done so). You'll then have two ways to trade: Seek Pokémon, or Deposit Pokémon.

Seek Pokémon

1. Choose a Pokémon you want

This function lets you search for desired Pokémon by name. Choose the first letter of a Pokémon from the menu. For Pokémon that you have not seen yet, choose "What Pokémon?" and type its name. You can usually also specify the Pokémon's gender and level. Once you're done specifying the conditions, tap Search with these conditions!

> **TIP**
>
> Lots of people want to trade for special Pokémon. If you want to exclude people who are seeking special Pokémon, tap "Options," and then tap "Don't include."

2. Choose a trading partner

Players who have offered Pokémon that match the conditions you've specified will be displayed. Choose a player you want to trade with. You can filter the players by the following conditions.

- Players who are seeking Pokémon that you have
- Players who are in the same region as you
- Players who are in a different region

3. Trade

Choose a Pokémon that the trading partner wants, and select Yes. The Pokémon will then be traded.

Deposit Pokémon

1. Choose a Pokémon to deposit

This function lets you deposit Pokémon for other players to browse over GTS. Choose a Pokémon you want to deposit from your party or PC Boxes, and then select Deposit.

2. Specify conditions

Search for a Pokémon that you want by its name. Choose the first letter of the Pokémon from the menu. For Pokémon that you have not seen yet, choose "What Pokémon?" and type its name. You can also specify its gender and level, and enter a message.

3. Deposit your Pokémon and wait for a trade

Tap Deposit with these conditions, and your Pokémon will be deposited. Now just sit back and wait! Check the GTS after a while to see if the trade is complete. If it is, you'll receive a Pokémon that you wanted.

> **TIP**
>
> If you want to take back a Pokémon that you've deposited to the GTS, tap "Summary of [Pokémon species name]," and then tap "Take back."

> **TIP**
>
> You cannot deposit a Pokémon Egg for trading over the GTS.

O-Powers

O-Powers are special powers that are activated through the PSS. Each O-Power has its own special benefits, and you may use these powers on yourself or on another player at any time. You can even use an O-Power that another player on the PSS is currently using, even if you haven't learned that power yet. It's a great way to help your friends and yourself! And the more you use your O-Powers, the more powerful they'll become—so use them as often as you can!

How to get O-Powers

As you progress through the adventure, men with colorful clothing and hair will show up in the Pokémon Center in Mauville City, one after the other. These colorful men will teach you O-Powers!

Orlando received an O-Power!

> **TIP**
>
> To learn an O-Power, you have to have learned all O-Powers listed above the O-Power. For example, to learn Befriending Power, you have to have learned Speed Power and Critical Power.

O-Power	How to get the O-Power
HP Restoring Power Lv. 1	Available by default when you get the PlayNav function on your PokéNav Plus.
Capture Power Lv. 1	Available by default when you get the PlayNav function on your PokéNav Plus.
Attack Power Lv. 1	Available by default when you get the PlayNav function on your PokéNav Plus.
Defense Power Lv. 1	Available by default when you get the PlayNav function on your PokéNav Plus.
Sp. Atk Power Lv. 1	Available by default when you get the PlayNav function on your PokéNav Plus.
Sp. Def Power Lv. 1	Available by default when you get the PlayNav function on your PokéNav Plus.
Speed Power Lv. 1	When you first arrive in Mauville City, listen to Giddy's first story.
Critical Power Lv. 1	When you first arrive in Mauville City, listen to Giddy's second story.
Befriending Power Lv. 1	After getting the Mauville City Gym Badge, listen to the Hipster's first story.
Encounter Power Lv. 1	After getting the Lavaridge Town Gym Badge, listen to the Hipster's second story.
Accuracy Power Lv. 1	After getting the Lavaridge Town Gym Badge, listen to the Hipster's third story.
Prize Money Power Lv. 1	After getting the Petalburg City Gym Badge, listen to the Bard's unfinished song.
Exp. Point Power Lv. 1	After getting the Fortree City Gym Badge, listen to the Bard's finished song.
Stealth Power Lv. 1	After getting the Mossdeep City Gym Badge, trade with the Trader.
Bargain Power Lv. 1	After getting the Sootopolis City Gym Badge, trade with the Trader again.
PP Restoring Power Lv. 1	After you've reached Ever Grande City, listen to the Storyteller's story.
Hatching Power Lv. 1	After becoming the Champion, visit the apartment of the five old men in Mauville Hills, and introduce the guy living across the hall to them.

How to use an O-Power

Using O-Powers is fast and easy. There are three main ways to use an O-Power.

1. Use an O-Power that you've learned on yourself

Tap O-Power on your PSS, choose an O-Power that you want to use, and then tap Use.

2. Use an O-Power on a specific person

There are two ways to use an O-Power on a specific player. Here's the first method.

1. Tap O-Power on your PSS, choose an O-Power that you want to give to another player, and then tap Give.

2. Tap the icon of a player you want to give the O-Power to, and then tap Yes.

And here's the second.

1. On your PSS, tap the icon of a player to whom you want to give an O-Power, and then tap O-Power.

2. Choose an O-Power that you want to give the player, and then tap Give.

Use an O-Power that another person is using

You can use any O-Power that another player is currently using—even O-Powers you haven't yet learned! Just tap a player icon that is currently glowing with an O-Power aura on your PSS, and then tap "O-Power." Tap "Receive an O-Power," and then tap "Yes." Bingo!

Power Points

To use an O-Power, you need power points. You automatically gain 1 power point every 4 minutes, and you can store up to 10 power points. The number of power points you need to use an O-Power depends on the O-Power. See the following list of O-Powers for details.

TIP	
The more steps you've recorded on your Nintendo 3DS system, the faster your power points will accumulate—so carry your 3DS with you and walk around!	
0–2,000 steps	1 power point every 4 minutes
2,001–3,000 steps	1 power point every 3 minutes
3,001–4,000 steps	1 power point every 2 minutes
4,001 steps or more	1 power point every 1 minute

O-Power	Duration	Points required (self)	Points required (other player)	Aura color	Effective in	No. of uses to level up	Effects
Encounter Power Lv. 1	3 min.	2	—	Yellow	Field	15	Increases the chance of encountering wild Pokémon a little.
Encounter Power Lv. 2	3 min.	3	—	Yellow	Field	30	Increases the chance of encountering wild Pokémon.
Encounter Power Lv. 3	3 min.	4	—	Yellow	Field	—	Increases the chance of encountering wild Pokémon a lot.
Stealth Power Lv. 1	3 min.	2	—	Yellow	Field	15	Decreases the chance of encountering wild Pokémon a little.
Stealth Power Lv. 2	3 min.	3	—	Yellow	Field	30	Decreases the chance of encountering wild Pokémon.
Stealth Power Lv. 3	3 min.	4	—	Yellow	Field	—	Decreases the chance of encountering wild Pokémon a lot.
Hatching Power Lv. 1	3 min.	2	1	Yellow	Field	15	Helps Eggs hatch a little faster.
Hatching Power Lv. 2	3 min.	3	2	Yellow	Field	30	Helps Eggs hatch faster.
Hatching Power Lv. 3	3 min.	4	3	Yellow	Field	—	Helps Eggs hatch much faster.
Befriending Power Lv. 1	3 min.	2	1	Yellow	Field	15	Helps Pokémon grow friendly a little faster.
Befriending Power Lv. 2	3 min.	3	2	Yellow	Field	30	Helps Pokémon grow friendly faster.
Befriending Power Lv. 3	3 min.	4	3	Yellow	Field	—	Helps Pokémon grow friendly much faster.
Bargain Power Lv. 1	3 min.	2	1	Yellow	Field	15	Poké Marts begin a bargain sale in which everything is 10% off.
Bargain Power Lv. 2	3 min.	3	2	Yellow	Field	30	Poké Marts begin a bargain sale in which everything is 25% off.
Bargain Power Lv. 3	3 min.	4	3	Yellow	Field	—	Poké Marts begin a bargain sale in which everything is 50% off.
HP Restoring Power Lv. 1	Immediate	2	1	Yellow	Field & battle	15	Restores 20 HP to the lead Pokémon.
HP Restoring Power Lv. 2	Immediate	3	2	Yellow	Field & battle	30	Restores 50 HP to the lead Pokémon.
HP Restoring Power Lv. 3	Immediate	4	3	Yellow	Field & battle	—	Restores 200 HP to the lead Pokémon.
PP Restoring Power Lv. 1	Immediate	2	1	Yellow	Field & battle	15	Restores 5 PP of the lead Pokémon's 4 moves.
PP Restoring Power Lv. 2	Immediate	3	2	Yellow	Field & battle	30	Restores 10 PP of the lead Pokémon's 4 moves.
PP Restoring Power Lv. 3	Immediate	4	3	Yellow	Field & battle	—	Restores all PP of the lead Pokémon's 4 moves.
Exp. Point Power Lv. 1	3 min.	4	2	Blue	Battle	15	Increases the Exp. Points from battles a little.
Exp. Point Power Lv. 2	3 min.	5	3	Blue	Battle	30	Increases the Exp. Points from battles.
Exp. Point Power Lv. 3	3 min.	6	4	Blue	Battle	—	Increases the Exp. Points from battles very much.
Prize Money Power Lv. 1	3 min.	4	2	Blue	Battle	15	Increases the prize money from battles by 50 percent.
Prize Money Power Lv. 2	3 min.	5	3	Blue	Battle	30	Doubles the prize money from battles.
Prize Money Power Lv. 3	3 min.	6	4	Blue	Battle	—	Triples the prize money from battles.
Capture Power Lv. 1	3 min.	4	2	Blue	Battle	15	Increases the chance to catch Pokémon a little.

O-Power	Duration	Points required (self)	Points required (other player)	Aura color	Effective in	No. of uses to level up	Effects
Capture Power Lv. 2	3 min.	5	3	Blue	Battle	30	Increases the chance to catch Pokémon.
Capture Power Lv. 3	3 min.	6	4	Blue	Battle	—	Increases the chance to catch Pokémon very much.
Critical Power Lv. 1	Until the end of a battle	3	1	Red	Battle	15	Increases the critical-hit ratio of the lead Pokémon by 1 during battle.
Critical Power Lv. 2	Until the end of a battle	5	2	Red	Battle	30	Increases the critical-hit ratio of the lead Pokémon by 2 during battle.
Critical Power Lv. 3	Until the end of a battle	8	3	Red	Battle	—	Increases the critical-hit ratio of the lead Pokémon by 3 during battle.
Attack Power Lv. 1	Until the end of a battle	3	1	Red	Battle	15	Raises the Attack stat of the lead Pokémon by 1 during battle.
Attack Power Lv. 2	Until the end of a battle	5	2	Red	Battle	30	Raises the Attack stat of the lead Pokémon by 2 during battle.
Attack Power Lv. 3	Until the end of a battle	8	3	Red	Battle	—	Raises the Attack stat of the lead Pokémon by 3 during battle.
Defense Power Lv. 1	Until the end of a battle	3	1	Red	Battle	15	Raises the Defense stat of the lead Pokémon by 1 during battle.
Defense Power Lv. 2	Until the end of a battle	5	2	Red	Battle	30	Raises the Defense stat of the lead Pokémon by 2 during battle.
Defense Power Lv. 3	Until the end of a battle	8	3	Red	Battle	—	Raises the Defense stat of the lead Pokémon by 3 during battle.
Speed Power Lv. 1	Until the end of a battle	3	1	Red	Battle	15	Raises the Speed stat of the lead Pokémon by 1 during battle.
Speed Power Lv. 2	Until the end of a battle	5	2	Red	Battle	30	Raises the Speed stat of the lead Pokémon by 2 during battle.
Speed Power Lv. 3	Until the end of a battle	8	3	Red	Battle	—	Raises the Speed stat of the lead Pokémon by 3 during battle.
Sp. Atk Power Lv. 1	Until the end of a battle	3	1	Red	Battle	15	Raises the Sp. Atk stat of the lead Pokémon by 1 during battle.
Sp. Atk Power Lv. 2	Until the end of a battle	5	2	Red	Battle	30	Raises the Sp. Atk stat of the lead Pokémon by 2 during battle.
Sp. Atk Power Lv. 3	Until the end of a battle	8	3	Red	Battle	—	Raises the Sp. Atk stat of the lead Pokémon by 3 during battle.
Sp. Def Power Lv. 1	Until the end of a battle	3	1	Red	Battle	15	Raises the Sp. Def stat of the lead Pokémon by 1 during battle.
Sp. Def Power Lv. 2	Until the end of a battle	5	2	Red	Battle	30	Raises the Sp. Def stat of the lead Pokémon by 2 during battle.
Sp. Def Power Lv. 3	Until the end of a battle	8	3	Red	Battle	—	Raises the Sp. Def stat of the lead Pokémon by 3 during battle.
Accuracy Power Lv. 1	Until the end of a battle	3	1	Red	Battle	15	Raises the accuracy of the lead Pokémon by 1 during battle.
Accuracy Power Lv. 2	Until the end of a battle	5	2	Red	Battle	30	Raises the accuracy of the lead Pokémon by 2 during battle.
Accuracy Power Lv. 3	Until the end of a battle	8	3	Red	Battle	—	Raises the accuracy of the lead Pokémon by 3 during battle.

SUPER TRAINING

Raise your Pokémon for Battle!

Super Training lets players raise their Pokémon's base stats from the start, which is a big help to competitive players. Take advantage of the two training modes provided in Super Training, and raise strong Pokémon! For more details on base stats, see page 325.

Super Training modes

There are two ways to increase a Pokémon's base stats in Super Training: Core Training and Super-Training Regimens.

Super Training Main Screen

1 **The Pokémon in training**

2 **The rest of your party Pokémon**
Tap a Pokémon to select it for training.

3 **Super Training**
Tap this to begin Super Training.

4 **The Pokémon's base stats**
You can raise them until they're full.

5 **Effort-o-Meter**
The inner green portion indicates the strength of the Pokémon's species, and the outer yellow portion indicates the Pokémon's base stats.

> **TIP**
>
> It's important to know how to raise your Pokémon to be strong. Their six stats—HP, Attack, Defense, Sp. Atk, Sp. Def, and Speed—increase every time they level up, but things aren't as simple as that. Each stat's value is also affected by a Pokémon's base stats. See page 325 to review the basics about base stats and their effects. Otherwise, read on to learn the ways that Super Training will hone them!

Core Training

In Core Training, help your Pokémon pound a training bag by tapping the bag on the Touch Screen. Just like that, your Pokémon's base stats will improve.

While you're pounding away at the plain bag that initially appears on the Core Training screen, special training bags may drop down from above. You can also receive special training bags as rewards for completing Super-Training Regimens. The following table lists all of the special training bags and their effects.

Special Training Bags

Training Bag	Effect	Training Bag	Effect
HP Bag S	Trains the HP stat slightly.	Speed Bag S	Trains the Speed stat slightly.
HP Bag M	Trains the HP stat a fair amount.	Speed Bag M	Trains the Speed stat a fair amount.
HP Bag L	Trains the HP stat quite a lot.	Speed Bag L	Trains the Speed stat quite a lot.
Attack Bag S	Trains the Attack stat slightly.	Strength Bag	Successful shots will award more points in the Pokémon's next Super-Training Regimen.
Attack Bag M	Trains the Attack stat a fair amount.		
Attack Bag L	Trains the Attack stat quite a lot.	Toughen-Up Bag	Makes the Balloon Bots' shots less effective in the Pokémon's next Super-Training Regimen.
Defense Bag S	Trains the Defense stat slightly.		
Defense Bag M	Trains the Defense stat a fair amount.	Swiftness Bag	Makes the Pokémon quicker the next time the Pokémon takes on a Super-Training Regimen.
Defense Bag L	Trains the Defense stat quite a lot.		
Sp. Atk Bag S	Trains the Sp. Atk stat slightly.	Big-Shot Bag	Makes shots more likely to hit the goals in the Pokémon's next Super-Training Regimen.
Sp. Atk Bag M	Trains the Sp. Atk stat a fair amount.		
Sp. Atk Bag L	Trains the Sp. Atk stat quite a lot.	Double-Up Bag	Doubles base-stat increases the next time the Pokémon takes on a Super-Training Regimen.
Sp. Def Bag S	Trains the Sp. Def stat slightly.		
Sp. Def Bag M	Trains the Sp. Def stat a fair amount.	Reset Bag	Completely resets all of the base stats of a Pokémon. Use it to start the Pokémon's training over again with a blank slate.
Sp. Def Bag L	Trains the Sp. Def stat quite a lot.	Soothing Bag	Makes a Pokémon slightly friendlier toward its Trainer.

Super-Training Regimens

Super-Training Regimens have three basic levels, each containing six stages—one for each of the six major Pokémon stats. The higher the regimen's level, the greater the challenge. You unlock new levels by clearing all six stages of a level. Once you've maxed out one Pokémon's stats, making it a Fully Trained Pokémon, you will unlock the 12 stages of the Secret Super-Training Regimens. Unlock each of these stages in turn by beating the stage before it. Unlock all 12 and take on the final challenge in the 12th Secret Super-Training Regimen stage: the battle for the best!

The further you make it through the Super-Training Regimens, the better the rewards. You'll earn more powerful training bags as you progress, and you may also receive rare items! As your Pokémon's stats go up, it will perform better in its regimens. For example, it will be able to score more points with its shots or maintain its barriers for longer periods.

Super Training 101

Super Training's main mode plays like a virtual sports game in which your chosen Pokémon faces off against Balloon Bots. Use the Circle Pad to dodge the balls that are launched by the Balloon Bots while simultaneously tapping the Touch Screen to shoot your own balls into the goals. You'll score points for goals, but being hit by a ball will subtract points from your total. To clear the challenge, reach the required score before time runs out!

Goal types

There are two basic types of goal: normal white goals and red bonus goals. White goals are the most common. They vanish after you hit them, giving you a certain number of points. They'll also disappear after a certain amount of time, turning orange to warn you before they disappear. Red bonus goals are more rare, and they do not vanish when hit. Instead, these special goals remain in play for a brief period of time, letting you rack up lots of points as you hit them repeatedly. Often a bonus goal will appear after you have made all of the normal white goals disappear by successfully hitting them with your shots. Take full advantage of those rare bonus goals!

Shot types

See the circle in the bottom of the screen, next to the score? That's your Pokémon's energy meter. When it's empty, your Pokémon will only be able to shoot regular gray balls. When it has stored up some energy, it can let loose with Energy Shots of different colors. Tap the Touch Screen to fire an individual shot, or keep tapping to fire off a volley—but watch that you don't run out of energy or your shots will become far less effective!

Your Pokémon can also use Charged Shots. If you hold the stylus to the Touch Screen, you'll begin to store up energy. Your Pokémon will begin to glow, and when the light flares up around its body, it's time for you to let go! These shots will score you far more points than regular shots or even Energy Shots, but don't charge them for too long. If you do, the Charged Shot will fail in a plume of smoke. Charged Shots are the key to getting great records in your Super-Training Regimens, and timing is vital!

Energy Shot varieties

There are five kinds of Energy Shots that different Pokémon can use as long as there is some energy in their energy meters. Each Pokémon's Energy Shot is determined by its species.

Black Balls: Have average power, speed, size, and energy consumption. These can be fired off quickly in succession.

Yellow Balls: Have low power, average speed, and small size, but with low energy consumption. These can be fired off quickly in succession.

Orange Balls: Have average speed, energy consumption, and time between shots. Their power is a bit weak, but the shots are large and less likely to miss.

Green Balls: Have high power, but high energy consumption. These shots are slow, but a bit bigger than average.

Blue Balls: Have average power, but they're fast. These balls are small and consume quite a lot of energy.

Barriers

In the later stages of Super Training, the use of barriers becomes an important tactic. Simply press Ⓛ to put up a barrier that temporarily shields you from the Balloon Bot's inbound balls. When Balloon Bots bring up barriers of their own, blast the roaming target to bring the barrier down quickly. Barriers can't be held forever, so be sure you time their usage well or you might be left exposed at an inopportune moment. Don't make the mistake of thinking you can keep Ⓛ held down forever. Instead you should throw up your barriers when you need them and let them drop between incoming shots.

Bitbots

Bitbots are small bits of errant data that Balloon Bots can summon around them. They may look like innocent balloons, but they can fire shots at you just like their parent Balloon Bot. They can also get in the way of your shots, making it harder to hit the Balloon Bot's goals. You can knock them out of the park with a well-aimed shot, but that won't provide relief for long, because these tricky Bitbots regenerate over time.

Awards and rewards

Your Pokémon can earn awards for completing Super-Training Regimens within the target time. Get rewards on every single regimen, and your Fully Trained Pokémon will become a Supremely Trained Pokémon! And you already knew that you could get new training bags for completing Super-Training Regimens, but don't forget that you can also get items in the more advanced regimens. Unlock the Secret Super-Training Regimens by fully training your Pokémon, and you can get great rewards, like Leaf Stones, Stardusts, Pretty Wings, and PP Maxes! These are just a few of the rare and valuable items you can get, so be sure to try Secret Super-Training Regimens for yourself!

Base stats and performance

As base stats grow, they'll not only help your Pokémon grow stronger for real battles, but they'll also improve how your Pokémon can perform in Super Training. The following table gives an easy breakdown of the gains you can expect to see in your Super-Training Regimens.

Increased base stat effects in Super Training

HP	Increases the size of the Pokémon's shots, making it easier to hit targets.	Sp. Atk	Increases the power of the Pokémon's shots, making them earn more points.
Attack	Increases the power of the Pokémon's shots, making them earn more points.	Sp. Def	Increases how quickly you gain energy for Energy Shots and how long you can hold a barrier.
Defense	Increases how quickly you gain energy for Energy Shots and how long you can hold a barrier.	Speed	Allows Pokémon to fire shots more quickly and move around the field more swiftly.
		Any	Reduces the number of points you lose when an enemy shot enters your goal.

POKÉMON-AMIE

Pokémon-Amie is one of the features available on your PlayNav. Using this feature, you can strengthen the bond between you and your Pokémon through a variety of fun activities, including petting your Pokémon, giving them delicious snacks called Poké Puffs, playing minigames with them, and playing the Making Faces game.

Check if your Pokémon is happy

Switch Pokémon!

Treecko

Affection
Fullness
Enjoyment

Select the Pokémon you'd like to play with!

On the Switch Pokémon screen, you can check the level of your Pokémon's Affection, Fullness, and Enjoyment. Check the table below on how each Pokémon-Amie activity affects these elements.

TIP

When the level of your Pokémon's Affection increases, you can get a Décor item. Also, affectionate Pokémon will do better in battles, from spontaneously curing themselves of status conditions to avoiding attacks or landing more critical hits. Please see page 76 to discover all of the benefits of Affection.

Activity	Affection	Fullness	Enjoyment
Pet your Pokémon	Increases	—	Decreases
Give Poké Puffs	Increases	Increases	—
Play minigames	—	Decreases	Increases
Play the Making Faces game	Increases	Decreases	Increases

Poké Puffs

Poké Puffs come in five flavors (Sweet, Mint, Citrus, Mocha, and Spice) and four levels (Basic, Frosted, Fancy, and Deluxe). The fancier the Poké Puff, the more Affection your Pokémon will gain from enjoying it.

	Type	Effect	Main way to obtain
	Basic Poké Puffs	Increases affection a little and increases fullness.	Clear minigames in easy mode
	Frosted Poké Puffs	Increases affection a little and increases fullness.	Clear minigames in normal mode
	Fancy Poké Puffs	Increases affection quite a bit and increases fullness.	Clear minigames in hard mode
	Deluxe Poké Puffs	Increases affection quite a bit and increases fullness.	Clear minigames in unlimited mode

TIP

If you get a full five stars in a minigame, you may obtain one of the next level of Poké Puffs. So clearing a minigame in easy mode with five stars may earn you a Frosted Poké Puff, as well as Basic Poké Puffs!

Poké Puffs (cont.)

Special Poké Puffs

There are also six special Poké Puffs to collect. Your Pokémon will feel much more affectionate toward you if you bestow one of these special prizes on it!

	Type	Effect	How to obtain
	Supreme Wish Poké Puff	Increases affection a lot and increases fullness.	Receive on your birthday
	Supreme Honor Poké Puff	Increases affection a lot and increases fullness.	Receive when you enter the Hall of Fame
	Supreme Spring Poké Puff	Increases affection a lot and increases fullness.	Receive when you beat a Pokémon-Amie minigame in unlimited mode with 5 stars
	Supreme Summer Poké Puff	Increases affection a lot and increases fullness.	Receive when you beat Head It in unlimited mode with 5 stars
	Supreme Autumn Poké Puff	Increases affection a lot and increases fullness.	Receive when you beat Berry Picker in unlimited mode with 5 stars
	Supreme Winter Poké Puff	Increases affection a lot and increases fullness.	Receive when you beat Tile Puzzle in unlimited mode with 5 stars

Play minigames

Pokémon-Amie also lets you play fun minigames with your Pokémon. These simple minigames are easy to grasp, yet challenging to master. Play together with your Pokémon to increase their enjoyment stats and earn more Poké Puffs to feed them as snacks! You must have at least three healthy Pokémon on your team to play minigames. You'll unlock more advanced minigame levels as your performance improves on each game, and the more advanced levels will reward you with fancier Poké Puffs as prizes.

Pokémon-Amie Minigames

Berry Picker

In Berry Picker, your goal is to feed Berries to your Pokémon as quickly as possible. Three different Berries hang from the trees in easy mode, and your Pokémon periodically pop up from the bottom of the screen with a Berry inside a thought bubble. Tap and drag the correct Berry down to the Pokémon to feed it. Take too long or give the wrong Berry, and your Pokémon will leave in annoyance. See how many Pokémon you can feed before time runs out. The more successful you are, the faster the demands will come at you! Easy mode will have you picking from three different Berries, with five in normal mode, and seven in hard mode. Once you unlock unlimited mode, you can see how long you can keep your Pokémon happy. It's three strikes and you're out in this mode, where three wrong or missed Berries will end the game.

TRAINER HANDBOOK

Head It

In Head It, you help your Pokémon headbutt falling balls of yarn back up into the sky. Simply tap your Pokémon just as a ball of yarn is about to reach it or fall past it. Be careful not to tap your Pokémon too soon! Keep hitting the balls of yarn without missing, and you'll soon rack up a combo. Try to keep that combo going for as long as possible to earn big points. The more successful hits in a row that you manage, the faster the balls will come flying at you—meaning that you can get a far higher combo! The main difference between easy, normal, and hard mode in this game is simply the speed at which the balls of yarn fall toward your Pokémon. Unlimited mode once again gives you three chances: miss three balls of yarn and it's game over!

Tile Puzzle

Tile Puzzle is perhaps the most challenging minigame. In Tile Puzzle, you must reassemble a scrambled image as quickly as you can by tapping the pieces to swap them around. Study the picture at the start and try to memorize the order of the three Pokémon. After the picture is scrambled, hurry to swap those tiles around and put it back together. When you place a tile correctly, it will sparkle as it snaps into place. You can't move that tile again, so don't worry about it anymore! In easy mode, the puzzle is made up of 20 pieces; in normal mode, it's 30 pieces; and in hard mode, it's 48 pieces. In unlimited mode, you solve as many increasingly complicated puzzles as you can before time runs out, and each successful puzzle completed will put some time back on the clock.

Play the Making Faces game

Notice the little smiley icon that appears in the lower-left corner of the Touch Screen. This icon appears when the Nintendo 3DS Camera is picking you up. If you take an action while this icon appears, like smiling, tilting your head to the side, blinking, opening your mouth wide, and so on, your Pokémon will imitate it. Do this three times to trigger the Making Faces game! Your Pokémon will tell you to make certain faces or perform certain actions. Try to keep the game going as long as you can! Making Faces won't score you any Poké Puffs, but it will make your Pokémon very happy, and thus more affectionate toward you.

Decorate your Pokémon's room

The Decorate option lets you change your Pokémon-Amie wallpaper and put out fancy Décor items such as cushions for Pokémon to enjoy. You can also put out Poké Puffs in the hope of attracting nearby players' Pokémon to visit. Visiting Pokémon may give you gifts of Décor items or Poké Puffs, so they're always welcome. Unlock more Décor items for yourself by making your way through the different difficulty levels on all the minigames and helping your Pokémon grow more affectionate. There are over 200 Décor items to collect in total, so enjoy decorating with Décor items and customizing your Pokémon-Amie experience!

ADVANCED HANDBOOK

ADVENTURE DATA

THE POKÉMON GLOBAL LINK

Website subject to change

The Pokémon Global Link, abbreviated as PGL, is a no charge website that can be linked to your game in *Pokémon Omega Ruby* or *Pokémon Alpha Sapphire*. Join the community of Pokémon Trainers, play attractions to get items, see how other people are playing and competing in Pokémon, and most importantly, take part in battles and competitions!

How to sign up

Signing up for the PGL is absolutely no charge. All you have to do is create a Pokémon Trainer Club account. Go to www.pokemon-gl.com on your computer or mobile device. You may have to select your region the first time. Select "Sign Up!" under the log-in area on the left-hand side of the page. Enter your birth date and country. Be truthful, because if you are ever found to be using false information during a competition, you could be disqualified!

Next, choose a username and password, and enter an email address you'd like to associate with your account. You can opt in or out for receiving marketing emails from The Pokémon Company International. Then verify your email and you're done!

What you'll find on the PGL

Features are always being updated and changing with the times, but here are some of the things on the current PGL.

News and Events

Learn about upcoming promotions, competitions, and big Pokémon news, like the release of new games!

Your Logbook

Your Logbook records your milestones and accomplishments in the game. You can make it viewable by others or keep it all to yourself.

PokéMileage Club

Exchange your Poké Miles for select items in the PokéMileage Shop, or use them to play attractions. Any items you buy or win can be transferred back to your game and used in your adventure!

Online Competitions

Sign up for Online Competitions, whether regional or international. This is one of the biggest draws of the PGL—read on to learn more!

Medals

Earn Medals for special accomplishments in the games. There are dozens to earn for bragging rights!

Rankings

See the current top-ranked Trainers in the world for each kind of battle format, and check out stats like which Pokémon are most popular to use in Online Competitions. You can even see which Pokémon are currently trending as the most popular to use in different Pokémon Contest Spectaculars in *Pokémon Omega Ruby* and *Pokémon Alpha Sapphire*!

> **TIP**
>
> There's even more you can do with your Pokémon Trainer Club ID on www.pokemon.com! There you can play minigames, create your personal avatar, watch episodes of the TV show, and even get started playing the Pokémon Trading Card Game Online—all for no charge!

What Are Poké Miles?

You earn Poké Miles in both *Pokémon Omega Ruby* and *Pokémon Alpha Sapphire* as your player character travels around the world. The more distance you cover in your adventure, the more Poké Miles you'll earn. You'll also earn tons of Poké Miles by trading Pokémon with other players, either by making Link Trades with friends on the PSS (p. 404), using Wonder Trade (p. 404), or trading with players worldwide on the Global Trade Station (p. 405). These Poké Miles can all be sent to the PGL using Game Sync (read on for details). Or you can exchange them for items at the PokéMileage Center located on the west side of Mauville City.

Linking your game to the PGL

Linking your game to the PGL is easy and can be completed in three short steps.

1. Start by generating a Game Sync ID in your game

Go to the PSS in your PlayNav and open the PSS menu by tapping the icon at the top of the main PSS screen. On the second page of the menu, select "Game Sync." You'll be asked if you want to connect to the Internet and then to save your game. If you're not currently in an environment where you can connect to the Internet, you won't be able to connect to Game Sync.

> **TIP**
>
> If you want to learn more about how to use Game Sync, choose Info from the Game Sync menu. You can also change your Game Sync settings by selecting Settings from the menu. This will allow you to decide things like when your game syncs, or what to do with your Poké Miles.

2. Choose "Create your Game Sync ID" from the menu that appears, and then select "Yes"

Your game will be authenticated online and you will be issued a Game Sync ID. Your Game Sync ID will be a 16-digit series of letters and numbers, which you'll need to enter at the PGL website to connect your game.

3. With your Game Sync ID handy, visit the PGL at www.pokemon-gl.com and log in

If you don't already have a PGL account, choose to sign up and follow the instructions (or have a parent help out) to activate your PGL account and enter your Game Sync ID when done!

If you already have a PGL account from playing *Pokémon X* or *Pokémon Y*, select "Account Settings" from the menu that appears under your profile image in the upper-right corner of the home page. In your Account Settings, you'll find an option for registering additional games. Select it, and then enter your Game Sync ID to add *Pokémon Omega Ruby* or *Pokémon Alpha Sapphire* to your PGL account.

Online Competitions and Rating Battles

There are two main ways to connect to other Trainers around the world using the Pokémon Global Link. One is Rating Battles, and the other is Online Competitions.

Rating Battles

To participate in Rating Battles, you need to register at the Pokémon Global Link.

Rating Battles are available during seasons, with each season typically lasting a few months. At the end of each season, the players' ranks are posted and published online. Filter the rankings, and you can see where you stand internationally, within other regions, or among your friends. You can also easily see who has moved up, down, or held onto their spot, thanks to the colored arrows to the right of each player's name. *Pokémon Omega Ruby* and *Pokémon Alpha Sapphire* will have a separate league for battles than *Pokémon X* and *Pokémon Y*. You will be matched up for Rating Battles among *Pokémon X* or *Pokémon Y* players when playing one of those games. If you're playing *Pokémon Omega Ruby* or *Pokémon Alpha Sapphire*, you'll be matched with other players of those games.

Rankings and Ratings

Every player begins with a rating of 1,500. This number goes up when you win battles and down when you lose. Note that if you choose to run away during a battle, or if you disconnect from the Internet during a battle, it is counted as a loss. Your ranking is decided by your aggregate rating from the battles you took part in.

Taking part in Rating Battles is easy. You don't have to perform any special registration, aside from setting up your main PGL account if you want to see how you rank in the world—you just need to have an Internet connection available for your game system. Once you're connected, open up the PSS (p. 401) from your PlayNav app and select "Battle Spot." Choose "Random Matchup Rating Battle" and then decide the regulations for the battle. You'll download a Digital Player ID the first time you participate in a Rating Battle, and then you're good to go!

TIP

Your battle records will be automatically sent to the PGL. You can participate in Single Battles, Double Battles, Triple Battles, Rotation Battles, or special battle formats that rotate every season. The top-ranking players in the top 100, top 500, and top 1,000 players receive special medals on the PGL.

Rating Battles are a great way to get started in competitive play and see the amazing strategies that other Trainers have come up with. When you're paired with an opponent, the system will select someone with a ranking similar to yours, so you shouldn't suddenly find yourself up against an impossible opponent. Give it a try and work your way up the rankings until you reach the top!

TIP

Visit 3ds.Pokemon-gl.com/support/2/en/manual/manual_battle/ for more information about the rules for participating in Rating Battles.

Online Competitions

Online Competitions are held throughout the year, with some being regional and some international. They're announced in advance, and you must register during a set registration window in order to participate. Signing up for an Online Competition is easy—just log in to the Pokémon Global Link and visit the Online Competition page. Follow the instructions to register, and then choose the "Battle Spot" option on the PSS in your game. Select "Online Competition" this time, and then choose "Participate" to download your Digital Player ID for the competition.

Welcome to the Online Competition!

Participate

Back

The Pokémon that you've placed in your PC Battle Box (p. 402) are the ones you'll use in an Online Competition. Your Battle Box will be locked for the length of the competition, and you won't be able to change your team, so set it up with care before the competition starts. Once the competition opens, select "Battle Spot" on your PSS, go to "Online Competition" again, and then choose "Battle." Your Battle Box will be locked the first time you participate, and the games will officially begin!

During the length of the competition, you can normally only participate in a set number of battles each day—but this quota will be rolled over to following days if you don't use up all of your battles. It's easy and fun to participate in competitions, and even if you don't end up winning, you'll usually still earn a prize just for playing. As long as you participate in at least one battle that ends in a win or loss, you are typically awarded special items, like rare Berries that normally can't be found in the game or piles of Poké Miles. Online Competitions are lots of fun, so be sure to try one at least once!

TIP

See 3ds.pokemon-gl.com/support/guide/competition/ for a complete guide to the registration process and more on the rules for Online Competitions.

POSTING TO THE MiiVERSE

The Miiverse is Nintendo's special platform for connecting with other players. It became available on your Nintendo 3DS system in 2013, so if you don't see it on your system, you may need to download a rather overdue update! On the Miiverse, you'll find a community for the games you're playing on your Nintendo 3DS system. You can ask questions, share achievements or tips, post your original art, and more as you share your love of *Pokémon Omega Ruby* or *Pokémon Alpha Sapphire* with other players from around the world.

Access the Miiverse by pressing the HOME button at any time. You won't have to close your game, so you can easily jump back and forth between *Pokémon Omega Ruby* or *Pokémon Alpha Sapphire* and the Miiverse to get help and more. Once you're on the HOME screen, tap the green icon that looks like several Miis standing together in the upper-right corner of the Touch Screen.

TIP

If you're posting something that might be a spoiler for later in the game, you can even choose to hide the full text so you don't ruin it for other players.

TIP

A note to parents: The Miiverse is designed to be a friendly environment for all ages to enjoy. But if you are concerned, you can limit your child's access to the Miiverse and other online features using the Parental Controls on the Nintendo 3DS system.

POKÉMON BANK AND POKÉ TRANSPORTER

Pokémon Bank is an application and service for *Pokémon Omega Ruby* and *Pokémon Alpha Sapphire* that lets you deposit, store, and manage your Pokémon in private Boxes on the Internet. *Pokémon Bank* is a paid service, with an annual charge for usage. *Pokémon Bank* is a powerful resource for players who like to obtain many different kinds of Pokémon, or for those who like to raise many Pokémon in preparation for battles and competitions!

When you download *Pokémon Bank*, you can also download the linked application, *Poké Transporter*, for no charge. When you insert a *Pokémon Black*, *Pokémon White*, *Pokémon Black 2*, or *Pokémon White 2* Game Card into a Nintendo 3DS system, you'll be able to use *Poké Transporter* to transfer Pokémon from these games into their own online Boxes. Then you can easily transfer those Pokémon into *Pokémon Omega Ruby* and *Pokémon Alpha Sapphire* using *Pokémon Bank*! Note that *Poké Transporter* can't return Pokémon to *Pokémon Black*, *Pokémon White*, *Pokémon Black 2*, or *Pokémon White 2* after they've been stored in an online Box.

TIP

You may find yourself unable to use *Pokémon Bank* or *Poké Transporter* to deposit any Pokémon created by software unauthorized by The Pokémon Company and Nintendo, and its affiliates into your online Boxes, or to move these Pokémon between online Boxes.

TIP

You can also transfer Pokémon from even older games, all the way back to the original *Pokémon Ruby* and *Pokémon Sapphire*, if you have the right hardware and software on hand. You would need to transfer your Pokémon from those games to *Pokémon Diamond*, *Pokémon Pearl*, *Pokémon HeartGold*, *Pokémon SoulSilver*, or *Pokémon Platinum* using the Pal Park that was present in those games. You would need to do this in a Nintendo DS or Nintendo DS Lite system that has a Game Boy Advance slot in it. Then move your Pokémon from those games to any of *Pokémon Black*, *Pokémon White*, *Pokémon Black 2*, or *Pokémon White 2* by using the Poké Transfer Lab on the Unova region's Route 15. Finally, insert your *Pokémon Black*, *Pokémon White*, *Pokémon Black 2*, or *Pokémon White 2* game into your Nintendo 3DS or 2DS system that has *Pokémon Bank* installed on it, and you can bring your old pals with you to these new games!

TRAINER HANDBOOK

ADVANCED HANDBOOK

ADVENTURE DATA

ADVENTURE DATA

Explanations of the Move List

Move........ The move's name

Type The move's type

Kind Physical moves deal more damage when a Pokémon's Attack is high. Special moves deal more damage when a Pokémon's Sp. Atk is high. Status moves cause effects, such as status conditions.

Pow. The move's attack power

Acc. The move's accuracy

PP............. How many times the move can be used

Range....... The number and types of targets the move affects

DA Moves that make direct contact with the target

Long........ Moves that can target the Pokémon on the other side during Triple Battles

Range Guide

Normal: The move affects the selected target.

Self: The move affects only the user.

1 Ally: The move affects an adjacent ally in Double, Triple, and Multi Battles.

Self/Ally: The move affects the user or one of its allies.

Your Party: The move affects your entire party, including party Pokémon who are still in their Poké Balls.

1 Random: The move affects one of the opposing Pokémon at random.

Many Others: The move affects multiple Pokémon at the same time.

Adjacent: The move affects the surrounding Pokémon at the same time.

Your Side: The move affects the side of the field where your Pokémon are.

Other Side: The move affects the opponent's side of the field.

Both Sides: The move affects the entire playing field without regard to opposing and ally Pokémon.

Varies: The move is influenced by things like the opposing Pokémon's move or the user's type, so the effect and range are not fixed.

POKÉMON MOVES

A

Move	Type	Kind	Pow.	Acc.	PP	Range	DA	Long	Effect
Absorb	Grass	Special	20	100	25	Normal	—	—	Restores HP by up to half of the damage dealt to the target.
Acid	Poison	Special	40	100	30	Many Others	—	—	A 10% chance of lowering the targets' Sp. Def by 1. Its power is reduced by 25% when it hits multiple Pokémon.
Acid Armor	Poison	Status	—	—	20	Self	—	—	Raises the user's Defense by 2.
Acid Spray	Poison	Special	40	100	20	Normal	—	—	Lowers the target's Sp. Def by 2.
Acrobatics	Flying	Physical	55	100	15	Normal	○	○	This move's power is doubled if the user isn't holding an item.
Acupressure	Normal	Status	—	—	30	Self/Ally	—	—	Raises a random stat by 2.
Aerial Ace	Flying	Physical	60	—	20	Normal	○	○	A sure hit.
After You	Normal	Status	—	—	15	Normal	—	—	The user helps the target and makes it use its move right after the user, regardless of its Speed. It fails if the target was going to use its move right after anyway, or if the target has already used its move this turn.
Agility	Psychic	Status	—	—	30	Self	—	—	Raises the user's Speed by 2.
Air Cutter	Flying	Special	60	95	25	Many Others	—	—	Critical hits land more easily. Its power is reduced by 25% when it hits multiple Pokémon.
Air Slash	Flying	Special	75	95	15	Normal	—	○	A 30% chance of making the target flinch (unable to use moves on that turn).
Ally Switch	Psychic	Status	—	—	15	Self	—	—	The user switches places with an ally. It fails if the user or target is in the middle (works only when the target is on the other end).
Amnesia	Psychic	Status	—	—	20	Self	—	—	Raises the user's Sp. Def by 2.
Ancient Power	Rock	Special	60	100	5	Normal	—	—	A 10% chance of raising the user's Attack, Defense, Speed, Sp. Atk, and Sp. Def stats by 1.
Aqua Jet	Water	Physical	40	100	20	Normal	○	—	Always strikes first. The user with the higher Speed goes first if similar moves are used.
Aqua Ring	Water	Status	—	—	20	Self	—	—	Restores 1/16 of max HP every turn.
Aqua Tail	Water	Physical	90	90	10	Normal	○	—	A regular attack.
Arm Thrust	Fighting	Physical	15	100	20	Normal	○	—	Attacks 2–5 times in a row in a single turn.
Aromatherapy	Grass	Status	—	—	5	Your Party	—	○	Heals status conditions of all your Pokémon, including those in your party.
Aromatic Mist	Fairy	Status	—	—	20	1 Ally	—	—	Raises one ally's Sp. Def by 1.
Assist	Normal	Status	—	—	20	Self	—	—	Uses a random move from one of the Pokémon in your party that is not in battle.
Assurance	Dark	Physical	60	100	10	Normal	○	—	Move's power is doubled if the target has already taken some damage in the same turn.
Astonish	Ghost	Physical	30	100	15	Normal	○	—	A 30% chance of making the target flinch (unable to use moves on that turn).
Attack Order	Bug	Physical	90	100	15	Normal	—	—	Critical hits land more easily.
Attract	Normal	Status	—	100	15	Normal	—	—	Leaves the target unable to attack 50% of the time. Only works if the user and the target are of different genders.
Aura Sphere	Fighting	Special	80	—	20	Normal	—	○	A sure hit.
Aurora Beam	Ice	Special	65	100	20	Normal	—	—	A 10% chance of lowering the target's Attack by 1.
Autotomize	Steel	Status	—	—	15	Self	—	—	Raises the user's Speed by 2 and lowers its weight by 220 lbs.
Avalanche	Ice	Physical	60	100	10	Normal	○	—	Always strikes last. This move's power is doubled if the user has taken damage from the target that turn.

Move	Type	Kind	Pow.	Acc.	PP	Range	DA	Long	Effect
Baby-Doll Eyes	Fairy	Status	—	100	30	Normal	—	—	Always strikes first. Lowers the target's Attack by 1.
Barrage	Normal	Physical	15	85	20	Normal	—	—	Attacks 2–5 times in a row in a single turn.
Barrier	Psychic	Status	—	—	20	Self	—	—	Raises the user's Defense by 2.
Baton Pass	Normal	Status	—	—	40	Self	—	—	User swaps out with an ally Pokémon and passes along any stat changes.
Beat Up	Dark	Physical	—	100	10	Normal	—	—	Attacks once for each Pokémon in your party, including the user. Does not count Pokémon that have fainted or have status conditions.
Belch	Poison	Special	120	90	10	Normal	—	—	Cannot be used without first eating a Berry.
Belly Drum	Normal	Status	—	—	10	Self	—	—	The user loses half of its maximum HP but raises its Attack to the maximum.
Bestow	Normal	Status	—	—	15	Normal	—	—	If the target is not holding an item and the user is, the user can give that item to the target. Fails if the user is not holding an item or the target is holding an item.
Bide	Normal	Physical	—	—	10	Self	○	—	Inflicts twice the damage received during the next 2 turns. Cannot choose moves during those 2 turns.
Bind	Normal	Physical	15	85	20	Normal	○	—	Inflicts damage equal to 1/8 the target's max HP for 4–5 turns. The target cannot flee during that time.
Bite	Dark	Physical	60	100	25	Normal	○	—	A 30% chance of making the target flinch (unable to use moves on that turn).
Blast Burn	Fire	Special	150	90	5	Normal	—	—	The user can't move during the next turn. If the target is Frozen, it will be thawed.
Blaze Kick	Fire	Physical	85	90	10	Normal	○	—	A 10% chance of inflicting the Burned status condition on the target. Critical hits land more easily. If the target is Frozen, it will be thawed.
Blizzard	Ice	Special	110	70	5	Many Others	—	—	A 10% chance of inflicting the Frozen status condition on the targets. Is 100% accurate in the hail weather condition. Its power is reduced by 25% when it hits multiple Pokémon.
Block	Normal	Status	—	—	5	Normal	—	—	The target cannot escape. If used during a Trainer battle, the opposing Trainer cannot switch Pokémon. Has no effect on Ghost-type Pokémon.
Body Slam	Normal	Physical	85	100	15	Normal	○	—	A 30% chance of inflicting the Paralysis status condition on the target. If the target has used Minimize, this move will be a sure hit and its power will be doubled.
Bone Club	Ground	Physical	65	85	20	Normal	—	—	A 10% chance of making the target flinch (unable to use moves on that turn).
Bone Rush	Ground	Physical	25	90	10	Normal	—	—	Attacks 2–5 times in a row in a single turn.
Bonemerang	Ground	Physical	50	90	10	Normal	—	—	Attacks twice in a row in a single turn.
Boomburst	Normal	Special	140	100	10	Adjacent	—	—	Its power is reduced by 25% when it hits multiple Pokémon. Strikes the target even if it is using Substitute.
Bounce	Flying	Physical	85	85	5	Normal	○	○	The user flies into the air on the first turn and attacks on the second. A 30% chance of the target.
Brave Bird	Flying	Physical	120	100	15	Normal	○	○	The user takes 1/3 of the damage inflicted.
Brick Break	Fighting	Physical	75	100	15	Normal	○	—	This move is not affected by Reflect. It removes the effect of Reflect and Light Screen.
Brine	Water	Special	65	100	10	Normal	—	—	This move's power is doubled if the target's HP is at half or below.
Bubble	Water	Special	40	100	30	Many Others	—	—	A 10% chance of lowering the targets' Speed by 1. Its power is reduced by 25% when it hits multiple Pokémon.
Bubble Beam	Water	Special	65	100	20	Normal	—	—	A 10% chance of lowering the target's Speed by 1.
Bug Bite	Bug	Physical	60	100	20	Normal	○	—	If the target is holding a Berry with a battle effect, the user eats that Berry and uses its effect.
Bug Buzz	Bug	Special	90	100	10	Normal	—	—	A 10% chance of lowering the target's Sp. Def by 1. Strikes the target even if it is using Substitute.
Bulk Up	Fighting	Status	—	—	20	Self	—	—	Raises the user's Attack and Defense by 1.
Bulldoze	Ground	Physical	60	100	20	Adjacent	—	—	Lowers the targets' Speed by 1. Its power is reduced by 25% when it hits multiple Pokémon.
Bullet Punch	Steel	Physical	40	100	30	Normal	○	—	Always strikes first. The user with the higher Speed goes first if similar moves are used.
Bullet Seed	Grass	Physical	25	100	30	Normal	—	—	Attacks 2–5 times in a row in a single turn.

Move	Type	Kind	Pow.	Acc.	PP	Range	DA	Long	Effect
Calm Mind	Psychic	Status	—	—	20	Self	—	—	Raises the user's Sp. Atk and Sp. Def by 1.
Camouflage	Normal	Status	—	—	20	Self	—	—	Changes the user's type to match the environment: Cave: Rock type. Dirt/Sand/Swamp: Ground type. Electric Terrain: Electric type. Grass / Grassy Terrain: Grass type. Indoors / Link: Normal type. Misty Terrain: Fairy type. Snow/Ice: Ice type. Water Surface / Puddle / Shoal: Water type
Captivate	Normal	Status	—	100	20	Many Others	—	—	Lowers the target's Sp. Atk by 2. Only works if the user and the target are of different genders.
Charge	Electric	Status	—	—	20	Self	—	—	Doubles the attack power of an Electric-type move used the next turn. Raises the user's Sp. Def by 1.
Charge Beam	Electric	Special	50	90	10	Normal	—	—	A 70% chance of raising the user's Sp. Atk by 1.
Charm	Fairy	Status	—	100	20	Normal	—	—	Lowers the target's Attack by 2.
Chatter	Flying	Special	65	100	20	Normal	—	○	When the user is Chatot, this move also inflicts the Confused status condition on the target. Strikes the target even if it is using Substitute.
Chip Away	Normal	Physical	70	100	20	Normal	○	—	Damage dealt is not affected by the opposing Pokémon's stat changes.
Circle Throw	Fighting	Physical	60	90	10	Normal	○	—	Always strikes last. Ends wild Pokémon battles after attacking. When battling multiple wild Pokémon or if the wild Pokémon's level is higher than the user's, no additional effect takes place. In a battle with a Trainer, this move forces another Pokémon to switch in. If there is no Pokémon to switch in, no additional effect takes place.
Clamp	Water	Physical	35	85	15	Normal	○	—	Inflicts damage equal to 1/8 the target's max HP for 4–5 turns. The target cannot flee during that time.
Clear Smog	Poison	Special	50	—	15	Normal	—	—	Eliminates every stat change of the target.

Move	Type	Kind	Pow.	Acc.	PP	Range	DA	Long	Effect
Close Combat	Fighting	Physical	120	100	5	Normal	○	—	Lowers the user's Defense and Sp. Def by 1.
Coil	Poison	Status	—	—	20	Self	—	—	Raises the user's Attack, Defense, and accuracy by 1.
Comet Punch	Normal	Physical	18	85	15	Normal	○	—	Attacks 2–5 times in a row in a single turn.
Confide	Normal	Status	—	—	20	Normal	—	—	A sure hit. Lowers the target's Sp. Atk by 1. Strikes the target even if it is using Detect, King's Shield, Mat Block, Protect, Spiky Shield, or Substitute.
Confuse Ray	Ghost	Status	—	100	10	Normal	—	—	Inflicts the Confused status condition on the target.
Confusion	Psychic	Special	50	100	25	Normal	—	—	A 10% chance of inflicting the Confused status condition on the target.
Constrict	Normal	Physical	10	100	35	Normal	○	—	A 10% chance of lowering the target's Speed by 1.
Copycat	Normal	Status	—	—	20	Self	—	—	Uses the last move used.
Cosmic Power	Psychic	Status	—	—	20	Self	—	—	Raises the user's Defense and Sp. Def by 1.
Cotton Guard	Grass	Status	—	—	10	Self	—	—	Raises the user's Defense by 3.
Cotton Spore	Grass	Status	—	100	40	Many Others	—	—	Lowers the targets' Speed by 2. Has no effect on Grass-type Pokémon.
Counter	Fighting	Physical	—	100	20	Varies	○	—	If the user is attacked physically, this move inflicts twice the damage done to the user. Always strikes last.
Covet	Normal	Physical	60	100	25	Normal	○	—	When the target is holding an item and the user is not, the user can steal that item. A regular attack if the target is not holding an item.
Crabhammer	Water	Physical	100	90	10	Normal	○	—	Critical hits land more easily.
Crafty Shield	Fairy	Status	—	—	10	Your Side	—	—	Protects the user and allies from status moves used in the same turn. Does not protect against damage-dealing moves.
Cross Chop	Fighting	Physical	100	80	5	Normal	○	—	Critical hits land more easily.
Cross Poison	Poison	Physical	70	100	20	Normal	○	—	Critical hits land more easily. A 10% chance of inflicting the Poison status condition on the target.
Crunch	Dark	Physical	80	100	15	Normal	○	—	A 20% chance of lowering the target's Defense by 1.
Crush Claw	Normal	Physical	75	95	10	Normal	○	—	A 50% chance of lowering the target's Defense by 1.
Curse	Ghost	Status	—	—	10	Varies	—	—	Lowers the user's Speed by 1 and raises its Attack and Defense by 1. If used by a Ghost-type Pokémon, the user loses half of its maximum HP, but the move lowers the target's HP by 1/4 of its maximum every turn.
Cut	Normal	Physical	50	95	30	Normal	○	—	A regular attack.

D

Move	Type	Kind	Pow.	Acc.	PP	Range	DA	Long	Effect
Dark Pulse	Dark	Special	80	100	15	Normal	—	○	Has a 20% chance of making the target flinch (unable to use moves on that turn).
Dazzling Gleam	Fairy	Special	80	100	10	Many Others	—	—	Its power is reduced by 25% when it hits multiple Pokémon.
Defend Order	Bug	Status	—	—	10	Self	—	—	Raises the user's Defense and Sp. Def by 1.
Defense Curl	Normal	Status	—	—	40	Self	—	—	Raises the user's Defense by 1.
Defog	Flying	Status	—	—	15	Normal	—	—	Lowers the target's evasion by 1. Nullifies the effects of Light Screen, Reflect, Safeguard, Mist, Spikes, Toxic Spikes, and Stealth Rock on the target's side.
Destiny Bond	Ghost	Status	—	—	5	Self	—	—	If the user faints due to damage from a Pokémon, that Pokémon faints as well.
Detect	Fighting	Status	—	—	5	Self	—	—	The user evades all moves that turn. If used in succession, its chance of failing rises.
Diamond Storm	Rock	Physical	100	95	5	Many Others	—	—	A 50% chance of raising the user's Defense by 1. Its power is reduced by 25% when it hits multiple Pokémon.
Dig	Ground	Physical	80	100	10	Normal	○	—	The user burrows underground on the first turn and attacks on the second.
Disable	Normal	Status	—	100	20	Normal	—	—	The target can't use the move it just used for 4 turns.
Disarming Voice	Fairy	Special	40	—	15	Many Others	—	—	A sure hit. Strikes the target even if it is using Substitute. Its power is reduced by 25% when it hits multiple Pokémon.
Discharge	Electric	Special	80	100	15	Adjacent	—	—	A 30% chance of inflicting the Paralysis status condition on the targets. Its power is reduced by 25% when it hits multiple Pokémon.
Dive	Water	Physical	80	100	10	Normal	○	—	The user dives deep on the first turn and attacks on the second.
Dizzy Punch	Normal	Physical	70	100	10	Normal	○	—	A 20% chance of inflicting the Confused status condition on the target.
Double Hit	Normal	Physical	35	90	10	Normal	○	—	Attacks twice in a row in a single turn.
Double Kick	Fighting	Physical	30	100	30	Normal	○	—	Attacks twice in a row in a single turn.
Double Slap	Normal	Physical	15	85	10	Normal	○	—	Attacks 2–5 times in a row in a single turn.
Double Team	Normal	Status	—	—	15	Self	—	—	Raises the user's evasion by 1.
Double-Edge	Normal	Physical	120	100	15	Normal	○	—	The user takes 1/3 of the damage inflicted.
Draco Meteor	Dragon	Special	130	90	5	Normal	—	—	Lowers the user's Sp. Atk by 2.
Dragon Ascent	Flying	Physical	120	100	5	Normal	○	○	Lowers the user's Defense and Sp. Def by 1.
Dragon Breath	Dragon	Special	60	100	20	Normal	—	—	A 30% chance of inflicting the Paralysis status condition on the target.
Dragon Claw	Dragon	Physical	80	100	15	Normal	○	—	A regular attack.
Dragon Dance	Dragon	Status	—	—	20	Self	—	—	Raises the user's Attack and Speed by 1.
Dragon Pulse	Dragon	Special	85	100	10	Normal	—	○	A regular attack.
Dragon Rage	Dragon	Special	—	100	10	Normal	—	—	Deals a fixed 40 points of damage.

Move	Type	Kind	Pow.	Acc.	PP	Range	DA	Long	Effect
Dragon Rush	Dragon	Physical	100	75	10	Normal	○	—	A 20% chance of making the target flinch (unable to use moves on that turn). If the target has used Minimize, this move will be a sure hit and its power will be doubled.
Dragon Tail	Dragon	Physical	60	90	10	Normal	○	—	Attacks last. Ends wild Pokémon battles after attacking. When battling multiple wild Pokémon or if the wild Pokémon's level is higher than the user's, no additional effect takes place. In a battle with a Trainer, this move forces another Pokémon to switch in. If there is no Pokémon to switch in, no additional effect takes place.
Drain Punch	Fighting	Physical	75	100	10	Normal	○	—	Restores HP by up to half of the damage dealt to the target.
Draining Kiss	Fairy	Special	50	100	10	Normal	○	—	Restores HP by up to 3/4 of the damage dealt to the target.
Dream Eater	Psychic	Special	100	100	15	Normal	—	—	Only works when the target is asleep. Restores HP by up to half of the damage dealt to the target.
Drill Peck	Flying	Physical	80	100	20	Normal	○	○	A regular attack.
Drill Run	Ground	Physical	80	95	10	Normal	○	—	Critical hits land more easily.
Dual Chop	Dragon	Physical	40	90	15	Normal	○	—	Attacks twice in a row in a single turn.
Dynamic Punch	Fighting	Physical	100	50	5	Normal	○	—	Inflicts the Confused status condition on the target.

E

Move	Type	Kind	Pow.	Acc.	PP	Range	DA	Long	Effect
Earth Power	Ground	Special	90	100	10	Normal	—	—	A 10% chance of lowering the target's Sp. Def by 1.
Earthquake	Ground	Physical	100	100	10	Adjacent	—	—	Does twice the damage if targets are underground due to using Dig. Its power is reduced by 25% when it hits multiple Pokémon.
Echoed Voice	Normal	Special	40	100	15	Normal	—	—	If this move is used every turn, no matter which Pokémon uses it, its power increases (max 200). If no Pokémon uses it in a turn, the power returns to normal. Strikes the target even if it is using Substitute.
Eerie Impulse	Electric	Status	—	100	15	Normal	—	—	Lowers the target's Sp. Atk by 2.
Egg Bomb	Normal	Physical	100	75	10	Normal	—	—	A regular attack.
Electric Terrain	Electric	Status	—	—	10	Both Sides	—	—	Electrifies the field for 5 turns. During that time, Pokémon on the ground will be able to do 50% more damage with Electric-type moves and cannot fall asleep.
Electrify	Electric	Status	—	—	20	Normal	—	—	Changes any attack used by the target in the same turn into an Electric-type move.
Electro Ball	Electric	Special	—	100	10	Normal	—	—	The faster the user is than the target, the greater the move's power (max 150).
Electroweb	Electric	Special	55	95	15	Many Others	—	—	Lowers the targets' Speed by 1. Its power is reduced by 25% when it hits multiple Pokémon.
Embargo	Dark	Status	—	100	15	Normal	—	—	The target can't use items for 5 turns. The Trainer also can't use items on that Pokémon.
Ember	Fire	Special	40	100	25	Normal	—	—	A 10% chance of inflicting the Burned status condition on the target. If the target is Frozen, it will be thawed.
Encore	Normal	Status	—	100	5	Normal	—	—	The target is forced to keep using the last move it used. This effect lasts 3 turns.
Endeavor	Normal	Physical	—	100	5	Normal	○	—	Inflicts damage equal to the target's HP minus the user's HP.
Endure	Normal	Status	—	—	10	Self	—	—	Leaves the user with 1 HP when hit by a move that would KO it. If used in succession, its chance of failing rises.
Energy Ball	Grass	Special	90	100	10	Normal	—	—	A 10% chance of lowering the target's Sp. Def by 1.
Entrainment	Normal	Status	—	100	15	Normal	—	—	Makes the target's Ability the same as the user's. Fails with certain Abilities, however.
Eruption	Fire	Special	150	100	5	Many Others	—	—	If the user's HP is low, this move has lower attack power. If the targets are Frozen, they will be thawed. Its power is reduced by 25% when it hits multiple Pokémon.
Explosion	Normal	Physical	250	100	5	Adjacent	—	—	The user faints after using it. Its power is reduced by 25% when it hits multiple Pokémon.
Extrasensory	Psychic	Special	80	100	20	Normal	—	—	A 10% chance of making the target flinch (unable to use moves on that turn).
Extreme Speed	Normal	Physical	80	100	5	Normal	○	—	Always strikes first. Faster than other moves that strike first, except for Fake Out. (If two Pokémon use this move, the one with the higher Speed goes first.)

F

Move	Type	Kind	Pow.	Acc.	PP	Range	DA	Long	Effect
Facade	Normal	Physical	70	100	20	Normal	○	—	This move's power is doubled if the user has a Paralysis, Poison, or Burned status condition.
Fairy Lock	Fairy	Status	—	—	10	Both Sides	—	—	The target cannot escape during the next turn. If used during a Trainer battle, the opposing Trainer cannot switch Pokémon. Has no effect on Ghost-type Pokémon.
Fairy Wind	Fairy	Special	40	100	30	Normal	—	—	A regular attack.
Fake Out	Normal	Physical	40	100	10	Normal	○	—	Always strikes first and makes the target flinch (unable to use moves on that turn). Only works on the first turn after the user is sent out. Faster than other moves that strike first.
Fake Tears	Dark	Status	—	100	20	Normal	—	—	Lowers the target's Sp. Def by 2.
False Swipe	Normal	Physical	40	100	40	Normal	○	—	Always leaves 1 HP, even if the damage would have made the target faint.
Feather Dance	Flying	Status	—	100	15	Normal	—	—	Lowers the target's Attack by 2.
Feint	Normal	Physical	30	100	10	Normal	—	—	Always strikes first. Faster than other moves that strike first, except Fake Out. If two Pokémon use this move, or if the other Pokémon uses the move Extreme Speed, the one with the higher Speed goes first. Strikes the target even if it is using Detect, King's Shield, Mat Block, Protect, Quick Guard, Spiky Shield, or Wide Guard, and eliminates the effects of those moves.
Feint Attack	Dark	Physical	60	—	20	Normal	○	—	A sure hit.
Fell Stinger	Bug	Physical	30	100	25	Normal	○	—	When the Pokémon knocks out an opponent with this move, its Attack goes up 2.
Final Gambit	Fighting	Special	—	100	5	Normal	○	—	Does damage to the target equal to the user's remaining HP. If the move lands, the user faints. If the move does not land, the user will not faint.

Move	Type	Kind	Pow.	Acc.	PP	Range	DA	Long	Effect
Fire Blast	Fire	Special	110	85	5	Normal	—	—	A 10% chance of inflicting the Burned status condition on the target. If the target is Frozen, it will be thawed.
Fire Fang	Fire	Physical	65	95	15	Normal	○	—	A 10% chance of inflicting the Burned status condition or making the target flinch (unable to use moves on that turn). If the target is Frozen, it will be thawed.
Fire Pledge	Fire	Special	80	100	10	Normal	—	—	When combined with Water Pledge or Grass Pledge, the power and effect change. If combined with Water Pledge, the power is 150 and it becomes a Water-type move. This makes it more likely that your team's moves will have additional effects for 4 turns. If combined with Grass Pledge, the power is 150 and it remains a Fire-type move. This damages opposing Pokémon, except Fire types, for 4 turns. If the target is Frozen, it will be thawed.
Fire Punch	Fire	Physical	75	100	15	Normal	○	—	A 10% chance of inflicting the Burned status condition on the target. If the target is Frozen, it will be thawed.
Fire Spin	Fire	Special	35	85	15	Normal	—	—	Inflicts damage equal to 1/8 the target's max HP for 4–5 turns. The target cannot flee during that time. If the target is Frozen, it will be thawed.
Fissure	Ground	Physical	—	30	5	Normal	—	—	The target faints with one hit if the user's level is equal to or greater than the target's level. The higher the user's level is compared to the target's, the more accurate the move is.
Flail	Normal	Physical	—	100	15	Normal	○	—	The lower the user's HP is, the greater the move's power becomes (max 200).
Flame Burst	Fire	Special	70	100	15	Normal	—	—	It deals damage equal to 1/16 of the max HP of any Pokémon next to the target during Double or Triple Battles. If the target is Frozen, it will be thawed.
Flame Charge	Fire	Physical	50	100	20	Normal	○	—	Raises the user's Speed by 1. If the target is Frozen, it will be thawed.
Flame Wheel	Fire	Physical	60	100	25	Normal	○	—	A 10% chance of inflicting the Burned status condition on the target. If the target is Frozen, it will be thawed. This move can be used even if the user is Frozen. If the user is Frozen, this also thaws the user.
Flamethrower	Fire	Special	90	100	15	Normal	—	—	A 10% chance of inflicting the Burned status condition on the target. If the target is Frozen, it will be thawed.
Flare Blitz	Fire	Physical	120	100	15	Normal	○	—	User takes 1/3 of the damage done to the target. A 10% chance of inflicting the Burned status condition on the target. If the target is Frozen, it will be thawed. This move can be used even if the user is Frozen. If the user is Frozen, this also thaws the user.
Flash	Normal	Status	—	100	20	Normal	—	—	Lowers the target's accuracy by 1.
Flash Cannon	Steel	Special	80	100	10	Normal	—	—	A 10% chance of lowering the target's Sp. Def by 1.
Flatter	Dark	Status	—	100	15	Normal	—	—	Inflicts the Confused status condition on the target, but also raises its Sp. Atk by 1.
Fling	Dark	Physical	—	100	10	Normal	—	—	The user attacks by throwing its held item at the target. Power and effect vary depending on the item.
Flower Shield	Fairy	Status	—	—	10	Adjacent	—	○	Raises the Defense of any Grass-type Pokémon by 1.
Fly	Flying	Physical	90	95	15	Normal	○	○	The user flies into the air on the first turn and attacks on the second.
Flying Press	Fighting	Physical	80	95	10	Normal	○	○	This move is both Fighting type and Flying type. If the target has used Minimize, it will be a sure hit and its power will be doubled.
Focus Blast	Fighting	Special	120	70	5	Normal	—	—	A 10% chance of lowering the target's Sp. Def by 1.
Focus Energy	Normal	Status	—	—	30	Self	—	—	Heightens the critical-hit ratio of the user's subsequent moves.
Focus Punch	Fighting	Physical	150	100	20	Normal	○	—	Always strikes last. The move misses if the user is hit before this move lands.
Follow Me	Normal	Status	—	—	20	Self	—	—	This move goes first. Opposing Pokémon aim only at the user.
Force Palm	Fighting	Physical	60	100	10	Normal	○	—	A 30% chance of inflicting the Paralysis status condition on the target.
Foresight	Normal	Status	—	—	40	Normal	—	—	Attacks land easily regardless of the target's evasion. Makes Ghost-type Pokémon vulnerable to Normal- and Fighting-type moves.
Forest's Curse	Grass	Status	—	100	20	Normal	—	—	Gives the target the Grass type.
Foul Play	Dark	Physical	95	100	15	Normal	○	—	The user turns the target's power against it. Damage varies depending on the target's Attack and Defense.
Freeze-Dry	Ice	Special	70	100	20	Normal	—	—	Super effective even against Water-type Pokémon. A 10% chance of inflicting the Frozen status condition.
Frenzy Plant	Grass	Special	150	90	5	Normal	—	—	The user can't move during the next turn.
Frost Breath	Ice	Special	60	90	10	Normal	—	—	Always delivers a critical hit.
Frustration	Normal	Physical	—	100	20	Normal	○	—	The lower the user's friendship, the greater this move's power (max 102).
Fury Attack	Normal	Physical	15	85	20	Normal	○	—	Attacks 2–5 times in a row in a single turn.
Fury Cutter	Bug	Physical	40	95	20	Normal	○	—	This move doubles in power with every successful hit (max 120). Power returns to normal once it misses.
Fury Swipes	Normal	Physical	18	80	15	Normal	○	—	Attacks 2–5 times in a row in a single turn.
Future Sight	Psychic	Special	120	100	10	Normal	—	—	Attacks the target after 2 turns. This move is affected by the target's type.

G

Move	Type	Kind	Pow.	Acc.	PP	Range	DA	Long	Effect
Gastro Acid	Poison	Status	—	100	10	Normal	—	—	Disables the target's Ability.
Geomancy	Fairy	Status	—	—	10	Self	—	—	Builds power on the first turn and increases the user's Sp. Atk, Sp. Def, and Speed by 2 on the second.
Giga Drain	Grass	Special	75	100	10	Normal	—	—	Restores HP by up to half of the damage dealt to the target.
Giga Impact	Normal	Physical	150	90	5	Normal	○	—	The user can't move during the next turn.
Glare	Normal	Status	—	100	30	Normal	—	—	Inflicts the Paralysis status condition on the target.
Grass Knot	Grass	Special	—	100	20	Normal	○	—	The heavier the target is compared to the user, the greater the move's power becomes (max 120).
Grass Pledge	Grass	Special	80	100	10	Normal	—	—	When combined with Water Pledge or Fire Pledge, the power and effect change. If combined with Water Pledge, the power is 150 and it remains a Grass-type move. This lowers the Speed of opposing Pokémon for 4 turns. If combined with Fire Pledge, the power is 150 and it becomes a Fire-type move. This damages all non-Fire types for 4 turns. If the target is Frozen, it will be thawed.

Move	Type	Kind	Pow.	Acc.	PP	Range	DA	Long	Effect
Grass Whistle	Grass	Status	—	55	15	Normal	—	—	Inflicts the Sleep status condition on the target. Strikes the target even if it is using Substitute.
Grassy Terrain	Grass	Status	—	—	10	Both Sides	—	—	Covers the field with grass for 5 turns. During that time, Pokémon on the ground will be able to do 50% more damage with Grass-type moves and will recover 1/16 of the Pokémon's maximum HP each turn.
Gravity	Psychic	Status	—	—	5	Both Sides	—	—	Raises the accuracy of all Pokémon in battle for 5 turns. Ground-type moves will now hit a Pokémon with the Levitate Ability or a Flying-type Pokémon. Prevents the use of Bounce, Fly, High Jump Kick, Jump Kick, Magnet Rise, Sky Drop, Splash, and Telekinesis. Pulls any airborne Pokémon to the ground.
Growl	Normal	Status	—	100	40	Many Others	—	—	Lowers the target's Attack by 1. Strikes the target even if it is using Substitute.
Growth	Normal	Status	—	—	20	Self	—	—	Raises the user's Attack and Sp. Atk by 1. Raises them by 2 when the weather condition is sunny or extremely harsh sunlight.
Grudge	Ghost	Status	—	—	5	Self	—	—	Any move that causes the user to faint will have its PP dropped to 0.
Guard Split	Psychic	Status	—	—	10	Normal	—	—	The user and the target's Defense and Sp. Def are added, then divided equally between them.
Guard Swap	Psychic	Status	—	—	10	Normal	—	—	Swaps Defense and Sp. Def changes between the user and the target.
Guillotine	Normal	Physical	—	30	5	Normal	○	—	The target faints with one hit if the user's level is equal to or greater than the target's level. The higher the user's level is compared to the target's, the more accurate the move is.
Gunk Shot	Poison	Physical	120	80	5	Normal	—	—	A 30% chance of inflicting the Poison status condition on the target.
Gust	Flying	Special	40	100	35	Normal	—	○	It even hits Pokémon that are in the sky due to using moves such as Fly and Bounce, dealing them twice the usual damage.
Gyro Ball	Steel	Physical	—	100	5	Normal	○	—	The slower the user is than the target, the greater the move's power becomes (max 150).

H · I

Move	Type	Kind	Pow.	Acc.	PP	Range	DA	Long	Effect
Hail	Ice	Status	—	—	10	Both Sides	—	—	Changes the weather condition to hail for 5 turns, dealing damage every turn equal to 1/16 of its max HP to each Pokémon in the field that is not an Ice type.
Hammer Arm	Fighting	Physical	100	90	10	Normal	○	—	Lowers the user's Speed by 1.
Harden	Normal	Status	—	—	30	Self	—	—	Raises the user's Defense by 1.
Haze	Ice	Status	—	—	30	Both Sides	—	—	Eliminates every stat change of the targets.
Head Smash	Rock	Physical	150	80	5	Normal	○	—	The user takes 1/2 of the damage inflicted.
Headbutt	Normal	Physical	70	100	15	Normal	○	—	A 30% chance of making the target flinch (unable to use moves on that turn).
Heal Bell	Normal	Status	—	—	5	Your Party	—	○	Heals status conditions of all your Pokémon, including those in your party. Affects the target even if it is using Substitute.
Heal Block	Psychic	Status	—	100	15	Many Others	—	—	Targets cannot have HP restored by moves, Abilities, or held items for 5 turns.
Heal Order	Bug	Status	—	—	10	Self	—	—	Restores HP by up to half of the user's maximum HP.
Heal Pulse	Psychic	Status	—	—	10	Normal	—	○	Restores the target's HP by up to half of its maximum HP.
Healing Wish	Psychic	Status	—	—	10	Self	—	—	The user faints, but fully heals the next Pokémon's HP and status conditions.
Heart Stamp	Psychic	Physical	60	100	25	Normal	○	—	A 30% chance of making the target flinch (unable to use moves on that turn).
Heat Wave	Fire	Special	95	90	10	Many Others	—	—	A 10% chance of inflicting the Burned status condition on the targets. If the targets are Frozen, they will be thawed. Its power is reduced by 25% when it hits multiple Pokémon.
Heavy Slam	Steel	Physical	—	100	10	Normal	○	—	The heavier the user is compared to the target, the greater the move's power becomes (max 120).
Helping Hand	Normal	Status	—	—	20	1 Ally	—	—	Always strikes first. Strengthens the attack power of one ally's moves by 50%.
Hex	Ghost	Special	65	100	10	Normal	—	—	Deals twice the usual damage to a target affected by status conditions.
Hidden Power	Normal	Special	60	100	15	Normal	—	—	Type changes depending on the user.
High Jump Kick	Fighting	Physical	130	90	10	Normal	○	—	If this move misses, the user loses half of its maximum HP.
Hone Claws	Dark	Status	—	—	15	Self	—	—	Raises Attack and accuracy by 1.
Horn Attack	Normal	Physical	65	100	25	Normal	○	—	A regular attack.
Horn Drill	Normal	Physical	—	30	5	Normal	○	—	The target faints with one hit if the user's level is equal to or greater than the target's level. The higher the user's level is compared to the target's, the more accurate the move is.
Horn Leech	Grass	Physical	75	100	10	Normal	○	—	Restores HP by up to half of the damage dealt to the target.
Howl	Normal	Status	—	—	40	Self	—	—	Raises the user's Attack by 1.
Hurricane	Flying	Special	110	70	10	Normal	—	○	A 30% chance of inflicting the Confused status condition on the target. Is 100% accurate in the rain / heavy rain weather conditions and 50% accurate in the sunny / extremely harsh sunlight weather conditions. It can hit Pokémon that are in the sky due to using moves such as Fly and Bounce.
Hydro Cannon	Water	Special	150	90	5	Normal	—	—	The user can't move during the next turn.
Hydro Pump	Water	Special	110	80	5	Normal	—	—	A regular attack.
Hyper Beam	Normal	Special	150	90	5	Normal	—	—	The user can't move during the next turn.
Hyper Fang	Normal	Physical	80	90	15	Normal	○	—	A 10% chance of making the target flinch (unable to use moves on that turn).
Hyper Voice	Normal	Special	90	100	10	Many Others	—	—	Strikes the target even if it is using Substitute. Its power is reduced by 25% when it hits multiple Pokémon.
Hypnosis	Psychic	Status	—	60	20	Normal	—	—	Inflicts the Sleep status condition on the target.

Move	Type	Kind	Pow.	Acc.	PP	Range	DA	Long	Effect
Ice Ball	Ice	Physical	30	90	20	Normal	○	—	Attacks consecutively over 5 turns or until it misses. Cannot choose other moves during this time. Damage dealt doubles with each successful hit (max 480). Its power is doubled if used after Defense Curl.
Ice Beam	Ice	Special	90	100	10	Normal	—	—	A 10% chance of inflicting the Frozen status condition on the target.
Ice Fang	Ice	Physical	65	95	15	Normal	○	—	A 10% chance of inflicting the Frozen status condition or making the target flinch (unable to use moves on that turn).
Ice Punch	Ice	Physical	75	100	15	Normal	○	—	A 10% chance of inflicting the Frozen status condition on the target.
Ice Shard	Ice	Physical	40	100	30	Normal	—	—	Always strikes first. The user with the higher Speed goes first if similar moves are used.
Icicle Crash	Ice	Physical	85	90	10	Normal	—	—	A 30% chance of making the target flinch (unable to use moves on that turn).
Icicle Spear	Ice	Physical	25	100	30	Normal	—	—	Attacks 2–5 times in a row in a single turn.
Icy Wind	Ice	Special	55	95	15	Many Others	—	—	Lowers the targets' Speed by 1. Its power is reduced by 25% when it hits multiple Pokémon.
Imprison	Psychic	Status	—	—	10	Self	—	—	Opposing Pokémon cannot use a move if the user knows that move as well.
Incinerate	Fire	Special	60	100	15	Many Others	—	—	Burns up the Berry or Gem being held by each of the targets, which makes them unusable. If the targets are Frozen, they will be thawed. Its power is reduced by 25% when it hits multiple Pokémon.
Inferno	Fire	Special	100	50	5	Normal	—	—	Inflicts the Burned status condition on the target. If the target is Frozen, it will be thawed.
Infestation	Bug	Special	20	100	20	Normal	○	—	Inflicts damage equal to 1/8 the target's max HP for 4–5 turns. The target cannot flee during that time.
Ingrain	Grass	Status	—	—	20	Self	—	—	Restores 1/16 of max HP every turn. The user cannot be switched out after using this move. Ground-type moves will now hit the user even if it is a Flying-type Pokémon or has the Levitate Ability.
Ion Deluge	Electric	Status	—	—	25	Both Sides	—	—	Attacks first. Changes any Normal-type moves used in the same turn into Electric-type moves.
Iron Defense	Steel	Status	—	—	15	Self	—	—	Raises the user's Defense by 2.
Iron Head	Steel	Physical	80	100	15	Normal	○	—	A 30% chance of making the target flinch (unable to use moves on that turn).
Iron Tail	Steel	Physical	100	75	15	Normal	○	—	A 30% chance of lowering the target's Defense by 1.

J · K · L

Move	Type	Kind	Pow.	Acc.	PP	Range	DA	Long	Effect
Jump Kick	Fighting	Physical	100	95	10	Normal	○	—	If this move misses, the user loses half of its maximum HP.
Karate Chop	Fighting	Physical	50	100	25	Normal	○	—	Critical hits land more easily.
Kinesis	Psychic	Status	—	80	15	Normal	—	—	Lowers the target's accuracy by 1.
King's Shield	Steel	Status	—	—	10	Self	—	—	The user evades all attacks that turn. If an opposing Pokémon uses a move that makes direct contact, its Attack will be lowered by 2. Fails more easily when used repeatedly.
Knock Off	Dark	Physical	65	100	20	Normal	○	—	The target drops its held item. It gets the item back after the battle. This move does 50% more damage to opponents holding items.
Land's Wrath	Ground	Physical	90	100	10	Many Others	—	—	Its power is reduced by 25% when it hits multiple Pokémon.
Last Resort	Normal	Physical	140	100	5	Normal	○	—	Fails unless the user has used each of its other moves at least once.
Lava Plume	Fire	Special	80	100	15	Adjacent	—	—	A 30% chance of inflicting the Burned status condition on the targets. If the targets are Frozen, they will be thawed. Its power is reduced by 25% when it hits multiple Pokémon.
Leaf Blade	Grass	Physical	90	100	15	Normal	○	—	Critical hits land more easily.
Leaf Storm	Grass	Special	130	90	5	Normal	—	—	Lowers the user's Sp. Atk by 2.
Leaf Tornado	Grass	Special	65	90	10	Normal	—	—	A 50% chance of lowering the target's accuracy by 1.
Leech Life	Bug	Physical	20	100	15	Normal	○	—	Restores HP by up to half of the damage dealt to the target.
Leech Seed	Grass	Status	—	90	10	Normal	—	—	Steals 1/8 of the target's max HP every turn and absorbs it to restore the user. Keeps working even after the user switches out. Does not work on Grass types.
Leer	Normal	Status	—	100	30	Many Others	—	—	Lowers the targets' Defense by 1.
Lick	Ghost	Physical	30	100	30	Normal	○	—	A 30% chance of inflicting the Paralysis status condition on the target.
Light Screen	Psychic	Status	—	—	30	Your Side	—	—	Halves the damage to the Pokémon on your side from special moves. Effect lasts 5 turns even if the user is switched out. Effect is weaker in Double and Triple Battles.
Lock-On	Normal	Status	—	—	5	Normal	—	—	The user's next move will be a sure hit.
Lovely Kiss	Normal	Status	—	75	10	Normal	—	—	Inflicts the Sleep status condition on the target.
Low Kick	Fighting	Physical	—	100	20	Normal	○	—	The heavier the target is compared to the user, the greater the move's power becomes (max 120).
Low Sweep	Fighting	Physical	65	100	20	Normal	○	—	Lowers the target's Speed by 1.
Lucky Chant	Normal	Status	—	—	30	Your Side	—	—	The Pokémon on your side take no critical hits for 5 turns.
Luster Purge	Psychic	Special	70	100	5	Normal	—	—	Has a 50% chance of lowering the target's Sp. Def by 1.

M

Move	Type	Kind	Pow.	Acc.	PP	Range	DA	Long	Effect
Mach Punch	Fighting	Physical	40	100	30	Normal	○	—	Always strikes first. The user with the higher Speed goes first if similar moves are used.
Magic Coat	Psychic	Status	—	—	15	Self	—	—	Always strikes first. Reflects moves with effects like Leech Seed or those that inflict status conditions such as Sleep, Poison, Paralysis, or Confused.
Magic Room	Psychic	Status	—	—	10	Both Sides	—	—	Always strikes last. No held items will have any effect for 5 turns. Fling cannot be used to throw items while Magic Room is in effect. The effect ends if the move is used again.

Move	Type	Kind	Pow.	Acc.	PP	Range	DA	Long	Effect
Magical Leaf	Grass	Special	60	—	20	Normal	—	—	A sure hit.
Magnet Bomb	Steel	Physical	60	—	20	Normal	—	—	A sure hit.
Magnet Rise	Electric	Status	—	—	10	Self	—	—	Nullifies Ground-type moves for 5 turns.
Magnetic Flux	Electric	Status	—	—	20	Your Party	—	○	Raises the Defense and Sp. Def of allies with either the Plus or Minus Abilities.
Magnitude	Ground	Physical	—	100	30	Adjacent	—	—	This move's power varies among 10, 30, 50, 70, 90, 110, and 150. Does twice the damage if targets are underground due to using Dig. Its power is reduced by 25% when it hits multiple Pokémon.
Mat Block	Fighting	Status	—	—	10	Your Side	—	—	Protects the user and allies from damage-dealing moves used in the same turn. Does not protect against status moves.
Me First	Normal	Status	—	—	20	Varies	—	—	Copies the target's chosen move and uses it with 50% greater power. Fails if it does not strike first.
Mean Look	Normal	Status	—	—	5	Normal	—	—	The target cannot escape. If used during a Trainer battle, the opposing Trainer cannot switch Pokémon. Has no effect on Ghost-type Pokémon.
Meditate	Psychic	Status	—	—	40	Self	—	—	Raises the user's Attack by 1.
Mega Drain	Grass	Special	40	100	15	Normal	—	—	Restores HP by up to half of the damage dealt to the target.
Mega Punch	Normal	Physical	80	85	20	Normal	○	—	A regular attack.
Megahorn	Bug	Physical	120	85	10	Normal	○	—	A regular attack.
Memento	Dark	Status	—	100	10	Normal	—	—	The user faints, but the target's Attack and Sp. Atk are lowered by 2.
Metal Burst	Steel	Physical	—	100	10	Varies	—	—	Targets the Pokémon that most recently damaged the user with a move. Inflicts 1.5 times the damage taken.
Metal Claw	Steel	Physical	50	95	35	Normal	○	—	A 10% chance of raising the user's Attack by 1.
Metal Sound	Steel	Status	—	85	40	Normal	—	—	Lowers the target's Sp. Def by 2. Strikes the target even if it is using Substitute.
Meteor Mash	Steel	Physical	90	90	10	Normal	—	○	Has a 20% chance of raising the user's Attack by 1.
Metronome	Normal	Status	—	—	10	Self	—	—	Uses one move randomly chosen from all possible moves.
Milk Drink	Normal	Status	—	—	10	Self	—	—	Restores HP by up to half of the user's maximum HP.
Mimic	Normal	Status	—	—	10	Normal	—	—	Copies the target's last-used move (copied move has a PP of 5). Fails if used before the opposing Pokémon uses a move.
Mind Reader	Normal	Status	—	—	5	Normal	—	—	The user's next move will be a sure hit.
Minimize	Normal	Status	—	—	10	Self	—	—	Raises the user's evasion by 2.
Miracle Eye	Psychic	Status	—	—	40	Normal	—	—	Attacks land easily regardless of the target's evasion. Makes Dark-type Pokémon vulnerable to Psychic-type moves.
Mirror Coat	Psychic	Special	—	100	20	Varies	—	—	If the user is attacked with a special move, this move inflicts twice the damage done to the user. Always strikes last.
Mirror Move	Flying	Status	—	—	20	Normal	—	—	Uses the last move that the target used.
Mirror Shot	Steel	Special	65	85	10	Normal	—	—	A 30% chance of lowering the target's accuracy by 1.
Mist	Ice	Status	—	—	30	Your Side	—	—	Protects against stat-lowering moves and additional effects for 5 turns.
Mist Ball	Psychic	Special	70	100	5	Normal	—	—	Has a 50% chance of reducing the target's Sp. Atk by 1.
Misty Terrain	Fairy	Status	—	—	10	Both Sides	—	—	Covers the field with mist for 5 turns. During that time, Pokémon on the ground take half damage from Dragon-type moves and cannot be afflicted with new status conditions.
Moonblast	Fairy	Special	95	100	15	Normal	—	—	A 30% chance of lowering the target's Sp. Atk by 1.
Moonlight	Fairy	Status	—	—	5	Self	—	—	Recovers 1/2 of the user's maximum HP in normal weather conditions. Recovers 2/3 of the user's maximum HP in sunny or extremely harsh sunlight weather conditions. Recovers 1/4 of the user's maximum HP in rain/heavy rain/sandstorm/hail weather conditions.
Morning Sun	Normal	Status	—	—	5	Self	—	—	Recovers 1/2 of the user's maximum HP in normal weather conditions. Recovers 2/3 of the user's maximum HP in sunny or extremely harsh sunlight weather conditions. Recovers 1/4 of the user's maximum HP in rain/heavy rain/sandstorm/hail weather conditions.
Mud Bomb	Ground	Special	65	85	10	Normal	—	—	A 30% chance of lowering the target's accuracy by 1.
Mud Shot	Ground	Special	55	95	15	Normal	—	—	Lowers the target's Speed by 1.
Mud Sport	Ground	Status	—	—	15	Both Sides	—	—	Lowers the power of Electric-type moves to 1/3 of normal for 5 turns.
Muddy Water	Water	Special	90	85	10	Many Others	—	—	A 30% chance of lowering the targets' accuracy by 1. Its power is reduced by 25% when it hits multiple Pokémon.
Mud-Slap	Ground	Special	20	100	10	Normal	—	—	Lowers the target's accuracy by 1.
Mystical Fire	Fire	Special	65	100	10	Normal	—	—	Lowers the target's Sp. Atk by 1.

N · O

Move	Type	Kind	Pow.	Acc.	PP	Range	DA	Long	Effect
Nasty Plot	Dark	Status	—	—	20	Self	—	—	Raises the user's Sp. Atk by 2.
Natural Gift	Normal	Physical	—	100	15	Normal	—	—	This move's type and power change according to the Berry held by the user. The Berry is consumed when this move is used. This move fails if the user is not holding a Berry.
Nature Power	Normal	Status	—	—	20	Normal	—	—	This move varies depending on the environment: Cave: Power Gem. Dirt/Sand: Earth Power. Grass / Grassy Terrain: Energy Ball. Electric Terrain: Thunderbolt. Ice: Ice Beam. Indoors / Link Battle: Tri Attack. Misty Terrain: Moonblast. Snow: Frost Breath. Swamp: Mud Bomb. Water Surface / Puddles / Shoals: Hydro Pump.
Needle Arm	Grass	Physical	60	100	15	Normal	○	—	A 30% chance of making the target flinch (unable to use moves on that turn).
Night Daze	Dark	Special	85	95	10	Normal	—	—	A 40% chance of lowering the target's accuracy by 1.
Night Shade	Ghost	Special	—	100	15	Normal	—	—	Deals a fixed amount of damage equal to the user's level.
Night Slash	Dark	Physical	70	100	15	Normal	○	—	Critical hits land more easily.

Move	Type	Kind	Pow.	Acc.	PP	Range	DA	Long	Effect
Nightmare	Ghost	Status	—	100	15	Normal	—	—	Lowers the target's HP by 1/4 of maximum after each turn. Fails if the target is not asleep.
Noble Roar	Normal	Status	—	100	30	Normal	—	—	Lowers the target's Attack and Sp. Atk by 1. Strikes the target even if it is using Substitute.
Nuzzle	Electric	Physical	20	100	20	Normal	○	—	Inflicts the Paralysis status condition on the target.
Oblivion Wing	Flying	Special	80	100	10	Normal	—	○	Restores HP by up to 3/4 of the damage dealt to the target.
Octazooka	Water	Special	65	85	10	Normal	—	—	A 50% chance of lowering the target's accuracy by 1.
Odor Sleuth	Normal	Status	—	—	40	Normal	—	—	Attacks land easily regardless of the target's evasion. Makes Ghost-type Pokémon vulnerable to Normal- and Fighting-type moves.
Ominous Wind	Ghost	Special	60	100	5	Normal	—	—	A 10% chance of raising the user's Attack, Defense, Speed, Sp. Atk, and Sp. Def stats by 1.
Origin Pulse	Water	Special	110	85	10	Many Others	—	—	Its power is reduced by 25% when it hits multiple Pokémon.
Outrage	Dragon	Physical	120	100	10	1 Random	○	—	Attacks consecutively over 2–3 turns. Cannot choose other moves during this time. The user becomes Confused after using this move.
Overheat	Fire	Special	130	90	5	Normal	—	—	Lowers the user's Sp. Atk by 2. If the target is Frozen, it will be thawed.

P

Move	Type	Kind	Pow.	Acc.	PP	Range	DA	Long	Effect
Pain Split	Normal	Status	—	—	20	Normal	—	—	The user and target's HP are added, then divided equally between them.
Parabolic Charge	Electric	Special	50	100	20	Adjacent	—	—	Restores HP by up to half of the damage dealt to the target. Its power is reduced by 25% when it hits multiple Pokémon.
Parting Shot	Dark	Status	—	100	20	Normal	—	—	Lowers the target's Attack and Sp. Atk. After attacking, user switches out with another Pokémon in the party. Strikes the target even if it is using Substitute.
Pay Day	Normal	Physical	40	100	20	Normal	—	—	Increases the amount of prize money received after battle (the user's level, multiplied by the number of attacks, multiplied by 5).
Payback	Dark	Physical	50	100	10	Normal	○	—	This move's power is doubled if the user strikes after the target.
Peck	Flying	Physical	35	100	35	Normal	○	○	A regular attack.
Perish Song	Normal	Status	—	—	5	Adjacent	—	○	All adjacent Pokémon in battle will faint after 3 turns, unless switched out. Strikes the target even if it is using Substitute.
Petal Blizzard	Grass	Physical	90	100	15	Adjacent	—	—	Its power is reduced by 25% when it hits multiple Pokémon.
Petal Dance	Grass	Special	120	100	10	1 Random	○	—	Attacks consecutively over 2–3 turns. Cannot choose other moves during this time. The user becomes Confused after using this move.
Phantom Force	Ghost	Physical	90	100	10	Normal	○	—	User disappears on the first turn and attacks on the second. Strikes the target even if it is using Detect, King's Shield, Mat Block, Protect, or Spiky Shield. If the target has used Minimize, it will be a sure hit and its power will be doubled.
Pin Missile	Bug	Physical	25	95	20	Normal	—	—	Attacks 2–5 times in a row in a single turn.
Play Nice	Normal	Status	—	—	20	Normal	—	—	A sure hit. Lowers the target's Attack by 1. Strikes the target even if it is using Detect, King's Shield, Mat Block, Protect, Spiky Shield, or Substitute.
Play Rough	Fairy	Physical	90	90	10	Normal	○	—	A 10% chance of lowering the target's Attack by 1.
Pluck	Flying	Physical	60	100	20	Normal	○	○	If the target is holding a Berry with a battle effect, the user eats that Berry and uses its effect.
Poison Fang	Poison	Physical	50	100	15	Normal	○	—	A 50% chance of inflicting the Badly Poisoned status condition on the target. Damage from being Badly Poisoned increases with every turn.
Poison Gas	Poison	Status	—	90	40	Many Others	—	—	Inflicts the Poison status condition on the targets.
Poison Jab	Poison	Physical	80	100	20	Normal	○	—	A 30% chance of inflicting the Poison status condition on the target.
Poison Powder	Poison	Status	—	75	35	Normal	—	—	Inflicts the Poison status condition on the targets. Has no effect on Grass-type Pokémon.
Poison Sting	Poison	Physical	15	100	35	Normal	—	—	A 30% chance of inflicting the Poison status condition on the target.
Poison Tail	Poison	Physical	50	100	25	Normal	○	—	A 10% chance of inflicting the Poison status condition on the target. Critical hits land more easily.
Pound	Normal	Physical	40	100	35	Normal	○	—	A regular attack.
Powder	Bug	Status	—	100	20	Normal	—	—	Always attacks first. Has no effect on Grass-type Pokémon. Deals damage equal to 1/4 of max HP if the target uses a Fire-type move in the same turn.
Powder Snow	Ice	Special	40	100	25	Many Others	—	—	A 10% chance of inflicting the Frozen status condition on the targets. Its power is reduced by 25% when it hits multiple Pokémon.
Power Gem	Rock	Special	80	100	20	Normal	—	—	A regular attack.
Power Split	Psychic	Status	—	—	10	Normal	—	—	The user and the target's Attack and Sp. Atk are added, then divided equally between them.
Power Swap	Psychic	Status	—	—	10	Normal	—	—	Swaps Attack and Sp. Atk changes between the user and the target.
Power Trick	Psychic	Status	—	—	10	Self	—	—	Swaps original Attack and Defense stats (does not swap stat changes).
Power Whip	Grass	Physical	120	85	10	Normal	○	—	A regular attack.
Power-Up Punch	Fighting	Physical	40	100	20	Normal	○	—	Raises the user's Attack by 1.
Precipice Blades	Ground	Physical	120	85	10	Many Others	—	—	Its power is reduced by 25% when it hits multiple Pokémon.
Present	Normal	Physical	—	90	15	Normal	—	—	This move's power varies among 40 (40% chance), 80 (30% chance), and 120 (10% chance). It also has a 20% chance of healing the target by 1/4 of its maximum HP.
Protect	Normal	Status	—	—	10	Self	—	—	The user evades all moves that turn. If used in succession, its chance of failing rises.
Psybeam	Psychic	Special	65	100	20	Normal	—	—	A 10% chance of inflicting the Confused status condition on the target.
Psych Up	Normal	Status	—	—	10	Normal	—	—	Copies the target's stat changes to the user.

Move	Type	Kind	Pow.	Acc.	PP	Range	DA	Long	Effect
Psychic	Psychic	Special	90	100	10	Normal	—	—	A 10% chance of lowering the target's Sp. Def by 1.
Psycho Cut	Psychic	Physical	70	100	20	Normal	—	—	Critical hits land more easily.
Psycho Shift	Psychic	Status	—	100	10	Normal	—	—	Shifts the user's Paralysis, Poison, Badly Poisoned, Burned, or Sleep status conditions to the target and heals the user.
Psyshock	Psychic	Special	80	100	10	Normal	—	—	Damage depends on the user's Sp. Atk and the target's Defense.
Psystrike	Psychic	Special	100	100	10	Normal	—	—	Damage depends on the user's Sp. Atk and the target's Defense.
Psywave	Psychic	Special	—	100	15	Normal	—	—	Inflicts damage equal to the user's level multiplied by a random value between 0.5 and 1.5.
Punishment	Dark	Physical	—	100	5	Normal	○	—	With each level that the target's stats increase, the move's power becomes greater (max 200).
Pursuit	Dark	Physical	40	100	20	Normal	○	—	Does twice the usual damage if the target is switching out.

Q · R

Move	Type	Kind	Pow.	Acc.	PP	Range	DA	Long	Effect
Quash	Dark	Status	—	100	15	Normal	—	—	The user suppresses the target and makes it move last that turn. Fails if the target has already used its move that turn.
Quick Attack	Normal	Physical	40	100	30	Normal	○	—	Always strikes first. The user with the higher Speed goes first if similar moves are used.
Quick Guard	Fighting	Status	—	—	15	Your Side	—	—	Protects the user and its allies from first-strike moves.
Quiver Dance	Bug	Status	—	—	20	Self	—	—	Raises the user's Sp. Atk, Sp. Def, and Speed by 1.
Rage	Normal	Physical	20	100	20	Normal	○	—	Attack rises by 1 with each hit the user takes.
Rage Powder	Bug	Status	—	—	20	Self	—	—	This move goes first. Opposing Pokémon aim only at the user. Has no effect on Grass-type Pokémon.
Rain Dance	Water	Status	—	—	5	Both Sides	—	—	Changes the weather condition to rain for 5 turns, strengthening Water-type moves by 50% and reducing the power of Fire-type moves by 50%.
Rapid Spin	Normal	Physical	20	100	40	Normal	○	—	Releases the user from moves such as Bind, Leech Seed, Spikes, and Wrap.
Razor Leaf	Grass	Physical	55	95	25	Many Others	—	—	Critical hits land more easily. Its power is reduced by 25% when it hits multiple Pokémon.
Razor Shell	Water	Physical	75	95	10	Normal	○	—	A 50% chance of lowering the target's Defense by 1.
Razor Wind	Normal	Special	80	100	10	Many Others	—	—	The user stores power on the first turn and attacks on the second. Critical hits land more easily. Its power is reduced by 25% when it hits multiple Pokémon.
Recover	Normal	Status	—	—	10	Self	—	—	Restores HP by up to half of the user's maximum HP.
Recycle	Normal	Status	—	—	10	Self	—	—	A held item that has been used can be used again.
Reflect	Psychic	Status	—	—	20	Your Side	—	—	Halves the damage to the Pokémon on your side from physical moves. Effect lasts 5 turns even if the user is switched out. Effect is weaker in Double and Triple Battles.
Reflect Type	Normal	Status	—	—	15	Normal	—	—	The user becomes the same type as the target.
Refresh	Normal	Status	—	—	20	Self	—	—	Heals Poison, Badly Poisoned, Paralysis, and Burned conditions.
Rest	Psychic	Status	—	—	10	Self	—	—	Fully restores HP, but makes the user sleep for 2 turns.
Retaliate	Normal	Physical	70	100	5	Normal	○	—	This move's power is doubled if an ally fainted in the previous turn.
Return	Normal	Physical	—	100	20	Normal	○	—	This move's power is affected by friendship. The higher the user's friendship, the greater the move's power (max 102).
Revenge	Fighting	Physical	60	100	10	Normal	○	—	Attacks last. This move's power is doubled if the user has taken damage from the target that turn.
Reversal	Fighting	Physical	—	100	15	Normal	○	—	The lower the user's HP is, the greater the move's power becomes (max 200).
Roar	Normal	Status	—	—	20	Normal	—	—	Attacks last. Ends wild Pokémon battles. If the opposing Pokémon's level is higher than the user's, this move fails. In a Double Battle with wild Pokémon, this move fails. In a battle with a Trainer, this move forces the opposing Trainer to switch Pokémon. When there is no Pokémon to switch in, this move fails. Strikes the target even if it is using Detect, King's Shield, Mat Block, Protect, Spiky Shield, or Substitute.
Rock Blast	Rock	Physical	25	90	10	Normal	—	—	Attacks 2–5 times in a row in a single turn.
Rock Climb	Normal	Physical	90	85	20	Normal	○	—	A 20% chance of inflicting the Confused status condition on the target.
Rock Polish	Rock	Status	—	—	20	Self	—	—	Raises the user's Speed by 2.
Rock Slide	Rock	Physical	75	90	10	Many Others	—	—	A 30% chance of making the targets flinch (unable to use moves on that turn). Its power is reduced by 25% when it hits multiple Pokémon.
Rock Smash	Fighting	Physical	40	100	15	Normal	○	—	A 50% chance of lowering the target's Defense by 1.
Rock Throw	Rock	Physical	50	90	15	Normal	—	—	A regular attack.
Rock Tomb	Rock	Physical	60	95	15	Normal	—	—	Lowers the target's Speed by 1.
Rock Wrecker	Rock	Physical	150	90	5	Normal	—	—	The user can't move during the next turn.
Role Play	Psychic	Status	—	—	10	Range	—	—	Copies the target's Ability. Fails with certain Abilities, however.
Rolling Kick	Fighting	Physical	60	85	15	Normal	○	—	A 30% chance of making the target flinch (unable to use moves on that turn).
Rollout	Rock	Physical	30	90	20	Normal	○	—	Attacks consecutively over 5 turns or until it misses. Cannot choose other moves during this time. Damage dealt doubles with every successful hit (max 480). Does twice the damage if used after Defense Curl.
Roost	Flying	Status	—	—	10	Self	—	—	Restores HP by up to half of the user's maximum HP, but takes away the Flying type from the user for that turn.
Rototiller	Ground	Status	—	—	10	Adjacent	—	○	Raises the Attack and Sp. Atk of Grass-type Pokémon by 1.
Round	Normal	Special	60	100	15	Normal	—	—	When multiple Pokémon use this move in a turn, the first one to use it is followed immediately by the others. Attack's power is doubled when following another Pokémon using the same move. Strikes the target even if it is using Substitute.

Move	Type	Kind	Pow.	Acc.	PP	Range	DA	Long	Effect
Sacred Sword	Fighting	Physical	90	100	15	Normal	○	—	Ignores the stat changes of the opposing Pokémon, except for Speed.
Safeguard	Normal	Status	—	—	25	Your Side	—	—	Protects the Pokémon on your side from status conditions and confusion for 5 turns. Effects last even if the user switches out.
Sand Attack	Ground	Status	—	100	15	Normal	—	—	Lowers the target's accuracy by 1.
Sand Tomb	Ground	Physical	35	85	15	Normal	—	—	Inflicts damage equal to 1/8 the target's max HP for 4–5 turns. The target cannot flee during that time.
Sandstorm	Rock	Status	—	—	10	Both Sides	—	—	Changes the weather condition to sandstorm for 5 turns. Raises the Sp. Def of Rock-type Pokémon by 50% for the length of the sandstorm. All Pokémon other than Rock, Steel, and Ground types take damage each turn equal to 1/16 of their max HP.
Scald	Water	Special	80	100	15	Normal	—	—	A 30% chance of inflicting the Burned status condition on the target. This move can be used even when the user is Frozen. Using this move will thaw the user, relieving the Frozen status condition.
Scary Face	Normal	Status	—	100	10	Normal	—	—	Lowers the targets' Speed by 2.
Scratch	Normal	Physical	40	100	35	Normal	○	—	A regular attack.
Screech	Normal	Status	—	85	40	Normal	—	—	Lowers the target's Defense by 2. Strikes the target even if it is using Substitute.
Secret Power	Normal	Physical	70	100	20	Normal	—	—	A 30% chance of one of the following additional effects, depending on the environment: Cave: Target flinches. Dirt/Sand: Lowers accuracy by 1. Grass / Grassy Terrain: Sleep status condition. Indoors / Electric Terrain / Link Battle: Inflicts Paralysis status condition. Misty Terrain: Lowers Sp. Atk by 1. Snow/Ice: Inflicts Frozen status condition. Swamp: Lowers Speed by 1. Water Surface / Puddles / Shoals: Lowers Attack by 1
Seed Bomb	Grass	Physical	80	100	15	Normal	—	—	A regular attack.
Seismic Toss	Fighting	Physical	—	100	20	Normal	○	—	Deals a fixed amount of damage equal to the user's level.
Self-Destruct	Normal	Physical	200	100	5	Adjacent	—	—	The user faints after using it. Its power is reduced by 25% when it hits multiple Pokémon.
Shadow Ball	Ghost	Special	80	100	15	Normal	—	—	A 20% chance of lowering the target's Sp. Def by 1.
Shadow Claw	Ghost	Physical	70	100	15	Normal	○	—	Critical hits land more easily.
Shadow Punch	Ghost	Physical	60	—	20	Normal	○	—	A sure hit.
Shadow Sneak	Ghost	Physical	40	100	30	Normal	○	—	Always strikes first. The user with the higher Speed goes first if similar moves are used.
Sharpen	Normal	Status	—	—	30	Self	—	—	Raises the user's Attack by 1.
Sheer Cold	Ice	Special	—	30	5	Normal	—	—	The target faints with one hit if the user's level is equal to or greater than the target's level. The higher the user's level is compared to the target's, the more accurate the move is.
Shell Smash	Normal	Status	—	—	15	Self	—	—	Lowers the user's Defense and Sp. Def by 1 and raises the user's Attack, Sp. Atk, and Speed by 2.
Shock Wave	Electric	Special	60	—	20	Normal	—	—	A sure hit.
Signal Beam	Bug	Special	75	100	15	Normal	—	—	A 10% chance of inflicting the Confused status condition on the target.
Silver Wind	Bug	Special	60	100	5	Normal	—	—	A 10% chance of raising the user's Attack, Defense, Speed, Sp. Atk, and Sp. Def stats by 1.
Simple Beam	Normal	Status	—	100	15	Normal	—	—	Changes the target's Ability to Simple. Fails with certain Abilities, however.
Sing	Normal	Status	—	55	15	Normal	—	—	Inflicts the Sleep status condition on the target. Strikes the target even if it is using Substitute.
Sketch	Normal	Status	—	—	1	Normal	—	—	Copies the last move used by the target. The user then forgets Sketch and learns the new move.
Skill Swap	Psychic	Status	—	—	10	Normal	—	—	Swaps Abilities between the user and target. Fails with certain Abilities, however.
Skull Bash	Normal	Physical	130	100	10	Normal	○	—	Builds power on the first turn and attacks on the second. It raises the user's Defense stat by 1 on the first turn.
Sky Attack	Flying	Physical	140	90	5	Normal	—	○	Builds power on the first turn and attacks on the second. Critical hits land more easily. A 30% chance of making the target flinch (unable to use moves on that turn).
Sky Drop	Flying	Physical	60	100	10	Normal	○	○	The user takes the target into the sky, and then damages it by dropping it during the next turn. Does not damage Flying-type Pokémon. Pokémon weighing over 440.9 lbs. cannot be lifted.
Sky Uppercut	Fighting	Physical	85	90	15	Normal	○	—	It even hits Pokémon that are in the sky due to having used moves such as Fly and Bounce.
Slack Off	Normal	Status	—	—	10	Self	—	—	Restores HP by up to half of the user's maximum HP.
Slam	Normal	Physical	80	75	20	Normal	○	—	A regular attack.
Slash	Normal	Physical	70	100	20	Normal	○	—	Critical hits land more easily.
Sleep Powder	Grass	Status	—	75	15	Normal	—	—	Inflicts the Sleep status condition on the target. Has no effect on Grass-type Pokémon.
Sleep Talk	Normal	Status	—	—	10	Self	—	—	Only works when the user is asleep. Randomly uses one of the user's moves.
Sludge	Poison	Special	65	100	20	Normal	—	—	A 30% chance of inflicting the Poison status condition on the target.
Sludge Bomb	Poison	Special	90	100	10	Normal	—	—	A 30% chance of inflicting the Poison status condition on the target.
Sludge Wave	Poison	Special	95	100	10	Adjacent	—	—	A 10% chance of inflicting the Poison status condition on the targets. Its power is reduced by 25% when it hits multiple Pokémon.
Smack Down	Rock	Physical	50	100	15	Normal	—	—	Ground-type moves will now hit a Pokémon with the Levitate Ability or a Flying-type Pokémon. They will also hit a Pokémon that is in the sky due to using a move such as Fly or Bounce.
Smelling Salts	Normal	Physical	70	100	10	Normal	○	—	Deals twice the usual damage to targets with Paralysis, but heals that status condition.
Smog	Poison	Special	30	70	20	Normal	—	—	A 40% chance of inflicting the Poison status condition on the target.
Smokescreen	Normal	Status	—	100	20	Normal	—	—	Lowers the target's accuracy by 1.
Snarl	Dark	Special	55	95	15	Many Others	—	—	Lowers the targets' Sp. Atk by 1. Its power is reduced by 25% when it hits multiple Pokémon. Strikes the target even if it is using Substitute.
Snatch	Dark	Status	—	—	10	Self	—	—	Steals the effects of recovery or stat-changing moves used by the target on that turn and applies them to the user.

TRAINER HANDBOOK

ADVANCED HANDBOOK

ADVENTURE DATA

Move	Type	Kind	Pow.	Acc.	PP	Range	DA	Long	Effect
Snore	Normal	Special	50	100	15	Normal	—	—	Only works when the user is asleep. A 30% chance of making the target flinch (unable to use moves on that turn). Strikes the target even if it is using Substitute.
Soak	Water	Status	—	100	20	Normal	—	—	Changes the target's type to Water.
Solar Beam	Grass	Special	120	100	10	Normal	—	—	Builds power on the first turn and attacks on the second. In sunny or extremely harsh sunlight weather conditions, attacks on first turn. In rain/heavy rain/sandstorm/hail weather conditions, the power is halved.
Sonic Boom	Normal	Special	—	90	20	Normal	—	—	Deals a fixed 20 points of damage.
Spark	Electric	Physical	65	100	20	Normal	○	—	A 30% chance of inflicting the Paralysis status condition on the target.
Spider Web	Bug	Status	—	—	10	Normal	—	—	The target cannot escape. If used during a Trainer battle, the opposing Trainer cannot switch Pokémon. Has no effect on Ghost-type Pokémon.
Spike Cannon	Normal	Physical	20	100	15	Normal	—	—	Attacks 2–5 times in a row in a single turn.
Spikes	Ground	Status	—	—	20	Other Side	—	—	Damages Pokémon as they are sent out to the opposing side. Power rises with each use, up to 3 times (1st time: 1/8 of maximum HP; 2nd time: 1/6 of maximum HP; 3rd time: 1/4 of maximum HP). Ineffective against Flying-type Pokémon and Pokémon with the Levitate Ability.
Spiky Shield	Grass	Status	—	—	10	Self	—	—	The user takes no damage in the same turn this move is used. If an opposing Pokémon uses a move that makes direct contact, the attacker will be damaged for 1/8 of its maximum HP.
Spit Up	Normal	Special	—	100	10	Normal	—	—	The more times the user has used Stockpile, the greater the move's power becomes (max 300). Fails if the user has not used Stockpile first. Nullifies Defense and Sp. Def stat increases caused by Stockpile.
Spite	Ghost	Status	—	100	10	Normal	—	—	Takes 4 points from the PP of the target's last used move.
Splash	Normal	Status	—	—	40	Self	—	—	No effect.
Spore	Grass	Status	—	100	15	Normal	—	—	Inflicts the Sleep status condition on the target. Has no effect on Grass-type Pokémon.
Stealth Rock	Rock	Status	—	—	20	Other Side	—	—	Damages Pokémon as they are sent out to the opposing side. Damage is subject to type matchups.
Steamroller	Bug	Physical	65	100	20	Normal	○	—	A 30% chance of making the targets flinch (unable to use moves on that turn). If the target has used Minimize, this move will be a sure hit and its power will be doubled.
Steel Wing	Steel	Physical	70	90	25	Normal	○	—	A 10% chance of raising the user's Defense by 1.
Sticky Web	Bug	Status	—	—	20	Other Side	—	—	Lowers the Speed of any Pokémon sent out to the opposing side by 1.
Stockpile	Normal	Status	—	—	20	Self	—	—	Raises the user's Defense and Sp. Def by 1. Can be used up to 3 times.
Stomp	Normal	Physical	65	100	20	Normal	○	—	A 30% chance of making the targets flinch (unable to use moves on that turn). If the target has used Minimize, this move will be a sure hit and its power will be doubled.
Stone Edge	Rock	Physical	100	80	5	Normal	—	—	Critical hits land more easily.
Stored Power	Psychic	Special	20	100	10	Normal	—	—	With each level that the user's stats increase, the move's power increases by 20 (max 860).
Storm Throw	Fighting	Physical	60	100	10	Normal	○	—	Always delivers a critical hit.
Strength	Normal	Physical	80	100	15	Normal	○	—	A regular attack.
String Shot	Bug	Status	—	95	40	Many Others	—	—	Lowers the targets' Speed by 2.
Struggle	Normal	Physical	50	—	1	Normal	○	—	This move becomes available when all other moves are out of PP. The user takes damage equal to 1/4 of its maximum HP. Inflicts damage regardless of type matchup.
Struggle Bug	Bug	Special	50	100	20	Many Others	—	—	Lowers the targets' Sp. Atk by 1. Its power is reduced by 25% when it hits multiple Pokémon.
Stun Spore	Grass	Status	—	75	30	Normal	—	—	Inflicts the Paralysis status condition on the target. Has no effect on Grass-type Pokémon.
Submission	Fighting	Physical	80	80	20	Normal	○	—	The user takes 1/4 of the damage inflicted.
Substitute	Normal	Status	—	—	10	Self	—	—	Uses 1/4 of maximum HP to create a copy of the user.
Sucker Punch	Dark	Physical	80	100	5	Normal	○	—	This move attacks first and deals damage only if the target's chosen move is an attack move.
Sunny Day	Fire	Status	—	—	5	Both Sides	—	—	Changes the weather condition to sunny for 5 turns, strengthening Fire-type moves by 50% and reducing the power of Water-type moves by 50%.
Super Fang	Normal	Physical	—	90	10	Normal	○	—	Halves the target's HP.
Superpower	Fighting	Physical	120	100	5	Normal	○	—	Lowers the user's Attack and Defense by 1.
Supersonic	Normal	Status	—	55	20	Normal	—	—	Inflicts the Confused status condition on the target. Strikes the target even if it is using Substitute.
Surf	Water	Special	90	100	15	Adjacent	—	—	Does twice the damage if the target is using Dive when attacked. Its power is weaker when it hits multiple Pokémon.
Swagger	Normal	Status	—	90	15	Normal	—	—	Inflicts the Confused status condition on the target, but also raises its Attack by 2.
Swallow	Normal	Status	—	—	10	Self	—	—	Restores HP, the amount of which is determined by how many times the user has used Stockpile. Fails if the user has not used Stockpile first. Nullifies Defense and Sp. Def stat increases caused by Stockpile.
Sweet Kiss	Fairy	Status	—	75	10	Normal	—	—	Inflicts the Confused status condition on the target.
Sweet Scent	Normal	Status	—	100	20	Many Others	—	—	Lowers the targets' evasion by 2.
Swift	Normal	Special	60	—	20	Many Others	—	—	A sure hit. Its power is reduced by 25% when it hits multiple Pokémon.
Switcheroo	Dark	Status	—	100	10	Normal	—	—	Swaps items between the user and the target.
Swords Dance	Normal	Status	—	—	20	Self	—	—	Raises the user's Attack by 2.
Synchronoise	Psychic	Special	120	100	10	Adjacent	—	—	Inflicts damage on any Pokémon of the same type as the user. Its power is weaker when it hits multiple Pokémon.
Synthesis	Grass	Status	—	—	5	Self	—	—	Recovers 1/2 of the user's maximum HP in normal weather conditions. Recovers 2/3 of the user's maximum HP in sunny or extremely harsh sunlight weather conditions. Recovers 1/4 of the user's maximum HP in rain/heavy rain/sandstorm/hail weather conditions.

Move	Type	Kind	Pow.	Acc.	PP	Range	DA	Long	Effect
Tackle	Normal	Physical	50	100	35	Normal	○	—	A regular attack.
Tail Glow	Bug	Status	—	—	20	Self	—	—	Raises the user's Sp. Atk by 3.
Tail Slap	Normal	Physical	25	85	10	Normal	○	—	Attacks 2–5 times in a row in a single turn.
Tail Whip	Normal	Status	—	100	30	Many Others	—	—	Lowers the targets' Defense by 1.
Tailwind	Flying	Status	—	—	15	Your Side	—	—	Doubles the Speed of the Pokémon on your side for 4 turns.
Take Down	Normal	Physical	90	85	20	Normal	○	—	The user takes 1/4 of the damage inflicted.
Taunt	Dark	Status	—	100	20	Normal	—	—	Prevents the target from using anything other than attack moves for 3 turns.
Teeter Dance	Normal	Status	—	100	20	Adjacent	—	—	Inflicts the Confused status condition on the target.
Telekinesis	Psychic	Status	—	—	15	Normal	—	—	Makes the target float for 3 turns. All moves land regardless of their accuracy except for Ground-type moves and one-hit KO moves such as Fissure, Guillotine, Horn Drill, and Sheer Cold.
Teleport	Psychic	Status	—	—	20	Self	—	—	Ends wild Pokémon battles.
Thief	Dark	Physical	60	100	25	Normal	○	—	When the target is holding an item and the user is not, the user can steal that item. When the target is not holding an item, this move will function as a normal attack.
Thrash	Normal	Physical	120	100	10	1 Random	○	—	Attacks consecutively over 2–3 turns. Cannot choose other moves during this time. The user becomes Confused after using this move.
Thunder	Electric	Special	110	70	10	Normal	—	—	A 30% chance of inflicting the Paralysis status condition on the target. Is 100% accurate in the rain or heavy rain weather condition and 50% accurate in the sunny or extremely harsh sunlight weather condition. It hits even Pokémon that are in the sky due to using moves such as Fly and Bounce.
Thunder Fang	Electric	Physical	65	95	15	Normal	○	—	A 10% chance of inflicting the Paralysis status condition or making the target flinch (unable to use moves on that turn).
Thunder Punch	Electric	Physical	75	100	15	Normal	○	—	A 10% chance of inflicting the Paralysis status condition on the target.
Thunder Shock	Electric	Special	40	100	30	Normal	—	—	A 10% chance of inflicting the Paralysis status condition on the target.
Thunder Wave	Electric	Status	—	100	20	Normal	—	—	Inflicts the Paralysis status condition on the target. Does not work on Ground types.
Thunderbolt	Electric	Special	90	100	15	Normal	—	—	A 10% chance of inflicting the Paralysis status condition on the target.
Tickle	Normal	Status	—	100	20	Normal	—	—	Lowers the target's Attack and Defense by 1.
Topsy-Turvy	Dark	Status	—	—	20	Normal	—	—	Reverses the effects of any stat changes affecting the target.
Torment	Dark	Status	—	100	15	Normal	—	—	Makes the target unable to use the same move twice in a row.
Toxic	Poison	Status	—	90	10	Normal	—	—	Inflicts the Badly Poisoned status condition on the target. Damage from being Badly Poisoned increases with every turn. It never misses if used by a Poison-type Pokémon.
Toxic Spikes	Poison	Status	—	—	20	Other Side	—	—	Lays a trap of poison spikes on the opposing side that inflict the Poison status condition on Pokémon that switch into battle. Using Toxic Spikes twice inflicts the Badly Poisoned condition. The damage from the Badly Poisoned condition increases every turn. Toxic Spikes' effects end when a Poison-type Pokémon switches into battle. Ineffective against Flying-type Pokémon and Pokémon with the Levitate Ability.
Transform	Normal	Status	—	—	10	Normal	—	—	The user transforms into the target. The user has the same moves and Ability as the target (all moves have 5 PP).
Tri Attack	Normal	Special	80	100	10	Normal	—	—	A 20% chance of inflicting the Paralysis, Burned, or Frozen status condition on the target.
Trick	Psychic	Status	—	100	10	Normal	—	—	Swaps items between the user and the target.
Trick Room	Psychic	Status	—	—	5	Both Sides	—	—	Always strikes last. For 5 turns, Pokémon with lower Speed go first. First-strike moves still go first. Self-canceling if used again while Trick Room is still in effect.
Trick-or-Treat	Ghost	Status	—	100	20	Normal	—	—	Gives the target the Ghost type in addition to its original type(s).
Trump Card	Normal	Special	—	—	5	Normal	○	—	A sure hit. The lower the user's PP is, the greater the move's power becomes (max 200).
Twineedle	Bug	Physical	25	100	20	Normal	—	—	Attacks twice in a row in a single turn. A 20% chance of inflicting the Poison status condition on the target.
Twister	Dragon	Special	40	100	20	Many Others	—	—	A 20% chance of making the targets flinch (unable to use moves on that turn). Does twice the damage if the targets are in the sky due to moves such as Fly or Bounce. Its power is reduced by 25% when it hits multiple Pokémon.

Move	Type	Kind	Pow.	Acc.	PP	Range	DA	Long	Effect
Uproar	Normal	Special	90	100	10	1 Random	—	—	The user makes an uproar for 3 turns. During that time, no Pokémon can fall asleep. Strikes the target even if it is using Substitute.
U-turn	Bug	Physical	70	100	20	Normal	○	—	After attacking, the user switches out with another Pokémon in the party.
Vacuum Wave	Fighting	Special	40	100	30	Normal	—	—	Always strikes first. The user with the higher Speed goes first if similar moves are used.
Venom Drench	Poison	Status	—	100	20	Many Others	—	—	Lowers the Attack, Sp. Atk, and Speed of opposing Pokémon afflicted with Poison or Badly Poisoned status conditions by 1.
Venoshock	Poison	Special	65	100	10	Normal	—	—	Does twice the damage to a target that has the Poison or Badly Poisoned status condition.
Vice Grip	Normal	Physical	55	100	30	Normal	○	—	A regular attack.
Vine Whip	Grass	Physical	45	100	25	Normal	○	—	A regular attack.
Vital Throw	Fighting	Physical	70	—	10	Normal	○	—	Always strikes later than normal, but has perfect accuracy.
Volt Switch	Electric	Special	70	100	20	Normal	—	—	After attacking, the user switches out with another Pokémon in the party.
Volt Tackle	Electric	Physical	120	100	15	Normal	○	—	The user takes 1/3 of the damage inflicted. A 10% chance of inflicting the Paralysis status condition on the target.

TRAINER HANDBOOK

ADVANCED HANDBOOK

ADVENTURE DATA

Move	Type	Kind	Pow.	Acc.	PP	Range	DA	Long	Effect
Wake-Up Slap	Fighting	Physical	70	100	10	Normal	○	—	Does twice the usual damage to a sleeping target, but heals that status condition.
Water Gun	Water	Special	40	100	25	Normal	—	—	A regular attack.
Water Pledge	Water	Special	80	100	10	Normal	—	—	When combined with Fire Pledge or Grass Pledge, the power and effect change. If combined with Fire Pledge, the power is 150 and it remains a Water-type move. This makes it more likely that your team's moves will have additional effects for 4 turns. If combined with Grass Pledge, the power is 150 and it becomes a Grass-type move. This lowers the Speed of opposing Pokémon for 4 turns.
Water Pulse	Water	Special	60	100	20	Normal	—	○	A 20% chance of inflicting the Confused status condition on the target.
Water Shuriken	Water	Physical	15	100	20	Normal	—	—	Always strikes first. The user with the higher Speed goes first if similar moves are used. Attacks 2–5 times in a row in a single turn.
Water Sport	Water	Status	—	—	15	Both Sides	—	—	Lowers the power of Fire-type moves to 1/3 of normal for 5 turns.
Water Spout	Water	Special	150	100	5	Many Others	—	—	If the user's HP is low, this move has lower power. Its power is reduced by 25% when it hits multiple Pokémon.
Waterfall	Water	Physical	80	100	15	Normal	○	—	A 20% chance of making the target flinch (unable to use moves on that turn).
Weather Ball	Normal	Special	50	100	10	Normal	—	—	In special weather conditions, this move's type changes and its attack power doubles. Sunny / extremely harsh sunlight weather condition: Fire type. Rain / heavy rain weather condition: Water type. Hail weather condition: Ice type. Sandstorm weather condition: Rock type.
Whirlpool	Water	Special	35	85	15	Normal	—	—	Inflicts damage equal to 1/8 the target's max HP for 4–5 turns. The target cannot flee during that time. Does twice the damage if the target is using Dive when attacked.
Whirlwind	Normal	Status	—	—	20	Normal	—	—	Ends wild Pokémon battles. If the opposing Pokémon's level is higher than the user's, this move fails. In a Double Battle with wild Pokémon, this move fails. Strikes the target even if it is using Substitute. In a battle with a Trainer, this move forces the opposing Trainer to switch Pokémon. When there are no Pokémon to switch in, this move fails. Strikes the target even if it is using Detect, King's Shield, Mat Block, Protect, or Spiky Shield.
Wide Guard	Rock	Status	—	—	10	Your Side	—	—	Protects your side from any moves used that turn that target multiple Pokémon.
Wild Charge	Electric	Physical	90	100	15	Normal	○	—	The user takes 1/4 of the damage inflicted.
Will-O-Wisp	Fire	Status	—	85	15	Normal	—	—	Inflicts the Burned status condition on the target.
Wing Attack	Flying	Physical	60	100	35	Normal	○	○	A regular attack.
Wish	Normal	Status	—	—	10	Self	—	—	Restores 1/2 of maximum HP at the end of the next turn. Works even if the user has switched out.
Withdraw	Water	Status	—	—	40	Self	—	—	Raises the user's Defense by 1.
Wonder Room	Psychic	Status	—	—	10	Both Sides	—	—	Always strikes last. Each Pokémon's Defense and Sp. Def stats are swapped for 5 turns. The effect ends if the move is used again.
Wood Hammer	Grass	Physical	120	100	15	Normal	○	—	The user takes 1/3 of the damage inflicted.
Work Up	Normal	Status	—	—	30	Self	—	—	Raises the user's Attack and Sp. Atk by 1.
Worry Seed	Grass	Status	—	100	10	Normal	—	—	Changes the target's Ability to Insomnia. Fails with certain Abilities, however.
Wrap	Normal	Physical	15	90	20	Normal	○	—	Inflicts damage equal to 1/8 the target's max HP for 4–5 turns. The target cannot flee during that time.
Wring Out	Normal	Special	—	100	5	Normal	○	—	The more HP the target has left, the greater the move's power becomes (max 120).

Move	Type	Kind	Pow.	Acc.	PP	Range	DA	Long	Effect
X-Scissor	Bug	Physical	80	100	15	Normal	○	—	A regular attack.
Yawn	Normal	Status	—	—	10	Normal	—	—	Inflicts the Sleep status condition on the target at the end of the next turn unless the target switches out.
Zap Cannon	Electric	Special	120	50	5	Normal	—	—	Inflicts the Paralysis status condition on the target.
Zen Headbutt	Psychic	Physical	80	90	15	Normal	○	—	A 20% chance of making the target flinch (unable to use moves on that turn).

Field Moves

Move	Effects in the field
Cut	Cuts down thorny trees so your party may pass.
Dig	Pulls you out of spaces like caves, returning you to the last entrance you went through.
Dive	Lets you move underwater.
Flash	Enables you to see farther and makes you less likely to encounter wild Pokémon in caves. The effect lasts until you exit the cave.
Fly	Whisks you instantly to a town or city you've visited before.
Milk Drink	Distributes part of the user's own HP among teammates.
Rock Smash	Smashes cracked rocks and walls so your party may pass. Smashed rocks may contain items or wild Pokémon.
Secret Power	Allows you to open suspicious-looking trees, bushes, and caves up to use as a Secret Base.
Soar	Lets you fly around freely, allowing access to previously inaccessible areas.
Soft-Boiled	Distributes part of the user's own HP among teammates.
Strength	Allows you to move large rocks and push them into holes to create new paths.
Surf	Allows you to move across the surface of a body of water.
Sweet Scent	Attracts wild Pokémon and makes them attack. If you are in an area prone to Horde Encounters, a horde of Pokémon will definitely appear.
Teleport	Transports you to the last Pokémon Center you used (cannot be used in caves or similar locations).
Waterfall	Allows you to climb up and down waterfalls.

How to Obtain TMs

No.	Move	How to Obtain	Price
TM01	Hone Claws	Buy at a stall in the Slateport Market	5,000
TM02	Dragon Claw	Find in Meteor Falls (need Surf and Waterfall)	—
TM03	Psyshock	Get in a house in Pacifidlog Town	—
TM04	Calm Mind	Defeat Gym Leaders Liza & Tate in Mossdeep City	—
TM05	Roar	Get from a Gentleman on Route 114	—
TM06	Toxic	Find on the Fiery Path (need Strength)	—
TM07	Hail	Find in Shoal Cave on Route 125 at low tide (need Surf)	—
TM08	Bulk Up	Defeat Gym Leader Brawly in Dewford Town	—
TM09	Venoshock	Buy from the upper clerk at the Mauville Poké Mart	10,000
TM10	Hidden Power	Get from an old woman in Fortree City	—
TM11	Sunny Day	Find in Scorched Slab on Route 120 (need Surf)	—
TM12	Taunt	Get as a reward in the Trick House	—
TM13	Ice Beam	Find in Sea Mauville on Route 108 (need Surf and Dive)	—
TM14	Blizzard	Buy in the Lilycove Department Store (4F)	30,000
TM15	Hyper Beam	Buy in the Lilycove Department Store (4F)	50,000
TM16	Light Screen	Buy in the Lilycove Department Store (4F)	10,000
TM17	Protect	Buy in the Lilycove Department Store (4F)	10,000
TM18	Rain Dance	Find in Sea Mauville on Route 108 (need Surf and Dive)	—
TM19	Roost	Defeat Gym Leader Winona in Fortree City	—
TM20	Safeguard	Buy in the Lilycove Department Store (4F)	10,000
TM21	Frustration	Get in a house in Pacifidlog Town (with an unfriendly Pokémon in lead position)	—
TM22	Solar Beam	Find in the Safari Zone (need Surf and Bikes)	—
TM23	Smack Down	Get from Professor Cozmo after rescuing him from Team Magma / Team Aqua	—
TM24	Thunderbolt	Get from Gym Leader Wattson in his apartment after helping sort out New Mauville	—
TM25	Thunder	Buy in the Lilycove Department Store (4F)	30,000
TM26	Earthquake	Find in the Seafloor Cavern on Route 128 (need Surf and Dive)	—
TM27	Return	Get in a house in Pacifidlog Town (with a friendly Pokémon in lead position)	—
TM28	Dig	Get from the Fossil Maniac's little brother in their home on Route 114	—
TM29	Psychic	Find in Ever Grande City (from Victory Road)	—
TM30	Shadow Ball	Find on Mt. Pyre	—
TM31	Brick Break	Get in a house in Sootopolis City	—
TM32	Double Team	Find on Route 113	—
TM33	Reflect	Buy in the Lilycove Department Store (4F)	10,000
TM34	Sludge Wave	Find on a shoal on Route 132	—
TM35	Flamethrower	Find on Victory Road	—
TM36	Sludge Bomb	Get from a Collector in Dewford Hall (need the Knuckle Badge)	—
TM37	Sandstorm	Find in the desert on Route 111 (need Go-Goggles)	—
TM38	Fire Blast	Buy in the Lilycove Department Store (4F)	30,000
TM39	Rock Tomb	Defeat Gym Leader Roxanne in Rustboro City	—
TM40	Aerial Ace	Buy from the upper clerk at the Mauville Poké Mart	10,000
TM41	Torment	Get from Sailor in Slateport's Contest Spectacular Hall	—
TM42	Facade	Buy from the upper clerk at the Mauville Poké Mart	10,000
TM43	Flame Charge	Find on Jagged Pass (need Acro Bike)	—

No.	Move	How to Obtain	Price
TM44	Rest	Get in a house in Lilycove City	—
TM45	Attract	Get from girl in Verdanturf's Contest Spectacular Hall	—
TM46	Thief	Get from Team Magma / Team Aqua Grunt in Slateport's Oceanic Museum	—
TM47	Low Sweep	Buy from the upper clerk at the Mauville Poké Mart	10,000
TM48	Round	Get in Crooner's Café on the west side of Mauville City	—
TM49	Echoed Voice	Get from a boy on Route 104	—
TM50	Overheat	Defeat Gym Leader Flannery in Lavaridge Town	—
TM51	Steel Wing	Get from Steven in Granite Cave	—
TM52	Focus Blast	Buy in the Lilycove Department Store (4F)	30,000
TM53	Energy Ball	Find in Safari Zone (need Surf and Bikes)	—
TM54	False Swipe	Get from man in Rustboro's Poké Mart	—
TM55	Scald	Find in Seafloor Cavern on Route 128 (need Surf and Dive)	—
TM56	Fling	Get in a house in Pacifidlog Town	—
TM57	Charge Beam	Buy from the upper clerk at the Mauville Poké Mart	10,000
TM58	Sky Drop	Get from a Delinquent in Mauville's Poké Mart	—
TM59	Incinerate	Find on Mt. Chimney	—
TM60	Quash	Get from a girl in the Mossdeep Poké Mart	—
TM61	Will-O-Wisp	Find on Mt. Pyre	—
TM62	Acrobatics	Find on Route 119 (need Surf and Waterfall)	—
TM63	Embargo	Receive from a Bug Maniac on the *S.S. Tidal*	—
TM64	Explosion	Find in the Sky Pillar (need Surf)	—
TM65	Shadow Claw	Find in Granite Cave's lower levels (need Acro Bike)	—
TM66	Payback	Find on Mirage Island #2	—
TM67	Retaliate	Defeat Gym Leader Norman in Petalburg City	—
TM68	Giga Impact	Buy in the Lilycove Department Store (4F)	50,000
TM69	Rock Polish	Find on Jagged Pass (need Acro Bike)	—
TM70	Flash	Get from a Hiker in Granite Cave	—
TM71	Stone Edge	Buy in the Lilycove Department Store (4F)	30,000
TM72	Volt Switch	Defeat Gym Leader Wattson in Mauville City	—
TM73	Thunder Wave	Buy at a stall in the Slateport Market	5,000
TM74	Gyro Ball	Find in Mirage Forest #8	—
TM75	Swords Dance	Get from a Black Belt in Lavaridge Town	—
TM76	Struggle Bug	Buy at a stall in the Slateport Market	5,000
TM77	Psych Up	Get from a Psychic on the upper part of Route 133	—
TM78	Bulldoze	Buy from the upper clerk at the Mauville Poké Mart	10,000
TM79	Frost Breath	Find in Shoal Cave on Route 125 at low tide (need Surf)	—
TM80	Rock Slide	Find on a shoal on Route 134	—
TM81	X-Scissor	Find on Victory Road	—
TM82	Dragon Tail	Buy from the upper clerk at the Mauville Poké Mart	10,000
TM83	Infestation	Get from Lisia's fan in Sootopolis	—
TM84	Poison Jab	Find on Mirage Mountain #2 (need Acro Bike)	—
TM85	Dream Eater	Get from a man in the entrance hall of the Safari Zone	—
TM86	Grass Knot	Find in Fortree City (need Devon Scope)	—
TM87	Swagger	Receive from a Lady in the Battle Resort's Pokémon Day Care in return for a loan	—
TM88	Sleep Talk	Get in a house in Lilycove City	—

No.	Move	How to Obtain	Price
TM89	U-turn	Find in Mauville Hills (need Rain Badge)	—
TM90	Substitute	Find on Mirage Island #5	—
TM91	Flash Cannon	Find on Mirage Island #8	—
TM92	Trick Room	Get as a reward in the Trick House	—
TM93	Wild Charge	Find in the Safari Zone (need Surf and Bikes)	—
TM94	Secret Power	Get from Aarune on Route 111	—
TM95	Snarl	Find in Mirage Cave #8	—
TM96	Nature Power	Get from Aarune in the Fiery Path (need the Heat Badge)	—
TM97	Dark Pulse	Find in Team Magma / Team Aqua Hideout (need Surf)	—
TM98	Power-Up Punch	Buy from the upper clerk at the Mauville Poké Mart	10,000
TM99	Dazzling Gleam	Get from a Fairy Tale Girl on Route 123	—
TM100	Confide	Buy at a stall in the Slateport Market	5,000

How to Obtain HMs

No.	Move	How to Obtain	Price
HM01	Cut	Get from a man in the Cutter's House in Rustboro City	—
HM02	Fly	Get from May/Brendan on Route 119	—
HM03	Surf	Get from Wally's father (need the Balance Badge)	—
HM04	Strength	Get from May/Brendan on Route 112	—
HM05	Waterfall	Defeat Gym Leader Wallace in Sootopolis City	—
HM06	Rock Smash	Get from Wally's uncle in Mauville City	—
HM07	Dive	Get from Steven in Mossdeep City (need the Mind Badge)	—

MOVE TUTORS

Other Places to Learn Moves around Hoenn

Location	Move	Restrictions
Move Reminder (Fallarbor Town)	Can teach Pokémon any move they can naturally learn by leveling up	Must have a Heart Scale to exchange
Pledge Move Dojo (Mauville City)	Fire Pledge / Grass Pledge / Water Pledge	Pokémon must be one that can be received from a professor and be friendly toward you
Song and Sword Move Academy (Mauville City)	Relic Song / Secret Sword	Relic Song can only be taught to Meloetta. Secret Sword can only be taught to Keldeo.
Ultimate Move Studio (Mauville City)	Blast Burn / Frenzy Plant / Hydro Cannon	Pokémon must be the final Evolution of one that can be received from a professor and be friendly toward you
Dragon-type Move Tutor (Sootopolis City)	Draco Meteor	Pokémon must be a Dragon type and be friendly toward you
Draconid Elder (Meteor Falls)	Dragon Ascent	Can only be taught to Rayquaza (must have completed Delta Episode)
Stand #1 at the Battle Resort	Electroweb / Gravity / Heal Bell / Magic Room / Stealth Rock / Tailwind / Wonder Room	Must enter Hall of Fame and have 8 BP to exchange
	Icy Wind	Must enter Hall of Fame and have 12 BP to exchange
Stand #2 at the Battle Resort	After You / Block / Gastro Acid / Helping Hand / Iron Defense / Magic Coat / Magnet Rise / Pain Split / Recycle / Role Play / Skill Swap / Snatch / Spite / Synthesis / Trick / Worry Seed	Must enter Hall of Fame and have 8 BP to exchange
Stand #3 at the Battle Resort	Bounce / Drill Run / Iron Head / Iron Tail / Uproar / Zen Headbutt	Must enter Hall of Fame and have 8 BP to exchange
	Aqua Tail / Dragon Pulse / Earth Power / Foul Play / Heat Wave / Hyper Voice / Last Resort / Seed Bomb	Must enter Hall of Fame and have 12 BP to exchange
	Focus Punch / Gunk Shot / Outrage / Sky Attack / Superpower	Must enter Hall of Fame and have 16 BP to exchange
Stand #4 at the Battle Resort	Bind / Bug Bite / Covet / Shock Wave / Snore / Water Pulse	Must enter Hall of Fame and have 4 BP to exchange
	Drain Punch / Fire Punch / Giga Drain / Ice Punch / Low Kick / Signal Beam / Thunder Punch	Must enter Hall of Fame and have 8 BP to exchange
	Dual Chop / Knock Off / Super Fang	Must enter Hall of Fame and have 12 BP to exchange
	Endeavor	Must enter Hall of Fame and have 16 BP to exchange

Where to Forget Moves in Hoenn

Location	Move	Restrictions
Move Deleter (Lilycove City)	Can delete any move, including HMs	—

POKÉMON ABILITIES

A

Ability	Effect in Battle	Effect when the Pokémon is the lead in your party
Adaptability	The power boost received by using a move of the same type as the Pokémon will be 100% instead of 50%.	—
Aerilate	Changes Normal-type moves to Flying type and increases their power by 30%.	—
Aftermath	Knocks off 1/4 of the attacking Pokémon's maximum HP when a direct attack causes the Pokémon to faint.	—
Analytic	The power of its move is increased by 30% when the Pokémon moves last.	—
Anger Point	Raises the Pokémon's Attack to the maximum when hit by a critical hit.	—
Anticipation	Warns if your opponent's Pokémon has supereffective moves or one-hit KO moves when the Pokémon enters battle.	—
Arena Trap	Prevents the opponent's Pokémon from fleeing or switching out. Ineffective against Flying-type Pokémon and Pokémon with the Levitate Ability.	Makes it easier to encounter wild Pokémon.

B

Ability	Effect in Battle	Effect when the Pokémon is the lead in your party
Battle Armor	Opposing Pokémon's moves will not hit critically.	—
Blaze	Raises the power of Fire-type moves by 50% when the Pokémon's HP drops to 1/3 or less.	—

C

Ability	Effect in Battle	Effect when the Pokémon is the lead in your party
Chlorophyll	Doubles Speed in the sunny or extremely harsh weather conditions.	—
Clear Body	Protects against stat-lowering moves and Abilities.	—
Cloud Nine	Eliminates effects of weather on Pokémon.	—
Color Change	Changes the Pokémon's type into the type of the move that just hit it.	—
Competitive	When an opponent's move or Ability lowers the Pokémon's stats, the Pokémon's Sp. Atk rises by 2.	—
Compound Eyes	Raises accuracy by 30%.	Raises encounter rate with wild Pokémon holding items.
Contrary	Makes stat changes have an opposite effect (increase instead of decrease and vice versa).	—
Cursed Body	Provides a 30% chance of inflicting Disable on the move the opponent used to hit the Pokémon. (Cannot use that move for three turns.)	—
Cute Charm	Provides a 30% chance of causing infatuation when hit with a direct attack.	Raises encounter rate of wild Pokémon of the opposite gender.

D

Ability	Effect in Battle	Effect when the Pokémon is the lead in your party
Damp	Prevents Pokémon on either side from using Explosion or Self-Destruct. Nullifies the Aftermath Ability.	—
Delta Stream	Makes the weather strong winds when the Pokémon enters battle. This weather makes Flying-type Pokémon receive half the damage from supereffective moves against them.	—
Desolate Land	Makes the weather extremely harsh sunlight when the Pokémon enters battle. This weather raises the power of Fire-type moves by 50%, reduces that of Water-type moves to zero, and prevents the Frozen status condition.	—
Drizzle	Makes the weather rain for five turns when the Pokémon enters battle. Does nothing when the weather is extremely harsh sunlight, heavy rain, or strong winds.	—
Drought	Makes the weather sunny for five turns when the Pokémon enters battle. Does nothing when the weather is extremely harsh sunlight, heavy rain, or strong winds.	—

E

Ability	Effect in Battle	Effect when the Pokémon is the lead in your party
Early Bird	Causes the Pokémon to wake quickly from the Sleep status condition.	—
Effect Spore	Provides a 30% chance of inflicting the Poison, Paralysis, or Sleep status conditions when hit with a direct attack. Grass-type Pokémon are immune to this effect.	—

F

Ability	Effect in Battle	Effect when the Pokémon is the lead in your party
Filter	Decreases the damage received from supereffective moves by 25%.	—
Flame Body	Provides a 30% chance of inflicting the Burned status condition when hit with a direct attack.	Facilitates hatching Eggs in your party.
Flash Fire	When the Pokémon is hit by a Fire-type move, rather than taking damage, its Fire-type moves increase power by 50%.	—
Forecast	Changes Castform's form and type. Sunny or extremely harsh weather conditions: changes to Fire type. Rain or heavy rain weather conditions: changes to Water type. Hail weather conditions: changes to Ice type.	—

Ability	Effect in Battle	Effect when the Pokémon is the lead in your party
Friend Guard	Reduces damage done to allies by 25%.	—
Frisk	Checks an opponent's held item when the Pokémon enters battle.	—

G

Ability	Effect in Battle	Effect when the Pokémon is the lead in your party
Gluttony	Allows the Pokémon to use its held Berry sooner when it has low HP.	—
Guts	Attack stat rises by 50% when the Pokémon is affected by a status condition.	—

H

Ability	Effect in Battle	Effect when the Pokémon is the lead in your party
Harvest	Provides at every turn end a 50% chance of restoring the Berry the Pokémon used, and a 100% chance when the weather conditions is sunny or extremely harsh sunlight.	—
Healer	At the end of every turn, it provides a 33% chance that an ally Pokémon's status condition will be healed.	—
Heavy Metal	Doubles the Pokémon's weight.	—
Huge Power	Doubles Attack.	—
Hustle	Raises Attack by 50%, but lowers the accuracy of the Pokémon's physical moves by 20%.	Makes it easier to encounter high-level wild Pokémon.
Hydration	Cures status conditions at the end of each turn during the rain or heavy rain weather conditions.	—
Hyper Cutter	Prevents Attack from being lowered.	—

I

Ability	Effect in Battle	Effect when the Pokémon is the lead in your party
Ice Body	Restores HP by 1/16 of the Pokémon's maximum HP at the end of every turn in the hail weather conditions rather than taking damage.	—
Illuminate	No effect.	Makes it easier to encounter wild Pokémon.
Immunity	Protects against the Poison status condition.	—
Infiltrator	Moves can hit ignoring the effects of Light Screen, Mist, Reflect, Safeguard, or Substitute.	—
Inner Focus	The Pokémon doesn't flinch as an additional effect of a move.	—
Insomnia	Protects against the Sleep status condition.	—
Intimidate	When this Pokémon enters battle, it lowers the opposing Pokémon's Attack by 1.	Lowers encounter rate with low-level wild Pokémon.
Iron Fist	Increases the power of Bullet Punch, Comet Punch, Dizzy Punch, Drain Punch, Dynamic Punch, Fire Punch, Focus Punch, Hammer Arm, Ice Punch, Mach Punch, Mega Punch, Meteor Mash, Power-Up Punch, Shadow Punch, Sky Uppercut, and Thunder Punch by 20%.	—

J

Ability	Effect in Battle	Effect when the Pokémon is the lead in your party
Justified	When the Pokémon is hit by a Dark-type move, Attack goes up by 1.	—

K

Ability	Effect in Battle	Effect when the Pokémon is the lead in your party
Keen Eye	Prevents accuracy from being lowered. Ignores evasiveness-raising moves.	Lowers encounter rate with low-level wild Pokémon.

L

Ability	Effect in Battle	Effect when the Pokémon is the lead in your party
Leaf Guard	Protects the Pokémon from status conditions when in the sunny or extremely harsh weather conditions.	—
Levitate	Gives full immunity from all Ground-type moves.	—
Light Metal	Halves the Pokémon's weight.	—
Lightning Rod	Draws all Electric-type moves to the Pokémon. When the Pokémon is hit by an Electric-type move, rather than taking damage, its Sp. Atk goes up by 1.	—
Liquid Ooze	When an opposing Pokémon uses an HP-draining move, it damages the user instead.	—

Ability	Effect in Battle	Effect when the Pokémon is the lead in your party
Magic Bounce	Reflects status moves that lower stats or inflict status conditions.	—
Magic Guard	The Pokémon will not take damage from anything other than indirect damage. Nullifies the Aftermath, Bad Dreams, Iron Barbs, Liquid Ooze, and Rough Skin Abilities, the hail and sandstorm weather conditions, and the Burned, Poison, and Badly Poisoned status conditions. The effects of Bind, Clamp, Curse, Fire Pledge, Fire Spin, Flame Burst, Infestation, Leech Seed, Magma Storm, Nightmare, Sand Tomb, Spikes, Stealth Rock, Whirlpool, and Wrap are negated, as are the item effects from Black Sludge, Life Orb, Rocky Helmet, and Sticky Barb. The Pokémon also receives no recoil or move-failure damage from attacks. Receives no damage from attacking a Pokémon that has used the Spiky Shield move or damage from using a Fire-type move after the Powder move has been used.	—
Magma Armor	Prevents the Frozen status condition.	Facilitates hatching Eggs in your party.
Magnet Pull	Prevents Steel-type opponents from fleeing or switching out.	Raises encounter rate with wild Steel-type Pokémon.
Marvel Scale	Defense stat increases by 50% when the Pokémon is affected by a status condition.	—
Mega Launcher	Raises the power of Aura Sphere, Dark Pulse, Dragon Pulse, Origin Pulse, and Water Pulse by 50%. Heal Pulse will restore 75% of the target's maximum HP.	—
Minus	Raises Sp. Atk by 50% when another ally has the Ability Plus or Minus.	—
Mold Breaker	Allows the Pokémon to use moves on targets regardless of their Abilities. Does not nullify Abilities that have effects after an attack. For example, the Pokémon can score a critical hit against a target with Battle Armor, but it will still take damage from Rough Skin.	—
Moody	Raises one stat by 2 and lowers another by 1 at the end of every turn.	—
Moxie	When the Pokémon knocks out an opponent with a move, Attack goes up 1.	—

Ability	Effect in Battle	Effect when the Pokémon is the lead in your party
Natural Cure	Cures the Pokémon's status conditions when it switches out.	—
No Guard	Moves used by or against the Pokémon always strike their targets.	Makes it easier to encounter wild Pokémon.
Normalize	Changes all of the Pokémon's moves to Normal-type.	—

Ability	Effect in Battle	Effect when the Pokémon is the lead in your party
Oblivious	Protects against infatuation. Immune to Captivate and Taunt.	—
Overcoat	Protects the Pokémon from weather damage, such as hail and sandstorm. Protects it from Cotton Spore, Poison Powder, Powder, Rage Powder, Sleep Powder, Spore, and Stun Spore. Immune to the Effect Spore Ability.	—
Overgrow	Raises the power of Grass-type moves by 50% when the Pokémon's HP drops to 1/3 or less.	—
Own Tempo	Protects against confusion.	—

Ability	Effect in Battle	Effect when the Pokémon is the lead in your party
Parental Bond	Causes attacks to strike twice, with the second hit dealing only half the normal damage. Does not affect moves that naturally strike multiple times or moves that strike multiple targets.	—
Pickpocket	Steals an item when hit with a direct attack. It fails if the Pokémon is already holding an item.	—
Pickup	At the end of every turn, the Pokémon picks up the item that the opposing Pokémon used that turn. Fails if the Pokémon is already holding an item.	If the Pokémon has no held item, it sometimes picks one up after battle (even if it didn't participate). It picks up different items depending on its level.
Pixilate	Changes Normal-type moves to Fairy type and increases their power by 30%	—
Plus	Raises Sp. Atk by 50% when another ally has the Ability Plus or Minus.	—
Poison Heal	Restores 1/8 of the Pokémon's maximum HP at the end of every turn if the Pokémon has the Poison or Badly Poisoned status condition rather than taking damage.	—
Poison Point	Provides a 30% chance of inflicting the Poison status condition when the Pokémon is hit by a direct attack.	—
Poison Touch	Provides a 30% chance of inflicting the Poison status condition when the Pokémon uses a direct attack.	—
Prankster	Gives priority to status moves.	—
Pressure	When the Pokémon is hit by an opponent's move, it depletes 1 additional PP from that move.	Makes it easier to encounter high-level wild Pokémon.
Primordial Sea	Makes the weather heavy rain when the Pokémon enters battle. This weather raises the power of Water-type moves by 50% and reduces that of Fire-type moves to zero.	—
Protean	Changes the Pokémon's type to the same type as the move it has just used.	—
Pure Power	Doubles its Attack stat.	—

TRAINER HANDBOOK

ADVANCED HANDBOOK

ADVENTURE DATA

Q

Ability	Effect in Battle	Effect when the Pokémon is the lead in your party
Quick Feet	Increases Speed by 50% when the Pokémon is affected by status conditions.	Lowers wild Pokémon encounter rate.

R

Ability	Effect in Battle	Effect when the Pokémon is the lead in your party
Rain Dish	Restores HP by 1/16 of the Pokémon's maximum HP at the end of every turn in the rain or heavy rain weather conditions.	—
Rattled	When the Pokémon is hit by a Ghost-, Dark-, or Bug-type move, Speed goes up by 1.	—
Reckless	Raises the power of moves by 20% with recoil damage.	—
Refrigerate	Changes Normal-type moves to Ice type and increases their power by 30%.	—
Regenerator	Restores 1/3 its maximum HP when withdrawn from battle.	—
Rivalry	If the target is the same gender, the Pokémon's Attack goes up by 25%. If the target is of the opposite gender, its Attack goes down by 25%. No effect when the gender is unknown.	
Rock Head	No recoil damage from moves like Take Down and Double-Edge.	—
Rough Skin	Knocks off 1/8 of the attacking Pokémon's maximum HP when the Pokémon makes a direct attack.	—
Run Away	Allows the Pokémon to always escape from a battle with a wild Pokémon.	

S

Ability	Effect in Battle	Effect when the Pokémon is the lead in your party
Sand Force	Raises the power of Ground-, Rock-, and Steel-type moves by 30% in the sandstorm weather conditions. Sandstorm does not damage the Pokémon.	
Sand Rush	Doubles Speed in the sandstorm weather conditions. Sandstorm does not damage the Pokémon.	—
Sand Stream	Makes the weather sandstorm for five turns when the Pokémon enters battle. Rock-type Pokémon's Sp. Def increases by 50% and Pokémon other than Rock, Steel, and Ground types take damage of 1/16 of the Pokémon's maximum HP during the weather sandstorm. Does nothing when the weather is extremely harsh sunlight, heavy rain, or strong winds.	—
Sand Veil	The accuracy of the opposing Pokémon's move decreases by 20% in the sandstorm weather conditions. Sandstorm does not damage the Pokémon with this Ability.	Lowers encounter rate with wild Pokémon in the sandstorm weather conditions.
Sap Sipper	When the Pokémon is hit by a Grass-type move, rather than taking damage, its Attack goes up by 1.	—
Scrappy	Allows the Pokémon to hit Ghost-type Pokémon with Normal- and Fighting-type moves. (The type matchup changes from "It's not very effective..." to normal.)	
Shadow Tag	Prevents the opposing Pokémon from fleeing or switching out. If both your and the opposing Pokémon have this Ability, the effect is canceled. Does not affect Ghost types.	—
Shed Skin	At the end of every turn, provides a 33% chance of curing the Pokémon's status conditions.	—
Sheer Force	When moves with an additional effect are used, power increases by 30%, but the additional effect is lost.	—
Shell Armor	Opposing Pokémon's moves will not hit critically.	—
Shield Dust	Protects the Pokémon from additional effects of moves.	—
Simple	Doubles the effects of stat changes.	—
Skill Link	Moves that strike successively strike the maximum number of times (2-5 times means it always strikes 5 times).	—
Sniper	Moves that deliver a critical hit deal 125% more damage.	—
Snow Cloak	The accuracy of the opposing Pokémon's move decreases by 20% in the hail weather conditions. Hail does not damage Pokémon with this Ability.	Lowers encounter rate with wild Pokémon in the hail weather conditions.
Snow Warning	Makes the weather hail for five turns when the Pokémon enters battle. Pokémon other than Ice types take damage of 1/16 of the Pokémon's maximum HP during the weather hail. Does nothing when the weather is extremely harsh sunlight, heavy rain, or strong winds.	
Solar Power	Raises Sp. Atk by 50%, but takes damage of 1/8 of the Pokémon's maximum HP at the end of every turn in the sunny or extremely harsh weather conditions.	—
Solid Rock	Decreases the damage received from supereffective moves by 25%.	
Soundproof	Protects the Pokémon from sound-based moves: Boomburst, Bug Buzz, Chatter, Confide, Disarming Voice, Echoed Voice, Grass Whistle, Growl, Heal Bell, Hyper Voice, Metal Sound, Noble Roar, Parting Shot, Perish Song, Roar, Round, Screech, Sing, Snarl, Snore, Supersonic, and Uproar.	—
Speed Boost	Raises Speed by 1 at the end of every turn.	—
Stall	The Pokémon's moves are used last in the turn.	—
Static	A 30% chance of inflicting the Paralysis status condition when hit with a direct attack.	Raises encounter rate with wild Electric-type Pokémon.
Steadfast	Raises Speed by 1 every time the Pokémon flinches.	—
Stench	Has a 10% chance of making the target flinch when the Pokémon uses a move to deal damage.	Lowers wild Pokémon encounter rate.
Sticky Hold	Prevents the Pokémon's held item from being stolen.	Makes Pokémon bite more often when fishing.

Ability	Effect in Battle	Effect when the Pokémon is the lead in your party
Storm Drain	Draws all Water-type moves to the Pokémon. When the Pokémon is hit by a Water-type move, rather than taking damage, Sp. Atk goes up by 1.	—
Sturdy	Protects the Pokémon against one-hit KO moves like Horn Drill and Sheer Cold. Leaves the Pokémon with 1 HP if hit by a move that would knock it out when its HP is full.	—
Suction Cups	Nullifies moves like Dragon Tail, Roar, and Whirlwind, which would force Pokémon to switch out.	Makes Pokémon bite more often when fishing.
Super Luck	Heightens the critical-hit ratio of the Pokémon's moves.	—
Swarm	Raises the power of Bug-type moves by 50% when the Pokémon's HP drops to 1/3 or less.	—
Swift Swim	Doubles Speed in the rain or heavy rain weather conditions.	—
Synchronize	When the Pokémon receives the Poison, Paralysis, or Burned status condition, this inflicts the same condition.	Raises encounter rate with wild Pokémon with the same Nature.

T

Ability	Effect in Battle	Effect when the Pokémon is the lead in your party
Tangled Feet	Raises evasion when the Pokémon has the Confused status condition.	—
Technician	If the move's power is 60 or less, its power will increase by 50%. Also takes effect if a move's power is altered by itself or by another move.	—
Telepathy	Prevents damage from allies.	—
Thick Fat	Halves damage from Fire- and Ice-type moves.	—
Tinted Lens	Nullifies the type disadvantage of the Pokémon's not-very-effective moves: 1/2 damage turns into regular damage, 1/4 damage turns into 1/2 damage.	—
Torrent	Raises the power of Water-type moves by 50% when the Pokémon's HP drops to 1/3 or less.	—
Tough Claws	Raises the power of direct attacks by 30%.	—
Toxic Boost	Increases the power of physical moves by 50% when it has the Poison or Badly Poisoned status condition.	—
Trace	Makes the Pokémon's Ability the same as the opponent's, except for certain Abilities like Trace.	—
Truant	Allows the Pokémon to use a move only once every other turn.	—

U

Ability	Effect in Battle	Effect when the Pokémon is the lead in your party
Unburden	Doubles Speed if the Pokémon loses or consumes a held item. Its Speed returns to normal if the Pokémon holds another item. No effect if the Pokémon starts out with no held item.	—
Unnerve	Prevent the opposing Pokémon from eating Berries.	—

V

Ability	Effect in Battle	Effect when the Pokémon is the lead in your party
Vital Spirit	Protects against the Sleep status condition.	Makes it easier to encounter high-level wild Pokémon.
Volt Absorb	When the Pokémon is hit by an Electric-type move, HP is restored by 25% of its maximum HP rather than taking damage.	—

W

Ability	Effect in Battle	Effect when the Pokémon is the lead in your party
Water Absorb	When the Pokémon is hit by a Water-type move, HP is restored by 25% of its maximum HP rather than taking damage.	—
Water Veil	Prevents the Burned status condition.	—
Weak Armor	When the Pokémon is hit by a physical attack, Defense goes down by 1, but Speed goes up by 1.	—
White Smoke	Protects against stat-lowering moves and Abilities.	Lowers wild Pokémon encounter rate.
Wonder Guard	Protects the Pokémon against all moves except supereffective ones.	—
Wonder Skin	Makes status moves more likely to miss.	—

POKÉMON'S NATURES & CHARACTERISTICS

Pokémon's Natures

Each individual Pokémon has a Nature, which affects how its stats grow when it levels up. Most Natures will cause one stat to increase more quickly and one stat to increase more slowly than others. A few Natures, however, provide no benefit and no liability.

Nature	ATK	DEF	SP. ATK	SP. DEF	SPD
Adamant	○		▲		
Bashful					
Bold	▲	○			
Brave	○				▲
Calm	▲			○	
Careful			▲	○	
Docile					
Gentle		▲		○	
Hardy					
Hasty		▲			○
Impish		○	▲		
Jolly			▲		○
Lax		○		▲	
Lonely	○	▲			
Mild		▲	○		
Modest	▲		○		
Naive				▲	○
Naughty	○			▲	
Quiet			○		▲
Quirky					
Rash			○	▲	
Relaxed		○			▲
Sassy				○	▲
Serious					
Timid	▲				○

○ Gains more upon leveling up
▲ Gains less upon leveling up

Pokémon's Characteristics

On top of having a Nature, each individual Pokémon has a Characteristic. This also affects how the Pokémon's stats grow when it levels up. Every Characteristic will make one stat increase more quickly than average.

Stat that grows easily	Characteristic
HP	Loves to eat.
	Takes plenty of siestas.
	Nods off a lot.
	Scatters things often.
	Likes to relax.
ATTACK	Proud of its power.
	Likes to thrash about.
	A little quick tempered.
	Likes to fight.
	Quick tempered.
DEFENSE	Sturdy body.
	Capable of taking hits.
	Highly persistent.
	Good endurance.
	Good perseverance.
SP. ATK	Highly curious.
	Mischievous.
	Thoroughly cunning.
	Often lost in thought.
	Very finicky.
SP. DEF	Strong willed.
	Somewhat vain.
	Strongly defiant.
	Hates to lose.
	Somewhat stubborn.
SPEED	Likes to run.
	Alert to sounds.
	Impetuous and silly.
	Somewhat of a clown.
	Quick to flee.

Base Stats Raised through Defeating Wild Pokémon in Hoenn

National Pokédex No.	Hoenn Pokédex No.	Pokémon	HP	ATTACK	DEFENSE	SP. ATK	SP. DEF	SPEED
14	—	Kakuna	—	—	○	—	—	—
17	—	Pidgeotto	—	—	—	—	—	○
19	—	Rattata	—	—	—	—	—	○
20	—	Raticate	—	—	—	—	—	○
25	163	Pikachu	—	—	—	—	—	○
27	117	Sandshrew	—	—	○	—	—	—
35	—	Clefairy	○	—	—	—	—	—
37	160	Vulpix	—	—	—	—	—	○
39	143	Jigglypuff	○	—	—	—	—	—
41	65	Zubat	—	—	—	—	—	○
42	66	Golbat	—	—	—	—	—	○
43	91	Oddish	—	—	—	○	—	—
44	92	Gloom	—	—	—	○	—	—
46	—	Paras	—	○	—	—	—	—
49	—	Venomoth	—	—	—	—	—	○
50	—	Diglett	—	—	—	—	—	○
53	—	Persian	—	—	—	—	—	○
54	165	Psyduck	—	—	—	○	—	—
56	—	Mankey	—	○	—	—	—	—
58	—	Growlithe	—	○	—	—	—	—
63	40	Abra	—	—	—	○	—	—
66	75	Machop	—	○	—	—	—	—
72	68	Tentacool	—	—	—	—	○	—
73	69	Tentacruel	—	—	—	—	○	—
74	58	Geodude	—	—	○	—	—	—
75	59	Graveler	—	—	○	—	—	—
77	—	Ponyta	—	—	—	—	—	○
79	—	Slowpoke	○	—	—	—	—	—
81	84	Magnemite	—	—	—	○	—	—
84	95	Doduo	—	○	—	—	—	—
86	—	Seel	—	—	—	—	○	—
87	—	Dewgong	—	—	—	—	○	—
88	111	Grimer	○	—	—	—	—	—
95	—	Onix	—	—	○	—	—	—
97	—	Hypno	—	—	—	—	○	—
98	—	Krabby	—	○	—	—	—	—
100	87	Voltorb	—	—	—	—	—	○
109	113	Koffing	—	—	○	—	—	—
111	176	Rhyhorn	—	—	○	—	—	—
114	—	Tangela	—	—	○	—	—	—
116	193	Horsea	—	—	—	○	—	—
117	194	Seadra	—	—	○	○	—	—
118	51	Goldeen	—	○	—	—	—	—
119	52	Seaking	—	○	—	—	—	—
120	148	Staryu	—	—	—	—	—	○
127	174	Pinsir	—	○	—	—	—	—
129	53	Magikarp	—	—	—	—	—	○
130	54	Gyarados	—	○	—	—	—	—
132	—	Ditto	○	—	—	—	—	—
133	—	Eevee	—	—	—	—	○	—
137	—	Porygon	—	—	—	○	—	—
168	—	Ariados	—	○	—	—	—	—
170	190	Chinchou	○	—	—	—	—	—
171	191	Lanturn	○	—	—	—	—	—
178	170	Xatu	—	—	—	○	—	○
183	56	Marill	○	—	—	—	—	—
184	57	Azumarill	○	—	—	—	—	—
190	—	Aipom	—	—	—	—	—	○
191	—	Sunkern	—	—	—	○	—	—
198	—	Murkrow	—	—	—	—	—	○
200	—	Misdreavus	—	—	—	—	○	—
201	—	Unown	—	○	—	—	—	—
202	168	Wobbuffet	○	—	—	—	—	—
203	171	Girafarig	—	—	—	○	—	—
205	—	Forretress	—	—	○	—	—	—
214	175	Heracross	—	○	—	—	—	—
218	108	Slugma	—	—	—	○	—	—
222	189	Corsola	—	—	○	—	○	—
223	—	Remoraid	—	—	—	○	—	—
224	—	Octillery	—	○	—	○	—	—
225	—	Delibird	—	—	—	—	—	○
226	—	Mantine	—	—	—	—	○	—
227	120	Skarmory	—	—	○	—	—	—
232	173	Donphan	—	—	○	—	—	—
234	—	Stantler	—	○	—	—	—	—
236	—	Tyrogue	—	○	—	—	—	—
239	—	Elekid	—	—	—	—	—	○
240	—	Magby	—	—	—	—	—	○
261	10	Poochyena	—	○	—	—	—	—
263	12	Zigzagoon	—	—	—	—	—	○
264	13	Linoone	—	—	—	—	—	○
265	14	Wurmple	○	—	—	—	—	—
266	15	Silcoon	—	—	○	—	—	—
268	17	Cascoon	—	—	○	—	—	—
270	19	Lotad	—	—	—	○	—	—
271	20	Lombre	—	—	—	—	○	—
273	22	Seedot	—	—	—	—	○	—
274	23	Nuzleaf	—	○	—	—	—	—
276	25	Taillow	—	—	—	—	—	○
278	27	Wingull	—	—	—	—	—	○
279	28	Pelipper	—	—	—	○	—	—
280	29	Ralts	—	—	—	○	—	—
283	33	Surskit	—	—	—	—	—	○
284	34	Masquerain	—	—	—	○	○	—
285	35	Shroomish	○	—	—	—	—	—
287	37	Slakoth	○	—	—	—	—	—
290	43	Nincada	○	—	—	—	—	—
293	46	Whismur	○	—	—	—	—	—
294	47	Loudred	○	—	—	—	—	—
296	49	Makuhita	○	—	—	—	—	—
297	50	Hariyama	○	—	—	—	—	—
299	61	Nosepass	—	—	○	—	—	—
300	63	Skitty	—	—	—	—	—	○
302	70	Sableye	—	○	○	—	—	—
303	71	Mawile	—	○	○	—	—	—
304	72	Aron	—	—	○	—	—	—
305	73	Lairon	—	—	○	—	—	—
307	78	Meditite	—	—	—	—	—	○
308	79	Medicham	—	—	—	—	—	○
309	80	Electrike	—	—	—	—	—	○
311	82	Plusle	—	—	—	—	—	○
312	83	Minun	—	—	—	—	—	○
313	89	Volbeat	—	—	—	—	—	○
314	90	Illumise	—	—	—	—	—	○
315	98	Roselia	—	—	—	○	○	—
316	100	Gulpin	○	—	—	—	—	—
318	102	Carvanha	—	○	—	—	—	—
319	103	Sharpedo	—	○	—	—	—	—
320	104	Wailmer	○	—	—	—	—	—
322	106	Numel	—	—	—	○	—	—
324	110	Torkoal	—	—	○	—	—	—
325	115	Spoink	—	—	—	—	○	—
327	119	Spinda	—	—	—	—	—	—
328	121	Trapinch	—	○	—	—	—	—
331	124	Cacnea	—	—	—	○	—	—
333	126	Swablu	—	—	—	—	○	—
335	128	Zangoose	—	○	—	—	—	—
336	129	Seviper	—	○	—	○	—	—
337	130	Lunatone	—	—	—	○	—	—
338	131	Solrock	—	○	—	—	—	—
339	132	Barboach	○	—	—	—	—	—
340	133	Whiscash	○	—	—	—	—	—
341	134	Corphish	—	○	—	—	—	—
342	135	Crawdaunt	—	○	—	—	—	—

National Pokédex No.	Hoenn Pokédex No.	Pokémon	HP	ATTACK	DEFENSE	SP. ATK	SP. DEF	SPEED
343	136	Baltoy	—	—	—	—	○	—
344	137	Claydol	—	—	—	—	○	—
349	145	Feebas	—	—	—	—	—	○
352	150	Kecleon	—	—	—	—	○	—
353	151	Shuppet	—	○	—	—	—	—
355	153	Duskull	—	—	—	—	○	—
357	156	Tropius	○	—	—	—	—	—
358	158	Chimecho	—	—	—	○	○	—
359	159	Absol	—	○	—	—	—	—
361	179	Snorunt	○	—	—	—	—	—
363	182	Spheal	○	—	—	—	—	—
364	183	Sealeo	○	—	—	—	—	—
366	185	Clamperl	—	—	○	—	—	—
369	188	Relicanth	○	—	○	—	—	—
370	192	Luvdisc	—	—	—	—	—	○
371	196	Bagon	—	○	—	—	—	—
402	—	Kricketune	—	○	—	—	—	—
404	—	Luxio	—	○	—	—	—	—
421	—	Cherrim	—	—	—	—	○	—
422	—	Shellos	○	—	—	—	—	—
425	—	Drifloon	○	—	—	—	—	—
427	—	Buneary	—	—	—	—	—	○
431	—	Glameow	—	—	—	—	—	○
432	—	Purugly	—	—	—	—	—	○
436	—	Bronzor	—	—	○	—	—	—
440	—	Happiny	○	—	—	—	—	—
441	—	Chatot	—	○	—	—	—	—
443	—	Gible	—	○	—	—	—	—
451	—	Skorupi	—	—	○	—	—	—
456	—	Finneon	—	—	—	—	—	○
458	—	Mantyke	—	—	—	—	○	—
506	—	Lillipup	—	○	—	—	—	—
517	—	Munna	○	—	—	—	—	—
519	—	Pidove	—	○	—	—	—	—
523	—	Zebstrika	—	—	—	—	—	○
524	—	Roggenrola	—	—	○	—	—	—
525	—	Boldore	—	○	—	—	—	—
530	—	Excadrill	—	○	—	—	—	—
531	—	Audino	○	—	—	—	—	—

National Pokédex No.	Hoenn Pokédex No.	Pokémon	HP	ATTACK	DEFENSE	SP. ATK	SP. DEF	SPEED
532	—	Timburr	—	○	—	—	—	—
535	—	Tympole	—	—	—	—	—	○
538	—	Throh	○	—	—	—	—	—
539	—	Sawk	—	○	—	—	—	—
540	—	Sewaddle	—	—	○	—	—	—
546	—	Cottonee	—	—	—	—	—	○
548	—	Petilil	—	—	—	○	—	—
551	—	Sandile	—	○	—	—	—	—
555	—	Darmanitan	—	○	—	—	—	—
556	—	Maractus	—	—	—	○	—	—
557	—	Dwebble	—	—	○	—	—	—
558	—	Crustle	—	—	○	—	—	—
559	—	Scraggy	—	○	—	—	—	—
563	—	Cofagrigus	—	—	○	—	—	—
568	—	Trubbish	—	—	—	—	—	○
570	—	Zorua	—	—	—	○	—	—
572	—	Minccino	—	—	—	—	—	○
574	—	Gothita	—	—	—	—	○	—
585	—	Deerling	—	—	—	—	—	○
592	—	Frillish	—	—	—	—	○	—
594	—	Alomomola	○	—	—	—	—	—
595	—	Joltik	—	—	—	—	—	○
599	—	Klink	—	—	○	—	—	—
602	—	Tynamo	—	—	—	—	—	○
605	—	Elgyem	—	—	—	○	—	—
610	—	Axew	—	○	—	—	—	—
613	—	Cubchoo	—	○	—	—	—	—
621	—	Druddigon	—	○	—	—	—	—
626	—	Bouffalant	—	○	—	—	—	—
627	—	Rufflet	—	○	—	—	—	—
628	—	Braviary	—	○	—	—	—	—
629	—	Vullaby	—	—	○	—	—	—
633	—	Deino	—	○	—	—	—	—
636	—	Larvesta	—	○	—	—	—	—
688	—	Binacle	—	○	—	—	—	—
690	—	Skrelp	—	—	—	—	○	—
692	—	Clauncher	—	—	—	○	—	—
707	—	Klefki	—	—	○	—	—	—
708	—	Phantump	—	○	—	—	—	—

Suggestions of Hordes of Pokémon to Battle for Great Base Stat Increases

If you want to raise your base stats most efficiently through wild Pokémon encounters, use the Sweet Scent move (or the item Honey) to attract Hordes of Pokémon that raise the base stat you are most interested in. Below are suggestions of Pokémon that appear commonly in hordes, and where they horde, for quick 5x base stat gains!

Base Stat	Pokémon	Where they appear in Hordes
HP	Whismur	Rusturf Tunnel
Attack	Shuppet	Mt. Pyre
Defense	Sandshrew	Route 111 (Central Desert)
Sp. Atk	Oddish	Route 119
Sp. Def	Swablu	Route 114 / Route 115
Speed	Zubat	Meteor Falls

ITEMS

A

	Item	Description	How to obtain	Price
	Ability Capsule	Allows a Pokémon with two Abilities (excluding Hidden Abilities) to switch between these Abilities.	Get for 200 BP in the Battle Maison in the Battle Resort	—
	Abomasite	When held, it allows Abomasnow to Mega Evolve into Mega Abomasnow during battle.	Berry fields on Route 123 after obtaining the National Pokédex	—
	Absolite	When held, it allows Absol to Mega Evolve into Mega Absol during battle.	Safari Zone	—
	Absorb Bulb	Raises the holder's Sp. Atk by 1 when it is hit by a Water-type move. It goes away after use.	Get for 32 BP in the Battle Maison in the Battle Resort / Sometimes held by wild Gloom or Oddish	—
	Adamant Orb	When held by Dialga, it boosts the power of Dragon-and Steel-type moves by 20%.	Route 128 (underwater)	—
	Aerodactylite	When held, it allows Aerodactyl to Mega Evolve into Mega Aerodactyl during battle.	Meteor Falls after obtaining the National Pokédex	—
	Aggronite	When held, it allows Aggron to Mega Evolve into Mega Aggron during battle.	Receive from Wanda's boyfriend after smashing rocks in Rusturf Tunnel	—
	Air Balloon	The holder floats and Ground-type moves will no longer hit the holder. The balloon pops when the holder is hit by an attack.	Get for 48 BP in the Battle Maison in the Battle Resort	—
	Alakazite	When held, it allows Alakazam to Mega Evolve into Mega Alakazam during battle.	Slateport Market in Slateport	—
	Altarianite	When held, it allows Altaria to Mega Evolve into Mega Altaria during battle.	Receive from a man in Lilycove City by answering "Altaria" when you have Altaria in your party	—
	Ampharosite	When held, it allows Ampharos to Mega Evolve into Mega Ampharos during battle.	New Mauville after obtaining the National Pokédex	—
	Amulet Coin	Doubles the prize money from a battle if the Pokémon holding it joins in.	Receive from your mom in your house after obtaining the Petalburg Gym Badge	—
	Antidote	Cures the Poison status condition.	Buy at Poké Marts after receiving Poké Balls from May/Brendan in Littleroot Town	100
	Armor Fossil	A Pokémon Fossil. When restored, it becomes Shieldon.	Can be obtained by breaking cracked rocks using Rock Smash in Mirage spots (*Pokémon Omega Ruby*)	—
	Assault Vest	Raises Sp. Def when held by 50%, but prevents the use of status moves.	Get for 48 BP in the Battle Maison in the Battle Resort	—
	Audinite	When held, it allows Audino to Mega Evolve into Mega Audino during battle.	Receive from Looker in the Battle Resort	—
	Awakening	Cures the Sleep status condition.	Buy at Poké Marts (after obtaining first Gym Badge)	250

B

	Item	Description	How to obtain	Price
	Balm Mushroom	A fragrant mushroom. It can be sold at shops for 6,250.	Petalburg Woods (using Dowsing Machine)	—
	Banettite	When held, it allows Banette to Mega Evolve into Mega Banette during battle.	The summit of Mt. Pyre	—
	Beedrillite	When held, it allows Beedrill to Mega Evolve into Mega Beedrill during battle.	Sea Mauville (Storage)	—
	Berry Juice	Restores the HP of one Pokémon by 20 points.	Get for 10 Poké Miles at the PokéMileage Center in Mauville City	—
	Big Mushroom	A big mushroom. It can be sold at shops for 2,500.	Win the Whismur Show in Battle Resort / Sometimes held by wild Paras or Shroomish	—
	Big Nugget	A big nugget of pure gold. It can be sold at shops for 10,000.	Sea Mauville (Storage) / Win in the Mauville Food Court when you order Mauville Ramen Bowl	—
	Big Pearl	A big pearl. It can be sold at shops for 3,750.	Route 109 / Safari Zone / Route 125 / Shoal Cave at high tide/ Sometimes held by wild Clamperl	—
	Big Root	When the holder uses an HP-draining move, it increases the amount of HP recovered by 30%.	Receive from a girl on Route 123 when you have a Grass-type Pokémon in your party	—
	Binding Band	When held, the damage done to a target by moves like Bind or Wrap will be 1/6 of the target's maximum HP every turn.	Get for 48 BP in the Battle Maison in the Battle Resort	—
	Black Belt	When held by a Pokémon, it boosts the power of Fighting-type moves by 20%.	Sometimes held by wild Makuhita, Sawk, or Throh	—
	Black Flute	Makes it easier to encounter strong Pokémon.	Receive from a guy in the Glass Workshop on Route 113 in exchange for collected ash (1,000g)	—
	Black Glasses	When held by a Pokémon, it boosts the power of Dark-type moves by 20%.	Route 116 (using the Dowsing Machine) and speak to a man who's looking for glasses	—
	Black Sludge	If the holder is a Poison-type Pokémon, it restores 1/16 of its maximum HP every turn. If the holder is any other type, it loses 1/8 of its maximum HP every turn.	Sometimes held by wild Grimer or Trubbish	—
	Blastoisinite	When held, it allows Blastoise to Mega Evolve into Mega Blastoise during battle.	*S.S. Tidal*	—
	Blazikenite	When held, it allows Blaziken to Mega Evolve into Mega Blaziken during battle.	Receive from Steven on Route 120 if you chose Torchic as your first Pokémon / Otherwise buy the stone titled "Fading Fire" on Route 114	1,500
	Blue Flute	Awakens sleeping Pokémon.	Receive from a guy in the Glass Workshop on Route 113 in exchange for collected ash (250g)	—
	Blue Orb	A shiny blue orb that is said to have a legend tied to it. It's known to have a deep connection with the Hoenn region.	Receive from an old woman at the summit of Mt. Pyre (*Pokémon Omega Ruby*) / Receive from Archie in the Cave of Origin (*Pokémon Alpha Sapphire*)	—

Item	Description	How to obtain	Price
Blue Scarf	When held by a Pokémon, it raises the Beauty aspect of the Pokémon in a Contest Spectacular.	Receive from the chairman of the Pokémon Fan Club in Slateport City when your lead Pokémon has the max Beauty stat	—
Blue Shard	A Shard you can trade for a Water Stone with the Treasure Hunter on Route 124.	Route 124	—
Bright Powder	Boosts the holder's evasion.	Sometimes held by wild Illumise, Volbeat, or Wurmple / Get for 48 BP in the Battle Maison in the Battle Resort	—
Burn Drive	When held by Genesect, it changes Genesect's Techno Blast move so it becomes Fire type.	Receive from a Street Thug standing near the stairs to the top of Mauville City when you have Genesect in your party	—
Burn Heal	Cures the Burned status condition.	Buy at Poké Marts (after obtaining first Gym Badge)	250

C

Item	Description	How to obtain	Price
Calcium	Raises the base Sp. Atk stat of a Pokémon.	Buy from the Energy Guru in Slateport Market / Lilycove Department Store (3F)	9,800
Cameruptite	When held, it allows Camerupt to Mega Evolve into Mega Camerupt during battle.	Receive from Team Magma during the Delta Episode (*Pokémon Omega Ruby*) / Receive from Team Magma in the Battle Resort (*Pokémon Alpha Sapphire*)	—
Carbos	Raises the base Speed stat of a Pokémon.	Buy from the Energy Guru in Slateport Market / Lilycove Department Store (3F)	9,800
Casteliacone	Heals all the status problems and confusion of a single Pokémon.	4th maze in the Trick House on Route 110 / Buy from a girl in Apt. 14 in Mauville Hills when you have Regice in your party	200
Cell Battery	Increases Attack by 1 when the holder is hit with Electric-type moves. It goes away after use.	Sometimes held by wild Minun or Plusle / Get for 32 BP in the Battle Maison in the Battle Resort	—
Charcoal	When held by a Pokémon, it boosts the power of Fire-type moves by 20%.	Receive from an old man in the Pokémon Herb Shop in Lavaridge Town / Sometimes held by wild Torkoal or Vulpix	—
Charizardite X	When held, it allows Charizard to Mega Evolve into Mega Charizard X during battle.	Fiery Path after obtaining the National Pokédex	—
Charizardite Y	When held, it allows Charizard to Mega Evolve into Mega Charizard Y during battle.	Scorched Slab (B2F) on Route 120 after obtaining the National Pokédex	—
Chill Drive	When held by Genesect, it changes Genesect's Techno Blast move so it becomes Ice type.	Receive from a Street Thug standing near the stairs to the top of Mauville City when you have Genesect in your party	—
Choice Band	The holder can use only one of its moves, but the power of physical moves increases by 50%.	Get for 48 BP in the Battle Maison in the Battle Resort	—
Choice Scarf	The holder can use only one of its moves, but Speed increases by 50%.	Get for 48 BP in the Battle Maison in the Battle Resort	—
Choice Specs	The holder can use only one of its moves, but the power of special moves increases by 50%.	Get for 48 BP in the Battle Maison in the Battle Resort	—
Claw Fossil	A Pokémon Fossil. When restored, it becomes Anorith.	Route 111 (Select either Root Fossil or Claw Fossil)	—
Cleanse Tag	Helps keep wild Pokémon away if the holder is the first one in the party.	Receive from an old woman on Mt. Pyre (1F) / Sometimes held by wild Chimecho	—
Clever Wing	Slightly increases the base Sp. Def stat of a single Pokémon. It can be used until the max of base stats.	Can be won by reaching Beginner Rank, Novice Rank, or Normal Rank in the Battle Institute in Mauville City	—
Comet Shard	A shard that fell to the ground when a comet approached. It can be sold at shops for 15,000.	Route 114 using Dowsing Machine / Receive from your fan in the Trainer Fan Club	—
Cover Fossil	A Pokémon Fossil. When restored, it becomes Tirtouga.	Can be obtained by breaking cracked rocks using Rock Smash in Mirage spots (*Pokémon Alpha Sapphire*)	—

D

Item	Description	How to obtain	Price
Damp Rock	Extends the duration of the rainy weather by three turns when held.	Receive from the receptionist in the Weather Institute on Route 119	—
Dawn Stone	It can evolve male Kirlia and female Snorunt.	Receive from Wally on Victory Road / Can be obtained by winning an Inverse Battle at the Inverse Battle Stop in Mauville City	—
Deep Sea Scale	When held by Clamperl, it doubles Sp. Def. Link Trade Clamperl while it holds the Deep Sea Scale to evolve it into Gorebyss.	Sometimes held by wild Chinchou, Lanturn, or Relicanth	—
Deep Sea Tooth	When held by Clamperl, it doubles Sp. Atk. Link Trade Clamperl while it holds the Deep Sea Tooth to evolve it into Huntail.	Sometimes held by wild Carvanha or Sharpedo	—
Destiny Knot	When a Pokémon holding it is inflicted with Infatuation, the Pokémon shares the condition with its attacker.	Sometimes picked up by a Pokémon with the Pickup Ability	—
Diancite	When held, it allows Diancie to Mega Evolve into Mega Diancie during battle.	Visit a Pokémon Center when you have Diancie distributed through past special events in your party	—
Dire Hit	Significantly raises the critical-hit ratio of the Pokémon on which it is used. It can be used only once and wears off if the Pokémon is withdrawn.	Buy from the Poké Mart in Slateport City / Lilycove Department Store (3F)	650
Dome Fossil	A Pokémon Fossil. When restored, it becomes Kabuto.	Can be obtained by breaking cracked rocks using Rock Smash in Mirage spots (*Pokémon Omega Ruby*)	—
Douse Drive	When held by Genesect, it changes Genesect's Techno Blast move so it becomes Water type.	Receive from a Street Thug standing near the stairs to the top of Mauville City when you have Genesect in your party	—
Draco Plate	When held by a Pokémon, it boosts the power of Dragon-type moves by 20%. (When held by Arceus, it shifts Arceus's type to Dragon type.)	Route 128 (Underwater)	—
Dragon Fang	When held by a Pokémon, it boosts the power of Dragon-type moves by 20%.	Sometimes held by wild Bagon or Druddigon	—
Dragon Scale	Link Trade Seadra while it holds the Dragon Scale to evolve it into Kingdra.	Sky Pillar (2F) / Sometimes held by wild Horsea or Seadra	—
Dread Plate	When held by a Pokémon, it boosts the power of Dark-type moves by 20%. (When held by Arceus, it shifts Arceus's type to Dark type.)	Route 127 (Underwater)	—

Item	Description	How to obtain	Price
Dubious Disc	Link Trade Porygon2 while it holds the Dubious Disc to evolve it into Porygon-Z.	Get for 32 BP in the Battle Maison in the Battle Resort	—
Dusk Stone	It can evolve Doublade, Lampent, Misdreavus, and Murkrow.	Can be obtained by winning an Inverse Battle at the Inverse Battle Stop in Mauville City	—

E

Item	Description	How to obtain	Price
Earth Plate	When held by a Pokémon, it boosts the power of Ground-type moves by 20%. (When held by Arceus, it shifts Arceus's type to Ground type.)	Route 130 (Underwater)	—
Eject Button	If the holder is hit by an attack, it switches places with a party Pokémon. It goes away after use.	Get for 32 BP in the Battle Maison in the Battle Resort	—
Electirizer	Link Trade Electabuzz while it holds the Electirizer to evolve it into Electivire.	Sometimes held by wild Elekid / Get for 32 BP in the Battle Maison in the Battle Resort	—
Elixir	Restores the PP of all of a Pokémon's moves by 10 points.	Route 110 / Route 111 / Route 119 / Route 123	—
Energy Powder	Restores the HP of one Pokémon by 50 points. Very bitter (lowers a Pokémon's friendship).	Buy at Pokémon Herb Shop in Lavaridge Town	500
Energy Root	Restores the HP of one Pokémon by 200 points. Very bitter (lowers a Pokémon's friendship).	Buy at Pokémon Herb Shop in Lavaridge Town	800
Escape Rope	Use it to escape instantly from a cave or a dungeon.	Buy at Poké Marts (after obtaining second Gym Badge)	550
Ether	Restores the PP of a Pokémon's move by 10 points.	Petalburg City / Petalburg Woods / Route 116	—
Everstone	Prevents the Pokémon that holds it from evolving.	Sometimes held by Geodude or Graveler / Often held by wild Boldore or Roggenrola	—
Eviolite	Raises Defense and Sp. Def by 50% when held by a Pokémon that can still evolve.	Receive from a Fisherman at 123 Go Fish on Route 123 after answering "Magikarp" to his question	—
Expert Belt	Raises the power of supereffective moves by 20%.	Trick Master's room in the Trick House on Route 110 / Get for 48 BP in the Battle Maison in the Battle Resort	—

F

Item	Description	How to obtain	Price
Fire Stone	It can evolve Eevee, Growlithe, Pansear, and Vulpix.	Fiery Path / Receive from the Treasure Hunter on Route 124 in exchange for a Red Shard	—
Fist Plate	When held by a Pokémon, it boosts the power of Fighting-type moves by 20%. (When held by Arceus, it shifts Arceus's type to Fighting type.)	Route 130 (Underwater)	—
Flame Orb	Inflicts the Burned status condition on the holder during battle.	Get for 16 BP in the Battle Maison in the Battle Resort	—
Flame Plate	When held by a Pokémon, it boosts the power of Fire-type moves by 20%. (When held by Arceus, it shifts Arceus's type to Fire type.)	Route 107 (Underwater)	—
Float Stone	Halves the holder's weight.	Receive from a guy in Devon company dormitory 2F in Rustboro City	—
Fluffy Tail	Guarantees escape from any battle with wild Pokémon.	Buy at Lilycove Department Store (2F)	1,000
Focus Band	Has a 10% chance of leaving the holder with 1 HP when it receives damage that would cause it to faint.	Receive from a Black Belt in the Shoal Cave (B1F) at low tide / Sometimes held by wild Machop / Get for 48 BP in the Battle Maison in the Battle Resort	—
Focus Sash	A holder with full HP is left with 1 HP when it is hit by a move that would cause it to faint. Then the item disappears.	Get for 48 BP in the Battle Maison in the Battle Resort	—
Fresh Water	Restores the HP of one Pokémon by 50 points.	Buy at a vending machine	200
Full Heal	Cures all status conditions and confusion.	Buy at Poké Marts (after obtaining third Gym Badge)	600
Full Incense	When held by a Pokémon, it makes the holder move later.	Buy from the Incense shop in Slateport Market	9,600
Full Restore	Restore the HP of a Pokémon and cures status conditions and confusion.	Buy at Poké Marts (after obtaining fifth Gym Badge)	3,000

G

Item	Description	How to obtain	Price
Galladite	When held, it allows Gallade to Mega Evolve into Mega Gallade during battle.	Talk to Professor Cozmo in Fallarbor Town (after clearing the Delta Episode)	—
Garchompite	When held, it allows Garchomp to Mega Evolve into Mega Garchomp during battle.	Receive from Aarune in the Secret Base Guild in Fortree City as a reward that your team reached Platinum Rank	—
Gardevoirite	When held, it allows Gardevoir to Mega Evolve into Mega Gardevoir during battle.	Receive from Wanda in her house in Verdanturf Town after obtaining the National Pokédex	—
Gengarite	When held, it allows Gengar to Mega Evolve into Mega Gengar during battle.	A house in the Battle Resort after obtaining the National Pokédex	—
Genius Wing	Slightly increases the base Sp. Atk stat of a single Pokémon. It can be used until the base stat reaches its maximum value.	Can be won by reaching Beginner Rank, Novice Rank, or Normal Rank in the Battle Institute in Mauville City	—
Glalitite	When held, it allows Glalie to Mega Evolve into Mega Glalie during battle.	Shoal Cave at low tide (Ice cavern)	—
Green Scarf	When held by a Pokémon, it raises the Cleverness aspect of the Pokémon in Contest Spectacular.	Receive from the chairman of the Pokémon Fan Club in Slateport City when your lead Pokémon has the max Cleverness stat	—

Item	Description	How to obtain	Price
Green Shard	A Shard you can trade for a Leaf Stone with the Treasure Hunter on Route 124.	Route 124 (Underwater)	—
Grip Claw	Extends the duration of moves like Bind and Wrap to seven turns.	Sometimes held by wild Sandshrew	—
Griseous Orb	When held by Giratina, it changes it into its Origin Forme, and boosts the power of Dragon- and Ghost-type moves by 20%.	Route 130 (Underwater)	—
Guard Spec.	Prevents stat reduction among the Trainer's party Pokémon for five turns. It can be used only once and wears off if the Pokémon is withdrawn.	Buy from the Poké Mart in Slateport City / Lilycove Department Store (3F)	700
Gyaradosite	When held, it allows Gyarados to Mega Evolve into Mega Gyarados during battle.	Scratch Poochyena in 123 Go Fish on Route 123	—

H

Item	Description	How to obtain	Price
Hard Stone	When held by a Pokémon, it boosts the power of Rock-type moves by 20%.	Receive from the Trick Master as a reward (Challenge 2) / Sometimes held by wild Aron	—
Heal Powder	Cures all status conditions and confusion. Very bitter (lowers a Pokémon's friendship).	Buy at Pokémon Herb Shop in Lavaridge Town	450
Health Wing	Slightly increases the base HP of a single Pokémon. It can be used until the max of base stats.	Can be won by reaching Beginner Rank, Novice Rank, or Normal Rank in the Battle Institute in Mauville City	—
Heart Scale	Give one to Move Maniac in Fallarbor Town, and he will have your Pokémon remember a move it has forgotten.	Route 134 (using Dowsing Machine) / Held by the Corsola you can get by trade in a house in Pacifidlog Town / Often held by wild Luvdisc	—
Heat Rock	When held by a Pokémon, it extends the duration of the sunny weather by three turns.	Receive from the receptionist in the Weather Institute on Route 119	—
Helix Fossil	A Pokémon Fossil. When restored, it becomes Omanyte.	Can be obtained by breaking cracked rocks using Rock Smash in Mirage spots (*Pokémon Alpha Sapphire*)	—
Heracronite	When held, it allows Heracross to Mega Evolve into Mega Heracross during battle.	Route 127	—
Honey	Attracts wild Pokémon where wild Pokémon can appear, and causes a Horde Encounter.	Receive from a Bug Maniac in the Pokémon Center in Fallarbor Town / Often held by wild Surskit	—
Houndoominite	When held, it allows Houndoom to Mega Evolve into Mega Houndoom during battle.	Lavaridge Town after obtaining the National Pokédex	—
HP Up	Raises the base HP of a Pokémon.	Buy from the Energy Guru in Slateport Market / Lilycove Department Store (3F)	9,800
Hyper Potion	Restores the HP of one Pokémon by 200 points.	Buy at Poké Marts (after obtaining second Gym Badge)	1,200

I

Item	Description	How to obtain	Price
Ice Heal	Cures the Frozen status condition.	Buy at Poké Marts (after obtaining first Gym Badge)	250
Icicle Plate	When held by a Pokémon, it boosts the power of Ice-type moves by 20%. (When held by Arceus, it shifts Arceus's type to Ice type.)	Route 130 (Underwater)	—
Icy Rock	Extends the duration of the hail by three turns when held.	Receive from the receptionist in the Weather Institute on Route 119	—
Insect Plate	When held by a Pokémon, it boosts the power of Bug-type moves by 20%. (When held by Arceus, it shifts Arceus's type to Bug type.)	Route 127 (Underwater)	—
Iron	Raises the base Defense stat of a Pokémon.	Buy from the Energy Guru in Slateport Market / Lilycove Department Store (3F)	9,800
Iron Ball	Halves the holder's Speed. If the holder has the Levitate Ability or is a Flying-type Pokémon, Ground-type moves can hit it.	Sometimes held by wild Mawile / Get for 48 BP in the Battle Maison in the Battle Resort	—
Iron Plate	When held by a Pokémon, it boosts the power of Steel-type moves by 20%. (When held by Arceus, it shifts Arceus's type to Steel type.)	Held by the Beldum you obtain in Steven's house in Mossdeep City after clearing the Delta Episode	—

J

Item	Description	How to obtain	Price
Jaw Fossil	A Pokémon Fossil. When restored, it becomes Tyrunt.	Can be obtained in *Pokémon X* and *Pokémon Y*	—

K

Item	Description	How to obtain	Price
Kangaskhanite	When held, it allows Kangaskhan to Mega Evolve into Mega Kangaskhan during battle.	Pacifidlog Town after receiving the National Pokédex	—
King's Rock	When the holder successfully inflicts damage, the target may also flinch. Link Trade Poliwhirl or Slowpoke while they hold a King's Rock to evolve them.	Receive from a guy in Mossdeep City / Sometimes held by wild Hariyama	—
Lagging Tail	When held by a Pokémon, it makes it move later.	Sometimes held by wild Slowpoke	—

	Item	Description	How to obtain	Price
	Latiasite	When held, it allows Latias to Mega Evolve into Mega Latias during battle.	Receive from your mom in Littleroot Town after the Delta Episode (*Pokémon Omega Ruby*) / Southern Island (*Pokémon Alpha Sapphire*)	—
	Latiosite	When held, it allows Latios to Mega Evolve into Mega Latios during battle.	Southern Island (*Pokémon Omega Ruby*) / Receive from your mom in Littleroot Town after the Delta Episode (*Pokémon Alpha Sapphire*)	—
	Lava Cookie	Lavaridge Town's famous specialty. Cures all status conditions and confusion.	Buy from an old woman at the summit of Mt. Chimney (after visiting Lavaridge Challenge 1 maze in the Trick House on Route 110)	200
	Lax Incense	Boosts the holder's evasion.	Buy from the Incense shop in Slateport Market	9,600
	Leaf Stone	It can evolve Exeggcute, Gloom, Nuzleaf, Pansage, and Weepinbell.	Route 119 / Receive from the Treasure Hunter on Route 124 in exchange for a Green Shard	—
	Leftovers	It restores 1/16 of the holder's maximum HP every turn.	S.S. Tidal (Storage)	—
	Lemonade	Restores the HP of one Pokémon by 80 points.	Buy at a vending machine	350
	Life Orb	Lowers the holder's HP each time it attacks, but raises the power of moves by 30%.	Sometimes held by wild Absol / Get for 48 BP in the Battle Maison in the Battle Resort	—
	Light Ball	Doubles the power of both physical and special moves when held by Pikachu.	Route 120 / Sometimes held by wild Pikachu	—
	Light Clay	Extends the duration of moves like Reflect and Light Screen by three turns.	Sometimes held by wild Baltoy or Claydol	—
	Lopunnite	When held, it allows Lopunny to Mega Evolve into Mega Lopunny during battle.	Receive from a guy in front of Apt. 12 in Mauville Hills (speak to him twice)	—
	Lucarionite	When held, it allows Lucario to Mega Evolve into Mega Lucario during battle.	Receive from Chaz after defeating Lisia in Master Rank contest	—
	Luck Incense	Doubles prize money from a battle if the holding Pokémon joins in.	Buy from the Incense shop in Slateport Market	9,600
	Lucky Egg	Increases the number of Experience Points received from battle by 50%.	Sometimes held by wild Happiny or Pelipper	—
	Lucky Punch	It is a pair of gloves that boosts Chansey's critical-hit ratio.	Can be obtained in *Pokémon X* and *Pokémon Y*	—
	Luminous Moss	Increases Sp. Def by 1 when the holder is hit with Water-type moves. It goes away after use.	Sometimes held by wild Corsola / Get for 32 BP in the Battle Maison in the Battle Resort	—
	Lumiose Galette	A popular pastry sold in Lumiose City. Cures all status conditions and confusion for one Pokémon.	Challenge 3 maze in the Trick House on Route 110	—
	Lustrous Orb	When held by Palkia, it boosts the power of Dragon- and Water-type moves by 20%.	Route 129 (underwater)	—

	Item	Description	How to obtain	Price
	Macho Brace	Halves Speed, but makes it easier to raise base stats.	Receive from Victoria after defeating four members of the Winstrate family on Route 111	—
	Magmarizer	Link Trade Magmar while it holds the Magmarizer to evolve it into Magmortar.	Sometimes held by wild Magby / Get for 32 BP in the Battle Maison in the Battle Resort	—
	Magnet	When held by a Pokémon, it boosts the power of Electric-type moves by 20%.	Receive from the Trick Master as a reward (Challenge 5)	—
	Manectite	When held, it allows Manectric to Mega Evolve into Mega Manectric during battle.	Route 110	—
	Mawilite	When held, it allows Mawile to Mega Evolve into Mega Mawile during battle.	Verdanturf Town	—
	Max Elixir	Completely restores the PP of all of a Pokémon's moves.	Team Magma Hideout (*Pokémon Omega Ruby*) / Team Aqua Hideout (*Pokémon Alpha Sapphire*) / Receive from brothers by showing affectionate Barboach or Shroomish in Sootopolis City	—
	Max Ether	Completely restores the PP of a Pokémon's move.	Rusturf Tunnel / Route 113	—
	Max Potion	Completely restores the HP of a single Pokémon.	Buy at Poké Marts (after obtaining fourth Gym Badge)	2,500
	Max Repel	Prevents weak wild Pokémon from appearing for 250 steps after its use.	Buy at Poké Marts (after obtaining third Gym Badge)	700
	Max Revive	Revives a fainted Pokémon and fully restores its HP.	Safari Zone / Team Magma Hideout (*Pokémon Omega Ruby*) / Team Aqua Hideout (*Pokémon Alpha Sapphire*) / Route 133	—
	Meadow Plate	When held by a Pokémon, it boosts the power of Grass-type moves by 20%. (When held by Arceus, it shifts Arceus's type to Grass type.)	Route 130 (Underwater)	—
	Medichamite	When held, it allows Medicham to Mega Evolve into Mega Medicham during battle.	Mt. Pyre (4F)	—
	Mental Herb	The holder shakes off the effects of Attract, Disable, Encore, Heal Block, Taunt, and Torment. It goes away after use.	Receive from a man in a house in Fortree City after speaking to a woman in a house in Mossdeep City / Sometimes held by wild Lotad, Lombre, or Sewaddle	—
	Metagrossite	When held, it allows Metagross to Mega Evolve into Mega Metagross during battle.	Defeat Steven once again in the Pokémon League after the Delta Episode	—
	Metal Coat	When held by a Pokémon, it boosts the power of Steel-type moves by 20%. Link Trade Onix or Scyther while they hold a Metal Coat to evolve them.	New Mauville / Sometimes held by wild Bronzor, Magnemite, or Skarmory	—
	Metal Powder	When held by Ditto, Defense doubles.	Sometimes held by wild Ditto / Win perfectly at the Mauville Food Court when you order Magnemite Croquettes	—
	Metronome	When held, it raises the power of a move used consecutively by that Pokémon (up to a maximum increase of 100%)	Buy from a guy on the top of Mauville City / Sometimes held by wild Chatot or Kricketune	1,000

	Item	Description	How to obtain	Price
	Mewtwonite X	When held, it allows Mewtwo to Mega Evolve into Mega Mewtwo X during battle.	Littleroot Town after obtaining the National Pokédex	—
	Mewtwonite Y	When held, it allows Mewtwo to Mega Evolve into Mega Mewtwo Y during battle.	Pokémon League	—
	Mind Plate	When held by a Pokémon, it boosts the power of Psychic-type moves by 20%. (When held by Arceus, it shifts Arceus's type to Psychic type.)	Route 126 (Underwater)	—
	Miracle Seed	When held by a Pokémon, it boosts the power of Grass-type moves by 20%.	Receive from a girl in Petalburg Woods / Sometimes held by wild Cherrim or Maractus	—
	Moomoo Milk	Restores the HP of one Pokémon by 100 points.	Buy from a woman in the Pokémon Center in Lavaridge Town	500
	Moon Stone	It can evolve Clefairy, Jigglypuff, Munna, Nidorina, Nidorino, and Skitty.	Meteor Falls (Entrance) / Sometimes held by wild Clefairy or Lunatone	—
	Muscle Band	When held by a Pokémon, it boosts the power of physical moves by 10%.	Get for 48 BP in the Battle Maison in the Battle Resort	—
	Muscle Wing	Slightly increases the base Attack stat of a single Pokémon. It can be used until the max of base stats.	Can be won by reaching Beginner Rank, Novice Rank, or Normal Rank in the Battle Institute in Mauville City	—
	Mystic Water	When held by a Pokémon, it boosts the power of Water-type moves by 20%.	Held by the Castform you can receive at the Weather Institute on Route 119 / Sometimes held by wild Goldeen or Seaking	—

N

	Item	Description	How to obtain	Price
	Never-Melt Ice	When held by a Pokémon, it boosts the power of Ice-type moves by 20%.	Shoal Cave at low tide (Ice cavern)	—
	Normal Gem	When held by a Normal-type Pokémon, it boosts the power of a Normal-type move by 30% one time. It goes away after use.	Can be obtained by breaking cracked rocks using Rock Smash	—
	Nugget	A nugget of pure gold. It can be sold at shops for 5,000.	Win in the Mauville Food Court when you order the Village Sub Combo / Receive from a man on the top of Mauville City / Route 112 / Route 120	—

O

	Item	Description	How to obtain	Price
	Odd Incense	When held by a Pokémon, it boosts the power of Psychic-type moves by 20%.	Buy from the Incense shop in Slateport Market	9,600
	Old Amber	A piece of amber that contains genetic material. When restored, it becomes Aerodactyl.	Can be obtained by breaking cracked rocks using Rock Smash in Mirage spots	—
	Old Gateau	The Old Chateau's hidden specialty. It can heal all the status conditions and confusion.	Challenge 5 maze in the Trick House on Route 110	—
	Oval Stone	Level up Happiny between 4:00 A.M. and 7:59 P.M. while it holds the Oval Stone to evolve it into Chansey.	Often held by wild Happiny	—

P

	Item	Description	How to obtain	Price
	Paralyze Heal	Cures the Paralysis status condition.	Buy at Poké Marts (after obtaining first Gym Badge)	200
	Pearl	A pretty pearl. It can be sold at shops for 700.	Often held by wild Clamperl / Can be obtained by breaking cracked rocks using Rock Smash / Receive from the Treasure Hunter in Secret Base	—
	Pearl String	Very large pearls that sparkle in a pretty silver collar. It can be sold at shops for 7,500.	Win in the Mauville Food Court when you order Magnemite Croquettes / Receive from the Treasure Hunter in Secret Base	—
	Pidgeotite	When held, it allows Pidgeot to Mega Evolve into Mega Pidgeot during battle.	Show the Intriguing Stone to Mr. Stone in Rustboro City after obtaining it in Verdanturf Town	—
	Pink Scarf	When held by a Pokémon, it raises the Cuteness aspect of the Pokémon in Contest Spectacular.	Receive from the chairman of the Pokémon Fan Club in Slateport City when your lead Pokémon has the max Cuteness stat	—
	Pinsirite	When held, it allows Pinsir to Mega Evolve into Mega Pinsir during battle.	Route 124	—
	Pixie Plate	When held by a Pokémon, it boosts the power of Fairy-type moves by 20%. (When held by Arceus, it shifts Arceus's type to Fairy type.)	Route 128 (Underwater)	—
	Plume Fossil	A Pokémon Fossil. When restored, it becomes Archen.	Can be obtained by breaking cracked rocks using Rock Smash in Mirage spots (*Pokémon Omega Ruby*)	—
	Poison Barb	When held by a Pokémon, it boosts the power of Poison-type moves by 20%.	Sometimes held by wild Skorupi, Roselia, Tentacool, or Tentacruel	—
	Poké Doll	Ensures that the holder can successfully run from a wild Pokémon encounter.	Buy at Lilycove Department Store (2F)	1,000
	Poké Toy	Ensures that the holder can successfully run from a wild Pokémon encounter.	Buy at Lilycove Department Store (2F)	1,000
	Potion	Restores the HP of one Pokémon by 20 points.	Buy at Poké Marts (from the start)	300
	Power Anklet	Halves the holder's Speed, but makes the Speed base stat easier to raise.	Get for 16 BP in the Battle Maison in the Battle Resort	—
	Power Band	Halves the holder's Speed, but makes the Sp. Def base stat easier to raise.	Get for 16 BP in the Battle Maison in the Battle Resort	—
	Power Belt	Halves the holder's Speed, but makes the Defense base stat easier to raise.	Get for 16 BP in the Battle Maison in the Battle Resort	—
	Power Bracer	Halves the holder's Speed, but makes the Attack base stat easier to raise.	Get for 16 BP in the Battle Maison in the Battle Resort	—

	Item	Description	How to obtain	Price
	Power Herb	The holder can immediately use a move that requires a one-turn charge. It goes away after use.	Sometimes held by wild Nuzleaf or Seedot / Get for 32 BP in the Battle Maison in the Battle Resort	—
	Power Lens	Halves the holder's Speed, but makes the Sp. Atk base stat easier to raise.	Get for 16 BP in the Battle Maison in the Battle Resort	—
	Power Weight	Halves the holder's Speed, but makes the HP base stat easier to raise.	Get for 16 BP in the Battle Maison in the Battle Resort	—
	PP Max	Increases the max number of PP as high as it will go.	Route 119 / Team Magma Hideout (*Pokémon Omega Ruby*) / Team Aqua Hideout (*Pokémon Alpha Sapphire*) / Meteor Falls Entrance	—
	PP Up	Increases the max number of PP by one level.	Route 104 / Route 109 / Route 115 / Route 123 / Victory Road	—
	Pretty Wing	A beautiful feather. It can be sold at shops for 100.	Often held by wild Wingull or Pelipper	—
	Protector	Link Trade Rhydon while it holds the Protector to evolve it into Rhyperior.	Get for 32 BP in the Battle Maison in the Battle Resort	—
	Protein	Raises the base Attack stat of a Pokémon.	Buy from the Energy Guru in Slateport Market / Lilycove Department Store (3F)	9,800
	Pure Incense	Helps keep wild Pokémon away if the holder is the first one in the party.	Buy from the Incense shop in Slateport Market	9,600

Q

	Item	Description	How to obtain	Price
	Quick Claw	Allows the holder to strike first sometimes.	Receive from the teacher in the Trainers' School in Rustboro City / Sometimes held by wild Persian or Zangoose	—
	Quick Powder	When held by Ditto, Speed doubles.	Often held by wild Ditto	—

R

	Item	Description	How to obtain	Price
	Rage Candy Bar	Mahogany Town's famous snack. Restores the HP of one Pokémon by 20.	Challenge 2 maze in the Trick House on Route 110	—
	Rare Bone	A rare bone. It can be sold at shops for 5,000.	Route 114 (using Dowsing Machine) / Receive from the Treasure Hunter in Secret Base	—
	Rare Candy	Raises a Pokémon's level by 1.	Granite Cave (B2F) / Route 110 / Route 114 / Route 119	—
	Razor Claw	Boosts the holder's critical-hit ratio. ●	Get for 48 BP in the Battle Maison in the Battle Resort	—
	Razor Fang	When the holder hits a target with an attack, there is a 10% chance the target will flinch. ★	Get for 48 BP in the Battle Maison in the Battle Resort	—
	Reaper Cloth	Link Trade Dusclops while it holds the Reaper Cloth to evolve it into Dusknoir.	Get for 32 BP in the Battle Maison in the Battle Resort	—
	Red Card	If the holder is hit by an attack that makes direct contact, the opposing Trainer is forced to switch out the attacking Pokémon. It goes away after use.	Get for 32 BP in the Battle Maison in the Battle Resort	—
	Red Flute	Snaps Pokémon out of infatuation.	Receive from a guy in the Glass Workshop on Route 113 in exchange for collected ash (500g)	—
	Red Orb	A shiny red orb that is said to have a legend tied to it. It's known to have a deep connection with the Hoenn region.	Receive from Maxie in the Cave of Origin (*Pokémon Omega Ruby*) / Receive from an old woman at the summit of Mt. Pyre (*Pokémon Alpha Sapphire*)	—
	Red Scarf	When held by a Pokémon, it raises the Coolness aspect of the Pokémon in Contest Spectacular.	Receive from the chairman of the Pokémon Fan Club in Slateport City when your lead Pokémon has the max Coolness stat	—
	Red Shard	A Shard you can trade for a Fire Stone with the Treasure Hunter on Route 124.	Route 124	—
	Repel	Prevents weak wild Pokémon from appearing for 100 steps after its use.	Buy at Poké Marts (after obtaining first Gym Badge)	350
	Resist Wing	Slightly increases the base Defense stat of a single Pokémon. It can be used until the max of base stats.	Can be won by reaching Beginner Rank, Novice Rank, or Normal Rank in the Battle Institute in Mauville City	—
	Revival Herb	Revives a fainted Pokémon. Very bitter (lowers a Pokémon's friendship).	Buy at Pokémon Herb Shop in Lavaridge Town	2,800
	Revive	Revives a fainted Pokémon and restores half of its HP.	Buy at Poké Marts (after obtaining second Gym Badge)	1,500
	Ring Target	Moves that would otherwise have no effect will hit the holder.	Get for 32 BP in the Battle Maison in the Battle Resort	—
	Rock Incense	When held by a Pokémon, it boosts the power of Rock-type moves by 20%.	Buy from the Incense shop in Slateport Market	9,600
	Rocky Helmet	When the bearer is hit with an attack that makes direct contact, it damages the attacker for 1/6 of its maximum HP.	Receive from the assistant in the Weather Institute on Route 119	—
	Root Fossil	A Pokémon Fossil. When restored, it becomes Lileep.	Route 111 (Select either Root Fossil or Claw Fossil)	—
	Rose Incense	When held by a Pokémon, it boosts the power of Grass-type moves by 20%.	Buy from the Incense shop in Slateport Market	9,600

● If you give Sneasel the Razor Claw to hold and level it up between 8:00 P.M. and 3:59 A.M., it will evolve into Weavile.

★ If you give Gligar the Razor Fang to hold and level it up between 8:00 P.M. and 3:59 A.M., it will evolve into Gliscor.

Item	Description	How to obtain	Price
Sablenite	When held, it allows Sableye to Mega Evolve into Mega Sableye during battle.	In front of the Cave of Origin in Sootopolis City	—
Sachet	Link Trade Spritzee while it holds the Sachet to evolve it into Aromatisse.	Get for 32 BP in the Battle Maison in the Battle Resort	—
Sacred Ash	Revives fainted Pokémon in a party and fully restores their HP.	Held by Ho-Oh you meet in Sea Mauville (*Pokémon Omega Ruby*)	—
Safety Goggles	Protects the holder from weather-related damage and from certain moves and an Ability. ◆	Receive from a guy in the desert on Route 111 / Get for 48 BP in the Battle Maison in the Battle Resort	—
Sail Fossil	A Pokémon Fossil. When restored, it becomes Amaura.	Can be obtained in *Pokémon X* and *Pokémon Y*	—
Salamencite	When held, it allows Salamence to Mega Evolve into Mega Salamence during battle.	Receive from an old woman in Meteor Falls after the Delta Episode	—
Sceptilite	When held, it allows Sceptile to Mega Evolve into Mega Sceptile during battle.	Receive from Steven on Route 120 if you chose Treecko as your first Pokémon / Otherwise, buy the stone titled "Withered Tree" on Route 114	1,500
Scizorite	When held, it allows Scizor to Mega Evolve into Mega Scizor during battle.	Petalburg Woods after obtaining the National Pokédex	—
Scope Lens	Boosts the holder's critical-hit ratio.	Get for 48 BP in the Battle Maison in the Battle Resort	—
Sea Incense	When held by a Pokémon, it boosts the power of Water-type moves by 20%.	Buy from the Incense shop in Slateport Market	9,600
Shalour Sable	Shalour City's famous shortbread. It can be used once to heal all the status conditions and confusion of a Pokémon.	Challenge 6 maze in the Trick House on Route 110	—
Sharp Beak	When held by a Pokémon, it boosts the power of Flying-type moves by 20%.	Receive from a guy from Unova in the storage of *S.S. Tidal* / Sometimes held by wild Doduo	—
Sharpedonite	When held, it allows Sharpedo to Mega Evolve into Mega Sharpedo during battle.	Receive from Team Aqua in the Battle Resort (*Pokémon Omega Ruby*) / Receive from Team Aqua during the Delta Episode (*Pokémon Alpha Sapphire*)	—
Shed Shell	Always allows the holder to be switched out.	Sometimes held by wild Scraggy, Seviper, or Venomoth	—
Shell Bell	Restores the holder's HP by up to 1/8th of the damage dealt to the target.	Receive from an old guy in Shoal Cave on Route 125 in exchange for 4 Shoal Salt and 4 Shoal Shells	—
Shiny Stone	It can evolve Floette, Minccino, Togetic, and Roselia.	Route 121 / Can be obtained by winning an Inverse Battle at the Inverse Battle Stop in Mauville City	—
Shoal Salt	Salt that is one of the ingredients for a Shell Bell.	Shoal Cave on Route 125 at low tide	—
Shoal Shell	A seashell that is one of the ingredients for a Shell Bell.	Shoal Cave on Route 125 at high tide	—
Shock Drive	When held by Genesect, it changes Genesect's Techno Blast move so it becomes Electric type.	Receive from a Street Thug standing near the stairs to the top of Mauville City when you have Genesect in your party	—
Silk Scarf	When held by a Pokémon, it boosts the power of Normal-type moves by 20%.	Receive from a guy in a house in Dewford Town	—
Silver Powder	When held by a Pokémon, it boosts the power of Bug-type moves by 20%.	Sometimes held by wild Masquerain	—
Skull Fossil	A Pokémon Fossil. When restored, it becomes Cranidos.	Can be obtained by breaking cracked rocks using Rock Smash in Mirage spots (*Pokémon Alpha Sapphire*)	—
Sky Plate	When held by a Pokémon, it boosts the power of Flying-type moves by 20%. (When held by Arceus, it shifts Arceus's type to Flying type.)	Route 124 (Underwater)	—
Slowbronite	When held, it allows Slowbro to Mega Evolve into Mega Slowbro during battle.	Receive from a guy in Shoal Cave when you have a Shell Bell made for the first time	—
Smoke Ball	Allows the holder to successfully run away from wild Pokémon.	Receive from the Trick Master as a reward (Challenge 4) / Sometimes held by wild Koffing	—
Smooth Rock	Extends the duration of the sandstorm weather by three turns when held.	Receive from the receptionist in the Weather Institute on Route 119	—
Snowball	Increases Attack by 1 when the holder is hit with Ice-type moves. It goes away after use.	Sometimes held by wild Snorunt / Get for 32 BP in the Battle Maison in the Battle Resort	—
Soda Pop	Restores the HP of one Pokémon by 60 points.	Buy at a vending machine / Buy at a Seashore House on Route 109 after defeating every Trainer in the house	300
Soft Sand	When held by a Pokémon, it boosts the power of Ground-type moves by 20%.	Receive from a girl on Route 109 / Sometimes held by wild Diglett, Nincada, or Trapinch	—
Soothe Bell	The holder's friendship improves more quickly.	Receive from a Poké Fan in Slateport City when you are with a friendly lead Pokémon	—
Spell Tag	When held by a Pokémon, it boosts the power of Ghost-type moves by 20%.	Sometimes held by wild Cofagrigus, Duskull, or Shuppet	—
Splash Plate	When held by a Pokémon, it boosts the power of Water-type moves by 20%. (When held by Arceus, it shifts Arceus's type to Water type.)	Route 129 (Underwater)	—
Spooky Plate	When held by a Pokémon, it boosts the power of Ghost-type moves by 20%. (When held by Arceus, it shifts Arceus's type to Ghost type.)	Route 127 (Underwater)	—
Star Piece	A red gem. It can be sold at shops for 4,900.	Route 108 / Route 133 / Route 134 / Sometimes held by wild Staryu	—
Stardust	Lovely, red-colored sand. It can be sold at shops for 1,000.	Route 111 / Often held by wild Lunatone, Staryu, or Solrock	—
Steelixite	When held, it allows Steelix to Mega Evolve into Mega Steelix during battle.	Granite Cave (B2F)	—
Stick	When held by Farfetch'd, it raises the critical-hit ratio of its moves.	Can be obtained in *Pokémon X* and *Pokémon Y*	—

◆ Safety Goggles protects from Cotton Spore, Poison Powder, Powder, Rage Powder, Sleep Powder, Spore, and Stun Spore, and the Effect Spore Ability.

	Item	Description	How to obtain	Price
	Sticky Barb	Damages the holder by 1/8 of its maximum HP every turn. It latches on to the attacker that touches the holder if the attacker doesn't have an item.	Sometimes held by wild Cacnea	—
	Stone Plate	When held by a Pokémon, it boosts the power of Rock-type moves by 20%. (When held by Arceus, it shifts Arceus's type to Rock type.)	Route 128 (Underwater)	—
	Sun Stone	It can evolve to Cottonee, Gloom, Helioptile, Petilil, and Sunkern.	Receive from a person at the Space Center in Mossdeep City / Sometimes held by wild Solrock	—
	Super Potion	Restores the HP of one Pokémon by 50 points.	Buy at Poké Marts (after obtaining first Gym Badge)	700
	Super Repel	Prevents weak wild Pokémon from appearing for 200 steps after its use.	Buy at Poké Marts (after obtaining second Gym Badge)	500
	Swampertite	When held, it allows Swampert to Mega Evolve into Mega Swampert during battle.	Receive from Steven on Route 120 if you chose Mudkip as your first Pokémon / Otherwise buy the stone titled "Ebb Tide" on Route 114	1,500
	Sweet Heart	Restores the HP of one Pokémon by 20 points.	Sometimes given by your fan after you've participated in a contest	—
	Swift Wing	Slightly increases the base Speed stat of a single Pokémon. It can be used until the max of base stats.	Can be won by reaching Beginner Rank, Novice Rank, or Normal Rank in the Battle Institute in Mauville City	—

T

	Item	Description	How to obtain	Price
	Thick Club	When held by Cubone or Marowak, the power of Physical Moves is doubled.	Can be obtained in *Pokémon X* and *Pokémon Y*	—
	Thunder Stone	It can evolve Eelektrik, Eevee, and Pikachu.	New Mauville / Receive from the Treasure Hunter on Route 124 in exchange for a Yellow Shard	—
	Tiny Mushroom	A tiny mushroom. It can be sold at shops for 250.	Often held by wild Paras or Shroomish	—
	Toxic Orb	Inflicts the Badly Poisoned status condition on the holder during battle.	Get for 16 BP in the Battle Maison in the Battle Resort	—
	Toxic Plate	When held by a Pokémon, it boosts the power of Poison-type moves by 20%. (When held by Arceus, it shifts Arceus's type to Poison type.)	Route 129 (Underwater)	—
	Twisted Spoon	When held by a Pokémon, it boosts the power of Psychic-type moves by 20%.	Sometimes held by wild Abra	—
	Tyranitarite	When held, it allows Tyranitar to Mega Evolve into Mega Tyranitar during battle.	Jagged Pass after obtaining the National Pokédex	—

U

	Item	Description	How to obtain	Price
	Up-Grade	Link Trade Porygon while it holds the Up-Grade to evolve it into Porygon2.	Get for 32 BP in the Battle Maison in the Battle Resort	—

V

	Item	Description	How to obtain	Price
	Venusaurite	When held, it allows Venusaur to Mega Evolve into Mega Venusaur during battle.	Route 119 after obtaining the National Pokédex	—

W

	Item	Description	How to obtain	Price
	Water Stone	It can evolve Eevee, Lombre, Panpour, Poliwhirl, Shellder, and Staryu.	Receive from the Treasure Hunter on Route 124 in exchange for a Blue Shard	—
	Wave Incense	When held by a Pokémon, it boosts the power of Water-type moves by 20%.	Buy from the Incense shop in Slateport Market	9,600
	Weakness Policy	Increases Attack and Sp. Atk by 2 if the holder is hit with a move that it's weak to.	Get for 32 BP in the Battle Maison in the Battle Resort	—
	Whipped Dream	Link Trade Swirlix while it holds a Whipped Dream to evolve it into Slurpuff.	Get for 32 BP in the Battle Maison in the Battle Resort	—
	White Flute	Makes it easier to encounter weak Pokémon.	Receive from a guy in the Glass Workshop on Route 113 in exchange for collected ash (1,000g)	—
	White Herb	Restores lowered stats. It goes away after use.	Sea Mauville / Get for 32 BP in the Battle Maison in the Battle Resort / Get from a girl on Route 104 after talking with the eldest sister of the flower shop and obtaining the Petalburg City Gym Badge	—
	Wide Lens	Raises the holder's accuracy by 10%.	Route 123 / Sometimes held by wild Sableye / Get for 48 BP in the Battle Maison in the Battle Resort	—
	Wise Glasses	When held by a Pokémon, it boosts the power of special moves by 10%.	Get for 48 BP in the Battle Maison in the Battle Resort	—

Item	Description	How to obtain	Price
X Accuracy	Raises the accuracy of a Pokémon on which it is used during battle.	Buy from the Poké Mart in Slateport City / Lilycove Department Store (3F)	950
X Attack	Raises the Attack stat of a Pokémon by 1 during battle.	Buy from the Poké Mart in Slateport City / Lilycove Department Store (3F)	500
X Defense	Raises the Defense stat of a Pokémon by 1 during battle.	Buy from the Poké Mart in Slateport City / Lilycove Department Store (3F)	550
X Sp. Atk	Raises the Sp. Atk stat of a Pokémon by 1 during battle.	Buy from the Poké Mart in Slateport City / Lilycove Department Store (3F)	350
X Sp. Def	Raises the Sp. Def stat of a Pokémon by 1 during battle.	Buy from the Poké Mart in Slateport City / Lilycove Department Store (3F)	350
X Speed	Raises the Speed of a Pokémon by 1 during battle.	Buy from the Poké Mart in Slateport City / Lilycove Department Store (3F)	350

Y

Item	Description	How to obtain	Price
Yellow Flute	Snaps Pokémon out of confusion.	Receive from a guy in the Glass Workshop on Route 113 in exchange for collected ash (500g)	—
Yellow Scarf	When held by a Pokémon, it raises the Toughness aspect of the Pokémon in Contest Spectacular.	Receive from the chairman of the Pokémon Fan Club in Slateport City when your lead Pokémon has the max Toughness stat	—
Yellow Shard	A Shard you can trade for a Thunder Stone with the Treasure Hunter on Route 124.	Route 124	—

Z

Item	Description	How to obtain	Price
Zap Plate	When held by a Pokémon, it boosts the power of Electric-type moves by 20%. (When held by Arceus, it shifts Arceus's type to Electric type.)	Route 129 (Underwater)	—
Zinc	Raises the base Sp. Def stat of a Pokémon.	Buy from the Energy Guru in Slateport Market / Lilycove Department Store (3F)	9,800
Zoom Lens	Raises the holder's accuracy by 20% when it moves after the opposing Pokémon.	Get for 48 BP in the Battle Maison in the Battle Resort	—

KEY ITEMS

Item	Description	How to obtain	Price
Acro Bike	A folding Bike that allows you to perform actions such as wheelies and bunny hops.	Receive from Rydel at Rydel's Cycles in Mauville City	—
Aqua Suit	A suit made with the collective technological know-how of Team Aqua. It can withstand any impact.	Receive from Archie in Sootopolis City (*Pokémon Alpha Sapphire*)	—
Clear Bell	A very old-fashioned bell that makes a gentle ringing sound. It allows you to meet Ho-Oh.	Receive from Captain Stern in Slateport City after finding the Scanner (*Pokémon Omega Ruby*)	—
Contest Costume	A very cool suit to be worn during the Contest Spectacular.	Receive from Lisia in Slateport City (if you chose the boy character)	—
Contest Costume	A very pretty suit to be worn during the Contest Spectacular.	Receive from Lisia in Slateport City (if you chose the girl character)	—
Contest Pass	A pass required for entering Pokémon Contests. It has a drawing of an award ribbon on its front.	Receive from Lisia in Slateport City	—
Devon Parts	A case that contains mechanical parts of some sort made by the Devon Corporation.	Get back from Team Magma / Aqua Grunt in Rusturf Tunnel	—
Devon Scope	A special device made by Devon Corporation that signals the presence of any unseen Pokémon.	Receive from Steven on Route 120	—
Devon Scuba Gear	A device made by Devon Corporation that provides oxygen to users during the use of Dive.	Receive from Steven in his house in Mossdeep City	—
DNA Splicers	A pair of splicers that fuse Kyurem and Zekrom or Reshiram.	Gnarled Den (using the Dowsing Machine)	—
Dowsing Machine	It searches for hidden items in the area and emits different lights and sounds when it detects something.	Receive from May / Brendan on Route 110	—
Eon Flute	A flute that can be used to summon Latios or Latias no matter where you are.	Receive from Steven in Sootopolis City	—
Exp. Share	When it is switched to ON, all of the Pokémon in your party will receive Exp. Points, even if they themselves do not battle.	Receive from a Devon researcher in Petalburg Woods	—
Go-Goggles	Nifty goggles to protect eyes from desert sandstorms.	Receive from May / Brendan in Lavaridge Town	—
Good Rod	A nice, new fishing rod. You can use it to fish for Pokémon from the waterside.	Receive from a Fisherman on Route 118	—
Gracidea	A flower to convey gratitude. Shaymin will change its Forme if Gracidea is used on it (except at night).	Receive from a man in Berry Master's House on Route 123 when you have Shaymin in your party	—
Intriguing Stone	A rather curious stone that might appear valuable to some.	Find the lost Shroomish in Verdanturf Town and speak to the girl who lost Shroomish	—
Key to Room 1	A key that opens a door inside Sea Mauville.	Receive from a Tuber girl in Sea Mauville	—
Key to Room 2	A key that opens a door inside Sea Mauville.	Check a file cabinet in Room 1 in Sea Mauville	—
Key to Room 4	A key that opens a door inside Sea Mauville.	Receive from a Fisherman on the beach by Sea Mauville (after speaking to the Fisherman, choose "You caught anything?")	—
Key to Room 6	A key that opens a door inside Sea Mauville.	Receive from a school girl in Room 2 in Sea Mauville	—
Letter	A letter entrusted to you by the President of Devon Corporation.	Receive from the president at 3F in Devon Corporation in Rustboro City	—
Mach Bike	A folding Bike that can double your movement speed.	Receive from Rydel at Rydel's Cycles in Mauville City	—
Magma Suit	A suit made with the collective technological know-how of Team Magma. It can withstand any impact.	Receive from Maxie in Sootopolis City (*Pokémon Omega Ruby*)	—
Mega Bracelet	The cuff that contains an untold power that somehow enables Pokémon carrying a Mega Stone to Mega Evolve in battle.	Receive from Steven in Southern Island	—
Meteorite	A meteorite originally found at Meteor Falls.	Receive from Maxie / Archie at the summit of Mt. Chimney	—
Meteorite Shard	One of the fragments of a meteorite from Granite Cave. It's faintly warm to the touch.	Receive during the Delta episode	—
Old Rod	An old and beat-up fishing rod. You can use it to fish for Pokémon from the waterside.	Receive from a Fisherman in Dewford Town	—
Oval Charm	An oval charm said to increase the chance of Pokémon Eggs being found at the Day Care.	Receive from Professor Birch in his lab in Littleroot Town after completing the Hoenn Pokédex	—
Pair of Tickets	Tickets for two to the astronomical show being held at the Mossdeep Space Center.	Receive from Norman after entering the Hall of Fame	—

Item	Description	How to obtain	Price
Pokéblock Kit	A set containing a Berry Blender for making Pokéblocks and a Pokéblock Case for storing Pokéblocks.	Receive from Lisia in Slateport City	—
Reveal Glass	A looking glass necessary to change Tornadus, Thundurus, and Landorus from Incarnate Forme into Therian Forme.	Receive from the shop keeper at Narcissus Mirror Shop in Mauville City when you have Tornadus, Thundurus, or Landorus in your party	—
S.S. Ticket	A ticket required for sailing on the ferry *S.S. Tidal*.	Receive from Norman in Littleroot Town after clearing the Delta Episode	—
Scanner	A device needed by Captain Stern for some research.	Sea Mauville after obtaining the National Pokédex	—
Shiny Charm	A shiny charm said to increase the change of finding a Shiny Pokémon in the wild.	Receive from Professor Birch in his lab in Littleroot Town after completing the National Pokédex	—
Soot Sack	A sack used to gather and hold volcanic ash.	Receive from a guy in the Glass Workshop on Route 113	—
Storage Key	A key that opens the storage hold inside Sea Mauville.	Find in Room 4 in Sea Mauville	—
Super Rod	An awesome, high-tech fishing rod. You can use it to fish for Pokémon from the waterside.	Receive from a Fisherman in a house in Mossdeep City	—
Tidal Bell	A very old-fashioned bell that makes a gentle ringing sound. It allows you to meet Lugia.	Receive from Captain Stern in Slateport City after finding the Scanner (*Pokémon Alpha Sapphire*)	—
Vs. Recorder	An amazing device that can record a battle between friends or the battles at certain special battle facilities.	Receive from a guy in the Battle Institute in Mauville City	—
Wailmer Pail	A tool for watering Berries you planted to make them grow more quickly.	Receive from a woman in the Pretty Petal Flower Shop on Route 104	—

POKÉ BALLS

Item	Description	How to obtain	Price
Poké Ball	A device for catching wild Pokémon.	Buy at Poké Marts (after receiving Poké Balls from May / Brendan in Littleroot Town)	200
Great Ball	A Poké Ball that provides a higher Pokémon catch rate than a standard Poké Ball can.	Buy at Poké Marts (after obtaining first Gym Badge)	600
Ultra Ball	A Poké Ball that provides a higher Pokémon catch rate than a Great Ball can.	Buy at Poké Marts (after obtaining third Gym Badge)	1,200
Master Ball	A Poké Ball that will catch any wild Pokémon without fail.	Find at Team Magma Hideout (B3F) (*Pokémon Omega Ruby*) / Team Aqua Hideout (B3F) (*Pokémon Alpha Sapphire*)	—
Premier Ball	A rare Poké Ball made to celebrate an event of some sort.	Buy 10 or more Poké Balls at a time	—
Dive Ball	A Poké Ball that works especially well when catching Pokémon that live underwater.	Buy at the Poké Mart in Fallarbor Town	1,000
Dusk Ball	A Poké Ball that makes it easier to catch wild Pokémon in caves or at night (between 8:00 P.M. and 3:59 A.M.).	Buy at the Poké Mart in Fallarbor Town	1,000
Heal Ball	A remedial Poké Ball that restores the HP of a Pokémon caught with it and eliminates any status conditions.	Buy at the Poké Mart in Verdanturf Town	300
Luxury Ball	A Poké Ball that makes a wild Pokémon quickly grow friendlier after being caught.	Buy at the Poké Mart in Verdanturf Town	1,000
Nest Ball	A Poké Ball that becomes more effective the lower the level of the wild Pokémon.	Buy at the Poké Mart in Verdanturf Town	1,000
Net Ball	A Poké Ball that is more effective when attempting to catch Water- or Bug-type Pokémon.	Buy at the Poké Mart in Rustboro City (after opening Rusturf Tunnel and talking to the Scientist outside)	1,000
Quick Ball	A Poké Ball that has a more successful catch rate if used at the start of a wild encounter.	Buy at the Poké Mart in Fallarbor Town	1,000
Repeat Ball	A Poké Ball that works especially well on a Pokémon species that has been caught before.	Buy at the Poké Mart in Rustboro City (after opening Rusturf Tunnel and talking to the Scientist outside)	1,000
Timer Ball	A Poké Ball that becomes progressively more effective the more turns that are taken in battle.	Buy at the Poké Mart in Rustboro City (after opening Rusturf Tunnel and talking to the Scientist outside)	1,000

ROCK SMASH

Items you can get by using Rock Smash

Item	Odds
Big Pearl	△
Ether	◎
Hard Stone	◎
Heart Scale	◎
Max Ether	○
Max Revive	△
Normal Gem	△
Pearl	○
Revive	○
Soft Sand	◎
Star Piece	◎

◎ Average ○ Rare △ Very rare

Fossils you can get in Mirage spots by using Rock Smash

Item	Version
Armor Fossil	*Pokémon Omega Ruby*
Cover Fossil	*Pokémon Alpha Sapphire*
Dome Fossil	*Pokémon Omega Ruby*
Helix Fossil	*Pokémon Alpha Sapphire*
Old Amber	*Pokémon Omega Ruby / Pokémon Alpha Sapphire*
Plume Fossil	*Pokémon Omega Ruby*
Skull Fossil	*Pokémon Alpha Sapphire*

Places where you can find rocks that can be smashed by Rock Smash

Place
Route 111
Route 114
Lilycove City
Rusturf Tunnel
Granite Cave (B2F)
Seafloor Cavern Room 1
Seafloor Cavern Room 2
Seafloor Cavern Room 4
Shoal Cave third cavern (low tide)

Mirage spots where you can find rocks that can be smashed by Rock Smash

Place
Mirage Forest 6
Mirage Cave 1
Mirage Cave 2
Mirage Cave 5
Mirage Cave 7
Mirage Island 2
Mirage Island 5
Mirage Mountain 7
Mirage Mountain 8

TRAINER HANDBOOK

ADVANCED HANDBOOK

ADVENTURE DATA

ITEMS HELD BY WILD POKÉMON IN HOENN

National Pokédex No.	Hoenn Pokédex No.	Pokémon	Often holding	Sometimes holding
25	163	Pikachu	—	Light Ball
27	117	Sandshrew	—	Grip Claw
35	—	Clefairy	—	Moon Stone
37	160	Vulpix	—	Charcoal
43	91	Oddish	—	Absorb Bulb
44	92	Gloom	—	Absorb Bulb
46	—	Paras	Tiny Mushroom	Big Mushroom
49	—	Venomoth	—	Shed Shell
50	—	Diglett	—	Soft Sand
53	—	Persian	—	Quick Claw
63	40	Abra	—	Twisted Spoon
66	75	Machop	—	Focus Band
72	68	Tentacool	—	Poison Barb
73	69	Tentacruel	—	Poison Barb
74	58	Geodude	—	Everstone
75	59	Graveler	—	Everstone
79	—	Slowpoke	—	Lagging Tail
81	84	Magnemite	—	Metal Coat
84	95	Doduo	—	Sharp Beak
88	111	Grimer	—	Black Sludge
109	113	Koffing	—	Smoke Ball
116	193	Horsea	—	Dragon Scale
117	194	Seadra	—	Dragon Scale

National Pokédex No.	Hoenn Pokédex No.	Pokémon	Often holding	Sometimes holding
118	51	Goldeen	—	Mystic Water
119	52	Seaking	—	Mystic Water
120	148	Staryu	Stardust	Star Piece
132	—	Ditto	Quick Powder	Metal Powder
170	190	Chinchou	—	Deep Sea Scale
171	191	Lanturn	—	Deep Sea Scale
222	189	Corsola	—	Luminous Moss
227	120	Skarmory	—	Metal Coat
239	—	Elekid	—	Electirizer
240	—	Magby	—	Magmarizer
263	12	Zigzagoon	Potion	Revive
264	13	Linoone	Potion	Max Revive
265	14	Wurmple	Pecha Berry	Bright Powder
270	19	Lotad	—	Mental Herb
271	20	Lombre	—	Mental Herb
273	22	Seedot	—	Power Herb
274	23	Nuzleaf	—	Power Herb
278	27	Wingull	Pretty Wing	—
279	28	Pelipper	Pretty Wing	Lucky Egg
283	33	Surskit	Honey	
284	34	Masquerain	—	Silver Powder
285	35	Shroomish	Tiny Mushroom	Big Mushroom
290	43	Nincada	—	Soft Sand

National Pokédex No.	Hoenn Pokédex No.	Pokémon	Often holding	Sometimes holding
296	49	Makuhita	—	Black Belt
297	50	Hariyama	—	King's Rock
299	61	Nosepass	—	Hard Stone
302	70	Sableye	—	Wide Lens
303	71	Mawile	—	Iron Ball
304	72	Aron	—	Hard Stone
305	73	Lairon	—	Hard Stone
311	82	Plusle	—	Cell Battery
312	83	Minun	—	Cell Battery
313	89	Volbeat	—	Bright Powder
314	90	Illumise	—	Bright Powder
315	98	Roselia	—	Poison Barb
316	100	Gulpin	Oran Berry	Sitrus Berry
318	102	Carvanha	—	Deep Sea Tooth
319	103	Sharpedo	—	Deep Sea Tooth
324	110	Torkoal	—	Charcoal
328	121	Trapinch	—	Soft Sand
331	124	Cacnea	—	Sticky Barb
335	128	Zangoose	—	Quick Claw
336	129	Seviper	—	Shed Shell
337	130	Lunatone	Stardust	Moon Stone
338	131	Solrock	Stardust	Sun Stone
343	136	Baltoy	—	Light Clay
344	137	Claydol	—	Light Clay
353	151	Shuppet	—	Spell Tag
355	153	Duskull	—	Spell Tag

National Pokédex No.	Hoenn Pokédex No..	Pokémon	Often holding	Sometimes holding
358	158	Chimecho	—	Cleanse Tag
359	159	Absol	—	Life Orb
361	179	Snorunt	—	Snowball
366	185	Clamperl	Pearl	Big Pearl
369	188	Relicanth	—	Deep Sea Scale
370	192	Luvdisc	Heart Scale	—
371	196	Bagon	—	Dragon Fang
402	—	Kricketune	—	Metronome
421	—	Cherrim	—	Miracle Seed
436	—	Bronzor	—	Metal Coat
440	—	Happiny	Oval Stone	Lucky Egg
441	—	Chatot	—	Metronome
451	—	Skorupi	—	Poison Barb
524	—	Roggenrola	Everstone	Hard Stone
525	—	Boldore	Everstone	Hard Stone
531	—	Audino	Oran Berry	Sitrus Berry
538	—	Throh	—	Black Belt
539	—	Sawk	—	Black Belt
540	—	Sewaddle	—	Mental Herb
556	—	Maractus	—	Miracle Seed
557	—	Dwebble	—	Hard Stone
558	—	Crustle	—	Hard Stone
559	—	Scraggy	—	Shed Shell
563	—	Cofagrigus	—	Spell Tag
568	—	Trubbish	—	Black Sludge
621	—	Druddigon	—	Dragon Fang

BERRIES

	Berry Name	Condition	Likelihood of Making Pokéblocks+	Hours to Harvest	Yield	Effects
	Aguav Berry	Clever	Very Low	4	3–15	Restores HP, but confuses Pokémon that don't like bitter taste
	Apicot Berry	Beautiful	Medium-High	12	2–13	Boosts Sp. Defense when HP is low
	Aspear Berry	Tough	Very Low	4	4–20	Cures Frozen
	Babiri Berry	Clever	Medium	8	2–10	Prevents one Steel-type move from dealing supereffective damage
	Belue Berry	Beautiful	Low	4	3–15	Can be used to make Pokéblocks
	Bluk Berry	Beautiful	Very Low	4	4–20	Can be used to make Pokéblocks
	Charti Berry	Tough	Medium	8	2–10	Prevents one Rock-type move from dealing supereffective damage
	Cheri Berry	Cool	Very Low	4	4–20	Cures Paralysis
	Chesto Berry	Beautiful	Very Low	4	4–20	Cures Sleep
	Chilan Berry	Tough	Medium	8	2–10	Reduces the damage from one Normal-type move by half
	Chople Berry	Cool	Medium	8	2–10	Prevents one Fighting-type move from dealing supereffective damage
	Coba Berry	Beautiful	Medium	8	2–10	Prevents one Flying-type move from dealing supereffective damage
	Colbur Berry	Cute	Medium	8	2–10	Prevents one Dark-type move from dealing supereffective damage
	Cornn Berry	Beautiful	Low	4	3–15	Can be used to make Pokéblocks
	Custap Berry	Cool	High	12	1–13	Guarantees first move for next turn when HP is low
	Durin Berry	Clever	Low	4	3–15	Can be used to make Pokéblocks
	Enigma Berry	Tough	High	12	1–13	Restores HP when hit with a supereffective move
	Figy Berry	Cool	Very Low	4	3–15	Restores HP, but confuses Pokémon that don't like spicy taste
	Ganlon Berry	Beautiful	Medium-High	12	2–13	Boosts Defense when HP is low
	Grepa Berry	Tough	Low	8	2–26	Makes Pokémon friendly, but lowers base Sp. Defense stat
	Haban Berry	Cool	Medium	8	2–10	Prevents one Dragon-type move from dealing supereffective damage
	Hondew Berry	Clever	Low	8	2–26	Makes Pokémon friendly, but lowers base Sp. Attack stat
	Iapapa Berry	Tough	Very Low	4	3–15	Restores HP, but confuses Pokémon that don't like sour taste
	Jaboca Berry	Tough	High	12	1–13	Deals damage to an opponent who deals physical damage
	Kasib Berry	Cute	Medium	8	2–10	Prevents one Ghost-type move from dealing supereffective damage
	Kebia Berry	Clever	Medium	8	2–10	Prevents one Poison-type move from dealing supereffective damage
	Kee Berry	Cute	Medium-High	12	2–13	Boosts Defense when dealt physical damage
	Kelpsy Berry	Beautiful	Low	8	2–26	Makes Pokémon friendly, but lowers base Attack stat
	Lansat Berry	Cute	Guaranteed	12	1–7	Makes it more likely to land a critical hit when HP is low
	Leppa Berry	Cool	Very Low	4	3–22	Restores 10 PP if PP for a move drops to 0
	Liechi Berry	Tough	Medium-High	12	2–13	Boosts Attack when HP is low
	Lum Berry	Clever	Low	8	2–18	Cures all status conditions and confusion
	Mago Berry	Cute	Very Low	4	3–15	Restores HP, but confuses Pokémon that don't like sweet taste

Note: One or two main ways to obtain each Berry are listed below, but most are available in numerous ways in the game, including from people you meet around Hoenn, from your Contest Spectacular fans (p. 362), from your Secret Pals (p. 390), and from achieving feats like winning Inverse Battles (p. 95).

Where to Find in the Wild	Main Ways to Obtain	Berry Name
Route 123 (Berry fields)	Reward for finishing perfectly on time for a Village Sub Combo in the Mauville Food Court	Aguav Berry
—	Receive from a Secret Pal with the Berry Farmer skill	Apicot Berry
Routes 114, 120, and 121	Youngest sister in the Pretty Petal flower shop / Berry Master's wife / Gentleman in Lilycove City	Aspear Berry
Route 123 (Berry fields)	Receive from a fan after reaching Master Rank in contests / Earn as a reward at the Inverse Battle Stop	Babiri Berry
—	Tell Berry Master's wife the special saying / Receive from a fan after reaching Hyper Rank in contests	Belue Berry
Route 115	Rich Boy on Route 114	Bluk Berry
Route 123 (Berry fields)	Receive from a fan after reaching Master Rank in contests / Earn as a reward at the Inverse Battle Stop	Charti Berry
Route 104	Youngest sister in the Pretty Petal flower shop / Berry Master's wife / Gentleman in Lilycove City	Cheri Berry
Routes 103 and 116	Youngest sister in the Pretty Petal flower shop / Berry Master's wife / Gentleman in Lilycove City	Chesto Berry
Route 123 (Berry fields)	Receive from a fan after reaching Master Rank in contests / Earn as a reward at the Inverse Battle Stop	Chilan Berry
Route 123 (Berry fields)	Receive from a fan after reaching Master Rank in contests / Earn as a reward at the Inverse Battle Stop	Chople Berry
Route 123 (Berry fields)	Receive from a fan after reaching Master Rank in contests / Earn as a reward at the Inverse Battle Stop	Coba Berry
Route 123 (Berry fields)	Receive from a fan after reaching Master Rank in contests / Earn as a reward at the Inverse Battle Stop	Colbur Berry
—	Berry Master / Little girl in Sootopolis	Cornn Berry
—	Only available through special events	Custap Berry
—	Tell Berry Master's wife the special saying / Receive from a fan after reaching Hyper Rank in contests	Durin Berry
—	Only available through special events	Enigma Berry
Route 123 (Berry fields)	Reward for finishing perfectly on time for a Village Sub Combo in the Mauville Food Court	Figy Berry
—	Receive from a Secret Pal with the Berry Farmer skill	Ganlon Berry
Route 123	Berry Master / Little girl in Sootopolis	Grepa Berry
Route 123 (Berry fields)	Receive from a fan after reaching Master Rank in contests / Earn as a reward at the Inverse Battle Stop	Haban Berry
Routes 119 and 123	Berry Master / Little girl in Sootopolis	Hondew Berry
Route 123 (Berry fields)	Reward for finishing perfectly on time for a Village Sub Combo in the Mauville Food Court	Iapapa Berry
—	Only available through special events	Jaboca Berry
Route 123 (Berry fields)	Receive from a fan after reaching Master Rank in contests / Earn as a reward at the Inverse Battle Stop	Kasib Berry
Route 123 (Berry fields)	Receive from a fan after reaching Master Rank in contests / Earn as a reward at the Inverse Battle Stop	Kebia Berry
—	Receive from a Secret Pal with the Berry farmer skill	Kee Berry
Route 115	Berry Master / Little girl in Sootopolis	Kelpsy Berry
—	Win 100 Super battles in a row in the Battle Maison and get from a girl in the next-door house	Lansat Berry
Routes 103, 110, 119, and 123	Youngest sister in the Pretty Petal flower shop / Berry Master's wife / Gentleman in Lilycove City	Leppa Berry
—	Receive from a Secret Pal with the Berry Farmer skill	Liechi Berry
Routes 123 (Berry fields)	Berry Master's wife / Gentleman in Lilycove City	Lum Berry
Route 123 (Berry fields)	Reward for finishing perfectly on time for a Village Sub Combo in the Mauville Food Court	Mago Berry

	Berry Name	Condition	Likelihood of Making Pokéblocks+	Hours to Harvest	Yield	Effects
	Magost Berry	Cute	Low	4	3–15	Can be used to make Pokéblocks
	Maranga Berry	Tough	Medium-High	12	2–13	Boosts Sp. Defense when dealt special damage
	Micle Berry	Clever	High	12	1–13	Boosts accuracy when HP is low
	Nanab Berry	Cute	Very Low	4	4–20	Can be used to make Pokéblocks
	Nomel Berry	Tough	Low	4	3–15	Can be used to make Pokéblocks
	Occa Berry	Cool	Medium	8	2–10	Prevents one Fire-type move from dealing supereffective damage
	Oran Berry	Beautiful	Very Low	4	4–20	Restores 10 HP if HP drops below half
	Pamtre Berry	Beautiful	Low	4	3–15	Can be used to make Pokéblocks
	Passho Berry	Beautiful	Medium	8	2–10	Prevents one Water-type move from dealing supereffective damage
	Payapa Berry	Cool	Medium	8	2–10	Prevents one Psychic-type move from dealing supereffective damage
	Pecha Berry	Cute	Very Low	4	4–20	Cures Poison
	Persim Berry	Cute	Very Low	4	4–20	Cures confusion
	Petaya Berry	Cute	Medium-High	12	2–13	Boosts Sp. Attack when HP is low
	Pinap Berry	Tough	Very Low	4	4–20	Can be used to make Pokéblocks
	Pomeg Berry	Cool	Low	8	2–26	Makes Pokémon friendly, but lowers base HP stat
	Qualot Berry	Cute	Low	8	2–26	Makes Pokémon friendly, but lowers base Defense stat
	Rabuta Berry	Clever	Low	4	3–15	Can be used to make Pokéblocks
	Rawst Berry	Clever	Very Low	4	4–20	Cures Burn
	Razz Berry	Cool	Very Low	4	4–20	Can be used to make Pokéblocks
	Rindo Berry	Clever	Medium	8	2–10	Prevents one Grass-type move from dealing supereffective damage
	Roseli Berry	Cool	Medium	8	2–10	Prevents one Fairy-type move from dealing supereffective damage
	Rowap Berry	Beautiful	High	12	1–13	Deals damage to an opponent who deals special damage
	Salac Berry	Clever	Medium-High	12	2–13	Boosts Speed when HP is low
	Shuca Berry	Tough	Medium	8	2–10	Prevents one Ground-type move from dealing supereffective damage
	Sitrus Berry	Tough	Low	8	3–27	Restores 1/4 maximum HP if HP drops below half
	Spelon Berry	Cute	Low	4	3–15	Can be used to make Pokéblocks
	Starf Berry	Clever	Guaranteed	12	1–7	Greatly boosts one random stat when HP is low
	Tamato Berry	Cool	Low	8	2–26	Makes Pokémon friendly, but lowers base Speed stat
	Tanga Berry	Clever	Medium	8	2–10	Prevents one Bug-type move from dealing supereffective damage
	Wacan Berry	Tough	Medium	8	2–10	Prevents one Electric-type move from dealing supereffective damage
	Watmel Berry	Clever	Low	4	3–15	Can be used to make Pokéblocks
	Wepear Berry	Clever	Very Low	4	4–20	Can be used to make Pokéblocks
	Wiki Berry	Beautiful	Very Low	4	3–15	Restores HP, but confuses Pokémon that don't like dry taste
	Yache Berry	Beautiful	Medium	8	2–10	Prevents one Ice-type move from dealing supereffective damage